Looking at Movies

W. W. NORTON & COMPANY
NEW YORK • LONDON

RICHARD BARSAM

Looking at Movies

AN INTRODUCTION TO FILM

W. W. Norton & Company has been independent since its founding in 1923, when William Warder Norton and Mary D. Herter Norton first published lectures delivered at the People's Institute, the adult education division of New York City's Cooper Union. The Nortons soon expanded their program beyond the Institute, publishing books by celebrated academics from America and abroad. By mid-century, the two major pillars of Norton's publishing program—trade books and college texts—were firmly established. In the 1950s, the Norton family transferred control of the company to its employees, and today—with a staff of four hundred and a comparable number of trade, college, and professional titles published each year—W. W. Norton & Company stands as the largest and oldest publishing house owned wholly by its employees.

Editor: Peter Simon
Developmental Editor: Kurt Wildermuth
Production Manager: Benjamin Reynolds
Manuscript Editor: Alice Falk
Assistant Editor: Nicole Netherton
Managing Editor: Marian Johnson
Art Director: Rubina Yeh

Composition by UG / GGS Information Services, Inc.
Manufactured by Quebecor World, Taunton
Digital art file manipulation by Jay's Publishers Services
Drawn art supplied by ElectraGraphics, Inc.
Author photo by Michael Schmelling

Library of Congress Cataloging-in-Publication Data

Barsam, Richard Meran.
 Looking at movies : an introduction to film / Richard Barsam.
 p. cm.
 Includes bibliographical references and index.

 ISBN 0-393-97436-7 (pbk.)

 1. Motion pictures. 2. Cinematography. I. Title.
PN1994.B313 2003
791.43—dc21

 2003048771

W. W. Norton & Company, Inc., 500 Fifth Avenue, New York, N.Y. 10110
 www.wwnorton.com

W. W. Norton & Company Ltd., Castle House, 75/76 Wells Street, London W1T 3QT

3 4 5 6 7 8 9 0

About the Author

RICHARD BARSAM (Ph.D., University of Southern California) is Professor Emeritus of Film Studies at Hunter College. He is the author of *Nonfiction Film: A Critical History* (rev., exp. ed. 1992), *The Vision of Robert Flaherty: The Artist as Myth and Filmmaker* (1988), *In the Dark: A Primer for the Movies* (1977), and *Filmguide to "Triumph of the Will"* (1975); editor of *Nonfiction Film Theory and Criticism* (1976); and contributing author to Paul Monaco's *The Sixties: 1960–1969* (Vol. 8, *History of the American Cinema*, 2001) and *Filming Robert Flaherty's "Louisiana Story": The Helen Van Dongen Diary* (ed. Eva Orbanz, 1998). His articles and book reviews have appeared in *Cinema Journal, Quarterly Review of Film Studies, Film Comment, Studies in Visual Communication*, and *Harper's*. He has been a member of the Executive Council of the Society for Cinema and Media Studies, the Editorial Board of *Cinema Journal*, and the Board of Advisers of the *History of American Cinema* series, and he cofounded the journal *Persistence of Vision*.

Contents

We all know what movies are. But how might we explain movies to someone completely unaware of their existence? Chapter 1 begins our exploration of this question with some fundamental principles that are shared by all movies, sketches some of the history of motion picture media, offers a snapshot of the film production process, and explains some of the categories that we use to classify movies. The image that opens chapter 1 is from Victor Fleming's *The Wizard of Oz* (1939), one of the most famous, popular, and iconographic movies.

2 FORM AND NARRATIVE 57

The relationship between *form* and *content*, a central concern in all art criticism, underlies our study of movies. Chapter 2 considers the general principles of film form and then turns to the formal structure with which we are all most familiar—narrative. After making the important distinction between a film's *story* and its *plot*, the chapter discusses the many components of film narrative, including its control of time, its development of character and setting, and its presentation of point of view. The image that opens chapter 2 is from Douglas McGrath's *Emma* (1996), one of several cinematic adaptations of Jane Austen's novel.

3 MISE-EN-SCÈNE AND DESIGN 121

The French phrase *mise-en-scène* literally means "staging (or putting on) a scene." Chapter 3 explores the many ways that filmmakers determine what an audience sees and hears onscreen—how they shape a movie's mise-en-scène. The discussion begins with general principles such as framing and movement, then turns to the specific importance of design—including costume and set design—on mise-en-scène. The image that opens chapter 3 comes from Baz Luhrmann's *Moulin Rouge!* (2001), every frame of which celebrates the expressive power of mise-en-scène.

4 CINEMATOGRAPHY 177

While cinematography might seem to exist solely to please our eyes with beautiful images, it is in fact an intricate *language* that can contribute to, enhance, or detract from a movie's overall meaning as much as the narrative, mise-en-scène, or acting does. Chapter 4 breaks this language down into basic parts that can inform our analyses of movies. The image that opens chapter 4 is from Bernardo Bertolucci's *The Last Emperor* (1987), which won the Academy Award for best cinematography.

5 ACTING 247

Screen acting can seem mysterious and magical as we're watching a film, but much planning and direction go into achieving the effects of a performance. Chapter 5 approaches screen acting from several angles, acknowledging the commercial considerations behind casting choices, examining actors' various styles, and considering the ways that acting intersects with other formal elements of filmmaking. The image that opens chapter 5 is from Spike Lee's *Malcolm X* (1992), starring Denzel Washington in the title role (a performance for which Washington was nominated for the Academy Award for best actor).

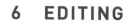

6 EDITING 295

In contemporary movies, transitions from shot to shot often occur so
smoothly that we barely notice them, while others call attention to them-
selves. Such manipulations—of order, duration, and rhythm of shots—
play a crucial role in shaping a movie's meanings. Chapter 6 looks at the
key components of film editing and provides language to discuss editing
in our own film analyses. The image that opens chapter 6 is from
Quentin Tarantino's *Pulp Fiction* (1994), which was nominated for an

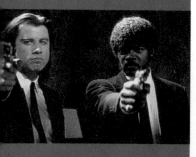

Academy Award for editing and won the 1995 American Cinema Editors' "Eddie" for best-edited feature film.

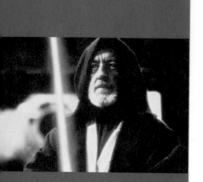

7 SOUND 351

Like every other aspect of film form, sound is deliberately generated and manipulated by filmmakers to achieve desired effects. Chapter 7 explores the ways that sound and silence can affect our interpretation of a movie's meanings, and it briefly traces the historical transition from silent to sound cinema. The image that opens chapter 7 is from George Lucas's *Star Wars* (1977), winner of an Academy Award for best sound as well as a special achievement award for sound effects.

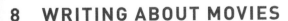

8 WRITING ABOUT MOVIES 403

Once we have mastered the vocabulary and concepts of film form, we are prepared to analyze movies more critically and perceptively. Chapter 8 presents fundamental techniques for writing about movies, describes the different levels of meaning that analyses might grapple with, and offers some practical tips about the writing process. The image that opens this chapter is from Curtis Hanson's *Wonder Boys* (2002), an irreverent look at, among other things, writers and their methods.

To Students

In 1936, the art historian Erwin Panofsky had an insight into the movies as a form of popular art, an observation that is more true today than it was when he wrote it:

> If all the serious lyrical poets, composers, painters and sculptors were forced by law to stop their activities, a rather small fraction of the general public would become aware of the fact and a still smaller faction would seriously regret it. If the same thing were to happen with the movies the social consequences would be catastrophic.[1]

Decades later, we would hardly know what to do without movies. They are a major presence in our lives, and, like personal computers, perhaps the most influential product of our technological age. In fact, some commentators feel that movies are too popular, too influential, too much a part of our lives. Since their invention a little more than one hundred years ago, movies have become one of the world's largest industries and the most powerful art form of our time.

A source of entertainment that makes us see beyond the borders of our previous experience, movies have always possessed powers to amaze, frighten, and enlighten us. They challenge our

senses, emotions, and intellects, pushing us to say, often passionately, that we *love* (or *hate*) them. Because they arouse our most public and private feelings—and can overwhelm us by the magic of their sights and sounds—it's easy to be excited by movies. The challenge is to join that enthusiasm with understanding, to say *why* we feel so strongly about particular movies. That is one reason why this book encourages you to go beyond movies' stories, to understand how those stories are told. Movies are not reality, after all, only illusions of reality, and (as with most works of art) their form and content work as an inter-related system, one that asks us to accept it as a given rather than as the product of a process. But as you read this book devoted to *looking* at movies—that is, not just passively watching them, but actively considering the relation of their form and their content—remember that there is no one way to look at any film, no one critical perspective that is inherently better than another, no one meaning that you can insist on after a single screening. Indeed, movies are so diverse in their nature that no one approach could ever do them justice.

This is not a book on film history, but it includes relevant historical information and covers a broad range of movies; not a book on theory, but it introduces you to some of the most essential approaches to interpreting movies; not a book about filmmaking, but one that clearly

[1] Erwin Panofsky, "Style and Medium in the Motion Pictures," in *Film Theory and Criticism: Introductory Readings*, ed. Leo Braudy and Marshall Cohen, 5th ed. (New York: Oxford University Press, 1999), 280.

and thoroughly explains production processes, equipment, and techniques; not a book of criticism, but one that shows you how to think and write about the films you study in your classes.

Everything we see on the movie screen—everything that engages our senses, emotions, and minds—results from hundreds of decisions affecting the interrelation of formal cinematic elements: narrative, composition, design, cinematography, acting, editing, and sound. Organized around chapters devoted to those formal elements, this book encourages you to look at movies with an understanding and appreciation of how filmmakers make the decisions that help them tell a story and create the foundation for its meaning. After all, in the real life of the movies, on the screen, it is not historians, theorists, or critics—important and valuable as their work is—but filmmakers who continually shape and revise our understanding and appreciation of film art.

The second century of movie history has just begun, and, as I write, the entire process of making, exhibiting, and archiving movies is fast becoming a digital enterprise. Older films are being restored in digital versions, new directors are finding that making movies with digital technology is faster, more efficient, and less expensive, and those of us who *look* at movies benefit from DVDs at home and from the digital projection and sound systems being installed in theaters. As the technology for making movies continues to evolve, however, the principles of film art covered in this book remain essentially the same. The things you learn about these principles and the analytical skills you hone as you read this book will help you look at motion pictures intelligently and perceptively throughout your life, no matter which medium delivers those pictures to you.

Preface

Students who read *Looking at Movies* carefully and who take advantage of the support materials surrounding the text will finish your course with a solid grounding in the major principles of film form, a taste of film history that may spark their interest in other film courses in your curriculum, and a more perceptive and analytical eye. To give you a sense of how *Looking at Movies* accomplishes these goals, a short description of its main features follows.

PEDAGOGY THAT DEVELOPS STUDENTS' ANALYTICAL SKILLS

A good introductory film book needs to help students make the transition from natural enjoyment of movies to a critical understanding—expressed in analytical writing—of movies' form, content, and meaning(s). *Looking at Movies* does so in the following ways:

- Hundreds of illustrative examples and analytical readings of film form throughout the book provide students with concrete models for their own analytical work.
- Each chapter, excluding chapter 1, ends with an "Analyzing" section that provides students with a sample analysis of a single

movie's (or a few movies') expression of the formal principle(s) described in the chapter.
- "Questions for Analysis" following every chapter provide students with a checklist of questions to ask about the movies they watch in class or on their own.
- Web-based "case studies" (one per chapter) provide more extensive analyses of seven of the most commonly screened films.
- A separate chapter on writing about film—with a complete sample student paper—helps students put everything they've learned about film form together to produce solid, analytical writing.

AN EXCEPTIONAL AND FLEXIBLE ILLUSTRATION PROGRAM

Looking at Movies was written with one goal in mind: to prepare students for a lifetime of intelligent and perceptive viewing of motion pictures. Much of that preparation will happen through words—and so *Looking at Movies* is clear, direct, and enjoyable to read. But recognizing the central role played by visuals in the film studies classroom, *Looking at Movies* comes

with an illustration program that is both visually appealing and pedagogically focused.

The main components of the book's visual support are:

IN-TEXT ILLUSTRATIONS

The text is accompanied by over 570 illustrations, in color and black and white. Nearly all the still pictures were "captured" from digital or analog sources, thus ensuring that the images directly reflect the textual discussions and the films from which they're taken. Unlike publicity stills, which are attractive as photographs but almost useless as teaching aids, the captured stills throughout this book provide visual information that will help students learn as they read, and—because they are reproduced in the aspect ratio of the original source—will serve as accurate reference points for student analysis.

Throughout the book, the illustrations function in three ways. Depending on the particular pedagogical points being raised, still images and their accompanying captions either correspond to the text, present material related to the text, or amplify the text by introducing new information.

FRAME SEQUENCE ANIMATIONS ON THE WEBSITE

Among many other features, **Looking at Movies online** (www.wwnorton.com/web/movies) offers students a menu of "frame sequence animations"—still images from particular shots or scenes, presented as moving sequences. Although these animations are no substitute for viewing the movies or clips described, they usefully complement the textual descriptions and give students a shorthand sense of movement within the frame.

FILM CLIPS ON THE CD-ROM

The enclosed CD-ROM offers students fifteen full-motion film clips, with sound where appropriate, of selected shots or scenes described in the text. Unencumbered by distracting design or voiceover (but accompanied by a scrollable reproduction of the relevant textual discussion), the clips are presented with the necessary viewing software, embedded in the disk for easy use.

These images, animations, and film clips were chosen from the hundreds of film examples mentioned in the book because they come from some of the most popular movies in the introductory film classroom. Prior to writing this book, the author and W. W. Norton collaborated on an extensive survey of instructors to determine which films were most frequently screened, either whole or in part. The resulting list guided us throughout our work on the book, and the illustration program reflects that guidance. We hope you find examples here that satisfy your teaching needs and that spark your students' interest in viewing all these films outside the classroom.

TEXT AND MEDIA THAT WORK TOGETHER

Looking at Movies is accompanied by two media ancillaries—a CD-ROM and a companion website. The CD offers a menu of film clips discussed in the text, and the website offers abundant material for student review, interaction, exploration, and research.

Seventy-five of the captions in the text refer students to either the website or the accompanying CD-ROM. These captions are clearly signaled by a solid black background and one of three icons:

 refers students to the website for more information on the topic discussed in the caption. Students will also find a list of web modules inside the book's back cover.

 sends students to the website to view an animated sequence of frames from a particular shot or scene. Students will also find a list of the sequences inside the book's front cover.

refers students to the CD-ROM to view a short film clip of a shot or scene. Students will also find a list of the clips inside the book's front cover.

CHAPTER-BY-CHAPTER REVIEW MATERIALS ON THE WEBSITE REINFORCE STUDENTS' LEARNING:

- "Learning objectives" online summarize each chapter's key themes.
- Over 250 self-quiz questions test students' retention of core concepts.
- An extensive timeline for each chapter highlights significant events in film history that intersect with the subject of the chapter.

A RESPONSIBLE INTEGRATION OF FILM HISTORY, FILM THEORY, AND FILM PRODUCTION

Looking at Movies is primarily focused on teaching the fundamentals of film form and on building students' analytical skills, but it also offers useful information about film history, film theory, and film production in a natural, unobtrusive way—at a level of sophistication and detail appropriate for an introductory-level course.

- Each chapter offers a synopsis of the historical development of the formal principle covered in the chapter.
- Most chapters offer basic information about the technology and personnel involved in the production of each of the major formal components of movies.
- Fundamental film theories are described in brief in chapter 8, "Writing about Movies."
- An appendix sketches a brief history of the Hollywood studio system and the independent production system that grew out of it.

ANCILLARIES FOR INSTRUCTORS

TEST-ITEM FILE

The test-item file for *Looking at Movies* offers nearly five hundred multiple-choice questions, delivered with Chariot™ software to ensure that tests are easy to generate.

NORTON RESOURCE LIBRARY

Class-management resources that are compatible with Web-CT and Blackboard software are available upon request. Ask your local representative for details.

Acknowledgments

Writing this book was, at times, very much like making a movie—a collaborative enterprise—and I have had the good fortune of working with excellent partners.

Robert Baird has been exceptionally helpful with his many suggestions and contributions, especially to the website and chapter 8, "Writing about Movies." Ed Glaser prepared the web quizzes and the timelines. For their generous responses to queries, special thanks are due to J. Dudley Andrew, Luis Antonio Bocchi, Royal S. Brown, Jeffrey Burke, Robert L. Carringer, Norman Clarius, Gregory Crosbie, Vincent LoBrutto, Russell Merritt, Rolando Perez, Richard Raskin, Charles Silver, and Steve Lloyd Wilson. At my request, Joel Zuker, at Hunter College, read and made many helpful suggestions on the entire manuscript, as did Renato Tonelli, also at Hunter, on the cinematography chapter. In assessing the first rough draft, Brenda Spatt contributed more than she will ever know.

My editor at W. W. Norton & Company, Pete Simon, enthusiastically supported the idea of this book from the outset and pledged his formidable organizational and editorial talents to seeing it through to completion. Kurt Wildermuth, the developmental editor, contributed significantly to the book's scope, content, and final appearance, and cheerfully supervised the countless details of final editing, design, and production. Alice Falk, the copyeditor, worked wonders with the manuscript. Collaborating with Pete, Kurt, and Alice proved both an education and a pleasure. I am grateful also to others at Norton, including Marian Johnson, managing editor; Rubina Yeh, book designer; Roberta Flechner, layout artist; Benjamin Reynolds, production manager; Nicole Netherton, assistant editor, art researcher, and permissions gatherer; Eileen Connell, media editor; and Jack Lamb, electronic media designer. No author could ask for a more creative, supportive team.

Special thanks are due to my research assistants: Gustavo Mercado worked tirelessly, always put his hands on exactly what I needed, and prepared numerous summaries, and Emanuel Leonard meticulously assembled the first master tape of film clips eventually used on the CD-ROM.

I owe a major debt of gratitude to Dave Monahan, of the University of North Carolina at Wilmington, a master teacher, gifted filmmaker, and treasured friend who has given untiring, generous support to my efforts. He was always ready to answer questions, suggest different approaches, and, especially, to recommend specific shots or scenes for analysis, and the final book owes much to his deep love for the movies and his inspiring work in the classroom.

Throughout this project, Edgar Munhall has offered steadfast encouragement, support, and

companionship, and, with his insight and understanding, has taught me as much about looking at movies as he has about looking at life. I gratefully dedicate this book to him.

REVIEWERS

For their review of the original proposal, I am grateful to David Cook, Walter Korte, and Dana Polan. The following colleagues responded to questionnaires: Norma M. Alter, Roy Anker, Todd Berliner, Matthew Bernstein, Dennis Bingham, Michael Budd, Marcia Butzel, Jackie Byars, Sandra Camargo, William V. Costanzo, Charles Derry, Gerald Duchovnay, Dirk Eitzen, Eric Friedman, Anne Friedberg, Maureen Furniss, Krin Gabbard, Claudia L. Gorbman, Diana J. Grahn, Leger Grindon, Ina Rae Hark, Gary L. Harmon, Joan Hawkins, Thomas Hemmeter, Elizabeth Henry, Amelia S. Holberg, Theodore Hovet, Bryan Hull, Christopher P. Jacobs, Joseph G. Kickasola, Jeffrey F. Klenotic, Arthur Knight, Joy Korinek, Donald Larsson, Leonard Leff, George Lellis, Julia Lesage, Julie R. Levinson, Leon Lewis, Anthony Libby, Susan Linville, Paul Loukides, Charles J. Maland, Phillipe D. Mather, Melani McAlister, Mary A. McCay, Joan McGettigan, Toby Miller, Stuart Minnis, Gerard Molyneaux, Robert Barry Moore, Diane Negra, Kimberly Neuendorf, Richard Neupert, Robert A. Nowlan, Patrice Petro, Carl Plantinga, David Popowski, Maria T. Pramaggiore, Diana Reep, Jack Riggs, Karen Schneider, Robert Shelton, Craig Shurtleff, Lisa Sternlieb, George Toles, Gerry Veeder, Eugene Walz, Gretchen S. Watson, Steven J. Whitton, Clyde V. Williams, Tony Williams, and J. Emmett Winn.

I am equally grateful to those who reviewed individual chapters, including Robert Baird, Robin Bates, Dennis Bingham, Donna Davidson-Symonds, John M. Desmond, Susan Glassow, William Gombash, Terence Hoagwood, Matthew Hurt, Donald Larsson, David Popowski, Glenn Reed, Don Staples, William Vincent, Michael Walsh, and J. Emmett Winn.

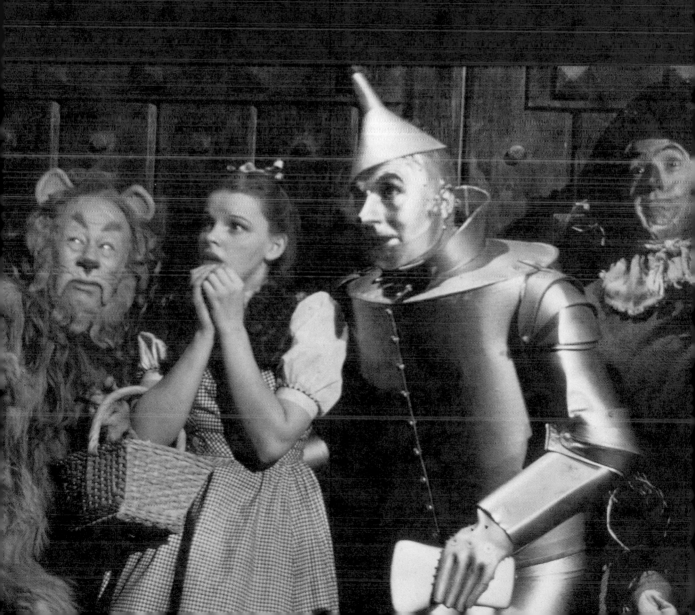

What Is a Movie?

If someone from a remote region, someone isolated from technology, were to ask you what a movie is, how would you answer? The question at first seems a simple one, with a simple answer. Yet faced with the prospect of providing a definition, most of us wouldn't know where to begin. Do we talk about the historical origins of moviemaking? How a movie is made today? How we experience one? The different kinds of movies that exist? Let's begin by establishing some fundamental principles.

FUNDAMENTAL PRINCIPLES

In just over one hundred years, movies have evolved into a complex form of artistic representation and communication: they are at once a hugely influential, global industry and a modern art—the most popular art form today. Although this new form has roots in much older ones, it depends on technologies that, historically speaking, coalesced in the second half of the nineteenth century: chemistry, optics, photography, precision machinery, electricity, and sound recording.

Today, digital technologies are augmenting and in some cases replacing the processes by which movies traditionally have been made and distributed. Older movies benefit from digitally assisted remastering that makes them look and sound as dynamic as they originally did, with sometimes even better color or clarity. The availability of movies on the Web for viewing on personal computers has, with varying degrees of success in initial attempts, provided a way for people to see films that might not draw sufficient audiences to theaters—either because they are made by relatively un-

known filmmakers or because they veer in some way from mainstream tastes. Entire movies, such as Spike Lee's *Bamboozled* (2000) and George Lucas's *Star Wars: Episode II—Attack of the Clones* (2002), are shot on digital videotape.[1]

Even as evolving technology brings us new terminology, new effects, new distribution channels, new viewing methods, and even new *experiences,* five principles continue to apply to movies as an art form. These principles are fundamental to the *nature* of movies, regardless of the techniques used to make particular movies:

1. Movies manipulate space and time in ways that other art forms cannot.
2. Movies depend on light.
3. Movies provide an illusion of movement.
4. Movies can depict worlds convincingly.
5. Movies generally result from a complex, expensive, and highly collaborative process.

MOVIES MANIPULATE SPACE AND TIME IN WAYS THAT OTHER ART FORMS CANNOT

Some of the arts, such as architecture, are mostly concerned with space; others, such as music, are mainly related to time. But through modern technologies, movies manipulate space and time and are thus both a spatial and a temporal art form. Movies can move seamlessly from one space to another (say, from a

[1]Movies and video differ in that the visual images we see in movies are made photographically, but those we see on video (or DVD) are made electronically. While both movies and video use electronic equipment in sound recording and editing, and while many contemporary movies employ aspects of video technology, the forms differ in so many essential ways that we will consider only movies.

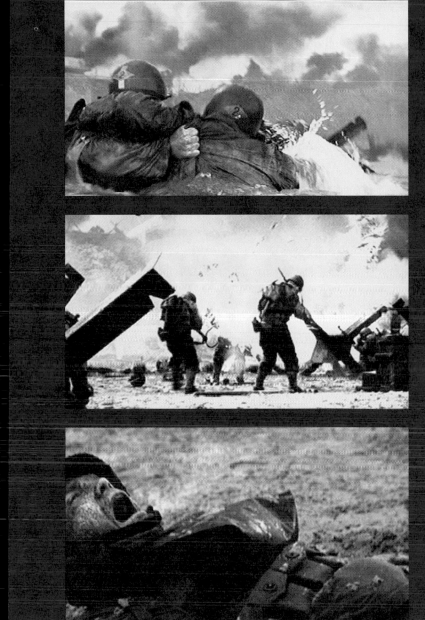

Manipulating space and time in ways possible only in movies, the twenty-five-minute opening sequence of Steven Spielberg's *Saving Private Ryan* re-creates the horrors of the 1944 D-Day invasion of Normandy. The shocking brutality of the violence, the disorienting camera work (inspired by actual World War II combat footage), and the many techniques employed to shape our sense of the cinematic "reality" all leave us exhausted and overwhelmed. As emotionally wrenching as the experience of watching this portion of *Saving Private Ryan* is for viewers who have had no combat experience, the experience for veterans, especially those who participated in the Normandy invasion, has been similar to revisiting a nightmare. One veteran said to his family after seeing the film, "Now you know how it was for me" (quoted in *"Now You Know". Reactions after Seeing "Saving Private Ryan,"* ed. Jesse Kornbluth and Linda Sunshine [New York: Newmarket Press], 1999, 15). To view a sequence of stills from this scene, go to <www.wwnorton.com/web/movies>. 1.1

room to a landscape to outer space), or make space move (as when the camera turns around or away from its subject, changing the physical, psychological, or emotional relationship between the viewer and the subject), or fragment time in many different ways.

Only movies can record "real" time in its chronological passing as well as "subjective" time as it passes in the mind. Only movies—through *editing*, the joining of different pictures or different sounds, a process we'll examine throughout this book—can thoroughly

manipulate spatial relationships and temporal rhythms in such a way as to distort, transform, and heighten a scene.

On the movie screen, space and time are relative, and we can't separate them or perceive one without the other. The movies give time to space and space to time, a phenomenon that art historian and film theorist Erwin Panofsky describes as the *dynamization of space* and the *spatialization of time*.[2] To understand this principle of "co-expressibility," compare your experiences of space when you watch a play and when you watch a movie. As a spectator at a play in the theater, your relationship to the stage, the settings, and the actors is *fixed*. Your perspective on these things is determined by the location of your seat, and everything on the stage remains the same size in relation to the entire stage. Sets may change between scenes, but within scenes the set remains, for the most part, in place. No matter how skillfully constructed and painted the set is, you know (because of the clear boundaries between the set and the rest of the theater) that it is not real, and that when actors go through doors in the set's walls, they go backstage into "wings," not into a continuation of the world portrayed on the stage. No matter how effective the performance is, you remain aware that you are *suspending disbelief* regarding the space in which the play is being performed. For the most part, you choose where to look on the stage. By contrast, when you watch a movie, your relationship to the space portrayed onscreen can be flexible. You still sit in a fixed seat, but the screen images *move*—the spatial relationships on the screen may constantly change, and the film directs your gaze. Say that during a scene in which two characters meet at a bar, for example, the action suddenly flashes forward to their later rendezvous at an apartment, then flashes back to the conversation at the bar, and so on; or a close-up focuses your attention on one character's (or both characters') lips. A live theater performance can accomplish such spatial effects, as film director Ingmar Bergman demonstrated in his 1970 stage production of Henrik Ibsen's *Hedda Gabler* (1890), where a spotlight left only the actor's face or lips visible, thus creating a kind of close-up; and it can accomplish such temporal effects, as in Arthur Miller's *Death of a Salesman* (1949), where past and present intermingle within scenes. But a play can't do so as seamlessly, immediately, persuasively, *intensely,* as a movie can. If one of the two actors in that bar scene were to back away from the other and thus disappear from the screen, you would perceive her as moving to another part of the bar, that is, into a continuation of the space already established in the scene. You can easily imagine this movement because of the *fluidity* of movie space, more of which is necessarily suggested than is shown. In the theater, we are sometimes distracted by such elements as the actors' movements on and off the stage or by the often noisy and clumsy changing of scenery. Although we generally accept such distractions, they challenge our ability to suspend disbelief. By contrast, at the movies, we are overwhelmed by the sheer size of the image, the spectacular visual and aural effects, and the elegance with which time and space change. Appearing to occur seamlessly, these functions not only make us feel more comfortable with what we see but also contribute to the credibility of the cinema, even at its most hyperreal.

[2]Erwin Panofsky, "Style and Medium in the Motion Pictures," in *Film Theory and Criticism: Introductory Readings,* ed. Leo Braudy and Marshall Cohen, 5th ed. (New York: Oxford University Press, 1999), 281–83.

Through their unique ability to manipulate space and time, movies create not reality but a convincing representation, an approximation, an illusion of reality. While theater can present convincing characters in convincing interior settings, it can't match cinema's lifelike illusions; it can't create a truly convincing street scene or landscape, for example. Theater critic Fintan O'Toole puts it this way: "After you have seen [Steven Spielberg's] *Saving Private Ryan* [1998], no stage production of *Henry V,* however spectacular, is ever going to look realistic."[3] O'Toole refers, in particular, to the film's vivid depiction of the D-Day invasion of Normandy, a massive operation that helped end World War II and that could never be portrayed so viscerally onstage. *Henry V* and *Saving Private Ryan* share a concern with the horrors of war, but only the film puts spectators in the middle of the shooting, suffering, and dying—as do the two powerful, but very different, film adaptations of Shakespeare's play: Laurence Olivier's in 1944 and Kenneth Branagh's in 1989.

The camera eye perceives what's placed before it through a series of different pictures (called *shots;* for a full discussion, see chapter 4), made with different lenses, from different camera positions and angles, using different movements, under different lighting, and so on. How does this resemble our own perception? During the photographic process, light passes through the lens and exposes images on the film in the camera. The human eye functions similarly with the pupil acting as the aperture and the retina as the film. The pupil enlarges and contracts in response to differing light strengths, and these automatic

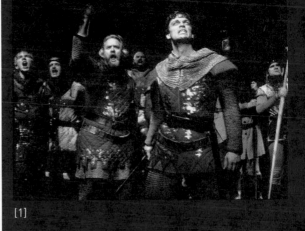

[1]

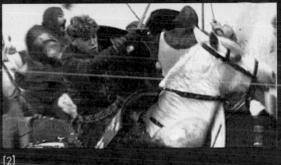

[2]

The unique ability of movies to manipulate space and time becomes obvious when we compare a staged version of a play to a film adaptation of that same play. (1) A staging of Shakespeare's *Henry V* at the Alabama Shakespeare Festival shows the title character rousing his men to battle. As in many theatrical productions, the actor resorts to a stage convention—facing and addressing the theater audience rather than the other actors—to overcome a practical limitation of theatrical space (that is, the problem of not being heard by the audience if he speaks toward the backstage area). Similarly, the theater is not conducive to staging convincing battle scenes, so combat is usually just *referred to* in plays, rather than played out. In movies, however, these limitations of space and time don't apply. (2) Kenneth Branagh's film adaptation of Shakespeare's *Henry V* brings us close to the violent action of the famous battle of Agincourt, transporting us from place to place within the cinematic space, and speeding up and slowing down our sense of time for heightened emotional effect. To learn more about the ways in which film "stages" its more realistic action, go to <www.wwnorton.com/web/movies>.

www

[3]Fintan O'Toole, "Mystic Scientist," review of *Threads of Time: Recollections,* by Peter Brook. *New York Review of Books* 19 November 1998, 28.

adjustments are similar to the changing of lenses to expose the film properly. But while the camera eye and the human eye can both see the movements, colors, textures, sizes, and locations of people, places, and things, the camera eye is more sophisticated. The camera frames its image, for example, while the eye doesn't. The camera can use special lenses to widen and foreshorten space, whereas the human eye can't. Through camera positioning, the lens can record a close-up, a radical departure from the human eye's inability to see just a face and not its context. In short, the camera *mediates* between the exterior (the world) and the interior (our eyes and brains). We use the term **mediation,** a key concept in film theory, literally to mean an agent, structure, or other formal element, whether human or technological, that transfers something (in the case of the movies, information) from one place to another. For example, the actor mediates between the script and the performance we see on the screen through the vocal interpretation of lines; the camera mediates between how this actor appears to it and how we see the actor on the screen through its choice of shots; and, of course, the film itself, through its use of the formal elements of cinema such as cinematography and editing, mediates between filmmakers and the audience. In thus providing only a partial or selective view of all the information available, mediation influences interpretation and meaning.

Does this mean the camera's perception is better than ours? Not exactly. No matter how "real" a movie looks or sounds, its records of time, space, and movement are all illusions, both in the way they were created and in the way we perceive them. The camera creates *cinematic time,* that is, the imaginary time in which its images appear or its narrative occurs; it sees and records only two dimensions,

height and width; its illusion of spatial depth is created by such techniques as composition, lighting, and cinematography (again, see chapter 4; on cinematic time, see chapter 2). Sound images, which can be manipulated as easily as visual images, create only an illusion of real sound (see chapter 7). By contrast, we experience the passing of time in verifiable units—seconds, hours, days, years, and so on—that provide us with reference points for comparing events or markers for remembering them. Though our eyes may be more limited in their perceptual powers, they show us what we generally call reality. We see the world as it unfolds before us, and we see it in three dimensions: height, width, and depth.

Cinema's ability to manipulate space is illustrated in Charlie Chaplin's *The Gold Rush* (1925). This brilliant comedy portrays the adventures of two prospectors: the "Little Fellow" (Chaplin) and his nemesis, Big Jim McKay (Mack Swain). After many twists and turns of the plot, the two find themselves sharing an isolated cabin. At night, the winds of a fierce storm blow the cabin to the brink of a deep abyss. Waking and walking about, the Little Fellow slides toward the door (and death). The danger is established by our first seeing the sharp precipice on which the cabin is located and then by seeing the Little Fellow sliding toward the door that opens out over the abyss. Subsequently, we see him and Big Jim engaged in a struggle for survival, which requires that they maintain the balance of the cabin on the edge of the abyss. The suspense exists because individual shots—one made outdoors, the other safely in a studio—have been edited together to create the illusion that they form part of a complete space. (We'll analyze such *parallel editing,* or *cross-cutting,* in chapter 6; a *cut* is the joining of two shots.) As we watch the cabin sway and teeter on the

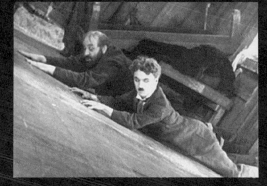

[1]

[2]

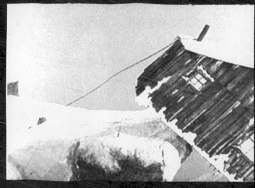

[3]

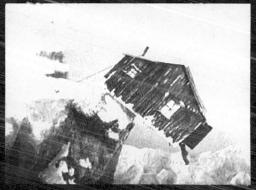

[4]

[5]

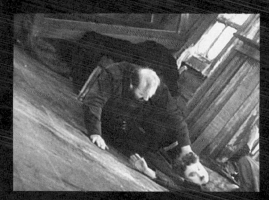

[6]

Film editing can convince us that we're seeing a complete space and a continuous action even though individual shots have been filmed in different places and at different times. In Charlie Chaplin's *The Gold Rush*, an exterior shot of the cabin (1) establishes the danger that the main characters only slowly become aware of (2). As the cabin hangs in the balance (3), alternating interior and exterior shots (4–6) accentuate our sense of suspense and amusement. To view a clip, consult your CD-ROM.

1.2

cliff's edge, we imagine the hapless adventurers inside; when the action cuts to the interior of the cabin and we see the floor pitching back and forth, we imagine the cabin perched precariously on the edge. The experience of these shots as a continuous record of action occurring in a complete (and realistic) space is an illusion that no other art form can convey as effectively as movies.

The manipulation of time (as well as space), a function of editing, is handled with great irony, cinematic power, and emotional impact toward the end of Francis Ford Coppola's *The Godfather* (1972; editors: William Reynolds and Peter Zinner). As Figure 1.1 illustrates, this five-minute **sequence** consists of thirty-six **scenes.** (Both sequences and scenes are series of interrelated shots, unified by theme or purpose, but sequences tend to be longer than scenes. For purposes of this discussion, we'll concentrate on the bigger picture, but keep in mind that many of these scenes are composed of multiple shots.) The scenes here, of differing lengths and occurring in ten different locations, are separated by hard cuts. Confirming Michael Corleone's (Al Pacino) replacement of his father, Don Vito Corleone (Marlon Brando), as the new Mafia don, the sequence contrasts the living and the dead. It opens with Michael and his wife, Kay (Diane Keaton), attending a baptism; scenes in which Michael, the child's godfather, repeats the baptismal vows alternate with scenes of his men killing their adversaries at various locations.

This back-and-forth (again, parallel) editing results in a complex set of contrasts in what we see, hear, think, and feel. The tender baptism service is carried along by the priest's Latin incantations and the Bach organ music, which picks up in pitch and loudness as the sequence progresses, rising to particular climaxes as the murders are committed. Juxtaposed with the words and music are gunshots, the only onscreen (or *diegetic;* see chapter 2) sounds coming from the murder scenes. Ironically, the organ music—which is offscreen *(nondiegetic)* because, even though we assume it comes from the cathedral, we do not know its actual source—underscores every scene in the sequence, not just those that take place in the cathedral. Michael remains cool and controlled throughout the service, while some of his gunmen sweat in the suspenseful preparation for their violent tasks. "Go in peace, and may the Lord be with you," the priest says to Michael in farewell, and we are left to reconcile this sentiment with the killings we have just witnessed. The dialogue underscores the cinematic conflict between peace and violence.

Now consider how differently two movies based on the same stage play—Terence Rattigan's *The Winslow Boy* (1946)—can handle space and time. British film director Anthony Asquith first adapted it in 1948; American playwright, screenwriter, and film director David Mamet created his version in 1999. Although Asquith began his career by making films that included experimental effects, he became famous for his straightforward film adaptations of stage hits, particularly those involving the upper classes; *The Winslow Boy* was his thirtieth film. Before becoming a film director, Mamet was famous for writing plays and screenplays (several of which were based on his own plays) distinguished by their crackling dialogue; *The Winslow Boy* is the sixth film he directed. Despite his long career as a film director, Asquith (who cowrote his screenplay with Rattigan and Anatole de Grunwald, the producer) did not explore the cinematic potential of this story, but essentially filmed a stage play; by contrast, Mamet,

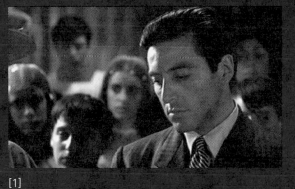

[1]

[2]

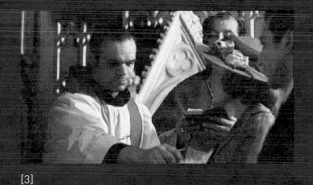

[3]

[4]

[5]

[6]

To inspire complex responses in viewers, Francis Ford Coppola's *The Godfather* juxtaposes a sacred, solemn, and deliberate ceremony with cold-blooded murders: a Catholic baptism (1–3) is matched by the actions of hit men (only one part of which is portrayed here, in frames 4–6) working for the baby's godfather, Michael Corleone (Al Pacino). As this sequence unfolds, contrasts come to mind (innocence versus corruption, the sacred versus the profane, the cradle versus the grave), as do many parallels (the striking similarity between the priest's ritualistic motions and the hit men's preparations, the virtual silence with which everyone onscreen, both in the cathedral and out in the world, goes about their business). [1] is from scene 1, [2] is from scene 4, [3] is from scene 10, [4–6] are from scene 22. To view a sequence of stills from this scene, go to *<www.wwnorton.com/web/movies>*.

1.3

FIG. 1.1	TIME AND SPACE IN THE "BAPTISM AND MURDER" SEQUENCE OF *THE GODFATHER*
Scene #	**Location and Action**
1	Location A: Cathedral interior; baptism service.
2	Location B: Apartment interior; man loading weapon.
3	Location C: House exterior; man heading toward car with cardboard box.
4	Location A: Cathedral interior.
5	Location D: Barbershop interior (in basement of building); barber lathering customer's face.
6	Location E: Apartment interior; man removing police uniform from suitcase.
7	Location A: Cathedral interior.
8	Location E: Apartment interior; man, dressed in uniform, taking police pistol and badges out of paper bag.
9	Location F: Building, interior staircase: man from scene 3 mounting stairs.
10	Location A: Cathedral interior.
11	Location G: Courthouse interior; man walking in hallway.
12	Location H: Courthouse exterior; man disguised as policeman (from scene 8) "on duty" in front of courthouse.
13	Location F: Building, interior staircase (from scene 9); man continues to mount stairs.
14	Location B: Apartment interior; man and accomplice prepare to leave their apartment with weapons.
15	Location D: Barbershop interior; customer leaves.
16	Location A: Cathedral interior.
17	Location H: Courthouse exterior; man from hallway (scene 11) with second man on courthouse steps.
18	Location D: Barbershop interior; customer mounts staircase leading from shop to lobby

Scene #	Location and Action
19	Location F: Building, interior staircase (from scene 13); man continues to mount stairs, stops on elevator landing, and pushes elevator call button.
20	Location I: Massage studio interior; masseur and customer (on table).
21	Location A: Cathedral interior.
22	Location F: Building, interior staircase landing; elevator doors open, two men exit, man standing on landing (scene 19) pushes them back into elevator and fires two shots at them.
23	Location A: Cathedral interior.
24	Location I: Massage studio interior; customer murdered.
25	Location A. Cathedral interior.
26	Location D: Barbershop interior; customer waits on staircase landing and then mounts toward building lobby.
27	Location D: Barbershop building lobby; customer locks man inside revolving door and shoots him.
28	Location A: Cathedral interior.
29	Location J: Apartment; two men (from scene 14) burst through door and kill couple in bed.
30	Location A: Cathedral interior.
31	Location H: Courthouse exterior; man disguised as policeman kills two men from scene 17 and bystander.
32	Location A: Cathedral interior.
33	Location J: Apartment; murdered couple in bed.
34	Location D: Barbershop building lobby, murdered man in revolving door.
35	Location H: Courthouse; murdered men on steps.
36	Location A: Cathedral interior.

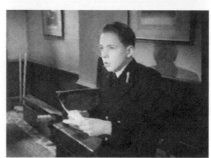

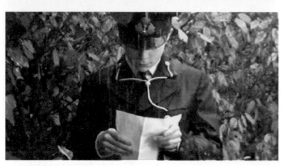

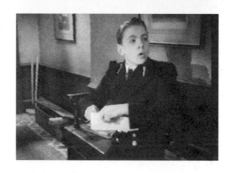

David Mamet's version of *The Winslow Boy* [left] makes better use of cinematic space than does Anthony Asquith's, offering more perspectives on the action as it unfolds (even an action as simple as opening a letter), placing actors in richer physical settings (both interior and exterior), and cutting back and forth between these different spaces (thus providing plenty of visual and aural detail to accentuate the sense of place). Mamet's camera moves fluidly inside the house and outside; contrasts shots of the warm, cozy interiors with those of the wet, cold garden; and uses different points of view, thus creating a strong sense of mood. Asquith's camera is more static, and his settings are less fleshed-out.

understanding the cinematic potential, fully transformed Rattigan's work. By *cinematic potential,* we mean the opportunity for filmmakers to mediate between the story and the movie audience; to employ such formal elements as design, cinematography, and editing; and thus to create not a filmed stage play but a movie that stands, and may be analyzed and judged, on its own.

Both movies tell the story of Ronnie Winslow, the young son of an established upper-class family, a cadet at a prestigious naval academy who has been accused of stealing a money order and expelled without a trial. When he arrives home, the family is at church, and he intercepts and opens a letter from the academy to his father notifying Mr. Winslow of the accusation. The boy insists that he is innocent, and his father believes him. From here on, the father does everything he can, including hiring one of London's most famous attorneys, to save the boy's reputation and protect the family name. Throughout the courtroom melodrama that occupies much of the plot, the authority of the British military establishment is under threat as well. At the moment that Ronnie returns home, Catherine Winslow, his sister, is close to becoming engaged to a military officer; a large part of the scene under study in these two films involves Mr. Winslow's interview with John Watherstone, the suitor, over the adequacy of his finances for marriage. Thus the scene establishes Ronnie's predicament, the family's predicament, and the suspenseful interplay between a possible scandal and the impending marriage.

Each version of the scene begins differently. Asquith opens with a shot of a studio-built interior setting: Ronnie (Neil North) sitting in the front hall of the family house, opening the letter addressed to his father. Hearing the family carriage arrive at the front of the house, he rushes into the back garden just as they enter. Mr. Winslow (Cedric Hardwicke) and Watherstone (Frank Lawton) have their talk, after which Ronnie quietly enters the house and explains his situation to Catherine (Margaret Leighton). By contrast, Mamet opens with an exterior shot: the family arriving home on foot from church. The moving camera puts us immediately in their midst, enabling us to hear their conversation and learn their identities and relationships with one another, and roots the impending drama in a city full of people and traffic. In fact, the focus is on the family and not, as in Asquith's film, on Ronnie. Just before the interview between Mr. Winslow (Nigel Hawthorne) and Watherstone (Aden Gillett), we see a worker, who has been putting up the family Christmas tree, finish his work and depart through the garden. His inadvertently leaving the garden gate open permits Ronnie (Guy Edwards) to sneak into the garden from the road. To set this up, Mamet cross-cuts between interior and exterior shots; and while the worker's carelessness may seem to be a bit of unnecessary "business," in fact it makes our first glimpse of Ronnie far more intriguing than it is in Asquith's version. Once the interview begins, Mamet again cuts between the house and the garden, where Ronnie holds the unopened letter. When the subsequent banging of the gate in the wind annoys Ronnie's father, he sends a maid out to close it. But she sees Ronnie and stops, sensing that something is wrong. Meanwhile, the interview has concluded, and Watherstone and Catherine (Rebecca Pidgeon) rendezvous on the terrace, from where she sees Ronnie. Thus Mamet establishes suspense, carefully preparing not only for our first sight of Ronnie but for the subsequent development of the plot. (He handles the remainder of this scene—Ronnie's

showing the letter to Catherine, and so on—pretty much as Asquith does.)

Asquith uses 49 shots in his version, which runs five minutes, forty-eight seconds. Mamet uses 116 shots, more than twice as many, in a scene that runs twelve minutes, thirty-four seconds, more than twice as long. Each director creates cinematic space differently, Asquith relying primarily on interiors, Mamet fashioning a sense of the larger world outside the family's house. Although Asquith's sets are convincing enough, they are essentially

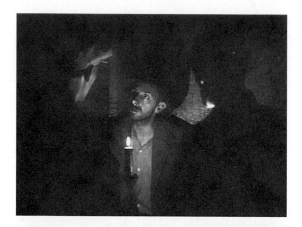

Strong contrasts between light and dark can be visually striking and can also evoke moods or meanings, as in these frames from John Ford's *The Grapes of Wrath* (1940).

individual rooms that do not seem linked to a whole house. Furthermore, the house is only vaguely connected to the outside world, which we hear instead of see, as when Ronnie hears the horses' hooves announcing the arrival of the family carriage and darts into the garden. In fact, at least in this scene, Asquith uses sound as the basic device for referring to spaces other than those we see onscreen. Having designed his version for the screen, Mamet preserves the naturalism of the setting and opens up his scene by cutting back and forth between the street, house, and garden, creating a unified world that we can see. His characters move freely within and between the rooms of the house as well as into the garden. The camera goes with them, observing, following, and sometimes even looking at them from behind half-closed doors as if it were eavesdropping on their conversations. Asquith uses the static camera as an observer of the action, Mamet the moving camera as both observer of and participant in the action. As a result, Mamet achieves genuinely cinematic effects that would have been impossible with Asquith's comparatively stagebound approach. In Mamet's version, fluid camera work involves us in the space and situates us within the cinematic world, rather than removing us from the action as the theater would. (In fact, Mamet shot the film in an actual house.) While neither director's handling of space and time would confuse an audience, Asquith's version ultimately seems static, while Mamet's is dynamic.

MOVIES DEPEND ON LIGHT

One of the most powerful black-and-white films ever made, John Ford's *The Grapes of Wrath* (1940) tells the story of an Oklahoma farming family that has been forced off its land

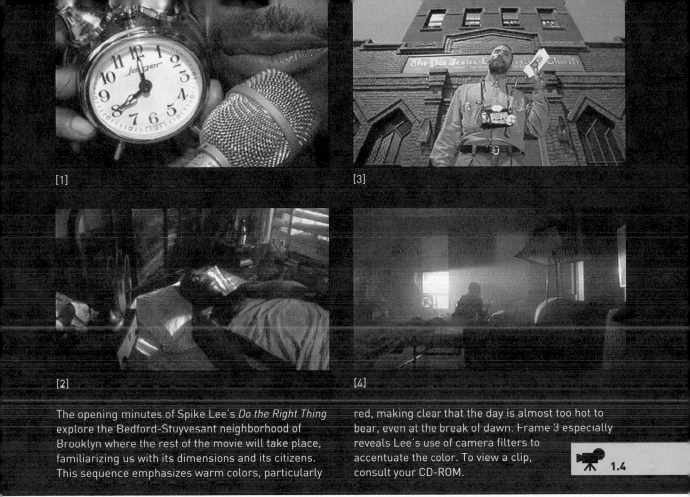

[1]

[3]

[2]

[4]

The opening minutes of Spike Lee's *Do the Right Thing* explore the Bedford-Stuyvesant neighborhood of Brooklyn where the rest of the movie will take place, familiarizing us with its dimensions and its citizens. This sequence emphasizes warm colors, particularly red, making clear that the day is almost too hot to bear, even at the break of dawn. Frame 3 especially reveals Lee's use of camera filters to accentuate the color. To view a clip, consult your CD-ROM.

1.4

by the violent dust storms that plagued the region during the Great Depression of the 1930s. The eldest son, Tom Joad (Henry Fonda), returns home after serving a prison sentence, only to find that his family has left their farm for the supposedly greener pastures of California. Tom and an itinerant preacher named Casey (John Carradine), whom he has met along the way, enter the Joad house, using a candle to help them see inside the pitch-black interior. Lurking in the dark, but illuminated by the candlelight, is Muley Graves (John Qualen), a farmer who has refused to leave Oklahoma with his family. As Muley tells Tom and Casey what has happened in the area, Tom holds the candle so that he and Casey can see him better, and the contrasts between the dark background and Muley's haunted face, illuminated by the flickering candle, reveals their collective despair. The story is told less through words than through the overtly symbolic light of a single candle. Such sharp contrasts of light and dark occur throughout the film, thus providing a pattern of meaning.

Spike Lee's *Do the Right Thing* (1989) uses light as well as color to establish setting and create meaning. The film takes place during the hottest day of the year on one block in the Bedford-Stuyvesant neighborhood of Brooklyn, New York, an area populated by blacks, whites, Asians, and Latinos, groups defined and divided by skin color. The opening scene takes place at 8 A.M., in the studio of Mister Señor Love Daddy (Samuel L. Jackson), a local disc jockey wearing dark glasses and a colorful shirt and giving the dire weather report. The heat, which is on everyone's mind, is emphasized through a design strategy based on such hot colors as red, orange, and yellow. For example, the three "cornermen," who function as a kind of chorus as they comment on everything they see, sit in front of a wall painted bright red. The camera pulls back and outside to introduce many key characters: some are outside in the clear light of the early-morning sun; others are inside, trying to keep cool while bright sunlight streams through their window blinds. Except for a few indoor scenes, the rest of the film takes place mainly outdoors, shot in natural light that, through technical manipulation, becomes even brighter and thus seemingly hotter and more oppressive. The twenty-four-hour cycle of light provides structural unity but also suggests themes, from the "heat" of the day, through the violence of the fire that destroys Sal's Pizzeria, to the hope implied by sunrise the following morning.

Through the use of light and dark, filmmakers not only give their movies different styles, textures, and moods but also convey emotion and meaning in ways that can augment, complicate, or even contradict other elements within those movies. In fact, whether photographed ("shot") on film or video, caught on a disk, created with a computer, or, as in animation, drawn on pieces of celluloid known as **cels,** the movies depend on light to achieve their effects. On one hand, this is a mundane technical reality—after all, the ability to see anything depends on light. On the other hand, it is a fundamental and unique characteristic of film art. Moviemaking technology, derived from still photography, makes it possible to "capture" light in seemingly infinite ways. To understand the latest optical effects in movies, we need to understand the technology behind them.

PHOTOGRAPHY. The word **photography** means literally "writing with light" and technically the static representation or reproduction of light. The concept has its beginnings in ancient Greece. In the fourth century B.C., the Greek philosopher Aristotle theorized about a device that later would be known as the **camera obscura** (Latin for "dark chamber"). In the late fifteenth century, Leonardo da Vinci's drawings gave tangible form to the idea. Both simple and ingenious, the camera obscura may be a box, or it may be a room large enough for a viewer to stand inside. Light entering through a tiny hole (later a lens) on one side of the box or room projects an image from the outside onto the opposite side or wall. An artist might then trace the image onto a piece of paper.

Photography was developed during the first four decades of the nineteenth century by Thomas Wedgwood, William Henry Fox Talbot, and Sir John Herschel in England; Joseph-Nicéphore Nièpce and Louis-Jacques-Mandé Daguerre in France; and George Eastman in the United States. In 1802, Wedgwood made the first recorded attempt to produce photographs. However, these were not camera images as we know them but basically silhouettes of objects placed on paper or leather sensitized with

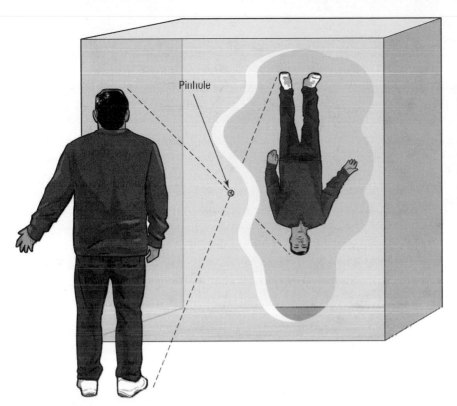

Pinhole

A basic camera obscura. Before the advent of photosensitive film, the camera obscura was used to facilitate lifelike *drawing*. In this simple schematic, for example, the "wall" upon which the image is projected might have been made of a semitranslucent material so that an artist could trace the image on a sheet of paper placed on the outside surface.

chemicals and exposed to light. These images faded quickly, for he did not know how to "fix" (that is, stabilize) them. Unaware of Wedgwood's work, Talbot devised a chemical method for recording the images he observed in his camera obscura. More important, he made significant progress toward fixing the image, and he invented the **negative**, or negative photographic image on transparent material, which makes possible the reproduction of the image. Nièpce experimented with sunlight and the camera obscura to make photographic copies of engravings as well as actual photographs from nature. The results of this heliographic (that is, sun-drawn) process—crude paper prints—were not particularly successful, but his discoveries influenced Daguerre, who, by 1837, was able to create a detailed image on a copper plate treated with chemicals, an image remarkable for its fidelity and detail. In

1839, Herschel perfected the *hypo* (short for hyposulfite thiosulfate—that is, sodium thiosulfate), a compound that fixed the image on paper and thus arrested the effect of light on it. Herschel first used the word *photography* in 1839 in a lecture at the Royal Society of London for the Promotion of Natural Knowledge.

What followed were primarily technological improvements on Herschel's discovery. In 1851, glass-plate negatives replaced the paper plates. More durable but heavy, glass was replaced by gelatin-covered paper in 1881. The new gelatin process reduced, from fifteen minutes to one-thousandth of a second, the time necessary to make a photographic exposure and thus made it possible to record action spontaneously and simultaneously as it occurred. In 1887, George Eastman began the mass production of a paper "film" coated with a gelatin emulsion; in 1889, Eastman im-

17

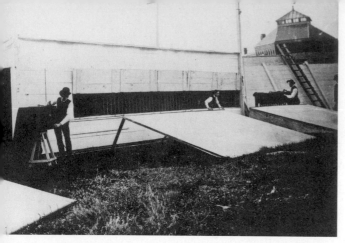

[1]

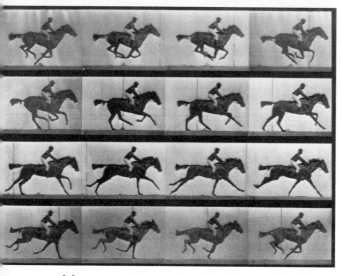

[2]

Edweard Muybridge's famous series of photographs documenting a horse in motion were made possible by a number of cameras placed side by side in the structure pictured above (1). The cameras were tied to individual trip wires. As the horse broke each wire, a camera's shutter would be set off. The result of this experiment—a series of sixteen exposures (2)—proved that a trotting horse momentarily has all four feet off the ground at once (see the third frame).

Series photography has been revived as a strategy for creating special effects in contemporary movies. On p. 26, you can see how a setup of multiple still-photography cameras was used during the filming of *The Matrix*.

proved the process by substituting clear plastic ("film") for the paper base. Though there have been subsequent technological improvements, this is the photographic film we know today.

This experimentation with optical principles and "still photography" in the nineteenth century made it possible to take and reproduce photographic images that could *simulate* action in the image. But simulation was not enough for the scientists, artists, and members of the general public who wanted to see images of life in motion. The intermediary step between still photography and cinematography came with the development of *series photography*.

SERIES PHOTOGRAPHY. **Series photography** records the phases of an action. In a series of still photographs, we see, for example, a man or a horse in changing positions that suggest movement, though the images themselves are static. Within a few years, three men—Pierre-Jules-César Janssen, Eadweard Muybridge, Étienne-Jules Marey—contributed to its development.

In 1874, Janssen, a French astronomer, developed the **revolver photographique,** or *chrono-photographic gun,* a cylinder-shaped camera that creates exposures automatically, at short intervals, on different segments of a revolving plate. In 1877, Muybridge, an English photographer working in California, used a group of electrically operated cameras (first twelve, then twenty-four) to produce the first series of photographs of continuous motion. On May 4, 1880, using an early projector known as the **magic lantern** and his **Zoopraxiscope** (a version of the magic lantern, with a revolving disk that had his photographs arranged around the center), he gave the first public demonstration of photographic images in motion—a cumbersome process, but a

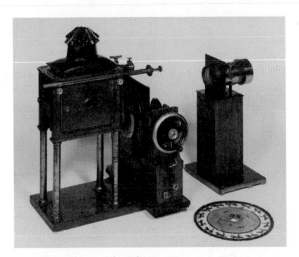

The Zoopraxiscope *(rear)*, a device created to assist Muybridge in his public lectures (for which he was in great demand because of his photographic experiments), permitted an animated projection of drawings made along the outer edge of a glass disk *(lower right)*. These drawings were based on the photographs he shot using his multiple-camera setup.

breakthrough. In 1882, Marey, a French physiologist, made the first series of photographs of continuous motion using the **fusil photographique** (another form of the chronophotographic gun), a single, portable camera capable of taking twelve continuous images. Muybridge and Marey later collaborated in Paris, but each was more interested in using the process for his scientific studies than for making or projecting motion pictures as such. Marey's invention solved the problems created by Muybridge's use of a battery of cameras, but the series was limited to forty images—three or four seconds long.

MOTION PICTURE PHOTOGRAPHY. In 1889, George Eastman began mass producing **celluloid roll film,** also known as **motion picture film** or *raw film stock,* which consists of long strips of perforated cellulose acetate on which

a rapid succession of still photographs known as **frames** can be recorded. One side of the strip is layered with an emulsion consisting of light-sensitive crystals and dyes; the other side is covered with a backing that reduces reflections. One side of the strip is perforated with sprocket holes that facilitate the movement of the stock through the sprocket wheels of the *camera,* the *processor,* and the *projector.* These three machines bring images to the screen in three distinct stages, and light plays a vital role throughout.

In the first stage, **shooting,** the camera exposes film to light, allowing that radiant energy to "burn" a negative image onto each frame.

In the second stage, **processing,** a laboratory technician washes this film with processing chemicals. Next, the technician develops this negative into positive prints. The processed negative is sandwiched with an equal length of raw stock and run through the **contact printer,** which shoots light through the positive and prints it onto the raw stock to make an exact positive copy. Today, ordinarily

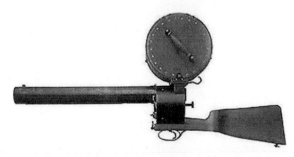

Étienne-Jules Marey's chrono-photographic gun enabled its user to shoot twelve frames with a single device, thus eliminating the need for elaborate setups such as the one Muybridge used for his horse experiments. This photograph shows the gun and the cartridge that contains the circular photographic plate on which the exposures would be made.

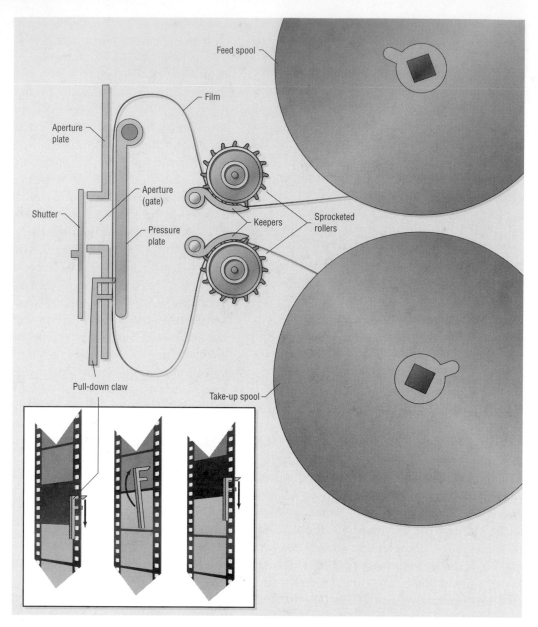

The motion picture camera moves unexposed film from the **feed spool,** a storage area, along the **sprocketed rollers,** which control the speed of that film as it moves through the camera and toward the lens, which focuses the image on the film as it is exposed. While the **aperture** defines the area of each frame of film exposed, the **pull-down claw,** a mechanism used in both cameras and projectors to advance the film frame by frame, is essential to creating on the movie screen the illusion of movement known as **persistence of vision** (discussed below in "Movies Provide an Illusion of Movement"); the **shutter** shields the film from light at the aperture during the film-movement portion of the intermittent cycle of shooting; and the **take-up spool** winds the film after it has been exposed.

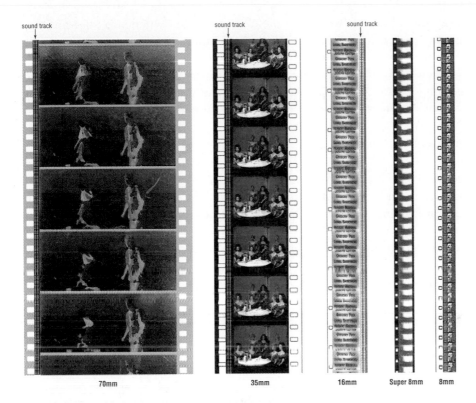

sound track

70mm　　35mm　　16mm　Super 8mm　8mm

The most common variations on standard motion picture film gauges.

the negative and the first positive print are stored in a vault for safekeeping; the actual editing is done on subsequent positive prints.

Then, in the third stage, **projecting,** the edited film is run through a projector, which shoots through the film a beam of light intense enough to reverse the initial process and project a large image on the movie theater screen. (This account greatly condenses the entire process to emphasize, at this point, only the cycle of light common to all three stages.) Projecting a strip of exposed frames at the same speed—generally 16 frames per second (fps) for silent film, 24 fps for sound—creates the illusion of movement. Silent cameras and projectors were often hand-cranked, and so the actual speed of the camera, which then had to be matched by the projectionist, could vary

from 12 to 24 fps. Cameras and projectors used for making and exhibiting professional films are powered by electric motors that ensure a perfect movement of the film.

A movie film's **format** is the **gauge,** or width, of the film stock and its perforations, measured in millimeters, and the size and shape of the image frame as seen on the screen. Formats extend from Super 8mm through 70mm, and beyond into such specialized formats as IMAX (ten times bigger than a 35mm frame and three times bigger than a 70mm frame). The **length** of film stock is the number of feet (or meters) or the number of reels being used in a particular film. The film stock's **speed** (or *exposure index*), the degree to which it is light-sensitive, ranges from very fast, at which it requires little light, to very

21

slow, at which it requires a lot of light. As will be discussed further in chapter 4, film is also categorized into black-and-white and color stock.

Today's digital technology (video or electronic photography) is transforming the making of motion pictures; nevertheless, just like conventional cinematographic technology, it uses a lens to capture light and record images. The primary difference between these technologies is that a film camera captures light on film stock, which, after processing, can be viewed on editing tables or through projectors; a video camera instead records images on magnetic tape, diskettes, or a hard disk, to be viewed through a television receiver or monitor. It is too early to know if, when, and at what cost the entertainment industry will *fully* convert to digital production, but one of the dominant trends currently bridging the gap is to shoot a movie on film and edit it on video, using personal computers. For the release of George Lucas's *Star Wars: Episode II—Attack of the Clones* (2002), which was shot entirely with digital cameras, a digital projection system was employed in select theaters. For the first time in history, a feature movie was produced and exhibited without a strip of celluloid clicking through the camera, printer, and projector.

INVENTING MOTION PICTURES. In the last years of the nineteenth century, a period of never-ending progress and invention, the rewards would be high for the first person who could perfect a system for exhibiting a motion picture to an audience. As we have seen, inventors such as Janssen, Muybridge, and Marey had experimented with various kinds of what they called "moving pictures," but these were limited in almost every way. The technologies needed to make moving pictures on film were in place and awaited only a synthesis of those technologies. In 1891, William Kennedy Laurie Dickson, working with associates in Thomas A. Edison's research labora-

Thomas A. Edison's Black Maria—the first motion picture "studio"—pictured from the inside and the outside. The interior view shows how awkward and static the Kinetograph was, because of both its bulk and its need to be tethered to a power source. In

addition, the performer had very little room to move, and the environment was hot and airless. The makeshift quality of the studio, as well as its relatively modest size, are evident from the external view.

tory, invented the **Kinetograph,** the first motion picture camera, and the **Kinetoscope,** a peephole viewer. The first motion picture made in the Kinetograph—actually the earliest complete film on record at the Library of Congress—was *Edison Kinetoscope Record of a Sneeze* (1894), popularly known as *Fred Ott's Sneeze,* which represents, on Edison and Dickson's part, a brilliant choice of a single, self-contained action for a single, self-contained film of very limited length. In 1893, Edison and his staff began making movies inside a crude, hot, cramped shack known as the **Black Maria.** This was really the first movie studio, for it contained the camera, technicians, and actors. The camera was limited in moving on a trolley closer to or away from the subject. Light was provided by the sun, which entered through an aperture in the roof, and the entire "studio" could be rotated to catch the light.

For motion pictures to develop further, some way had to be found to make the filmstrip available to a general audience, not just an individual spectator at a peephole viewer. Solving the problem of motion picture projection proved very difficult. The new machine had to be able to project the filmstrips with a light strong enough to provide a clear image, to roll the film smoothly and regularly past that light without tearing and burning it, and to provide the intermittent movement of the film that would create the illusion of continuous movement. This challenge was met by Auguste and Louis Lumière, French brothers who in 1895 invented the **Cinématographe,** a remarkably compact, portable, hand-cranked device that was a camera, processing plant, and projector all in one. It enabled the Lumières to do everything necessary to a strip of celluloid but edit it.

You can imagine the excitement of the first movie audiences as they looked at the Lu-

Auguste *(left)* and Louis Lumière, inventors of the Cinématographe, are generally acknowledged to have staged the first theatrical projection of a motion picture for a paying audience (on March 22, 1895, in the basement of the Grand Café, Boulevard des Capucines, in Paris, France). Appropriately, *lumière* means "light" in French.

mières' *The Arrival of a Train at La Ciotat* (*L'Arrivée d'un train à la Ciotat*, 1895). They saw a sight familiar from everyday life, a train, coming toward them. It arrived at an angle, but the image was so large, so believable, so convincing that some people, according to a newspaper account (perhaps reporting an "urban legend"?), drew back because they

The series of frames from William K. L. Dickson's *Fred Ott's Sneeze* that runs along the bottom of right-hand pages in this chapter can be used as a "flipbook" enabling you to watch this historically significant film. Like movies, flipbooks depend on the phenomenon called "persistence of vision" to achieve their illusion. To view a slide-show sample of other short films from the early years of cinema, go to <*www.wwnorton.com/web/movies*>.

1.5

imagined the train was going to come right out of the screen, while others ran to the back of the room in fright.

MOVIES PROVIDE AN ILLUSION OF MOVEMENT

Above all else, the movies *move* (the word *movies* is a shortened version of the phrase *moving pictures,* which literally captures the central importance of movement to film art). Or rather, they *seem* to move. As we sit in a movie theater, believing ourselves to be watching a continuously lit screen portraying fluid, uninterrupted movement, we actually watch a quick succession of twenty-four individual still photographs per second. And as the projector moves one of these images out of the frame to bring the next one in, the screen goes dark. Although the movies are distinguished from other arts by their dependence on light and movement, we spend a good amount of our time in movie theaters sitting in complete darkness, facing a screen with nothing projected on it at all!

The movement we see on the movie screen is an illusion, made possible by two interacting optical and perceptual phenomena: *persistence of vision* and the *phi phenomenon.* **Persistence of vision** is the process by which the human brain retains an image for a fraction of a second longer than the eye records it. You can observe this phenomenon by quickly switching a light on and then off in a dark room. Doing this, you should see an afterimage of the objects in the room, or at least of whatever you were looking at directly when you switched the light on. Similarly, in the movie theater we see a smooth flow of images and not the darkness between frames. Thus,

The Lumière brothers' Cinematographe. While Edison's Kinetograph was heavy (more than one hundred pounds), bulky, and tied to a battery power source, the Cinematographe was light (about sixteen pounds), portable, and hand-cranked, thus requiring no power source. Even more ingenious, it was actually three machines in one: camera, developer, and projector. Here, a stand positions the device at the correct height for projecting images on a screen. To learn about a contemporary use of the Cinematographe, go to <www.wwnorton.com/web/movies>.

www

the persistence of vision gives the *illusion of succession,* or one image following another without interruption. However, we must also experience the *illusion of movement,* or figures and objects within the image changing position simultaneously without actually moving. The **phi phenomenon** is the illusion of movement created by events that succeed each other rapidly, as when two adjacent lights flash on and off alternately and we seem to see a single light shifting back and forth. It is related to **critical flicker fusion,** which occurs when a single light flickers on and off with such speed that the individual pulses of light fuse together to give the illusion of continuous light. (Early movies were called *flicks* because the projectors used often ran at slower speeds than were necessary to sustain this illusion; the result was not continuous light but a *flickering* image onscreen. The most acute human eye can discern no more than fifty pulses of light per second. Because the shutters of modern projectors "double flash" each frame of film, we watch forty-eight pulses per second, close enough to the limit of perception to eliminate our awareness of the flicker effect.) The movie projector relies on such phenomena to trick us into perceiving separate images as one continuous image; and because each successive image differs only slightly from the one that precedes it, we perceive **apparent motion** rather than a series of jerky movements.

The most dazzling contemporary films, such as Andy and Larry Wachowski's *The Matrix* (1999), are full of kinetic excitement that makes the impossible look totally possible. How do they do this? Special effects, involving the most advanced computer technology in both hardware and software, play a large role in creating this virtual reality. Indeed, seam-

Frames from the Lumière brothers' *The Arrival of a Train at La Ciotat,* one of ten short films shown on March 22, 1895. Reliable eyewitness reports say that spectators at this event actually panicked at the sight of the locomotive coming toward them. Some scholars have their doubts, but it seems likely that the audience would have been both thrilled and "shocked," as most of us are in VR (virtual reality) environments at amusement parks.

Employing a setup much like Muybridge's, the special effects coordinator for Andy and Larry Wachowski's *The Matrix* placed 120 still cameras in an arc and coordinated their exposures using computers. The individual frames, shot from various angles but in much quicker succession than is possible with a motion picture camera, could then be edited together to create the slow camera-movement effect for which *The Matrix* is famous. But despite its contemporary look, this special effects technique is grounded in principles and methods established during the earliest years of motion picture history.

lessly integrated to create the film's virtual realm, special effects reportedly constitute 20 percent of *The Matrix.* But such sophisticated effects would not be possible without the simple illusions just discussed. Much of what we regard as the absolute cutting edge of moviemaking technology capitalizes on these illusions, especially the speeding up or slowing down of movement to achieve the desired effects. In making *The Matrix,* the filmmakers initially discovered that a number of the required action sequences might not be possible because they required that motion be captured at exceptionally high speeds. That is, to create the illusion of such slow motion, the camera would have had to speed up beyond its capacity. Working with engineers, the filmmakers developed new technology that resembled Muybridge's experiments in the 1870s. For ex-

ample, a scene in which Neo (Keanu Reeves) is fired at by another protagonist in the virtual world was shot not by one motion picture camera but by 120 still cameras mounted in a rollercoaster-style arc. Fired by a computer-driven program, this system ensured accuracy to within one-thousandth of a second.

MOVIES CAN DEPICT WORLDS CONVINCINGLY

Between 1895 and 1905, the French filmmakers Auguste and Louis Lumière and Georges Méliès established the two basic directions that the cinema would follow: the Lumières' **realism** (an interest in or concern for the actual or real, a tendency to view or represent things as they really are) and Méliès's **fantasy** (an interest in or concern for the abstract,

[1]

[2]

Whether presenting a scene from everyday life, as in the Lumière brothers' *Workers Leaving the Lumiere Factory* (1), or showing a fantastical scenario, as in Georges Méliès's *A Trip to the Moon* (2), motion pictures were recognized from the very beginning for their ability to create a feeling of *being there,* of seeing something that could *actually happen.* The

Lumière brothers favored what they called *actualités*—mini documentaries of scenes from everyday life—while Méliès made movies directly inspired by his interest in magicians' illusions; and yet both the Lumières and Méliès wanted to portray their onscreen worlds convincingly.

speculative, or fantastic). Although in the following years a notion evolved that a movie was either realistic or fantastic, in fact movies in general and any movie in particular can be both. William Cameron Menzies's *Things to Come* (1936), Stanley Kubrick's *2001: A Space Odyssey* (1968), George Lucas's *Star Wars* (1977), and Ridley Scott's *Blade Runner* (1982) are all science fiction films, for example, but they differ in the degree to which they combine realistic and fantastic elements.

Moving picture technology arose primarily from attempts to record natural images through photography, but it also was shaped by similar attempts in painting and literature. That is, the realist impulse of the visual arts—recording the visible facts of people, places, and social life, for a working-class and growing middle-class audience—helped inspire the first motion pictures. During the period immediately preceding the work of the Lumières, French painting, drawing, and caricature captured the surface look and sometimes the psychological depth of actual events and people, and it also established for the audience familiar subjects and formal conventions.

In painting, the new modes of representation informed the new romanticism of Eugène Delacroix and Théodore Géricault; the social realism of Jean-François Millet and Gustave Courbet; the social and psychological realism of Honoré Daumier; the movements of impressionism (Édouard Manet, Claude Monet, Pierre-Auguste Renoir, Édgar Degas, and Camille Pissarro) and postimpressionism (Georges Seurat, Vincent van Gogh, Henri de Toulouse-Lautrec, and Paul Gauguin); and, finally, the directions toward twentieth-century modernism in the work of Paul Cézanne, Henri Matisse, Georges Rouault, Georges Braque, and Pablo Picasso. In the novel and on the stage as well, writers sought to portray what they saw without idealizing it, choosing their subjects from everyday life. The concern for accurate, detailed description can be seen in such novels as Stendhal's *The Red and the Black* (*Le rouge et le noir,* 1830), Honoré de Balzac's *Cousin Bette* (*La cousine Bette,* 1846) and other works that make up Balzac's *The Human Comedy (La comédie humaine),* and Gustave Flaubert's *Madame Bovary* (1857).

In their recording of routine and commonplace activity, the Lumières were inspired by Courbet, whose work faithfully depicted reality, and by Daumier, whose depictions of the busy, noisy world of Paris life (especially the life of the poor) represented a kind of realism based on moral ideas. Still another influence on the Lumières was that variety of realistic painting that records the commonplace in an uncommonly scientific way. In describing the work of Thomas Eakins, an American realist painter and photographer who studied in France, art historian Robert Rosenblum might be describing the products of a filmmaker; Eakins, he writes, "insisted on fusing the art of painting with a scrupulous study of anatomy, light, mathematics, and perspective, and . . . believed, with so many of his contemporaries, that the photograph was a medium which provided objective truths to support the artist's painstaking reconstructions of the visible world."[4] Indeed, Eakins frequently used carefully composed photographs, taken in the field, as a reference point for his paintings, created in the studio. The paintings of Gustave Caillebotte suggest yet another possible influence on the Lumières, who also recorded the dignity of manual labor. Degas, like Caillebotte, rendered activities in deep-space perspectives (Degas in the Parisian theater,

[4]Robert Rosenblum and H. W. Janson, *Nineteenth Century Art* (Englewood Cliffs, N.J.: Prentice-Hall, 1984), 357.

Caillebotte in the Parisian streets); and while the cinematic illusion of deep space was not possible in the first films, a well-framed depiction of street scenes was. The delight of Claude Monet in the transitory changes of light on cathedral facades (as well as on railroad stations) may have had some attraction for the Lumières, who likewise captured this evanescent phenomenon; in reviewing a Lumière program in Russia in 1896, Maksim Gorky wrote poetically of being in a "kingdom of shadows."

Finally, in paintings such as Manet's *The Railroad* (1872–73), we find what Rosenblum calls the "extraordinary fusion of two worlds—that of the painting and that of the spectator" (355), which was to reach an even greater complexity in the first motion pictures. Painting and cinema appeal to different notions of realism: physical, visual (static versus moving), historical, factual, motivational, psychological, and cultural. The spatial and narrative structures of Manet's *Railroad* are complex. In the left foreground, our eyes fix on the mother's gaze; yet, in the right foreground, we look over a girl's shoulder as she watches, through the grate that separates foreground and background, the clouds of smoke in which a train leaves the station. In the Lumières' *The Arrival of a Train at La Ciotat*, there is no such artifice in the spatial and narrative structures; as people who have come to meet the train, we stand with the camera on the platform as the train enters the station, pulls up, and halts. In Manet's painting, the indirect event of the train is only one part of the picture; in the Lumières' film, the direct event is all. We do not know if the Lumières were aware of the iconography of the railroad in nineteenth-century French art, but they achieved something new in their way of looking at trains. They used motion picture pho-

Edouard Manet, *The Railroad* (1872–73).

tography not in an effort to reproduce the moral vision of a Daumier or the impressionist vision of a Monet, but as servants of science; to preserve the moment, to include all the details within the frame, and to provide a seemingly true, authentic, factual record. Before narrative, sound, or color had entered the movies, the initial impulse of cinema artists was to record commonplace reality: the Lumière brothers made what they called *actualités,* or documentary views, of such ordinary subjects as a boat leaving a port, blacksmiths at work, a family at play, and military processions.

Realism is a complex concept, in part because it refers to several significant and related ideas. Most of us believe the world really exists, but we don't agree about what level it exists on. (Comedian Lily Tomlin has suggested that reality may be nothing more than a "collective hunch.") Some trust in their senses, experiences, thoughts, and feelings. Others trust in a variety of historical, political, sociological, economic, and philosophical

theories to provide a framework for understanding. Still others rely on a combination of both approaches. Realism basically overrides these approaches and implies that the world it depicts looks, sounds, and moves like the real world. It is also a way of treating subject matter that reflects everyday life. Realistic characters are expected to do things that conform to our experiences and expectations of real people. Artists in every medium, however, make choices about what aspects of "reality" to depict and how to depict them. Realism, no matter how lifelike it might appear, always involves mediation. In the ways it is created and the ways it is perceived, realism is a kind of illusion.

Thomas Gainsborough, *Lady Innes* (1757).

If the characteristics listed here are one way to define realism in the movies, then we can define **antirealism** as a treatment that is against or the opposite of realism. We can illustrate their difference by contrasting two portrait paintings. The first, *Lady Innes,* by the eighteenth-century English painter Thomas Gainsborough, realistically depicts a recognizable woman. Its form is *representational,* meaning that it represents its subject in a form that conforms to our experiences and expectations of *how* a woman looks. Here, the overall composition of the painting and the placement of the figure emphasize unity, symmetry, and order. If you were to see the painting firsthand, you would notice that Gainsborough worked with light, rapid brush strokes and that he used delicate colors. Compare it with the second portrait, *Nude Descending a Staircase, No. 2,* by the twentieth-century French artist Marcel Duchamp, who worked in the styles of cubism, futurism, dadaism, and surrealism. Even in the largest sense of portraiture, Duchamp's work may not represent, to most people, a recognizable woman. Duchamp has transformed a woman's natural appearance (which we know from life) into a radically simplified form; the twentieth-century painting is less representational than its eighteenth-century predecessor. We say "less representational" because while its form is not completely recognizable, Duchamp's representation has sufficient form for us to at least identify it as a human being. If you were to see this painting firsthand, you would notice that the figure of the woman suggests an overall flatness, rather than the round, human quality of Gainsborough's figure; that the brush strokes are bold, rather than delicate; and that the colors are bold, rather than delicate.

But realism and antirealism (like realism and fantasy) are not polar opposites. And

Marcel Duchamp, *Nude Descending a Staircase, No. 2* (1912).

whether a movie is realistic, antirealistic, or a combination of the two, it can achieve a convincing appearance of truth: **verisimilitude.** Movies are verisimilar when they convince you that the things on the screen—people, places, what have you, no matter how fantastic or antirealistic—are "really there." In other words, the movie's vision seems internally consistent, giving you a sense that in the world onscreen, *things could be just like that.* Of course, you can be convinced by the physical verisimilitude of the world being depicted and still be unconvinced by the "unreality" of

the characters, their portrayal by the actors, the physical or logical implausibility of the action, and so on. In addition, audiences' expectations concerning "reality" change over time and across cultures.

Some of the most popular and successful movies of all time convincingly depict imaginative or supernatural worlds and events that have little or nothing in common with our actual experiences. For example, Victor Fleming's *Gone With the Wind* (1939) treats the American South of the Civil War as a soap opera rather than important history; Steven Spielberg's *Jurassic Park* (1993) almost convinces us that the dinosaur amusement park of the title really exists, just as Andy and Larry Wachowski's *The Matrix* (1999) makes us believe in an imaginary place where everything is as bad as it possibly can be; and John Lasseter's *Toy Story* (1995), a feature-length animation, bring us into the world of children's toys through a saturation of detail—when Woody walks on Andy's bed, for example, we can even see his foot indentations on the comforter. In Ridley Scott's *Gladiator* (2000), people, places, and things look, sound, and move in ways that are *believable* and even *convincing,* not because they are true to our experiences but because they conform to what common knowledge tells us about how life might have been lived and how things might have looked in the ancient world. More to the point, *Gladiator* adheres to the *cinematic conventions* established by previous movies about the ancient world—dozens of them, ranging from Fred Niblo's *Ben-Hur* (1925) to William Wyler's remake of *Ben-Hur* (1959) to Stanley Kubrick's *Spartacus* (1960)—and thus satisfies our individual experiences with the subject matter of the film.

By **cinematic conventions,** we mean those accepted systems, methods, or customs by

[2]

[1]

In what sense are the worlds portrayed in (1) Ridley Scott's *Gladiator* and (2) Steven Spielberg's *Jurassic Park* believable? On what basis can we call these films "realistic"? After all, does anyone alive today know how gladiatorial combat in ancient Rome actually occurred? Who among us knows what dinosaurs looked like or how they acted during the Mesozoic era? A more useful and flexible concept that helps explain the movies' unique capacity to create believable worlds is *verisimilitude*—the quality of appearing true, probable, or likely.

which the movies communicate. While realism is a convention, it also encompasses a network of differing conventions. Conventions are flexible, not "rules"; they imply a practice that has evolved through film history, not an indisputable or "correct" way of doing things. In fact, cinematic conventions represent a degree of agreement between the filmmaker and the audience about the mediating element between them: the film itself. Though some of the most convention-bound Hollywood films— "B"-grade westerns, for instance—seemed to roll off an assembly line like so many identical automobiles, filmmakers who took such an unenlightened attitude toward conventions likely deadened movie audiences' artistic and social experiences. Skillfully and imaginatively employed, conventions can enliven and enrich audiences' lives by making viewers feel almost as if they were in possession of some privileged information about how the movies are made.

Aided by cinematic conventions, filmmakers transform experiences—their own, others', purely imaginary ones, or some combination of all three—into viewing experiences for us. In addition to bringing our acceptance and understanding of conventions to looking at movies, we also bring our individual experiences. Obviously, these vary widely from person to person, not only in substance but also in the extent to which each of us trusts them. Personal observations of life may not be verifiable, quantifiable, or even believable, yet they are part of our perception of the world. They may reflect various influences, from intellectual substance to anti-intellectual prejudice; as a result, some people may regard gladiator movies as more meaningful than scholarly books on the subject. Thus both cinematic conventions and individual experiences play significant roles in shaping the "reality" depicted by films. As film scholar Christopher Williams writes, a movie

can combine attempts to copy life, to produce an adequate representation of it, with attempts to shape something else out of it, to

stand back from it, to turn it into a spectacle and/or to pass judgement on it. The point here is flexibility: the uses of the medium remain movable within the conventions of realism; the conventions allow degrees of freedom for producers and for audiences.[5]

And as you will see in "Types of Movies" below, that freedom ultimately extends to the kinds of highly experimental film that don't depict worlds at all—unless we define *worlds* in the most abstract sense.

MOVIES GENERALLY RESULT FROM A COMPLEX, EXPENSIVE, AND HIGHLY COLLABORATIVE PROCESS

In the movie industry, costs and profits are measured in hundreds of millions of dollars. In 2000, the *average* Hollywood film cost about $55 million to produce and about $30 million to market. Thus the individuals and financial institutions that invest in the production of films, and the producers and studios with whom they invest, care first about money (ensuring the safety and potential return of their investments) and second—a distant second—about art. They focus on movies as commodities and, for that reason, often consider release dates, distribution, and marketing as more important than the products themselves. It is all the more impressive, then, that the movie industry produces a small number of films each year that can be appreciated, analyzed, and interpreted as genuine works of art rather than simply as commercial products to be consumed.

[5]Christopher Williams, "After the Classic, the Classical and Ideology: The Differences of Realism," in *Reinventing Film Studies,* ed. Christine Gledhill and Linda Williams (London: Arnold, 2000), 211.

Because movie production involves a much more complicated and costly process than do most other artistic endeavors, very few of the decisions in filmmaking are "minor," and very few effects that a movie has on its audience are unintentional. Unlike some arts—painting, for example—in which the materials and the process are relatively inexpensive, every decision in filmmaking has significant financial ramifications. Painters may paint over pictures many times without incurring significant costs, and thus their decisions can be dictated almost entirely by artistic inspiration. Movies, in contrast, involve a constant tug-of-war between artistic vision and profitability. In order to understand certain aesthetic judgments made by film producers, directors, and their collaborators, you need to understand the moviemaking process.

A great movie generally results from two factors: a good script and a director's inspiration, vision, intelligence, and supervision (but not necessarily control) of all aspects of the film's production. Because a director holds the paramount role in the production process and in most cases has final judgment over the result, we ordinarily cite a film in this way: Julie Dash's *Daughters of the Dust* (1991). But although movie history began with individual filmmakers, movies were carried forward through the years by teamwork. From the moment the raw film stock is purchased through its exposure, processing, editing, and projection, filmmakers depend on technology, technicians, and craftspeople. And no matter how clear filmmakers' ideas may be at the start, their work will change considerably, thanks to technology and teamwork, between its early stages and its final version as released to the public. While many movie directors—working under such pressures as producers' clocks and budgets—have been known for taking their

power all too seriously (being difficult on the set, throwing tantrums, screaming at and even physically assaulting members of the cast and crew, and raging at the front office), movie-making is an essentially collaborative activity.[6] Even then, as film scholar Jon Lewis observes, "what ends up on the screen is not only a miracle of persistence and inspiration but also the result of certain practical concessions to the limitations of the studio system."[7]

One of the most important and complicating factors in film production is this: it is more cost-effective, and thus standard practice, for movies to be made out of chronological order. This means that the production crew shoots the film not in the order that preserves narrative continuity but in an order that allows the most efficient use of human and financial resources. During production, a script supervisor sits as close to the director as possible, for this person is an invaluable source of factual information about the shooting. The script supervisor records in the **lined script** all details of continuity from shot to shot, ascertaining that costumes, positioning and orientation of objects, and placement and movement of actors are consistent in each successive shot and, indeed, in all parts of the film. Overall, the pattern of production includes securing and developing a story with audience appeal; breaking the story into units that can be shot most profitably; shooting; establishing through editing the order in which events will appear onscreen; and then adding the sound,

music, and special effects that help finish the movie.

The process once took place in the vast, factory-like studios that dominated Hollywood and other major film-production centers around the world. Today, it happens in the self-contained worlds of individual production units, sometimes operating in leased studio facilities. The differences between these two modes of production are, in a sense, reflected in movies' production credits. In older films, all the (brief) production credits generally appear at the beginning, with, sometimes, the names of the leading actors repeated in (and constituting) the closing credits. Today, opening credits vary widely, but closing credits are extremely long and may include several hundred people, accounting for virtually every person who worked on a film or had something to do with it (e.g., caterers, animal handlers, accountants). Collective-bargaining agreements between producers and various labor unions—representing every person who works on a union production—impose clear definitions of all crew members' responsibilities as well as the size and placement of their screen credits. These credits properly and legally acknowledge people's contributions to films.[8]

In both the studio system and the independent mode, the film proceeds through three basic phases: *preproduction, production,* and *postproduction.* Each phase is the responsibility of a specific person or specific people and takes a different amount of time to complete.

[6] In a world of large egos, of course, collaboration can be a myth; and many things go wrong on most movie sets. For a list of movies about moviemaking or set within the industry, see "For Further Reading and Viewing" in the appendix.

[7] Jon Lewis, *Whom God Wishes to Destroy . . . Francis Coppola and the New Hollywood* (Durham, N.C.: Duke University Press, 1995), 4.

[8] Because many independent films are made by nonunion crews, these conventions of the division of labor and screen credit do not necessarily apply to them. Often their crew members are relatively inexperienced, not yet qualified for union membership, or willing to play several roles in return for the experience and screen credit. Governmental and volunteer contributions may also be credited.

FIG. 1.2

THREE MAJOR STAGES OF PRODUCTION

Stage	1. Preproduction: preparation and planning	2. Production: shooting	3. Postproduction: assembly, marketing, and distribution
Approximate time needed to complete this stage for a two-hour film of average complexity	Six months to two years or more	Four to eight weeks, with fifty days being the average shoot in 2002	Minimum of six to eight months
Key person or people in charge of this stage	Producer and his/her associates	Director and his/her associates	Producer, editor, director of marketing, director of distribution, and their associates

What goes on before and after ordinarily takes longer than what goes on during production. (Fig. 1.2 provides an overview of the personnel involved and time spent in each phase.)

PREPRODUCTION. Stage one, **preproduction,** involves planning and preparation. It takes as long as necessary to get the job done; on average, a year or two. First, filmmakers develop an idea or obtain a script they wish to produce. They may secure from a publisher the rights to a successful novel or buy a writer's "pitch" for a story. The opening segment of Robert Altman's *The Player* (1992) provides a comic view of the start of an independent-studio executive's typical day. The executive, Griffin Mill (Tim Robbins), has the responsibility of listening to initial pitches from writers and recommending to his boss the ones he likes. Moving blithely through a world of business politics, intrigue, and power games, he hears from people with and without appointments, losers, hangers-on, hacks, and

even experienced authors. Everyone he meets wants to be a screenwriter, and everyone wants to cast Julia Roberts. The pitches are, for the most part, desperate attempts to make a new movie out of two previously successful ones, as when one scriptwriter—who cannot even agree with her partner on what they are talking about—summarizes a proposal as *"Out of Africa* meets *Pretty Woman."* The final pitch before the credits end, about a "political thriller," serves as a transition to the thriller at the heart of Altman's film. One of Hollywood's most inventive and successful independent directors, Altman clearly knows the territory well enough to be able to laugh at it.

Once the rights to producing a story have been contracted and purchased, the producers can spend months arranging the financing for a production. The ease with which they accomplish this, and the funds they secure, will largely depend on the film they offer to their backers and its projected financial returns. As explained below, a director may spend another

[1]

[2]

[3]

[4]

Robert Altman's *The Player* begins with a long, continuous shot that follows a Hollywood producer (Griffin Mill, played by Tim Robbins) through his morning routine. In the space of just a few minutes, Mill listens to "pitches" for three separate movie ideas and then discovers among his daily mail a postcard (the front of which reads "YOUR DEAD") that will propel him into his own drama. To see a sequence of stills, go to <www.wwnorton.com/web/movies>.

1.6

month or more discussing the script with the screenwriter and the key people responsible for design, photography, music, and sound. Another two or three months may be spent rewriting the script. During this process of pre-visualization, before the cameras start to roll, the director and the chief collaborators decide how they want the film to look, sound, and move. At least two to three weeks more can be devoted to organizational issues and details such as scheduling studio space and scouting locations, obtaining permissions to use those locations, and arranging for the design and construction of sets, costumes, and properties. Just before shooting begins, another two weeks

will probably be devoted to rehearsals with the cast and crew. Up to this point, almost a year has elapsed—assuming that all has gone very smoothly. Though the entire process may seem straightforward, this description does not take into account the inevitable delays, the continuing difficulties in pulling together the financial package, and the countless details that must be attended to. For example, a film made at the peak of the Hollywood studio system would have been carefully planned, budgeted, and supervised by the producer in the front office, whether it was shot in a studio or on location. Daily reports to and from the set ensured that everyone knew, to the minute

and to the dollar, the progress and the cost. Thus Orson Welles extensively composed and planned the shots of his first film, *Citizen Kane* (1941), which was photographed entirely in the RKO studio and miraculously (considering Welles's later reputation as a spendthrift independent director) was completed in less than one year, almost within the allotted budget. By contrast, Francis Ford Coppola, already a highly experienced director by the time he made *Apocalypse Now* (1979), began without a clear plan of what he wanted to achieve, worked as an independent producer with financing from United Artists, and shot the film in a foreign country under very difficult conditions, ultimately exposing 115 hours of film for every hour used in the film. During the four years it took to complete the film, he spent more than twice his original budget. Nevertheless, in its initial release *Citizen Kane* did not appeal to audiences, while *Apocaypse Now* enjoyed great box-office success.

In making a film, meticulous preparation is everything, and key people take the time to think out alternatives and to choose the one that seems best for the film. Thorough planning does not stifle further creativity or improvisation during production but rather encourages it, because planning makes the alternatives clear. Director Sidney Lumet emphasizes the logistics:

> Someone once asked me what making a movie was like. I said it was like making a mosaic. Each setup is like a tiny tile [a *setup*, the basic component of a film's production, consists of one camera position and its associated lighting]. You color it, shape it, polish it as best you can. You'll do six or seven hundred of these, maybe a thousand. (There can easily be that many setups in a movie.) Then you literally paste them together and hope it's what you set out to do. But if you expect the final mosaic to look like anything, you'd better know what you're going for as you work on each tiny tile.[9]

PRODUCTION. Preproduction ends when the producer and director agree that the project is ready for stage two, **production.** This phase, the actual shooting, can last six weeks to several months or more. While the producer and director continue to work very closely together, the director ordinarily takes charge during the shooting. The director's principal activities during this period are conducting blocking and lighting rehearsals on the set with *stand-ins,* followed by rehearsals with the cast; developing the detailed daily **call sheets,** which indicate what is being shot each day and inform cast and crew members of their assignments; placing and, for each subsequent shot, re-placing cameras, lights, microphones, and other equipment; shooting each shot as many times as necessary until the director is satisfied and calls "print"; reviewing the results of each day's shooting (called *rushes* or *dailies;* discussed further in chapter 6) with key creative personnel and cast; and reshooting as necessary.

Every director works differently. Ordinarily, however, the director first further breaks down the shooting script into manageable sections, then sets a goal of shooting so many pages a day (typically, three pages is a full day's work). This process depends on the number of setups involved. Most directors try to shoot between fifteen and twenty setups a day when they are in the studio, where everything can be controlled; with exterior shoot-

[9]Sidney Lumet, *Making Movies* (1995; reprint, New York: Vintage Books, 1996), 58.

ing, the number of setups will vary. In any event, everyone involved in the production works a full day—usually from about 8 A.M. to about 6 P.M. (depending on their jobs and contracts), five days a week, with overtime when necessary. When complicated makeup and costuming is required, the actors may be asked to report for work early enough to finish that preparation before the crew is due to report. After each day's shooting, or as soon thereafter as the processing laboratory can deliver them, the director and others review the rushes. Recently, watching a movie shoot in a Manhattan store, which was closed for the day to give the crew maximum access, I saw again how much time it takes to complete even the simplest shot. By actual count, eighty crew members were there to support the director and four actors, who were ready to work. After the first setup was blocked, rehearsed, and lighted, the director made three takes. This process took three hours. However, only one more of the three setups scheduled for the day was completed, because the lighting brought in for the shoot failed. Why? The gaffer, the chief electrician, had neglected to ensure that the store's electrical capacity could support it. By the time generators were located and trucked to the site, two hours were lost. Of course, any one of a dozen problems—human and technical—could have kept the director and crew from meeting their schedule.

During production, the number of people required to film a particular shot depends on the needs of that shot or, more precisely, of the overall scene in which the shot occurs. Many factors determine the size of the crew for any shot or scene, including the use of studio or exterior locations, day or night shooting, shooting on an uncrowded exterior location or a crowded city street, camera and lighting setups, and the extent of movement by the cam-era and the actors. For example, a scene that involves two people in a simple interior setting, with a basic camera and lighting setup, may require a minimal crew, while a scene involving many people in an exterior setting, with several camera positions and carefully choreographed movement, normally requires a large crew. The creation of artificial weather (rain, wind, or snow) and the use of animals or crowds, all expensive factors, require additional personnel. Shooting on exterior locations is usually more expensive than shooting in a studio because it involves transportation and food, sometimes requires hotel accommodations, and depends completely on the weather.

To better understand what's involved in shooting, let's look briefly at the production of Robert Zemeckis's *Cast Away* (2001). The movie features Tom Hanks as Chuck Noland, a FedEx systems engineer based in Memphis, Tennessee. While he is en route from Moscow to the Far East, his plane crashes in the ocean, and Chuck, the only survivor, washes ashore on a desert island. After sustaining himself physically, emotionally, and spiritually for four years, Chuck builds a raft and attempts to return to civilization. Overwhelmed by the elements, and near death, he is picked up by a freighter and returned to Memphis, where he faces yet another emotional challenge.

In making *Cast Away,* the production crew faced daunting physical and logistical problems. Their largest challenge was to make the most efficient use of human, financial, and physical resources. The film, which cost $85 million to produce, was shot on sound stages in Hollywood, as well as on actual locations in Texas, Tennessee, Russia, and the Fiji island of Monuriki in the South Pacific; the task of planning the overall production schedule was relatively routine, however. Although the

[1]

[4]

[2]

[5]

[3]

[6]

These frames from Robert Zemeckis's *Cast Away* are taken from six different shots that illustrate in miniature the complexity of shooting a Hollywood film. Frames 1 and 6 were shot in California prior to the work on the island of Monuriki, but they come from opposite ends of the movie. Frames 2 and 3 depict scenes from the island, but only 2 was shot on Monuriki. Frame 3 is the result of a special effect—a shot made of Tom Hanks on a set in Hollywood superimposed onto a computer-generated image of the ocean below. Frames 4 and 5 were shot after a year-long hiatus during which Hanks lost fifty pounds to look the part of a haggard castaway.

largest part of the film's three-part structure is set on Monuriki, and features only one actor (Hanks), the cast actually includes nearly sixty other actors. The credits list another 123 members of the production crew, most involved in the creation of the visual and special effects. When shooting on Monuriki, the crew had to endure real winds, storms, and floods; and when nature would not cooperate with their shooting schedule, they had to create their own bad weather. Furthermore, their work depended on the tides and available sunlight (Chuck would not have had artificial light on the island). The airplane crash was simulated in Hollywood, where considerable shooting was done underwater, and the scenes of Chuck's attempted escape by raft were shot on the ocean as well as in the perilous surf off another Fijian island. After one month's shooting on Monuriki, capturing footage that established Chuck's overall challenge, the crew took a year-long hiatus while Hanks lost the fifty pounds he had gained to portray Chuck in the early part of the film. This change helped create the illusion that Chuck had spent four years on the island. Meeting these challenges as successfully as the filmmakers did (while maintaining visual consistency within the footage) was central to maintaining the film's verisimilitude.

POSTPRODUCTION. When the shooting on a film has been completed, stage three, **post-production,** begins. Postproduction consists of three phases: editing, preparing the final print, and bringing the film to the public (marketing and distribution). In brief, editing consists of assembling the visual images and sound recordings; adding the musical score and sound effects; adding the special effects; assembling the sound tracks; and doing any necessary dubbing. (Some preliminary editing

will have occurred during production; we will examine the editing process in detail in chapters 6 and 7.) Preparing the final print consists of timing the color print, a process of inspecting each shot of a film and assigning color corrections and printer light values to maintain consistency of brightness and color from shot to shot; completing the **answer print,** the first combined picture and sound print, in release form, of a finished film; possibly previewing the film; then possibly making changes in response to preview audiences' comments. Bringing the film to the public consists of determining the marketing and advertising strategies and budgets, setting the release date and number of theaters, finalizing distribution rights and ancillary rights, and finally exhibiting the film.[10]

TYPES OF MOVIES

NONFICTION FILMS

Traditionally, **nonfiction films** have been made in four basic styles—*factual, instructional, documentary,* and *propaganda films.* That these categories can overlap to create other hybrid forms demonstrates the versatility of the type and helps account for the production of thousands of "nonfiction" films each year. Remember, however, that the act of filmmaking involves mediation between filmmaker and subject. As we will see in subse-

[10]To learn more about film production and power relations within it, see the appendix, "Overview of Hollywood Production Systems," which includes information on labor, labor unions, and the division of labor; professional organizations and standardization; financing; and the history and development of studio and independent modes of production.

Robert Flaherty's *Nanook of the North*, a pioneering nonfiction film, gave general audiences their first visual encounter with Eskimo culture. While its subject matter made it significant (and successful), its use of narrative film techniques was pathbreaking. Flaherty edited together many different kinds of shots and angles, for example, and directed the Eskimos through reenactments of life events, some of which—such as hunting with spears—were no longer part of their lives. To learn more about the tension between factuality and narrative within documentaries, go to <*www.wwnorton.com/web/movies*>.

WWW

quent chapters, every aspect of filmmaking, no matter what type of film is being made, uses formal elements and technical properties—such as narration, camera angles, editing, and music—that alter the material being filmed. Thus, strictly speaking, a nonfiction film, even though it is usually about real people, places, and events, is no more "true" than a fiction film.[11]

Factual films usually present people, places, or processes in straightforward ways meant to entertain and instruct without unduly influencing audiences. Early examples include the Lumière brothers' *actualités*— films of trains arriving, boats leaving, soldiers marching off to the front, and the like—and the hundreds of films produced on all sides during World War I, when film became a

weapon of information *and* disinformation (or *propaganda,* as discussed below). Director Robert Flaherty insisted that his classic *Nanook of the North* (1922) was a factual account of Inuit life in the sub-Arctic, even though it clearly reflects Flaherty's staging of events for the camera as well as the Inuit's perspective. Perhaps the best we can say for this captivating film is that it is true to human nature but not true to the life the Inuit were living when Flaherty made the film. Thus it has little factual or anthropological value.

The three other subtypes can be distinguished by their rising concern with influencing viewers. **Instructional films** seek to educate viewers about common interests rather than persuading them to accept particular ideas. During World War II, instructional films were used to teach members of the armed forces and civilians about the challenges of wartime, such as homeland security and food shortages. Today, such films more

[11]See Richard M. Barsam, *Nonfiction Film: A Critical History,* rev. and exp. ed. (Bloomington: Indiana University Press, 1992).

likely teach skills, as in Tom Norland's *Swish—A Guide to Great Basketball Shooting* (1997). **Documentary films** were conceived and argued for by John Grierson, a British film producer who had his greatest influence in the 1930s. Their founding purpose was to address social injustice. When they are produced by governments and carry governments' messages, they overlap with **propaganda films,** which systematically disseminate deceptive or distorted information. For a brief period, the U.S. government directly and indirectly produced such films. A noteworthy example is Pare Lorentz's *The River* (1937), which proclaims the benefits of forest, land, and water conservation, particularly as carried out by President Franklin D. Roosevelt's Tennessee Valley Authority projects concerned with hydroelectric power. To see such a film is to be aware of the documentary's many-faceted nature. Indeed, many members of Congress, Republican and Democrat alike, considered the film a propaganda effort that had no place in our democracy. *The River* was produced by U.S. government agencies, released by Paramount Pictures in theaters, and considered as a possible nominee for the Academy Award for a short film. It is particularly worth seeing today, not necessarily for its concern with conserving natural resources, an argument that has since been more powerfully voiced elsewhere, but rather for its eloquent cinematography, narration, and music.

Genuine documentaries, those concerned with social issues and particularly with corporate and governmental injustice of all kinds, continue to be made by independent filmmakers and network television producers. Many of them are controversial: Peter Davis's *The Selling of the Pentagon* (1971) exposes the falseness of the U.S. government's justification of its escalation of the war in Vietnam; Mike Wallace and other journalists make powerful, short documentaries for the CBS news magazine *60 Minutes;* Kelly Anderson and Tami Gold's *Making a Killing* (2000) reveals the tactics of Philip Morris Companies Inc., warning viewers of how the company spreads tobacco addiction by misusing its size, promotional expertise, and political power.

The most famous propaganda film ever made, Leni Riefenstahl's *Triumph of the Will (Triumph des Willens,* 1935), records many events at the 1934 Nuremberg rally of the Nazi Party and thus might mistakenly be considered a "factual" film. But through its carefully planned cinematography and editing, it also presents a highly glorified image of Adolf Hitler, primarily for the consumption of non-German audiences before World War II. Soon after that war began, the United States began production of all these types of nonfiction films. Frank Capra's "Why We Fight" series constitutes the single most powerful nonfiction film achievement in the war effort. It contains seven titles: *Prelude to War* (1943), *The Nazis Strike* (1943), *Divide and Conquer* (1943), *The Battle of Britain* (1943), *The Battle of China* (1944), *The Battle of Russia* (1944), and *War Comes to America* (1945). Addressed to those in civilian and military audiences who doubted the need for another world war, these films, in Capra's view, "not only stated, but, in many instances, actually created and nailed down American and world pre-war policy."[12] They were made in historical order, depicting Nazi aggression and brutality, the major battles of the war, and, finally, the impact of prewar and war efforts on American public opinion. Remarkable compilation films—lucid and fresh in their handling of many cinematic

[12]Frank Capra, *The Name above the Title: An Autobiography* (New York: Macmillan, 1971), 336–37.

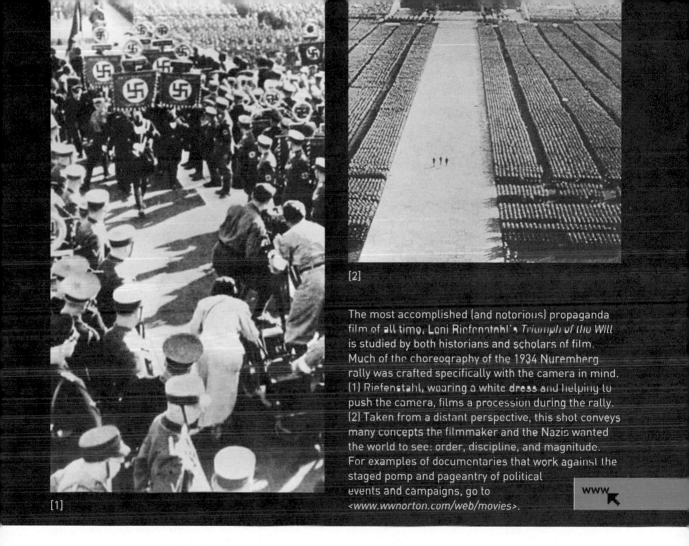

[1]

[2]

The most accomplished (and notorious) propaganda film of all time, Leni Riefenstahl's *Triumph of the Will* is studied by both historians and scholars of film. Much of the choreography of the 1934 Nuremberg rally was crafted specifically with the camera in mind. (1) Riefenstahl, wearing a white dress and helping to push the camera, films a procession during the rally. (2) Taken from a distant perspective, this shot conveys many concepts the filmmaker and the Nazis wanted the world to see: order, discipline, and magnitude. For examples of documentaries that work against the staged pomp and pageantry of political events and campaigns, go to <www.wwnorton.com/web/movies>.

www

sources, historically balanced, and persuasively and dramatically presented—they are also remarkable propaganda, made by film experts who had studied and restudied the best Nazi and British precedents. They are also, unfortunately, very racist in their depiction of our military enemies at the time: the German, Italian, and Japanese people.

Since the 1960s, the nonfiction film has experienced a renaissance. Not only have an un-precedented number of films been produced both for traditional distribution and for television broadcasting but also the quality of these films has increased, as has their influence on audiences and later filmmakers. Increasingly international, the form has branched into such new cinematic languages as "cinema verité" and "direct cinema." While these recent films primarily emphasized social issues, they paid more attention to the related personal issues

raised by the various movements for sexual liberation, and they deliberately blurred the lines between types of movies and between events staged for the camera and events filmed candidly. New masters, to name but a few, include Albert and David Maysles (*Grey Gardens,* codirected with Ellen Hovde, Muffie Meyer, and Susan Froemke, 1975), Frederick Wiseman (*Meat,* 1976), Emile De Antonio (*In the Year of the Pig,* 1969), Louis Malle (*Phantom India [L'Inde fantôme],* 1968), Marcel Ophüls (*The Sorrow and the Pity [Le chagrin et la pitié],* 1971), Barbara Kopple (*Harlan County, U.S.A.,* 1976), Errol Morris (*Gates of Heaven,* 1978), Henry Hampton (*Eyes on the Prize: America's Civil Rights Years, 1954–1965,* 1987), Amalie Rothschild (*It Happens to Us,* 1972), Martha Coolidge (*Not a Pretty Picture,* 1975), Michael Moore (*Roger and Me,* 1989), and Ken Burns (*Mark Twain,* 2002).

NARRATIVE FILMS

Narrative films, or *fiction films,* the principal product of the worldwide movie industry, are the movies with which we are the most familiar (and thus the ones that are this book's primary concern). "Fiction" means that the stories these films tell—and the characters, places, and events they represent—were conceived in the minds of the films' creators. These stories may be wholly imaginary or based on true occurrences, realistic or unrealistic or both, but because their content has been selected and arranged in various ways (which we will examine throughout this book), we regard them as fiction. They are based on a script, written by the screenwriter; staged and directed for the camera by the director on a studio setting or an actual location; and populated with actors. Robert E. Sherwood's screenplay for William Wyler's *The Best Years of Our Lives* (1946) was based on a verse novel by MacKinlay Kantor about the challenges facing veterans returning from World War II. The characters, each of whom represents a certain type, are fictional, but their experiences are believable, even realistic. In fact, the character of Homer Parrish, a seriously wounded sailor, was played by a veteran, Harold Russell, who wore prosthetic hooks to replace the hands he'd lost in the war and who gave one of the most tender and moving performances in the film; he won an Oscar for Best Supporting Actor (as well as a special Oscar for "bringing hope and courage to his fellow veterans"). By contrast, Robert Zemeckis's *Forrest Gump* (1994) is both realistic and fantastic in conception, putting us into the world of a slow-witted man who, through movie magic, seems to be involved in major events in American history between the 1950s and the '80s (a technique Woody Allen used in *Zelig,* his 1983 mock-documentary). A complex mixture of comedy, melodrama, and dream, the movie pushes against the boundaries imposed by *genre.*

GENRE. **Genre** refers to the categorization of fiction films by the stories they tell or the ways they tell them. Genres are defined by sets of conventions—aspects of storytelling, such as recurring themes and situations. The major genres of narrative films are

- musical (singing and dancing)
- comedy (physical or verbal humor)
- romance ("boy meets girl," "girl meets girl," etc.)
- biography (life stories)
- western (rural settings, cowboys, gunfights)
- action (violence)
- thriller (highly suspenseful situations)

- horror (monsters, shock effects)
- science fiction (science-related and/or future settings, special effects)
- crime (capers, cops and robbers)

Films belong to the same genre not because they tell the same story but because their stories share certain conventions in the way they are told (their *plots;* we'll examine the distinction between story and plot in chapter 2), their characters, their settings, and their themes. While the films may tell *similar* stories, the forms through which they tell the stories can vary considerably. The opening scenes of many westerns, for example, often present very similar *exposition,* but each director may present a different variation on the formula. (**Exposition,** which lays the foundation for the storytelling, includes the images, action, and dialogue necessary to give the audience the background of the characters and the nature of the situation they are in.)

On one hand, as a form of cinematic language, genres involve filmic realities that audiences can easily recognize and understand and that film distributors can market ("the greatest western ever made"). On the other hand, genres evolve, changing with the times and adapting to audience expectations, which are in turn influenced by a large range of factors—technological, cultural, social, political, economic, and so on. Genres play by continually changing rules, as when certain filmmakers (e.g., Antoine Fuqua in *Training Day,* 2001), bring the conventions of action films up to date by increasing the levels of violence.

During the past two decades, there has been a general and very popular trend toward making action films, such as James Cameron's *The Terminator* (1984), that feature fast-paced scenes usually involving astonishing stunt work and special effects. Many of these films star such actors as Arnold Schwarzenegger, Sylvester Stallone, and Bruce Willis, who often seem cast more for their physical abilities than for their skill in speaking the generally few lines of dialogue written for them. Many viewers' taste for action is boundless, and much social concern has been raised about the levels of violence in these films. Certainly, they reflect not only changes in our culture's sexual and moral values but also viewers' desire to escape their everyday lives. Action films visually move us from one world into another.

Many of the finest achievements in movie history are action films: Edwin S. Porter's *The Great Train Robbery* (1903); John Ford's *The Iron Horse* (1924); Fred Niblo's *Ben-Hur* (1925); Buster Keaton and Clyde Bruckman's *The General* (1926); the many swashbuckling, gangster, and war movies of the 1930s and '40s; Akira Kurosawa's *The Seven Samurai* (*Shichinin no samurai,* 1954); Peter Yates's *Bullitt* (1968); Sam Peckinpah's *The Wild Bunch* (1969); Steven Spielberg's *Raiders of the Lost Ark* (1981); John Woo's *The Killer* (*Die xue shuang xiong,* 1989). While all great action movies have chase sequences, Jean-Jacques Beineix's *Diva* (1982), a stylish thriller, sets a new standard for them. Jules (Frédéric Andréi), a Parisian mail carrier whose passion is making bootleg recordings of an opera singer he adores, must get away from two thugs who are trying to steal his tapes and sell them. To elude his pursuers, he drives his moped into the Paris subway, on and off platforms, in and out of trains, up and down escalators. While this joyous ride is full of vicarious excitement for the viewer, its flashy screen movement is also perfectly consistent with the daring and complexity of the film as a whole.

In short, genres have fairly open definitions, containing the seeds not only of varia-

Howard Hawks's *The Big Sleep,* a classic crime film and a quintessential film noir, based on Raymond Chandler's novel of the same title, follows private investigator Philip Marlowe (Humphrey Bogart) through a convoluted whodunit that even Hawks claimed he didn't completely understand.

tions but also of *subgenres.* Among the varieties of the action film, for example, are the disaster film (such as Mark Robson's *Earthquake,* 1974) and the war film (such as Terrence Malick's *The Thin Red Line,* 1998), which includes such subgenres as the prisoner-of-war film (David Lean's *The Bridge on the River Kwai,* 1957), the resistance film (Robert Bresson's *A Man Escaped [Un condamné à mort s'est échappé],* 1956, which is also a prisoner-of-war film), the antiwar film (Lewis Milestone's *All Quiet on the Western Front,* 1930), the war-is-hell film (Francis Ford Coppola's *Apocalypse Now,* 1979), the war-hero film (Sergei M. Eisenstein's *Alexander Nevski,* 1938), the wartime romance (Michael Curtiz's *Casablanca,* 1942), and even the wartime suspense comedy (Billy Wilder's *Five Graves to Cairo,* 1943). Among the varieties of the crime film are the gangster film (such as Howard Hawks

and Richard Rosson's *Scarface,* 1932, and Brian De Palma's 1983 update) and the film noir (Howard Hawks's *The Big Sleep,* 1946). French for "black film," *film noir* refers to highly stylized crime films, dominated by cynical characters in sleazy settings filled with shadowy atmosphere. Although identified as a type and named by French film critics, film noir developed in post–World War II Hollywood, in part as a reflection of anxiety stemming from the cold war and the nuclear age. Film scholars call film noir either a genre, a subgenre, or a *style,* depending on whether they see thematic or visual conventions as the unifying force among individual movies.

While conventional genre films may strictly follow ideological conventions (regarding class, race, sex, and gender, and so on), filmmakers also use genres to arouse and then adapt audiences' ideological expectations. Thus when Mel Brooks's *Blazing Saddles* (1974), an outlandish comedy, presents an African American sheriff in the American West of the 1860s, the movie parodies the western genre and offers social criticism, calling attention to how genres can reinforce stereotypes. Dennis Hopper's *Easy Rider* (1969), combining the road movie, the biker movie, and the male-buddy movie (all subgenres), makes a statement about divisions between "straight" and "hippie" subcultures; while Ridley Scott's *Thelma and Louise* (1991), combining the road movie and the female-buddy movie, creates a feminist parable.

ANIMATED FILMS. **Animated films** (or *cartoons*) are based on drawings or other graphic images that are placed in a series photography–like sequence to portray movement. Such images have been made since the beginning of motion pictures and—if we include persistence-of-vision devices such as the

thaumatrope, the phenakistiscope, and the praxinoscope—have existed from the early part of the nineteenth century. Animated motion pictures of great creative originality and importance were made in France by Georges Méliès (*The Four Troublesome Heads [Un homme de têtes],* 1898) and Émile Cohl (*Fantasmagorie,* 1908), and in the United States by J. Stuart Blackton (*The Enchanted Drawing,* 1900), Winsor McCay (*Gertie the Dinosaur,* 1914), and John Bray, whose *Colonel Heeza Liar's African Hunt* (1914) was both the first commercially released animated cartoon and the opening section of the first animated cartoon series.

Generally speaking, animation takes two forms: images that strive for the three-dimensional realism of the narrative film and images that exploit the inherently unrealistic, two-dimensional limitations of experimental films (discussed below) or abstract art. And there are several basic ways of making animated films: *drawing, puppet animation, clay animation, pixilation,* and *computer animation.*

Of these, drawing has, until recently, been the most common as well as the most tedious technique. First, artists drew characters in different movements and objects in different places on individual pieces of celluloid, a process invented by John Bray and perfected by his contemporaries Earl Hurd and Raoul Barre. These cels were then layered and photographed one by one on top of a static painted background. Projecting the photographs created the illusion of movement. Lively stories, colors, and music added to the appeal. Under the worldwide influence of the Walt Disney Studios, which released its first animated film, *Steamboat Willie,* in 1928, this process became the industry standard. Puppet animation, long an indispensable element in the brilliant animated movies made in Eastern Europe, uses three-dimensional figures or puppets that are moved incrementally for each frame of film. Clay animation starts with clay molds, from which dimensional plasticine figures are made; they depict action as they are changed in small increments through several frames. Pixilation photographs real people, animals, or objects, who move (or are moved) slightly between exposures and are then photographed again, creating the illusion that they are moving under their own power. Today, computer imaging is transforming animation. The computer can easily handle the laborious, repetitive task of making the many similar images needed to create the illusion of movement, as in John Lasseter's *Toy Story* (1995), the first animated film created entirely on the computer. In addition, the computer enables filmmakers to combine live action and animation in one shot, as in Steven Spielberg's *Jurassic Park* (1993) and Peter Jackson's *Lord of the Rings: The Fellowship of the Ring* (2001).

During the 1910s and 1920s, pioneering animation artists such as Max Fleischer, Paul Terry, Walter Lantz, Pat Sullivan, Ub Iwerks, and Otto Messmer, in addition to those mentioned above, created enduring cartoon figures—Krazy Kat and Felix the Cat, for example. But the diminutive Mickey Mouse made Walt Disney the giant of the American animation industry. During the late 1920s and early 1930s, Disney explored the artistic relationship between visuals, music, and color in such cartoons as *The Skeleton Dance* (1929), *Flowers and Trees* (1932), and *The Three Little Pigs* (1933). There soon followed such early classics as *Snow White and the Seven Dwarfs* (1937), the first American animated feature; *Pinocchio* (1940); and *Fantasia* (1940), which set varied animated scenes to classical music. In later years, Disney Studios produced more-elaborate full-length films such as *Beauty and the Beast*

David Hand's *Snow White and the Seven Dwarfs*, the first American animated feature film, was produced by a painstaking process involving many levels of drawing (such as this preliminary sketch of Snow White gazing into the magic mirror). A little less than sixty years later, John Lasseter's *Toy Story* took the emerging technologies of computer-generated imagery (CGI) to their logical extreme. It was the first animated film created entirely by computer. To learn more about the evolution of animation techniques in the digital environment, go to *<www.wwnorton.com/web/movies>*.

www

(1991), the first animated film to receive an Academy Award nomination for Best Picture; *The Lion King* (1994); and *Tarzan* (1999).

Alternatives to Disney's style emerged early in the animated films from the major studios as well as smaller, more specialized animation studios. Made by such artists as Chuck Jones, Friz Freleng, and Tex Avery, their films were characterized by a sharper, more surreal humor at the expense of cartoon characters that included Bugs Bunny, Daffy Duck, and Porky Pig. Animation artists Pete Burns, Bob Cannon, John Hubley, Gene Deitch, and Ernest Pintoff broke away from Disney during a strike, formed United Productions of America (UPA), and created such memorable characters as Mr. Magoo and Gerald McBoing-Boing. The advent of television brought a new group of animators—including Bill Hanna, Joe Barbera, and Jay Ward—and a surge of films (for an insatiable TV audience) featuring Yogi Bear, the Flintstones, Huckleberry Hound, Rocky and Bullwinkle, and other characters. At the same time, animation was flourishing in Yugoslavia, Czechoslovakia, and Russia in the work of Jiří Trnka (*The Emperor's Nightingale [Cisaruv Slavík]*, 1948), Dušan Vukotič (*Concerto for a Sub-machine Gun [Koncert za masinsku pusku]*, 1958), and Ivan Ivanov-Vano (*The Mechanical Flea [Mekhanicheskaya blokha]*, 1964). Japanese animation (known as *anime*), perhaps the most exciting work being done today, is immensely popular worldwide and includes such outstanding

films as Hayao Miyazaki's *Nausicaä* (*Kaze no tani no Naushika,* 1984), Katsuhiro Otomo's *Akira* (1988), and Osamu Tezuka's *Broken-Down Film* (*Onboro Film,* 1985), a parody of American silent movies.

Animation (and special effects) have also been fused with live action. The use of three-dimensional models and stop-motion photography by special effects expert Willis O'Brien contributed greatly to the success of Merian C. Cooper and Ernest B. Schoedsack's *King Kong* (1933). O'Brien teamed with Ray Harryhausen, famous for his model and puppet animation, in a variation on the King Kong theme in Schoedsack's *Mighty Joe Young* (1949), and Harryhausen alone created some very menacing dinosaurs for Don Chaffey's *One Million Years B.C.* (1966). This trend continued in such films as Henry Selick's *The Nightmare Before Christmas* (1993) and Nick Park's series of "Wallace and Gromit" films that began in the 1990s and continues today. The crossover from animation to special effects has contributed to the dominance of special effects in the movies of the past fifty years.

The future for animated films, including those that are fully animated and those that combine animation with live action, remains strong. Hallmarks of this future include the extraordinary success, in movie theaters, of feature-length animated films such as Andrew Adamson and Vicky Jenson's *Shrek* (2001) and, on television, of Matt Groening's series *The Simpsons;* the heavy promotional tie-ins for products appealing to children; and the ever-growing sophistication of computerized animation techniques, such as those developed by John Lasseter. At the same time, however, we can expect to see traditional animation techniques flourish in the work of those who pursue animation as a cinematic art form.

EXPERIMENTAL FILMS

Experimental films are also known as *avant-garde films,* a term implying that they are in the vanguard, out in front of traditional films. Therefore any film that cannot easily be classified as fiction, nonfiction, or animated, and thus pushes the boundaries of what most people think the movies are or should be, falls into this type. Such films are usually about unfamiliar, unorthodox, or obscure subject matter and are ordinarily made by independent (even underground) filmmakers, not studios, often with innovative techniques that call attention to, question, and even challenge their own artifice. For example, Michael Snow's *Wavelength* (1967) is a forty-five-minute film that consists, in what we see, only of an exceedingly slow zoom-lens shot through a loft. While human figures wander in and out of the frame, departing at will from that frame or being excluded from it as the camera moves slowly past them, the film is almost totally devoid of any human significance. Snow's central concern is space: how to conceive it, film it, and encourage viewers to make meaning of it. *Wavelength* is rich in differing qualities of space, light, exposures, focal lengths, and printing techniques, all offering rich possibilities for how we perceive these elements and interpret their meaning. As we know, space is fundamental to cinema, particularly in how it is framed, lighted, and photographed and, usually, in what that space contains. For those who believe that a movie must represent the human condition, *Wavelength* seems empty. But for those who believe with D. W. Griffith that a movie is meant, above all, *to make us see,* the work demonstrates the importance of utterly nonconventional filmmaking.

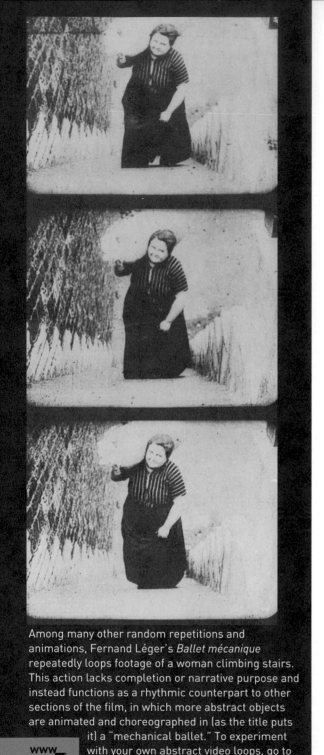

Among many other random repetitions and animations, Fernand Léger's *Ballet mécanique* repeatedly loops footage of a woman climbing stairs. This action lacks completion or narrative purpose and instead functions as a rhythmic counterpart to other sections of the film, in which more abstract objects are animated and choreographed in (as the title puts it) a "mechanical ballet." To experiment with your own abstract video loops, go to <www.wwnorton.com/web/movies>.

www

Because most experimental films do not tell a story in the conventional sense, but rather use nonlinear patterns of development, abstract images, or images produced by means other than cinematography (e.g., drawing directly on film stock to create an image, or reediting fiction or nonfiction footage for graphic effect), they help us understand in yet another way why movies are an art form. Disregarding audiences' traditional expectations, experimental films remind us that film—like painting, sculpture, music, or architecture—can be made in as many ways as there are artists.

In the 1920s, a truly experimental cinema movement was born in France, with its national climate of avant-garde artistic expression. Among the most notable works were films by painters: René Clair's *Entr'acte* (1924), Fernand Léger's *Ballet mécanique* (1924), Marcel Duchamp's *Anémic Cinéma* (1926), and Man Ray's *Emak Bakia* (1927). They are characterized uniformly by their surreal content, often dependent on dream impressions rather than objective observation; their abstract images, which tend to be shapes and patterns with no meaning other than the forms themselves; their absence of actors performing within a narrative context; and their desire to shock not only our sensibilities but also our morals. The most important of these films, the surrealist dreamscape *Un chien andalou* (*An Andalusian Dog*, 1929), was made in France by the Spanish filmmaker Luis Buñuel and the Spanish painter Salvador Dalí. Re-creating the sexual nature of dreams, its images metamorphose continually, defy continuity, even attack causality—as when a pair of breasts dissolve into buttocks.

While an alternative cinema has existed in the United States since the 1920s, an achieve-

ment of substance and style that is all the more remarkable in a country where film-making is synonymous with Hollywood, the first experimental filmmakers in the United States were either European-born or influenced by the French, Soviets, and Germans. The first major American experimental filmmaker was Maya Deren, whose surreal films—*Meshes of the Afternoon* (1943), co-directed with her husband, Alexander Hammid, is the best-known—virtually established alternative filmmaking here. Her work combines her interests in various fields, including film, philosophy, ethnography, and dance, and it remains the touchstone for those studying avant-garde movies. Concerned with the manipulation of space and time, which, after all, is the essence of filmmaking, Deren experimented with defying continuity, erasing the line between dream and reality; she used the cinematic equivalent of **stream of consciousness,** a literary style that gained prominence in the 1920s in the hands of such writers as Marcel Proust, Virginia Woolf, James Joyce, and Dorothy Richardson and that attempted to capture the unedited flow of experience through the mind. In *Meshes*, Deren is both the creative mind behind the film and the creative performer on the screen. She takes certain recognizable motifs—a key, a knife, a flower, a telephone receiver, a shadowy figure walking down a garden path—and repeats them throughout the film, each time transfiguring them into something else. So, for example, the knife evolves into a key and the flower into a knife. These changing motifs are linked visually but also structurally. Deren's ideas and achievements bridge the gap between the surrealism of the French avant-garde films and such dream-related movies as Alain Resnais's *Last Year at Marienbad* (*L'Année dernière à Marienbad,*

Luis Buñuel and Salvador Dalí collaborated to produce *Un chien andalou,* one of the most famous experimental films. Through special effects, its notorious opening sequence appears to show a woman's eyeball being slit by a razor.

1961), Federico Fellini's *8½* (1963), Ingmar Bergman's *Persona* (1966), and Luis Buñuel's *The Milky Way* (*La voie lactée,* 1969).

Greatly influenced by Deren's work, the "independent American cinema" or "American underground cinema" emerged in the 1950s and has since favored four subgenres: the formal, the self-reflexive, the satirical, and the sexual, each of which tends to include aspects of the lyrical approach so typical of Deren. Works of pure form include John Whitney's early experiments with computer imagery in such films as *Matrix* (1971); Shirley Clarke's *The Skyscraper* (1958), one of several lighthearted, abstract tributes to city life; Peter Kubelka's *Arnulf Rainer* (1960), which created its images through abstract dots; Jordan Belson's *Allures* (1961), using abstract color animation; and Robert Breer's *Fist Fight* (1964), which combines animation, images of handwriting, and other material. Self-reflexive films, meaning those that represent their own condi-

tions of production (movies, in other words, about movies, moviemaking, moviemakers, and so on), include Hans Richter's *Dreams That Money Can Buy* (1946), in the spirit of surrealism; Stan Brakhage's *Dog Star Man* (1961–64), whose lyricism is greatly influenced by Deren's work; Bruce Baillie's *Mass for the Dakota Sioux* (1964), which combines a lyrical vision and social commentary; Hollis Frampton's *Zorn's Lemma* (1970), a complex meditation on cinematic structure, space, and movement; and Michael Snow's *Wavelength* (1967), discussed above. Films that take a satirical view of life include James Broughton's *Mother's Day* (1948), on childhood; Stan Van Der Beek's *Death Breath* (1964), an apocalyptic vision using cartoons and other imagery; Bruce Conner's *Marilyn Times Five* (1965), which makes its comic points by compiling stock footage from other sources; and George and Mike Kuchar's *Sins of the Fleshapoids* (1965), an underground look at the horror genre. The satirical and sexual films often overlap, particularly in their portrayal of sexual activities that challenge conventional ideas of "normality." Examples of these include Kenneth Anger's *Scorpio Ris-*

ing (1963), an explicit homosexual fantasy that is tame by today's standards; Jack Smith's *Flaming Creatures* (1963), a major test case for pornography laws; and many of Andy Warhol's films, including *Lonesome Cowboys* (1968). These filmmakers tended to be obsessed, as was Deren, with expressing themselves and their subconscious through cinematic forms and images.

Since the collapse of the studio system, the growth of independent cinema has fostered a crossover and synthesis of conventional and experimental aesthetics and technique, as seen in John Cassavetes's *Shadows* (1959), John Waters's *Pink Flamingos* (1972), Jim Jarmusch's *Stranger Than Paradise* (1984), John Sayles's *Matewan* (1987), Allison Anders's *Gas, Food, Lodging* (1992), Charles Burnett's *To Sleep with Anger* (1990), and Richard Linklater's *Slacker* (1991). Today, the growing use of computers in filmmaking has created a new wave of technological and aesthetic experimentation. But as has happened so often in film history, such revolutions in filmmaking may quickly enter the conventional cinematic language.

QUESTIONS FOR REVIEW

This chapter introduces you to five fundamental principles that should help you understand what movies are; how movies resemble and differ from other art forms; how movies *move;* how movies are made; and how we group movies according to type. To review and master these concepts, answer the following questions.

1. Given the five fundamental principles of movies, is it still possible to think of this art form as independent from the other arts?
2. The classical arts, which originated in the ancient civilizations of Africa, Egypt, Greece, and Rome, are painting, sculpture, dance, architecture, poetry, music, and drama. Why was the invention of movies impossible before modern times?
3. How do the movies fool your eyes?
4. Why do the movies require a collaborative production effort?
5. How do movies differ from painting and still photography in the way they depict illusions of movement?
6. Why are considerations of space and time inseparable in looking at movies? What is the

principle of "co-expressibility"? Think of a film or scene that reflects the *dynamization of space* and one that reflects the *spatialization of time,* then explain your choices.

7. Given that we generally see both plays and movies in theaters, what do these art forms have in common? How do they differ in the ways they tell stories? How do our experiences in looking at the forms differ?

8. What aspects of technology are essential to the movies?

9. What is "experimental" about experimental films?

10. How do nonfiction and narrative films differ?

QUESTIONS FOR ANALYSIS

During the first or second weeks of the semester, your instructor may ask you to study film clips or a complete film. The following questions, based on the core concepts of this chapter, will help you know what to look for as you study the assigned material. These questions can, of course, be applied to the films suggested as "case studies."

1. How would you describe the movie's presentation of space and time? Are there recognizable patterns in this presentation? At this early stage in your study of film, you might limit your observations to the types of shots and editing that are used to tell the story. (For example, are there more long shots that show the vastness of the space, or more close-ups to concentrate our attention on the small space around and among the characters? Does the editing flow smoothly from scene to scene, or does it call attention to itself by manipulating time in an obvious way?)

2. How would you describe this movie's use of light? At which points in the movie do qualities of light and dark become obvious?

3. How would you describe the *movement* in this movie? How much, and in what ways, does the camera move in this movie? Does the camera movement (or lack of camera movement) contribute to the movie overall? In what ways?

4. Imagine this movie existing as a play, a novel, a painting. How would each form differ from what you have seen on the screen?

5. How does the camera in this movie *mediate* between the exterior (the world) and the interior (your eyes and brain)?

6. Does this movie seem to be a "realistic" depiction of the world? If not, does it present a *believable* fantasy world of its own? Describe the ways in which it does or does not achieve verisimilitude.

7. What can you learn about the people who made this movie, how much it cost to produce, how long it took to make, and the collaborative efforts that were required to make it happen?

8. To which genre does this movie belong? How does it compare with, or differ from, other movies in that genre?

A NOTE ON "CASE STUDIES"

Some chapters in this book will refer to "case studies," detailed analyses of individual films that can be studied in relation to the central issues of the chapters. These case studies are not printed in the book but can be found on the book's Web site: <*www.wwnorton.com/web/movies*>. Your instructor might choose to show or discuss the films in class, ask you to see them outside class, or assign different films altogether. (The films covered in case studies should be available in most video or DVD rental stores and in college or local libraries.) The movie suggested for this chapter is Vittorio De Sica's *Bicycle Thieves* (*Ladri di biciclette,* 1949), which you should see before you read the case study.

FOR FURTHER READING

Throughout the book, "For Further Reading" lists include sources not cited in the footnotes.

General

Bordwell, David, Janet Staiger, and Kristin Thompson. *The Classical Hollywood Cinema: Film Style and Mode of Production to 1960*. New York: Columbia University Press, 1985.

Dondis, Donis A. *A Primer of Visual Literacy*. Cambridge, Mass.: MIT Press, 1973.

Kawin, Bruce F. *How Movies Work*. 1987. Reprint, Berkeley: University of California Press, 1992.

Neale, Steve. *Cinema and Technology: Image, Sound, Colour*. Bloomington: Indiana University Press, 1985.

Thomson, David. *A Biographical Dictionary of Film*. 4th ed. New York: Knopf, 2002.

History

Balio, Tino. *Grand Design: Hollywood as a Modern Business Enterprise, 1930–1939*. History of the American Cinema, ed. Charles Harpole, vol. 5. New York: Scribner, 1993.

Barsam, Richard M. *Nonfiction Film: A Critical History*. Rev. and exp. ed. Bloomington: Indiana University Press, 1992.

Bordwell, David. *On the History of Film Style*. Cambridge, Mass: Harvard University Press, 1997.

Bowser, Eileen. *The Transformation of Cinema, 1907–1915*. History of the American Cinema, ed. Charles Harpole, vol. 2. New York: Scribner, 1990.

Ceram, C. W. *Archaeology of the Cinema*. New York: Harcourt, Brace, 1965.

Cook, David A. *A History of Narrative Film*. 3rd ed. New York: Norton, 1996.

———. *Lost Illusions: American Cinema in the Shadow of Watergate and Vietnam, 1970–1979*. History of the American Cinema, ed. Charles Harpole, vol. 9. New York: Scribner, 2000.

Crafton, Donald. *The Talkies: American Cinema's Transition to Sound, 1926–1931*. History of the American Cinema, ed. Charles Harpole, vol. 4. New York: Scribner, 1999.

Fielding, Raymond, comp. *A Technological History of Motion Pictures and Television: An Anthology from the Pages of the "Journal of the Society of Motion Picture and Television Engineers."* Berkeley: University of California Press, 1967.

Hark, Ina Rae, ed. *Exhibition, the Film Reader*. New York: Routledge, 2002.

Koszarski, Richard. *An Evening's Entertainment: The Age of the Silent Feature Picture, 1915–1928*. History of the American Cinema, ed. Charles Harpole, vol. 3. New York: Scribner, 1990.

Monaco, Paul. *The Sixties: 1960–1969*. History of the American Cinema, ed. Charles Harpole, vol. 8. New York: Scribner, 2001.

Musser, Charles. *The Emergence of Cinema: The American Screen to 1907*. History of the American Cinema, ed. Charles Harpole, vol. 1. New York: Scribner, 1990.

Prince, Stephen. *A New Pot of Gold: Hollywood under the Electronic Rainbow, 1980–1989*. History of the American Cinema, ed. Charles Harpole, vol. 10. New York: Scribner, 2000.

Schatz, Thomas. *Boom and Bust: The American Cinema in the 1940s*. History of the American Cinema, ed. Charles Harpole, vol. 6. New York: Scribner, 1997.

Theory

Allen, Richard. *Projecting Illusion: Film Spectatorship and the Impression of Reality*. New York: Cambridge University Press, 1997.

Andrew, J. Dudley. *The Major Film Theories: An Introduction*. New York: Oxford University Press, 1976.

Arnheim, Rudolf. *Art and Visual Perception: A Psychology of the Creative Eye*. Rev. ed. Berkeley: University of California Press, 1974.

———. *Film as Art*. Berkeley: University of California Press, 1957.

Bazin, André. *What Is Cinema?* Sel. and trans. Hugh Gray. 2 vols. Berkeley: University of California Press, 1967–71.

Benjamin, Walter. "The Work of Art in the Age of Mechanical Reproduction," trans. Harry Zohn. In *Film Theory and Criticism: Introductory Readings,* ed. Leo Braudy and Marshall Cohen, 731–51. 5th ed. New York: Oxford University Press, 1999.

Braudy, Leo, and Marshall Cohen, eds. *Film Theory and Criticism: Introductory Readings.* 5th ed. New York: Oxford University Press, 1999.

Burch, Noël. *Life to Those Shadows.* Trans. and ed. Ben Brewster. Berkeley: University of California Press, 1990.

———. *Theory of Film Practice.* Trans. Helen R. Lane. 1973. Reprint, Princeton: Princeton University Press, 1981.

Carroll, Noël. *Interpreting the Moving Image.* New York: Cambridge University Press, 1998.

———. *Theorizing the Moving Image.* New York: Cambridge University Press, 1996.

Henderson, Brian. *A Critique of Film Theory.* New York: Dutton, 1980.

Hollows, Joanne, Peter Hutchings, and Mark Jancovich, eds. *The Film Studies Reader.* London: Arnold; New York: Oxford University Press, 2000.

Kracauer, Siegfried. *Theory of Film: The Redemption of Physical Reality.* New York: Oxford University Press, 1960.

Lehman, Peter, ed. *Defining Cinema.* New Brunswick, N.J.: Rutgers University Press, 1997.

Mast, Gerald. *Film/Cinema/Movie: A Theory of Experience.* New York: Harper and Row, 1977.

Metz, Christian. *Film Language: A Semiotics of the Cinema.* Trans. Michael Taylor. New York: Oxford University Press, 1974.

———. *The Imaginary Signifier: Psychoanalysis and Cinema.* Trans. Celia Britton et al. Bloomington: Indiana University Press, 1982.

Perkins, V. F. *Film as Film: Understanding and Judging Movies.* Baltimore: Penguin, 1972.

Williams, Christopher, ed. *Realism and the Cinema: A Reader.* London: Routledge and Kegan Paul, 1980.

Wollen, Peter. *Signs and Meaning in the Cinema.* 4th ed. London: BFI Publishing, 1998.

Types of Film

Dixon, Wheeler Winston and Gwendolyn Audrey Foster, eds. *Experimental Cinema, The Film Reader.* New York: Routledge, 2002.

Le Grice, Malcolm. *Experimental Cinema in the Digital Age.* London: BFI Publishing, 2001.

Nichols, Bill, ed. *Maya Deren and the American Avant-Garde.* Berkeley: University of California Press, 2001.

Plantinga, Carl R. *Rhetoric and Representation in Nonfiction Film.* New York: Cambridge University Press, 1997.

Rothman, William. *Documentary Film Classics.* New York: Cambridge University Press, 1997.

Youngblood, Gene. *Expanded Cinema.* New York: Dutton, 1970.

See also titles (devoted to individual movies, directors, genres, and national cinemas) in the following series: BFI Film Classics, BFI Modern Classics, and BFI World Directors.

Genres

Altman, Rick. *The American Film Musical.* Bloomington: Indiana University Press, 1987.

Browne, Nick, ed. *Refiguring American Film Genres: History and Theory.* Berkeley: University of California Press, 1998.

Cohan, Steven, ed. *Hollywood Musicals, the Film Reader.* New York: Routledge, 2002.

Freeland, Cynthia A. *The Naked and the Undead: Evil and the Appeal of Horror.* Boulder, Colo.: Westview Press, 2000.

Gehring, Wes D., ed. *Handbook of American Film Genres.* New York: Greenwood Press, 1988.

Grant, Barry Keith, ed. *Film Genre Reader II.* Austin: University of Texas Press, 1995.

Hardy, Phil. *The Western.* 2nd ed. London: Aurum, 1991.

————, ed. *Horror.* Rev. updated ed. London: Aurum Press, 1993.

Jancovich, Mark, ed. *Horror, the Film Reader.* New York: Routledge, 2002.

Schatz, Thomas. *Hollywood Genres: Formulas, Filmmaking, and the Studio System.* New York: Random House, 1981.

Solomon, Stanley J. *Beyond Formula: American Film Genres.* New York: Harcourt Brace Jovanovich, 1976.

Tudor, Andrew. *Monsters and Mad Scientists: A Cultural History of the Horror Movie.* Oxford: Blackwell, 1989.

Form and Narrative

WHAT IS FORM?

If you've ever watched an unedited portion of surveillance tape, say from a convenience store or a bank, you know that it's a boring, almost pointless activity. Even when you watch an important event occurring—when, for example, a robbery has been recorded on tape—your excitement comes almost completely from knowing that the event really happened, and not from the videotape's having been shot in an exciting way. The camera's vantage point is always above and away from the action, the black-and-white image is usually blurry, the sound may be difficult to make out, and watching the robbery from beginning to end on the tape will (necessarily) take the same amount of time as it took to occur.

Consider, in contrast, a scene from Arthur Penn's *Bonnie and Clyde* (1967; screenwriters: David Newman and Robert Benton), a movie about the notorious 1930s bank robbers Bonnie Parker (Faye Dunaway) and Clyde Barrow (Warren Beatty) and their accomplices: Clyde's brother, Buck (Gene Hackman); Buck's wife, Blanche (Estelle Parsons); and C. W. Moss (Michael J. Pollard). The depiction of the gang's first bank robbery runs for one minute, thirty-nine seconds and includes forty-seven shots, which display a complex coordination of actors (choreographed staging of movements) and camera (various placements and angles). Each character in the scene—the gang members, the bank's employees and customers—is clearly photographed within an individual space to establish the layout of the bank and each person's placement within it. The robbers are stylishly dressed and charming, yet their demeanor and guns demonstrate another side of their personalities; the bank employees and customers,

townspeople and hard-pressed farmers, are dressed simply. In this well-delineated and tense situation, you see and understand layers of feeling, action, and reaction: the thieves' cool professionalism; the guards' frustration and humiliation; the tellers' efforts to appear unruffled while stuffing money into bags; most customers' fear; and one farmer's relief when Clyde refuses to take his money. The scene begins slowly as the gang enters the bank; increases in rhythm during the heist; and then increases again during the getaway, accompanied by spirited banjo music that "comments" on the action, making the potentially violent crime seem like a romp.

This scene from *Bonnie and Clyde* and the imaginary surveillance tape both depict robberies. Both are recorded on motion picture media. But they differ from each other in a fundamental way, and only one of them—*Bonnie and Clyde*—could be called a movie. The key to understanding the difference between these two examples is **form**. In this book, form may mean alternately

1. the arrangement or order of parts of a movie
2. the elements (such as pictures and sound) manipulated by filmmakers to create a movie
3. the commonly accepted ways in which the content of a movie is expressed (as in the *genre;* see "Types of Movies" in chapter 1)
4. the system (within a movie) that causes viewers to respond to, comprehend, and interpret the movie in particular ways

The form of *Bonnie and Clyde* has been deliberately manipulated by artists (Arthur Penn and his collaborators) to shape and influence the viewer's experience of its *content.* In con-

[1]

[2]

(1) We activate surveillance cameras and later view their tapes for a specific reason, unrelated to aesthetics. We want to know who did what at the scene of a crime, and thus the unscripted, relatively formless reality on the recording helps us solve a practical problem as quickly as possible. (2) Works of art, such as movies, have deliberate forms that convey information beyond who did what. Arthur Penn's *Bonnie and Clyde*, for example, portrays many bank robberies, each of which engages and rewards our attention in ways no surveillance tape could. Even this fraction of a scene conveys the care that went into the composition of the movie's images. The suave, smiling Clyde (Warren Beatty) clearly dominates, while Buck (Gene Hackman) provides solid, volatile support. Bonnie (Faye Dunaway), blurry here because this single frame can't capture her rapid motion, plays a more enigmatic role in the gang. To view a sequence of stills from this scene, go to <*www.wwnorton.com/web/movies*>.

2.1

trast, the form of the surveillance tape is constant and unchanging: the tape artlessly records (a limited) reality from a fixed point of view and with chronological continuity. No one, except the person who installed the camera on the ceiling and the employee who switched the recorder on for the day, made a conscious decision about how the action would be filmed. The meaning of the surveillance tape, to the extent that it has a meaning, is almost completely determined by *what* is recorded on video rather than by *how* it looks as we watch it. In the scene from *Bonnie and Clyde*, however, our understanding of the action is continually influenced and adjusted by its deliberately crafted form. All the details that contribute to *Bonnie and Clyde*'s look and feel—the clothing, set design, choreography, acting, camera movement, accompanying music, and many other "technical" elements—together constitute the film's form and are crucially important to our sense of the film's meaning.

The relationship between *form* and *content* is a central concern in all art, and it underlies our study of movies, too. At the most basic level, we might see **content** as the subject of an artwork and form as the means through which that subject is expressed. Such a perspective might help us distinguish one work of art from another, or to compare the styles and visions of different artists approaching the same subject. If we look at three sculptures of a male nude, for example—by Praxiteles, Alberto Giacometti, and Keith Haring, artists spanning history from ancient Greece to the present—we can see crucial differences in vision, style, and meaning. Each sculpture can be said to express the same subject, the male nude, but clearly they differ in form. Of the three, Praxiteles' sculpture comes closest to resembling a flesh-and-blood body. Giaco-

metti's elongates and exaggerates anatomical features, but the figure remains recognizable as a male human. Haring's version smooths out and simplifies the contours of the human body to create an even more abstract rendering. Once we recognize the formal differences and similarities among these three sculptures, we can ask questions about how the respective forms shape our emotional and intellectual responses to the subject matter. Look again at the ancient Greek sculpture. While there might once have been a living man whose body looked like this, very few bodies do. The sculpture is an idealization—less a matter of recording the way some man actually looked than of visually describing an ideal male form. As such, it is as much an interpretation of the subject matter as, and thus no more "real" than, the other two sculptures. Giacometti's version, because of its exaggerated form, conveys a sense of isolation, perhaps even anguish. Haring's sculpture, relying on stylized and almost cartoonlike form, seems more playful and mischievous than do the other two. Suddenly, because of the different form each sculpture takes, we realize that the "content" of each has changed: they are no longer "about" the same subject. Praxiteles' sculpture is somehow about defining an ideal; Giacometti's seems to reach for something that lies beneath the surface of human life and the human form; and Haring's appears to celebrate the body as a source of joy. As we become more attentive to their formal differences, these sculptures become more unlike each other in their content, too.

Thus rather than being separate things that come together to produce art, form and content are instead two aspects of the entire formal *system* of a work of art. They are interrelated, interdependent, and interactive. Nonetheless, as we study movies or analyze an

[1]

[2]

[3]

Compare these sculptures by (1) Praxiteles, who lived in Greece during the fourth century B.C.E.; (2) Alberto Giacometti (1901–1966), a Swiss artist; and (3) Keith Haring (1958–1990), an American. Although all three works depict the male figure, their forms are so different that their meanings, too, must be different. What, then, is the relationship between the form of an artwork and its content?

On October 3, 1993, nearly one hundred U.S. Army Rangers parachuted into Mogadishu, the capital of Somalia, to capture two men. Their mission was supposed to take about an hour, but they ended up in a fifteen-hour battle, the longest sustained ground attack involving American soldiers since the Vietnam War. Two U.S. Black Hawk helicopters were destroyed; eighteen Americans and hundreds of Somalis were killed; military and civilian casualties numbered in the thousands. Whereas its source, Mark Bowden's best-selling nonfiction book of the same title, was a minute-by-minute account of the firefight, Ridley Scott's narrative film *Black Hawk Down* re-creates events by dramatically condensing the action into 144 minutes. What relationship does each work bear to the facts? What would it mean, in this case, to say that "the movie is better than the book" or vice versa?

individual movie, we might have good reasons, conceptually and critically, to isolate content. It might be useful to do so when, say, comparing the rendition in Ridley Scott's *Black Hawk Down* (2001; screenwriter: Ken Nolan) of the 1993 U.S. military intervention in Somalia with a historical account of the same event. In such an analysis, issues of completeness, accuracy, and reliability would take precedence over cinematography and editing. If we find ourselves saying, "I'm interested in what the film has to say, not in its *technical* aspects," however, we are revealing the shortsightedness of this approach. By focusing solely on content, we risk overlooking the for-

mal aspects that make movies unique as an art form and interesting as individual works of art.

PRINCIPLES OF FILM FORM

This book describes some of the formal aspects of film—narrative, design, cinematography, acting, editing, sound—to provide you with a beginning vocabulary with which to talk about film form more specifically. But before you can graduate from merely watching movies to analyzing them (that is, looking at them critically), you need to understand some of the general principles of film form.

FORM AND EXPECTATIONS

Your decision to see a particular movie is almost always based on certain expectations. Perhaps you have enjoyed previous work by the director, the screenwriter, or the actors; or you have been attracted by publicity, advertisements, friends, or reviews; or the genre appeals to you; or you're curious about the techniques used to make it.

Even if you have no such preconceptions before stepping into a movie theater, you will form impressions very quickly once the movie begins, sometimes even from the moment the opening credits roll. (In Hollywood, producers and screenwriters assume that audiences decide whether they like or dislike a movie within its first ten minutes.) As the movie continues, you experience a more complex web of expectations, many of which may be tied to the **narrative**—to the overall connection of events within the world of the movie—and, specifically, to your sense that certain events follow others (related by cause and effect, logic, or

something else). The nineteenth-century Russian playwright Anton Chekhov famously said that when a theater audience sees a character produce a gun in the first act, they expect that gun to be used before the play ends, and movie audiences feel similar expectations. Very often a movie starts with a (perhaps *the*) "normal" world, which is altered by a particular incident, or catalyst, that forces the characters to act in pursuit of a goal. And once the narrative begins, we ask questions about the story's outcome, questions we will be asking ourselves repeatedly and waiting to have answered over the course of the film. When an explosion occurs at the beginning of Orson Welles's *Touch of Evil* (1958; screenwriter: Welles; see "Crane Shot" in chapter 4), we ask if "Mike" Vargas (Charlton Heston) will track down the killer. After the first attack in Steven Spielberg's *Jaws* (1975; screenwriters: Peter Benchley and Carl Gottlieb), we wonder if Chief Brody (Roy Scheider) or someone else will kill the shark.

In *Jaws,* a conflict starts early between the old shark hunter Quint (Robert Shaw) and the university-trained shark specialist Matt Hooper (Richard Dreyfuss), who provisions Quint's boat with all sorts of sophisticated equipment, including air tanks. Later, at sea, Hooper cautions the others to be careful of the tanks, which are dangerous and might blow up if mishandled, and Quint responds derisively that a shark could eat one. This event prepares us, as Chekhov would have it, for the tanks to be used as an offensive weapon; it also cements the struggle between Quint's intuitive and Hooper's scientific approaches to shark hunting. The longer the tanks remain unused, however, the more suspense we feel. Sometimes, of course, a filmmaker frustrates expectations, and thus surprises us, by ignoring the gun (air tanks, or what have you) or employing it in unforeseen ways. In Sam Mendes's *American Beauty* (1999; screenwriter: Alan Ball), we are introduced to two of the film's

[1]

[2]

Elements of narrative form often inspire expectations, which other elements either fulfill or contradict. Consider the expectations aroused in (1) Steven Spielberg's *Jaws,* where the air tanks aboard Quint's (Robert Shaw) boat are potentially explosive. "I don't know what that bastard shark's going to do with it," Quint says jokingly. "Might *eat* it, I suppose." We *know* that air tanks and shark will meet again at some

point. In the opening scene of (2) Sam Mendes's *American Beauty,* Ricky (Wes Bentley) videotapes Jane (Thora Birch). "Want me to kill him for you?" he asks. "Yeah, would you?" Jane answers. To learn more about how formal aspects of film inspire expectations, visit <www.wwnorton.com/web/movies>.

www

central characters—Jane Burnham (Thora Birch), the daughter of Lester Burnham (Kevin Spacey), and Ricky Fitts (Wes Bentley), the charismatic marijuana dealer and video artist who lives next door—through a precredits flashforward video interview that plants the idea that Ricky will kill Lester. Because of Ricky's rebellious nature, we assume that he will use a deadly weapon at some point or that a weapon will at least play a dramatic role in the story. This suspenseful situation becomes complicated when we meet Ricky's father, Frank Fitts (Chris Cooper), a gung ho, physically abusive Marine colonel. The complications mount when Jane's mother, Carolyn Burnham (Annette Bening), starts brandishing a gun, implying that she will use it to kill the husband she despises. Once a gun goes off, we must decide which of these characters acted on his or her motive.

Director Alfred Hitchcock treated his audiences' expectations in ironic, even playful ways—sometimes using the gun, so to speak, and sometimes not—and this became one of his major stylistic traits. Hitchcock used the otherwise meaningless term *MacGuffin* to refer to an object, document, or secret within a story that is of vital importance to the characters and thus motivates their actions and the conflict, but that turns out to be less significant to the overall narrative than we might at first imagine.[1] In *Psycho* (1960; screenwriter: Joseph Stefano), for example, Marion Crane (Janet Leigh) believes that the $40,000 she steals from her employer will help her start a new life. Instead, her flight with the money leads to the Bates Motel, the psychopath Norman Bates (Anthony Perkins), and her murder.

Much of the development and ultimate impact of Arthur Penn's *Bonnie and Clyde* depends on the sexual chemistry between the title characters, established through physical expression, dialogue, and overt symbolism. Clyde (Warren Beatty), handsome and ruthless, brandishes his gun threateningly and phallically. Attracted by this, the equally beautiful Bonnie (Faye Dunaway) is as surprised as we are when Clyde, resisting her, says, "I ain't much of a lover boy." We may not like this contradiction, but it is established early in the film and quickly teaches us that our expectations will not always be satisfied.

The money plays no role in motivating Bates's murderous actions, and in fact he doesn't seem to know it exists. Once the murder has occurred, the money—a classic MacGuffin—is of no real importance to the rest of the movie.

[1]Hitchcock discusses the MacGuffin in François Truffaut, *Hitchcock*, rev. ed. (New York: Simon and Schuster, 1985), 137–39.

Even as the narrative form of a movie is shaping and sometimes confounding our expectations, other formal qualities may perform similar functions. Seemingly insignificant and abstract elements of film such as color schemes, sounds, the length of shots, and the movement of the camera often cooperate with dramatic elements to either heighten or confuse our expectations. One way they do this is by establishing *pattern*.

FORM AND PATTERNS

Instinctively, we search for patterns and progressions in all art forms. The more these meet our expectations (or contradict them in interesting ways), the more likely we are to enjoy, analyze, and interpret the work. When we read a sonnet, for example, we expect it to follow a certain pattern that depends on its type. The Elizabethan, or Shakespearean, sonnet consists of fourteen lines, usually written in iambic pentameter: three quatrains and a couplet, rhyming *abab cdcd efef gg*.[2] Consider Shakespeare's Sonnet 55:

Not marble nor the gilded **monuments**	a
Of princes shall outlive this powerful **rhyme,**	b
But you shall shine more bright in these **contents**	a
Than unswept stone besmeared with sluttish **time.**	b
When wasteful war shall statues **overturn**	c
And broils root out the work of **masonry,**	d
Nor Mars his sword nor war's quick fire shall **burn**	c
The living record of your **memory.**	d

'Gainst death and all oblivious **enmity** e
Shall you pace forth; your praise shall still find **room** f
Even in the eyes of all **posterity** e
That wear this world out to the ending **doom.** f
So, till the judgement that yourself **arise,** g
You live in this, and dwell in lovers' **eyes.** g

'Gainst death and all oblivious **enmity**	e
Shall you pace forth; your praise shall still find **room**	f
Even in the eyes of all **posterity**	e
That wear this world out to the ending **doom.**	f
So, till the judgement that yourself **arise,**	g
You live in this, and dwell in lovers' **eyes.**	g

Artistic form does not always follow the expectations with which we begin an analysis of it. If the context changes, so will our experiences and expectations. Faced with a contemporary poem titled "Sonnet," we would be surprised to find not, say, a fourteen-line love poem in iambic pentameter but an epic prose poem about war. If we immediately adjust our understanding of the sonnet to include this form, we run the risk of widening the definition so much that it becomes meaningless. In other words, we come to the poem with certain expectations because of the title, but the form then defies those expectations. Our response to that defiance need not be acceptance. Instead, we must ask questions about the form. Has the poet applied this title because she really expects us to consider the poem a sonnet? If so, is she wrong? If the title doesn't fit, is the rest of the poem faulty? Is the poet simply being playful? Or is she ironically commenting on the sonnet form, the limitations of that form, literary history, and so on?

Poetry and cinema are basically comparable in at least one regard: they are both temporal arts, organized according to aspects of time (e.g., rhythm of editing in a movie and metrical arrangement of words in a poem). As we read a poem or watch a movie, we become aware that the poet or the director has organized the work according to certain structural principles. We respond to these and readjust our responses as the work

[2]The following is adapted from Barbara Herrnstein Smith, *Poetic Closure: A Study of How Poems End* (Chicago: University of Chicago Press, 1968), 1–27.

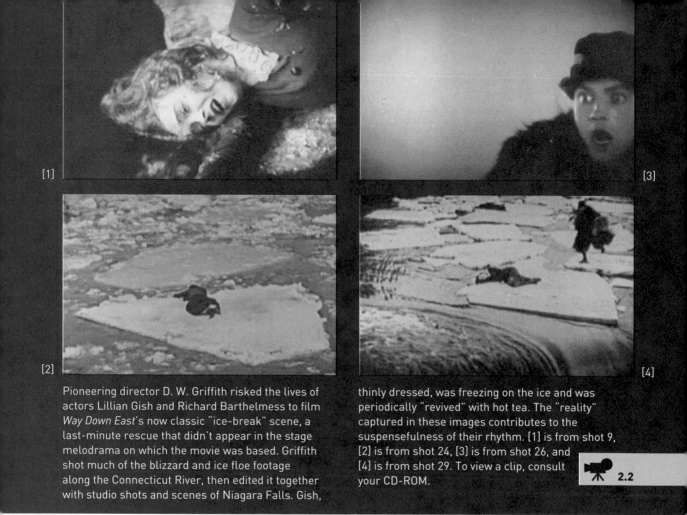

Pioneering director D. W. Griffith risked the lives of actors Lillian Gish and Richard Barthelmess to film *Way Down East*'s now classic "ice-break" scene, a last-minute rescue that didn't appear in the stage melodrama on which the movie was based. Griffith shot much of the blizzard and ice floe footage along the Connecticut River, then edited it together with studio shots and scenes of Niagara Falls. Gish, thinly dressed, was freezing on the ice and was periodically "revived" with hot tea. The "reality" captured in these images contributes to the suspensefulness of their rhythm. [1] is from shot 9, [2] is from shot 24, [3] is from shot 26, and [4] is from shot 29. To view a clip, consult your CD-ROM.

2.2

moves forward. Consider as an analogy those "critical thinking" tests that ask us to continue a series of which only the first few units are given. Perhaps we are given a series from the Roman alphabet, such as A B A B. The pattern that has been established already suggests that "A" is the most likely to come next. But look above at the Shakespearean sonnet. If we were told that this series described the beginning of a sonnet's rhyme scheme, then our sense of the form of A B A B would change completely, and we would say that "C" comes next.

Let's look at some examples. The penultimate scene in D. W. Griffith's *Way Down East* (1920; scenario: Anthony Paul Kelly), one of the most famous "chase" scenes in movie history, illustrates one effect of patterns. Banished from a "respectable" family's house because of her "scandalous" past, Anna Moore (Lillian Gish) tries to walk through a blizzard, but quickly becomes disoriented and wanders

onto a partially frozen river. She faints on an ice floe and, after much suspense, is rescued by David Bartlett (Richard Barthelmess) just as she is about to go over a huge waterfall to what clearly would have been her death. Griffith filmed this scene during an actual snowstorm, and both actors were in real danger of going over the falls where they were shooting. However, to heighten the drama of his characters' predicament, Griffith employs *parallel editing* (for a full discussion, see "Conventions of Editing" in chapter 6). He does not use shots of the actual falls, but rather cross-cuts between shots of Anna on the ice (A), David jumping from one floe to another as he tries to catch up with her (B), and Niagara Falls (C). Watching these three lines of action edited together (in a general pattern of A B C A C B C A B C A C B C) so that they appear simultaneous, we assume that the river flows over Niagara Falls. Fig 2.1 describes the action, type (yet another pattern—the types of shots will be discussed fully in chapter 4), and timing of each shot in the scene, beginning at the point when the ice begins to break up. Note that forty-six shots of slowly increasing tension lead up to this rescue scene (making a total of eighty-nine shots). In that sequence, David and Anna are widely separated in space: she is on the ice, and he is trying to reach her, running first along the shore and then across the ice blocks. As the tension increases—will David save Anna or will she plunge over the falls to her death?— particularly between shots 19 and 28, the shots get shorter and shorter, decreasing from 4 to 3 to 2 seconds. Shot 29, the moment of her triumphant rescue, is, at 8 seconds, the longest shot in the scene. Griffith had discovered the important principle that progressively shortening shots in a series heightens tension in an audience, and he used this technique repeatedly.

In Jonathan Demme's *The Silence of the Lambs* (1991; screenwriter: Ted Tally), a parallel-action sequence creates a different effect. Because earlier in the movie Demme has already shown us countless versions of a formal pattern in which two elements seen in separation are alternated and related (A B A B A B), we expect that pattern to be repeated. Thus when shots of the serial killer Buffalo Bill (Ted Levine) arguing with his intended victim, Catherine Martin (Brooke Smith), in his basement (A) are intercut with shots of the FBI team preparing to storm a house (B), we assume the FBI has targeted the same house in which Buffalo Bill is going about his grisly business (A). When the FBI attacks a different house (C), this breaks the pattern and thwarts our expectations.

In Jean-Pierre Jeunet and Marc Caro's *Delicatessen* (1991, screenwriters: Jeunet, Caro, and Gilles Adrien), one comic scene functions like a piece of music, with a classic verse-chorus-verse-chorus-verse-chorus pattern. When a butcher, Monsieur Clapet (Jean-Claude Dreyfus), makes love with his mistress, Mademoiselle Plusse (Karin Viard), the mattress and frame of the bed squeak noisily and in quickening rhythm that matches their increasing ardor. As the tempo increases, we expect the scene to end climactically. Playing on our expectations, Jeunet and Caro cut back and forth (A B A B A B A B A B A B) between the lovers and other inhabitants of the building, who hear the squeaking bed and unconsciously change the rhythm of their daily chores to keep time with the sounds' escalating pace. The sequence derives its humor from the way it satisfies our formal expectations for closure (the sexual partners reach orgasm) but frustrates the tenants, who just become exhausted in their labors.

The missile strike scene in Stanley

Shot	Action	Type of shot*	Length (sec.)
	TIMING PATTERN IN ICE-BREAK SCENE IN *WAY DOWN EAST* FIG. 2.1		
Title	"The ice jam gives way—rushing to the falls."		
1	Large moving ice field on river	LS	6
2	Flowing river	MS	6
3	Many large ice floes moving on river	LS	4
4	Single ice floe moving on river	MS	2
5	Large ice floes, breaking up	MS	3
6	Brink of the falls	MS	3
7	The falls	LS	4
8	River full of breaking ice field	LS	2
9	Anna lies on ice floe, head over edge, hair in water	CU	4
10	Anna on ice floe in river full of breaking ice field	LS	2
11	Ice floes plunge over edge of the falls	LS	4
12	David runs across snow-covered ground toward river	LS	4
13	David at river's edge	LS	5
14	David jumps onto moving ice and leaps across floes toward Anna	LS	4
15	David jumps onto moving ice and leaps across floes toward Anna	LS	1
16	Anna on swiftly moving ice floe	LS	4
17	Anna on swiftly moving ice floe	MS	3
18	Anna on swiftly moving ice floe	LS	3
19	David runs on ice floe toward Anna	LS	4

*LS = long shot; MS = medium shot; CU = close-up

Shot	Action	Type of shot*	Length (sec.)
20	Large ice floes plunge over the falls	LS	4
21	The falls seen from side view	LS	3
22	The falls seen from below	LS	3
23	Swirling river waters	LS	3
24	Anna on ice floe approaches edge of the falls	LS	4
25	David leaps across ice floes and gets very close to Anna	LS	2
26	David gasps in fear that Anna may go over edge of the falls	MS	2
27	Anna looks up	LS	2
28	David continues to leap across ice floes toward Anna	LS	2
29	Anna almost at edge of the falls; David runs into frame and grabs her	LS	8
30	David runs back away from edge of the falls with Anna in his arms; falls, struggles, gets up	LS	4
31	The falls seen from below in iris shot	LS	3
32	David leaps back away from edge of falls with Anna in his arms; falls, struggles, gets up	LS	3
33	David heads back toward shore, leaping across ice floes with Anna in his arms	LS	1
34	David leaps across ice floes with Anna in his arms	LS	4
35	Huge ice floes go over edge of the falls	LS	2
36	The falls seen from below (not an iris shot)	LS	2
37	David jumps from ice floe to ice floe	LS	3
38	David, close to shore, leaps from floe to floe, reaches shore, and falls	LS	6

Shot	Action	Type of shot*	Length (sec.)
39	David, now on land, struggles to get up	LS	5
40	David rests Anna on snow-covered ground	LS	4
41	David comforts Anna	MS	5
42	David lifts Anna and continues on land	LS	7
43	Two men enter scene and join David and Anna	LS	2
Title	"Quick! Quick! The doctor!"		

Kubrick's *Dr. Strangelove, or: How I Learned to Stop Worrying and Love the Bomb* (1964; screenwriters: Kubrick, Terry Southern, and Peter George) is one of several variations on a formal pattern that Kubrick has established earlier, one involving a B-52 attack bomber circling Earth, waiting for commands from its base. The sound track is the same in each variation: drum beats that indicate the plane's relentless progress; bugle calls; and the melody of "When Johnnie Comes Marching Home Again," which resonates with irony in the context of nuclear annihilation. In this variation, the plane is on a routine mission when it receives a message to attack a Russian target. After some cross-cutting between the bomber and the base, intended to confirm the surprising order, the navigator identifies a blip on his radar screen that he believes is a missile heading for the bomber. The rhythm of the drum beat continues as he calls out the missile's closing distance—sixty miles, fifty, forty, thirty, twenty, ten, six, two, and one, at which moment the missile barely misses hitting the plane and, instead, explodes outside it. The pattern is A A A A B, the B signifying the variation: the completely unexpected missile,

which breaks the crew's established pattern, throwing them into chaos and thwarting our expectations.

The "Odessa Steps" sequence in Sergei Eisenstein's *Battleship Potemkin* (*Bronenosets Potyomkin,* 1925; screenwriters: Eisenstein and Nina Agadzhanova) may be the most famous single scene ever filmed. Its dramatic and propagandistic effects introduced the world to the impact of *montage,* a dynamic form of editing that creates complex internal (graphic, rhythmic, spatial, and temporal) relationships between individual shots and thus results in meanings that do not exist in the individual shots (for a full discussion of this technique, see "Conventions of Editing" in chapter 6). In forcing images to conflict, contrast, and collide with one another, montage produces a composite visual, emotional, and intellectual effect on viewers. Through Eisenstein's dynamic editing of this sequence, we feel the action as well as see it.

In 1905, outside the Odessa harbor, sailors on the Russian battleship *Potemkin* grow rebellious after being beaten and served spoiled food. The officers put the disobedient men before a firing squad, but a sense of solidarity

[1]

[2]

[3]

[4]

[5]

[6]

Filmmakers can use patterns to catch us unawares. In *The Silence of the Lambs,* Jonathan Demme exploits our sense that when shots are juxtaposed they must share a logical connection. After FBI agents surround a house, an agent disguised as a delivery man (Lamont Arnold) rings the doorbell (1); a bell rings in the serial killer Buffalo Bill's (Ted Levine) basement (2); Bill reacts to that ring (3), leaves behind the prisoner he was about to harm, goes upstairs, and answers his front door (4), revealing not the delivery man we expect to see but Clarice (Jodie Foster). As agents storm the house they've been staking out (5), Clarice and Bill continue to talk (6). The agents have entered the wrong house, Clarice is now alone with a psychopath, and our anxiety rises as a result of the surprise.

[1]

[2]

[3]

[4]

[5]

[6]

[7]

[8]

Soviet filmmaker and theorist Sergei Eisenstein helped pioneer the expressive use of patterns in movies. Eisenstein's montage during the "Odessa Steps" sequence of *Battleship Potemkin* brings the violence to a climax in both what we see and how we see it. After Cossacks fire (1) on a young mother (2), she collapses (3), sending her baby's carriage rolling (4); an older woman reacts (5) to the carriage's flight down a series of steps (6), and a student cries out (7) as the carriage hits bottom (8). The movement from shot to shot, a formal element, conveys the devastating energy of the content. To view a clip, consult your CD-ROM.

2.3

develops between the sailors targeted for execution and those charged with shooting them. A riot breaks out, and the sailors take over the ship. Word of their rebellion reaches the shore and, in another show of solidarity, civilians plan to bring food and offer congratulations. Before they can set sail, the czar's soldiers massacre them.

Intended to elicit sympathy for the workers and the revolutionary cause, Eisenstein's restaging of this brutal scene is far from objective, despite its "documentary" look. He shoots from several angles, then manipulates time and space in two contradictory ways. First, working with Griffith's principle that progressively shortening the shot lengths in a series creates tension, he accelerates the pace of the massacre, conveying a sense of frenzy and panic. In terms of formal pattern, Eisenstein begins the scene with a fairly standard progression of shots (A B C A B C), which he then breaks into chaos (something like an alphabet soup of A B C A B C A D C E F A G A H, and so on). Second, in constantly cutting from shots of the crowd to shots of individual faces, he increases the duration of the historical moment so that the massacre takes much longer to watch onscreen than it would take to occur in reality. The patterning within this scene thus heightens our sympathetic anxiety and anger, as well as exaggerates the magnitude of what we've just witnessed.

FORM AND THEMES

Closely related to patterns are themes and variations on themes: dominant motifs or ideas that stand out. Although themes can be explicitly expressed by characters or can be inferred from what characters say, more often they are revealed through formal elements within a movie. One method a filmmaker can

use to signal an important theme is to establish a pattern that creates expectations in us, then contradict those expectations by interrupting the pattern. For example, the opening scene of David Lynch's *Blue Velvet* (1986; screenwriter: Lynch) establishes a pattern that it then breaks to introduce one theme of the movie. Let's label as "A" all shots that show us images of safety and serenity and label as "B" the shots of unsettling images. The series begins with eye-level shots of roses in front of a white picket fence (A), a fire truck moving slowly through a pleasant suburban neighborhood (A), friendly firefighters (A), kids in a crosswalk (A), a man watering his front lawn with a hose (A), a woman inside the house watching TV (A), and a leaking hose getting tangled (A), at which point the camera moves downward (B), following the man's collapse and a dog jumping on top of him to drink from the hose (B), closer and closer to the grass (B), and then to an extreme close-up (coupled with exaggerated sound effects) of black beetles raging beneath the surface (B). The A A A A pattern lulls us with images of safety and serenity, which drift soothingly by; the onset of B B B B plays with our expectations and suggests the unpredictable and potentially horrifying aspects of life, a theme that Lynch repeats and varies throughout the movie.

One principal theme of Spike Lee's *Do the Right Thing* (1989; screenwriter: Lee) is power. The Public Enemy song "Fight the Power" introduces this theme during the opening credits. Variations on it occur throughout the movie as conflicts between opposites: fathers versus sons, mothers versus daughters, brothers versus sisters, men versus women, Asians versus blacks, blacks versus Italians, Latinos versus blacks, blacks versus cops, and love versus hate. The film ends by setting passive resistance versus violence, concluding

[3]

[2]

[1]

[4]

Not a word is spoken throughout the opening scene of David Lynch's *Blue Velvet*, and yet the form and content of the shots signal the movie's overarching theme: that below the placid, brightly colored surface of suburban life (1 and 2) lurk violent, dark forces (3 and 4).

with quotations from Martin Luther King Jr. (advocating nonviolence in the face of oppressive power) and Malcolm X (arguing that violence may be an oppressed people's only form of self-defense against power). (In the suggested case study for this chapter, we will more fully examine themes and patterns in Roman Polanski's *Chinatown* [1974].)

COHERENCE, PROGRESSION, AND UNITY AND BALANCE

The form of a movie can establish patterns and themes in ways that create expectations in us and then satisfy or disrupt those expectations. As you learn more about specific elements of film form in the chapters that follow, you will be able to recognize more patterns than you have before—you will be more attentive to the artistic (formal) purposes of certain types of camera work, for example, or of set design and costuming, or of the intricate art of film editing—and will be able to analyze how these patterns contribute to the movie as a whole. Those contributions primarily help establish *coherence, progression,* and (within progression) *unity and balance.*

We find **coherence** in a movie when internally it is logically or aesthetically consistent, with all the basic elements of cinematic form organized to form a harmonious or credible whole. In some movies, of course, coherence

is not the intended effect (e.g., David Lynch's *Mulholland Dr.* [2001; screenwriter: Lynch], with its multilayered, dreamlike narrative strands). **Progression** is simply the process by which we move from the beginning, through the middle, to the end of a temporal work of art (poetry, fiction, music, theater, film). The patterns and themes within parts of a movie generally shape this larger pattern of progression, so our attentiveness to smaller patterns may help us understand and appreciate the overall form. Sometimes a well-wrought scene with a pleasing or impressive form of its own seems out of place or fails to contribute to a movie's overall progression. As we analyze movies (even universally acclaimed ones), we should thus remain alert to these parts that don't move the film forward or expand our understanding of the world portrayed in it.

Related to coherence and progression are **unity and balance,** two of the oldest and most universally recognized criteria in analyzing a work of art. Unity is sometimes called *organic unity,* a concept first proposed by the ancient Greek philosopher Aristotle. Since a work of art is not an organism, the word *organic* metaphorically suggests that the work has an organization similar in its complexity to that of a living thing. We might compare the human skeletal, vascular, muscular, and neurological subsystems, which provide an inner structure for the larger system of the human body, to the basic elements of cinematic form that are organized within and give structure to the larger system of the film. When the elements work in complementary ways, the movie as a whole seems unified and balanced. But if some element doesn't fit within the whole—all the

[1]

Director Spike Lee's use of wide, exaggerated close-ups enhances this short but heated argument in *Do the Right Thing.* One of the movie's many binary oppositions is between Bedford-Stuyvesant's white property owners and black renters, and here a white resident, Clifton (John Savage), argues with Buggin' Out (Giancarlo Esposito), whose sneakers he has accidently scuffed. (1) "I *own* this brownstone,"

[2]

Clifton says, after being told that he shouldn't be in the neighborhood at all. (2) "Who told you to buy a brownstone on *my* block, in *my* neighborhood, on *my* side of the street?" Buggin' Out responds. As other conflicts emerge and spread throughout the movie, this seemingly insignificant confrontation becomes part of the overall meaning.

interesting parts are gathered in the first third, for example, or the costuming and set design overwhelm the acting, or the actions of a character seem to have no connection to the movie as a whole—then the movie displays a lack of unity, a formal imbalance.

Some viewers feel that such imbalance characterizes Steven Spielberg's *A.I.: Artificial Intelligence* (2001), the fulfillment of a project begun by Stanley Kubrick, whose directorial style featured episodic structures. *A.I.* consists of three parts, the first concerned with the monstrousness of childhood, the second a journey through a nighttime future world, and the third a science fiction romance. The second and third parts seem to have little to do with the first, or with each other, in their story, style, or tone. Are they unified in other ways, such as through a quest motif or some other underlying theme? Or does the overall absence of form and balance call attention to itself in ways that weaken the film?

WHAT IS NARRATIVE?

Having now considered film form in terms of its most general principles (and effects), we can turn to the formal structure with which we are all most familiar—narrative form. Narratives play an essential part in our lives, and we are naturally inclined to look for narrative structure in life and in art. Although our lives may seem like "one thing after another" while we're living them, we nonetheless continually attempt to make narrative sense of them and to translate the various "things" (what we did over the weekend, the courses of our romantic relationships, our educations up to this point, etc.) into stories we

can tell our friends, our families, and even ourselves. We do this by establishing connections among events, creating chains of cause and effect. This activity—inferring causal relationships among events that occur in sequence or close to one another—runs through our conscious lives, and it sometimes even finds its way into our unconscious lives as we dream. Is it any wonder, then, that we're drawn to stories?

To be sure, not all movies tell stories, but any type of movie can tell one. In fact, the storytelling impulse runs through motion picture history. When movies were first developed, they often limited themselves to documenting an action—a sneeze, a kiss, the swing of a bat, the gait of a horse. These early films were only briefly interesting to audiences, however, and soon became mere curiosities in nickelodeons. Only after they began to tell stories did the movies reach a level of extraordinary popularity with audiences; and today, the movies discussed in the common culture, the movies most of us pay to see, the movies we commonly have in mind when we say the word *movies* are those that tell stories.

In telling a movie's story, filmmakers decide what to show and what not to show, how to dress characters and decorate sets, how to direct actors, how to use sound and music, and so on. As a result of these decisions, we receive information with which to interpret the unfolding narrative. When crucial information is missing, we fill in details based on our lived experiences, on our sense of what "normally" happens in movies, and on what has been shown to us already—on what, given the characters and events already portrayed, seems likely to occur within the world on-screen. The more we see of a movie, the more precise our predictions and interpretations become. Similarly, the more movies we have

seen, the better able we are to creatively anticipate the many directions a movie we're watching might take. Obviously, too, our ability to anticipate is shaped by how much life we have lived. But narrative is so tightly woven into our experience of life and art, seemingly such a "natural" part of human existence, that we often can be unaware of its parts and its effects. This chapter will describe some of those parts and trace some of those effects. Because narrative is *form,* something made, the product of deliberate decisions concerning content, we need to look as closely at *how* movies tell their stories as we look at "what happens" within the stories. Let's begin by considering how the narratives of contemporary Hollywood films fit into the overall production process.

TELLING THE STORY

Telling the story is often what a commercial movie is all about. During preproduction, the story is referred to as the "property" and may be an idea that a writer has "pitched" to the producer, an outline, or a completed script. No rules determine how an idea should be developed or an existing literary property should be adapted into a film script, but the process usually goes through several stages, involving many rewrites. The earliest form may be a **treatment** or **synopsis,** an outline of the action that briefly describes the essential ideas and structure for the film. The treatment is discussed and developed in sessions known as **story conferences,** during which it is transformed from an outline into what is known as a **rough draft screenplay** or **scenario.** At some point, these story conferences will be expanded to involve such key personnel as the production manager and the art director, as well as members of their individual teams.

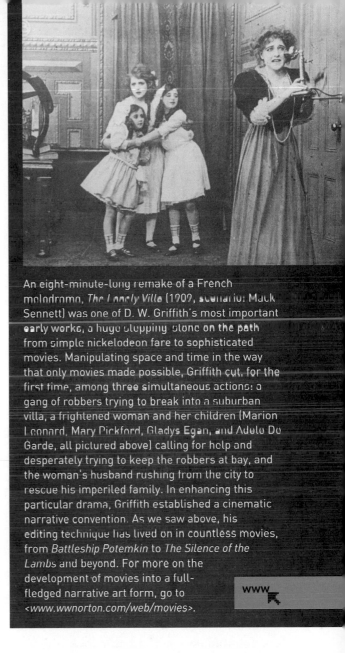

An eight-minute-long remake of a French melodrama, *The Lonely Villa* (1909, scenario: Mack Sennett) was one of D. W. Griffith's most important early works, a huge stepping-stone on the path from simple nickelodeon fare to sophisticated movies. Manipulating space and time in the way that only movies made possible, Griffith cut, for the first time, among three simultaneous actions: a gang of robbers trying to break into a suburban villa, a frightened woman and her children (Marion Leonard, Mary Pickford, Gladys Egan, and Adele De Garde, all pictured above) calling for help and desperately trying to keep the robbers at bay, and the woman's husband rushing from the city to rescue his imperiled family. In enhancing this particular drama, Griffith established a cinematic narrative convention. As we saw above, his editing technique has lived on in countless movies, from *Battleship Potemkin* to *The Silence of the Lambs* and beyond. For more on the development of movies into a full-fledged narrative art form, go to <www.wwnorton.com/web/movies>.

www

Next, the director transforms the literal script images of each scene into visualizations of specific shots and setups. The result is a strategy for shooting each scene (and its component shots). Some directors keep all this information in their heads; others develop a storyboard before shooting. A **storyboard** is a

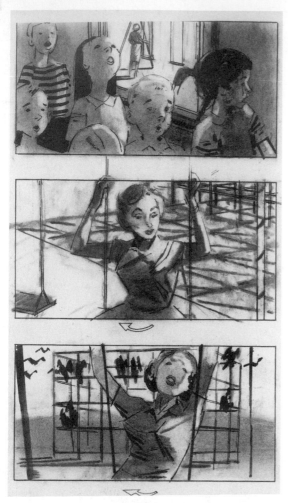

A page from the storyboard for Alfred Hitchcock's *The Birds* (1963).

tional tool, enabling the production manager to organize the actual shooting to maximize all resources, especially the assignment of personnel. Furthermore, it assists in maintaining the continuity of the movie. Because a movie is shot mostly out of sequence, it is essential to know in advance how edited shots in a sequence will relate to one another. The director must be concerned with the general continuity of space and time, as well as with the specific continuity of such elements as lighting, camera setups, action, props, costume, makeup, sound, and performance. Long after the shooting has stopped, the sets have been struck, and the actors have gone off to other work, a well-prepared storyboard will continue to provide backup for the work that remains to be done.

Among the director's final responsibilities before shooting is to prepare the **shooting script,** in which the details of each shot are listed and can thus be followed by the director and actors during filming. In only experimental films of the most independent kind does a director rely on *improvisation* (that is, actors' making up material on the spot; for a full discussion, see chapter 5) rather than a detailed shooting script. The costs of making traditional films are simply too great to permit even the best-funded director such freedom. The shooting script therefore serves as an invaluable guide and reference point for all members of the production unit, indicating where everything ought to be. It breaks down the individual shots by location (interior or exterior), setting (kitchen, football stadium, etc.), type (close-up, long shot, etc.), and editing between these shots (cut, wipe, dissolve, fade-out, etc.). Once the shooting script is developed, the director proceeds with the other key members of the team to determine *how* to shoot it. Their decisions will cover everything from fully visualizing the film in setups, deter-

scene-by-scene (sometimes a shot-by-shot) breakdown that combines sketches or photographs of how each shot is to look with written descriptions of the other elements that are to go with each shot, including dialogue, sound, and music. A storyboard serves several important functions. It is a graphic representation of the director's conception of the film and thus is vital in helping to explain his or her concepts to the team. It serves as an organiza-

THE PRODUCTION CODE AND THE HAYS OFFICE

Social mores, pressure from various organizations and authorities, and the desire to please a mass audience have helped regulate the content and distribution of movies, especially of mainstream Hollywood movies. During the early 1920s, after several years of relatively frank portrayals of sex and violence onscreen (a period in which the industry also suffered a wave of scandals), Hollywood faced a credible threat of censorship from state governments and of boycotts from Catholic and other religious groups. In 1922, in response to these pressures, Hollywood producers formed a regulatory agency called the Motion Picture Producers and Distributors of America (MPPDA, later the Motion Picture Association of America, or MPAA), headed by Will Hays, postmaster general under President Warren G. Harding. Originally conceived as a public relations entity to offset bad publicity and deflect negative attention away from Hollywood, the "Hays Office" in 1930 adopted the Motion Picture Production Code, a detailed set of guidelines concerning acceptable and unacceptable subject matter. Nudity, adultery, homosexuality, gratuitous or unpunished violence, and religious blasphemy were among the many types of content the code strongly discouraged. Perhaps even more significantly, the code explicitly stated that art can influence for the worse the morality of those who consume it (an idea that Hollywood has been reconsidering ever since).

Many movies made in 1930 or immediately thereafter illustrate the industry's awkward transition to the new standards. (To read the Motion Picture Code of 1930, see *The Movies in Our Midst: Documents in the Cultural History of Film in America,* ed. Gerald Mast [Chicago: University of Chicago Press, 1982], 321–33.) Directed by an originally uncredited Robert Z. Leonard, *The Divorcee,* one of the first movies released after the Motion Picture Production Code was announced, is about a woman who takes three lovers after discovering her husband's infidelity. Although the Hays Office warned MGM not to produce the movie, the studio's powerful head of production, Irving Thalberg, pushed the project forward, casting his wife, Norma Shearer, in the lead role and even influencing many other Hollywood power brokers to award Shearer the Oscar for Best Actress. The fact that Shearer had played virtuous women in previous films helped the movie avoid serious scrutiny, but later *The Divorcee* would be cited by protectors of public morality as justifying strict enforcement of the code. Shot in 1930, Howard Hawks's *Scarface* was delayed for two years while Hawks battled with the Hays Office over its violent content. Although released as *Scarface: The Shame of a Nation* and simply *The Shame of a Nation,* with a moralistic ending and many scenes removed, *Scarface* was nonetheless cited by civic groups and politicians as evidence of Hollywood's amorality.

The code remained fundamentally voluntary until the summer of 1934, when Joseph Breen, a prominent Catholic layman, was appointed head of the Production Code Administration (PCA), the enforcement arm of the MPPDA. For at least twenty years, the PCA rigidly controlled the general character and the particular details of Hollywood storytelling. After a period of practical irrelevance, the code was officially replaced in 1968, when the MPAA adopted the ratings system that remains in use.

To learn more about the ratings system, see the appendix, "An Overview of Hollywood Production Systems." To read more about the code and the nature of Hollywood filmmaking from 1930 through the summer of 1934, see Thomas Doherty, *Pre-Code Hollywood: Sex, Immorality, and Insurrection in American Cinema, 1930–1934* (New York: Columbia University Press, 1999), and Jon Lewis, *Hollywood v. Hard Core: How the Struggle over Censorship Created the Modern Film Industry* (New York University, 2000). For more on the long-standing debate about the relationship between movies and morality, go to <www.wwnorton.com/web/movies>.

www

mining which shots will be made in the studio and which will be made on location, establishing a photographic strategy and determining the visual look for each shot, settling the film's color palette, determining the film's tempo with final editing in mind, and casting the actors. All of these decisions will be based on the story; if the story changes (during rewrites), then these elements change also.

Now, imagine you are a filmmaker who wants to adapt a novel for the screen. It's a complex work with interlocking major and minor themes, numerous characters, settings in many different locations, and a time frame involving both past and present actions, but your budget will not permit you to include everything. Your first challenge is to determine how to tell this story in a way that will retain on the screen those aspects of the novel that attracted you in the first place, without exceeding your financial and logistical resources. You will thus be making decisions that involve both the content and the form of your narrative: what aspects of the story to tell and how to tell them. In making these decisions, you will need to understand, implicitly or explicitly, the major elements of narrative form.

ELEMENTS OF NARRATIVE

STORY AND PLOT

Narrative theory (sometimes called *narratology*) has a long history, starting with Aristotle and continuing with great vigor today. The complexities of narratology are beyond the scope of this book, but we can begin our study by distinguishing between two fundamental elements: story and plot. Although in everyday conversation we might use the words *story* and *plot* interchangeably, they mean different things when we write and speak about movies.[3]

A movie's **story** consists of (1) all the narrative events that are explicitly presented on the screen plus (2) all the events that are implicit or that we infer to have happened but are not explicitly presented. The total world of the story—the events, characters, objects, settings, and sounds that form the world in which the story occurs—is called its **diegesis,** and the elements that make up the diegesis are called **diegetic elements.** By contrast, the things we see and hear on the screen but that come from outside the world of the story are called **nondiegetic elements** (including background music, titles and credits, or voiceover comment from an omniscient narrator). A movie's **plot** is a structure for presenting everything we see and hear in a film: (1) the diegetic events arranged in a certain order plus (2) nondiegetic material. Story and plot overlap because each includes the narrative events that we explicitly see and hear onscreen (Fig. 2.2, "Story and Plot," illustrates this relationship).

Another way to understand the difference is to consider the story elements of a particular movie and determine which of them count as plot elements. Let's examine a very well-known movie, Michael Curtiz's *Casablanca* (1942; screenwriters: Julius J. Epstein, Philip G. Epstein, and Howard Koch):

[3]This chapter adapts material from, and is indebted to, Seymour Chatman, *Story and Discourse: Narrative Structure in Fiction and Film* (Ithaca: Cornell University Press, 1978), and *Coming to Terms: The Rhetoric of Narrative in Fiction and Film* (Ithaca: Cornell University Press, 1990). Other works of contemporary narrative theory are recommended at the end of the chapter.

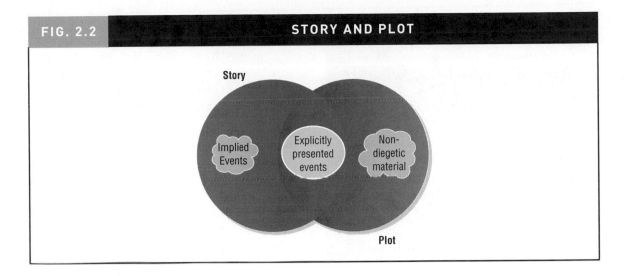

FIG. 2.2 STORY AND PLOT

Story

Implied Events

Explicitly presented events

Non-diegetic material

Plot

1. The time is 1941, soon after the beginning of World War II. This background information counts as *story,* but it comes to us through *nondiegetic plot elements:*

 OPENING TITLE AND CREDITS: Film title and cast and production credits over a political map of Africa; music consists of "La Marseillaise" (the French national anthem) and Arab-type background music. Use of "La Marseillaise" at the beginning and ending of the film signals a theme of solidarity with the Free French.

 NARRATION: In the style of contemporary newsreels, a "voice of God" narrator explains how refugees try to reach Lisbon, Marseilles, Oran, or Casablanca in the wake of the Nazi takeover of Europe; spinning globe appears with zoom-in shot toward Western Europe—Allied powers in light tone, neutral nations in a medium tone, and Axis powers in dark tone—with superimposed documentary footage of refugees.

2. Rick Blaine (Humphrey Bogart) is an American with a mysterious past. Apart from the fact that at some point he became an underground fighter in Europe, his life before we first see him is *story, not plot.* Characters comment on his past (suggesting, for instance, that he once killed a man), and we infer that certain romantic and political relationships between the past and the present form part of the story, but none of the events are illustrated.

3. Rick left Paris after the Germans occupied the city. Again, this information is *story, not plot,* because we hear about it after it has occurred.

4. Although Rick had planned to come to Casablanca with his lover, Ilsa Lund (Ingrid Bergman), she jilted him at the last minute. *Story, not plot.*

5. A man murdered Nazi couriers and took two exit visas from them. *Story, not plot.*

6. The man who murdered the couriers entrusts Rick with the exit visas. (When

"You played it for her, you can play it for me. Play it!" In Michael Curtiz's *Casablanca*, Sam (Dooley Wilson) provides the sound track to Rick's (Humphrey Bogart) broken heart: "It's still the same old story, / A fight for love and glory, / A case of do or die. / The world will always welcome lovers, / As time goes by." Written by Herman Hupfeld for a 1931 Broadway musical, the song is diegetic here; in addition, the sound was recorded as the camera rolled. A professional drummer, Wilson sang but only pretended to play the piano, as pianist Elliot Carpenter (uncredited) supplied the music offscreen.

this occurs, we find out the information in #5.) Because we *see* and don't just hear about the handoff of visas, this is our first *plot event*.

From here on, apart from one flashback, the plot is chronological and straightforward, holding together the story, which concerns the interaction of politics, personal ethics, and love:

7. Rick knows he can sell the visas for a great deal of money, but he could be arrested for the sale, and says that he will not risk his life for anyone.

8. Rick's former lover, Ilsa, and her husband, Victor Lazslo (Paul Henreid), wanted by the Nazis for being a Resistance leader, arrive in Casablanca needing exit visas to continue their flight to freedom, but Rick will not sell his to them.

9. Flashback to June 1940: Rick and Ilsa in Paris.

10. Rick also refuses Lazslo's suggestion that he use the visas to take Ilsa to safety. And so on.

Of course, Rick was accompanied to Casablanca by his loyal friend Sam (Arthur "Dooley" Wilson), the pianist and singer at Rick's Café Americain. When Sam plays "As Time Goes By," this is diegetic music, because it occurs within the world of the story, but the same musical theme is nondiegetic when it is played by an orchestra that we never see and cannot infer to be somewhere in the surroundings. (For a full discussion of movie sound, see chapter 7.)

The relationship between plot and story is important to filmmakers and to the audience. From the filmmaker's perspective, the story exists as a *precondition* for the plot, and the filmmaker must understand what story is being told before going through the difficult job of selecting events to present onscreen and determining the order in which they will be presented. For us as viewers, the story is an abstraction—a *construct*—that we piece together as the elements of the plot unfold before us onscreen, and our impressions about the story often shift and adjust throughout the movie as more of the plot is revealed. The plots of some movies—classic murder mysteries, for example—lead us to an unambiguous sense of the story by the time they are done.

Other movies' plots reveal very little about the causal relationships among narrative events, thus leaving us to puzzle over those connections, to construct the story ourselves. As you view movies more critically and analytically, pay attention not only to the story as you have inferred it but also to how it was conveyed through its plot. Understanding this basic distinction will help you appreciate and analyze the overall form of the movie more perceptively.

To picture the relationship between plot and story slightly differently, and to become more aware of the deliberate ways in which filmmakers construct plots from stories, you might watch a number of different movies that tell a story with which you are familiar—for example, Walt Disney's *Cinderella* (1950; screenwriters: Ken Anderson et al.), Frank Tashlin's *Cinderfella* (1960, starring Jerry Lewis; screenwriter: Tashlin), Garry Marshall's *Pretty Woman* (1990, starring Julia Roberts; screenwriter: J. F. Lawton), and Andy Tennant's *Ever After* (1998, starring Drew Barrymore; screenwriters: Susannah Grant, Andy Tennant, and Rick Parks), all of which rely on the basic story structure of the well-known fairy tale; or the very different film adaptations of Charles Dickens's 1861 novel *Great Expectations,* such as those by David Lean (1946; screenwriters: Lean et al.) and Alfonso Cuarón (1998; screenwriter: Mitch Glazer). This sort of critical comparison will enable you to see more clearly how the plots differ, how the formal decisions made by the filmmakers have shaped those differences, and how the overall form of each movie alters your perception of the underlying story.

Through plot, screenwriters and directors can provide structure to stories and guide (if not control) viewers' emotional responses. In

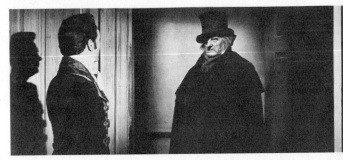

[1]

[2]

(1) David Lean's *Great Expectations* takes place, as Dickens's novel does, in nineteenth-century England. The young protagonist (John Mills), a student in London named Pip as in the novel, confronts his previously anonymous benefactor, Magwitch (Finlay Currie). (2) Fifty-two years later, Alfonso Cuarón's version of the same story is set in contemporary America. Finn (Ethan Hawke), a painter in New York City, confronts his previously anonymous benefactor, Arthur Lustig (Robert De Niro).

fact, a particular plot may be little more than a sequence of devices for arousing predictable responses of concern and excitement in audiences. We accept such a plot because we know it will lead to the resolution of conflicts, mysteries, and frustrations in the story. In Tony Richardson's *Tom Jones* (1963; screenwriter: John Osborne)—a successful adaption of Henry Fielding's 1794 novel of the same

title—events and resolutions depend on coincidence or improbability, but thanks to the melodramatic plot we "know" what is going to happen next. Our overall expectations of Tom's (Albert Finney) destiny, based on events we have seen throughout the film, gives us this confidence. Indeed, despite the narrator's informing us that Tom was "born to be hanged," and despite the rogue's life Tom leads, we trust that the character's good nature and kind deeds will be rewarded in the end. And we are not disappointed, for ultimately Tom turns out to be not an orphan but the legitimate son of Squire Allworthy's sister Bridget (Rachel Kempson). In contrast, the plot of Quentin Tarantino's *Pulp Fiction* (1994; screenwriters: Tarantino and Roger Avary) is full of surprises, is constructed in a nonlinear way, and fragments the passing of time. We might have to see the movie several times before being able to say at what point—in the plot and in the story—Vincent Vega (John Travolta) dies, for instance. Resolutions in action movies tend to be physical, usually violent: Sam Peckinpah's *The Wild Bunch* (1969; screenwriters: Peckinpah, Walon Green, and Roy N. Sickner) climaxes with an extended, bloody, "balletic" gunfight that, in its day, set a standard for carnage in movies. In movies focused more on psychology, resolutions tend to be intellectual or emotional and represent new states of awareness: Todd Solondz's *Happiness* (1998; screenwriter: Solondz; see "Analyzing Design" in chapter 3), which concerns three dysfunctional sisters, a pedophile psychiatrist, and a man who makes obscene phone calls, concludes in a way that not only surprises us but also inclines us to question, in human terms, the manner in which that ending is achieved. The final scene is a dinner reuniting the sisters and their parents, whose marriage is completely on the rocks. The fam-

ily talks of murder over the sweet potatoes and drinks "to life," which, in their circumstances, seems without hope. Yet the adolescent son of one of the sisters, a boy traumatized by his father's arrest for raping one of his schoolmates, proudly celebrates his own newfound sexuality. As this family's almost complete denial of their despair gives way to forced gaiety, the director steps back, leaving disunity, ambiguity, and a "coming of age" ritual in a recognizable but distorted world.

ORDER

One of the most fundamental decisions that filmmakers make about how to relay story information through the plot concerns the **order** of plot events. Unlike story order, which necessarily flows chronologically (as does life), plot order can be manipulated so that events are presented in nonchronological sequences that emphasize importance or meaning or that establish desired expectations in audiences. Many of the movies that puzzle but delight audiences—Alain Resnais's *Hiroshima, mon amour* (1959; screenwriter: Marguerite Duras), Danny Boyle's *Trainspotting* (1996; screenwriter: John Hodge), Christopher Nolan's *Memento* (2000; screenwriters: Christopher and Jonathan Nolan)—are built on risky moves by the filmmakers to scramble plot order or play with it in such a way that discerning the underlying story can be one of the audience's chief sources of interest and enjoyment. If any of these movies' plots had presented the story information in strict chronological order, viewers might have found them much less challenging. As we noted in "Story and Plot," *Casablanca,* one of the most popular movies of all time, follows a relatively straightforward plot order, in which the flashback to Paris is the only event presented out of chronological

sequence. In this wartime romance, the most important thing to the audience is the resolution of the dilemma that faces Rick and the Lazslos, and the plot is completely appropriate for telling their story.

Like so many other aspects of filmmaking, conventions of plot order have been established and challenged over the course of film history. For example, Orson Welles and Herman J. Mankiewicz, the coscreenwriters of *Citizen Kane* (1941), adopted an approach to plot order so radical for its time that it actually bewildered many viewers with its unconventional narrative style and structure. The movie's plot consists of nine sequences, five of which are flashbacks. The second of these sequences, the "News on the March" newsreel, grounds us by presenting Kane's (Welles) life in a reasonably chronological line; but Mr. Thompson (William Alland), the newsreel reporter, does not conduct his search for the meaning of "Rosebud" chronologically. After learning that the search will not be, as his boss claims, "a very simple thing," Thompson treats his investigation as a kind of detective story; and Welles and Mankiewicz, by incorporating ellipses (gaps and jumps) into the narrative, make the film's form another kind

In Christopher Nolan's *Memento*, Leonard Shelby (Guy Pearce) suffers from a disorder that prevents him from forming short-term memories. To remember details of his life, he takes Polaroid snapshots, jots notes on scraps of paper, and even tattoos "facts" on his body. The movie's two-stranded plot order, both chronological and reverse chronological, likewise challenges us to recall what we've seen and how the parts fit together.

of detective story. That is, just as Thompson tries to assemble clues about Kane's life into a solution of that life's mystery, so we must, even as we watch, fill in plot details. Some of the seven narrators tell Thompson the truth; one contradicts what the omniscient camera (a kind of narrator) has shown us; still others cannot always remember the past. Contrasts exist between what the narrators say and what

To provide a straightforward account of Charles Foster Kane's life and help viewers get their bearings within a highly unconventional plot order, Orson Welles's *Citizen Kane* begins with a fictionalized minidocumentary. "News on the March" is a satire on the famous weekly newsreel series *The March of Time* (1935–51), which was shown in movie theaters and which mixed location footage with dramatic reenactments.

the camera sees, and this discrepancy increases the film's realism and thus the work we must do to process all the contradictory information. We actually hear Kane say "Rosebud" twice in the movie: in the opening scene, as he dies and drops the glass ball, and after he has destroyed Susan's room. In the first instance, the camera shows us that no one is in the room when Kane dies; in the second, Raymond (Paul Stewart), the butler, is standing close enough to Kane to hear him, but he lies when he says to Thompson: "I heard it that other time, too. He just said, 'Rosebud,' then he dropped the glass ball and it broke on the floor. He didn't say anything after that, and I knew he was dead." Since we have seen, in a wide-angle view encompassing the entire room, that Kane was alone when he died, we can assume that *if* Raymond heard this, he must have been outside the room listening through the door. Though such techniques, ideas, and demands on an audience are now a standard part of film vocabulary, at the time audiences were unprepared for the challenge of taking in and working with so many audiovisual facts so quickly. Although *Citizen Kane* received highly favorable reviews, many people walked out of the movie, which still seems fresh, still challenges us, today.

EVENTS: HUBS AND SATELLITES

In any plot, some events are more important than others, and we infer their relative significance through the director's selection and arrangement of both major and minor details of action, character, or setting. We can distinguish between the events that seem crucial to the plot (and thus to the underlying story) and those that play a less crucial or even a supplementary role. **Hubs** are major events or branching points in the plot structure that force characters to choose between or among alternate paths. Ridley Scott's *Gladiator* (2000; screenwriters: David Franzoni, John Logan, and William Nicholson) recounts three stages in the life of Maximus Decimus Meridius (Russell Crowe) as he moves from general to slave, slave to gladiator, and gladiator to savior of the Roman people. Soon after the film opens, Emperor Marcus Aurelius (Richard Harris) dies, a hub event that forces the main character to escape the guards of the succeeding emperor, Commodus (Joaquin Phoenix), or be killed by them. Each succeeding stage in the plot turns on such hubs, which force Maximus to face similar choices. **Satellites,** on the other hand, are minor plot events that add texture and complexity to characters and events, but are not *essential* elements within the narrative. The love that Lucilla (Connie Nielsen), Commodus's sister, has long felt for Maximus—before he was married, during his marriage, and after his wife was murdered by Commodus's guards—creates satellite events. Her love surfaces at key moments, troubling and tempting Maximus; but because other things are more important to him, he is not forced to make a decision based on his feelings for her. Satellites enrich and complicate the diegesis (the world of the story) in a narrative film, but no single satellite is indispensable to the story. When filmmakers make decisions about which scenes to cut from a film during the editing phase, they generally look for satellites that, for one reason or another, don't contribute enough to the overall movie. As a critical viewer of movies, you can use these two terms—hubs and satellites—both to diagram a plot (as a practical way to understand it) and to chart a course of the major and minor events confronting the characters.

[1]

[2]

Hubs and satellites in Ridley Scott's *Gladiator:* (1) the death of Emperor Marcus Aurelius (Richard Harris) instantly transforms the fortunes of General Maximus Decimus Meridius (Russell Crowe) for the worse and sets the plot in motion. (2) Lucilla's (Connie Nielsen) love for Maximus informs the plot through a series of satellites, then produces a hub event near the end.

DURATION

Events, in life and in the movies, take time to occur. **Duration** is this length of time. When talking about narrative movies specifically, we can identify three specific kinds of duration: **story duration** is the amount of time that the implied story takes to occur; **plot duration** is the elapsed time of those events within the story that the film explicitly presents (in other words, the elapsed time of the plot); and

screen duration is the movie's running time onscreen. For example, in *Citizen Kane* the plot duration is approximately one week (the duration of Thompson's search), the story duration is more than seventy years (the span of Kane's life), and the screen duration is one hour and fifty-nine minutes, the time it takes us to watch the film from beginning to end without interruption.

These distinctions are relatively simple in *Citizen Kane*, but the three-part relation of story, plot, and screen durations can become quite complex in some movies. Balancing the three elements is especially complex for a filmmaker, since the screen duration is necessarily constrained by financial and other considerations. Movies may have gotten longer on average over the years, but filmmakers still must present their stories within a relatively short span of time. Most movies running more than three hours risk being seen as too long by the moviegoing public and thus risk failure at the box office.

The relationships among the three types of duration can be isolated and analyzed not only in the context of the entire narrative of the film but also within its constituent parts—in scenes and sequences. In these smaller parts, however, the relationship between plot duration and story duration generally remains stable—that is, in most mainstream Hollywood movies, the duration of a plot event is assumed to be equivalent to the duration of the story event it implies. At the level of scenes and sequences, the more interesting relationship is usually between screen duration and story duration. We can generally characterize that relationship in one of three ways: a **summary relationship** is one in which screen duration is shorter than story duration; **real time** is denoted by a direct correspondence of

screen duration to story duration; and a **stretch relationship** is one in which screen duration is longer than story duration. Both stretch and summary relationships are established primarily through editing techniques (discussed in detail in chapter 6). The summary relationship is very familiar to us and occurs much more frequently in mainstream movies than do the other two. In Terrence Malick's *Days of Heaven* (1978; screenwriter: Malick; see "Analyzing Cinematography" in chapter 4), a very short sequence shows (through time-lapse photography) the root of a wheat plant developing under the soil and thus encapsulates the more gradual changes that occur on farms in the cycle from planting to germination to harvest. In Anthony Asquith and Leslie Howard's *Pygmalion* (1938; screenwriters: George Bernard Shaw et al.), Professor Henry Higgins (Leslie Howard) starts Eliza Doolittle (Wendy Hiller) on a lengthy series of exercises meant to train her to speak perfect English. Her bewilderment is conveyed by a fast, expressionistic series of shots showing phonograph records, microphones, and other instruments that will be used in the process. In *Citizen Kane,* Welles depicts the steady disintegration of Kane's first marriage to Emily Norton (Ruth Warrick) through a rapid series of shots at the breakfast table that actually cover seven years of their life together. Through changes in dress, hairstyle, seating, and their preferences in newspapers, we see the couple's relationship go from amorous passion to sarcastic hostility.

The stretch relationship, because it is less common than summary, is often used to highlight a story event, stressing its importance to the overall narrative. A stretch relationship can be achieved by special effects such as slow motion, particularly when a graceful effect is needed, as in showing a reunited couple running slowly toward one another. It can also be constructed by editing techniques. As we saw in "Forms and Patterns," above, the "Odessa Steps" sequence in Eisenstein's *Battleship Potemkin* uses editing to stretch out the duration of the massacre so that our experience of it onscreen lasts longer than it would have taken to occur in reality. Eisenstein does this because he wants us to see the massacre as an important and meaningful event, as well as to increase our anxiety and empathy for the victims. The stretch relationship is also used to heighten suspense, as in the climax of Robert Zemeckis's *Back to the Future* (1985; screenwriters: Zemeckis and Bob Gale), an engaging screwball comedy about travel through time. Here, manic inventor Dr. Emmett Brown (Christopher Lloyd) has sent his friend Marty McFly (Michael J. Fox) from 1985 back to 1955. Now, he must arrange for McFly's return to 1985 to occur at 10:04 P.M., the exact moment when lightning will strike a clock tower and provide, through his wacky setup, the necessary electricity to power the return trip. But things have gone wrong, and they may not be ready at 10:04. The action is paced against shots of the movement of the clock's minute and second hands from 10:00 to 10:04. If it had been filmed in real time, the sequence would have lasted four minutes and would still be satisfying in its suspense. But the director increases the tension even more, with the frantic activities of the two main characters stretching to *four minutes and four seconds,* just enough to keep us on the edge of our seats. In a written description, four seconds may not seem like much—indeed, this sequence might seem to illustrate a real-time relationship— but when the characters' future depends on "scientific" timing and the clock has been counting the seconds, the relentless moving forward of the clock after the four-minute

[1]

[4]

[2]

[5]

[3]

Summary relationship: a sequence in Martin Scorsese's *Raging Bull* covers three years (story duration) in a few minutes (screen duration). Black-and-white shots of Jake La Motta's (Robert De Niro)

[6]

most significant boxing matches from 1944 to 1947 are intercut with color shots from home movies that show La Motta and his second wife, Vickie (Cathy Moriarty), during the early years of their marriage.

mark produces a kind of exquisitely pleasant torture for the audience.

The real-time relationship is the least common of the three relationships between screen duration and story duration, but its use has always interested and delighted film buffs. Many directors use real time within films, to create uninterrupted "reality" on the screen, but directors rarely use it for entire films. In *Rope* (1948; screenwriter: Arthur Laurents), Alfred Hitchcock used the *long take* (discussed further in chapter 6), an unedited, continuous shot, to preserve real time. One roll of motion picture film can record approximately eleven

Mike Figgis's *Timecode* (2000; screenwriter: Figgis) offers a dramatic and daring version of real time. Split into quarters, the screen displays four distinct but overlapping stories, each shot in one continuous ninety-three-minute take (the length of an ordinary digital videocassette), uninterrupted by editing. To learn more about the use of real, compressed, and expanded time in *Timecode* and other movies, go to <www.wwnorton.com/web/movies>.

www ↖

minutes of action, and thus Hitchcock made an eighty-minute film with ten shots that range in length from four minutes and forty seconds to ten minutes.[4] Six of the cuts between these shots are virtually unnoticeable because Hitchcock has the camera pass behind the backs of the people or furniture and then makes the cut on a dark screen, while four others are ordinary hard cuts from one person to another. Even these hard cuts do not break time or space, and so the result is fluid storytelling in which the plot duration equals the screen duration of eighty minutes.

In traditional movies, cuts and other editing devices punctuate the flow of the narrative and graphically indicate that the images occur in human-made **cinematic time,** not seamless real time. As viewers, we think that movies pass before us in the present tense, but we also

[4]Various critics have said that each shot lasts ten minutes, but based on the DVD release of the film, I find the timings (rounded off) to be: opening credits, 2:09; shot 1, 9:50; 2, 8:00; 3, 7:50; 4, 7:09; 5, 10:00; 6, 7:40; 7, 8:00; 8, 10:00; 9, 4:40; 10, 5:40; closing credits, 00:28.

understand that cinematic time can be manipulated through editing, among other means. As we accept these manipulative conventions, we also recognize that classic Hollywood editing generally goes out of its way to avoid calling attention to itself. Furthermore, it attempts to reflect the natural mental processes by which human consciousness moves back and forth between reality and illusion, shifting between past, present, and future.

Throughout the history of the experimental film (see "Types of Movies" in chapter 1), artists have emphasized cinema as a medium for conveying cinematic time and real time. One example stands out: Andy Warhol's *Empire* (1964), in which a static motion picture camera records New York City's Empire State Building for eight hours straight. The edifice remains the same, but everything else changes: the light and weather outside the building, the movements of people inside the building seen through the windows. Such experiments have been less frequently attempted in narrative film. Abel Gance's masterpiece,

Napoléon (1927; screenwriter: Gance), not only exhibits each of the relationships between duration and plot that we've just described but also includes some of the most dazzling technical innovations in film history. The legendary French director's handling of time, speed, and movement builds dramatically on D. W. Griffith's earlier experiments in awakening us to the manifold possibilities of the cinematic medium for manipulating both time and space. With astonishing fluidity, Gance jumps forward and backward in time, so that a moment in the present is often related to events that preceded it and often foreshadows the events that will follow. For example, in the famous snowball sequence near the beginning of the film, Napoleon's participation in a schoolyard snowball fight becomes a genuine battle, on one hand to restore the young man's reputation among his stupid, class-conscious schoolmates, and, on the other, to point toward his destiny as a military genius. Likewise, in the experiments with cinematic space, Gance introduced the Polyvision process, which used three synchronized cameras (and three synchronized projectors) to create spectacular visual effects. Predating Hollywood's widescreen ratio by more than twenty-five years (see "Framing of the Shot" in chapter 4), Polyvision enabled Gance to put three different actions on the screen simultaneously, as in a triptych, or to spread one vast composition across three screens. *Napoléon* concludes with not only such a triptych but also, within each panel, a rapid recapitulation of footage seen previously in the film, again a fluid demonstration of the symbolic continuity of past, present, and future. In its speed and liveliness, this reminder of the major events in Napoleon's life foreshadows the similar MTV style by more than a half century. Christopher Nolan's *Memento* (2000) represents an even bolder experiment, alternating black-and-white sequences that move forward in telling the story with color sequences that move backward.

SUSPENSE VERSUS SURPRISE

Suspense has been mentioned in the discussions above, and we should distinguish between it and and *surprise*. Although they are often confused, suspense and surprise are two fundamentally different elements in the development of many movie plots. Alfred Hitchcock mastered the unique properties of each, taking great care to ensure that they were integral to the internal logic of his plots. In conversation with French director François Truffaut, he explained the terms:

> We are now having a very innocent little chat. Let us suppose that there is a bomb underneath this table between us. Nothing happens, and then all of a sudden, "Boom!" There is an explosion. The public is *surprised*, but prior to this surprise, it has seen an absolutely ordinary scene of no special consequence. Now, let us take a *suspense* situation. The bomb is underneath the table and the public *knows* it, probably because they have seen the anarchist place it there. The public is *aware* that the bomb is going to explode at one o'clock and there is a clock in the decor. The public can see that it is a quarter to one. In these conditions this same innocuous conversation becomes fascinating because the public is participating in the scene. The audience is longing to warn the characters on the screen: "You shouldn't be talking about such trivial matters. There's a bomb beneath you and it's about to explode!"
>
> In the first scene we have given the public fifteen seconds of *surprise* at the moment of the explosion. In the second we have pro-

[1]

[2]

(1) Neil Jordan's *The Crying Game* (1992; screenwriter: Jordan) takes a very surprising turn when Fergus (Stephen Rea, background), an Irish terrorist, discovers that Dil (Jaye Davidson, foreground), the dark-skinned beauty he has fallen for, is a male transvestite, not a woman. Knowing that this revelation (in addition to the movie's interracial romance) would shock many people, the filmmakers ran advertisements stating "The movie everyone's talking about, but no one is giving away its secrets." This strategy achieved its aim, and the movie was very popular in part because of the surprise, but *The Crying Game* does not evoke suspense once we know the "secret" at its core. (2) Billy Wilder's *Some Like It Hot* (1959; screenwriters: Wilder and I. A. L. Diamond) concerns two musicians who witness a mob murder, disguise themselves as women, and leave town to work in an all-woman band. Although their attempts to maintain this disguise are frustrated by their desires for the women who surround them, they persist through a series of hilarious turns that heighten the suspense. When will they be discovered? What will happen as a result? Eventually, a rich millionaire, Osgood Fielding III (Joe E. Brown, *left*) falls in love with Jerry/Daphne (Jack Lemmon), who frantically explains to Osgood that they can't marry because they are both men. As a surprise to cap the suspense, Osgood simply shrugs his shoulders and makes one of the greatest comebacks in movie history: "Well, nobody's perfect."

vided them with fifteen minutes of *suspense*. The conclusion is that whenever possible the public must be informed. Except when the surprise is a twist, that is, when the unexpected ending is, in itself, the highlight of the story.[5]

Because there are no repeat surprises, we can be surprised in the same way only once. As a result, a **surprise,** a taking unawares, can be shocking, and our emotional response to it is generally short-lived. By contrast, suspense is a more drawn-out (and some would say more enjoyable) experience and one we may seek out even when we know what happens in a movie. **Suspense** is the anxiety brought on by a partial uncertainty—the end is certain, but the means is uncertain. Or, even more interestingly, we may know *both* the result and the means by which it's brought about, but we still feel suspense: we know what is going to happen and we desire to warn and protect the characters, for we have grown to empathize with them (though we can intellectually acknowledge the fact that they aren't "real" people).

[5]Hitchcock, quoted in Truffaut, *Hitchcock,* 73.

FREQUENCY

The **frequency,** or number of times, with which a story element recurs in a plot is an important aspect of narrative form. If an event occurs once in a plot, we accept it as a functioning part of the narrative's progression. However, its appearance more than once suggests a pattern and thus a higher level of importance. Like order and duration, then, frequency serves not only as a means of relaying story information but also as a *signal* that a particular event has a meaning or significance that should be acknowledged in our interpretation and analysis.

Repetition of story events can occur in various ways. A character may remember a key event at several times during the movie, indicating its importance psychologically, intellectually, or physically. The use of flashbacks or slow motion sequences tends to give a mythic quality to memory, making the past seem more significant than it might actually have been. For example, in Atom Egoyan's *The Sweet Hereafter* (1997; screenwriter: Egoyan), Mitchell Stephens (Ian Holm) is so troubled by his teenage daughter's drug addiction that he tries to put it out of his mind by frequently visualizing more pleasant memories of her as a child. In another form of repetition, the director relies on editing to contrast past and present. Alain Resnais's *Hiroshima, mon amour* (1959; screenwriter: Marguerite Duras), both a love story and a protest against nuclear weapons, opens with two lovers in bed: Elle (Emmanuelle Riva) is a French actress making a peace film in Hiroshima, and Lui (Eiji Okada) is an architect working to rebuild the city from the ruins left by the U.S. atomic bomb dropped in 1945. Despite the couple's mutual physical attraction, they are separated by emotional and cultural differ-ences as well as by memories of the past. Elle remembers Nevers, the French town where she was publicly denounced for having a love affair with a German soldier; Lui remembers Hiroshima before and after the bomb. To show how these memories are inextricably caught up with their current lives, Resnais contrasts the objective present and the subjective past by cutting back and forth between shots of the couple in bed and shots of Nevers and Hiroshima. Because they cannot reconcile their different pasts with their present, their affair ends. Such repetition is common in films that provide a cinematic equivalent to the literary technique of stream of consciousness (see "Point of View," below).

Another method is to present an event through different perspectives. In *Citizen Kane,* for example, an account of Susan's (Dorothy Comingore) opera debut is narrated three different times, and Welles enhances the repetition by having each account told by a different narrator: first, by the "News on the March" newsreel; second, by Jed Leland (Joseph Cotten); and, third, by Susan. Because each narrator constructs or remembers the same event differently, we learn something new each time we experience it. Furthermore, the importance of the event in shaping the marriage of the two main characters is reinforced. Similarly, in *Rashomon* (1950; screenwriters: Kurosawa and Shinobu Hashimoto), Akira Kurosawa poses the question "How can we ever know the truth?" by having four different characters recount the story of the same crime. Three were participants in the crime; the fourth witnessed it. Hal Hartley takes another approach to repeating plot elements and varying narrators in *Flirt* (1995; screenwriter: Hartley). It began life in 1993 as a twenty-three minute film set in New York; Hartley expanded it to eighty-five minutes by shooting the same screenplay—

[1]

[2]

Akira Kurosawa's *Rashomon* presents four different perspectives on a crime, and no single perspective seems entirely truthful. (1) A bandit (Toshiro Mifune) confesses to the murder of a nobleman and the rape of the nobleman's wife, but (2) the woman's (Machiko Kyo) version of the story differs significantly from his. The mystery of what happened is deepened by the accounts of a woodcutter, who claims to have witnessed the event from a hiding place in the forest where the crime occurred, and of the dead nobleman, who speaks through the lips of a medium. At the time of its release, *Rashomon*'s use of "unreliable" narrators, a device borrowed from literature, was shockingly original. For more on Akira Kurosawa, *Rashomon,* and the emergence of an "international cinema" during the 1950s and 1960s, go to <*www.wwnorton.com/web/movies*>.

www

with enough highly stylized variations to keep things interesting—two more times, once in Berlin and once in Tokyo. In each version, a lover has to choose whether to commit to a partner who is returning home.

CHARACTERS

Characters, another essential element of film narrative, play functional roles within the plot, either acting or being acted on. Stories can't exist if either plot or characters are missing. But at their best, characters don't have merely a technical function, as if they are mere pieces on a chessboard. After all, we go to movies in large part to witness stories about characters whom we can *imagine as real people,* with complex personalities and lives. When we infer a story from a plot, we employ our imaginations to enlarge our sense not only of what has happened but also of the personalities within the world of that story. Thus when we talk about characters in our analyses of movies, we should consider them both as beings who (much like living, breathing people) have discernible traits, habits, and dispositions and as formal elements that help develop the narrative.

One way to discuss characters, then, is in terms of the complexity of their traits. Making

a very useful distinction, English novelist and literary theorist E. M. Forster said that there were two kinds of characters: *round* and *flat*.[6] **Flat characters** are one-dimensional, possessing one or very few discernible traits, and their motivations and actions are generally predictable. By contrast, **round characters** are three-dimensional, possessing several traits, sometimes even contradictory ones. Round characters are unpredictable, complex, and capable of surprising us in a convincing way. Jack Torrance (Jack Nicholson) in Stanley Kubrick's *The Shining* (1980; screenwriters: Kubrick and Diane Johnson) is a flat character, presented less as an individual than as an illustration of the timelessness of evil. Supernatural forces are a causal factor in his violent descent, but that fact doesn't make Torrance or the movie any less compelling. An example of a round character is Dr. Hannibal Lecter (Anthony Hopkins) in Jonathan Demme's *The Silence of the Lambs* (1991; screenwriter: Ted Tally) As both a renowned psychiatrist *and* a cannibalistic murderer, he personifies evil *and* intelligence. Part of the effectiveness of the movie comes from the actor's ability to balance these two traits believably and thereby create a complex personality.

We also distinguish between *major characters* and *minor characters*—categories that signal the relative importance of characters within the narrative. **Major characters,** the most important characters in a movie, make the most things happen or have the most things happen to them. Because plots depend on conflict, major characters are often further described as **protagonists** ("heroes" who "win" the conflict) and **antagonists** (characters whose values or behavior are in conflict

[6]E. M. Forster, *Aspects of the Novel* (New York: Harcourt, Brace, and World, 1927), 103–18.

[1]

[2]

(1) Jack Nicholson as Jack Torrance and (2) Anthony Hopkins as Hannibal Lecter: two psychopaths portrayed by two great actors in two terrifying movies. Can you tell, just by looking at them, which of these characters is round and which is flat? In fact, you can't. To judge their dimensionality, you need to see the characters in action, look past their surfaces, and understand their motivations—to know which one embodies relentless evil (and is therefore flat) and which one follows the twists of his own diabolical intelligence (and is therefore round). Round and flat characters may be equally interesting, but they serve different dramatic ends.

with those of the protagonist). By contrast, **minor characters** are the supporting characters in a film; they play a less important role in the overall movie, functioning usually as a means of moving the plot forward or of fleshing out the motivations of the major characters. **Marginal characters** lack definition and are onscreen for very short periods of time. Although major characters are, generally speaking, also richer ("rounder") than minor characters, they need not be. In this regard, *Citizen Kane* fits the usual pattern. Charles Foster Kane (Orson Welles) is a major character, one whose many, contradictory traits make him recognizable as a complex human being. By contrast, his loyal business manager, Mr. Bernstein (Everett Sloane), is a minor character because we know almost nothing about him except his reliable presence and completely predictable behavior. He is far less important to the story than are, for example, Mary Kane (Agnes Moorehead), Jed Leland (Joseph Cotten), Walter Thatcher (George Coulouris), and Susan Alexander Kane (Dorothy Comingore). In fact, he is the only character in the film whose first name we don't learn. Giving this character more detail (e.g., a first name, a wife, a home life, children, pastimes, or the occasional disagreement with Kane) would not help tell this story. In Joseph L. Mankiewicz's *All About Eve* (1950; screenwriter: Mankiewicz), actress Margo Channing (Bette Davis) is the major character, perhaps as complex as Kane; her maid, Birdie Coonan (Thelma Ritter), is her subordinate, but never hesitates to say what she thinks. Loyal but invariably outspoken, Birdie provides a foil, or interesting contrast, for Channing's character (which Bernstein does not provide for Kane's). Thus Margo and Birdie illustrate the case in which major and minor characters are equally round.

As the examples of Lecter, Kane, and Channing remind us, central characters—whether round or flat, major or minor—do not necessarily arouse our sympathy. We develop our knowledge of all characters in several ways: from their traits, motivations, and actions; from the ways in which a narrator or other characters describe them; and from the style in which the actors interpret them. While characters can be motivated by many factors—social, economic, ethnic, racial, religious, or emotional, to name a few—the strongest of these usually is psychological. Part of the challenge and enjoyment of interpreting a movie is figuring out characters' motivations, something we do all the time in our daily lives when interpreting other people's behavior. We cannot easily say that what characters do is "natural," because "naturalness," like "eccentricity," is a cultural phenomenon; it varies from one society to another and from one era to another in the same society. Instead, we can ask whether or not the behavior is "probable" within the context of the film. If a character's action makes sense in the world of the movie, we won't need additional "explanation" to understand what motivated the action.

As narrative movies developed through their history, filmmakers increasingly left things out, or left them implicit, or left them to viewers to determine. Audiences learned to understand and accept these changing cinematic conventions, automatically filling in what was missing and thus themselves becoming responsible for the verisimilitude of the actions. Today, we may feel that filmmakers who offer too much explanation actually insult our intelligence. As we watch movies from other eras, we should be aware (and forgiving) of the ways in which the *conventions* of explaining character or establishing motivation have changed over time. Although

William K. Howard's *The Power and the Glory* (1933; screenwriter: Preston Sturges) is a lively, interesting film that employs a revolutionary, nonchronological narrative structure to tell the story of Thomas Garner (Spencer Tracy), a ruthless railroad tycoon, its opening sequence seems old-fashioned in the way it reveals information about one of its characters. It opens with Garner's funeral and then, through a series of flashbacks, recounts his rise and fall. The funeral is a somber event for family and friends, especially for Henry (Ralph Morgan), Garner's lifelong friend and personal secretary, whom the director introduces in a sequence running two minutes and ten seconds, a very long time for what we learn about Henry's character. The ten shots run in the following sequence: (1) Henry is listening to the eulogy; (2) before the service is finished, he rises and walks slowly down the aisle and out of the church; (3) he stands before the headquarters of Garner's railroad empire, enters, walks to the elevator, has a disagreement with the elevator operator about Garner, and turns to enter the elevator; (4) he slowly walks down the hall toward Garner's offices; (5) he opens an outer door with his key; (6) a sign on the interior door reads "Office of the President"; (7) Henry enters Garner's office, takes his hat off, and caresses items on the desk, including a photograph of Garner and him as children; (8) he picks up a photograph and looks at it closely; (9) he looks across the room at a bust of Garner; (10) he puts the photograph in his pocket and slowly leaves the office. While we could argue that the solemn, deliberate pace of these events establishes the grief that Henry experiences, this treatment nonetheless seems dated to contemporary audiences, since it explicitly shows us several things about Henry that we could easily have figured out for ourselves. Because our modern eyes have become comfortable with rapid shifts of character from setting to setting, shots 3, 4, 5, 6, and 9 seem unnecessary; a more contemporary treatment would probably cut straight from the church to the office.

If a character behaves or speaks in a way that disrupts the verisimilitude (in its improbability or eccentricity), we generally expect some form of explanation that can help us redefine either the world of the movie or the character. If no explanation is forthcoming, we are faced with a puzzle: either the improbability has revealed a flaw in the movie's form (in its unity and balance), or it has been *intentionally* placed in the movie to serve some other formal purpose. Either way, we should be alert to such moments. In Curtis Hanson's *Wonder Boys* (2000; screenwriter: Steven Kloves), novelist Grady Tripp (Michael Douglas) displays assorted peculiarities, which we initially read in light of his appearing to have writer's block, his heavy use of marijuana, his extramarital affair, and his failing marriage.

In Lars von Trier's *Breaking the Waves* (1996; screenwriters: von Trier and Peter Asmussen), simpleminded and good-hearted Bess McNeill (Emily Watson) receives instructions either from God or from a voice in her head. When Bess becomes erratic and self-destructive, we must decide if she is insane, masochistic, victimized, or saintly, and we don't have a clear sense of how to interpret her behavior until the very end.

In a career dominated by harsh and nightmarish visions of New York City, Martin Scorsese's *Kundun* stands out as an evocation of "exotic" locales. The movie chronicles the early life of the Fourteenth Dalai Lama, the Buddhist spiritual leader who grew up in Lhasa, Tibet, but was forced to flee his native country after the People's Republic of China invaded in 1959. Banned from Tibet, Scorsese filmed in Morocco.

Ultimately, we understand both his peculiarities and the background characteristics as related to (even symptoms of) the larger question of the state of Tripp's life—that is, to his having reached a midlife crisis that affects his perceptions and actions. By contrast, some movies leave extremely eccentric actions unmotivated, to be understood as representing very disturbed characters, people with whom none of us (let us hope) has any familiarity. Demme's *The Silence of the Lambs* (1991), for example, provides no explanation for why Hannibal Lecter commits such unspeakable acts as eating human flesh. Lecter speaks candidly and humorously about his crimes, but the movie has more to do with how Lecter's sociopathology can assist in the apprehension of another sociopath than with Lecter's own motivation. Likewise, David Lynch's *Blue Velvet* (1986; screenwriter: Lynch) presents Frank Booth (Dennis Hopper) as a case study in abnormal, violent, even psychopathic behavior. Booth's fetishistically rubbing a piece of blue velvet and repeating the word *mommy* hint at Freudian explanations and past traumas, but do so without offering resolution, perhaps even in a tongue-in-cheek manner. In psychoanalytic terms, Booth seems more an eruption of the id—the unconscious source of needs and drives—than an actual human being with recognizable feelings.

SETTING

The **setting** of a movie is the time and space in which the story takes place. It not only establishes the date, city, or country but also provides the characters' social, educational, and cultural backgrounds and other identifying factors vital for understanding them, such as what they wear, eat, and drink. Setting sometimes provides an implicit explanation for actions or traits that we might otherwise consider eccentric, because cultural norms vary from place to place and throughout time. It is difficult to imagine how we might analyze or

evaluate John Huston's *The African Queen* (1951; screenwriters: Huston and James Agee), Bernardo Bertolucci's *1900* (*Novecento*, 1976; screenwriters: Bernardo and Giuseppe Bertolucci and Franco Arcalli), Warren Beatty's *Reds* (1981; screenwriters: Beatty and Trevor Griffiths), or Martin Scorsese's *Kundun* (1997; screenwriter: Melissa Mathison) without referring to their respective African, Italian, American and Russian, and Tibetan settings.

In addition to providing us with essential contextual information that we can use to better understand story events and character motivation, setting also adds texture to the movie's diegesis, enriching our sense of the overall world of the movie. Terrence Malick's *Days of Heaven* (1978; screenwriter: Malick) features magnificent landscapes in the American West of the 1920s. At first, the extraordinary visual imagery seems to take precedence over the narrative. However, the settings—the vast wheat fields and the great solitary house against the sky—directly complement the depth and power of the narrative, which is concerned with the cycle of the seasons, the work connected with each season, and how fate, greed, sexual passion, and jealousy can lead to tragedy. Other films tell stories closely related to their international, national, or regional settings, such as the specific neighborhoods of New York City that form the backdrop of many Woody Allen films. Settings are not always drawn from real-life locales; an opening title card tells us that F. W. Murnau's *Sunrise* (1927; story writer: Carl Mayer) takes place in "no place and every place." Stanley Kubrick's *2001: A Space Odyssey* (1968; screenwriters: Kubrick and Arthur C. Clarke) creates an entirely new space-time continuum, while Victor Fleming's *The Wizard of Oz* (1939; screenwriters: Noel Langley, Florence Ryerson, and Edgar Allan Woolf) creates a fantasy world that includes the multicolor Munchkinland, the Wicked Witch's castle, and the Emerald City. The attraction of such science fiction films as George Lucas's *Star Wars* (1977; screenwriter: Lucas) and Ridley Scott's *Blade Runner* (1982; director's cut released 1992; screenwriters:

Based on Philip K. Dick's science fiction novel *Do Androids Dream of Electric Sheep?* (1968), Ridley Scott's *Blade Runner* takes place in 2019, in an imaginary world, where cities such as Los Angeles are ruled by technology and saturated with visual information.

Hampton Fancher and David Webb Peoples) is often attributed to their almost totally unfamiliar settings. These stories about outer space and future cities have a mythic or symbolic significance beyond that of stories set on Earth. Their settings may be verisimilar and appropriate for the purpose of the story, whether or not we can verify them as "real."

POINT OF VIEW

Although **point of view (POV)** in cinema is defined in a variety of ways, here we need to consider three fundamental definitions:

- *Physical point of view,* the position or angle from which the camera or a particular narrator or character observes an event or a scene.
- *Mental point of view,* the perspective, or slant, taken by a particular narrator or character in a story in seeing and hearing an event or scene, reflecting on an idea, creating a relationship between two or more things, or remembering events or dreams.
- Distinct formal elements *outside of and beyond the presence of either the camera or the characters alone,* including all the mediating processes that occur in postproduction (the editing, the music, the special effects, and so on) and the director's implied slant on the narrative. When a movie's POV is controlled by the first two approaches, the movie tends to maintain the continuities of time, space, and narrative and to suppress our awareness of this third approach, which not only provides us with further information but also filters and focuses what we have received from the camera, narrator(s), and characters.

Any movie can have multiple cameras, narrators, or characters, and, as a result, multiple points of view. The following discussion will emphasize camera point of view and narrator or character point of view, taking into account, where relevant, the additional mediating forces that help shape them.

OMNISCIENT POV. The **omniscient POV** is the most basic and most common point of view. *Omniscient* means that the camera has complete or unlimited perception of what the cinematographer *chooses* for it to see and hear. (In chapter 4, we'll examine the cinematographer's various choices, such as the framing of the shot, types of shots, and so on.) Also called the *objective* or *unrestricted* camera, the omniscient camera is usually placed above, beyond, or significantly away from the action and is more distanced from the action than any character in the film would generally be. Jim Jarmusch's *Stranger Than Paradise* (1984; screenwriter: Jarmusch) demonstrates how effectively a director can use the omniscient camera. Jarmusch tells his story through single shots, each followed by a cut to a black screen. In four of the first six shots, the camera remains stationary and distanced from the characters, giving us the impression that it is a very detached observer, a POV that it essentially maintains throughout the movie. When the camera moves, it seems interested in what it sees, but it never suggests what we might call inquisitiveness.

In the first shot, an eye-level, static camera is positioned sufficiently behind Eva (Eszter Balint) to show her from head to toe (this is known as a *long shot*). She is standing, quite improbably, on a mound of dirt at the edge of a New York airport runway; and after watching the airplanes for a moment, she picks up her suitcase and shopping bag and walks past the

camera and out of the frame. The camera remains to watch a plane take off, displaying no curiosity about who this woman is, why she is in this place, or where she is going. If it knows these things, it's not telling. After a cut to a black screen, we see the opening credits. In the second shot, the camera is at a low angle, looking upward at the door of an apartment, through which Willie (John Lurie) enters, walks toward the camera, answers the telephone, and learns from his aunt that his cousin Eva is arriving today from Hungary. Cut to black. The few things we learn about Willie come from his conversation; again, the camera remains detached. Following an ironic title, *THE NEW WORLD,* the static camera is at street level, showing a badly broken sidewalk. Eva enters from the right, pauses, takes a tape recorder from her bag, plays Screamin' Jay Hawkins's "I Put a Spell on You," and exits on the left. Again, the camera does not have the point of view of an inquiring sensibility: it does not follow her, does not seem to want to know any more about her than what it has seen. Cut to black. In the next shot, the camera is at eye level and intrigued enough to move horizontally alongside Eva (this is known as a *tracking shot*) as she walks through New York City's East Village. As she crosses a street, there is a cut to black. In the fifth shot, the static camera, using a wide-angle lens, produces a slightly distorted perspective, in which we see Eva (in a long shot) walk toward the camera, pause, turn, and walk toward the right side of the screen. Cut to black. Next, back inside Willie's apartment, the camera is positioned at a high angle looking down toward Willie on his bed. After he hears a knock on the door and moves right toward the door, the camera follows him (this is a *pan shot*) as he opens it and greets Eva. As she walks into the room, the camera then pans left to follow her

actions. Willie, tidying the bed, and Eva, looking around incredulously ("*This* is the New World?" she seems to be thinking), dominate the action, and the camera is sufficiently interested to keep them both in view. Cut to black.

By allowing us to see from the vantage point of the omniscient and basically detached camera, Jarmusch encourages us to view the characters not up close and personal but from a symbolic distance—that is, to give them literal *and* figurative, even universal meanings. This, after all, is the story of newcomers to the United States. While they have their preconceptions about and deeper understandings of the country, the camera reflects no such knowledge and behaves the same whether it's showing us New York, Ohio, or Florida. Thus here the omniscient POV, through the distance at which the camera is placed, helps us understand why the characters, like those in fables, seem so alienated from their past lives and current existence. (Of course, their deadpan appearance and deadbeat behavior also contribute greatly to the movie's comedy.) Note that an omniscient POV does not entail that the camera shows us *everything.* Editing plays a role in the storytelling, omitting aspects of the story and the plot. The movie ends where it began—at an airport, this time in Florida. Willie departs, but we do not see or learn through any other means what happens to him after that.

SUBJECTIVE OR RESTRICTED POV. Unlike the far more common omniscient POV, the **subjective** or **restricted POV** shows us a shot or scene as viewed by a character—major, minor, or marginal. When a movie gives us the *perceptual, subjective point of view of an individual character,* it enables us to occupy the person's actual physical position and to see and hear exactly as the person does. This can be done directly or indirectly.

[1]

[2]

In Buster Keaton and Clyde Bruckman's *The General*, (1) Johnnie (Buster Keaton) looks out through the hole and (2) sees Annabelle (Marion Mack). In this early use of indirect POV, the camera is approximately the same distance away from the surface of the tablecloth in both shots, probably because repeating the border of the cloth kept viewers from being confused.

Through the 1940s, maintaining spatial continuity was one of the defining hallmarks of the classical Hollywood cinema. In following decades, after audiences had grown accustomed to the cinematic convention of presenting a character's perspective, filmmakers did not have to maintain such strict spatial continuity.

The **direct POV** occurs when the character is in the frame and we see what he or she sees. In Welles's *Citizen Kane* (1941), the opening shot of Susan Alexander Kane's (Dorothy Comingore) account of her operatic debut—one of three such accounts in the film—represents one way to handle direct POV. The camera is positioned at the rear of the stage, not directly behind her to create an eyeline view or even in the over-the-shoulder position, but back a measurable distance. Through this placement of the camera, we understand that Susan is isolated physically and emotionally from everyone and everything around her. The curtain is about to rise, and Susan, in the center of the image, her back to the camera, receives last-minute instructions from her vocal coach. She is terrified by the commotion and embarrassed by her lack of talent, and, as the curtain rises, she sees (and we see with her) the footlights, which are so bright that they make the auditorium seem like a black void.

The **indirect POV** also affords us the opportunity to see and hear what the character does, but with an important difference, for it is a result of at least two consecutive shots. In the first shot, we see the character looking at something (which we cannot see); following a quick cut to the second shot, we see what the character presumably has seen. *The General*, codirected by Buster Keaton and Clyde Bruckman (1926; screenwriters: Keaton, Bruckman, Al Boasberg, and Charles Smith), takes place during the Civil War. Johnnie Gray (Keaton), a Southern railroad engineer lost and hungry in enemy territory, comes across a house. He enters to steal food, but quickly discovers that he has stumbled into enemy headquarters. We are with him as he dives underneath a table covered with a floor-length cloth, around which sit enemy officers

planning the next day's surprise attack on the Confederate troops. The trapped Gray can hear them talking, but cannot see anything until one of the men inadvertently places his cigar against the cloth, thereby burning open a peephole for him (and us). Furthermore, the hole in the tablecloth allows Johnnie to see his girlfriend, Annabelle Lee (Marion Mack), whom he did not know was on the train captured by the Yankees.

Alternatively, we may see the object first and then see the character looking at it; this is achieved through an editing convention called the *eyeline-match cut* (discussed further in chapter 6). In such cases, the implied narrator's role is tied not just to the camera or to the characters but also to the editing. At the end of John Frankenheimer's thriller *The Manchurian Candidate* (1962; screenwriter: George Axelrod), American intelligence officer Bennett Marco (Frank Sinatra) thwarts an assassination at a political convention after he looks up and sees, as an eyeline-match cut shows

In Gus Van Sant's *Drugstore Cowboy* (1989; screenwriters: Van Sant and Daniel Yost), after a physical, objective POV shows Bob (Matt Dillon) shooting up heroin, a subjective POV depicts Bob's experience. Special effects combine Bob's face and objects flying through the sky.

us, the killer's hiding place in a spotlight booth high above the arena. This POV emphasizes Marco's understanding of the situation. In Alfred Hitchcock's *Vertigo* (1958; screenwriters: Samuel A. Taylor and Alec Coppel), the camera often assumes the POV of Scottie Ferguson (James Stewart)—as, for example, when he first sees Madeleine Elster (Kim Novak) looking at the portrait.

In *The Searchers* (1956; screenwriter: Frank S. Nugent), director John Ford presents two contrasting points of view of the same incident: the first reflecting a character's racism, the second free from that racism. During a rescue operation, Ethan Edwards (John Wayne) frees white women from captivity by Comanche Chief Scar (Henry Brandon) and is as shocked as we are at their deranged condition. When an army doctor comments, "It's hard to believe they're white," Ethan responds with revulsion, "They ain't white—anymore. They're Comanch." Ford opposes Ethan's subjective POV, which reflects his lifelong racist attitudes, with an omniscient tracking shot that reveals Debbie Edwards (Natalie Wood)—Ethan's niece and the focus of the rescue operation—as a strong, self-possessed, and sane woman who has survived her years with the Indians without any apparent ill effects. This shift in POV is particularly important to this controversial film, for it clearly locates racist attitudes toward Native Americans in Ethan's, not Ford's, ideology.

Another variation is the *visual or auditory point of view of a single narrator*. At the beginning of Stanley Kubrick's *The Killing* (1956; screenwriters: Kubrick and Jim Thompson), the voiceover narrator identifies the name and background of the character placing bets. A variation on this involves a voiceover narrator who identifies him- or herself and later appears in the film. This can happen in several

[1]

[2]

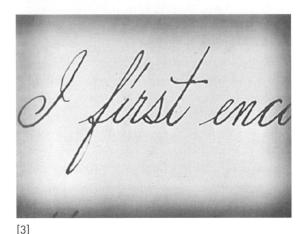

[3]

In Orson Welles's *Citizen Kane*, several characters serve as narrators and provide visual POVs. When Thompson (William Alland) reads the unpublished memoirs of Walter Parks Thatcher (George Coulouris), Kane's guardian, the scene involves three levels of narration: (1) Thatcher's own words in the diary: "I first saw Charles Foster Kane . . . "; (2) Thompson reading and comprehending those words; and (3) the camera scanning the page, apparently through Thompson's eyes, but only after it has moved behind his back to "read" over his shoulder. As the flashback begins, Thatcher's "I" becomes the narratorial camera "eye," removing Thatcher's direct narration and Thompson's mediation—even though Thatcher's perspective on the narration remains, through his physical presence in the following scene.

ways. In John Ford's *How Green Was My Valley* (1941; screenwriter: Philip Dunne), we not only hear the narrator, Huw Morgan (Roddy McDowall), as an adult looking back at his memories of youth but also see him as a youth. In Robert Enders's *Stevie* (1978; screenwriter: Hugh Whitemore)—a two-character stage play successfully adapted for the screen—Stevie Smith (Glenda Jackson) directly addresses us as she goes about the activities she is talking about; in addition, a male narrator wanders in and out of scenes and adds his comments. Martin Scorsese's *Goodfellas* (1990; screen-

writers: Scorsese and Nicholas Pileggi) includes voiceover narration from two different major characters. We see the action mostly through the eyes and narratorial voice of Henry Hill (Ray Liotta), an Italian American criminal; but his wife, Karen (Lorraine Bracco), who is Jewish and comes from outside his world, often adds a different view, enriching what we see and hear ourselves.

In *Rear Window* (1954; screenwriter: John Michael Hayes), Alfred Hitchcock brilliantly relates his use of POV to one of the film's themes: voyeurism, or pleasure taken from

watching others without being seen. Hitchcock gives us two kinds of camera and editing POV: (1) the visual and mental perceptions of L. B. "Jeff" Jeffries (James Stewart) and sometimes one of the other characters, signaled through eyeline matches; and (2) panning shots of Jeffries's courtyard that are independent of any character. A magazine photographer who has broken a leg on a dangerous assignment, Jeffries is confined to a wheelchair in his tiny Greenwich Village apartment. From inside, he sees the world through his own very special psychic lens, which has been shaped by his profession and his personal curiosity. Jeffries's chair is placed so that he can keep track of all his neighbors, day and night; sometimes, he uses a camera with a telescopic lens to augment what his eyes see under normal conditions. Hot, bored, and itching under his cast, he becomes the prisoner of his own fantasy life; in fact, his physical therapist, Stella (Thelma Ritter), warns that he might be arrested for being a "peeping Tom." Jeffries soon becomes involved in solving a murder that those around him at first refuse to believe happened. Everything, including the capture of the murderer, depends both on what Jeffries sees and hears and on how the other characters come to agree with his point of view. (For a closer look at *Rear Window*, see "Point-of-View Editing" in chapter 6.)

In one variation on the single-narrator POV, **interior monologue** allows us to see a character and hear that character's thoughts (in his or her own voice, even though the character's lips don't move). For instance, in Robert Bresson's *A Man Escaped* (*Un condamné à mort s'est échappé*, 1956; screenwriter: Bresson), the main character narrates his own story from prison, but varies his verb tenses in a revealing manner. In the present tense, he tells us what is happening as we see it happening; in the past tense, he tells us what happened. A second variation, *stream of consciousness* (see "Experimental Films" in chapter 1), attempts to present, through offscreen narration and onscreen images, the thoughts, images (both verbal and visual), and responses that run through an individual's mind at any one time. Alain Resnais's *Last Year at Marienbad* (*L'Année dernière à Marienbad*, 1961; scriptwriters: Resnais and Alain Robbe-Grillet) was the first full-length film to employ a single character's stream of consciousness throughout. It concerns three characters—two men and a woman—who meet at Marienbad, a fashionable European spa. The first man, "X" (Giorgio Albertazzi), meets "A" (Delphine Seyrig), a woman he insists he met the previous year at another spa and arranged to meet at this one. She denies all of this. The second man, "M" (Sacha Pitoeff), who is traveling with "A" and is probably her husband, is more concerned with playing little games of chance, which he tends to win, and does not seem particularly interested in what is happening. Our difficulty in making sense of events is compounded by X's voiceover narration, which reinforces our initial impression that all of this is happening inside his mind. Never establishing the basic facts of who, when, where, and why, this narrative is structured as the mind works, jumping from facts to dreams to memories, from past to present to future, and thus we cannot watch it as we would a traditional narrative. This universal structure enhances our spectatorship—the role we play in interpreting the film—and provides the challenges (and rewards) that come with confronting ambiguities and contradictions, trying to put the pieces of the puzzle together.

Presenting the range of a person's consciousness is often more successful in literature, which allows readers as much time as

necessary to understand such a free-form, often illogical flow of images. Neil Jordan's *The Butcher Boy* (1997; screenwriters: Jordan and Patrick McCabe) very convincingly adapts Patrick McCabe's stream-of-consciousness novel of the same title, relating the thoughts, physical responses, and psychological associations of its main character, Francie Brady (Eamon Owens), in a discontinuous and fragmented order. The underlying patterns of his spoken thoughts and the repetition of key visual images create a structure that keeps us oriented to what we see and hear. At the film's beginning, comic book illustrations, which serve as a background for the credits, morph into live action images, establishing one of the film's major themes: the dichotomy between Francie's illusions about reality and reality itself. The opening narration, spoken by an older man, also establishes a dichotomy between Francie's youth, which we see in flashback ("When I was a young lad . . ."), and his

adult years, which are spent in an institution. This flashback to Irish life in the 1950s introduces many themes and images that will be significant as narrative as well as repeated visual elements, such as Francie and Joe (Alan Boyle) as Indians, dressed up in face paint and feathers as they whoop war calls against Francie's nemesis, Mrs. Nugent (Fiona Shaw). The repetition of words (e.g., "pigs," "apples," "Mrs. Nugent," "don't let me down") and images (western movies on television, the kitchen where Francie's mother tried to hang herself, a water fountain) keep us oriented to Francie's intense way of looking at life.

SCOPE

Related to *duration, setting,* and *point of view* is **scope**—the overall range, in time and place, of the movie's story. Stories can range from the distant past to the narrative present or they can be narrowly focused on a short period, even a matter of moments. They can take us from one galaxy to another or they can remain inside a single room. They can present a rather limited perspective on their world or they can show us several alternative perspectives. Determining the general scope of a movie's story—understanding its relative expansiveness—can help you piece together and understand other aspects of the movie as a whole.

For example, a film about a person's life—whether historical or fictional—might tell the story in one of two ways: through one significant episode or period in the life of a person or through a series of events in a single life, sometimes beginning with birth and ending in old age. While David Lean's *Lawrence of Arabia* (1962; restored, 1989; screenwriters: Robert Bolt and Michael Wilson) focuses on one crucial period in T. E. Lawrence's life,

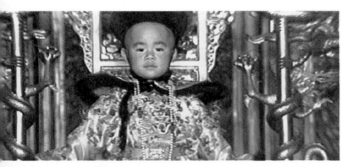

Bernardo Bertolucci's *The Last Emperor* (1987; screenwriters: Bertolucci, Mark Peploe, and Enzo Ungari) recounts the comparatively smaller story of the title character, China's Pu Yi (John Lone), against the political changes enveloping China as it moved from monarchy to communism from 1908 to 1967. Even though the two stories occur simultaneously and are related causally, the expansive scope of the historical epic takes precedence over the story of the emperor's life.

Richard Attenborough's *Gandhi* (1982; screenwriter: John Briley) presents almost the entire life of the Indian leader. Other examples include Abel Gance's *Napoléon* (1927; screenwriter: Gance), which, in nearly four hours, gives us Napoleon's career from childhood through his conquest of Italy, and Spike Lee's *Malcolm X* (1992; screenwriters: Lee and Arnold Perl), which takes its hero's story from birth to death by assassination.

Many war films have been limited in scope to the story of a single battle, while others have treated an entire war. Steven Spielberg's *Saving Private Ryan* (1998; screenwriter: Robert Rodat) covers two stories happening simultaneously: the larger story is that of the June 1944 D-Day invasion of Normandy, involving the vast Allied army; the more intimate story, and the one that gives the film its title, presents what happens from the time the U.S. government orders that Pvt. Ryan (Matt Damon) be removed from combat to the time he is actually located and saved from harm's way. Both stories are seen from the American point of view, perceptually and politically. By contrast, Ken Annakin and Andrew Marton's *The Longest Day* (1962; screenwriters: Romain Gary, James Jones, David Pursall, Jack Seddon, and Cornelius Ryan) relates the D-Day invasion to what was happening in four countries—the United States, France, England, and Germany—though also from the perspective of American politics. Thus its scope is broader, enhanced by the viewpoints of its large cast of characters. While Terrence Malick's *The Thin Red Line* (1998; screenwriter: Malick) focuses on the American invasion of the Japanese-held Pacific island of Guadalcanal, it ultimately uses the historical setting as a very personal backdrop for a meditation on war and its horrors.

ANALYZING NARRATIVE

Most of us can hardly avoid analyzing the narrative of a movie after we have seen it. We ask: "Why did the director choose *that* story?" "What is it about?" "Why did he choose to tell it in *that* way?" "What does it mean?" At the simplest level, we must fill in gaps in events, infer character traits from the clues or cues we receive, and interpret the significance of objects. In addition, sometimes we must revise our sense of the movie's world in response to how that world changes our everyday understanding of the "real" world, the one outside the movie. In Ang Lee's *Crouching Tiger, Hidden Dragon* (*Wo hu cang long*, 2000; screenwriters: Hui-Ling Wang, James Schamus, and Kuo Jung Tsai), people can fly through the air if they have the necessary skill. Although this ability doesn't mesh with our lived experience, we nonetheless adjust our expectations and reinterpret the world portrayed on the screen; once a few characters have flown, we are no longer surprised to see it happen, although we

Ed Harris's *Pollock* (2000; screenwriters: Barbara Turner and Susan J. Emshwiller) focuses primarily on the period from American artist Jackson Pollock's first success, through his discovery and development of "drip" painting, to his death in a car crash.

[1]

[2]

A biographical movie, or biopic, provides particularly rich opportunities to ask why the filmmakers chose to tell the story the way they did. After all, the facts of the main character's life are objectively verifiable and followed a particular order. But storytellers' shaping of that material, the form those facts take, determines how compelling the movie is dramatically, how interesting it is cinematically, and what it means ultimately. (1) Graeme Clifford's *Frances*, starring Jessica Lange as Frances Farmer, is one type of biopic, relying on objective facts to guide the narrative and thus encouraging us to analyze other formal structures within the film, such as the acting. (2) Werner Herzog's *Aguirre: The Wrath of God*, starring Klaus Kinski as Don Lope de Aguirre, is another type, using biographical facts as raw material for a more subjective narrative and thus inviting us to compare the historical record with the artistic vision. To learn more about the biopic and the tension between Hollywood storytelling conventions and historical accuracy, go to <*www.wwnorton.com/web/movies*>.

www

may remain impressed and entertained by the spectacle of people flying. Other movies, such as biographical ones, encourage us to suspend our disbeliefs and doubts in favor of the "facts" and thus not allow our lived experiences to get in the way of interpretation and analysis. This is particularly true when real-life characters undergo extreme conflicts with personal demons, as do alcoholic actress Lillian Roth (Susan Hayward) in Daniel Mann's *I'll Cry Tomorrow* (1955; screenwriters: Helen Deutsch and Jay Richard Kennedy), mentally ill actress Frances Farmer (Jessica Lange) in Graeme Clifford's *Frances* (1982; screenwriters: Eric Bergren, Christopher De Vore, and Nicholas Kazan), and painter Jackson Pollock (Ed Harris), perhaps both alcoholic and mentally ill, in Ed Harris's *Pollock* (2000; screenwriters: Barbara Turner and Susan J. Emshwiller). Somewhere in between fantasy and fact are those movies, such as Werner Herzog's *Aguirre: The Wrath of God* (*Aguirre, der Zorn Gottes*, 1972; screenwriter: Herzog), that freely adapt historical records for cinematic purposes. Herzog's movie tells the story of Don Lope de Aguirre (Klaus Kinski), a sixteenth-century Spanish explorer who believes the myth of El Dorado and is obsessed with finding this "lost city." Although the story is true, and the movie respects the broad outlines of this historical

truth, Herzog uses it to express a very personal vision of humanity and the world. More concerned with moods than events, psychology than history, obsession than rationality, he uses two narrative devices: voiceover narration from the diary on which the film is based and details recorded by the exceptionally observant, even expressionistic camera. By the end of the film, Herzog has altogether abandoned historical truth in favor of exploring Aguirre's single-minded determination to find El Dorado. He so pulls us into Aguirre's world that we cannot take our eyes off the hypnotic images on the screen, and he makes us believe so thoroughly in Aguirre's motivation that we are simultaneously repelled and attracted by his obsession. The landscape is no longer that of Peru but that of Aguirre's mind, distorted by his lust for gold and power; and without the conventional reference points of time and place, we must account for the workings of that mind (and the workings of point of view) in interpreting the movie.

JOHN FORD'S *STAGECOACH*

To see how the elements of narrative form (characters, point of view, order, duration, frequency, etc.) work together in a single movie, let's look closely at John Ford's *Stagecoach* (1939), the western by which all others are measured.

STORY. *Stagecoach*'s story is based on a familiar convention (sometimes called the "ship of fools") in which a diverse group of people—perhaps passengers traveling to a common destination, or residents of a hotel—must confront a common danger and, through that experience, confront themselves, both as individuals and as members of a group. Ford revitalized this convention and the often formulaic western genre by presenting sharp psychological portraits of vivid characters, magnificent imagery, and pointed social comment and by emphasizing all three of these components more than the Indian fight, which was what audiences expected to be stressed.

The screenplay—written by Dudley Nichols in collaboration with Ford—is based on Ernest Haycox's 1937 short story "Stage to Lordsburg."[7] The story concerns a diverse group of people (male and female, weak and strong, from different places, backgrounds, and professions, and with dissimilar temperaments), who have either been living in or are passing through the frontier town of Tonto. Despite a warning from the U.S. Cavalry that Apache warriors, under the command of the dreaded Geronimo, have cut the telegraph wires and threatened the settlers' safety, this group boards a stagecoach to Lordsburg. In charge of the coach is Buck Rickabaugh (Andy Devine), the driver, and Sheriff Curly Wilcox (George Bancroft), who is on the lookout for an escaped

[7]Both the story and the screenplay are in Dudley Nichols, *Stagecoach: A Film by John Ford and Dudley Nichols* (New York: Simon and Schuster, 1971). See also Edward Buscombe's excellent analysis of the film, *Stagecoach* (London: British Film Institute, 1992), to which I am indebted.

[1]

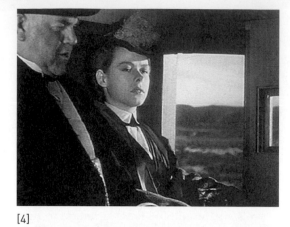

[4]

[2]

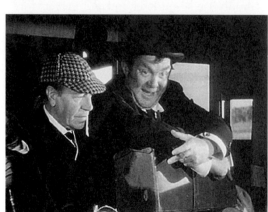

[5]

[3]

[6]

The cast of characters in John Ford's *Stagecoach:* (1) Buck Rickabaugh (Andy Devine, *left*) and Sheriff Curly Wilcox (George Bancroft); (2) Dallas (Claire Trevor) and Henry Gatewood (Berton Churchill); (3) the Ringo Kid (John Wayne); (4) Gatewood and Lucy Mallory (Louise Platt); (5) Samuel Peacock (Donald Meek, *left*) and Dr. Josiah Boone (Thomas Mitchell); and (6) Mr. Hatfield (John Carradine).

prisoner called the Ringo Kid (John Wayne). The seven passengers include Lucy Mallory (Louise Platt), the aloof, southern-born, and (as we later learn) pregnant wife of a cavalry officer whom she has gone west to join; Samuel Peacock (Donald Meek), a liquor salesman; Dr. Josiah Boone (Thomas Mitchell), a doctor who still carries his bag of equipment even though he has been kicked out of the profession for malpractice and now is being driven out of Tonto for drunkenness; Mr. Hatfield (John Carradine), a southern gambler, who is proud of the fact that he served in Lucy's father's regiment in the Civil War and leaves Tonto to serve as her protector on the trip; Henry Gatewood (Berton Churchill), the Tonto bank president, who is leaving town with a mysterious satchel that we later learn contains money he stole from his bank; and Dallas (Claire Trevor), a good-hearted prostitute, who has been driven out of town by a group of Tonto's righteous women. Ringo has been heading for Lordsburg to avenge his father's murder, but when his horse becomes lame outside Tonto, he stops the stagecoach and is arrested by the sheriff before he boards. Each passenger has his or her own reasons for leaving Tonto (or, in Ringo's case, prison) and making the perilous journey. Lucy, Hatfield, Gatewood, and Peacock all have specific purposes for traveling to Lordsburg; Dallas and Dr. Boone are being forced to leave town; and the Ringo Kid has a grudge to settle.

PLOT. The plot covers the two-day trip from Tonto to Lordsburg and is developed in a strictly chronological way without flashbacks or flashforwards (Fig. 2.3). The events follow one another coherently and logically, and their relation of cause and effect are easy to discern. Balance, harmony, and unity are the principal keys to understanding the relation-ship between the story and the plot. Indeed, the eminent French film theorist and critic André Bazin notes that

> *Stagecoach* (1939) is the ideal example of the maturity of a style brought to classic perfection. John Ford struck the ideal balance between social myth, historical reconstruction, psychological truth, and the traditional theme of the Western mise en scène [that is, staging; mise-en-scène is one subject of chapter 3]. None of these elements dominated any other. *Stagecoach* is like a wheel, so perfectly made that it remains in equilibrium on its axis in any position.[8]

PLOT ORDER. As we noted above, Ford maintains strict chronological order in using the journey to structure the story events. The journey provides both chronological and geographical markers for dividing the sequences. Furthermore, it reveals a clear pattern of cause and effect created primarily by each character's desire to go to Lordsburg on this particular day. That pattern proceeds to conflict (created both by internal character interaction and by the external Apache attack, which frustrates the characters' desires), reaches a turning point (the victory over the Apaches), and concludes with a resolution (Ringo's revenge on the Plummers and his riding off a free man with the woman he loves). Otherwise, the plot order is not manipulated in any way.

DIEGETIC AND NONDIEGETIC ELEMENTS. The diegetic elements are everything in the story except the opening and closing titles and credits and the background music, all of which are of course nondiegetic. One very im-

[8]André Bazin, "Evolution of the Western," in *What Is Cinema?* sel. and trans. Hugh Gray (Berkeley: University of California Press, 1967–71), 2:149.

FIG. 2.3 PLOT SEGMENTATION OF *STAGECOACH*

Note: the opening and closing titles and credits, enclosed in brackets, are nondiegetic elements.

{Title, cast names, and principal production credits}

I. MORNING OF THE FIRST DAY IN TONTO IN THE 1870s
 A. The U.S. Calvary office receives telegraph warning that Apache warriors, under the command of Geronimo, are cutting telegraph wires, a sign that they are preparing for an attack on the white settlers.
 B. Six passengers, the driver, and the sheriff board the stagecoach, which is accompanied by a cavalry escort.

II. FIRST STAGE OF JOURNEY TO LORDSBURG
 A. Conversations establish the passengers' basic antipathy to one another.
 B. A rifle shot announces the appearance of the Ringo Kid; he surrenders his rifle, and the sheriff arrests him as an escaped convict.
 C. Ringo enters the coach.
 D. Journey resumes without interruption.

III. NOONTIME MEAL AT DRY FORK STATION
 A. First official stagecoach stop for noon meal; underlying tensions flare up because Ringo has seated Dallas at the same table as Lucy.
 B. Hatfield suggests that Lucy will find it "cooler" to sit by the window, and Gatewood joins them at the far end of the table. Lucy and Hatfield establish a rapport when Hatfield tells her he served in her father's regiment during the Civil War.
 C. Dallas and Ringo become acquainted over lunch; he is attracted to her and tells her that he will not go back to prison until he takes care of some business in Lordsburg.
 D. Tensions among the travelers increase when they learn that the relief cavalry unit has not arrived, but the travelers vote to go on to Lordsburg with the understanding that they will shortly lose their military protection.

IV. MID-AFTERNOON: SECOND STAGE OF THE JOURNEY TO LORDSBURG
 A. Journey continues.
 B. Some passengers continue to express their moral indignation about having to travel in Dallas's company; Buck and Curly discuss Ringo's background. Rather than keeping the stagecoach on the desert track, Buck decides to avoid the Apaches by taking a route through the mountains, where it has begun to snow.

V. NIGHT AT THE APACHE WELLS REST STATION
 A. Passengers stop for the night at a rest station, where Chris, the proprietor, informs them that Apaches raided the station the night before and that Lucy's husband, a captain of the cavalry troop stationed there, was wounded in that raid and taken to Lordsburg for treatment.
 B. Lucy goes into labor; Dr. Boone reluctantly sobers up, goes to her aid, and, with Dallas's assistance, delivers a baby girl.
 C. Meanwhile, outside, Mexicans working at the station are frightened by the possibility of the Apaches' return and flee with all the spare horses.
 D. When Dallas goes outside for some fresh air, she is startled by Ringo's proposal that after they arrive in Lordsburg, she join him at his ranch across the border.
 E. Sheriff Curly's appearance reminds Ringo that he is not yet free to do as he wants.

VI. MORNING OF THE SECOND DAY
 A. Chris awakens the sleeping travelers with the news that his Apache wife has run away.
 B. Passengers prepare to leave for Lordsburg; Sheriff Curly, who is keeping close watch over Ringo, unlocks shackles between his leg and Ringo's.
 C. Dallas tells Ringo she will join him later on the condition that he escape now, stay away from Lordsburg, and go directly to his ranch to wait for her.
 D. Ringo attempts to escape, but is captured by the sheriff.
 E. With distant smoke signaling that the Apaches are preparing for war, the passengers depart for Lordsburg.

VII. THIRD STAGE OF THE JOURNEY TO LORDSBURG
 A. The previous social tensions among the passengers give way to fear about an Apache attack.
 B. Their fears are realized as they arrive at a ferry burned by the Apaches, but they manage nonetheless to pull the stagecoach across the river.
 C. Resuming its trip, with the stagecoach racing through the mountain terrain, the party mistakenly begins to feel safe; we see a line of armed Apaches on horseback waiting on the ridge of a hill, but the travelers do not realize their danger until an arrow flies through the window, striking Peacock in the chest.

VIII. APACHE ATTACK
 A. As the Apaches launch their full attack, the stagecoach heads for the flat desert terrain.
 B. Sheriff Curly distributes weapons to the passengers, and he and Ringo, who has climbed to the top of the stagecoach, fire at the Apaches, who are now parallel with the coach.
 C. After Buck is struck by a bullet and momentarily loses control of the horses, Ringo leaps from the coach to the first pair of horses and brings the stagecoach under control; they continue their determined attempt to leave the Apaches behind.
 D. Inside the coach, Lucy is terrified for her safety and that of her child; Hatfield, as her protector, reasons that she would be better off dead than in the hands of the Apaches; he quietly aims his pistol at Lucy's head, but is shot by the Apaches before he can pull the trigger.
 E. A distant bugle announces the imminent arrival of a cavalry troop, which repels the attack and drives off the Apaches.
 F. The coach stops on the desert floor, and as Ringo jumps off the lead horse and runs to the carriage, Hatfield, held by Dr. Boone, dies.

IX. NIGHTTIME ARRIVAL IN LORDSBURG
 A. Stagecoach arrives in Lordsburg; despite Dallas's kindness, Lucy thanks her grudgingly, with noticeable aloofness.
 B. In the saloon, where the Plummer gang is playing cards, news arrives that Ringo is in town; the frightened crowd leaves the bar, while the Plummers swagger through the bar preparing for the fight.
 C. The sheriff arrests Mr. Gatewood for embezzling funds from his bank.
 D. Recognizing Ringo's heroic action during the Apache attack, Sheriff Curly returns his rifle and allows him ten minutes of freedom in which to confront the Plummers.
 E. Outside, Ringo says farewell to Dallas.
 F. Inside the saloon, Dr. Boone threatens that he will have Luke Plummer indicted for the murder of Ringo's father and brother if he goes outside with his rifle; Plummer leaves his rifle on the bar and goes outside, where a woman gives him a rifle.
 G. The classic gunfight begins: the Plummers at one end of the street, Ringo at the other; they walk toward one another, and suddenly Ringo throws himself to the ground, fires three shots, and kills two Plummers; Luke Plummer is seriously wounded, but walks back into the saloon, where he drops dead.

X. REUNION OF RINGO AND DALLAS
 A. Dallas returns to the street and finds Ringo; they embrace as Sheriff Curly arrives with an open carriage and asks Ringo if he is ready. Ringo assumes that the sheriff is taking him back into custody, but the sheriff climbs down out of the carriage and suggests that Dallas get in.
 B. Sheriff Curly and Dr. Boone throw pebbles to startle the carriage horses, which charge off down the street. Ringo and Dallas realize the sheriff has given them another chance.
 C. When the lovers are almost out of sight, Dr. Boone says, "Well, they're saved from the blessings of civilization," and he and the sheriff head for the saloon.
 D. The carriage heads across the desert as the sun begins to rise.

{End titles and credits}

portant formal element in *Stagecoach* is American folk music, including the song "Bury Me Not on the Lone Prairie," most often heard in connection with Buck and representing his justifiable fears of dying on the range; a honky-tonk piano in the bar; and a symphonic score mixing many familiar folk tunes. The film's main theme is Stephen Foster's classic ballad "I Dream of Jeannie with the Light-Brown Hair." A song about remembering the past, perhaps with regret or loss, it is closely associated with the Old South and evokes the memories of Lucy Mallory and Hatfield: the devastating Civil War, the uncertain westward movement, the fragmented western territories, and, in all of this, a yearning for a simpler time and a woman with light-brown hair.

HUBS AND SATELLITES. The hubs in *Stagecoach*—those major events or branching points in the plot structure that force characters to choose between or among alternate paths—include (in the order of the plot) the passengers' decision to leave Tonto in spite of the cavalry's warning about Geronimo and his troops, Sheriff Wilcox's decision to let Ringo join the party, the passengers' vote to leave the Dry Fork Station for Lordsburg even though a relief unit of cavalry has not yet arrived, Dallas's decision at the Apache Wells Station to accept Ringo's proposal, Dr. Boone's willingness to sober up and deliver the baby, the group's decision to delay departure from Apache Wells until Lucy has rested from childbirth and is ready to travel, Ringo's attempt to escape at Apache Wells, the passengers' decision at the burned-out ferry landing to try to reach Lordsburg even though they realize that an Apache attack may be imminent, the arrival of the cavalry soon after the Apache attack has begun, Ringo's willingness to risk his life to bring the coach under control, Sheriff Wilcox's decision to reward Ringo's bravery by allowing him ten minutes of freedom in which to confront the Plummers, and the sheriff's decision to set Ringo free.

The principal satellites—those minor plot events that add texture and complexity to characters and events, but are not *essential* elements within the narrative—include (in plot order) the Apaches' cutting the telephone wires; Gatewood's anxiety about getting to Lordsburg no matter what happens along the route; Peacock's anxiety over Dr. Boone's helping himself to his stock of liquor; Buck's wavering enthusiasm for driving the stage-

coach against the odds; Lucy's, Hatfield's, and Gatewood's demonstrations of their self-perceived social superiority, especially at the lunch table at the Dry Fork station; Hatfield's attempt to defend Lucy from Apache attack, which results in his being shot; Sheriff Wilcox's distribution of weapons to the travelers for their self-defense during the Apache attack; Wilcox's arrest of Gatewood for embezzlement; and Ringo's successful killing of the three Plummer brothers.

DURATION. The story duration includes what we know and what we infer from the total lives of all the characters (e.g., Lucy's privileged upbringing in Virginia, marriage to a military officer, current pregnancy, and the route of her trip out west up until the moment the movie begins). The plot duration includes the time of those events within the story that the film chooses to tell, here the two days of the trip from Tonto to Lordsburg. The screen duration, or running time, is ninety-six minutes.

SUSPENSE. In 1875, it took two days for a fast stagecoach to make the trip from Tonto to Lordsburg, and the plot follows this two-day trip chronologically. However, the pace also serves other functions. The fear first expressed in the opening moments at the mention of the name Geronimo intensifies the suspense of the imminent Indian attack, thus providing a decisive crisis during which the characters respond to the challenges and rigors of the trip and reveal their true selves. Will Lucy stop acting like a spoiled rich woman? Will Dr. Boone sober up in time to deliver her child? Will Dallas accept Ringo's proposal? Since we know little of their origins, we must trust in what we see of their current surroundings as well as their interactions with each other and with the community (both the com-

munity of Tonto and the "community" that develops on the journey).

FREQUENCY. While no story events recur, character traits both recur (e.g., Gatewood's insensitive desire to keep moving, no matter what, puts in danger both individuals and the group as a whole) and transform as a result of the journey (e.g., Lucy tenderly acknowledges Dallas's invaluable assistance during childbirth: "Dallas, if there's ever anything I can do for . . .").

CHARACTERS. All the characters within the stagecoach—Dallas, Ringo, Hatfield, Peacock, Gatewood, Dr. Boone, and Lucy—are major, because they make the most things happen and have the most things happen to them. Dallas, Ringo, Dr. Boone, and Lucy are round characters: three-dimensional, possessing several traits, and unpredictable. The flat characters—one-dimensional, possessing one or very few discernible traits, and generally predictable—include Hatfield, Peacock, and Gatewood. Buck Rickabaugh and Sheriff Wilcox, riding on the bench at the exterior front of the coach, are essentially minor (and flat) characters; they play less important roles and usually function as a means of moving the plot forward or of fleshing out the motivations of the major characters.

SETTING. The story takes place in settings constructed in Hollywood—the interiors and exteriors of two towns and the stagecoach—and on actual locations in the spectacular Monument Valley of northern Arizona. (In "Scope," below, we will consider another setting, which we can call symbolic or mythical, meaning that it has a significance that goes beyond what we see.) Beautiful and important as Monument Valley and other exterior shots are

to the film, the shots made inside the stage-coach as it speeds through the valley are essential to developing other themes in the movie. As the war with the Apaches signifies the territorial changes taking place outside, another drama is taking place among the passengers. In journeying through changing scenery, they also change through their responses to the dangers they face and their relations with, and reactions to, one another. This may be a wilderness, but the settlers have brought from the East and the South their notions of social respectability and status. Thus as the film begins in Tonto, they enter the stagecoach in the descending order of their apparent importance within the film's social scale:

1. Gatewood, the banker, is a highly respected social pillar of Tonto.
2. Lucy, the transient army wife, is a respected southern aristocrat.
3. Hatfield, the transient gambler, seems to be a gentleman.
4. Peacock, the transient whisky salesman, is barely acceptable.
5. Dr. Boone has been run out of town by the Law and Order League.
6. Dallas, a prostitute, has also been run out of town.
7. Ringo, an escaped convict, has no social status.

However, after going through the challenges and conflicts of the two-day trip, Ford reverses this order of importance as they leave the coach in Lordsburg:

1. Ringo becomes the hero through his heroic defense of the stagecoach.
2. Dallas becomes the heroine by showing dignity in the face of humiliation and compassion in helping to deliver Lucy's baby.
3. Dr. Boone is redeemed when he sobers up and delivers Lucy's baby.
4. Peacock does not change.
5. Hatfield is redeemed by chivalrously dying to defend Lucy.
6. Lucy, still aloof, nonetheless acknowledges Dallas's kindness.
7. Gatewood is apprehended as a bank thief.

There is plenty of irony in these changes. At the end of the trip, the pretentious, overbearing Gatewood becomes the prisoner, while Ringo—who is guarded by the sheriff and feared by some of the passengers because he is an escaped convict—becomes the hero. Dallas's compassion takes precedence over Lucy's cold, haughty manner, and so on.

POINT OF VIEW. Ford uses both physical and mental points of view, including the omniscient point of view of the movie camera (particularly in the exterior shots of the stagecoach hurtling across the territory) and the characters' direct and indirect points of view. Although the movie includes neither narration nor interior monologue, it features one especially interesting use of auditory point of view when Lucy, a cavalry wife, is the first to recognize the bugle announcing the cavalry's arrival during the Apache attack.

When he needs to show that the characters do not form a community—for example, at the noontime lunch stop at the Dry Fork Station, where underlying tensions flare up because Ringo has seated Dallas at the same table as Lucy—Ford establishes and reinforces ideo-

logical and emotional differences by *cross-cutting* between (1) shots from an omniscient point of view and (2) shots from the characters' subjective points of view (for a full discussion of this editing technique, see "Conventions of Editing" in chapter 6). As a result, the space at the dinner table, even though it is physically larger, is as socially and morally restricted as the space inside the stagecoach. Ford's pattern of editing here establishes the camera's presence as "narrator," the social stratification within the group, Lucy's inflexibility, Hatfield's protectiveness, and Gatewood's pretentiousness. But it also reveals Ringo's kindness, Dallas's vulnerability, and Ford's sympathy for them, which engages our sympathy.

SCOPE. The story's overall range in time and place is broad, extending from early events—Dallas orphaned by an Indian massacre and the comparatively more pleasant childhood that Lucy enjoyed in Virginia—to those we see onscreen. And while we look essentially at those events on the two days that it takes the stagecoach to go from Tonto to Lordsburg, we are also aware of the larger scope of American history, particularly the westward movement, Ford's favorite subject. Made right before the start of World War II in Europe, *Stagecoach* presents a historical, social, and mythic vision of American civilization in the 1870s. Ford looked back at the movement west because he saw that period as characterized by clear, simple virtues and values. He viewed the pioneers as establishing the traditions for which Americans would soon be fighting: freedom, democracy, justice, and individualism.

One of the social themes of the movie is *manifest destiny,* a term used by conservative nationalists to explain that the territorial expansion of the United States was not only inevitable but also ordained by God. In that effort, embodied in the westward movement, the struggle to expand would be waged against the Native Americans. In his handling of the story, Ford strives to make a realistic depiction of settlers' life in a frontier town and the dangers awaiting them in the wilderness. Although scholars differ in interpreting the politics of Ford's vision, particularly as it relates to his depictions of whites and Native Americans (depictions that vary throughout his many movies), here his Apaches, just like the white men, are both noble (in their struggle) and savage (in war). Whether this particular story actually happened is not the point. As we understand American history, it could have happened. Ford accurately depicts the Apaches as well as the settlers—the stakes are high for each group—and though the cavalry rather theatrically arrives to save the stagecoach party, both sides suffer casualties and neither side "wins." In fact, Ringo's heroism during the Indian attack permits the stagecoach party to reach Lordsburg safely and earns him the freedom to avenge the deaths of his father and brother. That, of course, is one of the movie's personal themes: Ringo's revenge.

However, Ford sees many sad elements in the westward expansion, and these issues are related to the setting in which the story takes place: the displacement of the Native Americans, the migration of discriminatory social patterns from the East and South to the West, the establishment of uncivilized towns, and the dissolution of moral character among the settlers. Here and in his other westerns, Ford created his own vision of how the West was won. Most critics recognize that this vision is

part real and part mythic, combining as it does the retelling of actual incidents with a strong overlay of Ford's ideas on how people behaved (or should have behaved). One of Ford's persistent beliefs is that civilization occurs as a result of a genuine community built—in the wilderness—through heroism and shared values. In Ford's overall vision, the American hero is always fighting for his or her rights, whether that fight is against the British, the Native Americans, or the fascists. Precisely because the beauty of Monument Valley means so many different things to different people, it becomes a symbol of the many outcomes that can result from exploration, settlement, and the inevitable territorial disputes that follow. But there seems little doubt that Ford himself is speaking (through Dr. Boone) at the end of the film. As Ringo and Dallas ride off to freedom across the border, Dr. Boone utters the paradoxical observation, "Well. They're saved from the blessings of civilization."

QUESTIONS FOR REVIEW

1. What do we mean when we apply the terms *form* and *content* to a movie? What are the differences and similarities between them?
2. Given the different ways the terms *form* and *content* are defined, why do we emphasize that they are "interrelated, interdependent, and interactive"?
3. Why do people tend to respond more readily to a movie's *narrative* than to any other element of its form?
4. How (and why) do we distinguish between the *story* and the *plot* of a movie? What is meant by the *diegesis* of a story? What is the difference between *diegetic* and *nondiegetic elements* in the plot?
5. What is the one essential difference between novelistic and cinematic *point of view?*
6. How does the *omniscient point of view* differ from the *mental or subjective point of view of an individual character?*
7. Compare and contrast *scope* and *setting.* How are they interdependent? What implications for production are created by a movie's having great scope and many settings?
8. What is the primary difference between *cause-and-effect* and *ambiguous* plot order?
9. How does *suspense* differ from *surprise?*
10. How does *cinematic time* differ from *real time?*
11. Define the three kinds of *plot duration.*

QUESTIONS FOR ANALYSIS

1. In the movie or clip you are analyzing, how are the three kinds of *duration* employed?
2. What is the *genre* of its story (see "Types of Movies" in chapter 1)? In your experience with this genre, does this story conform or not conform to its usual type or expected pattern?
3. Does the plot achieve *form, coherence,* and *unity* in telling the story?
4. Which, if any, elements of the plot appear with noticeable *frequency?* What is the nature of this frequency (e.g., similar repetition or juxtaposition)? Does this frequency suggest ways in which you might interpret the movie or clip?
5. Does the director use elements such as flash-forwards or flashbacks to manipulate the plot order? If so, do they help create unity, or do they just call attention to themselves? Are they effective in helping you to understand the story?
6. Does the director of this movie deliberately use any of the following plot devices—*order, duration, frequency*—in creating meaning?

7. In this movie, are the *characters* more important than the *plot?* If so, explain how.

FOR FURTHER READING

Beardsley, Monroe C. *Aesthetics: Problems in the Philosophy of Criticism.* New York: Harcourt, Brace, 1958.

Bordwell, David. *Making Meaning: Inference and Rhetoric in the Interpretation of Cinema.* Cambridge, Mass.: Harvard University Press, 1989.

———. *Narration in the Fiction Film.* Madison: University of Wisconsin Press, 1985.

Branigan, Edward. *Narrative Comprehension and Film.* New York: Routledge, 1992.

———. *Point of View in the Cinema: A Theory of Narration and Subjectivity in Classical Film.* New York: Mouton, 1984.

Chatman, Seymour, *Coming to Terms: The Rhetoric of Narrative in Fiction and Film.* Ithaca: Cornell University Press, 1990.

———. *Story and Discourse: Narrative Structure in Fiction and Film.* Ithaca: Cornell University Press, 1978.

Fell, John. *Film and the Narrative Tradition.* Norman: University of Oklahoma Press, 1974.

Neale, Stephen, and Murray Smith, eds. *Contemporary Hollywood Cinema.* New York: Routledge, 1998.

Thompson, Kristin. *Storytelling in the New Hollywood: Understanding Classical Narrative Technique.* Cambridge, Mass.: Harvard University Press, 1999.

Production Code

Black, Gregory D. *Hollywood Censored: Morality Codes, Catholics, and the Movies.* Cambridge: Cambridge University Press, 1994.

Jacobs, Lea. *The Wages of Sin: Censorship and the Fallen Woman Film.* Madison: University of Wisconsin Press, 1991.

Martin, Olga J. *Hollywood's Movie Commandments: A Handbook for Motion Picture Writers and Reviewers.* New York: H. W. Wilson, 1937.

Moley, Raymond. "The Birth of the Motion Picture Code." In *The Movies in Our Midst: Documents in the Cultural History of Film in America,* ed Gerald Mast, 317–21. Chicago: University of Chicago Press, 1982.

"The Motion Picture Production Code of 1930." In *The Movies in Our Midst: Documents in the Cultural History of Film in America,* ed. Gerald Mast, 321–33. Chicago: University of Chicago Press, 1982.

Schumach, Murray. *The Face on the Cutting Room Floor: The Story of Movie and Television Censorship.* New York: Morrow, 1964.

Mise-en-Scène and Design

WHAT IS MISE-EN-SCÈNE?

Mise-en-scène (pronounced *meez-ahn-sen*) is a physical creation and an *emotional* concept; this may be why the French film theorist and filmmaker Alexandre Astruc once said, perhaps in jest, that Americans cannot genuinely understand it, because they rely too much on words and do not use their hands enough when they are explaining unfamiliar concepts. How would you convey the mood and atmosphere of your favorite restaurant to someone who has never been there? You might begin by describing with words and gestures details of architecture, decor, color, lighting, and sound to give your listener your own sense of the design, the form, of the place. The description would become a very personal thing. Similarly, in describing the mise-en-scène of a movie, you might use your hands, making inclusive gestures.

The French phrase *mise en scène* (staging, production) literally means "staging or putting on an action or scene" in the theater or cinema. In critical analyses of movies, the term refers to filmmakers' control of such staging, or how filmmakers determine what the audience sees and hears within the frame of the movie image. What are the functions of the frame and the process known as framing? To begin with, the frame demarcates the three dimensions—height, width, and depth—of the image we see on the screen (on the illusion of the third dimension within a two-dimensional image, see "Depth" in chapter 4). Working within those boundaries, filmmakers decide what to include and exclude; determine what is seen and not seen (offscreen and onscreen space); and control the distribution, balance, and spatial and perspectival relations of what appears on the screen. In controlling the fram-

ing, filmmakers shape the form, content, and meaning of the image. Thus mise-en-scène results from the filmmakers' total control of exactly what occurs within the frame, both visually and aurally.

In theory, framing is an exacting process, measured precisely in height, width, and depth. But, in the real world of moviemaking, it usually involves a period of trial and error, starting during preproduction with early rehearsals that involve the camera, lighting, and placement of the actors and continuing during production. Each rehearsal can suggest a different way of looking at a shot and putting it on film. The process of visualizing and composing a shot runs right up to the moment the cameras start to roll and, of course, may incorporate further change if experimentation keeps going with different takes of the same shot.

In other words, planning any shot means placing people, objects, and elements of decor; determining their movements (if any); setting up the lighting; figuring out the camera angles from which they will be photographed; and creating the sounds that emanate from the shot. Mise-en-scène—which includes both *what* is put before the camera and *how* it is photographed—is the *result* of that planning. To be sure, impressive aspects of a movie's mise-en-scène can occur by chance, *without* planning, whether through an act of nature (e.g., a sudden rainstorm), an actor's deviating from script, or other accident. Definitions of the term differ, but it generally denotes the total arrangement of settings, costumes, lighting, sound, and acting—everything you see and hear on the screen, from frame to frame. (Some critics and instructors limit mise-en-scène to people, objects, and elements of decor, while I and others include sound within mise-en-scène.) These variations re-

[1]

[2]

Two types of finely controlled mise-en-scène in Stanley Kubrick's *Eyes Wide Shut* (1999): (1) In this indirect-point-of-view shot, we see through the eyes of Dr. William Harford (Tom Cruise, not pictured) as he is brought before a ritualistic tribunal. Painterly framing concentrates our attention and thus accentuates the scene's harrowing, hallucinatory effects. Every particular in this image—the elaborate architecture, the beautiful masks and cloaks, the color scheme, the staging—makes clear that Harford is headed into the center of power within this cinematic underworld. (2) In contrast, a scene in

which Harford searches for a costume in New York City's Greenwich Village seems natural, chaotic, even haphazard—but this illusion has been constructed as carefully as every other one in the movie. Here, the darkly clad Harford is the focal point amid more visual information than we can absorb. We note the urgency of his quest, not the details of the surroundings. (In fact, Kubrick filmed the Greenwich Village scenes not in his native New York but on sets in his adopted home, London. That the street names and shop names do not correspond to real ones in New York alerts sharp-eyed viewers to the sets' artificiality.)

flect different views of how a movie is made: specifically, the extent to which the director has (or doesn't have) the sort of total control that we tend to associate with all creative artists. As the system of producing movies evolved into the rigidly compartmentalized studio system, the director often did not have that control, particularly over postproduction (e.g., sound recording). Today's movie industry, which combines many conventions established in the studio system with the more contemporary conventions of the independent

production system, has placed more power in the hands of the director.[1] In any event, while some directors display their control of mise-en-scène and some don't, directors usually

[1]David Bordwell argues that the evolution of mise-en-scène has been influenced by two factors: the desire to respond to technological progress and the desire to preserve some sense of stylistic continuity; see Bordwell, *On the History of Film Style* (Cambridge, Mass.: Harvard University Press, 1997), 163–267. For a full discussion of the studio and independent systems of Hollywood film production, see the appendix, "Overview of Hollywood Production Systems."

work collaboratively with their teams. Consciously and deliberately put there by someone, "staged" for the camera, mise-en-scène happens because the director and his or her creative colleagues have envisioned it.

You should find this term quite useful for explaining how all the formal elements of cinema contribute to your interpretation of a film's meanings. Indeed, the more familiar you become with film history, the more you will see that it can be used to describe the work of many great directors noted for their consummate manipulation of cinematic form: Sergei Eisenstein, John Ford, D. W. Griffith, Howard Hawks, Alfred Hitchcock, Buster Keaton, Stanley Kubrick, Fritz Lang, Kenji Mizoguchi, F. W. Murnau, Max Ophüls, Yasujiro Ozu, Otto Preminger, Nicholas Ray, Satyajit Ray, Jean Renoir, Roberto Rossellini, Josef von Sternberg, Erich von Stroheim, and Orson Welles, to name a few. The work of such directors calls our attention to scope as well as to detail, to light as well as to shadow or smoke, to action as well as to nuance. But while mise-en-scène can be highly personal, and can help us distinguish one director's work from another's, we can't lose sight of two somewhat contradictory facts: first, during Hollywood's golden age, the studios produced many films that bore their own, not the individual filmmakers', stylistic stamps; and second, within both the studio and independent systems, a particular collaborator on a film can make a marked difference in a film's look.

Let's look closely at the mise-en-scène of two continuous shots in F. W. Murnau's *Sunrise* (1927), his greatest film and a masterpiece of American and world cinema. After his earlier films, especially *Nosferatu* (1922) and *The Last Laugh* (*Der letzte Mann*, 1924), enjoyed great success in Germany, Murnau was invited by William Fox to Hollywood and given

complete freedom to make *Sunrise* at Twentieth Century Fox Studios. Much of the movie's reputation rests on how Murnau designed and photographed space to develop characters and psychological conflicts.

Sunrise tells the simple but powerful story of how the City Woman (Margaret Livingston), who is vacationing in a country village, threatens the happy marriage of the Man (George O'Brien) and the Woman (Janet Gaynor)—simple country people in comparison to the worldly woman—by seducing the husband and persuading him to kill his wife and run away with her. Murnau uses film to express a pattern of human relations, which over two days (chronicled by images of moon/sun/moon/sunrise again) progresses from the Man and the Woman's togetherness in love to their temporary but devastating separation by the Man's murder attempt, as well as by a storm, and eventually to their reunion in love. This pattern (togetherness/separation) is established by a single shot very early in the movie. In it, an older married couple—*not* the Man and the Woman—sit in the foreground eating dinner while the City Woman, who is lodging with them, enters the room through a door in the background. Dressed in her best evening clothes, she interrupts the couple's dinner to show the older woman some dirt on her shoes, at which point the older woman gets up. After a cut, she wipes the City Woman's shoes clean.

Murnau exercises complete control over all the compositional elements of this brief sequence, providing nothing extraneous to divert our attention and guaranteeing a single interpretation. The film wants to express a definite idea, and here the dominant action involves only one thing: the City Woman's interrupting the couple, coming between them visually, and making a gesture that implies

[1]

[2]

This is the first moment in F. W. Murnau's *Sunrise* when the City Woman dominates others and has her way, and a little dirt on her shoes lets us know that she represents trouble. But in designing, staging, and photographing the scene, Murnau goes far beyond this little kitchen to the worlds of other movies and myth. Through a single shot, he portrays the City Woman as a vamp, a woman who uses her sexual attractiveness to seduce and manipulate others. (Short for "vampire," the word *vamp* was applied to certain femmes fatales, such as the 1920s movie actor Theda Bara.) Taking a major idea from his *Nosferatu* (1922), the first film on the Dracula legend, Murnau further suggests that the City Woman is a kind of vampire who comes out only at night, dressed

In black, eventually to have clandestine sexual relations with a Man whose marriage and life she wants to destroy for her own selfish purposes. The exaggerated angles and proportions within this image call our attention to the deliberate composition and framing of the scene—and to the meanings that Murnau is trying to convey through his manipulation of the mise-en-scène. (2) Cutting from the exaggerated framing of the dining area to a shot of the Old Woman cleaning the City Woman's shoes, Murnau reinforces the City Woman's contempt for her hosts (and, by extension, all country folk), her "modernity" (she is smoking), and her seductiveness (she wears silk stockings).

condescendingly that she expects the old woman to be her servant. Murnau's cinematographers, Charles Rosher and Karl Struss, use camera position and angle to intensify this effect. The camera is at the right side of the set, shooting downward from a high angle at a tight triangular composition comprising these three people. Although Murnau is closely associated with the expressive use of the moving camera (a technique we'll explore below), the camera here remains stationary.

The composition is further exaggerated through a forced perspective in which the angle of the kitchen table is raked sharply downward from the left to the right of the foreground. This expressionistic element is further enhanced by the exaggerated size of the bowls and spoons with which the couple eat their meal. We look downward at the sitting couple while the City Woman stands straight and tall in the background. The couple heavily anchor the foreground of the shot, implying

their occupation of the house; the man clearly dominates (we see him from the waist up, his full face in a slight quarter turn to his left) and the woman is subordinate (her back is to the camera and we see nothing of her face, only her tightly coiffed hair, hunched shoulders, and rounded back). Indeed, she seems to be at the bottom tilt of a seesaw or even in danger of slipping off the screen.

Murnau very effectively uses a range of black-and-white tones to accentuate the density and contrast in the composition. The large, brightly lit globe of the lamp hanging at the top left side of the frame seems to have two functions: first, to fully illuminate the man's face; second, to anchor the top left side of the downward diagonal that ends with the equally round figure of the old woman. By contrast, the City Woman, dressed all in black, is backlit in the doorway, which "frames" her against the light and places her as a strong vertical element. According to the traditional scheme of color symbolism, white (the lamp, the man's face, his wife's shawl) here suggests good, and black (the City Woman's clothing and dark verticality against the lopsided horizontality of the foreground composition) suggests evil. Also note the significant contrast between the simple work clothes of the older couple and the City Woman's chic black dress and cloche hat, which are totally inappropriate for a vacation in a farm village (where there is absolutely nothing for her to do at night; this outfit enhances her exoticism when she begins to seduce the Man). Her smoking a cigarette and wearing high-heel shoes, which will sink into the mud later in the movie, further underscore how out of place she is.

Ordinarily, when discussing the composition of a frame, we divide it theoretically into three **planes**—foreground, middle ground, and background—and this helps us identify, say, the loaf of bread in the left foreground and the steaming pot on the stove in the right middle ground. However, the short distance between the man and the City Woman doesn't permit much discussion of background here. In fact, the scene has been foreshortened by the extreme angularity of the table, the receding composition upward and to the left from the older woman to the lamp, and the relative unimportance of the actual background (the area from which the City Woman has entered the room). In creating the space for this frame, space we can see as both physical and psychological, Murnau achieves several seemingly contradictory effects. He *romantically* idealizes the older couple's simple life, he *realistically* acknowledges the City Woman's threat to the stability of that life, and he *expressionistically* distorts and exaggerates the contrasts in the composition and setting.

Because of their complexity, two elements of mise-en-scène (as defined here) merit separate discussions—acting in chapter 5, sound in chapter 7. In this chapter, we will focus on the visual aspects of mise-en-scène—or on those filmmaking concepts and filmmakers' actions that determine just what we see onscreen. The more closely we look at individual frames and specific details from movies, the better we'll understand mise-en-scène as something more concrete than hand motions could ever convey.

COMPOSITION AND MISE-EN-SCÈNE

While mise-en-scène is a *product* of directorial vision and planning, **composition** is the *process* of visualizing and putting those plans

into practice. More precisely, composition is the organization, distribution, balance, and general relationship of stationary objects and **figures** (any significant things that move on the screen—people, animals, objects), as well as of light, shade, line, and color *within the frame*. Composition is one aspect of mise-en-scène; the two are bound together in a cause-and-effect relationship that calls attention to the actual work of the director and the production team. Ensuring that such organization helps develop a movie's narrative and suggest its meanings requires much thought and discussion, and filmmakers generally use drawings and models to aid them in visualizing each shot and achieving a unified whole: general sketches of the look of overall scenes, specific set designs, costume designs, storyboards for particular shot sequences, and so on. In shaping a movie's mise-en-scène, filmmakers determine two aspects of composition: *framing (what we see on the screen)* and *kinesis (what moves on the screen)*.

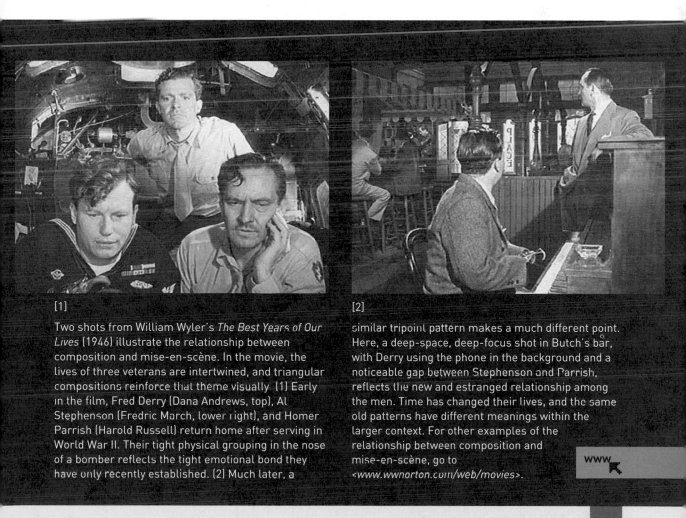

[1]

[2]

Two shots from William Wyler's *The Best Years of Our Lives* (1946) illustrate the relationship between composition and mise-en-scène. In the movie, the lives of three veterans are intertwined, and triangular compositions reinforce that theme visually. [1] Early in the film, Fred Derry (Dana Andrews, top), Al Stephenson (Fredric March, lower right), and Homer Parrish (Harold Russell) return home after serving in World War II. Their tight physical grouping in the nose of a bomber reflects the tight emotional bond they have only recently established. [2] Much later, a similar tripoint pattern makes a much different point. Here, a deep-space, deep-focus shot in Butch's bar, with Derry using the phone in the background and a noticeable gap between Stephenson and Parrish, reflects the new and estranged relationship among the men. Time has changed their lives, and the same old patterns have different meanings within the larger context. For other examples of the relationship between composition and mise-en-scène, go to <www.wwnorton.com/web/movies>.

www

FRAMING: WHAT WE SEE ON THE SCREEN

As we noted in chapter 1 (in "Movies Manipulate Space and Time in Ways That Other Art Forms Cannot"), the human eye and the camera eye see in different ways. The human eye, for example, can see outside the central area of focus (i.e., it has peripheral or side vision), and it automatically adjusts to conditions of light. The camera eye, and thus the motion picture image that results from it, restricts vision to what filmmakers want us to see. However, the frame around a motion picture image, unlike the impersonal frame around a painting, also has dynamic functions. It frames moving action, can move and thus change its viewpoint (thereby becoming a **moving frame**,) and actually helps create the image for us.

How filmmakers envision the look of a film, and how the camera interprets that vision, depends on the fundamental fact that cinematic seeing *is* framing. The frame of the camera's **viewfinder** (the little window you look through when taking a picture) indicates the boundaries of the camera's point of view. This is true for any camera, whether it takes still or moving photographs. What the camera operator sees through the viewfinder of a motion picture camera matches almost exactly what we see on the screen (absent, of course, elements added later, such as special effects). Even without a camera, you can demonstrate this to yourself. Put your hands together to form a rectangular frame, then look through it. If you move it to the left or the right, or tilt it up or down, you will see instantly how framing (and moving the frame) changes what you see. (On the relationship between the frame's width and its height, known as its *aspect ratio,* see "Framing of the Shot" in chapter 4.)

Furthermore, the frame offers filmmakers complete control over two kinds of cinematic space: the **onscreen space** inside the frame and the **offscreen space** outside it. Through framing, onscreen space includes the people and objects the filmmakers want us to see, creates relationships between people and objects, and focuses our concentration on what we see by excluding the rest of the world from the frame. Though such exclusion might seem to be its only function, offscreen space is more complex than that. Film theorist Noël Burch suggests that the entire visual composition of a shot depends on the existence of both on- and offscreen spaces, which he argues are equally important.[2] He divides offscreen space into six segments: the four infinite spaces that lie beyond the four borders of the frame; the spaces beyond the movie settings, which call our attention to entrances into and exits from the world of the frame; and the space behind the camera, which helps the viewer define the camera's point of view and identify a physical point beyond which characters may pass. Offscreen space has power, as Burch emphasizes: "The longer the screen remains empty, the greater the resulting tension between screen space and off-screen space and the greater the attention concentrated on off-screen space as against screen space" (25).

Orson Welles enjoyed exploiting the possibilities of this tension. For example, *The Magnificent Ambersons* (1942) includes a montage of townspeople talking in groups about the forthcoming marriage of Wilbur Minafer (Donald Dillaway) and Isabel Amberson (Dolores Costello). In one section, the camera frames an intimate scene that includes Mrs.

[2]Noël Burch, *Theory of Film Practice*, trans. Helen R. Lane (1973; reprint, Princeton: Princeton University Press, 1981), 25.

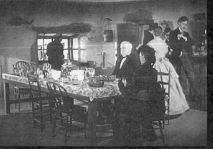

[1]

[2]

[3]

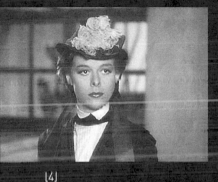

[4]

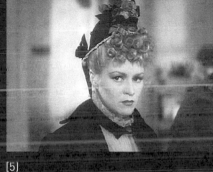

[5]

[6]

In John Ford's *Stagecoach* (1939), the noontime lunch stop at the Dry Fork Station illustrates social division among the characters. By cutting between different points of view—both omniscient and near-subjective—Ford literally divides the characters and dramatically energizes their onscreen and offscreen spaces.

[7]

[8]

(1) The scene opens by establishing the location, showing two of the room's four walls. Following this *establishing shot,* a series of cuts fills in parts of the room not seen here. (2) Revealing a third wall but keeping us oriented by showing the chairs and part of the table, this shot takes us to what had been offscreen space and remains marginal territory, where Ringo (John Wayne) and Dallas (Claire Trevor) interact before he seats her at the table. (3) Opposed to Ringo and Dallas, on the other side of the room, are Gatewood (Berton Churchill, on the left), Hatfield (John Carradine), and Lucy (Louise Platt), three characters who consider themselves socially superior to the others. (4) From yet another perspective, we see the room's fourth wall and Lucy, who stares coldly and haughtily at (5) Dallas, who yields no ground. (6) When Ringo defies the anger rising across the table (a reinforcement of his position in shot 2), (7) Hatfield escorts Lucy away from Dallas (a reinforcement of their position in shot 3) to (8) the opposite end of the table, which we see from an entirely new perspective. Thus an area that had been largely offscreen, hardly registering, takes prominence, especially in contrast to the brightly lit, vacant, and exposed end of the table. To view a clip, consult your CD-ROM.

3.1

Foster (Anne O'Neal) being fitted for a dress at home, surrounded by a group of her friends, with whom she enviously gossips. Suddenly, a hand holding a teacup abruptly enters the screen; Mrs. Foster takes the cup and addresses the woman who gave it to her. While this woman, now in the left corner of the frame, remains unidentified, her action reminds us that this intimate scene is taking place in a larger space. In *Chinatown* (1974), Roman Polanski uses a spatially deep scene to accentuate the crucial meeting between J. J. Gittes (Jack Nicholson) and Noah Cross (John Huston). From a camera viewpoint on an exterior terrace (foreground), we look through a door into an interior foyer (middle ground) and beyond to the front door of the house and its exterior front porch (background). As the scene begins, no one is in the frame, but a puff of cigarette smoke enters the left side of the frame and lets us know that Gittes is waiting there. Soon, Cross steps onto the front porch, enters the house, crosses the foyer, appears on the terrace, looks offscreen at Gittes, and says, "Oh, there you are." Gittes then enters the frame, and their conversation begins.

The first and most obvious function of the motion picture frame is to control our *perception* of the world by enclosing what we see within a rectangular border, generally wider than it is high. Because it shapes the image in a configuration that does not allow for peripheral vision, and thus does not conform to our visual perception, we understand framing as one of the many conventions through which cinema gives form to what we see on the screen. Film theorist Leo Braudy, one of many writers to study the relationship between cinematic arrangement and viewer perception, distinguishes between "open" and "closed" frames as two ways of representing the visible world, two ways of designing a film, two ways

of framing it, two ways of perceiving it, and two ways of interpreting it. We can define both types of frames simply and concretely: an **open frame** is one that people and things can enter and leave; a **closed frame** is one that neither characters nor objects enter or leave. The open frame is generally employed in realistic films, the closed frame in antirealistic (e.g., expressionistic) films. In the realistic film, the director thinks of the frame as a "window" on the world, a window that provides many views. Since the "reality" being depicted changes continuously, the movie's framing changes with it. In the antirealistic film, the director thinks of the frame as being similar to the frame of a painting or photograph, enclosing or limiting the world by providing only one view. Since only that one view exists, everything within the frame has its particular place. As Figure 3.1 shows, the differences between these ways of handling cinematic space is a matter of degree, not kind; of emphasis, not exclusive definition.

To explore this idea further, let's analyze the framing of two key scenes that take place at crossroads: an "open" treatment in Robert Zemeckis's *Cast Away* (2000) and a "closed" treatment in Alfred Hitchcock's *North by Northwest* (1959). In the final scene of *Cast Away,* Chuck Noland (Tom Hanks), a FedEx executive, returns to Memphis after surviving a plane crash and four years of being stranded on a South Pacific island. Assuming that he died in the crash, his former fiancée has married, so Noland leaves town, stopping first to deliver a package he saved from the crash. He then parks at a nearby crossroads to decide in which direction he wants to go next. Within Zemeckis's frame, we see a classic crossing of two country roads in the midst of green, fertile fields; the four corners are marked with directional signposts. A woman stops to give

[1]

[4]

[2]

[5]

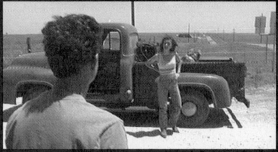
[3]

[6]

Open and closed framings at two American crossroads: In Robert Zemeckis's *Cast Away*, (1) Chuck Noland (Tom Hanks) receives directions from Bettina Peterson (Lari White), (2) considers his options, and (3) wonders if Peterson's path is the one he should follow. In Alfred Hitchcock's *North by Northwest*, (4) Roger Thornhill (Cary Grant) spots (5) the plane that (6) pursues him no matter where he runs. As vast and as similar as these physical places are, they represent very different psychological spaces: the T-shirted Noland ponders an open-ended choice while the nattily dressed, initially buttoned-up Thornhill faces diminishing options for escape. To view sequences of stills from these scenes, go to <*www.wwnorton.com/web/movies*>.

3.2

| FIG. 3.1 | OPEN AND CLOSED FILMS |

	Open	Closed
Description Keyword	Realistic	Expressionistic
Visual Characteristics	Normal depth, perspective, light, and scale; generally, color film stock and widescreen aspect ratio best present the open, "real" world; typically shot outside the studio.	Exaggerated and stylized depth; out of perspective; distorted or exaggerated light and shadow; distorted scale; generally, black-and-white film stock and Academy aspect ratio best present the closed, self-sufficient world, typically shot inside the studio, including depictions of the "real" world.
Framing of the Story's World	The world of the story, based on reality, changes, and framing changes with it; the director thinks of the frame as a "window" on the world, and other views of that world are possible.	The world of the story is the only one that exists, and everything within the frame has its place; the director thinks of the frame as being similar to the frame of a painting or photograph, and thus only one view of this world is possible.
Exclusive and Inclusive Framing	Characters may walk out of the frame to another place in the movie's world, and we understand where they are going and also accept that they may return to the film's current view of the world.	Characters are controlled by outside forces, ultimately by the director, and do not have the free will to come and go as they wish; they cannot escape from the logic that drives the film's actions and events.
Relationship of Characters to Design Elements	The characters are more important than the sets, costumes, and other design elements.	Design elements call attention to themselves and may be more important than the characters.
Story and Plot	Story and plot are generated by the characters' psychology and free will.	Story and plot do not grow from the characters and their motivations, but are imposed on them.
Endings	The conflicts are not necessarily resolved.	Conflicts have predetermined resolutions.

	Open	Closed
Description Keyword	Realistic	Expressionistic
Impact on Interpretation	We are able to interpret the "real" world of the "open" film as being complex, difficult to understand, and usually ambiguous, but basically benevolent.	We are led to see the "closed" world as understandable but almost impossible to escape from and thus basically malevolent.
Role of Viewers	We are "guests" of the director, who permits us interpretive freedom.	We are "victims" of the director, who exercises almost complete interpretive control over us.

Source: Adapted from Leo Braudy, *The World in a Frame: What We See in Films* (1976; reprint, Chicago: University of Chicago Press, 1984), 1–103.

Noland directions, and as she drives away, he realizes she is the person for whom he left the package. Noland's belated identification of the woman in the truck suggests he will follow her, but will he? Should he pursue this woman—who could potentially fill the void left by his former fiancée—or should he move on to an entirely unknown future? Framed in the exact center of the crossroads, Noland does not let us know which road he will take. By contrast, in *North by Northwest,* Roger O. Thornhill (Cary Grant) finds himself in the middle of farmland somewhere outside Chicago, as a result of a series of circumstances too complicated to relate here. Hitchcock frames him very differently than Zemeckis did Noland. We see a long, straight highway, from which dirt roads lead into the fields, and no signpost marks the place where the bus drops Thornhill. Unlike Noland, he has only a vague mission and is helpless because he does not know who or what he might encounter. Framed on a highway, as rigidly placed as if he were in the crosshairs of a gunsight, he becomes the target for a surreal and potentially deadly attack by a crop-dusting airplane. He literally has no choice about where to run or hide. Thornhill's eventual escape in a stolen truck indicates his quick-witted ability to use the means at hand to save himself, but notice the framing of this escape. He acts, but his actions take on a particular cast because of what we see in the frame. In the final shot, he makes a U-turn with the stolen truck, and, with the truck's owner running after him for a few hundred feet, he speeds down the deserted country highway toward the horizon. Although we're delighted by Thornhill's audacious escape, we're also left behind, distanced from him, asked not to enter into his consciousness, and encouraged to view him as an object rather than a subject within the mise-en-scène.

KINESIS: WHAT MOVES ON THE SCREEN

Kinesis—from the Greek word meaning motion in response to a stimulus such as light—helps differentiate those art forms that move (music, dance, cinema) from those that do not (painting, literature, architecture). This per-

ception of "motion" can be accomplished in many ways in film, including the use of music in an otherwise static scene, but it is caused mainly by the movement of objects and characters within the frame and by the apparent movement of the camera, which we call the *moving frame*. (The qualification "apparent" is needed because the illusion of movement can be created through animation or special effects.) Each type of cinematic movement—as indeed of musical or choreographic movement—can be as kinetic as the filmmakers wish. And while it is possible to "read" a musical score, a dance script (in one of the various forms of dance notation), or a movie script, they really provide little more than cues for experts to study. We must see actual performances or screenings of these art forms to grasp their essence—their *movement*—and to experience the pleasure of that movement. Although their particular applications will differ depending on the specific work, both types of movement are part of any movie's mise-en-scène because they are controlled—staged, put into the frame—by the filmmakers. How particular filmmakers handle the elements of cinematic form (cinematograpy, editing, and so on) determines how we will see and how we interpret all movement in a movie.

Throughout the history of film—from the swashbuckling of Hollywood legend Douglas Fairbanks to the cinematic portrayals of Shakespeare's *Hamlet* by Laurence Olivier, Mel Gibson, Kenneth Branagh, and many others to the movie careers of martial artists such as Bruce Lee and Jackie Chan—the old-fashioned art of swordplay has always been one of the most exciting forms of movement onscreen. Ang Lee's *Crouching Tiger, Hidden Dragon,* a contemporary update of Hong Kong sword-and-sorcery movies, combines martial arts with elaborate choreography. In playing the nobleman's-daughter-turned-warrior Jen Yu, shown above in one of many fight sequences, actress Ziyi Zhang used her training in dance as well as her martial-arts skills. To learn more about the artistry behind action scenes, and about our appreciation of kinesthetic motion in cinema, go to <www.wwnorton.com/web/movies>.

www

In other words, all movies *move,* but some move more and differently than others. Max Ophüls's *Lola Montès* (1955) almost overwhelms us with its rich choreography of actors and elegant camera movement. Some narrative films make us feel as if we have left all natural boundaries of time and space: Abel Gance's *Napoléon* (1927), in which shots of Napoleon's boat, tossed by a violent storm at sea, are intercut with shots of a political "storm" at a convention; Stanley Kubrick's *2001: A Space Odyssey* (1968), with its spacecraft "ballets" choreographed to Strauss waltzes; Ang Lee's *Crouching Tiger, Hidden Dragon* (*Wo hu cang long,* 2000), in which characters seem to fly, to fight in the air, and to balance on tree limbs. The movement in many experimental films tends to be abstract, meaning that we see moving shapes, objects, and forms, rather than actors, animals, or vehicles. Finally, the kinetic quality of many movies is determined by their genres: thus westerns, war films, cartoons, and comedies tend to include more and faster movement than do love stories or biographical films.

Many great films—Carl Theodor Dreyer's *The Passion of Joan of Arc* (*La passion de Jeanne d'Arc,* 1928), Robert Bresson's *Diary of a Country Priest* (*Journal dún curé de campagne,* 1950), Yasujiro Ozu's *Tokyo Story* (*Tokyo monogatari,* 1953), and Michelangelo Antonioni's *The Outcry* (*Il Grido,* 1957), for example—use little movement and action. That "lack" of action represents not only their way of looking at the world (framing it) but also the right way to tell their stories. So which movie is the more "cinematic"—one that moves all the time or one that moves hardly at all? Because kinetic power is only one of the inherent creative possibilities of movies, not an essential quality of every

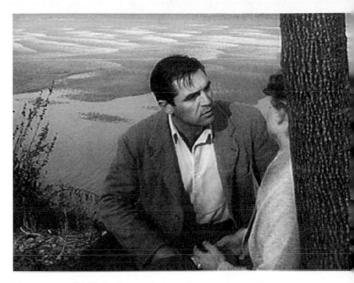

Movement within the frame is not always appropriate to the subject, the look, or the feel of a particular movie, scene, or shot. Although all movies provide the illusion of movement, some movies, such as Michelangelo Antonioni's *The Outcry,* are satisfying and rich precisely because of their relative stillness. Throughout *The Outcry,* Antonioni uses the setting—Italy's Po River valley—to echo the characters' emotions. In this shot, the desolate marshland in the background fills nearly half of the frame behind Aldo (Steve Cochran) as he realizes that recently widowed Irma (Alida Valli), whom he has waited seven years to marry, is rejecting him.

movie, this question can be answered only by examining the relationship among the movement, narrative, and overall mise-en-scène. In this way, we can determine what movement is appropriate and, furthermore, what movement *works* to control perceptions. To condemn *Tokyo Story*'s lack of movement when compared to the frenetic movement in, say, George P. Cosmatos's *Rambo: First Blood Part II* (1985) is equivalent to condemning Shakespeare for not writing in the style of contemporary playwright Harold Pinter. In other words, the comparison is unfair to both sides.

MOVEMENT OF FIGURES WITHIN THE FRAME.

The most important figure is usually the actor, who is cast, dressed, made up, and directed for the film and thus is a vital element in the mise-en-scène. The final element that the director and the filmmaking team must consider in designing a film is how all the actor figures will move within the space created to tell the story. *Where* and *how* a figure moves may dictate the width, depth, and height of the setting in which that movement occurs. The overall setting must be appropriate for both of these aspects of movement. Consider Buster Keaton, who was a master at designing cinematic space and framing and

Buster Keaton was a master of movement within the frame, a genius of pratfalls, near-misses, and physical coincidences. The impressive acrobatics and meticulous choreography in Keaton's *The General,* among the finest comic uses of movement in film history, are all the more impressive because he performed the stunts not through special effects but live, in full view of the camera. To view a clip, consult your CD-ROM.

3.3

photographing it to fit his style as an actor. In *The General* (1926), Johnnie Gray (Keaton), a locomotive engineer in command of a borrowed train, "The Texas," tries to reclaim his own train, "The General," from the enemy Northerners, who have stolen it. He attaches a cannon to his train, loads it with ammunition—first with a handful, and then more thoughtfully with a pinch—and lights it. We see the enemy, and then we see Johnnie's cannon firing and the ball landing right next to him in the locomotive. Nonchalantly, he rolls it off the train and seems bewildered when it explodes down the track a few moments later. Now, he reloads the cannon with everything he's got. However, as he struggles to get back to the locomotive and gain control of the train, he encounters various obstacles, such as getting entangled in a chain. As we watch Keaton use his acrobatic skills to overcome the physical challenges set in his path, we are sure that Johnnie is going to be killed in an explosion. Then comes one of the greatest moments in any Keaton film. As Johnnie's train moves to the left of the screen, the cannon fires ahead at the enemy train going right and blows it up. Thus, accidentally, Johnnie has won his first real confrontation with the enemy. Here, Keaton preserves cinematic time and space as if it were his stage, he keeps himself very much in the center of the frame and our attention, and he lets us see him doing all his stunts himself (no stunt men or "doubles" were used). Raising our expectations and creating considerable suspense, developing his character and encouraging our sympathy for him, Keaton steals the show without leaving the frame.

The great dance musicals—such as Stanley Donen's *Funny Face* (1957), featuring Fred Astaire, and *Singin' in the Rain* (1952), featuring Gene Kelly and codirected by Kelly and

Donen—were planned, composed, and shot to keep each dancer's full figure in view in such scenes as the one in which Kelly and Cyd Charisse (playing an unnamed dancer) perform a sultry routine on a large sound stage. This framing is also seen in all the dance films featuring Astaire and his legendary partner Ginger Rogers, as well as his performance with Cyd Charisse in the "girl hunt" dance sequence in Vincente Minnelli's *The Band Wagon* (1953). In Stanley Donen's *Royal Wedding* (1951), Tom Bowen (Fred Astaire), who is starring in a London musical, falls in love with one of the women in the cast but can't seem to win her over. In despair, he returns to his hotel room and imagines what it would be like to sing and dance for her. The result—Astaire dancing up one wall, across the ceiling, and down the other wall—one of the most truly innovative (not to mention dazzling) uses of cinematic space ever filmed, not only shows the exuberance and exhilaration of a man in love but also conveys the idea that love literally knows no boundaries.

The movements within film acting involve many challenges to actors. Out-of-continuity shooting tests actors' abilities to get "into" the appropriate "characters" at any point in the production, and directors' calls for repeated takes can tax actors' patience and stamina. But the biggest challenge, according to many film actors, is establishing the right relationship between actor and camera. While directors and members of the production team determine the actual physical relationships (called **blocking**), actors must remember that the camera records every facial movement, gesture, even blinking of eyes, especially in close-ups, which are magnified to a larger-than-life size on the screen. (For a full discussion of acting and its relationship to filmmaking, see chapter 5.)

During the Great Depression, director-choreographer Busby Berkeley helped bring to the screen a series of musical-comedy extravaganzas whose titles all began *Gold Diggers*. The first—Mervyn LeRoy's *Gold Diggers of 1933* (1933), choreographed by Berkeley—begins on a prosaic stage ("real," "open" space), enters a realm of complete fantasy (representing what happens to the space in the minds of the characters, as shown above), and then returns to the stage on which it opened. Note that the costumes copy the structure on which the women are standing, whose form repeats the contours of the neon violins they are playing. Furthermore, in keeping with the public's fascination with precision ensembles such as this, these actors' gowns, hairstyles, and smiles are identical.

In *The Unvanquished* (*Aparajito,* 1956), the second film in his Apu trilogy (which includes *The Song of the Little Road* [*Pather Panchali,* 1955] and *The World of Apu* [*Apur Sansar,* 1959]), the great Indian director Satyajit Ray memorably uses details of movement within the frame in two ways. They represent convincing visual images of the real world, and also suggest meanings beyond themselves, thereby functioning like figures of speech such as metaphor. In this case, Ray has used *metonymy*, a figure of speech in which an at-

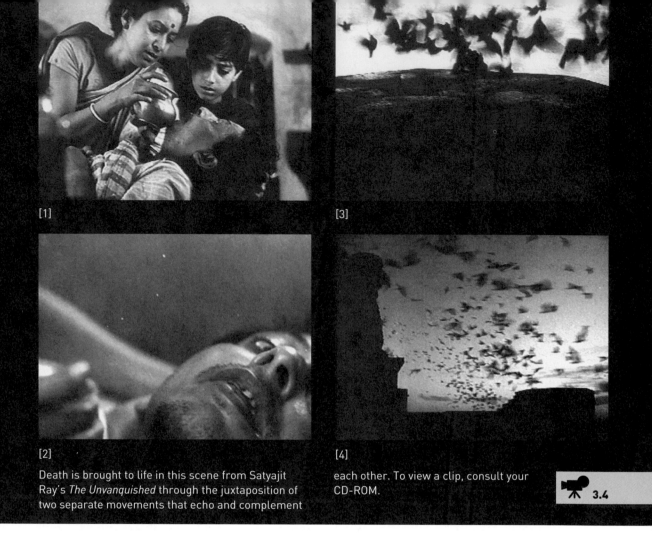

[1]

[3]

[2]

[4]

Death is brought to life in this scene from Satyajit Ray's *The Unvanquished* through the juxtaposition of two separate movements that echo and complement each other. To view a clip, consult your CD-ROM.

3.4

tribute of something stands for the thing itself (e.g., calling military officers "brass"). At this point in the story, Apu (played by Pinaki Sengupta as a ten-year-old and Smaran Ghosal at sixteen) is living with his family in Varanasi, the holiest Hindu city in India, where Harihar (Kanu Bannerjee), his father, a devout holy man, hopes to flourish as a teacher. Ironically, Harihar becomes so weak because of his intense devotion to his duties that he dies. At the moment of his death, Ray uses the flight of birds to represent the release of his soul into the afterlife. The brief scene begins with a close-up of Harihar's face; he sips holy water and collapses backward, at which point the birds take off in flight, then sweep back and forth across the screen. Ray uses the movements of the dying man and the flying birds within the frame, but he also cross-cuts, startlingly, between the shots, visually bringing this moment of death to life. As an element of mise-en-scène, the movement of flight in Ray's

metonymic imagery suggests both cinematic and spiritual meanings. "What did Ray mean by it?" asks film scholar John Russell Taylor. "Probably everything his commentators find and more. Like Ray's recurrent images, it is there for its suggestive power and its rich ambiguity, and it is remarkably successful, producing exactly the sense of release into a new dimension that the film at this point requires."[3]

ANALYZING MISE-EN-SCÈNE

JEAN RENOIR'S *THE RULES OF THE GAME*

French director Jean Renoir is universally acknowledged as one of the cinema's greatest artists. His films tell structurally complex stories, present memorable characters, employ poetic symbolism, and explore depth within their compositions and their cinematography. *The Rules of the Game* (*La Règle du jeu*, 1939) takes place in 1939, in the period preceding the Nazis' occupation of France. Even though an opening title announces that the film is not intended as "social criticism," Renoir called it "an anti-Fascist warning film in the guise of a story about a contemporary houseparty."[4] To accomplish this, Renoir creates what one critic calls "a completely controlled and totally integrated artistic universe"[5] in which

narrative and visual style (architecture, decor, costumes), to name but two elements, combine to create a powerful mise-en-scène, with weighty social, religious, political, and cultural meanings.

This narrative world, a microcosm for France, is represented by two contrasting houses owned by Robert de la Chesnaye (Marcel Dalio) and his wife, Christine (Nora Gregor): a luxurious Paris house and an equally grand country house, La Colinière (literally "the game player"), famous for its weekend hunting parties. The activities at these houses, which take place over several days, involve a group of parallel characters. Robert has a mistress, Geneviève de Narrast (Mila Parély), while Christine is pursued by André Jurieu (Roland Toutain), a famed aviator, as well as by Octave (Renoir). The romantic entanglements of the upper classes are echoed in the behavior of their servants: Christine's maid, Lisette (Paulette Dubost), is married to the gamekeeper, Schumacher (Gaston Modot), but pursued by Marceau (Julien Carette), a poacher. Theoretically, all the characters may engage in such behavior if they follow the "rules" that govern the "game" of marital infidelity; quite simply, you can have all the fun you want with someone else's husband or wife if you don't make the mistake of falling in love. As the title suggests, life is a game, in which winning or losing is less important than playing by the rules, whether those rules concern making love or shooting birds.

The contrasts in the story (city/country, marriage/infidelity, keeping rules/breaking rules, love/sex, old world/new world, comedy/tragedy) are matched by those of the plot, which is full of suspense (how will the various pairs of lovers end up? what will happen to society?) as well as the surprises that come with the disguises, mistaken identities, repetitive

[3]John Russell Taylor, "Satyajit Ray," in *Cinema: A Critical Dictionary: The Major Film-Makers,* ed. Richard Roud (New York: Viking, 1980), 2:818.

[4]Renoir, quoted in Penelope Gilliat, *Jean Renoir: Essays, Conversations, Reviews* (New York: McGraw-Hill, 1975), 59.

[5]Gerald Mast, *Filmguide to "The Rules of the Game"* (Bloomington: Indiana University Press, 1973), 71. My account draws liberally on Mast's excellent book.

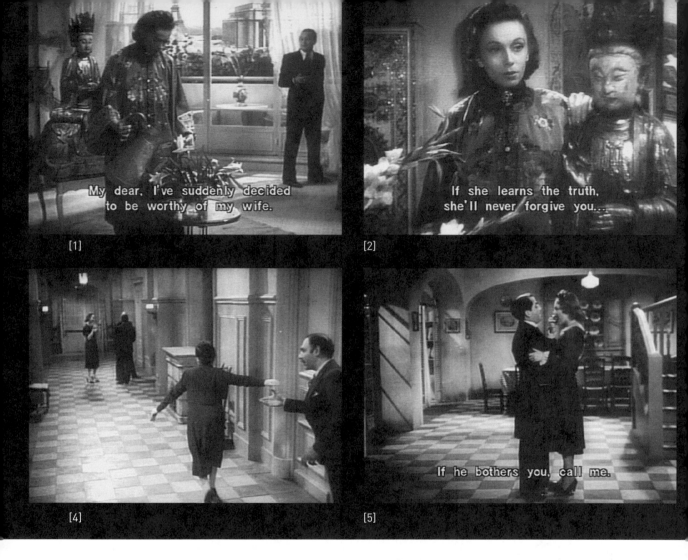

[1]

[2]

[4]

[5]

changing of partners, and comic interludes. In fact, much of the delight we feel in looking at Renoir's movie comes from recognizing how this formal structure permits him to juxtapose tragedy with comedy, heroism with cowardice, toys with real life, women with men, ruling class with serving class, and city with country. These parallels, contrasts, and juxtapositions not only enhance the *form, coherence,* and *unity* of the narrative but also help

provide the *order* that is essential to understanding the story and interpreting its meanings. Furthermore, they help us *feel* its order emotionally and unconsciously from the first, so effective is the mise-en-scène that results from the handling of form. Things come together, things fall apart; we sense this without always understanding why.

Renoir's visual style mirrors the parallel elements in the narrative and also helps create

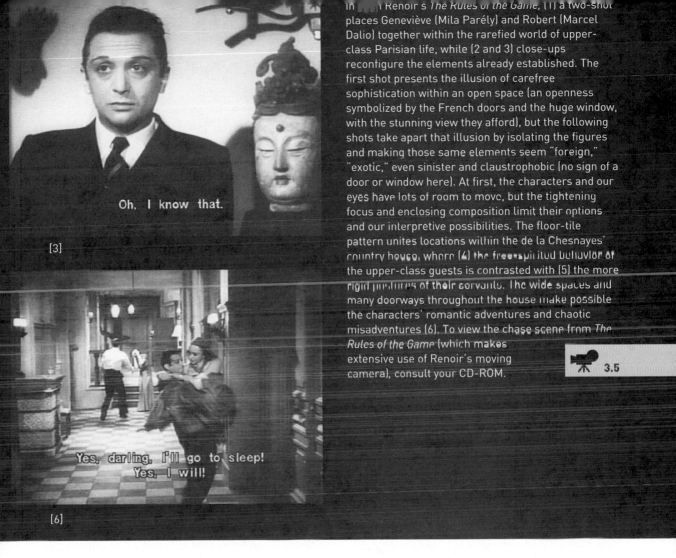

In [] Renoir's *The Rules of the Game*, (1) a two-shot places Geneviève (Mila Parély) and Robert (Marcel Dalio) together within the rarefied world of upper-class Parisian life, while (2 and 3) close-ups reconfigure the elements already established. The first shot presents the illusion of carefree sophistication within an open space (an openness symbolized by the French doors and the huge window, with the stunning view they afford), but the following shots take apart that illusion by isolating the figures and making those same elements seem "foreign," "exotic," even sinister and claustrophobic (no sign of a door or window here). At first, the characters and our eyes have lots of room to move, but the tightening focus and enclosing composition limit their options and our interpretive possibilities. The floor-tile pattern unites locations within the de la Chesnayes' country house, where (4) the free-spirited behavior of the upper-class guests is contrasted with (5) the more rigid postures of their servants. The wide spaces and many doorways throughout the house make possible the characters' romantic adventures and chaotic misadventures (6). To view the chase scene from *The Rules of the Game* (which makes extensive use of Renoir's moving camera), consult your CD-ROM.

3.5

the movie's meanings. To begin with, he depends heavily on the set design (see "Setting," below) by Eugène Lourié, who also designed the director's *Grand Illusion* (*La grande illusion,* 1937), *The Human Beast* (*La bête humaine,* 1938), *The Southerner* (1945), and *The Diary of a Chambermaid* (1946), all films in which the mise-en-scène and narrative are interdependent. The Chesnayes' houses in Paris and the country are grand, classical structures designed inside and out to reflect the wealth and social standing of their owners.

Let's examine the scene in Geneviève's Paris apartment in which Robert and Geneviève discuss the possibility of their breaking up. Here, composition (framing) and architecture are vital to the mise-en-scène, whose motif is contrasts. The composition alternates between two-shots, which keep the couple together (as they have been emotionally), and close-ups,

which separate them (as they think they would like to be). The shots, taken from a camera positioned inside the apartment, contrast the primarily Asian interior decor with the exteriors we see through the window: the Eiffel Tower in the background and a corner of the classical facade of the Palais du Chaillot (now, incidentally, the home of the Cinémathèque Française, the legendary museum and archive of French cinema). Inside, framed separately in close-ups, Robert and Geneviève stand beside statues of Buddha, representatives of a past culture that seems far away from the comparatively modern structures of their own society.

The interior architecture of these houses—especially the size and relationship of the rooms to one another—is integral to the mise-en-scène and to the narrative. Notice, for example, how the long corridor in the chateau is punctuated by doors to all the guests' rooms, so that characters may enter and exit this public and private space according to what they are doing at the moment. The arrangement of the rooms on the ground floor of the chateau not only lets us see action on three planes but also makes possible the farcical running around between those rooms as Schumacher and Marcel argue and the others attempt to stop them. The rushing about of characters in this and other scenes in the film is in the comic style of farce, where authority, order, and morality are at risk and ordinary people are caught up in extraordinary goings on, and it sets up a contrast between the danger of the conflict between the two men and the comedy of its depiction. Again, doors open and close to reveal the separate planes of the composition.

Throughout the film, the extensive use of the moving camera contributes to the restless mood (about half of the film's 337 shots are made with the moving camera); orients us to the size of each house and links its rooms; contrasts upstairs, where the upper classes play, and downstairs, where the lower classes work and play; and relates interior to exterior locations. The moving camera also functions as a fast-moving participant, especially in the duel and chase scenes. By capturing all three planes of the setting, particularly during the scenes inside the chateau, Renoir is able to permit intraframe movement (i.e., movement within, as opposed to between, the frames).

Renoir's mise-en-scène helps us identify the themes and meanings of *The Rules of the Game*. With meticulous detail, he shows us how his characters live, dress, eat, drink, and entertain themselves. As Gerald Mast observes, "Nothing in the film is accidental; everything counts; every event and character parallels or contrasts with some other event and character."[6] Among the explicit meanings are these: nothing is clear in this world, people understand lies better than the truth, and "rules" (whatever they may be) preserve order in society, even when the society itself is decadent. Renoir in addition shows that love, despite its powers, is also governed by rules. We recognize the implicit corollary: the people upstairs are ostensibly different from those who work downstairs, even though the servants emulate the manners of their masters, upsetting the balance between them and signifying another breakup of traditional society. An ideological meaning might be that in the light of imminent social and political changes (always implied rather than stated), the old society is doomed by its adherence to outmoded rules and conventions. Ultimately, Renoir views his world through both "open" and "closed" frames. On one hand, his world is closed because it is as carefully constructed as one of the film's mechanical toys, set in motion by the director and

[6]Mast, *Filmguide to "The Rules of the Game,"* 71.

operating according to the rules he has made for it. On the other hand, his world is open because it is based on reality—the "real" world is clearly there, just outside the chateau—and is therefore constantly changing. By leaving its conflicts open and unresolved, Renoir presents an ambiguous world.

WHAT IS DESIGN?

In creating mise-en-scène, controlling both *what* and *how* we see, filmmakers imagine and design a movie's images; that is, they conceive and create the images according to plan. Indeed, design plays a crucial part in any movie's illusion, for it is visually (and literally) a plan for creating the form of what we see on the screen (structure, size, color, texture, etc.). Sometimes the way a movie *looks* is the most powerful impression we take away from a first viewing. But design involves more than first impressions. Whatever its style and ultimate effect, design should help express a movie's vision; be appropriate for the narrative; create the correct times, spaces, and moods; and relate to developing themes. Let's look more closely at a movie whose overall design meets these criteria: Tim Burton's *Sleepy Hollow* (1999).

This highly stylized reimagining of Washington Irving's tale "The Legend of Sleepy Hollow" (1819–20) so totally changes its source that it in effect leaves the text behind; it emphasizes instead the director's stunning vision and his production team's meticulous realization of the design scheme. Burton's overall goal, in both narrative and production design, was to make this film as weird and scary as possible, linked not only to drawings and paintings of the eighteenth century but also to the horror film genre. While Irving describes the valley of Sleepy Hollow as filled with rippling brooks, cheerful birdcalls, and unchanging tranquillity, Burton depicts it using the design vocabulary of classic horror movies. Among these are James Whale's *Frankenstein* (1931), which ends with an angry mob trapping the Monster in a windmill that they set afire. Burton similarly places the spectacular climax of his film in an ominous windmill, where Ichabod Crane (Johnny Depp) lures the Headless Horseman (Christopher Walken), whose mysterious powers save him from death in the fiery explosion. In addition, Burton draws on Mario Bava's visually sumptuous vampire movie *Black Sunday* (*La maschera del demonio,* 1960), Roman Polanski's *The Fearless Vampire Killers* (1967), and films from Britain's Hammer Studios (the foremost producer of gothic horror films in movie history), whose style was characterized by careful attention to detail—including, of course, lots of blood—in such films as Terence Fisher's *The Curse of Frankenstein* (1957) and *Horror of Dracula* (1958). Burton pays homage to actor Christopher Lee, who played the Creature in *The Curse of Frankenstein,* by casting Lee as the Burgomaster in *Sleepy Hollow.* Finally, in an implicit homage, Depp's portrayal of Ichabod Crane as a frightened, would-be forensic scientist who dreams of justice-through-technology recalls Buster Keaton's portrayal of a man who dreams of being the world's greatest detective, in Keaton's *Sherlock, Jr.* (1924)—not a horror movie but an everlasting tribute to cinematic illusion.

The key members of Burton's design team were Rick Heinrichs, production designer, who shared the 2000 Oscar for Best Art Direction–Set Direction with Peter Young, set decorator; Emmanuel Lubezki, cinematographer; Colleen Atwood, costume designer; Colleen Callaghan, key hairstylist; and Bernadette

Mazur, key makeup artist. Heinrichs, Young, and Atwood had worked previously with Burton—notably, Heinrichs and Atwood on *Edward Scissorhands* (1990), and Heinrichs and Young on *Batman Returns* (1992), whose worlds are as imaginary as Sleepy Hollow—and they all subsequently worked on his *Planet of the Apes* (2001). Of the design scheme for the village, Heinrichs said, "One of the things we were trying to do was inspire a sense of scary portentousness in the village. I think it's different from Irving's Sleepy Hollow which is described as a dozing Dutch farming community. If our Sleepy Hollow is asleep, it's a fitful sort of sleep with nightmares."[7]

To create this gloomy atmosphere, Burton and his collaborators use a muted, even drab color palette, punctuated here and there by carefully placed bright details. (The only consistent deviation is in the sequences depicting Crane's dreams of his mother.) However, as the movie begins, with a prologue and the title credits, the dominant color is not muted but the red of dripping wax being used to seal a last will and testament, a red so evocative that we momentarily mistake it for blood. After sealing his will, Peter Van Garrett (Martin Landau in an uncredited performance), a pale figure wearing a pale yellow silk jacket, flees by carriage with the Headless Horseman in pursuit. The Horseman lops off the head of the coachman and then of Van Garrett, whose blood spatters all over an eerie orange pumpkin head mounted on a stake. Decapitation, a central theme of *Sleepy Hollow,* produces lots of blood, and blood continually spurts throughout the movie in the murders committed by the Horseman as well as in self-inflicted wounds and the gory examinations of dead bodies.

[7]Rick Heinrichs, qtd. in Denise Abbott, "Nightmare by Designs," *Hollywood Reporter,* international weekly edition, 29 February–6 March 2000, S-6.

[1]

[2]

[3]

In Tim Burton's *Sleepy Hollow,* (1) blood-red sealing wax and (2) blood splattered on an evil-looking jack-o'-lantern are the sorts of bold design details that stand out against the movie's generally muted, earth-toned palette, as seen in (3) the harvest party scene, where Katrina Anne Van Tassel (Christina Ricci), blindfolded, first encounters Ichabod Crane (Johnny Depp). Note, in contrast to the smiling children on the right, the jack-o'-lantern in the upper left corner, echoing the sour expression of Crane's eventual romantic rival, Brom Van Brunt (Casper Van Dien).

However, as Ichabod Crane travels by a closed, black carriage between New York City and Sleepy Hollow in the opening and closing scenes of the film, we are introduced to the principal color palette of late fall and early winter: gray river, gray wintry skies, trees almost barren of leaves, and rime on the ground. As day turns to twilight, Crane arrives at the village entrance, marked by two pillars topped by stone stags' heads, and walks down the road through the village and across the fields to the mansion of Baltus Van Tassel (Michael Gambon). The entire scene appears to have been shot in black and white, rather than color, for Crane's extremely pale face provides the only color here, signifying, as we have already learned in theory but will now learn in fact, that the townspeople are scared to death of the Horseman. Completely skeptical of what he considers the "myth" of the Horseman, Crane wears black and looks pallid, priggish, and wary throughout the early part of the movie. The village, the movie's most elaborate outdoor set, was constructed in England in a style that Heinrichs calls "Colonial Expressionism"; it includes a covered wooden bridge, church, general store, midwife's office, tavern, notary public, blacksmith, bank, mill house, warehouses, and several residences. Even the houses are scary, with their gray facades, doors, and shutters. Recalling English and Dutch architecture of the seventeenth and eighteenth centuries, many of these exteriors were also duplicated inside London studios, where heavy layers of artificial fog and smoke and controlled lighting helped create the illusion of a dark, misty valley under a leaden sky.

This mood was clearly influenced by the drawings and paintings of the eighteenth-century British artists William Hogarth and Thomas Rowlandson. In such works as *A Rake's Progress* (1735), Hogarth created series

[4]

[5]

[6]

(4) Baltus Van Tassel (Michael Gambon, standing left) is among the movie's many characters who might have stepped out of period paintings. Indeed, most of Sleepy Hollow's residents seem stuck in an antiquated, vaguely European style of dress, whereas (5) the darkly and sleekly dressed Crane is a "modern" American man of science, here wearing the ambitious but ridiculous instrument he has designed to perform forensic inspections. (6) In a flashback, the "Hessian" (Christopher Walken), who in death will become the Headless Horseman, is all spikes and sharp angles.

[7]

[8]

(7) The movie's primary palette, tending toward slate- and bluish-gray, complements the "Tree of Death." The overcast, foreboding look used in most of the outdoor shots enhances our sense of the mystery and danger lurking within the village. (8) Punctuating this overall grayness are magnificent homages to classic horror films, including a windmill straight out of James Whale's *Frankenstein* (1931).

of anecdotal pictures (similar to movie story-boards) that had both a moral and a satiric message. Rowlandson created an instantly recognizable gallery of social types, many of whom seem to have served as models for the characters we meet at Van Tassel's mansion. When Crane steps into the house, a harvest party is taking place, and the guests are dancing, drinking, and quietly talking. The color palette changes from the exterior gloom to soft

browns, grays, greens, and blacks. The interior colors are very subdued but warmed by a patterned tile floor, orange jack-o'-lanterns, candles, and firelight. (Here, as throughout the movie's interior scenes, candles seem to be the principal source of illumination.) Van Tassel wears a suit of beautiful dark-green velvet decorated with gold brocade, under which his cream-colored silk shirt is fastened with a bow; unlike many of the other men, he does not wear a wig. His beautiful, younger wife, Lady Mary Van Tassel (Miranda Richardson), wears an elaborate gown of yellow silk velvet decorated with an overlaid pattern in cut brown velvet; she wears jewels, and her hair is swept back from her high forehead. Their dress and manner leave no question as to who heads society in Sleepy Hollow.

Their status is confirmed in the next scene, when Crane is introduced to the other ranking members of the community. Here, in a scene that could have come straight from Hogarth, we are in Van Tassel's study, with its muted green wallpaper, leather chairs, books, portraits, oriental carpet, blazing fireplace, and candles mounted in wall sconces. Each man in the scene is striking in dress and manner. The Reverend Steenwyck (Jeffrey Jones) wears the most distinctive wig in the movie, while Magistrate Samuel Philipse (Richard Griffiths), seen pouring the contents of his flask into his tea cup, has the stock red face of a drinking man that one sees so often in portraits of British aristocrats by George Romney, another of Hogarth's contemporaries.

This meticulously created, if historically inaccurate, period atmosphere encourages us not only to escape into the past but also to suspend our disbelief. On this ground, two worlds collide: one is represented by Crane, a "modern" criminal investigator using the latest technology (most of it of his own invention);

the other is represented by the community of Sleepy Hollow, which itself ranges from the rich to the poor, all afraid of the Headless Horseman. Burton tells the story in part through fantastic objects and details, including Crane's notebook containing his drawings and notes, various forensic instruments, and peculiar eyeglasses; Katrina's (Christina Ricci) book of witchcraft and evil-eye diagrams, over which an ominous spider creeps; the fairy-tale witch's (Miranda Richardson) cave deep in the forest and her potions made of bats' heads and birds' wings; the mechanical horse used to propel the Horseman through the village and surrounding woods; the "Tree of Death," where the Horseman lives between murders; the windmill where he almost meets his end; and the fountain of blood at the climactic moment, when the Horseman's head is restored to him and he returns to life. Impressionistic, even expressionistic, much of what we see in this creepy place, with its frightening inhabitants and their eccentric costumes and hairstyles, was created by a large special effects team headed by Mitchell J. Coughlin.

PROCESS AND ELEMENTS OF DESIGN

ROLES OF THE ART DIRECTOR AND THE PRODUCTION DESIGNER

By the 1930s, each studio in Hollywood had established an art department, headed by an executive who, in addition to creating and maintaining the studio's distinctive visual style, took full screen credit and any awards the film received for art direction. Cedric Gibbons, supervising art director at MGM for thirty-two years, was the one art director the general public knew by name, not only because the quality of MGM's style was so high but also because he was nominated forty times for the Academy Award for art direction, an honor he won eleven times. At all the studios, the art department worked closely with the other departments that bore any responsibility for a film's visual look. The supervising art director, though nominally in charge of designing all the studio's films, in fact assigned an individual art director to each movie. Most art directors were trained as draftspeople or architects and so brought to their work a fundamental understanding of how to draw and build a building. In addition to having a thorough knowledge of architecture and design, art directors were familiar with decorative and costume styles of major historical periods and were acquainted with all aspects of film production. As a result, the most accomplished art directors worked closely with film directors in a mutually influential and productive atmosphere. Take, for example, Richard Day, who over his long career worked with such diverse directors as Erich von Stroheim (*The Wedding March,* 1928), William Wyler (*Dodsworth,* 1936), King Vidor (*Stella Dallas,* 1937), John Ford (*How Green Was My Valley,* 1941), and Elia Kazan (*On the Waterfront,* 1954); or Ward Ihnen, who worked with Josef von Sternberg (*Blonde Venus,* 1932), John Ford (*Stagecoach,* 1939), and Fritz Lang (*Rancho Notorious,* 1952).

In the United States, the credit title *production designer* was first used to acknowledge William Cameron Menzies's contributions to *Gone With the Wind* (1939), but it came into common use only in the 1960s, although it was adopted in British cinema in the 1940s. Menzies had drawn every shot of *Gone With the Wind,* and those meticulous drawings held

the production together through four directors, many writers, and the producer David O. Selznick's constant interventions. Before that—and through late 1950s—the credit title *art director* was generally used; in fact, Menzies won the first two Academy Awards for art direction, for movies made in 1927 and 1928. The difference between a production designer and an art director lies basically in the extent of responsibilities. Today, the production designer is usually hired by, and works directly with, the director as a collaborator in visualizing the script and then coordinating all elements of design, including sets, costumes, props, and color schemes. In the past, the art director's primary task was to design the settings and decor, while other design executives supervised costumes, hairstyles, and props.

Design begins with the intensive previsualization done by the director and production designer—imagining, thinking, discussing, sketching, planning—that is at the core of all movies. If their collaboration succeeds, the production designer inspires the director to understand not only how the characters, places, objects, and so on will look but also the relationships among these things. Responsible for everything on the screen except the actors, the production designer helps create visual continuity, balance, and dramatic emphasis; indeed, the production designer "organizes the narrative through design."[8] Even then, the designer's control is limited, because the cinematographer determines how things look in the picture. (We'll examine the cinematographer's role fully in chapter 4.)

Many art directors have become directors. Mitchell Leisen, for example, who began his career designing films for Cecil B. DeMille and

Ernst Lubitsch, was the director of a long string of stylish studio films between 1934 and 1967. From his early career as an art director, Alfred Hitchcock learned much about creating the visual and special effects that play such an important role in his movies. (Hitchcock's early career will be discussed as part of the case study for this chapter: *North by Northwest.*) Ridley Scott began his career as a set designer for England's BBC-TV and has directed a series of visually stylish films, including *Alien* (1979), *Blade Runner* (1982), *Thelma and Louise* (1991), and *Gladiator* (2000). David Fincher, who began his career doing special effects for Richard Marquand's *Return of the Jedi* (1983) and Steven Spielberg's *Indiana Jones and the Temple of Doom* (1984) and went on to do music videos for Madonna and other artists, directed *Alien³* (1992), *Se7en* (1995), *Fight Club* (1999), and *Panic Room* (2002).

During the process of envisioning and designing a film, the director, production designer, and art director (in collaboration with the cinematographer) are concerned with several major elements, which punctuate and underscore the movement of figures within the frame: *setting; lighting;* and *costume, makeup, and hairstyle.*

SETTING

As was discussed in chapter 2, the spatial and temporal *setting* of a film is the environment (realistic or imagined) in which the narrative takes place. The setting of Roman Polanski's *Chinatown* (1974) is a historically representational (versus a film noir stylized; see "Types of Movies" in chapter 1) Los Angeles in the 1930s; by contrast, the setting of Ridley Scott's *Blade Runner* (1992) is a historically speculative Los Angeles in 2019. Both settings include actual places and studio creations, interiors

[8]Charles and Mirella Jona Affron, *Sets in Motion: Art Direction and Film Narrative* (New Brunswick, N.J.: Rutgers University Press, 1995), 12.

and exteriors, and props, and both contribute significantly to the meanings of their respective movies. In the first two decades of moviemaking, the first preference was to shoot in exterior locations, for both authenticity and natural depth; but location shooting proved expensive, and the evolution of larger studios made possible interiors (or sets) that were large, three-dimensional spaces that permitted the staging of action on all three planes and that could also accommodate multiple rooms.

A movie **set** is not reality but a fragment of reality created as the setting for a particular shot, and it must be constructed both to look authentic and to photograph well. It gives the director and his or her collaborators complete freedom to control every aspect of what is photographed. The first movie sets were no different from theater sets: flat backdrops erected, painted, and photographed in a studio, observed by the camera as if it were a spectator in the theater. Indoor lighting was provided by skylights and artificial lights. (Outdoors, filmmakers often left natural settings unadorned and photographed them realistically.) The spectacular first sets to be specifically constructed for a film were made in Italy; and with Giovanni Pastrone's epic, *Cabiria* (1914), two scholars of art direction declare, "the constructed set emerged completely developed and demanding to be imitated."[9] Indeed, it was imitated in D. W. Griffith's *Intolerance* (1916), which featured the first colossal outdoor sets constructed in Hollywood. Other directors soon began to commission elaborate sets, constructed as an architectural unit out of wood, plaster, and other building materials or created from drawings that were manipulated by optical printers to look "real." (Today, computers have replaced the optical printers; see chapter

[9]Affron and Affron, *Sets in Motion*, 12.

Produced over six months at a cost that would be equivalent to $2 million today, Giovanni Pastrone's *Cabiria* is regarded by many as the greatest achievement of the era of Italian blockbusters (roughly from 1909 through 1914). Its set was the most complex and elaborate yet created for a motion picture, and, along with on-location shooting in Tunisia, Sicily, and the Alps, helped convince audiences that they were witnessing history in action (in this case, the Second Punic War between Rome and Carthage that raged from 218 to 201 B.C.E.). Italian pioneers of set design were later recruited by Hollywood producers and directors—including D. W. Griffith—to produce ever more convincing (and expensive) backdrops for epic historical dramas. Paolo and Vittorio Taviani's *Good Morning, Babylon* (1987) affectionately tells a fictionalized story of two Italian immigrants hired by Griffith as designers for *Intolerance*.

4.) Early films with elaborate settings include Erich von Stroheim's *Blind Husbands* (1919), *Foolish Wives* (1922), *Greed* (1924), and *The Wedding March* (1928); Allan Dwan's *Robin Hood* (1922); Fred Niblo's *Ben-Hur* (1925); and Cecil B. DeMille's *The King of Kings* (1927).

The old Hollywood studios kept back lots full of classic examples of various types of architecture, which were used again and again,

often with new paint or landscaping to help them meet the requirements of a new narrative. Today, the Universal City theme park preserves some of the sets from those lots. Sometimes, however, filmmakers will construct and demolish a set as quickly as possible to keep the production on schedule. Only those aspects of a set that are necessary for the benefit of the camera are actually built, whether to scale (life-size) or in miniature, human-made or computer-modeled. For example, the exterior front of a house may look complete, with curtains in the windows, but there may be no rooms behind that facade. Constructed on a **soundstage**—a windowless, soundproofed, professional shooting environment, which is usually several stories high and can cover an acre or more of floor space—will be only the minimum parts of the rooms needed to accommodate the actors and the movement of the camera: a corner, perhaps, or three sides. On the screen, these parts will appear, in proper proportions to one another, as whole units. Lighting helps sustain this illusion. In *Citizen Kane* (1941), Orson Welles, like many others before him, was determined to make his sets look more authentic and thus photographed them from both high angles (to show four walls) and low angles (to include both ceilings and four walls). In *The Shining* (1980), Stanley Kubrick mounted a special camera (called a *Steadicam*; see chapter 4) on a wheelchair that could follow Danny (Danny Lloyd) on his Big Wheel to provide the boy's close-to-the-floor view of the Overlook Hotel sets, which included ceilings, rooms with four walls, and a seemingly endless series of corridors.

LIGHTING

During the planning of a movie, most production designers and art directors include an idea of the lighting in their sketches. When the movie is ready for shooting, these sketches help guide the cinematographer in coordinating the camera and the lighting. Light not only is fundamental to the recording of images on film but also has many important functions in shaping the way the final product looks, guiding our eyes as we gaze at the movie and helping it tell its story. Light is an essential element in "drawing" the composition of a frame and realizing that arrangement on film. Through highlights, it calls attention to shapes and textures. Through shadows, it may mask or conceal things. Often, much of what we remember about a film is its expressive style of lighting faces, figures, surfaces, settings, or landscapes.

The cinematographer Stanley Cortez said that in his experience, only two directors understood the uses and meaning of light: Orson Welles and Charles Laughton.[10] Both directors began their careers on the stage in the 1930s, when theatrical lighting had evolved to a high degree of expressiveness. One of the great stage and screen actors of the twentieth century, Laughton directed only one film, *The Night of the Hunter* (1955), an unforgettable masterpiece of suspense. For his cinematographer, he chose Cortez, a master of **chiaroscuro**—the use of deep gradations and subtle variations of lights and darks within an image. Cortez (Welles's cinematographer on *The Magnificent Ambersons,* 1942), once remarked that he "was always chosen to shoot weird things,"[11] and *The Night of the Hunter*

[10]See Charles Higham, "Stanley Cortez," in *Hollywood Cameramen: Sources of Light* (London: Thames and Hudson in association with the British Film Institute, 1970), 99.

[11]Stanley Cortez, qtd. in Higham, *Hollywood Cameramen,* 102.

is a weird film in both form and content. Its story focuses on Harry Powell (Robert Mitchum), an itinerant, phony preacher who murders widows for their money. His victims include the widow of a man (Peter Graves) who had stolen $10,000 to protect his family during the Depression, hidden the money inside his daughter's doll, and sworn both of his children (Sally Jane Bruce and Billy Chapin) to secrecy. After Powell marries and murders their widowed mother (Shelley Winters), the children flee, ending up at a farm downriver kept by Rachel (Lillian Gish), a kind of fairy godmother devoted to taking in homeless children. Powell tracks down the kids and tries to convince Rachel that he is their father. In the scene when he first confronts her, both characters are seen together in the frame, separated by a short flight of stairs leading from the front yard to the porch of Rachel's house. Dressed in white, she stands at the top of the stairs; Powell, dressed in black, stands at the foot. The lighting further defines this as moral ground, with bright natural light intensifying her goodness and his evil. In a later scene, as she sits up all night to protect the children, she is photographed in a soft glow—somewhat ironic, given that she has a rifle in her lap.

Contrasts like this are also possible with color film. The story and emotional tones of Stanley Kubrick's *Barry Lyndon* (1975) are closely linked with the movie's visual look. Kubrick, production designer Ken Adam, and cinematographer John Alcott borrow the soft-color palette of eighteenth-century English and Austrian painters, and they work with natural light, such as the swiftly changing light that comes with cloudy skies. Fate's uniting of Redmond Barry (Ryan O'Neal) and the countess of Lyndon (Marisa Berenson) at the gaming tables, for instance, may be the

In Charles Laughton's *The Night of the Hunter*, Rachel (Lilian Gish) guards her household while Powell (Robert Mitchum, not pictured), lurking just outside, joins her in singing a religious hymn, "Lean on Jesus." The high contrast of light and dark throughout this scene contributes to our sense of anxiety and danger, and while we know who is good and who is evil in this climactic moment, their harmonizing voices—hers high, his low—momentarily suggest other possibilities that are not realized.

most famous scene ever shot using only candlelight, and Kubrick had special lenses designed to capture it. When Barry and the countess meet again, privately, the light is provided by the moon (or a simulation of it) and is substantially cooler. Kubrick's eighteenth-century world is no less a place of contrasts than those of the other films we have just considered. However, it is also a world of ambiguity, where money speaks louder than morals and where expediency and deception take the place of right and wrong, a point underscored with softer, more diffused lighting.

Literary adaptations pose special problems for movie designers: How faithfully should the period and the narrative details be reproduced? How can images do justice to the author's prose textures? Stanley Kubrick's design team met these challenges brilliantly in bringing to the screen William Makepeace Thackeray's novel *The Memoirs of Barry Lyndon, Esq.* (1844; originally published in a magazine as *The Luck of Barry Lyndon*). For the design team behind Jane Campion's *The Portrait of a Lady* (1996), the primary task was surely to find visual equivalents for the intricate, exquisitely wrought prose of Henry James's 1881 novel, considered by many Jamesians his finest work. Production designer Janet Patterson uses expressive lighting that is alternately diffuse and intense, warm and cool, borrowing (as Kubrick's film did) the palettes and qualities of light common in paintings of the period. Here, the lighting echoes and complements the emotions felt by the Lady of this literary-cinematic portrait, Isabel Archer (Nicole Kidman, foreground), as she reacts coldly to the presence of Madame Merle (Barbara Hershey) at the convent school.

COSTUME, MAKEUP, AND HAIRSTYLE

During the years of the Hollywood studio system (roughly from the 1930s until the 1950s), an actor's box-office appeal depended on his or her ability to project a screen image that audiences would love. Makeup and hair were the two most personal aspects of that image. The studios frequently took actors with star potential and "improved" their looks by having their hair dyed and restyled, their teeth fixed or replaced, or their noses reshaped or sagging chins tightened through cosmetic surgery. Such changes were based on each studio's belief that its overall "look" included a certain "ideal" kind of beauty, both feminine and masculine. Each studio had the right to ask actors under contract to undergo plastic or dental surgery to improve their images on and off the screen. Today, the elaborate remaking of actors' faces is comparatively rare. For one thing, the studio and star systems (see chapter 5) have become history. For another, it is now much less likely for actors to be cast in films solely on the basis of their faces. Audiences have learned to love actors for their individual looks and styles, not for their conformity to ideals determined by the studios. In many cases, this means that actors, and stars in par-

ticular, play a wider variety of roles than they would have in the 1930s and '40s.

For example, Jennifer Jason Leigh and Jack Nicholson, very versatile actors, have taken on many different parts, often changing their appearances (through costume, makeup, and hairstyle) to suit the roles. Leigh has played a teenager in Amy Heckerling's *Fast Times at Ridgemont High* (1982); a prostitute in Uli Edel's *Last Exit to Brooklyn* (1989); a married phone-sex operator in Robert Altman's *Short Cuts* (1993); a high-powered journalist in the Coen brothers' *The Hudsucker Proxy* (1994); the world-weary American humorist Dorothy Parker in Alan Rudolph's *Mrs. Parker and the Vicious Circle* (1994); a highly neurotic journalist in Taylor Hackford's *Dolores Claiborne* (1995), a physically unattractive nineteenth-century heiress in Agnieszka Holland's *Washington Square* (1997), based on Henry James's novel; and so on. Similarly, Nicholson has played a classical pianist turned oil-field worker in Bob Rafelson's *Five Easy Pieces* (1970), a crusty sailor in Hal Ashby's *The Last Detail* (1973), a suave but doomed private detective in Roman Polanski's *Chinatown* (1974), a convict feigning mental illness in Milos Forman's *One Flew Over the Cuckoo's Nest* (1975), a demented writer in Stanley Kubrick's *The Shining* (1980), the 1920s American dramatist Eugene O'Neill in Warren Beatty's *Reds* (1981), the Joker in Tim Burton's *Batman* (1989), an irritable Marine commander in Rob Reiner's *A Few Good Men* (1992), the aging labor leader Jimmy Hoffa in Danny DeVito's *Hoffa* (1992), a werewolf in Mike Nichols's *Wolf* (1994), a retired businessman in Alexander Payne's *About Schmidt* (2002), and so on—one different role after another, each requiring his attention to character development and the meticulous attention of designers and technicians to his appearance.

COSTUME. The setting of a film generally governs the design of the **costumes** (the clothing worn by an actor in a movie, sometimes known as *wardrobe*), which contribute to that setting, enhance the characters or suggest specific character traits, and help tell the story by providing details of plot development. When the setting is a historical era, costume designers may need to ensure authenticity by undertaking extensive and lengthy research. However, even with such research, the costumes in historical films often do not accurately depict such details as women's necklines, breast shapes, and waistlines. Hats tend to look more contemporary, and undergarments more lavish, than they would have historically.

Historical films tend to reflect both the years they hope to represent and the years in which they were created. Nonetheless, they shape our ideas of historical dress. For example, although Walter Plunkett's clothing designs for Victor Fleming's *Gone With the Wind* (1939) are often quite anachronistic, audiences usually see them as truly reflecting what people wore during the Civil War. (In truth, even though we have plenty of evidence to show what people wore in the mid-1800s, Vivien Leigh's appearance as Scarlett O'Hara only approximates how a woman of her social class might have dressed. Of course, Scarlett's green dress made from a curtain plays a major role within one scene and tells us a great deal about her character: the green reminds us of her Irish background, the use of curtains of her newfound practicality and frugality.) For Joseph L. Mankiewicz's *Cleopatra* (1963), costume designer Irene Sharaff created spectacular costumes for Elizabeth Taylor that were basically contemporary gowns designed to accentuate the actress's beauty; experts agree that they only vaguely suggest the elaborate styles of the late Graeco-Roman period.

When a film involves the future, as in science fiction, the costumes must both reflect the social structure and values of an imaginary society and look the way we expect "the future" to look. Ironically, these costumes almost always reflect historical influences. The characters may live on other planets, but the actors' costumes recall the dress of ancient Greeks and Romans (Richard Marquand's *Return of the Jedi,* 1983; costume designers: Aggie Guerard Rogers and Nilo Rodis-Jamero), Asian samurai and geisha (Daniel Haller's *Buck Rogers in the 25th Century,* 1979; costume designer: Jean-Pierre Dorléac), or medieval knights and maidens (Leonard Nimoy's *Star Trek III: The Search for Spock,* 1984; costume designer: Robert Fletcher).

The movies have always been associated with the greatest style and glamour. Beautiful clothes worn by beautiful women attract audiences, and as early as 1914, the enormously popular Pearl White often appeared in very

Some costumes primarily help render a mise-en-scène that matches our expectations of the time and place portrayed onscreen, while others deliberately contradict the historical setting. For Joseph L. Mankiewicz's *Cleopatra,* costume designer Irene Sharaff clearly sought to accentuate the beauty of Elizabeth Taylor, who was then at the height of her popularity, with modern clothing featuring sheer fabrics and plunging necklines. Despite this enticement, the movie was a critical and financial failure.

stylish clothes in such films as *The Perils of Pauline.* D. W. Griffith was influenced by Pastrone's Italian epic, *Cabiria* (1914), the first major film in which costumes were specifically designed to create the illusion of an earlier period (in this case, the Second Punic War ca. 200 B.C.E.), when he made *The Birth of a Nation* (1915; costume designer: Robert Goldstein) and *Intolerance* (1916; costume designer: Clare West), both notable for their authentic costumes. The first, concerned with the Civil War, featured Ku Klux Klan robes that have helped provoke public outrage against the film; the second told stories set in four different periods in history, each requiring its own costumes, some of which, as in the Babylon sequence, were researched carefully and realized extravagantly. Prior to those films, actors wore their own clothes, whether or not those garments were appropriate for the setting of a film. During the 1920s, costume design became a serious part of the glamour of such stars as Gloria Swanson (Erich von Stroheim's *Queen Kelly,* 1928), Theda Bara (J. Gordon Edwards's *Cleopatra,* 1917), and Clara Bow (Clarence Badger's *It,* 1927).

In the 1930s, with the studio and star systems in full swing, Hollywood began to devote as much attention to costume as to setting. Major costume designers such as Adrian, Walter Plunkett, Travis Banton, Edith Head, Howard Greer, Jean Louis, and Orry-Kelly designed the costumes for such legendary actors as Joan Crawford, Bette Davis, Marlene Dietrich, Ginger Rogers, Irene Dunne, and Greta Garbo. One measure of the impact of such fashionable design work was that the public bought huge quantities of copies of the clothing originally created for movie stars.

Yet Hollywood has tended to regard costume design less seriously than it has some of the other design areas in film. From its estab-

In W. S. Van Dyke's *Marie Antoinette* (1938), one of the most lavish costume epics ever made, the French queen (Norma Shearer) looks as glamorous as a movie star; Adrian, the designer, did everything within his power to embellish Shearer's screen image rather than make her resemble the queen, whose comparatively plain face is familiar from many paintings and other representations. While much of the film is true to history, many scenes seem to exist only to reinforce MGM's peculiar notions of royal behavior. In one preposterous scene, Marie Antoinette, still a princess in the French court, greets King Louis XV (John Barrymore) and his mistress, Mme du Barry (Gladys George), and attempts to assert her royal prerogatives by insulting them both. We see and remember not the personal and political tensions in the air, the issue of succession to the French throne, the power of the royal mistress, or the difficulties posed by the Austrian-born princess, but rather the decor, costumes, makeup, dancing, and music. To learn more about the uses of design in historical dramas, go to <www.wwnorton.com/web/movies>.

www

lishment in 1928, the Academy of Motion Picture Arts and Sciences (AMPAS) gave awards for art direction, but it did not establish awards for costume design until 1948 or makeup until 1981. Starting in 1948, two Oscars for costume design were given each year, one for a color film, the other for black-and-white; this varied slightly until 1967, when the distinction was removed.[12]

MAKEUP AND HAIRSTYLE. Traditionally, whether films took place in modern or historical settings, stars' makeup invariably had a contemporary look. This preserved the stars'

images and also led to new beauty products being developed that stars could advertise, enabling women consumers to use the makeup worn by their favorite stars. In fact, the history of the commercial makeup industry roughly parallels the history of the movies. The single most important person in the manufacture of movie makeup was Max Factor. In 1908, he began supplying wigs and makeup to the small movie studios cropping up around Los Angeles. In the early 1920s, makeup was usually the responsibility of the actors, but Factor standardized makeup procedures—and thus created the position of makeup designer. His products became the industry standard. Through research, the Max Factor Company continued to provide new forms of makeup to meet the challenges created by new camera

[12]See the AMPAS website—<*www.oscars.org*>—for a very useful database of all Oscar nominations and awards in all categories.

[1]

[2]

(1) For David Lynch's *The Elephant Man* (1980), makeup designers Beryl Lerman, Michael Morris, Wally Schneiderman, and Christopher Tucker convincingly rendered the title character, John Merrick (John Hurt), to help evoke our sympathy for this grotesquely deformed historical figure. (2) For Tim Burton's *Batman* (1989), makeup designers Paul Engelen and Nick Dodman transformed Jack Napier (Jack Nicholson), a cheap hood, into the Joker—a darkly comic deformation and a visual parallel to the character's combination of humor and evil.

lenses, lighting, and film stocks, especially color film, which required a very different approach to makeup than that required by black-and-white film (on the differences between film stocks, see chapter 4). The most important names in the history of makeup design are those of George Westmore and his six sons; succeeding generations of the Westmore family have continued to dominate the field.

Although many directors favor makeup that is as natural as possible, we tend to notice makeup design when it helps create an unusual or fantastic character: Boris Karloff as the Monster in James Whale's *Frankenstein* (1931; makeup designer: Jack P. Pierce); the self-transformation through science of Fredric March from the mild Dr. Jekyll into the evil side of his own character, the lustful and hideous Mr. Hyde, in Rouben Mamoulian's *Dr. Jekyll and Mr. Hyde* (1932; makeup designer: Wally Westmore); James Cagney as the great silent-screen actor Lon Chaney in Joseph Pevney's *Man of a Thousand Faces* (1957; makeup designers: Bud Westmore and Jack Kevan); the ape-men in Stanley Kubrick's *2001: A Space Odyssey* (1968; makeup designer: Stuart Freeborn); and so on.

During the studio years, hairstyles were based on modified modern looks rather than the period authenticity favored in costumes. Exceptions to this rule—such as Bette Davis's appearing as Queen Elizabeth I with shaved eyebrows and hairline in Michael Curtiz's *The Private Lives of Elizabeth and Essex* (1939), and with a bald head in the same role in Henry Koster's *The Virgin Queen* (1955)—are rare, because few studios were willing to jeopardize their stars' images. The idea of achieving historical accuracy in hairstyle was completely undercut in the late 1930s, when the studios developed a "Hollywood Beauty Queen" wig serviceable for every historical period. This all-purpose wig was worn by Norma Shearer in W. S. Van Dyke's *Marie Antoinette* (1938); Hedy Lamarr in Cecil B. DeMille's biblical epic *Samson and Delilah* (1949); Susan Hayward in another biblical epic, Henry King's *David and Bathsheba* (1951); and Glynis Johns in Norman Panama and Melvin Frank's medieval comedy,

The Court Jester (1956). Thus one hairstyle served to depict four different characters appearing in stories that span almost all of human history.

In fact, until the 1960s, actors in almost every film, whether period or modern, were required to wear wigs designed for the film, for reasons both aesthetic and practical. In shooting out of sequence, when continuous scenes can be shot weeks apart, it is particularly difficult to re-create colors, cuts, and styles. However, script supervisors can now take Polaroid snapshots to help maintain the continuity of such details; or they can use a tiny **video assist camera,** which is mounted in the viewing system of the film camera and provides instant visual feedback, enabling a script supervisor to view a scene (and thus compare its details with those of surrounding scenes) before the film is sent to the laboratory for processing. While the AMPAS has never recognized hair design as a craft within its awards system, hair design is so important today that many actors have their own hairdressers under personal contract.

INTERNATIONAL STYLES AND DEVELOPMENT

On one hand, new technology brings about stylistic change; on the other, the desire for a new style prompts technological improvements. The two fundamental styles of film design—the realistic and the fantastic—were established in France in the very first motion pictures. The Lumière brothers pioneered the nonfiction film, shooting short, realistic depictions of everyday activities. Georges Méliès created the fictional film, using illusions he had learned in the theater. As Méliès employed all kinds of stage tricks, mechanisms, and illusions, he invented a variety of cine-

matic effects. In so doing, he also invented the film set, and thus we can consider him the first art director in film history.

In Russia, after the 1917 revolution, the avant-garde constructivists and futurists reshaped the entire concept of cinema: what it is, how it is shot, how it is edited, and *how it looks.* The great Soviet filmmakers of the 1920s and '30s—Dziga Vertov, Lev Kuleshov, Sergei Eisenstein, Vsevolod Pudovkin, and Aleksander Dovzhenko—were influenced by two seemingly contradictory forces: by the nonfiction film with its "documentary" look and by a highly dynamic style of editing (see "Sergei Eisenstein's *Battleship Potemkin*" in chapter 6). Their films—masterpieces both of cinematic design and of political propaganda involving so-called Socialist Realism—combined highly realistic exterior shots with an editing rhythm that, ever since, has affected the handling of cinematic time and space. In 1922, Russian artists working in Paris introduced scenic conventions from the Russian realistic theater to French cinema and also experimented with a variety of visual effects influenced by contemporary art movements—cubism, dada, surrealism, and abstraction. In the following decades, the look of the Soviet film changed in many ways, including an increased use of art directors, studio and location shooting, and constructed sets and artificial lighting. Notable are Isaac Shpinel's designs for two great Eisenstein films—*Alexander Nevski* (1938), whose medieval helmets, armor, and trappings for horses rival any historical re-creation ever seen on the screen, and *Ivan the Terrible: Parts I and II* (*Ivan Groznyj,* 1944–46)—and, much later, Evgeni Enei and Georgi Kroplachev's designs for two Shakespearian films: Grigori Kozintsev's adaptations of *Hamlet* (*Gamlet,* 1964) and *King Lear* (*Korol Lir,* 1969). *Hamlet,* in particular, is

noteworthy for being filmed at Elsinore Castle in Denmark; the director uses its mighty staircases for highly choreographed movement and the sounds and sights of the surrounding sea for emotional effect.

But most important early developments in art direction took place in Germany. Expressionism, which emerged in the first decades of the twentieth century, influenced almost every form of German art, including the cinema. Its goal was to give objective expression to subjective human feelings and emotions through the use of such objective design elements as structure, color, or texture; it also aimed at heightening reality by relying on such nonobjective elements as symbols, stereotyped characters, and stylization. In German cinema, in the years immediately following World War I, expressionism gave rise to a new approach to composition, set design, and directing. The object was to create a totally unified mise-en-scène that would increase the emotional impact of the production on the audience. Expressionist films were characterized by extreme stylization in their sets, decor, acting, lighting, and camera angles. The grossly distorted, largely abstract sets were as expressive as the actors, if not more. To ensure complete control and free manipulation of the decor, lighting, and camera work, expressionist films were generally shot in the studio even when the script called for exterior scenes—a practice that was to have an important effect on how movies were later shot in Hollywood. Lighting was deliberately artificial, emphasizing deep shadows and sharp contrasts; camera angles were chosen to emphasize the fantastic and the grotesque; and the actors externalized their emotions to the extreme.

The first great German expressionist film was Robert Wiene's *The Cabinet of Dr. Caligari* (*Das Kabinett des Doktor Caligari,* 1919), designed by three prominent artists (Hermann Warm, Walter Reimann, and Walter Röhrig), who used painted sets to reflect the anxiety, terror, and madness of the film's characters and thus reflected psychological states in exterior settings. *Dr. Caligari* gave space—interior and exterior—a voice. Its highly experimental and stylized setting, decor, costumes, and figure movement influenced the design of later German silent classics such as F. W. Murnau's *Nosferatu* (1922) and Fritz Lang's *Destiny* (*Der müde Tod,* 1921), *Siegfried* (*Die Nibelungen: Siegfried,* 1922–24), *Kriemhild's Revenge* (*Die Nibelungen: Kriemhilds Rache,* 1923–24), and *Metropolis* (1926). Furthermore, its exaggerated and distorted look strongly influenced horror films, thrillers, and the American film noir (see "Types of Movies" in chapter 1).

At the same time that the expressionist film was evolving, the Germans developed a realist cinema (known as *Kammerspielfilm*), whose masterpiece is F. W. Murnau's *The Last Laugh* (*Der letzte Mann,* 1924). Murnau's film (like Griffith's and Pastrone's films in the previous decade) radically changed the way shots were framed, actors were blocked, and sets were designed and built, mainly thanks to Murnau's innovative use of the moving camera and the subjective camera. His "unchained camera" freed filmmakers from the limitations of a camera fixed to a tripod; his subjective camera used the camera eye as the eyes of a character in the film, so that the audience saw only what the character saw. These new developments intensified the audience's involvement in events onscreen, extended the vocabulary by which filmmakers could tell and photograph stories, and thus influenced the conception and construction of sets.

English films of the 1930s and '40s were, in most instances, indistinguishable in look from

The imagery in Robert Wiene's *The Cabinet of Dr. Caligari* ushered in an era of expressionistic cinematography, design, and mise-en-scène in German cinema that subsequently influenced filmmaking in the United States and elsewhere. That influence is clear in, for example, Charles D. Hall's designs for James Whale's *Frankenstein* (1931) and *Bride of Frankenstein* (1935), Jack Otterson's designs for Rowland V. Lee's *Son of Frankenstein* (1939), Van Nest Polglase and Perry Ferguson's designs for Orson Welles's *Citizen Kane* (1941), and the designs of countless film noirs. To get a sense of how contemporary filmmakers continue to find inspiration in *Caligari*'s imagery, compare the perspectival relations in this image and the ritualistic-tribunal image from Stanley Kubrick's *Eyes Wide Shut* (p. 123); the abstract imagery of this forest and the tree from Tim Burton's *Sleepy Hollow* (p. 146); and the chariascuro effects here and in the image of Rachel from Charles Laughton's *The Night of the Hunter* (p. 151).

Hollywood films. We might note such experiments as Laurence Olivier's *Henry V* (1944), with its deliberately artificial sets in a "France" inspired by a medieval book of hours, *Les très riches heures du duc de Berry*, but the two major exceptions were the films directed by Hitchcock and those designed by Vincent Korda. Because of his background as a designer, Hitchcock's films were always unusually stylish, including such early works as the first version of *The Man Who Knew Too Much* (1934), *Sabotage* (1936), and *The Lady Vanishes* (1938). Korda's distinctive, lavish style can be seen in Michael Powell's *Thief of Bagdad* (1940), a colorful adaptation of an Arabian Nights tale, and in most of the films produced by London Films, headed by his brother Alexander, including the historical epics *The Private Life of Henry VIII* (1933) and

Rembrandt (1936). In addition, Korda helped design the sets for designer-director William Cameron Menzies's stylish science fiction film *Things to Come* (1936) and was one of several designers on Carol Reed's *The Third Man* (1949), set in decadent Vienna after World War II and perhaps the most stylish of all black-and-white movies in the film noir style. Michael Powell and Emeric Pressburger, as creative partners, coproduced and codirected a body of major films that reflect serious attention to design elements, including *The Life and Death of Colonel Blimp* (1943; production designer: Alfred Junge), *Black Narcissus* (1947; production designer: Alfred Junge), and *The Red Shoes* (1948; production designer: Hein Heckroth). David Lean, who also got his start during this period, paid particular attention to accurate historical detail in faithful

If, as noted above, movies such as Stanley Kubrick's *Eyes Wide Shut*, Charles Laughton's *The Night of the Hunter*, and Tim Burton's *Sleepy Hollow* all owe visual and even thematic debts to Robert Weine's *The Cabinet of Dr. Caligari*, then the missing link connecting them all might be Carol Reed's hugely influential thriller *The Third Man*. In this masterpiece of design and mise-en-scène, pulp writer Holly Martins (Joseph Cotten) finds himself in a shadowy, angular, mazelike Vienna. As Martins's investigation into the mysterious death of a long-lost friend yields as much deceit as truth, the city becomes not just a backdrop but a kind of major character, the troubled Martins's alter ego. The film's climactic chase scene—set in the labyrinthine sewer system, with bright lights revealing the sweating tunnel walls and police officers splashing through the dark waters—is one of the most memorable nightmare visions in movie history. That Harry Lime, the subject of the police chase, is played by Orson Welles has led some viewers to regard *The Third Man* as an homage to both *Caligari* and Welles's *Citizen Kane* (1941). Indeed, because of its characteristically Wellesian "look," other viewers mistakenly think Welles directed it.

adaptations of Charles Dickens's novels *Great Expectations* (1946) and *Oliver Twist* (1948), both designed by John Bryan.

Italian neorealism, developed during World War II, influenced how cinema worldwide handled both narrative and design (or, in this case, absence of design). Its use of nonprofessional actors, handheld cameras, and location sets all diverged strongly from the practices of studio-bound productions, even those shot on

location, and opened the door for new styles in Europe, India, and Hollywood. Its humanism and concerns with social conditions during and after the war broke away from conventional movie narrative and established a "new realism" both in story and style in the early films of Roberto Rossellini (*Rome, Open City* [*Roma, città aperta*], 1945), Vittorio De Sica (*Shoeshine* [*Sciuscià*], 1946, and *Bicycle Thieves* [*Ladri di biciclette*], 1948), Michelangelo Antonioni (*The Adventure* [*L'Avventura*], 1960), and Federico Fellini (*The Young and the Passionate* [*I vitelloni*], 1953). The latter two writer-directors went on, throughout their long careers, to employ highly nonrealistic design in innovatively expressive ways, particularly in such color films as Fellini's *Juliet of the Spirits* (*Giulietta degli spiriti*, 1965) and Antonioni's *Zabriskie Point* (1970). Designer Ferdinando Scarfiotti did extraordinary work on Bernardo Bertolucci's *The Conformist* (*Il conformista,* 1970), *Last Tango in Paris* (*Ultimo tango a Parigi,* 1972), and *The Last Emperor* (1987); and in Luchino Visconti's *Death in Venice* (*Morte a Venezia,* 1971), he demonstrates his mastery of the lush style of decor and dress in late-nineteenth-century Venice.

Art direction and design is a very important element in the films of the three Japanese directors best known in the West—Akira Kurosawa, Kenji Mizoguchi, and Yasujiro Ozu. Yoshiro Muraki and Shinobu Muraki's design brings visual simplicity and dramatic power to Kurosawa's *Ran* (1985), for example. In Mizoguchi's *Sansho the Bailiff* (*Sanshô dayû,* 1954), Kisaku Ito's design is both poetic and realistic in its considerable beauty. Design credits seldom appear on Ozu's films, but we can discern a consistent visual style, austere and beautifully balanced in composition, in his *An Autumn Afternoon* (*Sanma no aji,* 1962). In India, the films of Satyajit Ray, who was successful as a graphic designer before he turned to film directing, are noted for their adherence to the principles of Italian neorealism, particularly the emphasis on shooting in real locations. Ray is also highly esteemed by audiences and his

Michael Powell and Emeric Pressburger's *The Red Shoes* (1948), although a financial disaster for its producers, remains a revelation to many moviegoers and to subsequent filmmakers because of its integration of music, dance, narrative, and design into a sumptuous artistic (and unabashedly romantic) whole. In this frame, the flowing curtain seems to be echoing the graceful moves of ballerina Victoria Page (Moira Shearer). The subtle use of color by designers Hein Heckroth and Arthur Lawson, recorded beautifully by Jack Cardiff's cinematography, reflect Powell and Pressburger's declared admiration for director Rouben Mamoulian's tasteful, controlled use of color in *Becky Sharp* (1935), the first three-color Technicolor feature. To view a slide show of stills from movies celebrated for their designs, go to <www.wwnorton.com/web/movies>.

3.6

fellow film directors for his mastery of details that reveal character, setting, and mood in such films as *The Music Room* (*Jalsaghar,* 1958), *The Goddess* (*Devi,* 1960), *Charulata* (1964), and *The Home and the World* (*Ghare baire,* 1984). Chinese films display diverse visual styles. In the People's Republic of China, distinctive directors include Chen Kaige (*Yellow Earth* [*Huang Tudi*], 1984) and Zhang

Yimou, whose films *Red Sorghum* (*Hong gaoliang,* 1988) and *Raise the Red Lantern* (*Da hong denglong gao gao,* 1991) exploit color in impressive ways. In Hong Kong, a new cinema emerged in the 1960s, characterized by its focus on the local Cantonese culture and on technological sophistication, rather than style. Its distinctive achievements include Ann Hui's political *Ordinary Heroes* (*Qian*

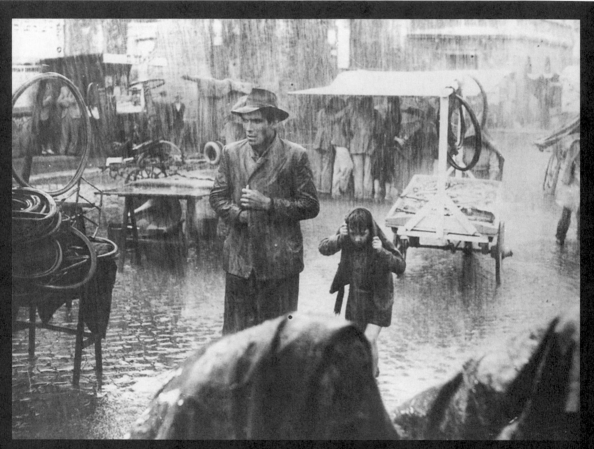

Vittorio De Sica's *Bicycle Thieves* is perhaps the best-loved movie from Italy's neorealist period, in part because its simple story speaks to many people by focusing on the details and chance events of ordinary lives. As Antonio Ricci (Lamberto Maggiorani) and his son Bruno (Enzo Staiola) pursue an old man who can identify the thief of Antonio's bicycle, for example, a rainstorm delays them and enables the old man to get away. The rainstorm was real and filmed on location. For an in-depth analysis of *Bicycle Thieves*, see the case study for chapter 1: <*www.wwnorton.com/web/movies*>.

www

yan wan yu, 2000), Tsui Hark's epic *Peking Opera Blues* (*Do ma daan,* 1986), and John Woo's superviolent *The Killer* (*Die xue shuang xiong,* 1989), a strong influence on director Quentin Tarantino and others. In Taiwan, several important directors have emerged, including Edward Yang, whose *The Day on the Beach* (*Haitan de yitian,* 1983) reflects Antonioni's austere style, and Hou Hsiao-Hsien, whose *A City of Sadness* (*Beiqing chengshi,* 1989) adheres to a more traditional Chinese cinematic style. Most famous internationally is Ang Lee, whose early films include *The Wedding Banquet* (*Hsi yen,* 1993) and *Eat Drink Man Woman* (*Yin shi nan nu,* 1994). Since crossing over into mainstream Western film production, he has made movies set in utterly disparate worlds: *Sense and Sensibility* (1995), based on the 1811 novel by English writer Jane Austen; *The Ice Storm* (1997), based on the 1994 novel by American writer Rick Moody; and *Crouching Tiger, Hidden Dragon* (*Wo hu cang long,* 2000), which tells a Chinese love story in the highly kinetic style reminiscent of Hong Kong martial-arts films.

Apart from such postmodern filmaking efforts as the Danish "Dogma" movement (with its location shooting, using handheld cameras and natural light), the style that prevails internationally today is the seamless integration of studio and natural settings. Instead of working in a self-contained studio that could supply or build anything required, today's independent production designer must assemble his or her own staff and start from scratch on most films. Most of the work once performed by the studio art departments is now assigned to independent contractors. Furthermore, much of today's shooting happens on location, both interior and exterior.

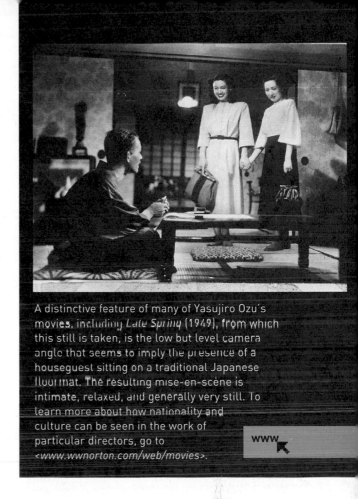

A distinctive feature of many of Yasujiro Ozu's movies, including *Late Spring* (1949), from which this still is taken, is the low but level camera angle that seems to imply the presence of a houseguest sitting on a traditional Japanese floor mat. The resulting mise-en-scène is intimate, relaxed, and generally very still. To learn more about how nationality and culture can be seen in the work of particular directors, go to <*www.wwnorton.com/web/movies*>.

ANALYZING DESIGN

The better the fit between design and movie, the more likely we are to take that design for granted. A design may be so well thought out and put together that it seems merely something *given* for the director and the cinematographer to film, rather than the deliberately produced result of labor by a team of artists and craftspeople. While design plays a crucial role in creating the illusion of naturalness that encourages our enjoyment of movies as

spectators, we must consciously *resist* that illusion so we can graduate from being mere spectators to being students of film, people who *look at movies* rather than just watch them. Looking at design critically does not mean taking the fun away from movies. You may still have as much fun as you like with (or is the better word *in*?) *The Matrix* while realizing that everything you see in it was put there for a purpose.

Design and overall vision have been particularly well married in a series of contemporary movies that explore the bright surfaces of U.S. cities and suburbs while revealing the hidden dark side beneath of the people who inhabit them. These films therefore come out of a very specific place in our history and culture and constitute a small genre of their own, (sub)urban noir. In such films as David Lynch's *Blue Velvet* (1986), Jonathan Demme's *Something Wild* (1986), Steven Soderbergh's *sex, lies, and videotape* (1989), Robert Altman's *Short Cuts* (1993), David O. Russell's *Spanking the Monkey* (1994) and *Flirting with Disaster* (1996), Neil LaBute's *In the Company of Men* (1997) and *Your Friends and Neighbors* (1998), Gary Ross's *Pleasantville* (1998), Bill Condon's *Gods and Monsters* (1998), and Peter Weir's *The Truman Show* (1998), visual details have been so carefully envisioned and designed that the places become *symbolic*—representative more of the values and lifestyles of American society in general than of any one place in particular. Thus these settings *mean* more than we might at first think. As you know from previous chapters, the relationship between form and content helps develop a film's meaning, and one formal element is the design of the total environment in which the movie takes place. To see this process at work, let's look at three films in this genre: Todd Solondz's *Happiness*

(1999), Sam Mendes's *American Beauty* (1999), and Michael Almereyda's *Hamlet* (2000).

TODD SOLONDZ'S *HAPPINESS*

Solondz's film tells a complex story involving an extended family for which the word *dysfunctional* is insufficient: Lenny and Mona Jordan (Ben Gazzara and Louise Lasser), retired and living in a luxurious condo in Florida, and their three daughters, who live in

and around New York City. Two of the sisters are single: Joy (Jane Adams), a lost soul who writes sappy folk songs, and Helen (Lara Flynn Boyle), a successful writer. The third sister, Trish (Cynthia Stevenson), "has it all," including a psychiatrist husband, Bill Maplewood (Dylan Baker), and three children. Among the characters moving in and out of this family's sphere is Allen (Philip Seymour Hoffman), an overweight, sexually frustrated nerd who makes obscene phone calls to various women, including two of his neighbors: Helen Jordan and Kristina (Camryn Manheim), an overweight, sexually repressed woman who looks for love while talking about how she murdered a man who raped her. Each of these characters seeks "happiness," which here means different things to different people.

Solondz's vision of contemporary American life is both shockingly comic and deeply disturbing, and in expressing it on the screen, his production designer Thérèse DePrez and cinematographer Maryse Alberti repeat a framing pattern that includes two people—would-be, disenchanted, or unhappy lovers—sitting at opposite ends of a sofa, bed, or restaurant banquette. This design strategy, which presents a principal theme of the film—people talking but failing to connect—is established in the scene before the credits. An early scene opens with a medium two-shot in which Joy Jordan and Andy Kornbluth (Jon Lovitz) sit side by side on a banquette in a luxurious restaurant, where the table is set with beautiful china, crystal, and silver and banked by a huge flower arrangement that seems as if it will swallow them up. They have just finished their dinner, but before either character speaks we sense the tension between them; our suspicions are confirmed when Joy clumsily makes clear that she has enjoyed knowing

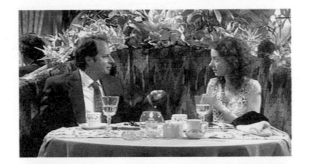

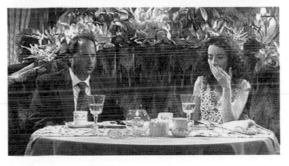

Andy but doesn't want to see him any longer. With this conflict established, we start to look at the two characters more closely, particularly at those details, such as facial expressions, clothes, and hairstyles, that might help us understand them. Joy's face is pale, pretty, and open, but she is nonetheless concerned about the impact that what she has said will have on Andy. As yet, we know nothing else about her, but her flowery dress, mass of curly hair, and simple makeup suggest the post-

1960s hippie that we'll come to know better as the film progresses. By contrast, Andy—who understands that people regard him as unattractive—can barely control himself when he realizes that he is being rejected, probably not for the first time in his life. In fact, he will burst into tears but quickly regain control, setting the emotional tone for what is to come as the scene unfolds. For the moment, however, his dark suit and conservative shirt and tie suggest a serious man for whom we should have empathy. The soft lighting, which falls evenly on both characters, creates a romantic atmosphere. Solondz fully exploits the power of these design elements, and the ironies of the resulting mise-en-scène, by getting us to see, hear, and even *feel* that such situations can be simultaneously funny and sad. This dinner table conversation is not what we would expect in such a comfortable environment, and it thus takes an expected course.

Andy suggests that Joy has been leading him on by letting him take her out without wanting to become involved. That's a familiar enough complaint of jilted suitors, but as the control of the conversation shifts from Joy to Andy, he reveals a darker aspect of his character that we don't expect. In presenting Joy with a gift, a reproduction of a late-nineteenth-century American bowl (she calls it a "collector's item"), he tells her it is just a symbol of all the good things he would have given her had she not rejected him. Joy accepts the gift as if she is going to keep it, and, for a moment, we wonder if she might change her mind about Andy. However, he snatches the gift out of her hands and becomes abusive, finally declaring that he is "champagne" and she is "shit." Here the scene ends, as it began, with the two characters sitting side by side, speechless, and staring into the camera. Joy is now the one who has been rejected, and Andy,

if just for a moment, seems triumphant. Happiness indeed!

Here and throughout the movie, setting, decor, lighting, costume, hairstyle, and other details reveal character. Joy, who dresses like a hippie, still lives in the New Jersey apartment once occupied by her parents, where, in the midst of receiving an obscene phone call, she vainly tries to thaw a frozen steak by hitting it with a wooden spoon. Helen's stylish clothes and hairstyle, cool manner, and fame as an author suggest she would live in Man-

hattan, but instead she is trapped across the Hudson in New Jersey, on the same floor of the apartment building that houses Allen and Kristina. We soon learn that for all her style and bravado, Helen is not the sophisticated woman she pretends to be. When we meet Allen, who lives across the hall in unkempt bachelor's digs, the details of setting, decor, and lighting help us understand him: ratty furniture, torn maps taped to the wall, baseball caps hanging from hooks, piles of dirty clothes on the floor, and an unmade bed, where he sits in yellowing underwear, under unflattering light, as he makes his calls. We enter Kristina's apartment directly through the kitchen, the most important room in her life. Trish and her family live in a perfect suburban house, where meals are prepared in a high-tech kitchen and served in the dining room. In their spotless Florida condo, Mona and Lenny talk to one another from separate rooms, their voices blurred by the sounds of a sports event

on television. In each instance, the design elements help define the characters.

Nuances in the presentation of characters' dreams and desires also reveal meaning. The psychiatrist, Bill Maplewood, visits his own psychiatrist and recounts a dream in which he uses a machine gun to kill two gay lovers and several other people in a park. This frightening incident has been designed, directed, and acted to tell us that Dr. Maplewood is a homophobe. In reality, he drugs and rapes two boys.

Meticulously selected design elements open the lives of these misfit characters to scrutiny, thereby saving them from being stereotypes and making the film a superb black comedy. While scathingly satirical, *Happiness* forces us to see and interpret the details for ourselves. With the exception of the dreams, everything we see here suggests that these characters, not the director and his designers, have chosen their houses, decor, clothes. These elements seem natural extensions of what we know about the characters, even though we know they have been carefully planned, selected, and arranged not only for maximum comic effect but also to unify the film's vision of a hopeless, deluded, and sometimes sick world in which happiness is unattainable.

SAM MENDES'S *AMERICAN BEAUTY*

Like *Happiness, American Beauty* concerns unhappy parents and children on the verge of crises. Because Solondz's film is overtly satiric, design details such as the commemorative bowl point directly to the targets of that satire. Mendes's film is more subtly satirical and uses its design scheme in a more general way. Here, the details are integral elements in an overall vision, patiently creating and re-

vealing the characters while establishing the context for their lives and conflicts. We find nothing as blatant as the commemorative bowl in Mendes's film.

American Beauty concerns two families, the Burnhams and the Fittses. The Burnham family includes Lester (Kevin Spacey), an advertising executive who quits his job in an attempt to free himself from the limits of middle-class life; his wife, Carolyn (Annette Bening), a real estate agent who is a compulsive perfectionist; and Jane (Thora Birch), their teenage daughter, who coolly regards them both as "gross."

The movie opens with an aerial shot, moving over a tree-lined street, that sets the suburban scene. Another aerial shot, this one inside Lester and Carolyn's bedroom, sets the scene of the Burnham's loveless marriage. We see Lester just before the alarm clock awakens him, alone in the big bed, which is flanked by two identical end tables. Next, we see him masturbating in the shower ("This will be the high point of my day. It's all downhill from here"), followed by a shot of a perfect rose growing outside, and then another of Carolyn cutting the rose from its stem. Roses are traditionally symbols of love, but Carolyn's decisive use of the scissors underscores her emasculating behavior toward her husband.

These families live in what the movies have often tried to make us believe is a "typical" neighborhood. In keeping with this type of film—one that explores bright domestic surfaces and murky angst-filled depths and, in so doing, strips away many aspects of the American Dream—the exterior shots are bathed in clear, abundant sunlight, making everything look new, bright, and welcoming. The Burnhams live in a two-story white house, surrounded by a white picket fence, with blue shutters and a bright red door. In fact, bright

red is used prominently throughout the movie: that red door, Carolyn's hobby of growing red roses, Lester's fantasies of his daughter's friend Angela (Mena Suvari) in a bathtub filled with red rose petals, his red car, and, almost the last thing we see in the film, Lester's red

everything exactly where she wants it. Cooking pans hang over the island work space; a bowl of ripe fruit provides healthy snacks; small appliances are lined up neatly on the counters; dish towels are folded and hung; no dirty dishes linger in the sink; no messages are fastened to the refrigerator door with magnets. The decor of the dining room, where the Burnhams eat, reflects Carolyn's pretensions to formality—drapes, curtains, framed pictures, a tablecloth (with place mats to protect it), candles, and each person seated on his or her side of the table. Somewhat oddly, though, the floor is bare (a touch of coldness). While Carolyn thinks it's lovely to listen to Frank Sinatra during dinner, Jane calls it "elevator music," while Lester calls it "Lawrence Welk shit." In fact, Carolyn is so much in control of her environment that, as Lester tells us, "the handle of her gardening shears matches her gardening clogs—and that's no accident!" When Lester has been drinking beer, and then attempts to make love to her on the sofa, she worries that he will spill the beer. In the ensuing argument, this element of decor provides a defining moment for them both. She shrieks, "It's a $4,000 sofa upholstered with Italian silk!" to which he responds, "This isn't life—it's just *stuff!*" Such stuff surrounds and suffocates them.

The Fitts family, next door, includes Colonel Frank Fitts (Chris Cooper), a Marine obsessed with guns, discipline, and homophobia; his automatonlike wife, Barbara (Allison Janney); and their teenage son, Ricky (Wes Bentley), who is part student, part drug dealer, part poet (he shoots moody videotapes featuring dead birds and plastic bags in the wind), and, even though his father abuses him terribly, the most stable and happy person in the film. Theirs is a more modest house, also immaculately kept, no doubt reflecting Frank's

blood splattered on the kitchen wall. Inside, the house looks "perfect" in the choice and maintenance of its decor. For example, the kitchen, where Carolyn prepares "nutritious but savory meals," is immaculate. Everything has a place, and Carolyn has no doubt placed

military background. They appear to be less materialistic and have not tried to keep up with the Burnhams—their chairs are covered in plastic, Barbara does not bring home a second income—and have no pretensions to style. Inside Frank's den, a locked cabinet holds a gun collection and a dinner plate from Hitler's private service. Ricky pretends that he buys his state-of-the-art audio and video equipment with money earned from a job working for a caterer—a perfect example that all is not what it seems in these lives.

Their clothing also reveals the characters. Carolyn Burnham, who is always beautifully coiffed and made up, wears "power" outfits. By contrast, Barbara Fitts, who never seems to leave the house, sitting at the kitchen and dining room tables in a near-catatonic state, has dark circles under her eyes and wears drab clothing. Once he has quit his job, Lester wears jeans when he is relaxing and next to nothing when he is working out with weights in his garage. His goal is to "look good naked," as he tells the gay couple who live next door. These men, by the way, meet Carolyn Burnham's standards: "I *love* your tie ... that *color*," she tells one of them. Frank Fitts wears white T-shirts and pressed khakis, an outfit as close as he can get to a uniform without actually wearing one. The serious, confident Ricky—he probably makes more money than anyone else in the movie—looks decidedly different at high school, wearing a white shirt, tie, dark pants, dark sweater, and dark ski cap. Jane looks down-to-earth: simple T-shirts, pants, and sweaters. She usually wears a strand of beads, has on a little lipstick, and pulls her hair back in a ponytail. Angela, who has delusions about her attractiveness and potential as a model, appears somewhat more sophisticated than Jane and the other young women at school, wearing heavy makeup, sporting a shoulder bag, wearing her blond hair long, and smoking cigarettes. She thinks Ricky is a weirdo and asks Jane, "Why does he dress like a Bible salesman?"

Mendes and production designer Naomi Shohan employ such details not only to define characters but also to attack various aspects of contemporary American society, including consumerism and corporate culture, violence, puritanical sexual mores, mindless patriotism, self-empowerment jargon, peer pressure, drug use, unemployment, loneliness, and discrimination. The only sure thing in these lives, the only "American beauty," is death, and Ricky, who finds beauty in photographing dead birds, smiles knowingly after looking into the dead Lester's eyes. What he sees there, however, is left for us to decide. Perhaps that red door is a warning—that, to paraphrase Dante, we should abandon any hope when entering this particular vision of suburban hell.

MICHAEL ALMEREYDA'S *HAMLET*

Hamlet was first filmed in 1900, with the legendary actress Sarah Bernhardt as the prince; since then, more than fifty film and video versions have been made of Shakespeare's most famous play. Michael Almereyda has created an adaptation for the MTV generation and made it speak *to* and *for* them, turning it inside out with visual and verbal images that complement and clash with one another. The result is a unique vision both of *Hamlet* and of the United States, and production designer Gideon Ponte makes startling design choices in bringing it to the screen. One key to this film's design scheme comes from Hamlet's advice to the players—"to hold as 'twere the mirror up to nature, to show virtue her own feature, scorn her own image, and the very age and body of the time his form and pressure" (3.2.20–22). To convey the theme of self-confrontation, interior scenes are reflected on rooms' windows—giving us two images of action at once—and faces are reflected in mirrors, on the glass door of a washing machine, and on security video screens. Here the focus is the big city, not suburbia, Manhattan, not Denmark: but, like Solondz and Mendes, Almereyda directs our attention both to the surface and to what's beneath. The transformations are dazzling. Shakespeare's Danish royal house becomes the Denmark Corporation, with its headquarters in a Times Square skyscraper; the new king, Claudius (Kyle MacLachlan), becomes its president and CEO; Hamlet (Ethan Hawke), scholar-poet-playwright-actor on the page, becomes student-poet-filmmaker-videographer on the screen; the ghost of his dead father appears frequently, not on foggy battlements like a figment of the imagination but right in front of Hamlet, on terraces, in rooms, on security camera images. While delivering part of the "Rogue and peasant slave" speech, Hamlet uses his portable DVD unit to watch James Dean (a moody, Hamlet-like actor) in Nicholas Ray's *Rebel Without a Cause* (1955), as well as the late, legendary actor John Gielgud playing Hamlet. The play-within-the-play of course becomes a film-within-the-film. Ophelia (Julia Stiles) remains a bewildered and dreamy young woman, but she's also a

hip photographer living in a SoHo loft. In the end, Laertes and Hamlet are not killed by foils; instead, Laertes (Liev Schreiber) uses a gun (without which this could not be an "action" film) to kill Hamlet and then himself. And instead of killing Claudius with a poisoned rapier, the mortally wounded Hamlet takes Laertes's gun and shoots him. We are introduced to many of these aspects in the opening sequence.

In this world and in this *Hamlet,* technology abounds. Hamlet's apartment includes an array of electronic equipment, including portable video cameras, editing machines, and DVD players. Hamlet relies on computers as well, cunningly using the cut-and-paste function of his word processor to alter Claudius's secret order to kill him by substituting the names of Rosencrantz and Guildenstern for his own. Even the final fencing match is conducted with the aid of computerized sensors that register each "hit." Elsewhere, important messages emanate from fax machines; a video screen provides entertainment to limousine passengers; and another screen serves as a teleprompter for the anchorman (played by real-life TV news anchor Robert MacNeil) who delivers an "epilogue" that, in Shakespeare's text, is actually spoken by the Player King before the performance of *The Mouse Trap:*

> Our wills and fates do so contrary run
> That our devices still are overthrown;
> Our thoughts are ours, their ends none of our
> own. (3.2.193–95)

(As in life outside the movies, the anchorman has the last word on the day's events.)

The *camera* may be the single most important object in the film, for cameras are every-

where. Video security cameras reveal moments of great importance, including the Ghost's first appearance and Ophelia's body floating in a reflecting pool. Media representatives interview and photograph Claudius and Gertrude as if they were rock stars. Hamlet's cameras and other devices are his constant companions. In her mad scene, filmed at the Guggenheim Museum, Ophelia discards Polaroid pictures of pansies, fennel, columbine, rosemary, violets, and rue, the flowers mentioned in Shakespeare's text.

Costumes, makeup, and decor further develop milieu, story, and character. Hamlet wears black or pinstriped suits with T-shirts and a knitted hat from Peru. He has an incipient moustache and beard, wears tinted, wraparound sunglasses, and carries a shoulder bag. Ophelia wears stylish outfits and clumsy shoes. Gertrude (Diane Venora) is usually dressed in stylish black, including a black leather pantsuit that she wears to bid farewell to Hamlet and a large black feather hat at Ophelia's funeral. Claudius and his henchmen are also in black. Polonius (played here by Bill Murray as a tedious fool) is unkempt and unstylish. The ghost of Hamlet's father (Sam Shepard) wears a tweed jacket. People smoke, drink Denmark's Carlsberg beer, and chew gum.

Almereyda further refashions the play by cutting major speeches, restructuring the plot, and transforming Shakespeare's verbal images into visual ones. For example, here Hamlet delivers the "To be or not to be" soliloquy both directly and through interior monologue as he strolls through aisles of action videos at a Blockbuster store. Filled with indecision, he does not select a film, for what film could equal the revenge he contemplates? He also reveals his conflicted state of mind through the images he makes and keeps in his video diary. In this way, Almereyda's radical vision of *Hamlet* relies on his design strategies. In fact, the visual images compete with the words, sometimes replacing them, a technique that provides a tacit criticism of contemporary media- and image-saturated American society. Thus Shakespeare's play proves both its timelessness and its timeliness.

QUESTIONS FOR REVIEW

1. What are the differences between *mise-en-scène*, *composition*, and *design*?
2. How is mise-en-scène both a *physical creation* and an *emotional concept*?
3. What is *framing*? What controls framing in a movie? What is the difference between the *static frame* and the *moving frame*?
4. What are the essential differences between the *open* and the *closed frame*?
5. What are the *two basic types of movement* in a movie? Why do we need to screen a movie in order to fully grasp its *movement*?
6. Name and briefly discuss the *three major elements of cinematic design.*
7. Why is it possible to analyze *design* and *mise-en-scène* separately and together?
8. Why do most shots in a film rely on both *on-screen* and *offscreen spaces*?
9. Explain two significant ways in which mise-en-scène *creates meaning* in Renoir's *The Rules of the Game.*

QUESTIONS FOR ANALYSIS

1. Describe, as fully as you can, the *mise-en-scène* of the movie (or clip) you are analyzing.
2. Does the movie's designer appear to have followed a unified plan in designing it?
3. How would you describe the *settings*, both interior and exterior? From a design standpoint, do they have any relationship?
4. Is the framing of this film (or clip) *open,* or is it *closed*?
5. Using specific examples, explain how this film's (or clip's) design helps tell its story and create its meanings.
6. What is the relationship between the *narrative* (including genre) and *design* of this film (or clip)? Did the narrative require the art director to devote more than ordinary attention to the design?
7. Are the *two principal types of movement* evident in this film (or clip)? Does either take

precedence over the other, or do they function together?
8. Was achieving *verisimilitude* in the setting important to the design of this film (or clip)?

FOR FURTHER READING

Andrew, Dudley, ed. *The Image in Dispute: Art and Cinema in the Age of Photography.* Austin: University of Texas Press, 1997.

Annas, Alicia. "The Photogenic Formula: Hairstyles and Makeup in Historical Films." In *Hollywood and History: Costume Design in Film*, ed. Edward Maeder, 52–72. New York: Thames and Hudson, 1987.

Arnheim, Rudolf. *Art and Visual Perception: A Psychology of the Creative Eye.* Rev. ed. Berkeley: University of California Press, 1974.

———. *The Power of the Center: A Study of Composition in the Visual Arts.* New version. Berkeley: University of California Press, 1988.

Barr, Charles. "CinemaScope: Before and After." In *Film Theory and Criticism: Introductory Readings,* Gerald Mast and Marshall Cohen, ed., 140–68. 2nd ed. New York: Oxford University Press, 1979.

———. "A Letter from Charles Barr." *Velvet Light Trap,* no. 21 (summer 1985): 5–7.

Barsacq, Léon. *Caligari's Cabinet and Other Grand Illusions: A History of Film Design.* [Trans. Michael Bullock.] Rev. and ed. Elliot Stein. New York: New American Library, 1976.

Bazin, André. "The Evolution of the Language of Cinema." In *What Is Cinema?,* sel. and trans. Hugh Gray, 1: 23–40. Berkeley: University of California Press, 1966–71.

———. "Three Essays on Widescreen Film." *Velvet Light Trap,* no. 21 (summer 1985): 8–18.

Belton, John. "CinemaScope: The Economics of Ideology." *Velvet Light Trap,* no. 21 (summer 1985): 35–43.

Bertrand, Paul. "The Set Designer." *Unifrance Film,* no. 20 (October 1952): 3.

Bordwell, David. *On the History of Film Style.* Cambridge, Mass.: Harvard University Press, 1997.

———. "Widescreen Aesthetics and Mise en Scene Criticism." *Velvet Light Trap,* no. 21 (summer 1985): 18–25.

Brandy, Leo. *The World in a Frame: What We See in Film.* 1976. Reprint. Chicago: University of Chicago Press, 1984.

Brewster, Ben, and Lea Jacobs. *Theatre to Cinema: Stage Pictorialism and the Early Feature Film.* New York: Oxford University Press, 1997.

Brockett, Oscar G., and Robert R. Findlay. *Century of Innovation: A History of European and American Theatre and Drama since 1870.* Englewood Cliffs, N.J.: Prentice-Hall, 1973.

Carr, Robert E., and R. M. Hayes. *Wide Screen Movies: A History and Filmography of Wide Gauge Filmmaking.* Jefferson, N.C.: McFarland, 1988.

Carrick, Edward [Edward Anthony Craig]. *Designing for Films.* New ed. London: Studio Publications, 1949.

Carringer, Robert L. *The Making of "Citizen Kane."* Rev. ed. Berkeley: University of California Press, 1996.

Chisholm, Brad. "Widescreen Technologies." *Velvet Light Trap,* no. 21 (summer 1985): 67–74.

Corliss, Mary, and Carlos Clarens. "Designed for Film: The Hollywood Art Director." *Film Comment,* no. 14 (May/June 1978): 26–60.

Corson, Richard. *Stage Makeup.* 6th ed. Englewood Cliffs, N.J.: Prentice-Hall, 1981.

Dalle Vacche, Angela. *Cinema and Painting: How Art Is Used in Film.* Austin: University of Texas Press, 1996.

Dubery, Fred, and John Willats. *Perspective and Other Drawing Systems.* New York: Van Nostrand Reinhold, 1983.

Dunning, William V. *Changing Images of Pictorial Space: A History of Spatial Illusion.* Syracuse: Syracuse University Press, 1991.

Eisner, Lotte H. *The Haunted Screen: Expressionism in the German Cinema and the Influence of Max Reinhardt.* [Trans. Roger Greaves.] Berkeley: University of California Press, 1969.

Gibbons, Cedric. "The Art Director." In *Behind the Screen: How Films Are Made,* ed. Stephen Watts, 41–50. New York: Dodge Publishing, 1938.

Head, Edith, and Jane Kesnor Ardmore. *The Dress Doctor.* Boston: Little, Brown, 1959.

Heisner, Beverly. *Hollywood Art: Art Direction in the Days of the Great Studios.* Jefferson, N.C.: McFarland, 1990.

———. *Production Design in the Contemporary American Film: A Critical Study of 23 Movies and Their Designers.* Jefferson, N.C.: McFarland, 1997.

Henderson, Brian. "Notes on Set Design and Cinema." *Film Quarterly* 42 (fall 1988): 17–28.

Hincha, Richard. "Selling CinemaScope: 1953–1956." *Velvet Light Trap,* no. 21 (summer 1985): 44–53.

Hochberg, Julian. "The Representation of Things and People." In *Art, Perception, and Reality,* by E. H. Gombrich, Julian Hochberg, and Max Black, 47–94. Baltimore: Johns Hopkins University Press, 1972.

Horner, Harry. "The Production Designer." In *Filmmakers on Filmmaking: The American Film Institute Seminars on Motion Pictures and Television,* ed. Joseph McBride, 2:149–61. Los Angeles: J. P. Tarcher, 1983.

Hudson, Roger. "Three Designers." *Sight and Sound* 34, no. 1 (winter 1964–65): 26–31.

Katz, David. "A Widescreen Chronology." *Velvet Light Trap,* no. 21 (summer 1985): 62–64.

Kehoe, Vincent J-R. *The Technique of the Professional Make-up Artist for Film, Television, and Stage.* Boston: Focal Press, 1985.

Leese, Elizabeth. *Costume Design in the Movies.* New York: Frederick Ungar, 1976.

LoBrutto, Vincent. *By Design: Interviews with Film Production Designers.* Westport, Conn.: Praeger, 1992.

Lourié, Eugene. *My Work in Films.* San Diego: Harcourt Brace Jovanovich, 1985.

Maeder, Edward, ed. *Hollywood and History: Costume Design in Film.* New York: Thames and Hudson, 1987.

Mandelbaum, Howard, and Eric Myers. *Forties Screen Style: A Celebration of High Pastiche in Hollywood.* New York: St. Martin's Press, 1989.

Marner, Terence St. John, and Michael Stringer,

comps. *Film Design*. London: Tantivy Press; New York: A. S. Barnes, 1974.

McNamara, Brooks. "The Scenography of Popular Entertainment." *Drama Review* 18, no. 1 (March 1974): 16–24.

Meisel, Martin. *Realizations: Narrative, Pictorial, and Theatrical Arts in Nineteenth-Century England*. Princeton: Princeton University Press, 1983.

Mills, Bart. "The Brave New Worlds of Production Design." *American Film* 7, no. 4 (February 1982): 40–46.

Neumann, Dietrich, ed. *Film Architecture: Set Designs from "Metropolis" to "Blade Runner."* Exhib. cat., David Winton Bell Gallery, Brown University. New York: Prestel, 1999.

Nizhny, Vladimir. *Lessons with Eisenstein*. Trans. Ivor Montague and Jay Leyda. New York: Hill and Wang, 1962.

Olson, Robert L. *Art Direction for Film and Video*. Boston: Focal Press, 1999.

Perkins, V. F. *Film as Film: Understanding and Judging Movies*. Harmondsworth: Penguin, 1972.

Preston, Ward. *What an Art Director Does: An Introduction to Motion Picture Design*. Los Angeles: Silman-James Press, 1994.

Sennett, Robert S. *Setting the Scene: The Great Hollywood Art Directors*. New York: Harry N. Abrams, 1994.

Solso, Robert L. *Cognition and the Visual Arts*. Cambridge, Mass.: MIT Press, 1994.

Spellerberg, James. "CinemaScope and Ideology." *Velvet Light Trap*, no. 21 (summer 1985): 26–34.

Surowiec, Catherine A. *Accent on Design: Four European Art Directors*. London: British Film Institute, 1992.

Tashiro, C. S. *Pretty Pictures: Production Design and the History Film*. Austin: University of Texas Press, 1998.

Vardac, A. Nicholas. *Stage to Screen: Theatrical Method from Garrick to Griffith*. Cambridge, Mass.: Harvard University Press, 1949.

Weismann, Donald L. *The Visual Arts as Human Experience*. Englewood Cliffs, N.J.: Prentice-Hall, 1970.

White, John. *The Birth and Rebirth of Pictorial Space*. 2nd ed. New York: Harper and Row, 1972.

Wright, Lawrence. *Perspective in Perspective*. London: Routledge and Kegan Paul, 1983.

Note: *Velvet Light Trap,* no. 21 (summer 1985), a special issue titled "American Widescreen," contains an annotated widescreen bibliography as well as the articles listed above.

Cinematography

WHAT IS CINEMATOGRAPHY?

The word *cinematography* comes to us from the word *photography,* or "writing with light." Cinema derives from *kinesis,* "movement," and so "writing with light" becomes "writing with movement." ("Painting with light," cinematographer John Alton's definition, emphasizes aesthetics rather than etymology.) Cinematography's conversion of the still photographic image—multiplied and projected in quick succession—is of course the basis of making movies. Its methods, technology, and unique systems of framing images differentiate cinematography from still photography.

How often have you heard someone say about a movie, "The photography was just *gorgeous*"? While cinematography initially might seem to exist solely to please our eyes with beautiful images, it is in fact an intricate language that can (and in the most complex and meaningful films *does*) contribute to, enhance, or detract from a movie's overall meaning as much as the story, mise-en-scène, and acting do. The cinematographer uses the camera as a maker of meaning, just as the painter uses the brush or the writer uses the pen: the angles, heights, and movements of the camera function both as a set of techniques and as expressive material, the cinematic equivalent of brush strokes or of nouns, verbs, and adjectives. In addition, as we will see later in this chapter, complex relationships exist not only *within* the borders of individual pictures but also *between* the pictures. Thus to make an informed analysis and evaluation of a movie, we need to consider whether the cinematographer, in collaboration with the other filmmakers on the project, has successfully harnessed the powers of this visual language to help tell the story and convey the meaning(s) of the movie. As director Satyajit Ray puts it, "There is no such thing as good photography *per se.* It is either right for a certain kind of film, and therefore good; or wrong—however lush, well-composed, meticulous—and therefore bad."[1]

Every aspect of a movie's preproduction—writing the script, casting the talent, imagining the look of the finished work, designing and creating the sets and costumes, and determining what will be placed in front of the camera and in what arrangement and manner—leads to the most vital step: representing the mise-en-scène on film or video. While what we see on the screen reflects the vision and design of the filmmakers as a team, everyone involved visualizes the shooting script from a different point of view.[2] The producers worry about costs, public and critical reaction, and box-office receipts. The actors must learn their lines and explore their characters. Myriad technicians focus on details related to their individual areas of expertise. Finally, the director, the art director, and the director of photography (or D.P., also known as the cinematographer) look at the comparatively static shooting script and storyboard (if one is being used) to determine how they will transform them into moving images. Freddie Young, who won Best Cinematography Oscars for three David Lean movies—*Lawrence of Arabia* (1962), *Doctor Zhivago* (1965), and *Ryan's Daughter* (1970)—defines the D.P.'s job within the overall process of film production:

[1]Satyajit Ray, *Our Films, Their Films* (1976; reprint, New York: Hyperion, 1994), 68

[2]See John Alton, *Painting with Light* (Berkeley: University of California Press, 1995). Although some of the equipment it describes is now obsolete, this is a thorough, witty, and practical introduction to the art and science of cinematography.

The cameraman stands at the natural confluence of the two main streams of activity in the production of a film—where the imagination meets the reality of the film process.

Imagination is represented by the director, who in turn is heir to the ideas of the scriptwriter, as he is to those of the original author of the story. Three minds, and three contributing sources of imagination have shaped the film before the cameraman can begin to visualize it as a physical entity.[3]

In the ideal version of this working relationship, the director's vision shapes the process of rendering the mise-en-scène on film, but the cinematographer makes the very specific decisions about how the movie will be photographed. The three key terms used in shooting a movie are *shot, take,* and *setup.* A **shot** is one *uninterrupted* run of the camera. It can be as short or as long as the director wants, with the obvious condition that it not exceed the length of the film stock in the camera. **Take** indicates the number of times a particular shot is taken (e.g., shot 14, take 7). A **setup** is one camera position and everything associated with it. Whereas the shot is the basic building block of the film, the setup is the basic component of the film's production. The camera is an active agent, of course, not a neutral one, because it selects and arranges elements of the image we see on the screen, but what the camera sees is what the filmmakers want us to see—or, more precisely, what the director expects the director of photography to capture on film. As John Alton explains,

The screen offers the advantage of an ability (although we do not always utilize it) to photograph the story from the position from

On the set of *Citizen Kane*, cinematographer Gregg Toland and director Orson Welles *(bottom left and right, respectively)* set up a low-angle shot. When Welles was preparing to shoot the movie, his first, Toland was the world's most famous cinematographer. Yet he approached Welles and offered to shoot it, saying: "I want to work with somebody who never made a movie. That's the only way to learn anything—from somebody who doesn't know anything."

which the director thinks the audience would like to see it. The success of any particular film depends a great deal upon the ability of the director to anticipate the desires of the audience in this respect. . . .

[On the contrary,] the director of photography visualizes the picture purely from a photographic point of view, as determined by

[3]Freddie Young and Paul Petzold, *The Work of the Motion Picture Cameraman* (New York: Hastings House, 1972), 23.

lights and the moods of individual sequences and scenes. In other words, how to use angles, set-ups, lights, and camera as means to tell the story.[4]

As directors and their collaborators translate visions into realities, however, they follow not inflexible rules but rather conventions, which are open to interpretation by the artists entrusted with them. "You will accomplish much more," advises Gregg Toland—the cinematographer famous for such classics as John Ford's *The Grapes of Wrath* (1940), Orson Welles's *Citizen Kane* (1941), and William Wyler's *The Best Years of Our Lives* (1946)—"by fitting your photography to the story instead of limiting the story to the narrow confines of conventional photographic practice. And as you do so you'll learn that the movie camera is a flexible instrument, with many of its possibilities still unexplored."[5]

THE DIRECTOR OF PHOTOGRAPHY

The director of photography is both an artist and an executive. As an artist, the D.P is responsible for composing, lighting, and shooting the film and for translating the director's ideas into the look and atmosphere of the film. As an executive, the D.P. oversees the photography unit, which consists of two distinct groups. The first, responsible for the camera, includes the camera operator, assistant camera operators, and the **clapper/loader** (the person responsible for slating shots with the **clapperboard** and loading film containers into the camera); the second, responsible for electricity, includes the **gaffer** (chief electrician), **best boy** (first assistant electrician), electricians, and **grips** (all-round handypeople who work with both camera crew and electrical crew).

THE D.P.'S RESPONSIBILITIES

The cinematographer must have a thorough knowledge of the entire process of film production. During the preproduction conferences, he or she begins to plan the shooting. At that time, an experienced D.P. can offer suggestions that could benefit the producer and director both economically and practically. When the shooting begins, the basic working procedure usually goes something like this. As soon as the set is more or less complete, the D.P. reviews the lighting plan with the grips and instructs them to position the main lights accordingly. Next, he or she meets with the actors for initial lighting and composition checks. These enable the cameraperson to ensure that the lighting setup is satisfactory for the action in the shots and to make any necessary adjustments to enhance the actors' appearance. With the actors on the set, the D.P. reviews his or her initial compositions in terms of the action, repositioning the camera where needed to give the best composition for each shot and adding any camera movement that might improve a shot. In all of this, the director and the D.P. may reblock the actors' positions or movements to improve a shot or scene. Another rehearsal permits the D.P. and his or her crew to check the mise-en-scène (particularly the movement of the actors) against what was initially planned and thus to sense

[4]Alton, *Painting with Light*, 33.

[5]Gregg Toland, "How I Broke the Rules in *Citizen Kane*," in *Focus on "Citizen Kane,"* ed. Ronald Gottesman (Englewood Cliffs; N.J.: Prentice-Hall, 1971), 77.

the whole effect of what each shot will look like. There may be additional rehearsals, during which adjustments or improvements are made, before the actual photography begins. At that point, as many takes of each shot as necessary may be made before the director decides that one is good enough to use in the movie. Neither rule nor convention governs this matter. John Ford often used the first and only take, while directors as diverse as William Wyler and Stanley Kubrick were notorious (with producers, actors, and crew) for making dozens of takes before getting the right one.

The process is nowhere near as mechanical as it may seem in this brief summary. As both an artist and an executive, the D.P. must understand that all the artists working on a film share his or her commitment to the project; respect the egos, anxieties, and peculiarities of the actors; calculate just how far to push the lighting and camera crews; and, at the same time, respond to changes in the director's needs. In summary, the cinematographer's responsibilities for each shot and setup (as well as for each take) fall into four broad categories:

- cinematographic properties of the shot (film stock, lighting, lenses)
- framing of the shot (visualization and composition, types of shots, depth, camera angle and height, scale, camera movement)
- speed and length of the shot
- special effects cinematography

Although these categories necessarily overlap, we will look at each one separately. In the process, we will also examine the tools and equipment involved and what they enable the cinematographer to do.

CINEMATOGRAPHIC PROPERTIES OF THE SHOT

The D.P. controls the cinematographic properties of the shot, those basics of motion picture photography that make the movie image appear the way it does. These include the *film stock, lighting, lenses,* and *style.* By employing them, the cinematographer modifies not only the camera's basic neutrality but also the look of the finished image that the audience sees.[6]

FILM STOCK

The two basic types of **film stock** one to record images in black and white, the other to record them in color—are completely different and have their own technical properties and cinematic possibilities. Film stock is manufactured in several standard gauges, or widths measured in millimeters, including 8mm, Super 8mm, 16mm, 35mm, 65mm, and 70mm. The standard gauge for amateur work ("home movies") is digital video, which has made Super 8mm, once the standard, practically extinct; for student or other low-budget production work, 16mm is standard; for professional film production, either 35mm or 70mm is normally used. Generally, the wider the gauge, the more expensive the film and, all other factors being equal, the better the quality of the image. (As we noted in "Movies Depend on Light" in chapter 1, film stock also comes in various speeds, from very fast to very slow.)

[6]An invaluable guide to all essential aspects of motion picture technology is Bruce F. Kawin, *How Movies Work* (1987; reprint, Berkeley: University of California Press, 1992).

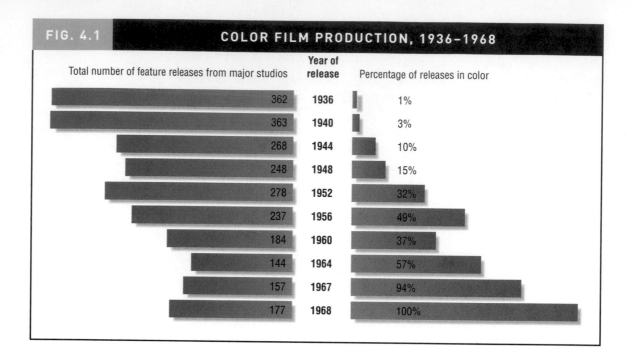

FIG. 4.1

COLOR FILM PRODUCTION, 1936–1968

Total number of feature releases from major studios	Year of release	Percentage of releases in color
362	1936	1%
363	1940	3%
268	1944	10%
248	1948	15%
278	1952	32%
237	1956	49%
184	1960	37%
144	1964	57%
157	1967	94%
177	1968	100%

Which stock is right for a particular film depends on the story being told; but with only a few outstanding exceptions, virtually all movies are now shot in color, for that is what the public is accustomed to and therefore expects. As Figure 4.1 shows, when Hollywood began to use color film stock, only 1 percent of the feature releases from major studios in 1936 were in color; the growth of color production slowed during World War II because all film stock, especially color, was in short supply; but by 1968 virtually all feature releases were in color. While color can heighten the surface realism (if not the verisimilitude) and the spectacle of many stories, it is not suitable for all films. For example, films in the expressionist or film noir styles are deliberately conceived to be shot in black and white; it's almost impossible to imagine anyone having shot F. W. Murnau's *Nosferatu* (1922) or Fritz Lang's *The Big Heat* (1953) in color.[7] By contrast, many movies shot in color might have been even better in black and white; for example, John Ford's *The Searchers* (1956; cinematographer: Winton C. Hoch) is a psychological western, concerned less with the western's traditional struggle between good and evil than with Ethan Edwards's (John Wayne) struggle against his own personal devils. Here Ford shot Monument Valley in color (it was not his first color film); and while the landscape so often photographed in black and white now has a totally new presence, it is so *red*—faithful to the terrain itself—that we begin to wonder if we should ask if the colors

[7]Werner Herzog made *Nosferatu the Vampyre* (1979) in color, offering interesting possibilities for comparing the two versions, particularly the relationships between film stocks and narratives.

are symbolic. Of the twenty-two feature films (not including documentaries and films for television) that Ford made after *She Wore a Yellow Ribbon* (1949), fifteen were shot in color, a major stylistic shift very much related to industry trends.

BLACK-AND-WHITE FILM STOCK. Black-and-white movies are not pictures that lack color, for black and white (and the range in between) *are* colors.[8] You can study the beauties and expressive possibilities of black and white in such contemporary black-and-white films as Martin Scorsese's *Raging Bull* (1980; cinematographer: Michael Chapman), Francis Ford Coppola's *Rumble Fish* (1983; cinematographer: Stephen H. Burum), Spike Lee's *She's Gotta Have It* (1986; cinematographer: Ernest Dickerson), Stephen Soderbergh's *Kafka* (1991; cinematographer, Walt Lloyd), Steven Spielberg's *Schindler's List* (1993; cinematographer: Janusz Kaminski), and John Boorman's *The General* (1998; cinematographer: Seamus Deasy)—all of which include some sequences in color. In addition, four of Woody Allen's films (photographed by Gordon Willis) have especially memorable black-and-white cinematography: *Manhattan* (1979), *Stardust Memories* (1980), *Zelig* (1983; some sections in color), and *Broadway Danny Rose* (1984).

Black-and-white film stock offers compositional possibilities and cinematographic effects that are impossible with color film stock, yet today—apart from the types of exceptions listed above—it is used almost exclusively for nonprofessional productions. Because of its use in documentary films (before the 1960s) and in newspaper and magazine photographs

[8]Alton, *Painting with Light,* ix.

[1]

[2]

Stagecoach (1), made in 1939, was the first film John Ford shot in Arizona's Monument Valley. Bert Glennon's black-and-white cinematography conveys the Old West differently than does Winton C. Hoch's color cinematography in *The Searchers* (2), from 1956, one of the last films Ford shot in Monument Valley. While the expressive photography was state-of-the-art in both films, the use of black and white and of color was not a matter of aesthetics but was dictated by industry standards.

(before the advent of color newspaper and magazine printing), we have, ironically, come to associate black-and-white photography and cinematography with a stronger sense of "gritty" realism than that provided by color

film stock. But the distinct contrasts and hard edges of black-and-white cinematography can express an abstract world (i.e., a world from which color has been abstracted or removed) perfectly suited for the kind of morality tales told in westerns, film noirs, and gangster films (see "Types of Movies" in chapter 1). In Fred Zinnemann's classic western *High Noon* (1952; cinematographer: Floyd Crosby), for example, high-contrast black-and-white cinematography not only provides documentary-like authenticity but also underscores the abstract conflict between the forces of good, led by Will Kane (Gary Cooper), and those of evil, represented by Frank Miller (Ian MacDonald). In fact, while many excellent color films have been made in these same genres—think of contemporary noirs such as Roman Polanski's *Chinatown* (1974; cinematographer: John A. Alonzo) or gangster films such as Quentin Tarantino's *Pulp Fiction* (1994; cinematogra-

pher: Andrzej Sekula)—we generally view their distinctive black-and-white predecessors as the templates for the genres.

Tonality—the system of tones—is the distinguishing quality of black-and-white film stock. This system includes the complete range of tones from black to white. Anything on the set—furniture, furnishings, costumes, and makeup—registers in these tones. Even when a film is shot in black-and-white, it is easier to design its settings and costumes in color. Most colors photograph well in black and white, and their tones can easily be controlled to produce the desired effects on the screen. Here is a simple example. Warm tones (such as those of two human faces on the screen) easily blend into one another. To separate them, cold tones (blues, for example) are often used for the settings. Black-and-white cinematography achieves its distinctive look through such manipulation of the colors being

Shot in 1979—long after Hollywood had fully converted to color—Woody Allen's *Manhattan* uses black and white to evoke the romance of New York City and to focus our vision on shapes, tones, and textures. The Queensboro Bridge (also known as the 59th St. Bridge) doesn't always look this splendid, but Gordon Willis's cinematography has helped make the view from Manhattan's glamorous Sutton Place iconic.

photographed, as well as through the lighting of them. The first thing we notice about most black-and-white films is their use of, and emphasis on, texture and spatial depth within the images. The cinematographer can change the texture of an image by manipulating shadows and can control the depth of the image by manipulating lighting.

In addition to creating texture and depth, the range of "colors" in black-and-white films carries with it certain preconceived interpretations. We usually interpret black-and-white images in fairly obvious ways (e.g., black = evil, white = good). As simplistic, misleading, and potentially offensive as these interpretations may be, they reflect widespread cultural traditions that have been in effect for thousands of years. The earliest narrative films, which greatly appealed to immigrant audiences (most of whom could neither read nor speak English), often relied on such rough distinctions to establish the moral frameworks of their stories. Later, even though both audiences and cinematography became more sophisticated, these distinctions held together the narratives of countless films in diverse genres. The great Hollywood cinematographer James Wong Howe, for example, strove for a strict naturalism in his black-and-white cinematography. When we admire, say, the sharp-contrast, deep-focus, and film noir effects in Howe's work on Alexander Mackendrick's *The Sweet Smell of Success* (1957), we are struck by its ability to capture the sleazy allure of New York City's Times Square (before its renovation in the late 1990s) and to help tell a story of urban menace, corruption, and decay.

COLOR FILM STOCK. Although full-scale color film production arrived only in the

This shot from Fred Zinneman's *High Noon* illustrates the tonal range possible in black-and-white cinematography—from absolute white (in the shirt), through a series of grays, to absolute black (in the bottom of the hat's brim). For the purposes of explanation, this illustration includes only ten tones out of the complete range. Note that although he is the movie's protagonist, Will Kane (Gary Cooper) wears a black hat—typically, in less sophisticated morality tales, the symbolic mark of the bad guy.

1930s, it was possible to create color images from the movies' beginning. The earliest method was to hand-paint each frame, a process so tedious that at first only selective frames were colored. Since silent film had sixteen frames per second, hand-tinting even a ten-minute film meant painting each of 9,600 frames separately. Edwin S. Porter's *The Great Train Robbery* (1903; cinematographers: not credited), the best-known and most commercially successful American film of the pre-Griffith era, includes hand-painted frames, as

do some of Georges Méliès's films, made in France around the same time.[9]

Tinting, one of two other early methods for creating color images, involved printing the black-and-white negative on specially colored film stock; this provided shots or scenes in which a single color set the time of day, distinguished exterior from interior shots, created an emotional mood, or otherwise affected the viewer's perception. D. W. Griffith used this technique very effectively in such films as *Broken Blossoms* (1919; cinematographer: G. W. Bitzer), as did Robert Wiene in *The Cabinet of Dr. Caligari* (*Das Kabinett des Doktor Caligari,* 1919; cinematographer: Willy Hameister). Toning, the other process, offered greater aesthetic and emotional control over the image; it used chemicals that converted the image from black and white to color.

Imaginative as hand-painting, tinting, and toning are, they do not begin to accurately reproduce the range of colors that exists in nature. The Technicolor "additive" two-color process could reproduce a specific color by adding and mixing combinations of the three primary colors (red, yellow, and blue) in their required proportions. It was used for color sequences in such films as Cecil B. DeMille's *The Ten Commandments* (1923; cinematographers: Bert Glennon, Peverell Marley, Archie Stout, and Fred Westerberg) and Erich von Stroheim's *Merry Widow* (1925; cinematographers: Oliver Marsh and Ben F. Reynolds), as well as in such complete features as Irvin Willat's *Wanderer of the Wasteland* (1924; cinematographer: Arthur Ball) and Albert Parker's *The Black Pirate* (1926; cinematographer: Henry Sharp).

By the early 1930s, the additive gave way to the subtractive process (introduced by Technicolor in 1932), which works as follows. A black-and-white negative is made through three light filters, each representing a primary color. These three "color-separation" negatives are then superimposed and printed as a positive in natural color. The term *subtractive* is used because the final color results from the removal of certain color components from each of the three emulsion layers. The first films to be made with the subtractive process were Walt Disney's short "Silly Symphony" cartoons *Flowers and Trees* (1932) and *The Three Little Pigs* (1933) and Pioneer Pictures' live-action film *La Cucaracha* (1934). The first feature-length film made in the three-color subtractive process was Rouben Mamoulian's *Becky Sharp* (1935; cinematographer: Ray Rennahan).[10]

Making a Technicolor movie was complicated and cumbersome and cost almost 30 percent more than comparable black-and-white productions. The Technicolor camera, specially adapted to shoot three strips of film at one time, required a great deal of light. Its size and weight restricted its movements and potential use in exterior locations. Furthermore, the studios were obliged by contract to employ Technicolor's own makeup, which resisted melting under lights hotter than those used for shooting black-and-white films, and to process the film in Technicolor's labs, initially the only place that knew how to do this

[9]For an excellent account of the birth of the cinema, see Charles Musser, *The Emergence of Cinema: The American Screen to 1907* (New York: Scribner, 1990).

[10]Rouben Mamoulian, an outstanding New York theater director before going to Hollywood, was one of the first movie directors to exploit the creative uses of both sound and color in the movies. See Mamoulian, "Color and Light in Films," *Film Culture*, no. 21 (summer 1960): 68–79.

work. For all these reasons, in addition to a decline in film attendance caused by the Great Depression, producers were at first reluctant to shoot in color. However, by 1937, color had entered mainstream Hollywood production; by 1939, it had proven itself much more than a gimmick in movies such as Victor Fleming's *Gone With the Wind* (cinematographer: Ernest Haller) and *The Wizard of Oz* (cinematographer: Harold Rosson) and John Ford's *Drums Along the Mohawk* (cinematographers: Bert Glennon and Ray Rennahan), all released that year.

In 1941, Technicolor introduced its Monopack, a multilayered film stock that could be used in a conventional camera. Since the bulky three-strip camera was no longer necessary, Technicolor filming could now be done outdoors. Eventually, the rival Eastmancolor system—which required less light and could be processed at lower cost—replaced Technicolor, and it remains the standard color film stock in use today. But just as Hollywood took several years to convert from silent film to sound (see chapter 7), so too the movie industry did not immediately replace black-and-white film with color. During the 1950s, Hollywood used it strategically, like the widescreen ratio (see "Framing of the Shot," below), to lure people away from their television sets and back into theaters. By 1968, however, all feature releases from the major studios were in color.

During the 1970s and '80s, certain television moguls tried to "improve" the "old" movies they were showing on television with the process of **colorization:** using digital technology, in a process much like hand-tinting, they "painted" colors on great movies meant by their creators to be seen in black and white. The unimpressive results were limited by the state of computer graphics at that time; but even though computer color technology has

Victor Fleming's *Gone With the Wind* marked a turning point in Hollywood film production, ushering in an era of serious filmmaking in color. Its vibrant and nostalgic images of the antebellum South delighted audiences and earned it a special commendation at the 1939 Academy Awards for "outstanding achievement in the use of color for the enhancement of dramatic mood."

improved tenfold, the practice has abated. We seem to have realized that colorization tramples on the film artists' right to have their movies shown in the format in which they were made. Both black-and-white and color films have their own place in movie history, and neither needs to be "transformed" into something else. For example, many viewers had become so used to seeing Monument Valley in John Ford's black-and-white films that when he shot his first film there in color (*She Wore a Yellow Ribbon,* 1949; cinematographer: Winton Hoch), they reacted unfavorably even though the vibrant colors they were seeing—reds and browns, the constantly changing blues of the sky—naturally prevailed there. For viewers with such fixed expectations, Monument Valley existed only in black

and white. Orson Welles was so opposed to—at that time, predigital—colorization of any movie that he inserted a clause in his *Citizen Kane* contract prohibiting that film from being so altered; however, when Turner Entertainment Company announced plans to colorize their archives of black-and-white film classics, Welles reportedly told filmmaker Henry Jaglom, "Don't let Ted Turner deface my movie with his crayons."

Now that color film dominates, a new naturalism has become the cinematographic norm. It has become the standard because most films are shot on location, utilizing natural light, so that what we see on the screen looks very much like what we would see in real life. Today, when we say that a particular movie's "cinematography is beautiful," we

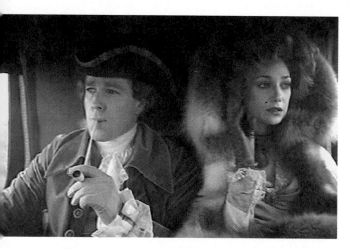

Because we experience the world in color, color films may strike us as more "realistic" than black-and-white ones. Many color films, however, use their palettes not just expressively but also expressionistically—that is, they call our attention to their evocativeness. For Stanley Kubrick's *Barry Lyndon*, cinematographer John Alcott has helped convey both a historical period and a painterly world of soft pastels, gentle shading, and misty textures.

may actually mean that the scenery itself is beautiful and that the camera has recorded it faithfully. But color film stock doesn't necessarily produce a naturalistic image. Film artists and technicians can manipulate the colors in a film as completely as they can any other formal element. Much of Stanley Kubrick's *Barry Lyndon* (1975; cinematographer: John Alcott), for example, employs a color palette that reflects its setting: the world of soft pastels and gentle shadows depicted in the paintings of such eighteenth- and nineteenth-century artists as Thomas Gainsborough, William Hogarth, and Adolf von Menzel.

Ultimately, just like its black-and-white counterpart, color film can capture realistic, surrealistic, imaginary, or expressionistic images. Thus realistic images characterize most of Arthur Penn's *Bonnie and Clyde* (1967; cinematographer: Burnett Guffey), although a surrealistic sequence invokes the dreamlike world in which Bonnie visits her mother. In a similar vein, the interplay of fantasy and screen reality is brilliantly, vibrantly conveyed in Federico Fellini's *Juliet of the Spirits* (*Giulietta degli spiriti*, 1965; cinematographer: Gianni Di Venanzo). Bernardo Bertolucci creates expressionistic images that exaggerate otherwise natural aspects in *The Conformist* (*Il conformista*, 1970; cinematographer: Vittorio Storaro), where color is frequently drained of its tones, as it is also in Michelangelo Antonioni's *Red Desert* (*Il deserto rosso*, 1964; cinematographer: Carlo Di Palma). Colors are heightened to call attention to the heat of the day in Spike Lee's *Do the Right Thing* (1989; cinematographer: Ernest Dickerson), and to the darkness of the jungle in Terrence Malick's *The Thin Red Line* (1998; cinematographer: John Toll). In the complex baptism sequence in Francis Ford Coppola's *The*

Godfather (1972; cinematographer: Gordon Willis;), which cross-cuts (see "Parallel Editing" in chapter 6) between the cathedral and a series of murders, the color cinematography ranges from realistic to surrealistic to expressionistic, each style appropriate to the mood of the shot and its function in the story.[11]

LIGHTING

During preproduction, most designers include an idea of the lighting in their sketches, but in actual production, the cinematographer determines the lighting once the camera setups are chosen. Ideally, the lighting shapes the way the movie looks and it helps tell the story. As a key component of composition, lighting creates our sense of cinematic space by illuminating people and things, creating highlights and shadows, and defining shapes and textures. Among its properties are its *source, quality, direction, color,* and *style.*[12]

SOURCE. The two sources of light are *natural* and *artificial.* Daylight is the most convenient and economical source. The movie industry made Hollywood the center of American movie production in part because of its almost constant sunshine. Even when movies are shot outdoors on clear, sunny days, however, filmmakers use reflectors and artificial lights because they don't count on nature's cooperation. And even if nature does provide the right amount of natural light at the right

In Billy Wilder's comedy *Some Like It Hot* (1959), a spotlight suggestively doubles as a virtual neckline for Marilyn Monroe during her famous performance of "I Wanna Be Loved by You." As he often did during his long career as screenwriter and director, Wilder was playfully testing the boundaries of Hollywood moviemaking—seeing what he could get away with.

time, that light may need to be controlled in various ways. Artificial lights are called *instruments* to distinguish them from the light they produce. Among the many kinds of these instruments, the two most basic are **focusable spots** and **floodlights,** which produce, respectively, the two basic qualities of light: *hard* (specular) and *soft* (diffuse). Direct sunlight is specular; it creates harsh, well-defined shadows. But when sunlight passes through clouds, it becomes diffuse. A focusable spotlight can produce either a hard, direct spotlight beam or a more indirect floodlight beam. When it is equipped with black metal doors (known as *barn doors*), it can be used to cut and shape the light in a variety of ways. In either case, it produces distinct shadows. Floodlights produce diffuse, indirect light with very little to no shadows. The most effective floodlight for filmmaking is the *softlight,* which creates a very soft, diffuse, almost shadowless light.

[11]This sequence is discussed in chapter 1; see also Kawin, *How Movies Work,* 175–85, for another analysis.

[12]Two useful reference books on lighting are Kris Malkiewicz, *Film Lighting: Talks with Hollywood's Cinematographers and Gaffers* (New York: Prentice-Hall, 1986), and Gerald Millerson, *The Technique of Lighting for Television and Film,* 3rd ed. (Boston: Focal Press, 1991).

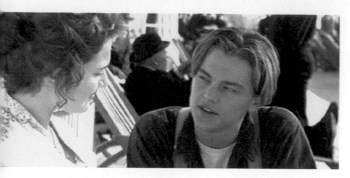

Outdoor shots in direct sunlight pose a risk of casting harsh shadows on actors' faces. This shot from James Cameron's *Titanic* (1997) shows the effect of using a reflector board to soften shadows and to cast diffuse light on the bottom of the chin and the nose and under the brow, thus giving Leonardo Di Caprio's face a softer, warmer look onscreen.

Another piece of lighting equipment, the **reflector board,** is not really a lighting instrument, because it does not rely on bulbs to produce illumination. Essentially, it is a double-sided board that pivots in a U-shaped holder. One side is a hard, smooth surface that reflects hard light; the other is a soft, textured surface that provides softer fill light. It comes in many sizes and is used frequently, both in interior and especially in exterior shooting; most often it reflects sunlight into shadows during outdoor shooting.

QUALITY. By the *quality* of the light we mean the level or intensity of its illumination, which can be either hard or soft. As just noted, lights differ principally by the nature and amount of shadow they create. Since lighting is used to reinforce the narrative, we can generally (but not always) associate dark lighting with serious or tragic stories, bright lighting with romantic or comic ones. These reactions to lighting are also influenced by the direction from which the light comes (see below). However, the quality of light can also be manipu-

lated by **filters,** pieces of plastic or glass placed in front of the lens. Special filters exist for each type of film stock (black-and-white and color) as well as for each type of light (natural and artificial). Some all-purpose filters work with either type of film stock.

DIRECTION. Light can be thrown onto a movie setting (exterior or interior) from virtually any direction: from the front or back of the subject, from below or above it. Thus its quality and direction can be manipulated to

Backlighting can provide a dramatic sense of depth, especially when it is the sole light source, as in the projection room scene in Orson Welles's *Citizen Kane.* The intensity of light coming from the projection booth's windows provides clear visual cues to the depth of the onscreen space by creating a deep shadow in the foreground, a bright focus in the middle ground, and murky gray in the background. The shape of the beams of light—receding toward a vanishing point behind the wall—not only contributes to our sense of depth but also accentuates the two main characters in the scene: Jerry Thompson (William Alland, *left*), the reporter who prepared the "News on the March" sequence, and his boss, Mr. Rawlston (Philip Van Zandt).

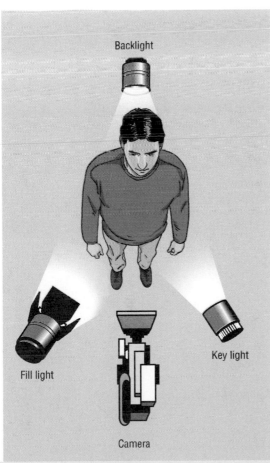

Backlight

Fill light

Key light

Camera

The classical Hollywood three-point lighting system creates an even and glamorous effect, as in this close-up of Grace Kelly taken from Alfred Hitchcock's *Rear Window* (1954). In this shot, the key light is most likely to the right of the camera, since there is a slight shadow cast on the right side of Kelly's nose. The fill light would likely have been lower than the key (notice the lack of shadow under her nose) and to the left of the camera. The backlight appears to be above the top edge of the frame, rather than directly behind Kelly, thus creating a halolike glow in her hair.

produce expressive visual images that suggest various meanings. For example, backlighting, known for its expressiveness, can be used to achieve very different effects: to create depth in a shot by separating a figure from the background, as in the projection room scene in Orson Welles's *Citizen Kane* (1941; cinematographer: Gregg Toland), where Mr. Rawlston (Phillip Van Zandt) and Jerry Thompson (William Alland) are outlined by the strong backlight from the projector; to create "glamour" shots that idealize a figure, as in shots of Queen Christina (Greta Garbo) before the fire in Rouben Mamoulian's *Queen Christina* (1933; cinematographer: William Daniels); or to accentuate malice, as in the sight of Phillip Vandamm (James Mason) against a table lamp during his first appearance in Alfred Hitchcock's *North by Northwest* (1959; cinematographer: Robert Burks). Such effects can make lighting seem complicated; but the classical Hollywood three-point system, the fundamental approach to film lighting, is relatively simple. It employs three sources of light, each aimed from a different direction: *key light, fill light,* and *backlight.*

The **key light** (also known as the *main* or *source light*) is the brightest light falling on the subject. Positioned to one side of the camera, it creates hard shadows. **High-key lighting** produces an image with very little contrast between the darks and the lights. It is used extensively in dramas, musicals, comedies, and adventure films, and its even, flat illumination does not call particular attention to the subject being photographed. Its opposite, **low-key lighting,** creates stronger contrasts; sharper, darker shadows; and an overall gloomy atmosphere. It is used in horror films, mysteries, psychological dramas, crime stories, and film noirs, and its contrasts between light and dark often imply ethical judgments. The **fill light,** which is positioned at the opposite side of the camera from the key light, can fill in the shadows created by the brighter key light. Fill light may also come from a reflector. The **backlight,** usually positioned behind and in line with the subject and the camera, is used to create highlights on the subject as a means of separating it from the background and increasing its appearance of three-dimensionality. In studio lighting, the backlight is usually a spotlight positioned above and behind the subject. In exterior shooting, the sun is often used as a backlight. However, the backlight is the least essential of these three sources, and the overall character of the image is determined mainly by the relationship between the key and fill lights.

COLOR. Here, color refers to the *color of the light source,* not to color film stock. The light sources used in making movies are generally pure white: the hot, white light of the sun or the equally hot, white light produced by artificial sources such as the arc lights used for color shooting. This pure white light can be controlled by filters, diffusers, or other devices placed in front of the light source. The technique of measuring and filtering light is an important, highly technical aspect of filmmaking, and it has been so perfected that filmmakers today can manipulate the light in any way they want.

LENSES

Each camera lens has a different *focal length* and thus a different *depth of field.* The **focal length** is the distance from the optical center of a **lens** to the focal point (the film plane—foreground, middle ground, or background—that the camera person wants to keep in focus)

The short-focal-length lens used in this scene from Stanley Kubrick's *Dr. Strangelove* (1964) keeps nearly the entire onscreen space in focus, and it comically reinforces our sense of the powerlessness of Group Captain Lionel Mandrake (Peter Sellers, facing the camera) as he meets with his superior officer, Brigadier General Jack D. Ripper (Sterling Hayden). The resulting wide-angle composition makes Mandrake look almost like a toy doll standing on the powerful general's desk.

A middle-focal-length lens was used to shoot this image from Billy Wilder's *Sunset Blvd.* (1950). Perspective relations in this picture are more or less as we see them in our everyday lives. Bathed in the light from a movie projector, silent-screen star Norma Desmond (Gloria Swanson), enthralled by one of her movies, clutches the arm of Joe Gillis (William Holden), a screenwriter who she hopes will revitalize her career.

when the lens is focused at infinity. The **depth of field** is the distance in front of a camera and its lens in which objects are in apparent sharp focus. The four major types of lenses are

- the **short-focal-length lens** (also known as the *wide-angle lens*), which creates the illusion of depth, albeit with some distortion at the edges of the frame
- the **middle-focal-length lens** (the *"normal" lens*), which does not distort perspectival relations
- the **long-focal-length lens** (the *telephoto lens*), which flattens the space and depth and thus distorts perspectival relations
- the **zoom lens,** which has a variable focal length and can be continuously adjusted—within the camera to which it is attached—to provide various degrees

This image from Stanley Kubrick's *Barry Lyndon* (1975) shows the flattening effect of a telephoto lens. In this picture, we might estimate that twenty-five feet of actual depth is flattened onto the picture plain: essentially eight rows of marching soldiers occupy the space, and each row probably occupies a little more than three feet.

In Alfred Hitchcock's *Vertigo* (1950), Scottie Ferguson (James Stewart) suffers from a strong fear of heights. Here, Hitchcock illustrates the character's feeling through a disorienting zoom-lens shot that seems to make the bottom of a stairwell recede.

of magnification without loss of focus (and thus combines the features of the other three lenses)

In virtually all movie shooting, cinematographers keep the lenses in sharp focus to maintain clear spatial and perspectival relations within frames. However, they can put all or part of individual pictures out of focus if stories require that effect. An assistant camera operator responsible for following and maintaining the focus during shots is called the **focus puller.**

STYLE. The overall style of a film is determined by its **production values,** or the amount of human and physical resources devoted to the image, and that includes the style of its lighting. For example, in the films produced in the Hollywood studio system, we can usually identify the studio itself by the overall look of the film's lighting: somber, low-key lighting in black-and-white pictures from Warner Bros.; sharp, glossy lighting in the films from Twentieth Century Fox; and bright, glamorous lighting for MGM's many color films, especially the musicals. There are as many lighting styles as there are directors of photography, and we recognize the impor-

tance of a particular D.P.'s style when a film's lighting calls attention to itself.

Let's examine a few examples of such lighting. In *Way Down East* (1920; cinematographer: Billy Bitzer), D. W. Griffith uses hand-tinting and light to express his vision of how the warm, secure interior of a farmhouse reflects the simple life lived there. In *Rebecca* (1940; cinematographer: George Barnes), Alfred Hitchcock uses contrasting dark and light shadows to express and underscore the fear that Mrs. De Winter (Joan Fontaine) feels for the cold, threatening housekeeper, Mrs. Danvers (Judith Anderson), who reveres the memory of her predecessor, Rebecca De Winter. In Orson Welles's *Citizen Kane* (1941; cinematographer: Gregg Toland), pools of light within the inky-black deep-space composition of Xanadu's great hall reveal how far apart from one another, physically and emotionally, are Charles Foster Kane (Orson Welles) and his wife, Susan (Dorothy Comingore). Rarely has lighting said as much as it does in John Ford's *The Grapes of Wrath* (1940; also photographed by Gregg Toland), where the high, bright midday sun creates an interplay of light, darkness, and the gray areas in between to establish not only the mise-en-scène but also the moral climate, as in the argu-

ment between the (evil) unnamed banker's agent (Adrian Morris) with an order for eviction and the (good) farmer, Muley Graves (John Qualen), the subject of the order. The sunlight causes the agent to squint, and, as Muley squats to deliver his memorable soliloquy about his family's ownership of the farm, his body casts a long shadow across a patch of that land. Similarly, lighting helps develop the moral ambiguities in Otto Preminger's *Laura* (1944; cinematographer: Joseph LaShelle), a stylish, psychological murder mystery. In some scenes, high-contrast light differentiates the good people from the evil ones. However, during the scene in which police detective Mark McPherson (Dana Andrews) interviews a group of socially prominent but unsavory citizens who knew the victim, a high-contrast light plays on the actors, while a cool and matter-of-fact light washes on the background (window curtains

In Orson Welles's *Citizen Kane*, Susan Kane (Dorothy Comingore) tends to a jigsaw puzzle (not shown in frame) while her husband, Charles Foster Kane (Welles), broods in his thronelike chair deep in the background. The entire space offers a gloomy, almost medieval setting for the couple's deepening rift.

filter and soften the sunlight as it strikes the opposite walls). This makes ambiguous characters seem even more evil than they at first appear. Preminger and LaShelle modulate the expectations traditionally raised by film noir lighting (see "Types of Movies" in chapter 1), so that the lighting here both directs and complicates our interpretation of what we see.

FRAMING OF THE SHOT

VISUALIZATION AND COMPOSITION

A painter can choose any size of canvas as the area in which to create a picture: large or small, square or rectangular, oval or round, flat or three-dimensional. A director and cinematographer find their choices more limited, and they must work with both the possibilities and the limitations of their "canvas." What one perceives with the naked eye becomes

In Alfred Hitchcock's *Rebecca,* Joan Fontaine *(right)* conveys Mrs. De Winter's fear; Judith Anderson conveys Mrs. Danvers's sinister nature. Our anxiety results in part from their acting and in part from specific filmmaking techniques, such as the extreme lighting that enhances the drama within this scene.

very different when seen through the view-finder. Camera framing turns the comparatively *infinite* sight of the human eye into a *finite* movie image, an *unlimited* view into a *limited* view. Furthermore, it shapes that view into dimensional variations on a rectangle. This rectangle largely results from photographic technology; nothing *absolutely* dictates that our experience of moving images must occur within a rectangle. However, because of the standardization of equipment and technology within the motion picture industry, we have come to know this rectangle as the "shape" of movies.

From the earliest days, movie directors have experimented with variations on the rectangle. In so doing, they often use a **mask**—an opaque sheet of metal, paper, or plastic with a cutout

Mike Nichols's *The Graduate* features one of the most famous (and amusing) maskings of the frame in movie history. As the scene ends, Ben Braddock (Dustin Hoffman), framed in the provocative bend of Mrs. Robinson's (Anne Bancroft) knee, asks, "Mrs. Robinson, you're trying to seduce me. . . . Aren't you?"

In this shot from Charles Laughton's *The Night of the Hunter,* Harry Powell (Robert Mitchum) makes his way nonchalantly toward the house in which his stepchildren are hiding from him. Although he acts as though he cannot see them, the iris-out that follows his progress toward the house and that eventually frames the children's fearful faces peering out of the basement window makes clear to us that he knows *exactly* where they are hiding.

(known as an **iris** when circular) that is placed in front of the camera and admits light to a specific area of the frame—to create a frame within the frame. Its obvious function is to draw our eyes to that particular place and thus to emphasize what we see there. Charles Laughton uses an **iris-out**—a transitional effect in which the iris contracts from larger to smaller—in *The Night of the Hunter* (1955; cinematographer: Stanley Cortez), where we see Harry Powell (Robert Mitchum) walking toward a ground-level window behind which his stepchildren are hiding from him. Masks can also be created by lighting, as when Laughton isolates a stripper within the frame by accentuating the spotlight in which she is performing. Architectural details are frequently used to mask a frame, and a person placed between the camera and its subject can also mask the frame. In Mike Nichols's *The Graduate* (1967; cinematographer: Robert Surtees), during her initial seduction scene of Ben Braddock (Dustin Hoffman), Mrs. Robinson (Anne Bancroft) sits at the bar in her house and raises one leg onto the stool next to her, forming a triangle through which he is framed, or, perhaps, trapped.

The relationship between the frame's two dimensions is known as its **aspect ratio,** the ratio of the width of the image to its height. Each movie is made to be shown in one aspect ratio from beginning to end. That ratio can be controlled in the camera by various means or, more ordinarily, by lenses, which can be *flat* or *anamorphic.* An anamorphic lens squeezes an image in one direction, usually horizontally, and thus produces a wider view of the events and objects that appeared in front of the camera than would be possible with standard lenses. The following list includes the most common aspect ratios:

- 1.33 : 1 Academy (35mm flat)
- 1.66 : 1 European widescreen (35mm flat)
- 1.85 : 1 American widescreen (35mm flat)
- 2.2 : 1 Super-Panavision and Todd-AO (70mm flat)

1.33:1

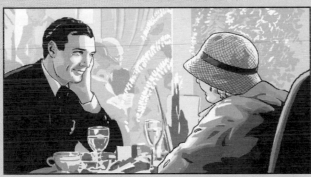

1.85:1

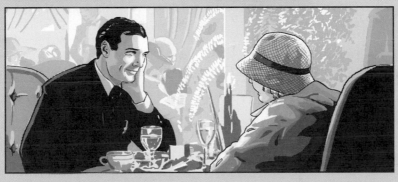

2.35:1

- 2.35 : 1 Panavision and CinemaScope
 (35mm anamorphic)
- 2.75 : 1 Ultra-Panavision
 (70mm anamorphic)

Until the 1950s, when the widescreen image became popular, the standard aspect ratio for a flat film was the Academy ratio of 1.33 : 1, meaning that the frame is 33 percent wider than it is high—a ratio corresponding to the dimensions of a single frame of 35mm film stock. Today's more familiar widescreen variations provide wider horizontal and shorter vertical dimensions. Most commercial releases are shown in the 1.85 : 1 aspect ratio, which is almost twice as wide as it is high. This ratio is achieved by placing a masking plate in the aperture opening of the projector and thereby cutting off the top of the image. When a film shot in the 1.85 : 1 ratio appears on television, much of the frame is lost; however, commercial videotapes marked *letterbox version* preserve the 1.85 : 1 ratio on the television screen. Other widescreen variations include a 2.2 : 1 or 2.35 : 1 ratio when projected.

TYPES OF SHOTS

The names of the most commonly used shots employed in a movie—the *long shot,* the *medium shot,* and the *close-up*—refer to the distance between the camera lens and the subject being photographed. These names reflect the study of proxemics (a term derived from the word *proximity*). The standard measure for designating shots is the scale of the human body in relationship to the camera.

The **long shot** (LS) shows the full human body, usually filling the frame, and some of its surroundings. The full-body shot was used frequently by early filmmakers, including Charlie Chaplin, who, like Buster Keaton,

wanted the audience to know that he (not a stuntman) was responsible for his comic stunts. For example, in Henry Lehrman's *Kid Auto Races at Venice* (1914; cinematographers: Enrique Juan Vallejo and Frank D. Williams), Chaplin appears for the first time in the costume of his legendary character, the Tramp. The LS can also be used to diminish the size of the character in relation to some larger force, as in his *Modern Times* (1936; cinematographers: Ira Morgan and Roland Totheroh), where Chaplin, a working man, is overwhelmed by the machinery he tends. The **extreme long shot** (ELS)—where the human figure is placed far away from the camera—is

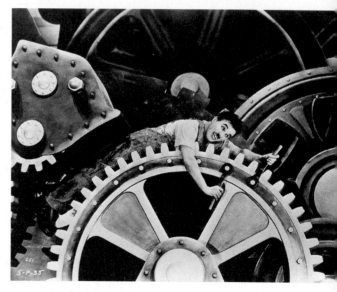

A long shot (LS) from Charlie Chaplin's *Modern Times* establishes the relative scale of the Little Tramp's (Chaplin) body against the machinery with which he contends. As always, the Little Tramp is at the mercy of the social order, this time represented by the machinery of an industrial colossus. Try as he does to tighten the bolts, they inevitably loosen, ultimately undoing him. Some critics see parallels between his character's conflict with the machinery and the contemporary challenge Chaplin faced in adapting to sound film.

An extreme long shot (ELS) from Chaplin's *The Great Dictator* leaves the dictator (Chaplin) overwhelmed by his surroundings. The effect makes this character, a lampoon of Adolf Hitler, ridiculous rather than menacing.

used in Chaplin's *The Great Dictator* (1940; cinematographers: Karl Struss and Roland Totheroh); there Chaplin, lampooning Adolf Hitler as Adenoid Hynkel, is dwarfed by his enormous office.

The **medium shot** (MS) shows the human body, usually from the waist up. In Martin Scorsese's *Raging Bull* (1980; cinematographer: Michael Chapman), for example, a MS depicts Jake LaMotta (Robert De Niro) at the dinner table. The MS, which is probably the most frequently used type of shot because it replicates our human experience of proximity without intimacy, provides more detail of the body than the LS. The principal variation on the MS is the **medium long shot** (MLS, also known as the *American shot* and the *plan américain*), which is taken from the knees up and includes most of a person's body. In Scorsese's *Taxi Driver* (1976; cinematogra-

pher: Michael Chapman), a MLS shows Sport Matthew (Harvey Keitel) from the thighs up and Travis Bickle (Robert De Niro) from the waist up. This type of MLS is also a **two-shot,** a MS or MLS with two people in the frame.

The **close-up** (CU) often shows a part of the body filling the frame—traditionally a face, but possibly a hand, eye, or mouth. In *The Grapes of Wrath* (1941; cinematographer: Gregg Toland), for the scene in which Ma Joad (Jane Darwell) packs up her meager possessions before the family leaves the farm from which they have been evicted and heads for California, John Ford uses a close-up that is rich in symbolic value and physical and psychological detail. Lit by only a candle, Ma holds up a pair of earrings and imagines what life might have been if the Great Depression and the dust storms had not devastated her family. With the flicker of the candle reflected in the glass of the earring, and her weary face and sweet smile evoking lines from the movie's haunting theme ("Red River Valley"), we see her wistfulness for the past, anxiety about the future, and pragmatism about the present. It is one of the greatest close-ups in

A representative medium shot of Jake La Motta (Robert De Niro), taken from Martin Scorsese's *Raging Bull.*

A representative medium long shot of Sport Matthew (Harvey Keitel, *left*) and Travis Bickle (Robert De Niro), taken from Scorsese's *Taxi Driver*. Because two figures are in the frame, this is also a two-shot.

Darren Aronofsky's *Requiem for a Dream* (2000) uses the extreme close-up extensively to show the repetitive motions and rituals of drug use.

movie history—sentimental, yes, but memorable for bringing us so near to sorrow, pain, and hope. A variation on the close-up is the **extreme close-up** (ECU), which is a very close shot of some detail, such as a person's eye, a ring on a finger, or a watch face. In the same scene from *The Grapes of Wrath,* as Ma Joad sorts through her possessions, deciding which

This close-up from Paul Thomas Anderson's *Boogie Nights* (1997) excludes from our view nearly every aspect of the sex scene that porn actors Maggie (Julianne Moore) and Eddie (Mark Wahlberg) are about to shoot. Instead, it focuses our attention on their faces and thus on the emotional bond that develops almost immediately between them.

to take and which to throw into the fire, an ECU shows a newspaper clipping with the headline "Joad Gets Five Years"—something she wants to forget now that Tom Joad has returned home from prison.

Let's examine a scene that fluidly uses all three basic shots. François Truffaut's *Jules and Jim* (*Jules et Jim,* 1961; cinematographer: Raoul Coutard) begins when Jules (Oskar Werner) and Jim (Henri Serre) fall in love with the face on a fragment of a statue they see on an Adriatic island. When they return to Paris, they meet Catherine (Jeanne Moreau), whose face has the same mysterious appeal of that statue. Truffaut celebrates this moment, and pays tribute to the power of Moreau's legendary beauty, by introducing her in a LS on a staircase with two other women; gently reframing to a MS; and concluding with a rapid montage of CUs of her face, some made with a zoom lens to exaggerate the power of the shot. The LS establishes the overall setting, the exterior of a large house; from its rear, the three women descend one side of a double curved staircase into a garden where Jules and Jim await them. As the

narrator mentions Catherine, the MS singles her out from the other two women, a process continued in the montage of CUs.

DEPTH

Historically, a major challenge in composing movie images has been to make an essentially

two
dept
graphic
zen Kane
of such an
nor the only
problem, but it h
one who brought

[1]

[2]

[4]

[5]

[3]

[6]

In François Truffaut's *Jules and Jim*, this scene follows immediately after the title characters have returned from a trip to the Adriatic, where they have seen a beautiful statue. Truffaut uses all the major

shot types to give us multiple perspectives on Catherine (Jeanne Moreau), with whom both Jules and Jim will be obsessed for the rest of the movie.

...ositive contribution on his part to the action ...progress"; and that it "reintroduced ambi-...ty into the structure of the image if not of ...ssity . . . at least as a possiblity,"[14] In pre-...ving the continuity of space and time, ...eep-focus cinematography is more like human perception.

But deep-space composition and deep-focus cinematography are useful only for those stories in which images of extreme depth are required. Ordinarily, filmmakers achieve cinematic depth through the manipulation of space and perspective by composition, mise-en-scène, lighting, and the choice of lenses. Precisely because the projected image is flat, designers and cinematographers had to find a way to maximize the potential of the image, put its elements into balance, and create the illusion of depth. Their solution was the compositional principle known as the **rule of thirds.** This rule, like so many other "rules" in cinema, is convention that can be adapted as needed. It takes the form of a grid pattern that, when superimposed on the image, divides it into horizontal thirds representing the foreground, middle ground, and background planes and into vertical thirds that break up those planes into further elements. This grid, which evolved from the human perceptual experience of the eyes studying the entire field before them, assists the designer and cinematographer in visualizing the overall potential of the height, width, and depth of any cinematic space. Our eyes seek balance, order, and depth in the phenomena they see. When filmmakers use this grid to place figures and other design elements in such a way as to suggest depth, they succeed in fooling our eyes into seeing an illusion of

er, improved the ...ssively—partic ...Ford's *The Lor* ...he had alr a ...plane depth than ...; experi stock; ...th; crea from the ...s; used ras to en- ...ts f aces. These ...ed S related tech- ...tion, a total vi-...ccupies all three ...hereby creates an il-...p-focus cinematogra-...e short-focal-length lens, ...ace composition and its illu-...*Citizen Kane* had a profound in-...the look of subsequent movies, as ...s developments in cinematic realism ...ed distance Hollywood even further from ...ne editing-centered theories of the Russian formalist directors (e.g., Eisenstein) and brought them closer to the realism of such European directors as Jean Renoir.[13] French film critic André Bazin emphasized that deep-focus cinematography "brings the spectator into a relation with the image closer to that which he enjoys with reality"; that "it implies, consequently, both a more active mental attitude on the part of the spectator and a more

[13]See Toland, "How I Broke the Rules in *Citizen Kane*," 73–77, and "Realism for *Citizen Kane*," *American Cinematographer* 22, no. 12 (December 1941): 154, 162. See also Patrick Ogle, "Technological and Aesthetic Influences upon the Development of Deep-Focus Cinematography in the United States," *Screen* 13 (spring 1972): 45–72.

[14]André Bazin, "The Evolution of the Language of Cinema," in *What Is Cinema?* trans. Hugh Gray (Berkeley: University of California Press, 1966–71), 1:35–36.

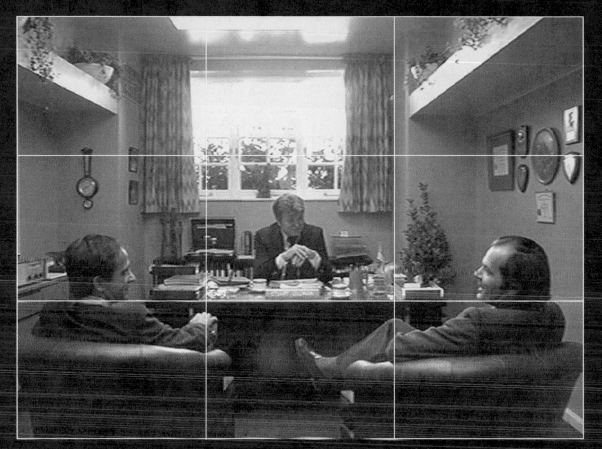

With an imaginary grid superimposed on this image from Stanley Kubrick's *The Shining* (1980), we see the compositional principle of the "rule of thirds" at work. In his office at the Overlook Hotel, Stuart Ullman (Barry Nelson, *center*), the hotel's manager, is interviewing Jack Torrance (Jack Nicholson, *right*), for the job of winter caretaker. Horizontally, Torrance and Bill Watson (Barry Dennen), a hotel employee, are in the foreground; Ullman is in the middle ground; and sunlight shines directly into the camera in the background. Although the vertical thirds break these planes into further elements, the most important "third" is the center grid, occupied by the person who will decide Torrance's suitability for the job. To learn more about the rule of thirds and to create your own compositions, go to *<www.wwnorton.com/web/movies>*.

www

depth in a two-dimensional image, thus approximating the third dimension we normally see with our own eyes. You can prove to yourself that this works by placing four strips of quarter-inch masking tape on your television screen (to conform to the interior lines in the grid) and then looking at any movie being shown in the standard aspect ratio. The lines will almost invariably intersect those areas of interest within the frame to which the designer and cinematographer wish to draw your attention. Simple as it is, the rule of thirds takes our natural human ability to create balance and gives it an artistic form; it

In the final scene of Lewis Milestone's *The Strange Love of Martha Ivers*, Walter O'Neil (Kirk Douglas) points a gun at Martha Ivers (Barbara Stanwyck), who places her finger over his on the trigger and causes the gun to fire, killing her. The camera eye's proximity to the actors' bodies produces an image with no depth, just the beautifully balanced composition of their hands on the gun next to her waistline.

the only thing the director wants you to see. Such a composition occurs in the final shot of Lewis Milestone's *The Strange Love of Martha Ivers* (1946; cinematographer: Victor Milner). Young Martha Ivers (Janis Wilson plays Martha as a girl, Barbara Stanwyck as an adult) killed her sadistic aunt, an act witnessed by two boys, Walter O'Neil (Kirk Douglas) and Sam Masterson (Van Heflin). Masterson, who became a gambler, has returned to the town in which they were children. O'Neil, who grew up and became the district attorney, is now unhappily married to Martha (Stanwyck). In the climatic scene, Martha, revolted by O'Neil's despondent drinking and in love with Masterson, suggests that he kill her husband. When Masterson rejects the suggestion, she pulls a gun on him but is still too much in love to pull the trigger, and he walks out. O'Neil, disgusted by Martha's life of scheming and deception, pretends to forgive her but actually points the gun at her stomach; she puts her hands on the gun, pulls the trigger, and kills herself, as we see in a flat, balanced shot of their hands over their bodies.

By contrast, if you watch a shot in which one part of the action takes place in the foreground and another in either the middle ground or the background, you will understand that an unbalanced frame is being used to tell the story. You will also know what to expect when you see an image in depth, one in which complexity is more important than balance. When you see a shot composed in depth—one employing action on all three planes—you realize that the filmmaker is exploiting all the available resources of composition to depict simultaneous action at different places within one frame. In a long shot from Terrence Malick's *Days of Heaven* (1978; cinematographer: Nestor Almendros), you see great depth within a two-dimensional image;

helps us see in the movies as we see in real life. Furthermore, in helping to direct our eyes to obvious areas of interest within a cinematic composition, it reminds us yet again that movies result from a set of deliberate choices.

Many designers use the actual grid as a tissue overlay on top of drawings to guide their work, but the viewer of course does not see the grid on the screen; nevertheless, in analyzing a shot, you can see how the grid was employed to create the image and its meaning. Let's look at three different examples. If you watch a shot that has little or no depth, a shot in which the action takes place close to the camera, you will see a balanced foreground image and may assume that this action is the most important thing at the moment—for example, at a turning point or climax—and thus

it is divided into three principal planes that re-
cede from the foreground (truck and people
entering right), through the middle ground
(geese walking left), to the background (a farm
building); after the camera pans right, the
house appears in extreme background, thus
reorienting the shot. Here, balance is essential
to creating not only the illusion of depth in the
frame but also the explicit meanings of the
shot. The shot also orients us to the terrain of
the ranch, the placement and interrelation-
ship of its buildings, and its social hierarchy.
The workers must stay on the lower ground in
the foreground while the owner lives in a
large house on the higher ground in the back-
ground. Though they are curious about one
another, they do not actually meet until later
in the movie. (See "Analyzing Cinematogra-
phy" at the end of this chapter for further
analysis of *Days of Heaven*.)

In addition to helping filmmakers achieve
distribution and balance in the general rela-
tionship of what we see on the screen, the rule
of thirds helps cinematographers ensure that
compositions flow appropriately from one
shot to another. Without that visual consis-
tency, the editor will be unable to establish
continuity—though he or she may choose to
preserve graphic discontinuity as part of
telling the story (see the discussion of "Match
Cut" in chapter 6, under "Conventions of Edit-
ing"). For the viewer, such visual continuity
suggests meanings through the placement and
interrelationships of figures on the screen.
Consider a scene from Alan Parker's *Birdy*
(1984; cinematographer: Michael Seresin) that
illustrates the relationship between a film's
composition and its meaning, with particular
reference to the rule of thirds. When the
movie begins, we meet two injured Vietnam
veterans: Birdy (Matthew Modine) is so psy-
chologically wounded that he cannot speak;

This shot from Terrence Malick's *Days of Heaven*
establishes complex relationships, both spatially and
thematically. The workers in the foreground are, as
the direction of the woman's glance toward the house
implies, curious about their employer, but they are
physically (and culturally) removed from him. His
house looms deep in the background; and although it
is necessarily *small* within the frame, we can tell that
it represents the position of power, mainly because it
occupies the very edge of the high ground.
Underscoring this, the employer's agent walks, left,
around the front of the car to explain that the workers
are forbidden to go near the house.

Al Columbato (Nicolas Cage) has his face
wrapped in bandages. Through flashbacks to
their adolescent friendship in working-class
Philadelphia, we learn of Birdy's desire to fly
like a bird. The military hospital where Al vis-
its Birdy looks like a prison, but to Birdy it is a
cage, reflecting his fear of enclosed or divided
spaces. While flight takes place at the end, im-
ages of entrapment help tell the story. As you
study the five shots from this scene, concen-
trate on the imaginary grid that has been
placed over them, so you can understand the
method and meaning of the composition.

■ Shot 1 (MCU; static frame): Birdy on the
floor of his hospital room, where the
floor tiles form a pattern behind him.
■ Shot 2 (LS; static frame): Birdy "trapped"

[1]

[5]

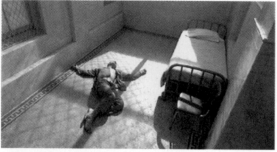

[2]

[3b]

[3a]

[4]

on the floor by patterns of tile, light, and shadow.

- Shot 3 (LS; moving frame): camera pans left to right as Al walks across a porch, rain and white fence forming patterns in front of him, a Venetian blind forming patterns behind him.
- Shot 4 (MCU; static frame): Al smoking, the shadows cast by the porch railing and the window blinds partly concealing his bandaged face.
- Shot 5 (LS; moving frame, repeating Shot 3, but reversing the direction of

movement): camera pans left to right across the floor, where Birdy has discarded his clothes, and ends with him crouching beside a toilet, the shadows of the window bars forming a pattern across him to reinforce his sense of entrapment.

From studying the still photographs, you can see that a consistent pattern of visual development and continuity is created by the compositions and types of shots; the scene moves from Birdy's captivity in shots 1 and 2 to Al's

comparative freedom in shots 3 and 4 and back to Birdy's captivity in shot 5. Beginning and ending with provocative shots of Birdy, it shows us that each man exists in a different space. Furthermore, throughout the film, visual compositions reinforce other contrasts: dream versus reality, black versus white, madness versus sanity, human versus animal, love versus jealousy, flight versus urban ugliness, and (perhaps most important) freedom versus captivity.

CAMERA ANGLE AND HEIGHT

The camera's **shooting angle**, the level and height of the camera in relation to the subject being photographed, is another framing element that offers many expressive possibilities. The five basic camera angles—*eye level, high angle, low angle, Dutch angle,* and *aerial view*—must be used appropriately to and consistently with a movie's storytelling. Any of these angles can be used to depict *point of view.* In most movies, the camera is omniscient: able to go anywhere and see anything, either at average human eye level or above it. Eye-level, high, and low shooting angles, however, raise questions of objectivity and subjectivity; sometimes, as we have seen, directors use them to play against our expectations, to control or mislead us. Before any shot can be composed and photographed, the movie camera must be level (that is, unless the camera is deliberately tilted; see the Dutch-angle shot, below). The camera operator ensures this position by checking a small bubble, centered within a circle, that functions just like the bubble on a carpenter's level.

EYE-LEVEL SHOT. An **eye-level shot** is made from the observer's eye level and usually implies that the camera's attitude toward the subject being photographed is neutral. When Miss Wonderly (Mary Astor) introduces herself to Sam Spade (Humphrey Bogart) at the beginning of John Huston's *The Maltese Falcon* (1941; cinematographer: Arthur Edeson), the director uses an omniscient eye-level camera to establish a neutral client-detective relationship that seems to be what both characters want. This effect deliberately deceives us; only later in the film do we realize, as we observe her constant attempts to deceive people, that Miss Wonderly is not the innocent person she claims to be (or that the eye-level angle suggested). By contrast, in *The Grifters* (1990; cinematographer: Oliver Stapleton), director Stephen Frears uses a similar eye-level shot to arouse our suspicions. From the beginning of the film, we know that Lilly Dillon (Anjelica Huston) and her son, Roy (John Cusack), are grifters, or con artists. After an eight-year estrangement, they meet again,

In John Huston's *The Maltese Falcon,* this eye-level shot, used throughout the initial meeting of Miss Wonderly (Mary Astor) and Sam Spade (Humphrey Bogart), leads us to believe that the facts of their meeting are "on the level."

but each still regards suspiciously everything the other says or does. An eye-level shot reveals the hollow dialogue and tension of their reunion and is thus ironic, since they know (as we do) that their relationship is off-balance and that they are both swindlers. In fact, this angle is used elsewhere in the film, which is about varieties of grifters, liars, and thieves, all pretending to be what they are not, and so merely appearing to each other (as well as to us) to be on the level, so to speak.

HIGH-ANGLE SHOT. A **high-angle shot** (or *downward-angle shot*) is made with the camera above the action and typically implies the observer's sense of superiority to the subject being photographed. In Rouben Mamoulian's *Love Me Tonight* (1932; cinematographer: Victor Milner), a Parisian tailor (Maurice Cheva-

lier), masquerading as a nobleman, falls in love with a princess; when his true identity is discovered, he is photographed from a high angle, observed by servants who now feel superior to him. However, a high-angle shot can be used to play against its traditional implications. For example, in *North by Northwest* (1959; cinematographer: Robert Burks), director Alfred Hitchcock shoots two of the villains, Phillip Vandamm (James Mason) and Leonard (Martin Landau), from a high angle that does not imply superiority, for they continue to look entirely threatening as they plot against Eve Kendall (Eva Marie Saint).

LOW-ANGLE SHOT. By contrast, a **low-angle shot** (or *upward-angle shot*) is made with the camera below the action and typically places the observer in the position of

[1]

[2]

These two high-angle shots from Alfred Hitchcock's *North by Northwest* convey completely different meanings. (1) The angle reflects Roger Thornhill's (Cary Grant) anxiety as he receives a menacing phone call in a hotel room that is not his own; the camera makes clear that Thornhill is losing control of his situation. (2) Though taken from a high angle, this shot makes Phillip Vandamm (James Mason) and Leonard (Martin Landau) appear even more menacing than they have up to this point. For an in-depth analysis of *North by Northwest*, see the case study for chapter 3: <www.wwnorton.com/web/movies>.

www

feeling helpless in the presence of an obviously superior force, as when we look up at King Kong on the Empire State Building or up at the shark from the underwater camera's point of view in *Jaws*. In Spike Lee's *Do the Right Thing* (1989; cinematographer: Ernest Dickerson), Radio Raheem (Bill Nunn), who both entertains and intimidates the neighborhood by playing loud music on his boom box, appears menacing when photographed from a low, oblique angle; this could also be identified as a Dutch-angle shot (see below). However, filmmakers often play against this expectation. In Rouben Mamoulian's *Love Me Tonight* (1932; cinematographer: Victor Milner), the princess (Jeanette MacDonald) stubbornly stands in the path of a train on which the tailor is riding, a low-angle shot stressing her power to stop it and regain the tailor for herself. In Orson Welles's *Citizen Kane* (1941; cinematographer: Gregg Toland), Kane (Orson Welles), reflecting on his defeat at the polls, and Jed Leland (Joseph Cotten) are photographed from low to extremely low angles as an ironic comment on Kane's destroyed power. In Stanley Kubrick's *The Shining* (1980; cinematographer: John Alcott), when Wendy (Shelley Duvall) discovers a manuscript that suggests her husband is insane, a low-angle shot emphasizes her anxiety and fear.

Now let's examine how a director can effectively combine eye-level, high-angle, and low-angle shots in a single scene. The phrases *to look up to* and *to look down on* reveal our physical viewpoint as well as connoting admiration or condescension. Even a slight upward or downward angle of a camera may be enough to express an air of inferiority or superiority. Fritz Lang's *M* (1931; cinematographers: Fritz Arno Wagner and Gustav Rathje) concerns the crimes of a serial child murderer

[1]

[2]

Like high angles, low angles can convey different meanings depending on their context. In Spike Lee's *Do the Right Thing*, a low-angle shot (1) of Radio Raheem (Bill Nunn) makes us feel as intimidated and angered by his presence as the character facing him is. In Orson Welles's *Citizen Kane*, a low-angle shot (2) of Kane (Welles) and his now very disillusioned (and drunk) friend, Jed Leland (Joseph Cotton), signals the utter defeat that both characters feel after Kane's failed political campaign.

in Berlin and portrays how citizens become so traumatized by the police's inability to capture the criminal that they begin to suspect everyone. In a sequence of seven shots the director employs all three kinds, each of which helps

us understand what is occurring; Figure 4.2 shows how the camera angles match the meanings of the specific actions in each shot. The scene is established in shots 1–3, where eye-level angles record the action and, through it, hint at what is to come. Shots 4–6 use alternating high and low angles to show how quickly the situation between two men deteriorates. Shot 7 returns to the eye-level angle, ironic in light of the quick heightening of the crowd's angry mood. Through a calculated use of camera angles, economical staging of action, and fluid movement from shot to shot, Lang very rapidly establishes a turning point (in a tense situation that has been growing more dangerous from the beginning of the

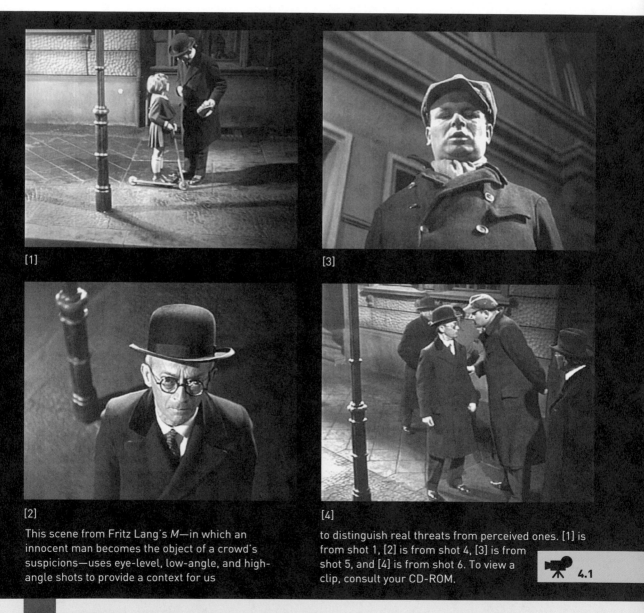

[1]

[2]

[3]

[4]

This scene from Fritz Lang's *M*—in which an innocent man becomes the object of a crowd's suspicions—uses eye-level, low-angle, and high-angle shots to provide a context for us to distinguish real threats from perceived ones. [1] is from shot 1, [2] is from shot 4, [3] is from shot 5, and [4] is from shot 6. To view a clip, consult your CD-ROM.

4.1

Shot	Description of Action in Shot	Camera Angle and Function

FIG. 4.2 — **CAMERA ANGLES IN A SCENE FROM M**

Shot	Description of Action in Shot	Camera Angle and Function
1	Cut (with sound bridge) from previous shot, in which police are consoling the mother of a recently murdered girl: "Look . . . police must follow every clue. Any man on the street could be the guilty one." Short man walks into frame from the right (we don't see his head), and young girl enters on her scooter left; as she looks *up* to him and asks the time, the camera pans upward slightly to reveal his face.	Angle: Straight-angle shot becomes low-angle shot as girl looks up. Functions: (1) Establishes neutral meeting between short man and girl in overall climate of fear and suspicion; (2) reinforces the characters' differences in height.
2	Nearby, two women on the left side of the frame comment on what they have seen (the meeting of short man and girl, as a tall man enters from the right).	Angle: Straight angle. Function: Reinforces general climate of fear and suspicion among the townspeople, heightened when aggressor appears.
3	Short man says to girl, "Now, my child, go home. Where do you live?" as tall man enters in rear of frame; as girl departs, short man turns to look up at tall man, reinforcing (as in shot 1) their differences in height, as tall man says, "Is that your kid?"	Angle: Repeats pattern of shot 1; straight angle becomes low angle as suspect looks up. Functions: Same as shot 1.
4	From tall man's point of view, suspect appears pitifully small as he looks up at the aggressor looming over him and says, "What?"	Angle: High angle. Function: (1) Establishes aggressor's dominance of the scene through his height and size; (2) confirms his suspicions about suspect.
5	From suspect's point of view, his aggressor appears dominant and threatening as he asks, "Why were you bothering that kid?"	Angle: Low angle (reverses angle of shot 4) Function: Establishes suspect's vulnerability and apparent fear of aggressor.
6	Suspect protests his innocence to aggressor ("I did nothing! What do you want?") as onlookers enter the frame and behave as an angry mob.	Angle: Straight to slightly high angle. Function: Implies omniscient camera's suspicion.
7	Crowd gathers. Tall man: "You wait and see." Short man: "Let me go—it's an outrage. . . . I did nothing." Tall man: "You wanted to get her alone and then kill her like all the others." Crowd: "It's the murderer! It's him! Hold him! Call the Police!"	Angle: eye level (slightly above crowd). Function: (1) Ironically maintains camera neutrality as crowd's ugly mood rapidly worsens; (2) confirms police comment at beginning that "any man on the street could be the guilty one."

film) at which mass hysteria permits the strong to take advantage of the weak. With the help of camera angles, Lang warns us to avoid acting like the crowd, which trusts what it thinks it sees; we should instead look beyond mere appearances and seek the truth.

An example of alternating angles used to convey tension between two characters in a scene occurs early in Neil Jordan's *The Crying Game* (1992; cinematographer: Ian Wilson) in a confrontation between Fergus (Stephen Rea), an IRA gunman, and Jody (Forest Whitaker), a British-born black soldier whom Fergus and his terrorist cohorts have taken hostage. Power, race, and politics set them in an adversarial relationship, as confirmed by the alternating use of high- and low-angle shots from the perspectives of both characters, although they start to relax when Jody shows Fergus a picture of his "wife." By the time Jody talks about his experiences as a cricket player, they are speaking as men with much in common, and the camera angle shifts to eye level to confirm the change. The shot helps demonstrate that the men have more in common than their differences at first suggested and that even Fergus, a terrorist, can recognize the impossible situation in which he and his cohorts have placed Jody.

DUTCH-ANGLE SHOT. In a **Dutch-angle shot** (or *Dutch-tilt* or *oblique-angle shot*), the camera is tilted from its normal horizontal and vertical position so that it is no longer straight, giving the viewer the impression that the world in the frame is out of balance.[15] For the

[15]The adjective *Dutch* (as in the phrases *Dutch uncle*, *Dutch treat*, and *Dutch auction*) indicates something out of the ordinary, or, in this case, out of line—a shot composed with the horizon not parallel with the bottom of the frame. I am grateful to Professor Russell Merritt for clarifying this for me.

sequence in *Bride of Frankenstein* (1935; cinematographer: John Mescall) in which Dr. Frankenstein (Colin Clive) and Dr. Pretorius (Ernest Thesiger) create a bride (Elsa Lanchester) for the Monster (Boris Karloff), director James Whale creates a highly stylized mise-en-scène—a tower laboratory filled with grotesque, futuristic machinery—that he shoots with a number of Dutch angles. The Dutch angles accentuate the unnatural nature of the doctors' unnatural actions, which are both funny and frightening.

POINT-OF-VIEW SHOT. The camera can take different points of view (POV), which in cinematography means the *physical positions* from which the camera shoots. The most familiar are the **omniscient point of view,** showing what the omniscient camera sees, typically from a high angle; a **single character's point of view,** in which the shot is made with the camera close to the line of sight of a character (or animal or surveillance camera), showing what that person would be seeing of the action; and the **group point of view,** in which we see what a group of characters would see at their level, not from the much higher omniscient point of view. Consider a very fast and active scene in Alfred Hitchcock's *The Birds* (1963; cinematographer: Robert Burks), where a classic use of camera angle and point of view establishes and retains the viewer's orientation as the townspeople of Bodega Bay become increasingly agitated because of random attacks by birds. During one such attack, frightened people watch from the window of a diner as a bird strikes a gas station attendant, causing a gasoline leak that results in a tragic explosion. Chief among these spectators are Melanie Daniels (Tippi Hedren) and Mitch Brenner (Rod Taylor). You should study Figure 4.3 before proceeding.

[1]

[2]

In *Bride of Frankenstein*, James Whale uses Dutch-angle shots to enhance the campy weirdness of lab work (1 and 2). This scene culminates in one of the most famous Dutch-angle shots of all time (3)—that of the Bride (Elsa Lanchester) first seeing the Monster.

[3]

The basic pattern of camera angles alternates between shots from a high angle in the restaurant, looking out and down, to those from eye level, looking from the exterior through the window of the restaurant. These alternating points of view give the sequence its power. Of the forty shots, twenty-three use the omniscient POV, twelve use Melanie's POV, and five use the group's POV. The shots from the omniscient POV keep us well oriented as to who is where (in the restaurant and outside the window) and what is happening. Those from the group's POV reinforce the diversity of townspeople and their collective anxiety about the events taking place. However, the shots from Melanie's POV are the more important—especially shots 27–39, when she is photographed in CUs and MCUs, completely bewildered at what she sees. What Figure 4.3 cannot show is the tempo of the editing, which

FIG. 4.3 ANALYSIS OF CAMERA POINT OF VIEW IN *THE BIRDS*

Shot	Type of shot	Angle	Point of view	Action
	CU = close-up LS = long shot MCU = medium close-up MLS = medium long shot MS = medium shot XLS = extreme long shot	A = aerial E = eye-level H = high	G = group's POV O = omniscient POV M = Melanie's POV	
1	MS	E	O	Melanie, Rod, and others in restaurant discuss birds
2	MS	H	M	Discussion continues as Melanie moves to look out window
3	LS	H	M	Birds fly over gas station
4	MS	E	O	Group joins Melanie at window
5	LS	H	G	Bird attacks gas station attendant
6	LS	E	O	Men start to run from restaurant
7	MLS	E	O	Men leave restaurant
8	MS	E (looking in through restaurant window from exterior)	O	Melanie runs to window with group
9	LS	H	G	Men run toward victim
10	MS	H	O	Gas runs from hose
11	MS	H	O	Startled group
12	LS	H	G	Gas runs down hill

13	MS	H	O	Group looks out
14	LS	H	G	Gas runs down hill
15	MCU	E	O	Melanie's face
16	LS	H	M	Gas
17	MCU	E	O	Melanie's face
18	LS	F	M	Gas runs under car's tire
19	LS	H	O	Melanie looks down, right then left, following trail of gas
20	LS	H	M	Man gets out of car and fusses with matches
21	MS	H	O	Melanie sees man start to light cigar
22	LS	H	M	Man lights cigar
23	MCU	E	O	Melanie opens window and screams at man
24	LS	H	O	Man with cigar
25	MCU	E	O	Group in window
26	LS	H	G	Man burns finger with match
27	CU	E	O	Melanie's face
28	LS	H	M	Explosion
29	CU	E	O	Melanie's reaction
30	LS	H	M	Car in flames
31	MCU	E	O	Melanie looking left

Shot	Type of shot	Angle	Point of view	Action
32	MS	H	M	Camera pans trail of flames from lower right to upper left of trail of gas
33	MCU	E	O	Melanie stares down
34	MS	H	M	Flames
35	MCU	E	O	Melanie, startled, looks right
36	LS	H	M	Gas station
37	MCU	E	O	Melanie stares right
38	LS	H	M	Cars at station explode
39	MCU	E	O	Melanie covers her face with her hands
40	XLS	A	O	Flames spread; gulls fly into shot

increases after shot 30. How does Hitchcock's use of alternating points of view create meaning in the sequence? It shows us (not for the first time) that the birds really do maliciously attack unsuspecting people. It also demonstrates that at least in this cinematic world, people close to an impending tragedy—people like Mitch, Melanie, and the man with the cigar—can do virtually nothing to stop it. In fact, the man with the cigar is so self-absorbed that he remains oblivious to the gasoline swirling around the tires of his car and to the people in the restaurant who try to warn him not to strike the match.

AERIAL-VIEW SHOT. An **aerial-view shot** (or *bird's-eye-view shot*), an extreme type of

In this action-packed scene from *The Birds*, Alfred Hitchcock orients us by manipulating type of shot, camera angle, and point of view. It includes (1) an eye-level medium close-up of Melanie (Tippi Hedren) and two men, who (2) see a gas station attendant hit by a bird; (3) an eye-level medium shot of Melanie and another woman, who (4) through high-angle shots, such as this close-up, watch gasoline run through a nearby parking lot; (5) a slightly low-angle close-up of a group, warning (6) a man in the parking lot, seen in this high-angle long shot, not to light his cigar, though he doesn't hear the warning; (7) the resulting explosion and fire, seen in a long shot from high angle; and (8) Melanie watching (9) the fire spread to the gas station, which (10) the birds observe from on high. [1] is from shot 4, [2] is from shot 5, [3] is from shot 8, [4] is from shot 18, [5] is from shot 25, [6] is from shot 26, [7] is from shot 28, [8] is from shot 33, [9] is from shot 38, and [10] is from shot 40. To view a sequence of images from this scene, go to <*www.wwnorton.com/web/movies*>.

4.2

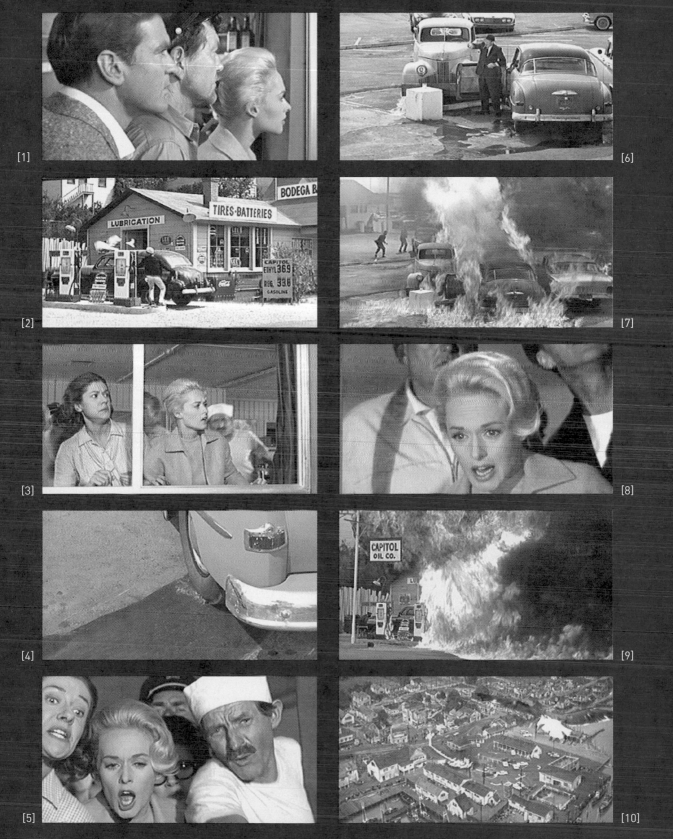

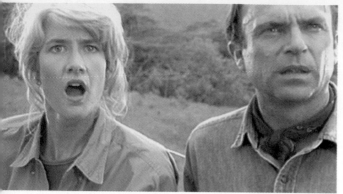

[1]

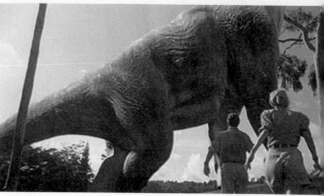

[2]

(1) In Steven Spielberg's *Jurassic Park,* the reaction of Dr. Sattler (Laura Dern, *left*), and Dr. Grant (Sam Neill) to their first dinosaur sighting prepares us for an impressive image onscreen, and we are not disappointed. In placing the reaction before the action itself, Spielberg heightens the suspense of the scene. (2) The scale of the brontosaurus is exaggerated by the framing of this shot, too, which implies that the beast is so gargantuan that it can't fit into the frame.

point-of-view shot, is taken from an aircraft or very high crane and implies the observer's omniscience. We have just looked at a classic example of the bird's-eye view at the end of *The Birds.* After the gasoline explosion, the director cuts from the standard high-angle point-of-view shots to a high aerial shot (literally a bird's-eye view) in which the circling birds seem almost gentle in contrast to the tragedy they have just caused below. Hitchcock said he used this aerial shot to show, all at once, the gulls massing for another attack on the town, the topography of the region, and the gas station on fire. Furthermore, he did not want to "waste a lot of footage on showing the elaborate operation of the fireman extinguishing the fire. You can do a lot of things very quickly by getting away from something."[16] Coyly, Hitchcock does not admit that by distancing the camera from the action, he has placed the birds in total control and increased the magnitude of the viewer's terror.

[16]Alfred Hitchcock, in François Truffaut, *Hitchcock,* rev. ed. (New York: Simon and Schuster, 1985), 292–94.

SCALE

Scale is the size and placement of a particular object or a part of a scene in relation to the rest, a relationship determined by the type of shot used and the position of the camera. Scale may change from shot to shot. From what you learned in the preceding section, you can see that the type of shot affects the scale of the shot *and* thus the effect and meaning of a scene. In *Jurassic Park* (1993; cinematographer: Dean Cundey), Spielberg exploits scale to create awe and delight. John Hammond (Richard Attenborough) uses his money to fund two very different activities: on one hand, scientific excavations for dinosaur bones led by Dr. Alan Grant (Sam Neill) and Dr. Ellie Sattler (Laura Dern) and, on the other hand, growing actual dinosaurs from long-dormant DNA for his Caribbean island theme park. The director knows that we really want to see the dinosaurs, and he slowly builds our apprehension by delaying this sight. When he introduces the first dinosaur here, just at the

right moment to outsmart the doubting Grant and Sattler, through whose POV we are gazing, he maximizes—through the manipulation of scale and special effects cinematography—the astonishment that characters and viewers alike feel.

At Jurassic Park, jeeps carrying the group arrive on a grassy plain, clearly establishing the human scale of the scene. But Drs. Grant and Sattler, preoccupied with scientific talk, take a moment to realize that Hammond has just "introduced" them to a live dinosaur, as benign as it is huge, which looks down upon them. ELSs make the dinosaur seem even taller. When the dazed Grant asks, "How did you do this?" Hammond relies, "I'll show you." It's impossible to forget what Spielberg then shows us: not just the first dinosaur but also a spectacular vista in which numerous such creatures move slowly across the screen. Creating a sense of *wonder* is one of Spielberg's stylistic trademarks, and his use of scale here does just that as it also helps create meaning. Because this is a science fiction film, we are prepared for surprises when we are introduced to a world that is partly recognizable and partly fantastic. Once the dinosaurs make their actual appearance, we know that humans, however powerful in their financial and scientific pursuits, are not only one among many species on Earth but also smaller than some and thus highly vulnerable.

CAMERA MOVEMENT

From the moment in 1895 when cinema was invented, directors and their camera operators looked for ways to create steady moving shots. In 1897, the Lumière brothers put their camera in a gondola and floated through Venice to give viewers a dynamic view of the city. In 1908, D. W. Griffith began to exploit the power of the simplest movement—a horizontal turning motion called a *pan* (see below)—to create associations within the frame and, in some cases, to establish a cause-and-effect relationship. In *The Birth of a Nation* (1915), within one shot, he establishes a view of a Civil War battle, turns the camera toward a woman and small children on a wagon, and then turns back to the battle. From that instinctive, fluid camera movement, we understand the relationship between the horror of the battle and the misery it has created for innocent civilians. Of course, Griffith could have cut between shots of the battle and the bystanders, but breaking up the space and time with editing would not achieve the same subtle effect as that one shot. In the 1920s, German filmmakers took this very simple type of camera movement to the next stage, perfecting fluid camera movement within and between shots. In fact, F. W. Murnau, who is associated with some of the greatest early work with the moving camera in such films as *The Last Laugh* (*Der letzte Mann*, 1924) and *Sunrise* (1927), referred to it as the "unchained" camera, thereby suggesting that it has a life of its own, with no limits to the freedom with which it can move.

The smoothly moving camera helped change how movies were made and thus the ways in which we see and interpret them. It can search and increase the space, introduce us to more details than would be possible with a static image, choose which of these details we should look at or pass by, follow movement through a room or across a landscape, and establish complex interrelationships between figures in the frame—especially in long takes, those that are longer than the average (on *long takes,* see "Speed and Length of the Shot," below). Furthermore, when the moving camera is used in a POV shot, it records, as it moves through space, a subjective view of

what a character sees. David Bordwell notes that the moving camera provides "a horizontal equivalent of depth, a 'lateral depth of field' that suggests a seamless world enveloping the action."[17]

The concurrent introduction of two major technological developments—sound and the moving camera—created problems for the mainstream film industry. For several years after the introduction of sound, the motion picture camera was immobilized in a bulky soundproof booth and the microphone had to remain stationary; these new techniques could not be used together until further progress had been made. This challenge was soon met, and by the mid-1930s, innovative filmmakers such as Rouben Mamoulian and Jean Renoir could exploit the combined use of sound, fluid camera movement, deep-focus imagery, and long takes to record, in a new kind of "realism," the spatial and temporal continuum of what we see in the everyday world. (On the development of sound technology, see chapter 7.)

When a static frame is employed, the camera does not move and thus the frame does not move, although things can move *within* the frame. Things can move within a moving (or mobile) frame as well, but the camera's movement means that everything within the frame also "moves" (or, more correctly, "changes"). For example, moving the camera means that camera height, angle, distance, or level will almost always change *within* the shot. The elements of framing discussed above—camera angle, level, height, types of shots, and scale—are all greatly modified by camera movement.

The basic types of shots involving camera movement are the *pan, tilt, tracking,* and *crane*

[17]David Bordwell, *On the History of Film Style* (Cambridge, Mass.: Harvard University Press, 1997), 67.

shots, as well as those made with the *Steadicam* and the *zoom lens*. Each involves a particular kind of movement, depends on a particular kind of equipment, and has its own expressive potential. That is, as the moving camera eliminates some elements and reveals others within the frame, it helps create meaning.

PAN SHOT. A **pan shot** is the horizontal movement of a camera mounted on the gyroscopic head of a stationary tripod. This head ensures smooth panning and tilting (see below) and keeps the frame level. Basic as it is, the pan is a very versatile shot. In *Sling Blade* (1996; cinematographer: Barry Markowitz), director Billy Bob Thornton photographs the opening monologue as a four-minute-long take, using fluid camera movement. In this one shot, set in a mental hospital, the camera pans right as an inmate drags a chair, then left for a perpendicular MS profile of Karl Childers

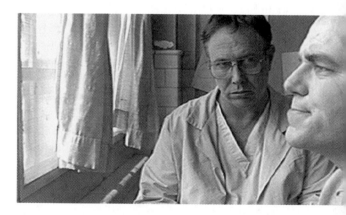

This frame comes at the end of the opening pan shot in Billy Bob Thornton's *Sling Blade*. The movie's main character turns out to be Karl Childers (Thornton), the inmate facing left, marginalized, all but cut out of the picture. Even if we try to focus on the inmate facing the camera, his eyes and the tilt of his head direct us toward Childers. Thus the camera guides our viewing and our reading of the image—in this case, of a hard-to-read man.

(Thornton) with the other inmate facing the camera. We know from the very beginning of the movie, through this composition and cinematography, that Childers physically isolates himself from others, particularly from crude people like the inmate in this scene.

TILT SHOT. A **tilt shot** is the vertical movement of a camera mounted on the gyroscopic head of a stationary tripod. Like the pan shot, it is a simple movement with dynamic possibilities for creating meaning. Orson Welles makes excellent use of this shot in *Citizen Kane* (1941; cinematographer: Gregg Toland). When Susan Kane finally summons the psychological and emotional strength to leave her tyrannical husband, he reacts by destroying her bedroom. At the peak of his violent rage, he seizes the glass globe with an interior snow scene; the camera tilts upward from the ball to Kane's face; he whispers "Rosebud" and leaves the room. The tilt links the roundness and mystery of the glass ball with Kane's round, bald head; furthermore, it reminds us that the first place we saw the glass ball was on Susan's dressing table in her rooming house bedroom, thus further linking the meaning of "Rosebud" with her.

TRACKING SHOT. A **tracking shot** moves smoothly with the action (alongside, above, beneath, behind, or ahead of it) when the camera is mounted on a set of tracks, a dolly, a crane, or an aerial device, such as an airplane, helicopter, or balloon. Some of the most beautiful effects in the movies are created by tracking shots, especially when the camera seems to move with a life of its own.

Jean Renoir used long takes to create the feeling of real time and the moving camera to create the feeling of real space, a rhythmic flow of action, and a rich mise-en-scène. In

[1]

[2]

In Orson Welles's *Citizen Kane*, the camera presents the first half of this shot (1), then tilts upward to present the second half (2). Of course, Welles could have shown us both halves, even Kane's entire body, within one static frame. The camera movement directs our eyes, however, and makes the symbolism unmistakable. A child's happiness contrasts with an adult's despair: the glass ball, which belonged to Kane's now-estranged wife, contains a snowy scene very much like the one in which we are introduced to young Charlie and his sled.

The Grand Illusion (*La grande illusion*, 1937; cinematographer: Christian Matras), Renoir's brilliant film about World War I, we receive an intimate introduction to Major von Rauffenstein (Erich von Stroheim), the commandant

For the ball sequence in Victor Fleming's *Gone With the Wind* (1939), a camera mounted on a dolly records a tracking shot. Fleming is seated on the dolly, looking delighted; below the microphone boom (see "Technological Challenges" in chapter 7), Rhett Butler (Clark Gable) dances with Scarlett O'Hara (Vivien Leigh).

to warm them and make them easier to slip on his hands. Offscreen, Rauffenstein complains about the air in the room and orders the valet to open the window; in response to the valet's comment that only two pairs of white gloves are left, he says: "It's too complicated to get more. Try to make them last until the war is over." The camera follows the valet as he offers "Herr Major" more coffee, then tilts from Rauffenstein's white-gloved hand up to his face, and stops as the valet hands him a list of the new prisoners. Finally, through the door of the room (where the new prisoners are waiting), we see Rauffenstein spray himself with cologne before entering to meet them. This dazzling scene reflects careful planning, careful choice of details, and fluid camera tracking, all of which contribute to its meaning. It provides everything we need to decode and

of a German prison camp, through a long tracking shot (plus four other brief shots) that reveals details of his life. The prison is located in Wintersborn, a former castle, and Rauffenstein's quarters are in the former chapel. The scene opens with a shot of a crucifix; then the camera tracks downward and backward past a portrait of Field Marshal Paul von Hindenburg, past a small cabinet holding a geranium plant, across a table holding Rauffenstein's personal and military effects—champagne bottle and bucket, pistol, leather-bound volume from Casanova's memoirs, photograph of a woman, volume of Heinrich Heine's poetry, nude statue, binoculars, perfume atomizer, whips, spurs, sword—then on to observe the valet blowing into Rauffenstein's white gloves

In Jean Renoir's *The Grand Illusion*, the contradictory aspects of Field Marshal Hindenburg's life are engagingly and economically captured by the long tracking shot that catalogs the objects in his living quarters. The pistol on top of a volume of Casanova's memoirs is an especially telling detail: he's a lover and a fighter.

understand Rauffenstein's background and character—that he is a meticulous man, from privileged circumstances, for whom the war is but an interruption of his former life.

CRANE SHOT. A **crane shot** is made from a camera mounted on an elevating arm that, in turn, is mounted on a vehicle capable of moving on its own power. A crane may also be mounted on a vehicle that can be pushed along tracks. The arm can be raised or lowered to the degree that the particular crane permits. Shots made with a crane differ from those made with a camera mounted on a dolly or an ordinary track (each of which is, in theory, capable only of horizontal movement) because the crane has the full freedom of both horizontal and vertical movement. Thus a filmmaker can use a crane to shoot with extraordinary flexibility. As equipment for moving the camera has become more versatile, crane shots have become more commonplace. In *The Black Pirate* (1926; cinematographer: Henry Sharp), director Albert Parker uses this shot not only to frame space but to create and change it from something material to something symbolic. His star, Douglas Fairbanks, was famous for flying through the air in *The Mark of Zorro* (1920), and in *The Black Pirate* he flies all over a ship, from the mast to the hold, in which he is then trapped. Once he is rescued by his comrades, who lift him up, the camera tilts to follow his ascent. The upward flight is miraculous in itself, as he easily transcends all obstacles in his path, but it is even more impressive because his men *visually* lift him up to a position of power, reestablishing their solidarity and his leadership.

Perhaps the most famous crane shot in movie history (a shot with a duration of three minutes, twenty seconds) occurs at the opening of Orson Welles's *Touch of Evil* (1958; cinematographer: Russell Metty; *Touch of Evil* is the suggested case study for this chapter). Welles was so far ahead of his time with this shot that the studio, Universal International, did not understand what he was doing. Universal added music by Henry Mancini and superimposed the opening titles, thus subordinating this astonishing shot to the background of a conventional opening. Although the version with music and titles appears in many prints circulating today, a restored print released in 1998 (edited by Walter Murch) reflects Welles's detailed instructions for the film. The restoration puts the titles and credits at the end, removes the music from the opening, and thus permits us to experience exactly what Welles intended: the versatility of the crane-mounted camera, the intricate choreography of the human and vehicular traffic it records, and diegetic sounds emanating from the street and from nightclubs. Huge amounts of planning and choreography went into the composition, camera movement, and figure movement of this single shot.

We'll use the restored version as our text in analyzing this scene, which takes place at night in Los Robles, a seedy town on the U.S.-Mexico border. After the Universal International logo dissolves from the screen, we see a CU of a man's hand swinging toward the camera and setting a timer that will make the bomb he holds explode in about three minutes. The camera pans left to reveal two figures approaching the camera from the end of a long interior corridor; the bomber, Manelo Sanchez (Victor Millan), runs left into the frame, realizes that these people are his targets, and runs right out of the frame as the camera pans right to follow him. He places the bomb in the trunk of a luxurious convertible, the top of which is down, and disappears screen right just as the couple enter the frame

[1]

[2]

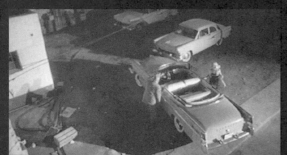

[3]

[4]

[5]

[6]

[7]

[8]

These stills from the opening crane shot in Orson Welles's *Touch of Evil* show the progress of the camera over a wide-ranging space through a continuous long shot that ends only at the point where the car blows up. A reaction shot of Mike and Susan Vargas (Charlton Heston and Janet Leigh) follows, and as the Vargases run toward the site of the explosion, the mystery at the heart of the movie begins. For an in-depth analysis of *Touch of Evil*, see the case study for chapter 4: <www.wwnorton.com/web/movies>.

www

at top left; the camera tracks backward and re-frames to a LS. As the couple get into the car, the camera (mounted on a crane that is, in turn, mounted on a truck) swings to an extreme high angle. The car pulls forward alongside a building and turns left at the front of the building as the camera reaches the roof level at its back. We momentarily lose sight of the car, but the camera, which has oriented us to where it is, merely pans left and brings it back into the frame as it moves left across an alley into a main street. The camera cranes down to an angle slightly higher than the car, which has turned left and now heads toward the camera on a vertical axis moving from background to foreground. When the car pauses at the direction of a policeman, who permits other traffic to cross in the foreground on a horizontal axis, the camera begins tracking backward to keep the car in the frame. The camera continues to track backward, reframes to an XLS, and pans slightly to the left. The car stops at an intersection.

A man and woman ("Mike" Vargas, a Mexican narcotics agent played by Charlton Heston, and Susan Vargas, whom he has just married, played by Janet Leigh) enter the intersection at screen right and continue across the street as the camera lowers to an eye-level LS. The car turns left onto the street on which the Vargases are walking; the couple scurry to get out of its way as the car moves out of the frame. They continue walking with the camera tracking slightly ahead of them; it keeps them in the frame as they pass the car, which is now delayed by a herd of goats that has stopped in another intersection. The camera continues to track backward, keeping the couple and car in the frame; this becomes a deep-space composition with the car in the background, crossway traffic in the middle ground, and the Vargas couple in the foreground. The

couple reaches the kiosk marking the entrance to the border crossing and pass it on the right, still walking toward the camera, which now rises, reframing into a high-angle LS that reveals the car driving past the left side of the kiosk. The frame now unites the two couples (one in the car, the other walking) as they move forward at the same time to what we, knowing that the bomb is in the car, anticipate will be a climactic moment.

The camera stops and reframes to a MS with the Vargases standing on the right and the car stopped on the left. While the first border agent begins to question the newlyweds, soon recognizing Vargas, the second agent checks the car's rear license plate. The agents and Vargas discuss smashing drug rings, but Vargas explains that he and his wife are crossing to the American side so that his wife can have an ice cream soda. Meanwhile, the driver of the targeted car, Mr. Linnekar (actor not credited), asks if he can get through the crossing. The Vargases walk out of the frame, continuing the discussion about drugs, then apparently walk around the front of the car and reenter the frame at the left side; the camera pans slightly left and reframes the Vargases, border agents, and Linnekar and Zita (Joi Lansing), his companion. After a few moments of conversation, the Vargases walk away toward the back and then left of the frame; the car moves slowly forward; Zita complains to one of the guards—in a moment of delicious black humor—that she hears a "ticking noise." As the car leaves the frame, the camera pans left to another deep-focus composition with the Vargases in the background, two military policemen walking from the background toward the camera, and pedestrians passing across the middle ground. The camera tracks forward and reframes to a MS; the Vargases embrace as the bomb

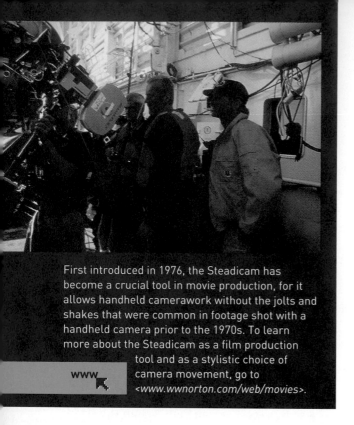

First introduced in 1976, the Steadicam has become a crucial tool in movie production, for it allows handheld camerawork without the jolts and shakes that were common in footage shot with a handheld camera prior to the 1970s. To learn more about the Steadicam as a film production tool and as a stylistic choice of camera movement, go to <www.wwnorton.com/web/movies>.

www

attempts to grab the audience's attention, or does it create meaning? The answer, of course, is it has both purposes. Its virtuosity astonishes, but with a point. In addition to witnessing the inciting device for the plot, we learn that Los Robles is a labyrinth of activity, lights, shadows, and mysteries; and that the destinies of Linnekar, Zita, Vargas, and Susan are in some way tangled. The odd and extreme camera angles (at both the beginning and the end of the scene) reinforce the air of mystery and disorient us within the cinematic space. All the while, the bold black-and-white contrasts pull us into the deep shadows of vice, corruption, and brutal crime.

STEADICAM. From the beginning of the movies, movie cameras (handheld as well as those mounted on tripods, dollies, or other moving devices) have allowed filmmakers to approach their subjects, as when they move in for close-ups. But the handheld camera frequently produces a jumpy image, characteristic of avant-garde filmmaking and usually not acceptable in the mainstream. (Movements from the French "New Wave" and American "direct cinema" of the 1960s to the Danish "Dogma" group of the late '90s advocate an aesthetic approach that minimizes the difference between the filmed and the finished film; they therefore renounce such mainstream techniques as steady, level camera work and continuity editing.) Thus mainstream filmmakers embraced the **Steadicam,**® a camera actually *worn* by the cameraman (so it is not "handheld"), which removes that jumpiness and is now much used for smooth, fast, and intimate camera movement. The Steadicam system, which is perfectly balanced, automatically compensates for any movements made by the camera operator, whether in running down stairs, climbing a hill, or maneuvering in tight

explodes. Startled, they look up, and a cut ends this long take with a shot of the car in flames.

With extraordinary virtuosity, Welles has combined nearly all types of shots, angles, framings, and camera movements. He accomplishes the changes in camera height, level, angle, and framing by mounting the camera on a crane that can be raised and lowered smoothly from ground level to an extreme high angle, reframed easily, and moved effortlessly above and around the setting (parking lot, market arcade, street, intersections, border inspection area). Here, the moving camera is both unchained and fearless, a thoroughly omniscient observer as well as a voyeur, particularly in its opening observations of the bomber. But what is the function of this cinematographic tour-de-force? Is it just one of Welles's razzle-dazzle

places where dollies or tracks cannot fit. Director Martin Scorsese uses the Steadicam throughout *Raging Bull* (1980; cinematographer: Michael Chapman). The boxing matches of Jake LaMotta (Robert De Niro), the former middleweight champion of the world, are staged for the camera, photographed in black and white with high-contrast lighting, and punctuated with vibrant sounds. The camera operator moves intimately and expertly along with the boxers, putting us in the ring during the bloody and disturbing fights. However, when this violence extends into LaMotta's private life, it challenges us to go beyond the camera's intimate, engrossing observations and find some meaning in what we see.

ZOOM LENS. Though it is not exactly a camera movement, the zoom lens provides the illusion of motion (see the section on lenses, later in this chapter).[18] The zoom lens can move by itself without having the camera move, move with the camera, or move against the camera's movements. It can establish a scene and then move to isolate a character within it, as in John Singleton's *Boyz N the Hood* (1991; cinematographer: Charles Mills), where the young Tre Styles (Desi Arnez Hines II) arrives home with his father, Furious Styles (Laurence Fishburne), just as the police have taken some neighbors into custody. As the police drive away with the suspects, the camera zooms in on Tre, who is seen in clear focus in the foreground, with his father slightly out of focus in the middle ground. In *Goodfellas* (1990; cinematographer: Michael Ballhaus), during the scene in which Henry Hill (Ray Liotta) meets Jimmy Conway (Robert De Niro) in a diner, Martin Scorsese achieves a memo-

In John Singleton's *Boyz N the Hood*, a zoom lens pulls us closer to Tre Styles (Desi Arnez Hines II) even as he walks toward the camera. These combined movements of lens and actor increase the pace at which we're brought close enough to read his reaction to the arrest of his neighbors (offscreen).

rable effect (influenced by earlier uses of the technique by Alfred Hitchcock in *Vertigo* [1958] and Steven Spielberg in *Jaws* [1975]) with the moving camera and the zoom lens. He tracks *in* (while moving the zoom lens *out*) and tracks *out* (while moving the zoom lens *in*) to reflect Henry's paranoid, paralyzed state of mind. As the camera and lens move *against* one another, the image traps Hill inside the hermetic world of the mob and us inside a world of spatial disorientation in an ordinary diner.

[18]See John Belton, "The Bionic Eye: Zoom Esthetics," *Cinéaste* 9, no. 1 (winter 1980–81): 20–27.

SPEED AND LENGTH OF THE SHOT

Up to this point, we have emphasized the spatial aspects of how a shot is composed, lighted, and photographed. But the image we see on the screen has both spatial *and* temporal dimensions. Its length can be as important as any other characteristic. Although a shot is one uninterrupted run of the camera, no convention governs what that length should be. Before the coming of sound, the average shot lasted about five seconds; after sound arrived, that average doubled to approximately ten seconds. Nonetheless, a shot can (and should) be as long as it needs to be in order to do its part in telling the story.

By controlling the length of shots, filmmakers not only enable each shot to do its work—establish a setting, character, or cause of a following event—but also control the relationship of each shot to the others and thus to the rhythm of the film. The length of any shot is controlled by three factors: the screenplay (the amount of action and dialogue written for each shot; on dialogue, see "Types of Film Sound" in chapter 7), the cinematography (the duration of what is actually shot), and the editing (what remains of the length of the actual shot after the film has been cut and assembled; see chapter 6).

Here, we will concentrate on the second of those factors: the relationship between cinematography and time. What kind of time does the camera record? As you know from chapter 1, when we see a movie, we are aware of basically two kinds of time: *real time,* time as we ordinarily perceive it in "real" life outside the movie theater, and *cinematic time,* time as conveyed to us through the movie. *Citizen Kane* omits a great deal of real time (the movie presents seventy-five years of Kane's life in two hours), but we learn more about Kane's life than this disparity might suggest. Through a simple adjustment of the camera's motor, cinema can manipulate time with the same freedom and flexibility with which it can manipulate space and light. Thus **slow motion** decelerates action by photographing it at a rate greater than the normal 24 fps, so that it takes place in cinematic time less rapidly than the real action that took place before the camera. **Fast motion** accelerates action by photographing it at less than the normal filming rate, then projecting it at normal speed, so it takes place cinematically more rapidly.

While the average shot lasts ten seconds, the **long take** can run anywhere from one to ten minutes. (An ordinary roll of film runs for ten minutes, but specially fitted cameras can accommodate longer rolls of film that permit takes of anywhere from fourteen to twenty-two minutes.) One of the most elegant techniques of cinematography, the long take has the double potential of preserving both real space and real time. Ordinarily, we refer to a **sequence** as a series of edited shots characterized by inherent unity of theme and purpose. The long take is sometimes referred to as a *sequence shot* because it enables filmmakers to present a unified pattern of events within a single period of time in one shot. However, with the exception of such extraordinary examples as the opening of Orson Welles's *Touch of Evil* (discussed above), the long take is rarely used for a sequence filmed in one shot. Instead, even masters of the evocative long take—directors such as F. W. Murnau, Max Ophüls, Orson Welles, William Wyler, Kenji Mizoguchi, and Stanley Kubrick—combine two or more long takes by linking them, often unobtrusively, into an apparently seamless whole. Coupled with the moving camera, the long take also eliminates the need

for separate setups for long, medium, and close-up shots. It permits the internal development of a story involving two or more lines of action without the cross-cutting normally employed to tell such a story. Furthermore, if a solid sense of cause and effect is essential to developing a sequence, the long take permits both the cause *and* the effect to be recorded in one take. Conventional motion picture technology limited the fluid long take that these directors were striving for, but digital technology has enabled a director to achieve it. Using a Steadicam fitted with a high-definition video camera, Russian director Aleksandr Sokurov made *Russian Ark* (*Russkij kovcheg*, 2002; cinematographer: Tilman Büttner), a ninety-six-minute historical epic that is the longest unbroken shot in film history.

A sequence incorporating short and long takes and the moving camera occurs in William Wyler's *The Little Foxes* (1941; cinematographer: Gregg Toland), a melodrama about the Hubbards, a late-nineteenth-century southern family that owns most of their town and wants to control the rest. The scene we are studying here concerns Regina Hubbard Giddens (Bette Davis), who is married to Horace Giddens (Herbert Marshall), a man she detests because he opposes her scheming brothers and their plan to expand the Hubbard holdings by exploiting cheap labor. The sequence takes place in their parlor after Giddens has returned home from a long hospital stay for treatment of his serious heart condition. When Regina asks him to put more funds into strengthening the family enterprise, he tells her that he has changed his will, leaving her nothing but bonds, which, he does not know, members of her family have already stolen. Realizing that a man she despises has unknowingly trapped her in a difficult situation and that her family's lawbreaking may

soon be revealed, she retaliates by telling him how she has always hated him. During her tirade, Giddens has the first seizures of a heart attack. In attempting to take his medicine, he drops the bottle; and when he asks Regina to get the spare bottle upstairs, she makes the decision to let him die, sitting perfectly still as he staggers toward the stairs and collapses.

Let's look at how Wyler and Toland break this scene into a sequence of short and long takes. Shot 1 is a short MS of Regina, back to the camera, saying, "But it didn't take me long to find out my mistake." After Regina turns to face the camera, a cut takes us to the deep-focus shot 2, which combines a modified LS (in deep focus) in which Regina is seen in almost full length at the right of the screen and a CU of Horace at the left (a composition that Welles and Toland used frequently in *Citizen Kane*); as she walks out of the frame, not seeing the first spasm of Horace's attack, the resulting CU maintains the emphasis on him. After a cut, shot 3 is a MS of Horace in his wheelchair moving left across the room, with a reframing that brings them back together in the frame, she on the left and he struggling to open his medicine bottle on the right. In shot 4, a CU shows the bottle dropping. Shot 5 is a MS of her reaction, followed by shot 6, which returns to the framing of shot 3, in which he asks her to get the spare bottle and she stays put. In shot 7, a CU, Horace registers his disbelief; calls for Addie, the maid; and slowly gets up. In shot 8, a MS, he struggles up, staggers past and behind Regina, casting his shadow over her impassive but fearful face, and calls for Addie once again. As he moves farther from her and the foreground plane, he gets progressively out of focus; he approaches the stairway and finally collapses on it, at which point she leaps out of her chair and calls for help. Both the shadow of Horace's body across her face and his move out

[1]

[3]

[2]

[4]

Within a sequence combining short and long takes at the climax of William Wyler's *The Little Foxes*, Horace (Herbert Marshall) responds (1) and rises (2)

while Regina (Bette Davis) remains rigid (3), her emotions heightened, as he staggers to his death (4).

of focus implicitly mark Horace's impending death, visually representing not only his slipping away from life but also her state of mind in shutting his plight from her consciousness.

Primarily, the scene involves interaction between two characters that occurs on a two-plane field. This is not, strictly speaking, a complete deep-focus shot (since the rain on the windows in shot 1 actually masks the depth of

the view, and the staircase in the background plane is barely visible and is unimportant until the last moment). Nonetheless, Toland exploits the potential of a two-plane shot by using it (as if it were deep focus) to combine and reframe among close-up, medium, and long shots and to permit effortless and effective camera movement, thus facilitating the blocking and movement of the actors. In the film as a whole, the

staircase is indeed a symbolic part of the house's architecture—the goings up and down of the characters signify personal, moral, and financial ups and downs—so Wyler and Toland's inclusion of it here is an important reminder of that function as well as a slightly modified use of the film's overall deep-focus cinematographic plan.

SPECIAL EFFECTS CINEMATOGRAPHY

Cinema itself is a "special effect," an illusion that fools the human eye and brain into perceiving motion. Special effects cinematography (abbreviated SPFX or FX) creates images that would be too dangerous, too expensive, or, in some cases, simply impossible to achieve with the traditional cinematography discussed above. Special effects expert Mat Beck says, "The art of visual effects is the art of what you can get away with, which means you really have to study a lot about how we perceive the world in order to find out how we can trick our perceptions to make something look real when it isn't."[19]

Such illusions are accomplished in essentially three ways: through **in-camera effects** created in the production camera (the regular camera used for shooting the rest of the film) on the original negative, through **laboratory effects** created on a fresh piece of film stock, and through **computer-generated effects** created by digital technology. Traditionally, the first category—in-camera effects—has included such simple illusory effects as the *fade,* the *wipe,* the *dissolve,* and *montage.* (Although these are shots in themselves, together with editing they create transitional effects or manipulate time; for definitions and examples, see "Conventions of Editing" in chapter 6.)[20] Other in-camera effects include *split screen, superimposition, models and miniatures, glass shots, matte paintings, in-camera matte shots,* and *process shots.* You have seen **process shots** many times, and while they have become virtually obsolete, it is useful to know how filmmakers used **rear** or **front projection** to make them. With rear projection, stills or footage are projected onto a translucent screen as a background for live shooting; thus, in its most familiar usage, you see actors sitting in a car, which remains stationary in front of this screen as the highway, seen sometimes through the car's rear window, unrolls behind them. With front projection, stills or footage are projected from the same direction as the camera onto the process screen; this intentionally allows the actors in front of the screen to cast their shadows on it, thus creating a greater sense of "reality" than that achieved with rear projection. The second category—laboratory effects—includes more complicated procedures, such as *contact printing* and *bi-pack,* as well as *blow-ups, cropping, pan and scan, flip shots, split-screen shots,* and *day-for-night shooting.*[21]

[19]Mat Beck, qtd. in "Special Effects: Titanic and Beyond," *Nova,* produced for PBS by the Science Unit at WGBH Boston, 3 November 1998.

[20]The standard reference work on how special effects are created through cinematography is Raymond Fielding, *The Technique of Special Effects Cinematography,* 4th ed. (Boston: Focal Press, 1985).

[21]The technical nature of these special effects goes beyond the purview of this book, but for a fuller discussion of split-screen laboratory effects, see "Conventions of Editing" in chapter 6. For excellent descriptions of the effects in the first and second categories, see Kawin, *How Movies Work,* 411–32, and his glossary.

For Fritz Lang's *Metropolis*, a pioneering science fiction film, the city of the future was a model created by designer Otto Hunte. Special effects photography (coordinated by Eugen Schüfftan, who developed trick-shot techniques that are still in use today) turned this miniature into a massive place onscreen, filled with awe-inspiring objects and vistas.

The special effects in Stanley Kubrick's *2001: A Space Odyssey* took up more than 60 percent of the movie's production budget and required nearly eighteen months to complete. When the movie was released in 1968, the results were immediately celebrated. A year before the first moon landing, this was human beings' closest look at outer space.

The movies' ability to create illusion has always been one of their major attractions for audiences. Indeed, the first special effect appeared in Alfred Clark's *The Execution of Mary Stuart* in 1895, the year the movies were born. To depict the queen's execution, Clark photographed the actor in position, stopped filming and replaced the actor with a dummy, then started the camera and beheaded the dummy. (Incidentally, this film involved another kind of illusion: a man played Queen Mary.) From that point forward, special effects appeared regularly in the films of Georges Méliès, the great illusionist, who used multiple exposures and stop-motion animation. Edwin S. Porter's *The Great Train Robbery* (1903) featured matte and composite shots; and his *Rescued from an Eagle's Nest* (1908) included a mechanical eagle, created by Richard Murphy, that was the forerunner of "animatronic" creatures in contemporary films. By the mid-1920s, extraordinary effects were featured in such films as Fritz Lang's *Metropolis* (1926), for which designer Otto Hunte created the city of the future in miniature on a tabletop; the first U.S. version of *The Hunchback of Notre Dame* (1923), directed by Wallace Worsley; Cecil B. DeMille's first version of *The Ten Commandments* (1923), in which technicians could part the Red Sea because it was made of two miniature slabs of Jello;[22] the first version of *Ben-Hur* (1925), directed by Fred Niblo; the first of three versions of *The Thief of Bagdad* (1924), directed by Raoul Walsh; and the first of four versions of *The Lost World* (1925), directed by Harry O. Hoyt. The special effects on *The Lost World* were the

[22]The 1956 version of parting the Red Sea, which cost $2 million—the most expensive special effect to that time—involved matte shots, miniatures, six hundred extras, and a thirty-two-foot-high dam channeling tens of thousands of gallons of water.

work of Willis O'Brien, who went on to create the special effects of Merian C. Cooper and Ernest B. Schoedsack's *King Kong* (1933), in which the giant ape terrorizing New York City from the top of the Empire State Building was, in fact, a marionette.

Outstanding special effects appeared in films of diverse genres through the following decades, but it was not until Stanley Kubrick's *2001: A Space Odyssey* (1968; special effects designer and director: Kubrick; supervisors: Wally Veevers, Douglas Trumbull, Con Pederson, and Tom Howard) that they reached an unsurpassed level of technical sophistication, visual elegance, integration with the story, and power to create meaning. Kubrick's was the first film that seamlessly linked footage shot by the camera and prepared by the computer, and, decades later, its look continues to amaze audiences.[23] But three directors George Lucas, Steven Spielberg, and Francis Ford Coppola—changed forever the balance between cinematic form and content in American filmmaking. Lucas, Spielberg, and Coppola understood what audiences wanted, and many of their action, adventure, and science fictions films were enormous commercial successes. They all went on to make other kinds of films, but their early work changed how films look and how we look at films. The titles are familiar: Lucas's *THX-1138* (1971) and his "Star Wars" trilogy—*Star Wars* (1977), *The Empire Strikes Back* (1980, director: Irvin Kershner), and *Return of the Jedi* (1983, director: Richard Marquand); Spielberg's *Jaws* (1975), *Close Encounters of the Third Kind* (1977), *Raiders of the Lost Ark* (1981), *E.T.: The Extra-Terrestrial* (1982), *Indiana Jones and the Temple of Doom* (1984), *Indiana Jones*

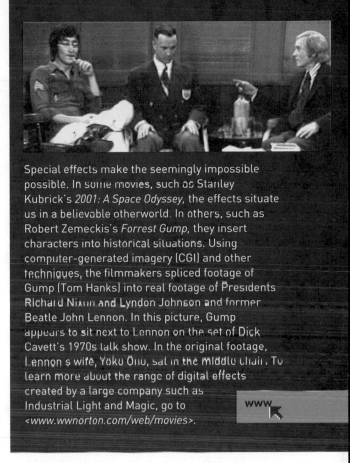

Special effects make the seemingly impossible possible. In some movies, such as Stanley Kubrick's *2001: A Space Odyssey,* the effects situate us in a believable otherworld. In others, such as Robert Zemeckis's *Forrest Gump,* they insert characters into historical situations. Using computer-generated imagery (CGI) and other techniques, the filmmakers spliced footage of Gump (Tom Hanks) into real footage of Presidents Richard Nixon and Lyndon Johnson and former Beatle John Lennon. In this picture, Gump appears to sit next to Lennon on the set of Dick Cavett's 1970s talk show. In the original footage, Lennon's wife, Yoko Ono, sat in the middle chair. To learn more about the range of digital effects created by a large company such as Industrial Light and Magic, go to <www.wwnorton.com/web/movies>.

www

and the Last Crusade (1989), and *Jurassic Park* (1993); and Coppola's *The Godfather* (1972), *The Conversation* (1974), *Apocalypse Now* (1979), and *One From the Heart* (1982), a romantic musical in which the special effects, abundant and often quite beautiful, simply overwhelm the narrative. In the wake of such films, SPFX have dominated the movies, with the production of big-budget blockbusters in the action, adventure, and science fiction genres. These films seek to entertain as they also satisfy the moviegoing audience's need or desire for fantasy. They also do very well at box offices worldwide because their spectacles seldom involve any significant problems of language translation.

[23]The June 1968 issue of *American Cinematographer* (49, no. 6) provides an excellent introduction to the techniques used in Kubrick's film in three illustrated articles.

Hironobu Sakaguchi and Moto Sakakibara's *Final Fantasy: The Spirits Within* (2001) broke new ground in the world of special effects and CGI by being the first motion picture to feature a cast that—while convincingly human in features and motions—was entirely computer-generated. To learn more about the history of special effects, go to *<www.wwnorton.com/web/movies>*.

www

In the past two decades, rapidly improving digital technology has created the third category, computer-generated special effects. For these, the computer is used not only to alter cinematographic images (e.g., adding a character to a scene, as in Robert Zemeckis's *Forrest Gump,* 1994) but also (and increasingly) to create entire sequences of images and entire films, such as John Lasseter's *Toy Story* (1995). Before the 1970s, special effects ordinarily were created under the supervision of the director of photography, for they basically (and, often, very simply) involved just mise-en-scène, cinematography, and fairly conventional laboratory work: placing something before the camera, photographing it, and manipulating the image in the laboratory. But since the mid-1970s, when so many films have incorporated a large number of special effects, separate companies—whose artists and technicians usually work in consultation with the director, production designer, and director of photography—have been responsible for them. This artistry, now virtually a separate industry within the film industry, is expensive, but it has achieved astonishingly realistic effects at costs acceptable to producers. Two of the best-known of these companies are Industrial Light and Magic (a division of director George Lucas's company, Lucasfilm) and Mat Beck's Light Matters (now Light Matters/Pixel Envy).

Directors James Cameron and Ridley Scott are among those at the forefront of the current achievements in postproduction laboratory

work and special effects. Cameron's *Titanic* (1997) cost approximately $200 million to produce, and most of its budget was spent on the state-of-the-art technology that made its illusions believable. Even though many of the shots were made with miniature scale models and with composite cinematography and computer imaging—techniques that Cameron, cinematographer Russell Carpenter, and the production crew brought to perfection—the film's images are verisimilar. Equally distinguished achievements enabled Scott's *Gladiator* (2000) to convincingly re-create ancient Rome.

ANALYZING CINEMATOGRAPHY

To bring this chapter full circle, and to illustrate how the language of cinematography can guide us to the meanings within images, let's look at a full sequence from a film. The purpose of this exercise is to deliberately slow down the viewing process—to consider what happens in each shot, how that action is photographed, and how the cinematography helps create meaning. This kind of shot-by-shot analysis highlights many basic aspects of film production, particularly the previsualization and design work that go into preparing each shot, the nonchronological nature of shooting, and the importance of editing. Warning us not to take anything in a movie for granted, it trains us to be more careful viewers, sensitive to what we expect to see and what we actually see.

TERRENCE MALICK'S *DAYS OF HEAVEN*

We'll examine the second sequence of Terrence Malick's *Days of Heaven* (1978; cinematographer: Nestor Almendros), often called one of the most beautiful movies ever made. When the narrator, Linda, describes a traveling circus as being "all tied up in space and eating your eyes out," she might be describing this movie, whose ravishing images are also deeply meaningful and rich with interpretive possibilities. Malick knew exactly how he wanted the movie to look, instructing the legendary Nestor Almendros to film appropriate scenes during what is called the "magic hour." Although opinions vary on when this magic hour occurs, Almendros's working definition of it is a period of twenty to twenty-five minutes just *after* the sun sets but before it gets dark. The quality of light available during this period depends on several factors, including geographic location (Almendros shot much of the film in Alberta, Canada), season (he shot during all four seasons), and air quality (he shot in a rural area free from air pollution). Almendros used the light available to him under these conditions to record events that take place at both dusk and dawn, when the light is similar: soft, clear, golden, with deep shadows, a realistic but strange light that audiences had rarely seen before. Though shooting in "magic" light posed something of a challenge to Almendros, "it was all justified by the logic of the script," and he praises Malick's knowledge of cinematography, light, and mood: "He is an artist from head to toe. Every little molecule in him is an artist. For a director of photography to work with him, it is the treat of your life. . . . I just helped him in achieving what he wanted."[24]

[24]Nestor Almendros, interview in Dennis Schaefer and Larry Salvato, *Masters of Light: Conversations with Contemporary Cinematographers* (Berkeley: University of California Press, 1984), 15. An interview with Haskell Wexler (see n. 25) also appears in this book.

To fulfill the director's precise vision, Almendros brought to bear his mastery of the closed frame (also demonstrated in such films as François Truffaut's *The Story of Adele H.* [*L'Histoire d'Adèle H.*,1975], Eric Rohmer's *Perceval* [*Perceval le Gallois,* 1978], and Robert Benton's *Places in the Heart* [1984]), precise observation of nature, and knowledge of American landscape paintings and documentary photographs.

The resulting cinematography helps tell a story about nature, greed, and fate.[25] Set in the early 1900s, the story involves four characters: Bill (Richard Gere), an unhappy and hot-tempered con man; Linda (Linda Manz), his teenage sister, who has already had all the joy beaten out of her; Abby (Brooke Adams), the woman Bill loves but whom he calls his sister for his own private reasons; and the Farmer (Sam Shepard), a wealthy Texas rancher. After Bill kills the foreman in a Chicago steel mill where he works, he, Linda, and Abby jump on a train with a crowd of others heading for the Texas plains to look for work. They find jobs on the Farmer's vast and prosperous ranch and settle into the daily routine of hard work and small pleasures. After discovering that the Farmer is interested in Abby but has a serious illness and only a year to live, Bill persuades Abby to marry the Farmer so she can inherit his fortune. However, Bill is not prepared for the conse-

quences of this deception: Abby likes her new life and thus forces Bill to remain in the role of her "brother."

The sequence we will analyze begins just after the opening titles and runs about four minutes, with Linda providing the voiceover narration. It consists of three sections (which for convenience are here called "The Train

[25]The credits list "additional photography by Haskell Wexler." According to Wexler—who can be seen (along with Almendros) discussing his work on the film in Arnold Glassman, Todd McCarthy, and Stuart Samuels's documentary about cinematographers, *Visions of Light: The Art of Cinematography* (1992)—he picked up after Almendros had to leave for another assignment. Almendros seems responsible for the film's poetic look, while Wexler, who made his reputation with documentary-style shooting, handled the more factual shots.

Journey," "From the Train to the Ranch," and "Travelers' New Life," titles not given in the film). A direct relation exists between the narrative and the cinematography in this sequence. The plot segmentation follows a chronological pattern that develops the sequence's primary themes: first, the journey and the changes that come with it; second, the

arrival and the expectations it arouses; third, the realities of a new life.

Although each shot in the sequence is different, they are all shots of exterior locations, making us aware of the landscape and the horizon; all are photographed in natural light; most utilize a compositional pattern of strong horizontal lines and directions; and straight cuts separate the shots unless otherwise noted. While a shot-by-shot analysis might examine numerous aspects of individual shots (e.g., design, lighting, mise-en-scène, sound, editing, acting), here we will consider only three aspects of each shot: the action, the type of shot, and the framing. Now, within the three-part structure of the sequence, let's look closely at each shot.

SECTION 1: TRAIN JOURNEY. In shot 1, we see Bill, Abby, and Linda (from bottom of frame to top) run toward a waiting railroad train. This low-level LS uses deep-space composition and deep-focus cinematography to preserve all three planes of depth in focus; it is static, emphasizing the forward curve of the tracks and the journey to follow. Following the cut to shot 2, another LS pictures the train moving across a high trestle bridge from right to left. The static frame becomes a moving frame as the camera pans left to keep the train's locomotive in the middle third of the frame. Shot 3, a static-framed MS from an angle slightly above the figure, shows Linda lying on a pile of blankets. In shot 4, a crowd of people rides on top of the moving railroad cars. The static camera, mounted amid the crowd, looks toward the locomotive and the horizon beyond; the static frame becomes a moving frame as it pans down to reveal Bill and Abby lying together. Shot 5 (LS; the moving frame pans left and reframes slightly as the train moves across the frame) returns to

the larger scene, as we see the train, starting with the locomotive (which is followed by many other cars), moving diagonally across the frame from left to right, reminding us of the crowd riding on top. Having established the train and its passengers, the movie now shows us more of what is happening on board the train as well as in the countryside it is passing through. Shot 6, a MCU in a static frame, shows a man sitting on top of the train, wearing a fur hat, smoking, and looking at land as the train passes by. Shot 7, also a MCU in a static frame, shows two girls apparently waiting for the train at a forward destination. Shot 8, a bird in flight, is a MS, with the static frame becoming a moving frame as the camera pans right and reframes to keep the bird in the frame. In shot 9 (MCU, static frame), Linda looks toward screen right. Shot 10 takes us inside one of the railroad cars, where in a MS we see a man and two children; the static frame becomes a moving frame as the camera pans left and reframes to a MCU of the man. Shot 11, a LS in a static frame, returns us to Bill and Abby, who are (as in shot 4), lying together and laughing. In shot 12, the train continues its journey across the landscape, moving diagonally from right to left across the middle third of the static frame; this is a LS again using deep-space composition and deep-focus cinematography to keep all three planes of depth in focus. Shot 13, a LS in a static frame of an antelope grazing in a field, signals that the journey is reaching its destination; the next shot (14, LS; the moving frame pans down and reframes to follow a person moving from the top of the train to the ground) confirms this as the train stops momentarily and people climb down from the top of car and run toward the front of the train. In the final shot of this section (15, LS; the static frame becomes a moving frame as

the camera pans down and reframes to include action in the frame), we see the train moving again, slowly, as people toss their bags down and jump from the cars to the ground. There is no break in time as the sequence continues to the next section.

SECTION 2: FROM THE TRAIN TO THE RANCH. This is the shortest of the three sections in this sequence, meant primarily to mark the transition from journey to arrival. It begins (shot 16, LS) with the farm foreman moving toward the camera with a megaphone to greet the arrivals and offer them work; the static frame becomes a moving frame as the camera pans and reframes to keep the foreman in the frame; in shot 17 (LS), the moving frame

pans right as the crowd runs toward the foreman; and in shot 18 (LS, static frame), we see the foreman's truck and other employees with megaphones. After this general situation has been established, shot 19 (MS; static frame) shows Bill approaching the foreman and being hired. Shot 20—comparatively more complex—shows a convoy of trucks and carriages carrying workers toward the ranch, through its massive gate, and toward the Farmer's great house; the pattern of movement is now right to left. Here, Almendros uses a LS in which the static frame becomes a moving frame as the camera pans to keep the convoy in the frame and then to reveal the Farmer's house in the far background. Up to this point, the dominant movement has been right to left

to emphasize the journey; the left-to-right movement in this shot emphasizes the arrival. Shot 21 begins with a *dissolve* (an editing convention, discussed in chapter 6) to the Farmer's house, with the Farmer stepping off the front porch, his luxury car parked to one side. This LS, from a low angle and with tight framing of the house, makes it all seem very imposing from the presumed point of view of the workers as they first see it. Shot 22 provides more information. We see a farm building in the background, geese walking left in the middle ground, and a truck and people entering right in the foreground; after the camera pans right, the house appears in extreme background, thus reorienting the shot. Cinematographically, this is also a comparatively more complex shot than those immediately preceding; it is a LS, with deep-space composition and deep-space cinematography preserving all three planes of depth; the static frame becomes a moving frame as the camera pans right to reestablish the position of the Farmer's house in the far background. The purpose here is to orient us to the principal points near the Farmer's house. The final shot in this section (23) is a simple LS with the static frame showing the Farmer standing in front of his house, eating an apple, and watching the arrival of his workers. Without a break in time, the sequence continues directly into its final section.

SECTION 3: TRAVELERS' NEW LIFE. The travelers' expectations of a new life on the plains now meet the reality of that life. This section opens (shot 24) with a truck entering the frame, moving from right to left; the Farmer's house is in the background as Abby gets off the truck and asks whose house it is, and the foreman tells her and the others that it's the owner's and they're not to go near it. In

this LS, the moving frame pans right to left to keep the truck in the frame and then reframes into a MLS for the conversation between the foreman and Abby. In shot 25 (LS that pans to follow the action), Bill, Abby, and Linda walk right to left away from the truck. Time now flows less precisely than it has up to this point, becoming somewhat dreamlike as impressionistic images continue to convey the workers' new lives. In shot 26 (a LS, with deep-space composition and deep-focus cinematography keeping three planes of depth in focus within a static frame) we see a solitary figure (whom we identify as Bill in the next shot) walk right to left in the middle ground of a vast wheatfield; in shot 27 (a static frame CU), Bill walks right to left in the wheatfield, looking at something offscreen; in shot 28 (LS, static frame), a herd of cattle look back at Bill; Bill scans the landscape in shot 29 (CU, static frame). This reverie is broken in shot 30 when a bird flies right to left across the middle ground of the frame through a vast landscape; in this LS, the moving frame pans left to keep the bird's flight within the frame. A dissolve takes us to shot 31, a MS in which Linda and a girlfriend are walking in a field, with the camera reframing to follow their walk. Shot 32 depicts a large insect moving downward on a wheat stalk—a simple image of a natural phenomenon, but later in the film we realize it is an ominous foreshadowing of the locusts' destruction of the wheatfields. In shot 33, a MS, the two girls try to catch the insect, the moving frame panning left for a closer look, then panning right to follow the girls' walk. In shot 34 (LS, static frame), we see an Asian man lying in the wheatfield reading a book, followed by shot 35 (MS, static frame), an image of two men talking in a foreign language. In the final shot of this sequence (36), we see Linda, Abby, and Bill playing a game of tag in a wheatfield, sug-

gesting that they are content for the moment before there is a dissolve to the next scene.

RELATION OF PARTS TO WHOLE. In the beginning, the cinematography concentrates

on the group of harvesters as a whole, for whom the journey from Chicago to Texas is quiet. Most of them never say a word, but images of their facial expressions and body language reveal the anxiety involved in their struggle to exist; yet shots of their faces also reveal their delight in the landscape and fresh air, and their anticipation of a new life. As the sequence progresses, the cinematography also distinguishes between the main characters, helping define the relationship between Abby and Bill and acquainting us with Linda's philosophical nature (which is also conveyed through her voiceover narration). While Bill and Abby seem happy to be on the move, Linda remains curious, skeptical, and apprehensive. However, Almendros uses long shots to show the three principal characters together at crucial moments: shot 1, when Bill, Abby, and Linda are together before the journey begins; shot 25, when they reunite on arrival at the ranch; and shot 36, when they are happily playing a game of tag together. Across the three sections analyzed above, Almendros uses strong horizontal compositions (2, 5, 8, 12, 26, 27, 29, and 30) to emphasize the particular activities taking place within them, whether it is the train chugging through the landscape, the passengers lying atop the cars, animals standing along the tracks, or birds flying. He tends to frame the principal characters according to their moods: three together within the frame when they are happily united (1, 25, 36), Linda alone in the frame when thinking (3 or 9), or the Farmer alone watching the new arrivals (21, 23). Where the composition includes movement within the frame—right to left, top to bottom, bottom to top, and left to right—Almendros uses the moving frame (or static frame that becomes a moving frame) to record that moving activity and reinforce the idea the movement brings changes. Finally, he uses static shots to delineate the borders of this closed world.

As you can see, these shots alternate in their types, angles, and camera movement. While Malick and Almendros use the moving

frame basically to keep action within the frame and avoid cutting, conventional editing between the shots creates contrasts that, in themselves, supply meaning. For example, the shots of isolated birds or animals—8 (bird), 13 (antelope), 28 (cattle), 30 (bird), and 32 (insect)—suggest the solitude and loneliness of the journey. When these shots are intercut with equally isolated people—9 (Linda looking offscreen, perhaps at the bird in shot 8), 27 and 28 (Bill alone in the wheatfield near a herd of cattle), 31 (Abby and girlfriend alone in the field), 34 (man reading a book in the field)—we see and understand the interconnection of physical nature and human nature.

In addition, individual shots create and raise questions about symbolic meanings. The gateway (shot 20) explicitly marks the boundary of the Farmer's ranch; but does it represent the gateway to days of heaven—the paradise implied by the film's title—or days of wretched labor, as implied by the foreman's attitude, particularly his warning (shot 24) about staying away from the Farmer's house?

Pleasant as life on the ranch may be, shots 23 and 24 confirm that the ranch is not paradise. In 23, the Farmer stands in front of the mansion that testifies to his wealth and power and watches the new group of workers arriving in the fields below. He bites into an apple, the fruit we associate with the expulsion of Adam and Eve from Eden (Chicago is not Eden, of course, but Bill has already committed the sin of murder).

Throughout, the camera takes the omniscient point of view, observing and sometimes judging, and the lighting in the magic hour remains ambiguous, neither dusk nor dark. The imagery communicates the powerful oppositions inherent in the film's themes, especially the idea of nature as both beauty and fury. As in stories from the Bible or ancient Greek myth, here the landscape—transformed by the cinematography from the ordinary to the magical—is so vast that it overwhelms the human story. The characters seem to make their own decisions, but ultimately fate controls them.

QUESTIONS FOR REVIEW

1. What is the difference between a *setup*, a *shot*, and a *take*?
2. A cinematographer depends on *two crews of workers*. What is each crew responsible for?
3. In distinguishing between *color film stock* and *black-and-white film stock*, why do we say that black and white (and the range in between) are colors?
4. How the *lighting* for any movie looks is determined, in part, by its *source* and *direction*. Explain these terms.
5. What are the *four major lenses* used on movie cameras? What is the principal characteristic of the image that each creates?
6. What are the *three most commonly used shots* in a movie? What is the principle by which they are distinguished?
7. What is the *rule of thirds*?
8. The movie camera can shoot from various angles. What are they? What does each *imply* in terms of meaning? Do these implications always hold true in interpreting meaning?
9. What are the basic types of *camera movement*?
10. What is a *long take*? What can it achieve that a *short take* cannot? What is the difference between a *long take* and a *long shot*?
11. Special effects create images that might not be possible with traditional cinematography. What are the three basic ways to create special effects?

QUESTIONS FOR ANALYSIS

1. A movie's *cinematographic plan* is the overall look decided on by the cinematographer in collaboration with the director and other personnel directly involved in creating a movie's images. Do you think that the movie (or clip) that you are analyzing has such a plan? If so, describe its components, paying particular attention to the *film stock, lighting, lenses, framing, angles, depth, POV, scale, camera movement,* and *use of long takes.*

2. Does this movie (or clip) use *camera angles* in a way that creates explicit or implicit meanings? If so, which angles create what meanings?

3. Does the filmmaker's choice of *film stock* seem appropriate for the story being told? Explain.

4. Certain movies, such as those shot in the film noir style, create anticipated meanings. Does the overall system of lighting in the movie (or clip) you are analyzing create a system of meaning?

5. Cinematographic language ordinarily relies on *interaction among the three most commonly used shots.* Does the movie (or clip) you are analyzing conform to that statement? Explain.

6. To what extent and to what purpose does this movie (or clip) use *long takes*?

7. Does this movie (or clip) use *camera angles, scale within the shot, camera movement,* and *camera POV* in a way that calls attention to these techniques?

8. Is there a *pattern of framing* in this movie (or clip) that, in itself, helps to create meaning?

9. Do the images alone create meanings that are not reflected in the characters' action or dialogue? Explain.

10. Are you more likely to remember (a) the cinematography of this movie or (b) the narrative? Why?

FOR FURTHER READING

Almendros, Nestor. *Man with a Camera.* Trans. Rachel Phillips Belash. New York: Farrar, Straus, and Giroux, 1984.

Alton, John. *Painting with Light.* Berkeley: University of California Press, 1995.

American Society of Cinematographers. *American Cinematographer Video Manual.* Hollywood: ASC Press, 1994.

Andrew, Dudley, ed. *The Image in Dispute: Art and Cinema in the Age of Photography.* Austin: University of Texas Press, 1997.

Astruc, Alexander. "The Birth of a New Avant-Garde: *Le Caméra Stylo.*" In *The New Wave: Critical Landmarks,* ed. Peter Graham, 7–18. Garden City, N.Y.: Doubleday, 1968.

Barr, Charles. "CinemaScope: Before and After." In *Film Theory and Criticism: Introductory Readings,* ed. Gerald Mast and Marshall Cohen, 140–68. 2nd ed. New York: Oxford University Press, 1979.

Basten, Fred. *Glorious Technicolor: The Movies' Magic Rainbow.* Cranbury, N.J.: A. S. Barnes, 1980.

Bordwell, David, Janet Staiger, and Kristin Thompson. *The Classical Hollywood Cinema: Film Style and Mode of Production to 1960.* New York: Columbia University Press, 1985.

Brakhage, Stan. *Metaphors on Vision.* [Ed. P. Adams Sitney.] New York: Film Culture, 1963.

———. "A Moving Picture Giving and Taking Book." In *Brakhage Scrapbook: Collected Writings, 1964–1980,* ed. Robert A. Haller, 53–77. New Paltz, N.Y.: Documentext, 1982.

Branigan, Edward. "Color and Cinema: Problems in the Writing of History." *Film Reader* 4 (1979): 16–34.

———. *Point of View in the Cinema: A Theory of Narration and Subjectivity in Classical Film.* Berlin: Mouton, 1984.

Brockett, Oscar G., and Robert R. Findlay. *Century of Innovation: A History of European and American Theatre and Drama Since 1870.* Englewood Cliffs, N.J.: Prentice-Hall, 1973.

Brodbeck, Emil E. *Movie and Videotape Special Effects.* Philadelphia: Chilton Book, 1968.

Campbell, Russell, comp. and ed. *Practical Motion Picture Photography.* London: A. Zwemmer; New York: A. S. Barnes, 1970.

Carr, Robert E., and R. M. Hayes. *Wide Screen Movies: A History and Filmography of Wide Gauge Filmmaking.* Jefferson, N.C.: McFarland, 1988.

Case, Dominic. *Motion Picture Film Processing.* London: Focal Press, 1985.

Chell, David. *Moviemakers at Work: Interviews.* Redmond, Wash.: Microsoft Press, 1987.

Cheshire, David. *The Book of Movie Photography: The Complete Guide to Better Moviemaking.* New York: Knopf, 1979.

Coe, Brian. *The History of Movie Photography.* Westfield, N.J.: Eastview Editions; London: Ash and Grant, 1981.

Culhane, John. *Special Effects in the Movies: How They Do It.* New York: Ballantine, 1981.

De Grandis, Luigina. *Theory and Use of Color.* Trans. John Gilbert. New York: Abrams, 1986.

Deren, Maya. *An Anagram of Ideas on Art, Form, and Film.* Yonkers, N.Y.: Alicat Book Shop Press, 1946. (Reprinted in *The Art of Cinema: Selected Essays,* ed. George Amberg. New York: Arno, 1972.)

———. "Cinematography: The Creative Use of Reality." *Film Theory and Criticism: Introductory Readings,* ed. Leo Braudy and Marshall Cohen, 216–27. 5th ed. New York: Oxford University Press, 1999.

Dreyer, Carl. "Color Film and Colored Films." In *Dreyer in Double Reflection,* ed. Donald Skoller, 168–73. New York: Dutton, 1973.

Dubery, Fred, and John Willats. *Perspective and Other Drawing Systems.* New York: Van Nostrand Reinhold, 1983.

Duncan, Jody. "The Beauty in the Beasts." *Cinefex* 55 (August 1993): 44–95.

———. "A Once and Future War." *Cinefex* 47 (August 1991): 4–59.

Dunn, Linwood G., and George E. Turner. *The ASC Treasury of Visual Effects.* Hollywood: American Society of Cinematographers, 1983.

Durgnat, Raymond. "Colours and Contrasts." *Films and Filming* 15, no. 2 (November 1968): 58–62.

Eisenstein, Sergei. *The Film Sense.* Trans. and ed. Jay Leyda. New York: Harcourt Brace, 1947.

Ettedgui, Peter. *Cinematography.* Woburn, Mass.: Focal Press, 1998.

Fielding, Raymond, comp. *A Technological History of Motion Pictures and Television: An Anthology from the Pages of "The Journal of the Society of Motion Picture and Television Engineers."* Berkeley: University of California Press, 1967.

Finch, Christopher. *Special Effects: Creating Movie Magic.* New York: Abbeville Press, 1984.

Gartenberg, Jon. "Camera Movement in Edison and Biograph Films." *Cinema Journal* 19, no. 2 (spring 1980): 1–16.

Graham, Arthur. "Zoom Lens Techniques." *American Cinematographer* 44, no. 1 (January 1963): 28–29.

Halas, John, and Roger Manvell. *The Technique of Film Animation.* 2nd ed. New York: Hastings House, 1968.

Hamilton, Jake. *Special Effects: In Film and Television.* New York: DK Publishing, 1998.

Harpole, Charles H. *Gradients of Depth in the Cinema Image.* New York: Arno Press, 1978.

Harryhausen, Ray. *Film Fantasy Scrapbook.* South Brunswick, N.J.: A. S. Barnes, 1972.

Henderson, Brian. "The Long Take." In *A Critique of Film Theory,* 48–61. New York: Dutton, 1980.

Herdeg, Walter, and John Halas. *Film and TV Graphics: An International Survey of Film and Television Graphics.* Zurich: W. Herdeg, Graphis Press, 1967.

Hertogs, Daan, and Nico de Klerk, eds. *Disorderly Order: Colours in Silent Film.* Amsterdam: Stichtung Nederlands Filmmuseum, 1996.

Higham, Charles. *Hollywood Cameramen: Sources of Light.* Bloomington: Indiana University Press, 1970.

Joannides, Paul. "The Aesthetics of the Zoom Lens." *Sight and Sound* 40, no. 1 (winter 1972): 40–42.

Johnson, William. "Coming to Terms with Color." *Film Quarterly* 20, no. 1 (fall 1966): 2–22.

Kaminsky, Stuart M. "The Use and Abuse of the Zoom Lens." *Filmmakers Newsletter* 5, no. 12 (October 1972): 20–23.

Kawin, Bruce F. *How Movies Work*. Berkeley: University of California Press, 1992.

Krasilovsky, Alexis. *Women behind the Camera: Conversations with Camerawomen*. Westport, Conn.: Praeger, 1997.

Levitan, Eli L. *An Alphabetical Guide to Motion Picture, Television, and Videotape Production*. New York: McGraw-Hill, 1970.

Lightman, Herb A. "The Fluid Camera." *American Cinematographer* 27, no. 3 (March 1946): 82, 102–3.

LoBrutto, Vincent. *Principal Photography: Interviews with Feature Film Cinematographers*. Westport, Conn.: Praeger, 1999.

Malkiewicz, Kris. *Cinematography: A Guide for Film Makers and Film Teachers*. 2nd ed. New York: Prentice Hall Press, 1989.

———. *Film Lighting: Talks with Hollywood's Cinematographers and Gaffers*. New York: Prentice Hall Press, 1986.

Maltin, Leonard. *The Art of the Cinematographer: A Survey and Interviews with Five Masters*. Corr. and enl. ed. New York: Dover, 1978.

Mamer, Bruce. *Film Production Technique: Creating the Accomplished Image*. Belmont, Calif.: Wadsworth, 1995.

Manvell, Roger, ed. *The International Encyclopedia of Film*. New York: Crown, 1972.

Mascelli, Joseph V. *The Five C's of Cinematography: Motion Picture Filming Techniques*. 1965. Reprint, Los Angeles: Silman-James Press, 1998.

Millerson, Gerald. *The Technique of Lighting for Television and Film*. 3rd ed. Boston: Focal Press, 1991.

Murch, Walter. "Restoring the Touch of Genius to a Classic." *New York Times*, 6 September 1998, sec. 2, pp. 1, 16–17.

Musser, Charles. *The Emergence of Cinema: The American Screen to 1907*. New York: Scribner, 1990.

Netzley, Patricia D. *Encyclopedia of Movie Special Effects*. Phoenix: Oryx Press, 2000.

Ogle, Patrick. "Technological and Aesthetic Influences upon the Development of Deep-Focus Cinematography in the United States." *Screen* 13 (spring 1972): 45–72.

Perkins, V. F. "Rope." In *The Movie Reader*, ed. Ian Cameron Alexander, 35–37. New York: Praeger, 1972.

Rieser, Martin, and Andrea Zapp, eds. *New Screen Media: Cinema/Art/Narrative*. London: British Film Institute, 2001.

Rogers, Pauline B. *Contemporary Cinematographers on Their Art*. Boston: Focal Press, 1999.

Ryan, Roderick T. *A History of Motion Picture Color Technology*. New York: Focal Press, 1977.

———, ed. *The American Cinematographer Manual*. 7th ed. Hollywood: American Society of Cinematographers, 1993.

Salt, Barry. "Statistical Style Analysis of Motion Pictures." *Film Quarterly* 28, no. 1 (fall 1974): 13–22.

Schaefer, Dennis, and Larry Salvato. *Masters of Light: Conversations with Contemporary Cinematographers*. Berkeley: University of California Press, 1984.

Schechter, Harold, and David Everitt. *Film Tricks: Special Effects in the Movies*. New York: H. Quist, 1980.

Sharits, Paul. "Red, Blue, Godard." *Film Quarterly* 19, no. 4 (summer 1966): 24–29.

Society of Motion Picture and Television Engineers. *Elements of Color in Professional Motion Pictures*. New York: Society of Motion Picture and Television Engineers, 1957.

Thomas, David Bowen. *The First Colour Motion Pictures*. London: H.M.S.O., 1969.

Vaz, Mark Cotta, and Patricia Rose Duignan. *Industrial Light and Magic: Into the Digital Realm*. New York: Ballantine, 1996.

Vertov, Dziga. *Kino-Eye: The Writings of Dziga Vertov*. Ed. Annette Michelson. Trans. Kevin O'Brien. Berkeley: University of California Press, 1984.

Wees, William C. "Prophecy, Memory, and the Zoom: Michael Snow's *Wavelength* Re-Viewed." *Ciné-Tracts*, nos. 14/15 (summer/fall 1981): 78–83.

Weinstock, Neil. *Computer Animation*. Reading, Mass.: Addison-Wesley, 1986.

White, John. *The Birth and Rebirth of Pictorial Space.* 2nd ed. New York: Harper and Row, 1972.

Winston, Brian. *Technologies of Seeing: Photography, Cinematography, and Television.* London: British Film Institute, 1996.

Wright, Lawrence. *Perspective in Perspective.* London: Routledge and Kegan Paul, 1983.

Youngblood, Gene. *Expanded Cinema.* New York: Dutton, 1970.

Zelanski, Paul, and Mary Pat Fisher. *Colour for Designers and Artists.* London: Herbert Press, 1989.

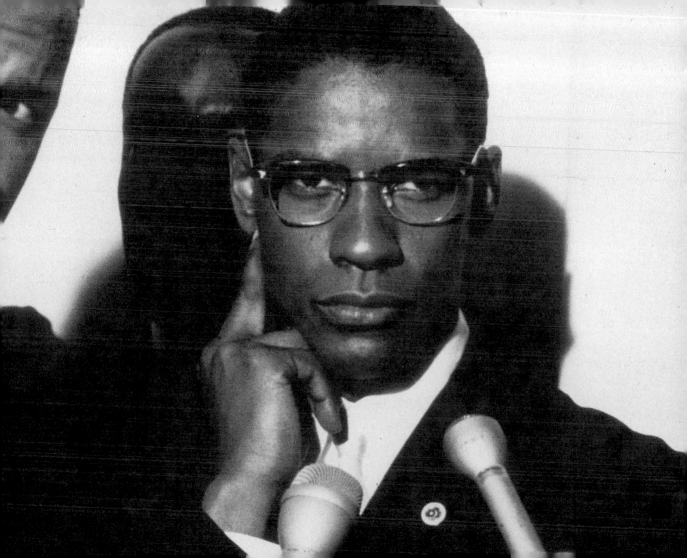

WHAT IS ACTING?

When Richard M. Nixon was president of the United States, the public generally regarded him as a cold, calculating politician. Yet when Anthony Hopkins played him in Oliver Stone's *Nixon* (1995), many were astonished at the depth of humanity they saw on screen. Hopkins persuaded audiences that Nixon had unexpected dimensions, turning him into a far more sympathetic *character.*

Screen acting of this kind is an art, in which an actor uses imagination, intelligence, vocal technique, facial expressions, body language, and an overall knowledge of the filmmaking process to realize, under the director's guidance, the character created by the screenwriter. The performance and effect of that art can seem mysterious and magical when we're enjoying a movie, and acting turns out to be even more complex than we might at first assume.

Our initial interest in a movie is almost always sparked by the actors featured in it. As critic Pauline Kael says, "I think so much of what we respond to in fictional movies is acting. That's one of the elements that's often left out when people talk theoretically about the movies. They forget it's the human material we go to see."[1] The power of some actors—Julia Roberts or Tom Hanks, for example—to draw an audience is frequently more important to a movie's financial success than any other factor. Because of this, some observers regard screen actors as mere "commodities," cogs in a machine of promotion and hype designed only to generate revenue. Although even the most accomplished screen actors can be used as fodder for promotional campaigns,

such a view overlooks the many complex and important ways that skillful acting can influence the narrative, style, and meanings of a film. Writer-director-producer-actor Orson Welles questioned nearly every other aspect of filmmaking dogma, but he firmly believed in the importance of acting: "I don't understand how movies exist independently of the actor—I truly don't."[2]

Despite its central importance, acting is also the aspect of filmmaking over which directors have the least precise control. Directors may describe literally what they want from their principal collaborators—for example, screenwriters or costume designers—but they can only *suggest* to actors what they want. Screen actors, or at least *experienced* screen actors, know that the essential relationship is between them and the camera, not the director—not even the audience. Actors' interpretations of the director's guidance occur in the area between the actors and the lens, an intimate and narrowly defined space that necessarily concentrates much of the actors' energy on their faces. Through composition, close-ups, camera angles and movements, and other cinematic techniques, movie actors always come *closer* to the audience, and appear *larger,* than actors on the stage.

English film actor Michael Caine has compared the movie camera to an impossibly attentive lover who "hangs on your every word, your every look; she can't take her eyes off you. She is listening to and recording everything you do, however minutely you do it."[3] The camera makes possible an attention to de-

[1]Leonard Quart, "I Still Love Going to Movies: An Interview with Pauline Kael," *Cineaste* 25, no. 2 (2002).

[2]Orson Welles and Peter Bogdanovich, *This Is Orson Welles,* ed. Jonathan Rosenbaum (New York: Harper Collins, 1992), 262.

[3]Michael Caine, *Acting in Film: An Actor's Take on Moviemaking* (New York: Applause, 1990), 4.

When Frank T. J. Mackey (Tom Cruise) appears at the deathbed of his estranged father, "Big Earl" Partridge (Jason Robards, lower right), two generations of acting talent meet in Paul Thomas Anderson's *Magnolia* (1999). It's no surprise that the nearly eighty-year-old Robards delivers the kind of strong, subtle, thorny performance that characterized his long career on stage, and in radio, television, and film. Still proving himself as a serious actor, however, the thirty-seven-year-old Cruise surprises us by bringing out the many layers of a despicable character. The business and the art of Hollywood moviemaking intersect when "bankable" stars such as Cruise take on challenging, unglamorous roles that transcend their physical attractiveness.

tail that was impossible before the invention of cinema, mainly because stage acting forced actors to "project" their voices and their gestures to the back of the theater. Screen acting, as an experience, can be as tight and intimate as examining a painting at arm's length. As American screen actor Joan Crawford put it, "a movie actor paints with the tiniest brush."[4]

While previous generations of stage actors knew their duty was to convey emotion through recognized conventions of speech and gesture (mannerisms), screen actors have enjoyed a certain freedom to adopt individual styles that communicate emotional meaning through subtle, and highly personal, gestures, expressions, and varieties of intonation. American screen actor Barbara Stanwyck credited director Frank Capra with teaching her that "if you can think it, you can make the audience know it. . . . On the stage, it's mannerisms. On the screen, your range is shown in your eyes."[5]

In addition, many different types of inspiration fuel screen acting; many factors guide actors toward their performances in front of the camera. Consider American movie actor Sissy Spacek, who has been nominated six times for the Academy Award for Best Actress, and who won for her performance as country singer Loretta Lynn in Michael Apted's *Coal Miner's*

[4]Joan Crawford, qtd. in Lillian and Helen Ross, *The Player: A Profile of an Art* (New York: Simon and Schuster, 1962), 66.

[5]Barbara Stanwyck, in *Actors on Acting for the Screen: Roles and Collaborations*, ed. Doug Tomlinson (New York: Garland, 1994), 524.

[2]

[1]

A contemporary actress of substance who has never become a Hollywood superstar, Sissy Spacek has exhibited great flexibility not only in the roles she chooses but also in the techniques she employs to convey her characters' often complex emotional lives. [1] In Terrence Malick's *Badlands*, she embodies the innocent sexuality and dreaminess of romance novels. [2] In Brian De Palma's *Carrie*, she convincingly takes us into the disturbing, supernatural realm of horror.

Daughter (1980). We might say that Spacek's appearance—diminutive figure; pale red hair; large, open, very blue eyes; sharp, turned-up nose; abundant freckles; and Texas twang— has destined her to play a certain type of role: a sweet, seemingly simple and frail, but ulti-

mately strong, perhaps strange and even otherworldly woman. Spacek brings out the depths within her characters, however, making each unique, believable, and easy to connect with or at least care about. Depending on what the role calls for, she can make herself look plain (avoiding makeup and hair styling) or beautiful. Between the ages of twenty-four and twenty-seven, she played three characters in their teens, all childlike and somewhat naive. In Terrence Malick's *Badlands* (1973), she plays Holly, whose unemotional narration, taken from her flat yet poetic diary entries, contrasts markedly with her physical passion for Kit (Martin Sheen), a murderer who takes her on a horrifying odyssey. In Brian De Palma's *Carrie* (1976), a horror movie based on a novel by Stephen King, she plays the title character, a lonely, misunderstood teenager raised by a fundamentalist mother, tormented by her conceited schoolmates, and possessing the telekinetic ability to perform vengeful acts. In Robert Altman's *3 Women* (1977), she plays Pinky Rose, perhaps the most enigmatic of these three characters: vulnerable, unsophisticated, sensitive to what others think of her, and clumsy, but also shrewd in getting what she wants and psychologically haunted by what seems to be a dream of the past.

Spacek recalls how three very different directors helped bring out these three very different types of screen performance:

> From Terry Malick I learned how to approach a character. . . . With Terry you feel an incredible intimacy. We spent a lot of time just talking about our lives, remembering things that help you to tie the character [to] your own life. . . . Bob [Altman] works by bringing elements together, not expecting anything—he brings things together to capture the unexpected.

Brian [De Palma] approaches films more like a science project. With Brian I learned to work with the camera. . . . [E]verything was storyboarded. . . . You can act your guts out and the camera can miss it. But one little look, if you know how it's going to be framed, can have a thousand times more impact.[6]

Each directorial style requires something different from actors. Malick, encouraging actors to identify with characters, promotes a style loosely referred to as *method* acting. Altman, favoring spontaneity and unpredictability in actors' performances, encourages *improvisation*. De Palma, choosing neither of these two roads, pushes his actors to see their performances from a cinematographic point of view, to explicitly imagine how their gestures and expressions will *look* onscreen. In doing so, he essentially encourages actors to think more than to feel, to perform their roles almost as if they were highly skilled technicians whose main task is to control one aspect of the mise-en-scène (performance) much as set designers control the look and feel of sets, sound mixers control sound, directors of photography control cinematography, and so on.

THE PARADOX OF ACTING

We can find the basis of such theories of film acting in eighteenth-century France (the birthplace, some one hundred years later, of cinema). In his book *The Paradox of Acting* (*Paradoxe sur le comédien,* pub. 1830), Denis Diderot considered the nature of acting. He concluded, paradoxically, that actors should not *feel* the emotions of the characters they

portray. To move an audience, actors must remain unmoved by the characters.

In 1839, François Delsarte, a French teacher of acting and singing, introduced the kind of training that Diderot had advocated, and he confronted the same paradox. Although he formulated a series of rules for coordinating actors' voices and body language, and produced a manual of illustrations showing how actors should appear when representing various emotions, his approach could not make acting seem "natural." Delsarte's theories were very influential in the United States, but only modern explorations of human psychology—including the relation of the conscious and the unconscious—enabled actors to solve this dilemma.

EARLY SCREEN-ACTING STYLES

The people on the screen in the very first movies were not actors but ordinary people playing themselves. The early films caught natural, everyday actions—feeding a baby, leaving work, yawning, walking up and down stairs, swinging a bat, sneezing—in a simple, realistic manner, and "acting" was simply a matter of trying to ignore the presence of the camera as it recorded the action. In the early 1900s, filmmakers started to tell stories with their films and thus needed professional actors. Most stage actors at the time scorned film acting, however, and refused to take work in the fledgling industry. The first screen actors were thus usually rejects of the stage or fresh-faced amateurs eager to break into the emerging film industry. Lack of experience (or talent) wasn't the only hurdle facing them. Because no standard language of cinematic expression, nor any accepted tradition of film direction, existed at the time, these first actors had little option but to adopt

[6]Sissy Spacek, in Tomlinson, ed., *Actors on Acting for the Screen,* 518.

the acting style favored in the nineteenth-century theater and try to adapt it to their screen roles. The resulting quaint, unintentionally comical style consists of exaggerated gestures, overly emphatic facial expressions, and a bombastic mouthing of words (which could not yet be recorded on film) that characterized the stage melodramas popular at the turn of the century.

Sarah Bernhardt (1844–1923), known as *La voix d'or* (the golden voice) and *La divine Sarah,* was a star of the French stage and the first great theatrical actress to appear in a movie, Clément Maurice's *Hamlet* (*Le duel d'Hamlet,* 1900). Despite her very mixed feelings about the new medium, she made a series of critically and commercially successful movies with La Société Film d'Art, including André Calmettes's *Camille* (*La dame aux camélias,* 1911) and Henri Desfontaines and Louis Mercanton's *Queen Elizabeth,* pictured above. In this silent, filmed play, Bernhardt employs the emphatic gestures and Delsartian training that served her so well on the stage; she even bows at the end. To see different acting styles in action, compare Bette Davis's portrayal of Elizabeth in Michael Curtiz's *The Private Lives of Elizabeth and Essex* (1939) and Cate Blanchett's performance in Shekhar Kapur's *Elizabeth* (1998).

In 1908, La Société Film d'Art (or Art Film Society), a French film company, was founded with the purpose of creating a serious artistic cinema that would attract equally serious people who ordinarily preferred the theater. Commercially, this was a risky step, not only because cinema was in its infancy but also because since the sixteenth century the French had seen theater as a temple of expression. Its glory was (and remains) the Comédie Française, the French national theater; and to begin its work at the highest possible level, La Société Film d'Art joined creative forces with this revered organization, which agreed to lend its actors to the society's films. In addition, the society commissioned leading theater playwrights, directors, and designers, as well as prominent composers, to create its film productions. The most famous of these were *The Assassination of the Duc de Guise* (*L'Assassinat du duc de Guise,* 1908) and *Queen Elizabeth* (*Les amours de la reine Élisabeth,* 1912).

Interesting as it is to see Sarah Bernhardt, one of the early twentieth century's greatest actors, as Elizabeth I, it is even more interesting to observe how closely this "canned theater" resembled an actual stage production. The space we see is that of the theater, limited to having actors enter and exit from stage left or right, not that of the cinema, where characters are not confined to the physical boundaries imposed by theater architecture. For all her reputed skill, Bernhardt's acting could only echo what she did on the stage. Thus we see the exaggerated facial expressions, strained gestures, and clenched fists of late-nineteenth-century melodrama. While such artificiality was conventional and thus accepted by the audience, it was all wrong for the comparative intimacy between the spectator and the screen that existed even in the earliest movie theaters.

Despite its heavy-handed technique, *Queen Elizabeth* succeeded in attracting an audience interested in serious drama on the screen, made the cinema socially and intellectually respectable, and therefore encouraged further respect for the industry and its development. What remained to be done was not to teach Sarah Bernhardt how to act for the camera, but to develop cinematic techniques uniquely suitable for the emerging narrative cinema as well as a style of acting that could help actors realize their potential in this new medium.

D. W. GRIFFITH AND LILLIAN GISH

American film pioneer D. W. Griffith needed actors trained to work only before the camera, and, by 1913, he had recruited a group that included some of the most important actors of the time: Mary Pickford, Lillian and Dorothy Gish, Mae Marsh, Blanche Sweet, Lionel Barrymore, Harry Carey, Henry B. Walthall, and Donald Crisp. Some had stage experience, some did not. All of them earned much more from acting in the movies than they would have on the stage, and all enjoyed long, fruitful careers (many lasting well into the sound era).

Because the cinema was silent during this period, Griffith worked out more naturalistic movements and gestures for his actors rather than training their voices. The longer stories of such feature-length films as *The Birth of a Nation* (1915), *Intolerance* (1916), *Hearts of the World* (1918), and *Broken Blossoms* (1919) gave the actors more screen time and thus more screen space in which to develop their characters. Close-ups required them to be more aware of the effects that their facial expressions would have on the audience, and actors' faces increasingly became more important than their bodies (although in the silent

This portrait of D. W. Griffith dates from sometime between 1908 and 1913, his early years with the American Biograph Company, where he was just beginning to advance the narrative form of film. The more than 450 short movies, or "one-reelers," Griffith created for the company provided the testing ground for new directorial ideas and methods, among them the naturalization of screen acting.

comedies of the 1920s, the full presence of the human body was virtually essential to conveying the humor).

Under Griffith's guidance, Lillian Gish invented screen acting. Griffith encouraged her to study the movements of ordinary people on the street or in restaurants, to develop her physical skills with regular exercise, and to tell stories through her face and body. He urged her to watch the reactions of movie audiences, saying, "If they're held by what you're doing, you've succeeded as an

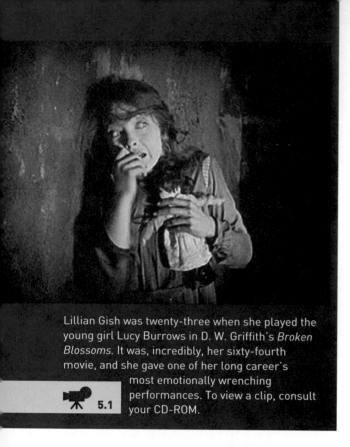

Lillian Gish was twenty-three when she played the young girl Lucy Burrows in D. W. Griffith's *Broken Blossoms*. It was, incredibly, her sixty-fourth movie, and she gave one of her long career's most emotionally wrenching performances. To view a clip, consult your CD-ROM.

5.1

The interaction of narrative, acting, extremely confined cinematic space, and exploitation of the audience's fears gives this scene its beauty, power, *and* repulsiveness. Seen from various angles within the closet, which fills the screen, Lucy clearly cannot escape. Hysterical with fear, she finally curls up as her father breaks through the door. At the end, she dies in her bed, forcing the smile that has characterized her throughout the film. Terror and pity produce the cathartic realization within the viewer that Lucy's death, under these wretched circumstances, is truly a release.

In creating this scene, Gish invoked a span of emotions that no movie audience had seen before and few have seen since. Her performance illustrates the qualities of great screen acting: appropriateness, expressive coherence, inherent thoughtfulness/emotionality, wholeness and unity. Amazingly, it resulted from her instincts—her sense of what was right for the climactic moment of the story and the mise-en-scène in which it took place—rather than from Griffith's direction:

> The scene of the terrified child alone in the closet could probably not be filmed today. To watch Lucy's hysteria was excruciating enough in a silent picture; a sound track would have made it unbearable. When we filmed it I played the scene with complete lack of restraint, turning around and around like a tortured animal. When I finished, there was a hush in the studio. Mr. Griffith finally whispered: "My God, why didn't you warn me that you were going to do that?"[8]

actress."[7] Gish's performance in *Broken Blossoms* was the first great film performance by an actor. Set in the "Limehouse" (or Chinatown) section of London, the movie presents a very stylized fable about the love of an older Chinese merchant, Cheng Huan (Richard Barthelmess), for an English adolescent, Lucy Burrows (Gish). Lucy's racist father, the boxer Battling Burrows (Donald Crisp), beats her for the slightest transgression. Enraged by her friendship with the merchant, Burrows drags her home; and when Lucy hides in a tiny closet, he breaks down the door and beats her so savagely that she dies soon after.

Gish gives a similar, powerful performance—her character shoots the man who raped her—

[7]Lillian Gish with Ann Pinchot, *The Movies, Mr. Griffith, and Me* (Englewood Cliffs, N.J.: Prentice-Hall, 1969), 97–101; quotation, 101. See also Jeanine Basinger, *Silent Stars* (New York: Knopf, 1999).

[8]Gish, *The Movies, Mr. Griffith, and Me*, 200. For another version of how this scene was prepared and shot, see Charles Affron, *Lillian Gish: Her Legend, Her Life* (New York: Scribner, 2001), 125–31.

in Victor Sjöström's *The Wind* (1928); and her work in confined spaces influenced such later climactic scenes as those in Alfred Hitchcock's *Psycho* (1960) and Stanley Kubrick's *The Shining* (1980).

KONSTANTIN STANISLAVSKY AND METHOD ACTING

Konstantin Stanislavsky cofounded the Moscow Art Theater in 1898 and spent his entire career there. Developing what became known as the **Stanislavsky system** of acting, he trained students to strive for realism, both social and psychological, and to bring their own past experiences and emotions to their roles. This intense psychological preparation required the actors' conscious efforts to tap their unconscious selves. On one hand, they had to portray living characters onstage; on the other, they could not allow their portrayals to detract from the acting ensemble and the play as a whole and as written text.

Stanislavsky's ideas influenced the Soviet silent film directors of the 1920s—Sergei M. Eisenstein, Aleksandr Dovzhenko, Lev Kuleshov, and Vsevolod I. Pudovkin—all of whom had learned much from Griffith's work. But they often disagreed about acting, especially about how it was influenced by actors' appearances and by editing, which could work so expressively both for and against actors' interpretations.

Among this group, Pudovkin, whose *Film Acting* (1935) was one of the first serious books on the subject, has the most relevance to mainstream movie acting today. Although he advocates an explicitly Stanislavskian technique based on his observations of the Moscow Art Theater, he writes from the standpoint of film directors and actors working together. Because film consists of individual shots, he reasons,

both directors and actors work at the mercy of the shot and must strive to make acting (out of sequence) seem natural, smooth, and flowing while maintaining expressive coherence across the shots. He recommends close collaboration between actors and directors, with long periods devoted to preparation and rehearsal. He also advises film actors to ignore voice training because the microphone makes it unnecessary, notes that the close-up can communicate more to the audience than can overt gestures, and finds that the handling of "expressive objects" (e.g., Charlie Chaplin's cane) can convey emotions and ideas even more effectively than close-ups.

Outside the Soviet Union, Stanislavsky's books *My Life in Art* (1924) and *An Actor Prepares* (1936) had a lasting impact. In 1947, directors Elia Kazan and Lee Strasberg founded the Actors Studio in New York City. They

Elia Kazan *(center)* and Marlon Brando *(right)* on location during the filming of *On the Waterfront* (1954). The two had worked together on Kazan's 1951 screen adaptation of Tennessee Williams's *A Streetcar Named Desire*, and Brando's performances in both films set a standard for method acting.

loosely adapted Stanislavsky's ideas, not only his principle that actors should draw on their own emotional experiences to create characters but also his emphasis on the importance of creating an ensemble and expressing the subtext, the nuances that lay beneath the lines of the script. The naturalistic style they popularized, which came to be known as **method acting** (or *the method*), encourages actors to speak, move, and gesture not in a traditional stage manner but just as they would in their own lives. Thus it is an ideal technique for representing convincing human behavior on the stage and on the screen. The method has led to a new level of realism and subtlety, influencing such actors as Marlon Brando, James Dean, Montgomery Clift, Shelley Winters, Walter Matthau, Paul Newman, Robert Duvall, Gene Hackman, Faye Dunaway, Sidney Poitier, Dustin Hoffman, Jon Voight, Dennis Hopper, Jack Nicholson, Al Pacino, Robert De Niro, Harvey Keitel, Holly Hunter, and John Goodman.[9]

To understand some of the differences between method and nonmethod acting, you might compare the performances in Elia Kazan's *East of Eden* (1955) and John Ford's *The Man Who Shot Liberty Valance* (1962). Under Kazan's direction, James Dean's portrayal of Cal Trask—a brooding, sensitive man, mumbling and inarticulate—is a classic method performance that embodies the style's major characteristics as displayed by male actors such as Brando, De Niro, and Hoffman. Indeed, Dean's performances here and in

[9]See Carole Zucker, "An Interview with Lindsay Crouse," *Post Script: Essays in Film and the Humanities* 12, no. 2 (winter 1993): 5–28. See also Foster Hirsch, *A Method to Their Madness: The History of the Actors' Studio* (New York: Norton, 1984), and Steven Vineberg, *Method Actors: Three Generations of an American Acting Style* (New York: Schirmer Books, 1991).

Nicholas Ray's *Rebel Without a Cause* (1955) have made him an icon for misunderstood young men. In Ford's film we see very different definitions of manhood and more straightforward, less inner-directed acting styles. John Wayne plays Tom Doniphon, a man of action who believes that liberty depends on the use of force, while James Stewart plays Ransom Stoddard, an idealistic lawyer (in the spirit of the young Abraham Lincoln) who believes that liberty is won through education. Within this careful schematic and directed by the no-nonsense Ford, who always placed great weight on how characters were written, Wayne and Stewart inhabit their roles without visibly exploring their characters' psychologies.

BERTOLT BRECHT

After Stanislavsky, the second major European influence on acting was the German playwright Bertolt Brecht, who allied his theatrical ideas with Marxist political principles to create a nonnaturalistic theater. His professional home was the Berliner Theatre Ensemble, but he directed theater in numerous countries, including the United States. Unlike Stanislavsky, who worked solely in theater, Brecht had a little experience in film production; he wrote and codirected a five-minute silent film, *A Man's a Man* (*Mann ist Mann,* 1931); cowrote the screenplay for the propagandistic feature *To Whom Does the World Belong?* (*Kuhle Wampe oder: Wem gehört die Welt?,* 1932); and provided the story for Fritz Lang's *Hangmen Also Die* (1943).

While Stanislavsky strove for realism, Brecht believed that audience members should not think they are watching something actually happening before them. Instead, he wanted every aspect of a theatrical production

to limit the audience's identification with characters and events, thereby creating a psychological distance (called the **alienation effect** or **distancing effect**) between them and the stage. Overall, this theory has not had much influence on mainstream filmmaking—after all, unlike theater, cinema can change as often as it wants the relationship between the spectator and the screen, alternately alienating them from or plunging them into the action—but we do see it when actors "step out" of character, face the camera, and directly address the audience. It has also influenced some experimental films and a few narrative films (see "Types of Movies" in chapter 1), such as the Marxism-oriented work of Jean-Luc Godard (e.g., *My Life to Live* [*Vivre sa vie*], 1962) and Lindsay Anderson (*O Lucky Man!*, 1973). In addition, Brecht's theories continue to influence acting and production in the contemporary theater, contemporary film theory and criticism, and films based on his plays, such as Menahem Golan's *Mack the Knife* (1989, based on *The Threepenny Opera* [*Die Dreigroschenoper*], 1928; book by Brecht, score by Kurt Weill).

THE INFLUENCE OF SOUND

Instead of instantly revolutionizing film style, the coming of sound, in 1927, meant that over several years the industry had to convert to this new form of production (see chapter 7). Filmmakers made dialogue more comprehensible by developing better microphones; finding the best placements for the camera, microphones, and other sound equipment; and encouraging changes in actors' vocal perfor-

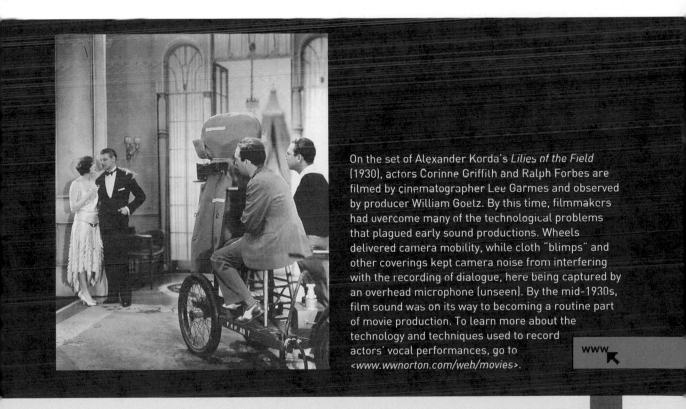

On the set of Alexander Korda's *Lilies of the Field* (1930), actors Corinne Griffith and Ralph Forbes are filmed by cinematographer Lee Garmes and observed by producer William Goetz. By this time, filmmakers had overcome many of the technological problems that plagued early sound productions. Wheels delivered camera mobility, while cloth "blimps" and other coverings kept camera noise from interfering with the recording of dialogue, here being captured by an overhead microphone (unseen). By the mid-1930s, film sound was on its way to becoming a routine part of movie production. To learn more about the technology and techniques used to record actors' vocal performances, go to <www.wwnorton.com/web/movies>.

www

mances. Initially, they encased the camera, whose overall size has changed relatively little since the 1920s, in either a bulky soundproof booth or the later development known as a **blimp**—a soundproofed enclosure somewhat larger than a camera, in which the camera may be mounted so that its sounds would not reach the microphone. Such measures prevented the sounds of its mechanism from being recorded, but also restricted the freedom with which the camera—and the actors—could move. Actors accustomed to moving around the set without worrying about speaking now had to curtail their movements inside the circumscribed sphere where recording took place. Furthermore, technicians required time to adjust to the recording equipment, which restricted their movements as well. Eventually, technicians were able to free the camera for all kinds of movement and to find ways of recording sound that allowed the equipment and actors alike more mobility.

Monumental as the conversion to sound was—in economic, technological, stylistic, and human terms—Hollywood found humor in it, making it the subject of one of the most enjoyable of all movie musicals: Gene Kelly and Stanley Donen's *Singin' in the Rain* (1952), which vividly and satirically portrays the technical difficulties of using the voice of one actor to replace the voice of another who hasn't been trained to speak, trying to move a camera weighted down with soundproof housing, and forcing actors to speak into microphones concealed in flowerpots. As film scholar Donald Crafton writes, "Many of the clichés of the early sound cinema (including those in *Singin' in the Rain*) apply to films made during this period: long static takes, badly written dialogue, voices not quite in control, poor-quality recording, and a speaking style with slow cadence and emphasis on

'enunciated' tones, which the microphone was supposed to favor."[10]

How did the "talkies" influence actors and acting? While sound enabled screen actors to use all their powers of human expression, it also created a need for dialogue coaches to help them find their voices. The more actors and the more speaking a film included, the more complex the narrative could become. Directors had to make changes, too. Before sound, a director could call out instructions to the actors during filming; once the microphone could pick up every word uttered on the set, directors were forced to rehearse more extensively with their actors, thus adopting a technique from the stage to deal with screen technology. Though many actors and directors could not make the transition from silent to sound films, others emerged from silent films ready to see the addition of sound less as an obstacle than as the means to a more complete screen verisimilitude.

Let's look at two innovative productions from this period: Rouben Mamoulian's *Applause* (1929; sound-recording technician: Ernest Zatorsky) and George W. Hill's *The Big House* (1930), for which Douglas Shearer of the MGM sound department received the first Academy Award for sound recording. *Applause,* the first Hollywood backstage melodrama made after the coming of sound, is photographed in a style that mixes naturalism with expressionism; *The Big House,* the first prison drama, tells its story by portraying the gritty details of life behind bars.

Mamoulian, after several years of directing theater productions in London and New York, made his screen-directing debut with *Applause.* From the opening scene, a montage of

[10]Donald Crafton, *The Talkies: American Cinema's Transition to Sound, 1926–1931* (New York: Scribner, 1997), 14.

activity that plunges us right into the lively world of burlesque, the film reveals his mastery of camera movement. But when the camera does not move, as in the many two-shots full of dialogue, we can almost *feel* the limited-range microphone boom hovering over the actors, one step beyond the use of flowerpots. In contrast to the vibrant shots with the moving camera, these static shots are lifeless and made even more confusing by the loud, expressionistic sounds that overwhelm ordinary as well as intimate conversations. Obviously, such limitations have an impact on how we perceive the acting, which is the movie's weak point throughout. In all likelihood knowing that symphonies of city sounds and noises would be the main impression of many scenes, the actors have little to say or do. However, the movie remains interesting because of a new technique in sound recording that Mamoulian introduced and that soon became common practice. Earlier, all sound in a particular shot was recorded and manipulated on a single soundtrack. Mamoulian persuaded the sound technicians to record overlapping dialogue in a single shot using two separate microphones and then to mix them together on the soundtrack. When April (Joan Peers), her head on a pillow, whispers a prayer while her mother, Kitty Darling (Helen Morgan), sits next to her and sings a lullaby, the actors almost seem to be singing a duet, naturally, intimately, and convincingly. (In his next films, Mamoulian made other innovations in sound, including the sound flashback in 1931's *City Streets* and the lavish use of contrapuntal sound in the opening of 1932's *Love Me Tonight*.)

In *The Big House,* the hardness of prison life is conveyed in part through often discordant sound: the guards' and inmates' various accents and speech impediments, the clangor

Rouben Mamoulian's *Applause* marked a technical transition from single-track sound recording to multitrack recording and mixing, a technique that opened the door to greater flexibility in camera movement and, eventually, to more naturalistic screen acting. Here, true to the sordid world of the second-rate vaudeville theater, the sassy chorus girls parade up and down the runway as they taunt the men in the audience.

of the machine shop, the roar of rioting men, and the deafening silence of solitary confinement. Much of Wallace Beery's performance as "Machine Gun" Butch Schmidt depends on close-ups and the clear recording of his tough-guy voice. These powerful effects make us forgive such dubious choices as having the prisoners march in time to the background music.

MOVIE STARS IN THE GOLDEN AGE OF HOLLYWOOD

From the early years of moviemaking, writes Robert Allen, "the movie star has been one of the defining characteristics of the American

cinema."[11] Most simply, a **movie star** is two people: the actor and the character(s) he or she has played. In addition, the star embodies an image created by the studio to coincide with the kinds of roles associated with the actor. That the star also reflects the social and cultural history of the period in which that image was created helps explain the often rapid rise and fall of stars' careers. But this description reveals at its heart a set of paradoxes, as Allen points out:

> The star is powerless, yet powerful; different from "ordinary" people, yet at one time was "just like us." Stars make huge salaries, yet the work for which they are handsomely paid does not appear to be work on the screen. Talent would seem to be a requisite for stardom, yet there has been no absolute correlation between acting ability and stardom. The star's private life has little if anything to do with his or her "job" of acting in movies, yet a large portion of a star's image is constructed on the basis of "private" matters: romance, marriage, tastes in fashion, and home life. (174)

The golden age of Hollywood, roughly from the 1930s until the '50s, was the age of the movie star, and acting in American movies generally meant *star acting.* During this period, the major studios gave basic lessons in acting, speaking, and movement; but since screen appearance was of paramount importance, they were more concerned with enhancing actors' screen images than with improving their acting.

During this period, when the studio system and the star system went hand in hand, the studios had almost complete control of their actors. Every six months, the studio reviewed an actor's standard seven-year **option contract:** if the actor had made progress in being assigned roles and demonstrating box-office appeal, the studio picked up the option to employ that actor for the next six months and gave him or her a raise; if not, the studio dropped the option and the actor was out of work. The decision was the studio's, not the actor's. Furthermore, the contract did not allow the actor to move to another studio, stop work, or renegotiate for a higher salary. In addition to those unbreakable terms, the contract also

> had restrictive clauses that gave the studio total control over the star's image and services; it required an actor "to act, sing, pose, speak or perform in such roles as the producer may designate"; it gave the studio the right to change the name of the actor at its own discretion and to control the performer's image and likeness in advertising and publicity; and it required the actor to comply with rules covering interviews and public appearances.[12]

Thus acting ability was often considered secondary to an actor's screen presence or aura, physical or facial beauty, athletic ability or performance skills, or character "type." Although many stars were also convincing actors, capable of playing a variety of parts (e.g., Bette Davis, Henry Fonda, Barbara Stanwyck, Jimmy Stewart), surprisingly little serious at-

[11]For a study of stars in Hollywood from which this section liberally draws, see Robert C. Allen and Douglas Gomery, *Film History: Theory and Practice* (New York: Knopf, 1985), 172–89, quotation, 174 (reprinted as Robert C. Allen, "The Role of the Star in Film History [Joan Crawford]," in *Film Theory and Criticism: Introductory Readings,* ed. Leo Braudy and Marshall Cohen, 5th ed. [New York: Oxford University Press, 1999], 547–61).

[12]Tino Balio, *Grand Design: Hollywood as a Modern Business Enterprise, 1930–1939* (New York: Scribner, 1993), 145.

tention was paid to screen acting. As Charles Affron observes:

> An almost total absence of analytical approaches to screen acting reflects the belief that screen acting is nothing more than the beautiful projection of a filmic self, an arrangement of features and body, the disposition of superficial elements. Garbo is Garbo is Garbo is Garbo. We mortals are left clutching our wonder, and victims of that very wonder, overwhelmed by our enthusiasm and blinded by the light of the star's emanation.[13]

Today, film acting has become the subject of new interest among theorists and critics in semiology, psychology, and cultural studies who wish to study acting as an index of cultural history and an aspect of ideology.[14] This approach stresses that stars are a commodity created by the studio system through promotion, publicity, movies, criticism, and commentary. As Richard Dyer notes in *Heavenly Bodies,* "Stars are involved in making themselves into commodities, they are both labour and the thing that labour produces. They do not produce themselves alone" (5). Such analyses emphasize less the art and expressive value of acting, the ways in which actors make meaning, than the ways in which culture makes meaning.

[13]Charles Affron, *Star Acting: Gish, Garbo, Davis* (New York: Dutton, 1977), 3. See also Roland Barthes, "The Face of Garbo," in Braudy and Cohen, eds., *Film Theory and Criticism,* 536–38, and Alexander Walker, *Stardom: The Hollywood Phenomenon* (New York: Stein and Day, 1970).

[14]See Richard Dyer, *Stars,* new ed. (London: British Film Institute, 1998), and *Heavenly Bodies: Film Stars and Society* (New York: St. Martin's Press, 1986). See also Richard DeCordova, "The Emergence of the Star System in America," *Wide Angle* 6, no. 4 (1985): 4–13; Carole Zucker, ed., *Making Visible the Invisible: An Anthology of Original Essays on Film Acting* (Metuchen, N.J.: Scarecrow Press, 1990); and Christine Gledhill, *Stardom: Industry of Desire* (New York: Routledge, 1991).

Materialistic as it was, the star system dominated the movie industry until the studio system collapsed—and was then replaced by a similar industrial enterprise powered essentially by the same motivation of making profits for its investors. However, since every studio had its own system, creating different goals and images for different stars, there was no typical star. For example, when Lucille Fay Le Sueur (also known early in her career in the theater as Billie Cassin), went to Hollywood in 1925, MGM decided that her name must be changed and that her image would be that of an ideal American "girl." Through a national campaign conducted by a fan magazine, the public was invited to submit names; the first choice, Joan Arden, was already being used by another actress, so Lucille Le Sueur became Joan Crawford, a name to which she objected for several years. Her career soon took off and reached a high level of achievement in the mid-1930s, when she became identified with the "woman's film." Subsequently, in a long series of films, she played women who, whether by family background or social circumstances, triumphed over adversity and, usually, paid a price for independence. No matter what happened to them, her characters remained stylish and distinctive in their looks—chic, self-generated survivors. Like many stars, Crawford became indelibly associated with the roles she played. Yet she received little serious acclaim for her acting until the mid-1940s, when she left MGM for Warner Bros. For Michael Curtiz's *Mildred Pierce* (1945), her first film there, she won the Academy Award for Best Actress—her only Oscar, though she received two more nominations. After her success at Warner Bros., she worked for various major studios and independents, shedding her image as the stalwart, contemporary American woman. Sometimes,

[1]

[2]

"My first impression of Joan Crawford was of glamour," James Stewart once said. "She is the personification of the Movie Star" is how Bette Davis put it. A classic figure of the studio-driven "star system," Crawford was a chorus-line dancer before moving to Hollywood and landing her first movie roles. During a career of more than fifty years, she changed course several times, adapting to times and circumstances. (1) In Harry Beaumont's *Our Dancing Daughters* (1928), her breakthrough film with MGM,

Crawford *(foreground)* played Diana Medford, a free-spirited flapper who, along with her friends Beatrice (Dorothy Sebastian) and Anne (not pictured), embraces the liberated lifestyle of the American Jazz Age. (2) Almost twenty years later, Crawford played the title character in Michael Curtiz's *Mildred Pierce*, a drama/murder mystery about a successful restaurateur trying to raise her spoiled and willful daughter.

her performances were excellent: in Curtis Bernhardt's *Possessed* (1947), David Miller's *Sudden Fear* (1952), and, costarring with Bette Davis, Robert Aldrich's *What Ever Happened to Baby Jane?* (1962).

Davis was a star of another sort, leading a principled and spirited fight against the studio and star systems' invasion into virtually every aspect of actors' personal and professional lives. In fact, Davis's career (from 1931 to

1989) comes as close to any as demonstrating the systems at their best and worst. In the mid-1930s, when she walked out of Warner Bros. demanding better roles, the studio success-fully sued her for breach of contract. Though she returned to work rewarded by increased respect, a new contract, and better roles, her career sagged after World War II, for she had reached her early forties, an age at which fe-male actors are seldom offered good parts.

Ironically, playing just such a character—an older stage actress in danger of losing roles because of her age—she triumphed in *All About Eve* (1950), generally regarded as her greatest performance. During her long career, she was nominated eleven times for the Oscar as Best Actress, winning for Alfred E. Green's *Dangerous* (1935) and William Wyler's *Jezebel* (1938).

SCREEN ACTING TODAY

From the earliest years, the development of movie acting has relied on synthesizing various approaches, including those discussed above. Contemporary actors employ a range of physically or psychologically based approaches, with only action stars such as Bruce Willis and Arnold Schwarzenegger relying entirely on physical effect. Directors also take different approaches toward actors. Robert Altman, for example, who is particularly good at capturing the mood of a group of actors within a narrative, encourages improvisation and the exploration of individual styles. Joel Coen, in contrast, tends to regard acting as a critical component of the highly stylized mise-en-scène within the often cartoonlike movies he creates with his brother, Ethan. In Altman's *The Player* (1992), Tim Robbins plays Griffin Mill, a Hollywood producer, at once emotively and satirically. He uses his big, open face and charming manner to draw us into Mill's professional and existential crises, then turns edgy enough to distance us as Mill becomes a murderer and ruthless careerist. In Altman's *Kansas City* (1996), Jennifer Jason Leigh delivers an emotional hurricane of a performance as the cheap, brassy, tough Blondie O'Hara, a Jean Harlow wannabe. Her scowl, furrowed brow, rotten teeth under big red lips, and screeching-cat voice

leave no room for the kind of gently ironic distance that Robbins creates in *The Player*. In Coen's *The Hudsucker Proxy* (1994), however, both Robbins and Leigh tailor their performances to fit the madcap mood and mannered decor of an art deco screwball comedy. Indeed, part of the movie's appeal lies in watching an ensemble of actors working in this style. Channeling Cary Grant and Rosalind Russell in Howard Hawks's *His Girl Friday* (1940) and Spencer Tracy and Katharine Hepburn in Walter Lang's *Desk Set* (1957), Robbins plays Norville Barnes, a goofy mailroom clerk who becomes company president, and Leigh plays Amy Archer, a hard boiled, wisecracking newspaper reporter. Robbins and Leigh's zany comic interaction fits per-

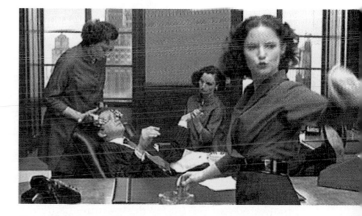

From *Blood Simple* (1984) to *O Brother, Where Art Thou?* (2000) and beyond, filmmakers Joel and Ethan Coen have paid homage to Hollywood genres in highly artificial ways, as when *The Hudsucker Proxy* tosses together 1940s screwball comedies, melodramas, and film noirs. Tim Robbins *(seated)* and Jennifer Jason Leigh *(foreground)* flesh out and find the heart within the movie's plastic world, a kind of live-action cartoon. While reminding us of acting styles from the period, they create emotional lives for their characters, a mailroom-guy-turned-executive and a cigar-smoking, fast-talking career woman.

fectly in Coen's jigsaw, which lovingly pays tribute to an era when movie style often transcended substance.

Today, actors struggle to get parts and to create convincing performances and, like their earlier counterparts, seldom have the chance to prove themselves across a range of roles. Once **typecast,** or cast in particular kinds of roles because of their looks or "type" rather than for their acting talent or experience, they continue to be awarded such parts as long they bring in good box office. No star system exists to sustain careers and images, but now as in earlier periods of movie history, some individuals use films to promote themselves; music or sports stars, or other celebrities, sometimes appear in a movie or two, leaving no mark on the history of film acting.

The transition from studio production to independent production has markedly affected the livelihood of actors and the art of acting. The shape of the average career has fundamentally changed; since fewer major movies appear each year, actors supplement film work with appearances on television shows, in advertisements, and in theater. (Salaries and contractual benefits, such as residual payments for television reruns, provide excellent financial security.) In addition, since today the average movie is a comedy targeted—indeed, mass-marketed—at the under-thirty audience (and a comedy relying on physical humor, often of a scatalogical nature, rather than verbal wit), there are fewer quality roles available to actors.

Some extremely versatile actors—Julianne Moore, Johnny Depp, Benicio del Toro, Christina Ricci, Samuel L. Jackson, Kevin Spacey, and Leonardo Di Caprio—have, with two or three successful films, become stars quickly. The greater their drawing power at the box office, the greater the urgency to promote them to top rank and cast them in more films. As independent agents, however, they can contract for one film at a time and thus hold out for good roles, rather than having to make a specific number of films for a given studio. In addition, these newcomers can negotiate a new salary for each film, and they routinely make more money from a first picture than some of the greatest stars of classical Hollywood made in their entire careers. But because audience reaction and not studios' publicity offices maintains their status, such actors often face highly unpredictable futures.

Finally, for every advance in the world of special effects, narrative and the acting that propels it lose some of their importance. Movies such as Stanley Kubrick's *2001: A Space Odyssey* (1968) and Stephen Spielberg's *E.T.: The Extra-Terrestrial* (1982) made us familiar, even comfortable with nonhuman creatures that had human voices and characteristics; Ash Brannon and John Lasseter's *Toy Story 2* (1999), with its shiny, computer-generated graphics, took this process another step forward. With technology now revolutionizing filmmaking, will actors be replaced by digitally created *synthespians* (a name coined by the digital effects expert Jeff Kleiser, who with Diana Walczak created the first one for the 1988 short *Sextone for President*)? Yes and no. While the computer-generated "actors" in Hironobu Sakaguchi and Moto Sakakibara's *Final Fantasy: The Spirits Within* (2001) and Andrew Niccol's *S1m0ne* (2002) seem to be another stage in this evolution, they may ultimately prove just one of the illusions on which the movies have thrived for more than one hundred years. They might even end up looking like the kinds of gimmicks that Hollywood has always employed to keep the world on edge, such as the wide-

With the success of one or two major movies, contemporary actors can become stars almost overnight. Benicio Del Toro has been appearing in movies since 1988, with varying degrees of success and recognition, but he began attracting serious attention in independent films such as Bryan Singer's *The Usual Suspects* (1995) and Julian Schnabel's *Basquiat* (1996). He remained relatively unknown to American audiences until his breakthrough performance, above, as the Mexican police officer Javier Rodriguez Rodriguez in Steven Soderbergh's *Traffic* (2000), for which he won the Academy Award for Best Supporting Actor.

screen ratio (see "Framing of the Shot" in chapter 4); the short-lived Sensurround, which relied on a sound track to trigger waves of high-decibel sound in the movie theater, making viewers feel "tremors" during Mark Robson's *Earthquake* (1974); or the even shorter-lived Odorama process, involving scratch-and-sniff cards, for John Waters's *Polyester* (1981). Indeed, the use of computer technology to replace actors is one side effect of our current fascination with virtual reality. While the evolving film technology may enable filmmakers to realize their most fantastic visions, we should remember, as film theorist André Bazin has so persuasively argued, that such developments may extend and enrich the illusions that the movies create at the ex-

pense of the film artists themselves, including directors, designers, cinematographers, editors, *and* actors.[15]

CASTING ACTORS

There is no one way to choose and hire actors for a movie. Although casting usually happens during preproduction after the script has been written, it may also occur during development, in cases in which scripts are written for specific actors. In the studio system, each studio ran its casting department and thus tended to restrict casting to its own actors. Today, professional casting directors work under contract to independent producers and also have their own professional association, the Casting Society of America (CSA). Casting can be done either by professionals hired for a particular film or by a casting agency. In either case, the people in charge generally work closely with the producer, director, and screenwriter in first determining casting needs. To aid in the initial selection of candidates, they maintain files of actors' resumes, with photographs.

Similarly, there is no one way for actors to find out about parts they may want to play. Producers, directors, screenwriters, or casting directors may alert agents or contact actors directly. Audition calls may be published in trade papers such as *Variety* or the *Hollywood Reporter,* or word may spread through networks of actors.

Regardless of actors' experience, they may be asked to read for parts, either alone or

[15]André Bazin, "The Myth of Total Cinema," in *What Is Cinema?*, sel. and trans. Hugh Gray (Berkeley: University of California Press, 1967–71), 1:17–22.

In a screen test for Victor Fleming's *Gone With the Wind* (1939), actor Jean Arthur *[left]* tries out for Scarlett O'Hara. Arthur, a husky-voiced comedian, was one of four finalists out of ninety aspirants for the role that went to actor Vivien Leigh. Playing opposite Arthur is actor Hattie McDaniel, who portrayed Mammy in the film.

with other actors, or to take **screen tests** (trial filmings). If they are chosen for the parts, negotiations will, in most cases, be handled by their agents; but if they belong to one of the actors' unions—the Screen Actors Guild (SAG) or the American Federation of Television and Radio Artists (AFTRA)—the conditions of their participation will be governed by union contract.

FACTORS INVOLVED IN CASTING

The art of casting actors takes many factors into account. In theory, the most important considerations are the type of role and how the actors' strengths and weaknesses relate to it. In reality, casting—like every other aspect of movie production—depends, one way or another, on the budget and expected revenues. Here, gender, race, ethnicity, and age also come into play. The American film industry has tended to produce films with strong, white, male leads, usually younger than fifty.

Thus male actors such as Tom Hanks, Mel Gibson, and Tom Cruise dominate the lists of "most popular actors" and receive higher salaries per picture than do, say, Julia Roberts, Annette Bening, and Sissy Spacek. As audiences respond to such films favorably at the box office, the industry responds accordingly with more of the same.

Yet it is also true that today gender, race, ethnicity, and age have become important issues in the movies, as in other areas of American popular culture. Both the characters depicted on the screen and the actors playing them have grown more diverse, particularly in terms of race and ethnicity; and this diversification has, in turn, changed the people who make movies, the audiences for them, and the financing that makes them possible. Twenty years ago, if you wanted to see a movie about African Americans, you waited for the next Spike Lee release, and you were generally out of luck if you wanted to see a mainstream movie about Hispanic, Latino, or Asian Americans. By contrast, now every week—depending, of course, on the distribution of movies in your part of the country—you can choose from a range of movies that reflect our country's social diversity in the stories they tell and the filmmakers and actors who made them. Here, the industry has learned that significant profits can be gained by targeting film releases to different demographics.

For decades, movie producers have intentionally contradicted social reality by casting actors who are *not* of a certain race or ethnicity to portray that race or ethnicity. Think, for example, of Richard Barthelmess as Cheng Huan in Griffith's *Broken Blossoms* (1919; see "D. W. Griffith and Lillian Gish," above), Luise Rainer as O-Lan in Sidney Franklin's *The Good Earth* (1937), Marlon Brando as

In Richard Attenborough's *Gandhi* (1982), the English actor Ben Kingsley plays the Indian political and spiritual leader Mahatma Mohandas K. Gandhi (1869–1948) from his youth until his assassination. Kingsley, born Krishna Bhanji, the son of an Indian doctor and an English fashion model, looks so much like Gandhi and inhabits the role so completely that for many viewers the two men are inextricably linked. Before this film, for which he won the Academy and Golden Globe Awards for Best Actor, Kingsley was mainly known for his work in the theater. In 2000, he received acclaim for his performance as the wired, psychotic villain Don Logan, a kind of anti-Gandhi, in Jonathan Glazer's neonoir *Sexy Beast*.

Sakini in Daniel Mann's *Teahouse of the August Moon* (1956), or Mickey Rooney as Mr. Yunioshi in Blake Edwards's *Breakfast at Tiffany's* (1961). Their explanation for this custom, now virtually extinct,[16] was that they could not find the appropriate actors. Instead, they gave such all-purpose actors as Anthony Quinn, an Irish Mexican, roles of different races and ethnicities. Using costume, makeup, and accents to change himself, Quinn played a Spaniard, an Italian, a Greek, a Frenchmen, an Arab, and a Native American, while Alec Guinness, a great British actor famous for his facility in international accents, played an Indian, an Arab, and a Scotsman. Laurence

Olivier played an equally diverse set of roles on the stage and screen, including Shakespeare's Moor, Othello, for which he studied black speech and movement patterns.[17] This does not mean that Quinn, Guinness, and Olivier took these roles because they could not get other work; or that they did not *look* or *sound* appropriate in these roles, which they most often did; or even that actors should be limited to roles matching their own genders, races, ethnicities, or ages (since acting is, after all, about the *creation* of a character); but it is clear that producers simply felt more comfortable casting roles in this manner, that minority actors were disqualified as a result, and

[16]But not entirely; for example, in Julian Schnabel's *Before Night Falls* (2000), Sean Penn plays a dark-skinned Cuban, Cuco Sanchez. The somewhat darker-skinned Johnny Depp plays both Bon Bon, a transvestite, and Lieutenant Victor, a Cuban military officer.

[17]See Stuart Burge's *Othello* (1965); also see Orson Welles's blackface version in his own *Tragedy of Othello* (1952). The first African American to play Othello onscreen was Laurence Fishburne, in Oliver Parker's 1995 movie.

In Martha Coolidge's *Introducing Dorothy Dandridge* (1999), Halle Berry plays Dandridge, here starring as the title character in Otto Preminger's *Carmen Jones*. For her role in that film, which featured an all-black cast, Dandridge was the first black woman to receive an Academy Award nomination for Best Actress; Grace Kelly received the Oscar that year (for her performance in George Seaton's *The Country Girl*). Nearly fifty years later, Halle Berry became the first African American woman to win the Academy Award for Best Actress, for her performance in Marc Forster's *Monster's Ball* (2001). Berry began her acceptance speech, "This moment is for Dorothy Dandridge, Lena Horne, Diahann Carroll . . . and it's for every nameless, faceless woman of color that now has a chance because this door tonight has been opened." To learn more about contemporary treatments of race in popular cinema, go to <www.wwnorton.com/web/movies>.

www

that absent public opposition the custom continued unabated.

Such barriers were not always in place, or at least not so firmly. Beginning in the 1920s, in reaction to the stereotyping of African Americans in D. W. Griffith's *The Birth of a Nation* (1915), some African Americans strove to make their own films. Producer, director, and exhibitor Oscar Micheaux was the most prominent among the leaders of this effort. Although he made about forty feature films, only ten survive. And while Hollywood also tried appealing to the African American audience with all-black musicals, its efforts were few and disappointing. However, from the beginning, Hollywood drew many actors from various racial backgrounds. In the 1930s, the great comic actor Stepin Fetchit was the first African American to receive featured billing in the movies. Butterfly McQueen, Louise Beavers, and Hattie McDaniel (who won an Oscar as Best Supporting Actress for her performance in *Gone With the Wind* [1939]) all

had durable careers playing maids and mammies. Paul Robeson, a great actor and singer on the Broadway stage, was featured in several movies, most notably Dudley Murphy's *The Emperor Jones* (1933), James Whale's *Show Boat* (1936), and Julien Duvivier's *Tales of Manhattan* (1942). In the 1950s, Sidney Poitier and Dorothy Dandridge became the first African American movie *stars*. Poitier has enjoyed an extraordinarily successful career, but Dandridge was not so fortunate. She began by playing stereotypical African American roles in twenty-one movies, later was nominated for the Oscar as Best Actress for her leading role in Otto Preminger's sumptuous musical production *Carmen Jones* (1954), but ended her career after starring (opposite Poitier) in Preminger's *Porgy and Bess* (1959). Among the African Americans who have since become stars are James Earl Jones, Diahann Carroll, Pearl Bailey, Bill Cosby, Laurence Fishburne, Pam Grier, Morgan Freeman, Eddie Murphy, Samuel L. Jackson, Forest

Whitaker, and Denzel Washington. (Among the many Hispanic, Latino, and Asian stars are Dolores Del Rio, Cesar Romero, María Móntez, Rita Moreno, Lupe Vélez, José Ferrer, Fernando Lamas, Ricardo Montalban, Raúl Juliá, Edward James Olmos, Alfred Molina, Jennifer Lopez, Antonio Banderas, Keye Luke, Anna May Wong, Toshiro Mifune, Haing S. Ngor, Chow Yun Fat, Nancy Kwan, Gong Li, and Joan Chen.)

Traditionally, because audiences have shown little interest in films about women older than forty-five, the industry has produced few of them. Some women older than this cutoff—Joan Crawford, Bette Davis, Elizabeth Taylor, Shirley MacLaine, Shelley Winters, Angela Lansbury, Debbie Reynolds—have taken roles as stereotyped eccentrics, where the camp value of their performances translates into the triumphant statement "I'm still here!" Furthermore, audiences love it when a great star from a former era makes a rare "comeback," as Gloria Swanson did in Billy Wilder's *Sunset Blvd.* (1950). But while many excellent movies have featured older actors—Spencer Tracy, Henry Fonda, Jimmy Stewart, Jack Lemmon, Jason Robards, Walter Matthau—the apparent bias against older female actors remains a box-office fact and thus a reality of casting in Hollywood. By contrast, the British lack such prejudices, for their actors—including Judi Dench, Alec Guinness, Laurence Olivier, Peter O'Toole, Joan Plowright, Vanessa Redgrave, Ralph Richardson, Margaret Rutherford, and Maggie Smith—generally work as long as they can. Their popularity in the United States may say something about American audiences' cultural stereotypes—namely, that they'll accept and even expect aging, as long as it happens to other people.

Complicating the issue of age is young actors' ability, in part through the magic of makeup, to play characters older than themselves: think of Jane Fonda as writer Lillian Hellman in Fred Zinnemann's *Julia* (1977) and Jack Nicholson as teamster boss Jimmy Hoffa in Danny DeVito's *Hoffa* (1992). Or they can play characters from youth to old age, as did Dustin Hoffman as Jack Crabb in Arthur Penn's *Little Big Man* (1970), Ben Kingsley in Richard Attenborough's *Gandhi* (1982), and Robert Downey Jr. in Attenborough's *Chaplin* (1992). In the standard variation on this approach, two or more actors play the same character during different stages of the character's life, as Kate Winslet and Gloria Stuart did in James Cameron's *Titanic* (1997).

ASPECTS OF PERFORMANCE

TYPES OF ROLES

Actors may play *major roles*, *minor roles*, *character roles*, *cameo roles*, and *walk-ons*. In addition, roles may be written specifically for *bit players*, *extras*, *stunt persons*, and even *animal performers*. Actors who play **major roles** (also called *main, featured,* or *lead roles*) become principal agents in helping to move the plot forward. Whether stars or newcomers, they appear in many scenes and—ordinarily, but not always—receive screen credit "above the title." In the Hollywood studio system, major roles were traditionally played by stars such as John Wayne, whose studios counted on them to draw audiences regardless of the parts they played. Their steadfastness was often more important than their versatility as actors, although Wayne surprises us more often than we may admit. One of the strengths

In John Huston's *The Maltese Falcon* (1941), Humphrey Bogart stars as hard-boiled private eye Sam Spade. Gladys George has a small part as Iva Archer, Spade's former lover and the widow of his business partner, Miles Archer. In this scene, George delivers a strongly emotional performance, against which Bogart displays a relative lack of feeling that fills us in on relations between the characters. Stars' performances often depend on the solid and even exceptional work of their fellow actors. The unusually fine supporting cast in this movie includes Hollywood greats Mary Astor, Peter Lorre, and Sydney Greenstreet, who received an Oscar nomination for Best Supporting Actor. To learn more about stars' acting styles and "star vehicles," go to <www.wwnorton.com/web/movies>.

www

of the studio system was its grooming of professionals in all its creative departments, including actors at all levels, from leads such as Henry Fonda and Katharine Hepburn to character actors such as Thelma Ritter and Andy Devine—best remembered as, respectively, the wise-cracking commentator on Jeff's (Jimmy Stewart) actions in Alfred Hitchcock's *Rear Window* (1954) and the Ringo Kid's (John Wayne) loyal friend in John Ford's *Stagecoach* (1939). Indeed, one of the joys of looking at movies from this period comes from those character actors whose faces, if not names, we always recognize: Marjorie Main, Franklin Pangborn, Butterfly McQueen, Harry Carey Jr., Una O'Connor, Ernest Thesiger, Mary Boland, Erskine Sanford, Gladys George, Ray Collins, Laura Hope Crews, and Walter Brennan, to name a distinctive few out of hundreds.

Stars may be so valuable to productions that they have **stand-ins,** actors who look reasonably like them in height, weight, coloring, and so on and who substitute for them during the tedious process of preparing setups or tak-

ing light readings. Since actors in major roles are ordinarily not hired for their physical or athletic prowess, **stunt persons** double for them in scenes requiring special skills or involving hazardous actions, such as crashing cars, jumping from high places, swimming, and riding (or falling off) horses. Through SPFX, however, filmmakers may now augment actors' physical exertions so that they appear to do their own stunts, as in Andy and Larry Wachowski's *The Matrix* (1999) and McG's *Charlie's Angels* (2000). In effect, the computer becomes the stunt double.

Actors who play **minor roles** (or *supporting roles*) rank second in the hierarchy. They also help move the plot forward (and thus may be as important as actors in major roles), but they generally do not appear in as many scenes as the featured players. They may hold **character roles,** which represent distinctive character types (sometimes stereotypes): society leaders, judges, doctors, diplomats, and so on. **Bit players** hold small speaking parts, while **extras** usually appear in nonspeaking or

crowd roles and receive no screen credit. **Cameos** are small but significant roles often taken by famous actors, as in Robert Altman's Hollywood satire, *The Player* (1992), which features appearances by sixty-five well-known actors and personalities. **Walk-ons** are even smaller roles, reserved for highly recognizable actors or personalities. As a favor to his friend Orson Welles, with whom he'd worked many times before, Joseph Cotten played such a role in Welles's *Touch of Evil* (1958), where he had a few words of dialogue but literally walked on and off the set.

Animal actors, too, play major, minor, cameo, and walk-on roles. For many years, Hollywood made pictures built on the appeal of such animals as the dogs Lassie, Rin Tin Tin, Asta, and Benji; the cat Rhubarb; the parakeets Bill and Coo; the chimp Cheta; the mule Francis; the lion Elsa; the porpoise Flipper, and the killer whale Willy. Most of these animals were specially trained to work in front of the camera, and many were sufficiently valuable that they, like other stars, had stand-ins for setups and stunt doubles for hazardous work. Working with animal performers often proves more complicated than working with human actors. For example, six Jack Russell Terriers, including three puppies, played the title character in Jay Russell's *My Dog Skip* (2000), a tribute to the indomitable Jack Russell Terrier.

PREPARING FOR ROLES

In creating characters, screen actors begin by synthesizing basic sources, including the script and the director's counsel, their own experiences and observations, and the influences of other actors. Different roles have different demands, and all actors have their own approaches, whether they get inside their characters, get inside themselves, or do further research. Bette Davis, whose roles were often assigned her by studios, said: "It depends entirely on what the assignment happens to be. . . . [But] I have never played a part which I did not feel was a person very different from myself."[18] Jack Lemmon, a method actor who generally chose his own roles, explained: "it's like laying bricks. You start at the bottom and work up; actually I guess you start in the middle and work to the outside."[19] Building a character "brick by brick" is an approach also used by Harvey Keitel and John Malkovich, who might have varied this approach slightly when he played himself in Spike Jonze's *Being John Malkovich* (1999).[20] Liv Ullmann and Jack Nicholson believe that the actor draws on the subconscious mind. Ullmann says: "Emotionally, I don't prepare. I think about what I would like to show, but I don't prepare, because I feel that most of the emotions I have to show I know about. By drawing on real experience, I can show them."[21] In describing his work with director Roman Polanski on *Chinatown* (1974), Nicholson says that the director "pushes us farther than we are conscious of being able to go; he forces us down into the subconscious—in order to see if there's something better

[18]"Bette Davis: The Actress Plays Her Part," in *Playing to the Camera: Film Actors Discuss Their Craft,* ed. Bert Cardullo, Harry Geduld, Ronald Gottesman, and Leigh Woods (New Haven: Yale University Press, 1998), 177–85: quotation, 179.

[19]"Jack Lemmon: Conversation with the Actor," in Cardullo et al., eds., *Playing to the Camera,* 267–75: quotation, 267.

[20]See entries on Malkovich and Keitel in Tomlinson, ed., *Actors on Acting for the Screen,* 361, 302–04.

[21]"Liv Ullmann: Conversation with the Actress," in Cardullo et al., eds., *Playing to the Camera,* 157–65: quotation, 160.

there.'[22] Jodie Foster works from instinct, doing what she feels is right for the character.[23] To create The Tramp, Charlie Chaplin started with the character's costume: "I had no idea of the character. But the moment I was dressed, the clothes and the make-up made me feel the person he was."[24] Alec Guinness said that he was never happy with his preparation until he knew how the character walks, and Laurence Olivier believed that he would not be any good as a character unless he "loved" him.[25]

Olivier, one of the greatest stage and screen actors of the twentieth century, defined acting in various ways, including as "convincing lying."[26] Although Olivier stands out for the extraordinary range of the roles he undertook, on both stage and screen, and for his meticulous preparation in creating them, this remark suggests that he had little patience with theories of acting. Indeed, when asked how he created his film performance as the king in *Henry V* (1944; director: Olivier), he replied simply, "I don't know—I'm England, that's all."[27] Olivier had made this film to bolster English morale during the last days of World War II, and thus he wanted Henry V to embody traditional British values.

Sir Laurence Olivier in the first screen adaptation of *Henry V;* this very popular film during a troubled time (World War II) was uniformly praised for the quality of its acting. The many previous screen adaptations of Shakespeare's plays were mainly faithful records of stage productions, but Olivier's film, his first as a director, benefited from his understanding of cinema's potential as a narrative art, his extensive acting experience, his deep knowledge of Shakespeare's language, and his sharp instincts about the national moods in Great Britain *and* the United States. *Henry V* received an Oscar nomination for Best Picture, and Olivier received a Best Actor nomination as well as an Oscar for his outstanding achievement as actor, producer, and director for bringing *Henry V* to the screen.

[22]See entry on Nicholson in Tomlinson, ed., *Actors on Acting for the Screen,* 404–07: quotation, 405.

[23]See entry on Foster in Tomlinson, ed., *Actors on Acting for the Screen,* 196–97.

[24]Charles Chaplin, *My Autobiography* (New York: Simon and Schuster, 1964), 260.

[25]See entry on Guinness in Tomlinson, ed., *Actors on Acting for the Screen,* 232–33; Laurence Olivier, *Confessions of an Actor: An Autobiography* (1982; reprint, New York: Penguin, 1984), 136–37.

[26]Olivier, *Confessions of an Actor,* 20.

[27]Olivier, qtd. in Donald Spoto, *Laurence Olivier: A Biography* (New York: Harper Collins, 1992), 111–12.

The great silent-era director F. W. Murnau emphasized intellect and counseled actors to restrain their feelings, to *think* rather than *act.* He believed actors capable of conveying the intensity of their thoughts so that audiences would understand. Director Rouben Mamoulian gave Greta Garbo much the same advice when she played the leading role in his *Queen Christina* (1933). The film ends with the powerful and passionate Swedish queen sailing to Spain with the body of her lover, a Spanish no-

A colorized publicity still illustrates the iconic look that Greta Garbo achieved in the final scene of Rouben Mamoulian's *Queen Christina*. Thanks to images like this, people called her the Face and the Swedish Sphinx. Eight years later, at age thirty-six, Garbo retired from the screen and became a recluse, in part to keep her screen image eternally young and glistening.

bleman killed in a duel. In preparing for the final close-up, in which the queen stares out to sea, Garbo asked Mamoulian, "What should I be thinking of? What should I be doing?" His reply: "Have you heard of *tabula rasa?* I want your face to be a blank sheet of paper. I want the writing to be done by every member of the audience. I'd like it if you could avoid even blinking your eyes, so that you're nothing but a beautiful mask."[28] Is she remembering the past? Imagin-

[28]Mamoulian, qtd. in Tom Milne, *Rouben Mamoulian* (Bloomington: Indiana University Press, 1969), 74.

ing the future? With the camera serving as an apparently neutral mediator between actress and audience, Garbo's "blank" face asks us to transform it into what we *hope* or *want* to see.

NATURALISTIC AND NONNATURALISTIC STYLES

We have all seen at least one movie in which a character, perhaps a whole cast of characters, is like no one we have ever met, nor like anyone we *could* ever meet. Either because the world they inhabit functions according to rules that don't apply in our world or because their behaviors are extreme, such characters aren't realistic in any colloquial sense of the word. But if the actors perform skillfully, we likely will accept the characters as believable within the context of the story. We might be tempted to call such portrayals *realistic*, but we'd do better to use the term *naturalistic*.

Actors who strive for appropriate, expressive, coherent, and unified characterizations must also choose between rendering their performances naturalistically and nonnaturalistically. Screen acting appears naturalistic when actors re-create recognizable or plausible human behavior for the camera. The actors not only look like the characters should (in their costume, makeup, and hairstyle) but also think, speak, and move the way people would offscreen. By contrast, nonnaturalistic performances seem excessive, exaggerated, even overacted; may employ strange or outlandish costumes, makeup, or hairstyles; aim for effects beyond the normal range of human experience; and often intend to distance or estrange audiences from characters (though not necessarily in a formal, political, Brechtian sense). They frequently are found in horror, fantasy, and action films.

[1]

[2]

Naturalistic and nonnaturalistic performances sometimes overlap, but these categories help us relate actors' contributions to a filmmaker's overall vision. [1] In *Fresh* (1994), Sean Nelson's naturalistic performance becomes part of director Boaz Yakim's clear-eyed depiction of contemporary American urban life. Yakim's film is about truth, "the way it is." [2] Johnny Depp's nonnaturalistic performance enables director Tim Burton to draw us into the exaggerated, downright weird world of *Edward Scissorhands*. Burton's film is about fantasy, the way things might be in that world. The two performances differ widely, but they suit their respective movies. Imagine how out of place either character would be in the other's world! To learn more about naturalistic and nonnaturalistic performances, as well as the use of nonactors in movies go to *<www.wwnorton.com/web/movies>*.

www

In Wayne Wang's *Smoke* (1995), Harvey Keitel gives a naturalistic performance as Auggie Wren, a middle-aged, white Brooklynite who runs a cigar store, lives alone, and maintains an idiosyncratic photographic record of his neighborhood. In Boaz Yakin's *Fresh* (1994), Sean Nelson naturalistically plays the title character, a young, black Brooklynite working as a courier for a dope dealer between going to school and looking out for his older sister. In Tim Burton's *Edward Scissorhands* (1990), Johnny Depp gives a nonnaturalistic performance as the title character, a kind of Frankenstein's monster created by a mad inventor who died before his work was finished. Depp's stylized performance fits the entirely artificial world of the movie: a deteriorating Gothic castle on a mountaintop that overlooks a nightmarishly pastel suburb. The brilliance of the performance is that it simultaneously humanizes this scissor-handed "boy." In each of these films, the acting fits precisely within the entire mise-en-scène. Thus we easily recognize as nonnaturalistic a performance in which the character has strange makeup, hair, costume, and scissor hands; lives in a castle; and visits a candy-colored suburban housing development, where he delights the local housewives with his gardening skills.

IMPROVISATIONAL ACTING

Improvisation can mean extemporizing—that is, delivering lines based only loosely on the written script or without the preparation that comes with studying a script before rehearsing it. It can also mean "playing through" a

moment, making up lines to keep scenes going when actors forget their written lines, stumble on lines, or have some other mishap. Of these two senses, the former is most important in movie acting, particularly in the post-studio world; the latter is an example of professional grace under pressure.

Improvisation can be seen as an extension of Stanislavsky's emphasis that the actor striving for a naturalistic performance should avoid any mannerisms that call attention to technique. Occupying a place somewhere between his call for actors to bring their own experiences to roles and Brecht's call for actors to distance themselves from roles, it often involves collaboration between actors and directors in creating stories, characters, and dialogue, which may then be incorporated into scripts. According to film scholar Virginia Wright Wexman, what improvisers

> seem to be striving for is the sense of discovery that comes from the unexpected and unpredictable in human behavior. If we think of art as a means of giving form to life, improvisation can be looked at as one way of adding to our sense of the liveliness of art, a means of avoiding the sterility that results from rote recitations of abstract conventional forms.[29]

For years, improvisation has played a major part in actors' training, but it was anathema in the studio system—where practically everything was preprogrammed—and it remains comparatively rare in narrative moviemaking. Actors quite commonly confer with directors about altering or omitting written lines, but this form of improvisation is so limited in scope that we can better understand it as the sort of fertile suggestion-making intrinsic to collaboration. Though certain directors encourage actors not only to discover the characters within themselves but also to imagine what those characters might say (and how they might act) in any given situation, James Naremore, an authority on film acting, explains that even great actors, when they improvise, "tend to lapse into monologue, playing from relatively static, frontal positions with a second actor nearby who nods or makes short interjections."[30] Among the director-actor collaborations that have made improvisation work effectively are Elia Kazan and Marlon Brando (*On the Waterfront,* 1954); Jean-Luc Godard and Jean-Paul Belmondo (*Breathless* [*À bout de souffle*], 1959); Bernardo Bertolucci and Brando (*Last Tango in Paris* [*Ultimo tango a Parigi*], 1972); Martin Scorsese, Robert De Niro, and Harvey Keitel (*Taxi Driver,* 1976); Robert Altman and a large company of actors (*Nashville,* 1975; *Short Cuts,* 1993; *Gosford Park,* 2001); Mike Leigh and various actors (*Life Is Sweet,* 1990; *Naked,* 1993; *Topsy-Turvy,* 1999; *All or Nothing,* 2002); and John Cassavetes and Gena Rowlands (*Faces,* 1968; *A Woman Under the Influence,* 1974; *Gloria,* 1980).

The Cassavetes-Rowlands collaboration is particularly important and impressive, not only for what it accomplished but also for the respect it received as an experimental approach within the largely conventional film industry. "John's theory," Rowlands explains,

> is that if there's something wrong, it's wrong in the writing. If you take actors who can act in other things and they get to a scene they've

[29]Virginia Wright Wexman, "The Rhetoric of Cinematic Improvisation," *Cinema Journal* 20, no. 1 (fall 1980): 29. See also Maurice Yacowar, "An Aesthetic Defense of the Star System in Films," *Quarterly Review of Film Studies* 4, no. 1 (winter 1979): 48–50.

[30]James Naremore, *Acting in the Cinema* (Berkeley: University of California Press, 1988), 45.

"You talkin' to me? . . . You talkin' to *me*?" Screenwriter Paul Schrader wrote no dialogue for the scene in Martin Scorsese's *Taxi Driver* in which Travis Bickle (Robert De Niro) rehearses his dreams of vigilantism before a mirror. Prior to filming, De Niro improvised the lines that now accompany one of the most memorable moments in film history, a disturbing, darkly comic portrait of an unhinged mind talking to itself.

honestly tried to do, and if they still can't get it, then there's something wrong with the writing. Then you stop, you improvise, you talk about it. Then he'll go and rewrite it—it's not just straight improvisation. I'm asked a lot about this, and it's true, when I look at the films and I *see* that they look improvised in a lot of different places where I know they weren't.[31]

Improvised acting requires directors to play even more active roles than if they were working with prepared scripts, because they must not only elicit actors' ideas for characters and dialogue but also orchestrate those contribu-

[31]Gena Rowlands, in Tomlinson, ed., *Actors on Acting for the Screen*, 482.

tions within overall cinematic visions. Ultimately, directors help form all contributions, including those of actors. Nearly all directors who employ improvisation have the actors work it out in rehearsal, then lock it down for filming, perhaps radically changing their plans for how such scenes will be shot. This is how, for example, Martin Scorsese and Robert De Niro worked out the originally silent "You talkin' to me" scene in *Taxi Driver* (1976). Unless directors and actors have talked publicly about their work, we seldom know when and to what extent improvisation has been used in a film. Since we know that Cassavetes prepared his actors with precise scripts that they refined with extensive improvisational exercises, by studying the original script we

can prepare to look for the improvisation, to judge its usefulness, and to determine whether improvised performances seem convincing or, ironically, less convincing than scripted ones.

DIRECTORS AND ACTORS

Directors and actors have collaborated since the days when D. W. Griffith established screen acting *with* Lillian Gish (see "D. W. Griffith and Lillian Gish," above). Inevitably, such relationships depend on the individuals: what each brings to their work, what each can do alone, and what each needs from a collaborator. Such different approaches taken by different directors in working with actors are as necessary, common, and useful as the different approaches taken by different actors as they prepare for roles.

Some veterans of the studio system, such as William Wyler and George Cukor, are known as "actors' directors," meaning that the directors inspired such confidence that they could actively shape actors' performances. Although Wyler may have enjoyed the trust of Bette Davis, Fredric March, Myrna Loy, Barbra Streisand, and other notable actors, the atmosphere on the set was considerably tenser when Laurence Olivier arrived in Hollywood for his first screen role, as Heathcliff in Wyler's *Wuthering Heights* (1939). Olivier had already earned a considerable reputation on the London stage and was frankly contemptuous of screen acting, which he thought serious actors did only for the money. Wyler, on the other hand, was one of Hollywood's great stylists, a perfectionist who drove actors crazy with his keen sense of acting and love of multiple takes. Everyone on the set perceived the tension between them. Wyler encouraged Olivier to be patient in responding to the chal-

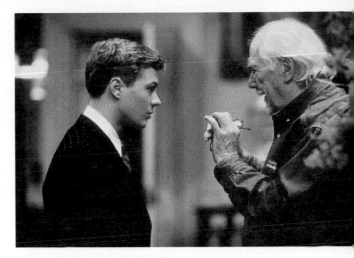

Director Robert Altman [*right*], well known for collaborations with large teams of actors, confers with actor Ryan Phillippe, who plays Henry Denton, on the set of *Gosford Park* (2001).

lenges involved in acting for the camera, and eventually Olivier overcame his attitude of condescension to give one of his greatest film performances.

In developing his relationships with actors, director John Ford encouraged them to create their characters to serve the narrative. He preferred to work with the same actors over and over, and his working method never changed. John Wayne, who acted in many of Ford's films and has been described as the director's alter ego, said Ford gave direction "with his entire personality—his facial expressions, bending his eye. He didn't verbalize. He wasn't articulate, he couldn't really finish a sentence. . . . He'd give you a clue, just an opening. If you didn't produce what he wanted, he would pick you apart."[32] Newcomers faced a challenge in getting it right the first

[32]John Wayne, qtd. in Joseph McBride, *Searching for John Ford: A Life* (New York: St. Martin's Press, 2001), 299.

time. However rigid Ford's approach may at first seem, we find it in similarly fruitful collaborations between Rouben Mamoulian and Greta Garbo, Josef von Sternberg and Marlene Dietrich, John Huston and Humphrey Bogart, François Truffaut and Jean-Pierre Léaud, Akira Kurosawa and Toshiro Mifune, Satyajit Ray and Soumitra Chatterjee, Martin Scorsese and Robert De Niro, and Spike Lee and Denzel Washington. These directors know what they want, explain it clearly, select actors with whom they work well, and then collaborate with them to create movies that are characterized in part by the seamless line between "direction" and "acting."

By contrast, the line that can exist *between* directing and acting is evident in the work of director Alfred Hitchcock, who tends to place mise-en-scène above narrative and both above acting. His movies were so carefully planned and rehearsed in advance that actors were expected to follow his direction closely, so that even those with limited talent (e.g., Tippi Hedren in *The Birds* [1963] and Kim Novak in *Vertigo* [1958]) gave performances that satisfied the director's needs. On the other hand, Kubrick, who was as rigidly in control of his films as Hitchcock, was more flexible. When directing *Barry Lyndon* (1975), a film in which fate drove the plot, Kubrick gave his principal actors—Ryan O'Neal and Marisa Berenson—almost nothing to say and then moved them about his sumptuous mise-en-scène like pawns on a chessboard. However, when working with a more open story, he encouraged actors to improvise in rehearsal or on the set, resulting in such memorable moments as Peter Sellers's final monologue as Dr. Strangelove (and the film's last line, "*Mein Führer,* I can walk!") and Jack Nicholson's manic "Heeeere's Johnny!" before the climax of *The Shining*

(1980). Malcolm McDowell in *A Clockwork Orange* (1971) and Tom Cruise and Nicole Kidman in *Eyes Wide Shut* (1999) are also said to have worked out their performances in improvisations with the director.

HOW FILMMAKING AFFECTS ACTING

Actors must understand how a film is made, because every aspect of the filmmaking process can affect performances and the actors' contributions to the creation of meaning. Out-of-continuity shooting, for example, often forces actors who are being filmed in isolation to perform their parts as though they were *inter*acting with other people. Producers' extreme pressure on cast and crew to keep to shooting schedules often means that actors have less rehearsal time than they would like.

In the following chapters we will examine editing and sound and the ways they relate to acting and meaning. Here, we'll look briefly at the effects on acting of framing, composition, lighting, and the types and lengths of shots.

FRAMING, COMPOSITION, LIGHTING, AND THE LONG TAKE

Framing and composition can bring actors together in a shot or keep them apart (see chapter 4). Such inclusion and exclusion create relationships between characters, and these, in turn, create meaning. The physical relation of the actors to each other and to the overall frame (height, width, and depth) can significantly affect how we see and interpret a shot. Throughout *Citizen Kane* (1941), for example, Orson Welles creates meanings

Shot	Timing (approx. mins.)	Cinematography	Action
	FIG. 5.1	**FRAMING, COMPOSITION, LIGHTING, AND LONG TAKE IN SCENE FROM *CITIZEN KANE***	
1	.05	Dissolve to: Camera outside; ext. LS cut to next shot	Charles Kane on sled; throws snowball out of frame; cut to next shot
2	.03	Camera outside; ext. MS; cut to next shot	Snowball hits sign on building: "Mrs. Kane's Boarding House"
3	1.45	Camera inside; int. LS; at left of window; camera tracks backward, showing Thatcher at right of window; Mary Kane walks into f.g., with sharp light and shadow dividing her face in half; Jim Kane comes on, joining Thatcher and Mary; Thatcher and Mary sit at table in right f.g. with Jim at left; we see and hear Charles in b.g.; cut to next shot	Deep-focus shot: b.g.: Charles playing in the snow and calling to imaginary boys, saying "The Union forever"; m.g.: Mary Kane, at the window, calls out to remind him to pull his muffler around his neck; and then comes into a second room in the f.g., where she takes seat at table with Thatcher; Jim Kane stands at left; the three adults talk; she signs contract, at which point Jim walks to the b.g. and shuts the window; Mary rises and walks to the b.g. and opens the same window; cut to next shot
4	1.55	Camera outside; ext. CU looking in through window at Mary Kane; camera moves left, reframes to MLS. Camera angle is normal within deep-focus shot, but, when they meet, Thatcher towers over Charles, establishing their lifelong antagonistic relationship	At window, Mrs. Kane sharply calls "Charles" and then says that she's had his trunk packed for a week; camera pans left and reframes and the Kanes and Thatcher go outside; Charlie is told the news of his mother's contract with Thatcher; he becomes upset and strikes Thatcher; his father attempts to whip him; his mother shelters him and begins to speak: "That's why . . . " (on cut)
5	.05	Ext. CU	Mother continues: " . . . he's going to be brought up where you can't get at him" (dissolve to next shot)
6	1.05	Ext. MS	Snow falling on sled
Total	4.18		

CU = close-up; MS = medium shot; MLS = medium long shot; LS = long shot
b.g. = background; f.g. = foreground; m.g. = middle ground

[1]

[2]

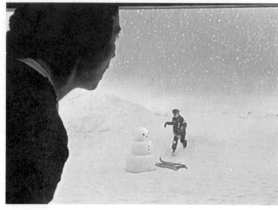

[3]

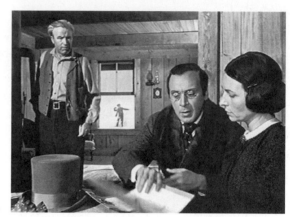

[4]

The contract-signing scene in *Citizen Kane:* [1] is from shot 1, [2] is from shot 2, and [3] and [4] are from shot 3.

within frames and trains our eyes to look for those meanings.

The inciting moment of the plot and one of the principal keys to understanding the movie—for many viewers, its most unforgettable moment—occurs when Charles Foster Kane's mother, Mary Kane (Agnes Moorehead), signs the contract that determines her son's future. It consists of only six shots, the third and fourth of which are long takes. Rely-

ing on design, lighting, cinematography, and acting, Welles creates a scene of almost perfect ambiguity (Fig. 5.1). In designing the scene, he puts the four principal characters involved in the incident in the same frame for the two long takes, but, significantly, divides the space within this frame into exterior and interior spaces: Charles (Buddy Swan) is outside playing with the "Rosebud" sled in the snow, as yet oblivious to how his life is being changed for-

[5]

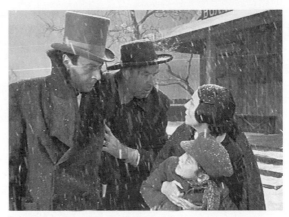

[6]

[7]

[8]

[5] and [6] are from shot 4, [7] is from shot 5, and [8] is from shot 6.

ever, while Mary; her husband, Jim (Harry Shannon); and Walter Parks Thatcher (George Coulouris) are in the house for shots 1–3 and outside for shot 4. In shot 3, this division of the overall space into two separate physical and emotional components is dramatically emphasized after Mary signs the contract and Jim walks to the background of the frame and shuts the window, symbolically shutting Charles out of his life and also cutting us off from the sound of his voice. Mary immediately walks to the same window and opens it, asserting her control over the boy by sharply calling "Charles" before going out to explain the situation to him. Of the six shots, 3 and 4 carry the weight of the scene. These long takes require the adult actors to work closely together in shot 3 and with Buddy Swan in shot 4. They begin inside the house as a tightly framed ensemble confronting one another

across a small table—their bodies composed and their faces lighted to draw attention to the gravity of the decision they are making—and continue outdoors, where these tensions break into the open as young Charles learns of his fate.

The lighting also helps create the meaning. Lamps remain unlit inside the house, where the atmosphere is as emotionally cold as the snowy landscape is physically cold. Outside, the light is flat and bright; inside, this same bright light, reflected from the snow, produces deep shadows. This effect appears most clearly after the opening of shot 3, when Mary Kane turns from the window and walks from the background to the foreground. As she does, lighting divides her face, the dark and light halves emphasizing how torn she feels as a mother in sending Charles away.

Welles's use of the long take involved drilling his actors to the point of perfection in rehearsals, giving them amazing things to do (such as Moorehead's pacing up and down the narrow room), and then letting this pay off (as it indeed had in theater and radio) in moments of great theatrical vitality. Look closely, for example, at the performance of Agnes Moorehead, with whom Welles had worked in radio productions.[33] Moorehead knew exactly how to use the tempo, pitch, and rhythm of her voice to give unexpected depth to the familiar melodramatic type she is playing here. In the carefully designed and controlled setting—the long room, dividing window, and snowy exterior—Mrs. Kane, whose makeup, hairstyle, and costume are those of a seemingly simple pioneer woman, reveals herself to be some-

thing quite different. She is both unforgettably humane as she opens the window and calls her son sharply to the destiny she has decreed, and—given that her only business experience has been in running a boardinghouse—surprisingly shrewd in obviously having retained Thatcher to prepare the contract that seals this moment. In fact, this is one of the few scenes in the movie in which a female character totally dominates the action—not surprising, for it is a scene of maternal rejection. As Mary Kane throws open the window, she cries out "Charles" in a strained, even shrill voice that reveals her anxiety about what she is doing; yet a moment later, sounding both tender and guilty, she tells Thatcher she has had Charles's trunk packed for a week. Should we read the cold mask of her face as the implacable look of a woman resigned to her decision or as a cover for maternal feelings? Does it reflect the doubt, indecision, and dread any person would feel in such a situation? Is it the face of sacrifice? Is it all of these possibilities and more? And how should we read Charles, who in the span of a moment goes from playful to wary to angry to antagonistic? Though the downtrodden Jim Kane protests his wife's actions, when Thatcher coolly informs him that he and his wife will receive $50,000 per year, he feebly gives in—"Well, let's hope it's all for the best"—a remark that invariably, as it should, provokes laughter from viewers. And Thatcher, wearing a top hat and dressed in the formal clothes of a big-city banker, sends contradictory signals. He's precise in overseeing Mrs. Kane's signature, dismissive of Mr. Kane, fawning as he meets Charles, and angry when Charles knocks him to the ground. In encouraging this kind of richly nuanced acting, and its resulting ambiguity, Welles shifts the challenge of interpretation to us.

[33]Welles reportedly called her "the best actor I've ever known"; qtd. in Simon Callow, *Orson Welles: The Road to Xanadu* (New York: Viking, 1995), 512.

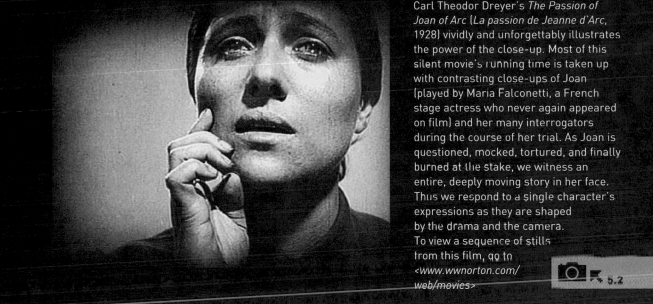

Carl Theodor Dreyer's *The Passion of Joan of Arc* (*La passion de Jeanne d'Arc*, 1928) vividly and unforgettably illustrates the power of the close-up. Most of this silent movie's running time is taken up with contrasting close-ups of Joan (played by Maria Falconetti, a French stage actress who never again appeared on film) and her many interrogators during the course of her trial. As Joan is questioned, mocked, tortured, and finally burned at the stake, we witness an entire, deeply moving story in her face. Thus we respond to a single character's expressions as they are shaped by the drama and the camera. To view a sequence of stills from this film, go to <www.wwnorton.com/web/movies>

THE CAMERA AND THE CLOSE-UP

The camera creates a greater naturalism and intimacy between actors and audience than would ever be possible on the stage, and thus it serves as screen actors' most important collaborator. Nowhere is the camera's role—that is, its effect on the actor's role—more evident than in a close-up. The "true" close-up isolates an actor, concentrating on his or her face; it can be active (commenting on something just said or done, reminding us who is the focus of a scene) or passive (revealing an actor's beauty). Thus actors' most basic skill is understanding how to reveal themselves to the camera during the close-up.

All great movie actors understand, instinctively or from experience, what to do and not do with their faces when the camera moves in. They must temporarily forget their bodies' expressive possibilities, must stand as close to the camera as they would to a person in real life, must smoothly balance their voices because of the closeness of the microphone, and must focus on the communicative power of even the slightest facial gesture.

Close-ups can shift interpretation to the viewer, as in Garbo's final close-up in *Queen Christina* (see "Preparing for Roles," above), or they can leave little room for independent interpretation, as in Marlene Dietrich's opening scene in Josef von Sternberg's *Morocco* (1930; cinematographer: Lee Garmes). On the deck of a ship bound for Morocco, the mysterious and beautiful Amy Jolly (Dietrich) drops her handbag. A sophisticated, older Frenchman— Monsieur Le Bessiere (Adolphe Menjou)—kneels at her feet to retrieve her things and then offers to assist her in any way he can when she arrives at her destination. In a relatively quick close-up, Amy looks off into space and tells him she will not need any help. Design elements further distance us from the actress and the character: Dietrich wears a hat

[1]

[2]

We might call these definitive examples of how to play a Japanese warlord and a mute Victorian pianist: (1) Toshiro Mifune in the death scene of Lord Washizu in Akira Kurosawa's *Throne of Blood* and (2) Holly Hunter in Jane Campion's *The Piano,* a performance for which she won the Academy Award for Best Actress. To analyze the performances, we need to consider their contexts, the particular movies in which they appear. Kurosawa's film draws on a specific genre—the *jidai-* *geki,* or historical drama, traditionally full of action. Campion's film draws on history, but focuses more on psychology than on action. Thus Mifune uses ritualized, nonnaturalistic facial expressions and body language, while Hunter, who speaks only in voiceover, appears more naturalistic, inner-directed, "muted" (i.e., subdued). For an in-depth analysis of *The Piano*, see the case study for this chapter: <www.wwnorton.com/web/movies>.

www

with a veil, and thus the shot is "veiled by the 'Rembrandt' light, by the fog, by the lens, and by the diaphanous fabric."[34] Although we do not yet know who Amy is, what she does, and why she is going to Morocco, we certainly understand Le Bessiere's interest.

Close-ups can also reveal both the process of thinking and the thoughts at its end. In a close-up during the climactic moment of John Ford's *The Searchers* (1956), Ethan Edwards (John Wayne) transforms from hateful to loving before halting his premeditated attempt to murder his niece, Debbie (Natalie Wood), instead lifting

[34]Naremore, *Acting in the Cinema,* 141.

her to the safety of his arms. The shot doesn't give us time to analyze *why* he has changed his mind, only to see the results of that change. In a bar scene in Elia Kazan's *On the Waterfront* (1954), Terry Malloy (Marlon Brando), playing the tough guy, tells Edie Doyle (Eva Marie Saint) his philosophy: "Do it to him before he does it to you." Up to this point, he has remained aloof after witnessing the mob's murder of Edie's brother, an attitude he continues to display until Edie, who is trying to do something about the corruption on the waterfront, asks for his help. Stopped in his tracks, Terry sits down, and a series of close-ups reveals the shakiness of his unfeeling posture. In a soft, car-

ing, but slightly nervous voice (in this bar set-
ting, surrounded by other tough guys, he's a lit-
tle self-conscious of being tender with a
woman), he tells her, "I'd like ta help," thus re-
vealing to her, the camera, and us a more sensi-
tive man under the macho mannerisms.

ANALYZING ACTING

In their everyday moviegoing, people tend to
appreciate acting very subjectively. They like
an actor's performance when he or she looks,
speaks, and moves in ways that confirm their
expectations for the character (or type of char-
acter). Conversely, they dislike a performance
that baffles those expectations. This approach,
though understandable, can also be limiting.
How many of us have the sufficient life experi-
ences to fully comprehend the range of char-
acters that appear on the screen? What back-
ground do we bring to an analysis of the
performance of Lillian Gish as a battered child
in D. W. Griffith's *Broken Blossoms* (1919),
Humphrey Bogart as a cold-blooded private
eye in John Huston's *The Maltese Falcon*
(1941), Carlo Battisti as a retired, impover-
ished bureaucrat in Vittorio De Sica's *Umberto
D* (1952), Giulietta Massina as a childlike cir-
cus performer in Federico Fellini's *La Strada*
(1954), Toshiro Mifune as a Japanese warlord
(based on Shakespeare's Macbeth) in Akira
Kurosawa's *Throne of Blood* (*Komonosu jo*,
1957), Marlon Brando as a Mafia don in Fran-
cis Ford Coppola's *The Godfather* (1972),
Holly Hunter as a mute Victorian relocated
from Scotland to New Zealand in Jane Cam-
pion's *The Piano* (1993; the suggested case
study for this chapter), or Sissy Spacek as the
mother of a murdered son in Todd Field's *In
the Bedroom* (2001)? Movie acting may be, as

Laurence Olivier once said, the "art of persua-
sion."[35] Yet it is also a formal cinematic ele-
ment, one as complex as design or cinematog-
raphy. To get a sense of how it works, on its
own and ultimately in relation to the other for-
mal elements, we need to establish a set of cri-
teria more substantial than our subjective feel-
ings and reactions.

Because every actor, character, and perfor-
mance in a movie is different, it is impossible
to devise standards that would apply equally
well to all of them. Furthermore, different ac-
tors, working with different directors, often
take very different approaches to the same
material, as you can judge for yourself by com-
paring the many remakes in movie history
(see the discussion of two screen versions of
The Winslow Boy in "Movies Manipulate
Space and Time in Ways That Other Art Forms
Cannot" in chapter 1). Within the world of a
particular story, your goal should be to deter-
mine the quality of the actor's achievement in
creating the character and how that perfor-
mance helps tell the story. Thus you should
discuss an actor's specific performance in a
specific film—discussing, say, Peter Sellers's
acting in Hal Ashby's *Being There* (1979) as it
serves to create the character of Chance and
tell the story of that film without being influ-
enced by expectations possibly raised by your
having seen Sellers in other movies. In ana-
lyzing any actor's performance, you might
consider

- *Appropriateness:* Does the actor look and
 act naturally like the character he or she
 portrays, as expressed in physical
 appearance, facial expression, speech,
 movement, and gesture? If the
 performance is nonnaturalistic, does the

[35]Olivier, *Confessions of an Actor*, 51.

actor look, walk, and talk the way that character might or should?

Paradoxically, we expect an actor to behave as if he or she is *not* acting but simply living the illusion of a character we can accept within the context of the movie's narrative. Such appropriateness in acting is also called *transparency,* meaning that the character is so clearly recognizable—in speech, movement, and gesture—for what he or she is supposed to be that the actor becomes, in a sense, invisible. Most actors agree that the more successfully they create characters, the more we will see those characters and not them.

- *Inherent thoughtfulness or emotionality:* Does the actor convey the character's thought process or feelings behind the character's actions or reactions? In addition to a credible appearance, does the character have a credible inner life?

An actor can find the *motivations* behind a character's actions and reactions at any time before or during a movie's production. They may come to light in the script (as well as in any source on which it is based, such as a novel or play), in discussions with the director or with other cast members, and in spontaneous elements of inspiration and improvisation that the actor discovers while the camera is rolling. No matter which of these aspects or combination of them delineates the character's motivation, we expect to *see* the actor reflect them within the character's consciousness, or as part of the illusion-making process by which the character appears. Another way of saying this is that the character must appear to be *vulnerable* to forces in the narrative, capable of thinking about them, and, if necessary, changing his or her mind or feelings about them.

- *Expressive coherence:* Has the actor used these first two qualities (appropriateness and inherent thoughtfulness/emotionality) to create a characterization that holds together?

Whatever behavior an actor uses to convey character, it must be intrinsic, not extraneous to the character, "maintaining not only a coherence of manner, but also a fit between setting, costume, and behavior."[36] When an actor achieves such a fit, he or she is *playing in character.* Maintaining expressive coherence enables the actor to create a very complex characterization and performance, to express thoughts and reveal emotions of a recognizable individual without veering off into mere quirks or distracting details.

- *Wholeness and unity:* In spite of the challenges inherent in most film productions, has the actor maintained the illusion of a seamless character, even if that character is purposely riddled with contradictions?

Whereas expressive coherence relies on the logic inherent in an actor's performance, wholeness and unity are achieved through the actor's ability to achieve aesthetic consistency while working with the director, crew, and other cast members; enduring multiple takes; and projecting toward the camera

[36]Naremore, *Acting in the Cinema,* 69.

rather than an audience. However, wholeness and unity need not mean uniformity. The point is this: as audience members we want to feel we're in good hands—when we're confused or asked to make sense of seemingly incoherent elements, we want to know that the apparent incoherence happened intentionally, for an aesthetic reason, as part of the filmmakers' overall vision. For example, if a given character suddenly breaks down or reveals himself to be pretending to be somebody he isn't, the actor must sufficiently prepare for this change in the preceding scenes, however he chooses, so that we can accept it.

To begin applying these criteria, let's examine the work of two very distinctive, successful actors: Barbara Stanwyck in King Vidor's *Stella Dallas* (1937) and Maggie Smith in Jack Clayton's *The Lonely Passion of Judith Hearne* (1987). Stanwyck plays a strong, assertive woman and brings a significant amount of physicality—movements and gestures—to her portrayal. By contrast, Smith plays a meek, delicate woman, whom she depicts more through reactions than through actions.

BARBARA STANWYCK IN KING VIDOR'S *STELLA DALLAS*

Stella Dallas, based on Olive Higgins Prouty's 1923 novel of the same title, tells the story of a brassy, scheming, but charming young woman from a working-class family who is openly derided by members of the middle and upper-middle classes but who has married Stephen Dallas (John Boles), a socially prominent

In King Vidor's *Stella Dallas*, the title character (Barbara Stanwyck) pleads with a police officer to allow her one more minute to watch through the window of the townhouse in which her daughter, Laurel (Anne Shirley), has just been married. Stanwyck received an Oscar nomination for Best Actress; Shirley, for Best Supporting Actress. To compare their performances to other actors' handling of the same roles, see Henry King's *Stella Dallas* (1925), starring Belle Bennett and Lois Morgan, and John Erman's *Stella* (1990), starring Bette Midler and Trini Alvarado.

man.[37] Although they have a daughter, Laurel (Anne Shirley), the Dallases separate when they realize their social and educational backgrounds are too different for them to be happy together. Stella is a formidable character for any actress to attempt, but Stanwyck beauti-

[37] *Stella Dallas* has been of interest to many feminist critics; see E. Ann Kaplan, "The Case of the Missing Mother: Maternal Issues in Vidor's *Stella Dallas*," and Linda Williams, "'Something Else Besides a Mother': *Stella Dallas* and the Maternal Melodrama," both in *Feminism and Film*, ed. Kaplan (New York: Oxford University Press, 2000), 466–79, 480–504.

fully meets the challenge of balancing the character's nonnaturalistic and naturalistic qualities. On one hand, Stella is loud and overdressed in clothes of her own making; on the other, she is a tender mother who sacrifices everything for her daughter's happiness. After Stephen has returned to his former fiancée, Helen Morrison (Barbara O'Neil), Stella visits Helen, offering to divorce Stephen if he and Helen will marry and raise Laurel as their own. Stella wears a gaudy fur coat, ridiculous hat, and fussy blouse. Her blunt way of speaking, mannish walk, and nervous fidgeting with her hands set her apart completely from the elegant, cultured, simply dressed, and well-groomed Helen.

When Laurel becomes engaged to marry Richard Grosvenor (Tim Holt), Stella is pleased that her daughter will achieve the upper-middle-class married life that has eluded her, but she realizes that she will be an embarrassment to Laurel. She pretends to leave the country, but instead stands outside the New York townhouse in which the marriage takes place, watching the ceremony through a big window. All the movie's major themes culminate here, in the Depression-era contrasts between those born to wealth and those born to work; in the contrast between the warm, secure interior and the cold, rainy exterior, where envious strangers grab a quick glimpse at what's going on inside before being hurried along; and in the contrast between Laurel in her white wedding dress and her mother, who is dressed plainly. Indeed, although she wears her usual heavy makeup, Stella's appearance has changed. Having always set herself apart from the ordinary, she now wears clothes that help her blend into the crowd—a cloth coat with fur trim and a simple felt hat—and she is not wearing jewelry. Stanwyck called this her favorite scene in the

movie: "I had to indicate to audiences, through the emotions shown by my face, that for Stella joy ultimately triumphed over the heartache she had felt."[38] We do not know whether she arrived at this interpretation intuitively or at Vidor's suggestion.

Let's look more closely at what she expresses facially and through gestures with a handkerchief, which Naremore, borrowing Pudovkin's term, calls an "expressive object."[39] As the wedding progresses, Vidor cuts between long and middle shots of the interior from Stanwyck's point of view and middle shots and close-ups of Stanwyck's face, a classic method for emphasizing the contrasts inherent in the scene. As the ceremony begins, Stella's face is open and curious, but what is she thinking? Within the narrative context, it must be how happy she is to be there. As Richard places the ring on Laurel's hand, however, Stella runs through a range of emotions. She smiles tenderly, she shudders slightly, tears well up in her eyes, and finally she swallows hard to suppress her emotion. When a police officer asks the crowd to disperse, Stella asks for another minute, the only time she speaks in the scene, which otherwise is underscored by the kind of highly charged music intended to make the audience cry. After the officer gives Stella extra time to see the bride and groom kiss each other, Stanwyck brings the handkerchief into play. Looking like she's about to lose control of her emotions, she slowly lifts the handkerchief as though to wipe away tears. Instead, she puts a corner of it in her mouth and, like a child, begins to chew and suck on it. She looks down in

[38]Stanwyck, qtd. in Ella Smith, *Starring Miss Barbara Stanwyck* (New York: Crown, 1974), 99.

[39]See Naremore's excellent discussion of this scene in *Acting in the Cinema,* 86–87; quotation, 85.

a moment of perfect maternal happiness, then looks up, her eyes shining and brimming with tears. Vidor then cuts to a long shot of Stanwyck walking confidently toward the camera, looking fulfilled, and swinging the handkerchief back and forth freely. As she crumples the handkerchief into her hand, squares her shoulders, and straightens her posture, the film ends. This is the sort of tear-jerking ending that made Hollywood's "women's films" so popular, and Stanwyck's performance is consistent not only with the character she plays but also with the melodramatic narrative. She gives us Stella's range of character between tough and sensitive, but, with her final self-confident stride, she also emphasizes the fulfillment in a mother's dream of seeing her daughter happily married. Ultimately, Stanwyck's performance transcends the story's melodrama. In her natural physical appearance, movements, and gestures (especially with the handkerchief); expressive coherence (aided by our belief that Stella is doing the right thing); and emotional consistency (alternating feelings of happiness and sorrow, determination and doubt), Stanwyck remains true to the good-hearted character she has been building from the first scene.

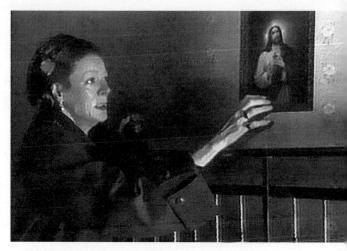

In Jack Clayton's *The Lonely Passion of Judith Hearne*, the title character (Maggie Smith) hides her shame from Jesus's gaze as she falls again for the comforts of whiskey. An actor of extraordinary range, Smith has scored triumphs on the London and New York stages; won an Oscar for Best Actress in Ronald Neame's *The Prime of Miss Jean Brodie* (1969); and gained a new generation of fans by portraying Professor McGonagall in the ongoing *Harry Potter* series.

MAGGIE SMITH IN JACK CLAYTON'S *THE LONELY PASSION OF JUDITH HEARNE*

The Lonely Passion of Judith Hearne, based on Brian Moore's 1955 novel of the same title and set in 1960s Dublin, is about a poor, unmarried piano teacher (Smith), who was raised by her rich, tyrannical aunt and who carries pictures of her aunt and Jesus wherever she goes. A secret drinker, she blames the Catholic Church for her unhappiness, which is fueled by her thwarted sexuality. A sharp-talking Irishman, James Madden (Bob Hoskins), seems like Mr. Right, but he jilts her when he discovers she has less money than he thought. Judith is then caught in a downward spiral of alcoholism as she moves from one seedy rooming house to another.

This film, in the British realist tradition, very subtly depicts Judith's despair. Clayton coolly observes his characters from the beginning to the end, making no judgments about the large cultural forces that shape them; he even changes the novel's conclusion to make it ambiguous, letting viewers decide whether Judith will begin yet another cycle of addiction and despair or be redeemed and make a new beginning. We might say that he simply hands

the film to Maggie Smith and her restrained manner, gentle gestures, enigmatic facial expressions, and large, expressive eyes. To longtime observers of Smith's work on the screen, this performance can be astonishing, for it is free from the comic mannerisms that have made her famous. For years, others had tried to make the film, hoping to cast Wendy Hiller (who plays the aunt here), Deborah Kerr, or Katharine Hepburn—but Clayton said that he was "more than happy with Maggie Smith."[40]

We meet Judith Hearne in the opening scene as she steps out of a taxi to take up new lodgings in a boardinghouse. We know from her fragile-looking body, pale and drawn face, and thin lips that she is in despair. As the driver takes her bag from the trunk, she says pleadingly, "There's precious things in there"—looking and sounding as if her life depends on its contents. When Judith unpacks, we learn what the things are: a photograph of her aunt, a cheaply colored picture of Jesus, and a satchel, which she conceals in the armoire and which we later learn contains a bottle of whiskey. Although she looks at the picture of her aunt and says, "A new start. I promise," this is hardly an auspicious beginning. After meeting Madden, who also lives in the boardinghouse, she becomes a different person, a woman with sparkling eyes and color in her cheeks, only to discover once he has treated her to a movie and a fancy dinner that he merely wants her to invest in his business scheme. She then returns to the boardinghouse, where we see the shattered woman who lurks beneath Judith's valiant attempt to keep up appearances. Locking the door to her little room, still wearing her coat and hat and

the flower corsage that Madden has given her, Judith seems, in the harsh light, much older than her years. Rarely do movie actors allow themselves to look as miserable as Smith does in this scene: faded, frightened, and lost. After turning the pictures of her aunt and Jesus around (because she is ashamed of what they might witness), she turns to the only consolation that works. Taking the satchel from the armoire, she removes a bottle of whiskey, and, her trembling giving way to weeping, pours herself a drink. She sobs, sniffling and gulping. Her face is stained with tears, veins stand out prominently on her forehead, and folds of skin cascade unflatteringly on her neck (effects achieved by makeup and lighting). At first she drinks tentatively, but then, gulping one drink after another, she feels the whiskey's warmth and takes comfort. Gradually, she quiets down, the tears subside, and she rests against the headboard. After a cut to a violent scene in which Madden rapes Mary (Rudi Davies), the teenage housemaid, we return to Judith. Now drunk, she gets up from her bed and begins to dance around the room. As she keeps on drinking, we hear the alcoholic's self-deceptions when she says she'll have "just a wee one" and sings (badly), "When you're smiling . . . the whole world smiles with you" (for her, *smiling* means *drinking*).

The scene is harrowing, as we respond both to Judith's delusions and to Smith's crystal-clear performance: playing not broadly or frantically but with masterly self-control, she shows us a woman victimized by large forces, shows us how frequently Judith has succumbed to her addiction and how far she has fallen, but also demonstrates that Judith has faced this crisis of self-doubt and despair before and knows how to handle it. Portraying a character such as this, who is up one day and down the next, presents an extraordinary

[40]Clayton, in "Jack Clayton," in *An Autobiography of British Cinema: As Told by the Filmmakers and Actors Who Made It*, ed. Brian McFarlane (London: Methuen, 1997), 131.

challenge to the actor, who must maintain expressive coherence—understanding what it means to worry about looking prim when you have a hangover and not worrying how you look when you're drunk—as well as bring unity to the characterization over the long period of filming. As her unforgettable secret smile at the end of the film reminds us, however, Maggie Smith is the kind of great actor who understands *and can make us understand* all kinds of feelings, from extreme vulnerability to invincible strength.

QUESTIONS FOR REVIEW

1. How is *movie acting* different today than it was in the period from the 1930s through the 1960s?
2. Why is the *relationship between the actor and the camera* so important in making and looking at movies?
3. What did D. W. Griffith, Konstantin Stanislavsky, and Bertolt Brecht contribute to the development of *screen acting?*
4. How did the *coming of sound* influence moving acting and actors?
5. What's the difference between *movie stars* and *movie actors?* Why do some critics emphasize that movie stars are a commodity created by the movie industry?
6. What factors influence the *casting* of actors in a movie?
7. How are *naturalistic* and *nonnaturalistic* movie acting different?
8. What is *improvisational acting?*
9. How do *framing, composition, lighting,* and *the long take* affect the acting in a movie?
10. Given the range of techniques available to movie actors, why do we say that their most basic skill is understanding how to reveal themselves to the camera during the close-up?

QUESTIONS FOR ANALYSIS

1. In the movie (or clip) you are analyzing, which factors seem apparent: the screenwriter's role in creating the major character? the context (historical, political, etc.) in which that character was created? the challenges faced by the actor in representing this character on the screen?
2. Why was this actor, and not another, cast for the role?
3. Does the actor's performance create a coherent, unified character? If so, how?
4. Does the actor look the part? Is it necessary that the actor look the part?
5. Does the actor's performance convey the actions, thoughts, and internal complexities we associate with natural or recognizable characters? Or does it exhibit the excessive approach we associate with nonnaturalistic characters?
6. What elements are most distinctive in how the actor conveys the character's actions, thoughts, and internal complexities: body language, gestures, facial expressions, language?
7. What special talents of imagination or intelligence might the actor have brought to the role?
8. How does the actor rely on the filmmaking process in creating the character?
9. Does the actor work well with his or her fellow actors in this film? Do any of the other actors detract from the lead actor's performance?
10. How, if at all, is the actor's conception of the character based on logic? How does the performance demonstrate "expressive coherence"?
11. Does the actor's performance have the expressive *power* to make us forget that he or she is "acting"? If it does, how do you think the actor achieved this effect?

FOR FURTHER READING

Allen, Robert C., and Douglas Gomery. *Film History: Theory and Practice.* New York: Knopf, 1985.

Ankerich, Michael G. *Broken Silence: Conversations with Twenty-Three Silent Film Stars.* Jefferson, N.C.: McFarland, 1993.

Antonioni, Michelangelo. "Reflections on the Film Actor." *Film Culture,* nos. 22–23 (summer 1961): 66–67.

Balász, Béla. "The Close-Up." In *Film Theory and Criticism: Introductory Readings,* ed. Leo Braudy and Marshall Cohen, 304–11. 5th ed. New York: Oxford University Press, 1999.

Barr, Tony. *Acting for the Camera.* Boston: Allyn and Bacon, 1982.

Blum, Richard. *American Film Acting: The Stanislavsky Heritage.* Ann Arbor, Mich.: UMI Research Press, 1984.

Brandes, D. "Roman Polanski on Acting." *Cinema Papers,* no. 11 (January 1977): 226–29.

Braudy, Leo. "Film Acting: Some Critical Problems and Proposals." *Quarterly Review of Film Studies* 1, no. 1 (February 1976): 1–18.

Brecht, Bertolt. *Brecht on Theatre: The Development of an Aesthetic.* Ed. and trans. John Willett. 1964. Reprint, New York: Hill and Wang, 1976.

Budd, Michael. "Genre, Director, and Stars in John Ford's Westerns: Fonda, Wayne, Stewart, and Widmark." *Wide Angle* 2, no. 4 (1978): 52–61.

Callow, Simon. *Being an Actor.* 1984. Reprint, New York: Grove, 1988.

Campbell, Russell, ed. "The Actor." *Velvet Light Trap,* no. 7 (winter 1972/73): 1–60.

Cardullo, Bert, Henry Geduld, Ronald Gottesman, and Leigh Woods, eds. *Playing to the Camera: Film Actors Discuss Their Craft.* New Haven: Yale University Press, 1998.

Cole, Toby, and Helen Krich Cinoy, eds. *Actors on Acting: The Theories, Techniques, and Practices of the Great Actors of All Times as Told in Their Own Words.* 2nd ed. New York: Crown, 1964.

Cukor, George. "Dialogue on Film: George Cukor." *American Film* 3, no. 4 (February 1978): 33–48.

Dmytryk, Edward, and Jean Porter Dmytryk. *On Screen Acting: An Introduction to the Art of Acting for the Screen.* Boston: Focal Press, 1984.

Dyer, Richard. *Heavenly Bodies: Film Stars and Society.* New York: St. Martin's Press, 1986.

———. *Stars.* New ed. London: British Film Institute, 1998.

Eisenstein, Sergei. *Film Form [and] The Film Sense.* Ed. and trans. Jay Leyda. New York: Meridian, 1957.

Funke, Lewis, and John E. Booth, eds. *Actors Talk about Acting: Fourteen Interviews with Stars of the Theater.* New York: Random House, 1961.

Gardner P. "Bette Davis: A Star Views Directors." *Action,* no. 5 (October 1974): 10–17.

Higson, Andrew. "Film Acting and Independent Cinema." *Screen* 27, nos. 3–4 (1986): 110–32.

Hirsch, Foster. *Acting Hollywood Style: With Photographs from the Kobal Collection.* New York: Abrams, 1991.

Kael, Pauline. "The Man from Dream City (Cary Grant)." *New Yorker,* 14 July 1975, 40–42ff.

Keane, Marian. "Dyer Straits: Theoretical Issues in Studies of Film Acting." *Post Script: Essays in Film and the Humanities* 12, no. 2 (winter 1993): 29–39.

Kuleshov, Lev. *Kuleshov on Film.* Ed. and trans. Ronald Levaco. Berkeley: University of California Press, 1974.

McVay, Douglas. "The Art of the Actor." *Films and Filming* 12, no. 10 (July 1966): 19–25.

———. "The Art of the Actor." *Films and Filming* 12, no. 11 (August 1966): 36–42.

———. "The Art of the Actor." *Films and Filming* 12, no. 12 (September 1966): 44–50.

———. "The Art of the Actor." *Films and Filming* 13, no. 1 (October 1966): 26–33.

———. "The Art of the Actor." *Films and Filming* 13, no. 2 (November 1966): 26–33.

Merritt, R. "The Griffith-Gish Collaboration: A Tangled Affair." *Griffithiana* 14, nos. 40–42 (October 1991): 101–3.

Meyerson, Harold. "The Case of the Vanishing Character Actor." *Film Comment* 13, no. 6 (November–December 1977): 6–15.

Munk, Erika, ed. *Stanislavski and America: An Anthology from the "Tulane Drama Review."* New York: Hill and Wang, 1966.

Olivier, Laurence. *On Acting.* New York: Simon and Schuster, 1986.

Prouse, Derek. "Notes on Film Acting." *Sight and Sound* 24, no. 4 (spring 1955): 174–80.

Pudovkin, V. I. *Film Technique and Film Acting.* Ed. and trans. Ivor Montagu. Rev. and enl. ed. New York: Grove Press, 1970.

Rogosin, Lionel. "Interpreting Reality: Notes on the Esthetics and Practices of Improvisational Acting." *Film Culture*, no. 21 (summer 1960): 20–29.

Rosenbaum, Jonathan. "Improvisations and Interactions in Altmanville." *Sight and Sound* 44, no. 2 (spring 1975): 90–95.

Stanislavksy, Konstantin. *An Actor Prepares.* Trans. Elizabeth Reynolds Hapgood. New York: Theatre Arts Books, 1936.

———. *Building a Character.* Trans. Elizabeth Reynolds Hapgood. New York: Theatre Arts Books, 1949.

Strasberg, Lee. *Strasberg at the Actors Studio: Tape-Recorded Sessions.* Ed. Robert H. Hethmon. New York: Viking, 1965.

Tucker, Patrick. *Secrets of Screen Acting.* New York: Routledge, 1994.

Weis, Elisabeth, ed. *The National Society of Film Critics on the Movie Star.* New York: Viking, 1981.

Wexman, Virginia Wright. "Kinesics and Film Acting: Humphrey Bogart in *The Maltese Falcon* and *The Big Sleep.*" *Journal of Popular Film and Television* 1 (1978): 42–55.

———, ed. *Film Acting.* Special issue of *Cinema Journal* (20, no. 1 [fall 1980]).

Wood, Robin. "Acting Up." *Film Comment,* no. 12 (April 1976): 20–25.

Yacowar, Maurice. "Actors as Conventions in the Films of Robert Altman." *Cinema Journal* 20, no. 1 (fall 1980): 14–28.

Zucker, Carole. "The Concept of 'Excess' in Film Acting: Notes toward an Understanding of Non-naturalistic Performance." *Post Script: Essays in Film and the Humanities* 11–12, no. 2 (winter 1993): 54–62.

———, ed. *Film Acting.* Special issue of *Post Script: Essays in Film and the Humanities* (12, no. 2 [winter 1993]).

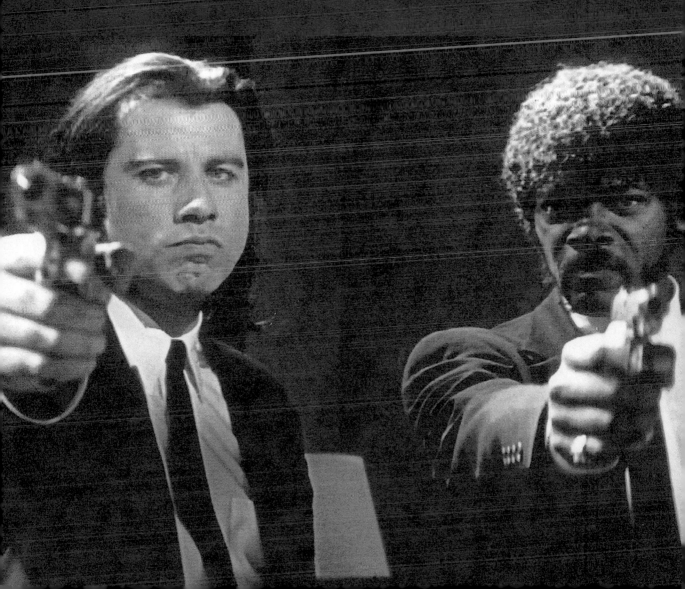

Editing

WHAT IS EDITING?

The first movies, by the Lumière brothers and by Thomas A. Edison, each consisted of only one shot. An event or rudimentary narrative—a train coming into a station, workers leaving a factory, or soldiers marching in formation—was recorded chronologically, seamlessly, and inherently *within* that shot, not created *between* shots. The cinematic space remained whole and continuous, and the shot was limited by the amount of footage on the small reel. In order to tell the kind of story that sets the movies apart from the other narrative arts, two things were necessary: larger reels (a simple challenge) and a "language" (a systematic means, with understood meanings) for coordinating a series of shots into a coherent whole. Between 1895 and 1926 (the coming of sound; see "Sound Versus Silence" in chapter 7), the development of film technique was primarily the development of that language, known as *editing.*

The process and the results of editing may not be apparent to people unfamiliar with filmmaking. The smooth editing of many contemporary movies convinces such viewers that scenes were shot in the order they appear and that no manipulation of that order was necessary. Usually, as you know from chapter 1 (see "Movies Generally Result from a Complex, Expensive, and Highly Collaborative Process"), that is not true. Movies are shot out of continuity, often in many takes; and therefore someone or some group of people has to choose which pieces of footage to use, putting them together in a form that will be comprehensible to the audience, create meaning, and perhaps evoke specific emotional and intellectual responses. Because of that process of selection and arrangement, much unused footage is left on the cutting-room floor. It is not uncommon for the ratio between unused and used footage to be as high as fifty to one, meaning that for every minute you see on the screen, fifty minutes have been discarded. Editing consists, in part, of the techniques and conventions used to arrange and assemble the remaining footage, both picture and sound, and to govern the relations between shots and between scenes. During preproduction and production—even from the moment the movie is conceived—the editor may make suggestions for composition, blocking, lighting, and shooting that will help the editing itself. Editing, of course, begins in the postproduction stage and ends with the finished film. An editor literally works behind the scenes (pun intended), but his or her contributions can make the difference between artistic success and artistic failure, between an ordinary movie and a masterpiece.

Film editor and scholar Ken Dancyger distinguishes among the *technique,* the *craft,* and the *art* of editing.[1] The technique (or method) is the actual joining together of two shots—often called **cutting** or **splicing**, because the editor must first cut (or splice) each shot from its respective roll of film before gluing or taping all the shots together (on this form of editing, called *linear,* and on the more advanced *nonlinear digital editing,* see "The Editor's Tools," below). The craft (or skill) is the ability to join shots and produce a meaning that does not exist in either one of them individually. The art of editing, he declares, "occurs when the combination of two or more shots takes meaning to the next level—excitement, insight, shock, or the epiphany of discovery" (xv).

[1]Ken Dancyger, *The Technique of Film and Video Editing: Theory and Practice,* 2nd ed. (Boston: Focal Press, 1997), xiv–xv.

In this roughly half-minute sequence from Darren Aronofsky's *Requiem for a Dream* (2000; editor: Jay Rabinowitz), thanks to an editing technique called *split-screen* (discussed below), we see a contemporary demonstration of the Kuleshov effect. As pictures are juxtaposed, literally placed side by side, the meaning of one affects the meaning of the other. That is, together the shots influence our creation of their meaning—and their combined meaning then affects how we see the following two halves, whose meaning undergoes a transformation similar to that of the first two, and so on. This interpretive process goes on through the sequence, into the following shot, the following sequence, and ultimately the entire movie. Our creation of meaning proceeds from increment to increment, though at a much faster rate of calculation than this caption can convey.

All of these images, in this context, relate to drug use. Without showing the actors' physical movements, the sequence seeks to approximate the characters' frantic experience, to represent the perceptual changes that accompany their intake of narcotics. Through the language of editing, Aronofsky has given us a fresh look at a way of seeing and being—a way that, as the nightmarish quality of these images suggests and as the rest of the film depicts, has nowhere to go from this high but down.

As an experiment, try to imagine different juxtapositions of these same images, taken not in sequence but in isolation. Outside the context of drugs, what might George Washington's image on a dollar bill next to a widened, bloodshot eye mean? What might gritting teeth next to that reddish flow mean? For that matter, to what use might someone, maybe the creator of television commercials or public-service messages, put each image alone? To learn more about the Kuleshov effect and the cinematic juxtaposition of images, go to <*www.wwnorton.com/web/movies*>.

www

The early Soviet film theorist and filmmaker Lev Kuleshov experimented with cutting in various ways. His most important film (now lost) was a short one in which an identical shot of an expressionless actor appeared after shots of a dead woman, a child, and a dish of soup (dead woman/actor/child/actor/soup/actor; this technique, called *parallel editing* or *cross-cutting,* is explored below). The audience reportedly assumed that the actor reacted to each stimulus by changing his expression appropriately—sorrow for the dead, tenderness for the young, and hunger for the food—when in fact his expression remained the same. This *Kuleshov effect* is one way in which cinema fools the eye, drawing on the rapid juxtaposition of shots to create an association (and an illusion) in the viewer's mind.

Every shot has two explicit values: alone, it is a photographic image; edited in coordination with other shots, it acquires a different meaning. Fundamentally, then, editing manipulates those values to help tell a story, create an idea or feeling, or call attention to itself as an element of cinematic form. Among other things, editing determines not only the duration of a shot but also the duration of a sequence of shots. Thus it controls the length of time you can look at those shots and absorb the information within them. By fixing the duration, frequency, and rhythm of shots, placing them once or repeating them when and wherever necessary in a film, editing further controls the film's emphasis on a person, setting, or object. Determining emphasis is another way that editing helps create meaning. As Ralph Rosenblum—the editor of thirty-two films, including Sidney Lumet's *The Pawnbroker* (1965) and six by Woody Allen—explains, however,

a key part of . . . [the editor's] job in the months he will spend absorbed in the seem-

ingly endless footage will be to make his own contribution as imperceptible as possible. No viewer should walk out of that film saying, "I really dug the editing." The final product should have a natural seamless effect, as if it were originally shot just the way it looks on the screen.[2]

Rosenblum refers here to one kind of editing—the apparently seamless, *continuity* editing that characterizes most movies—but other kinds of editing achieve other kinds of goals. While we will also consider editing that deliberately seeks *discontinuity,* this chapter focuses primarily on conventional editing that preserves continuity in telling a story.

CONTINUITY EDITING

Among the first important films to explore the possibilities of fictional storytelling were Georges Méliès's *Cinderella* (*Cendrillon,* 1899), which consisted of twenty shots joined by cuts and **intertitles** (brief texts within the body of the film), and *A Trip to the Moon* (*La voyage dans la lune,* 1902), thirty shots in chronological order. At almost the same time, Edison produced Edwin S. Porter's *Life of an American Fireman* (1903); in both its nine- and twenty-shot versions, the shots are simply joined together, mainly by straight cuts, as are the fourteen shots in Porter's most important film, *The Great Train Robbery* (1903), which runs for a little over twelve minutes at the standard silent speed of 16 fps. Here, Porter cross-cuts between two actions occurring at the same time but in different places. His overall achievement was the discovery of what has come to be called **continuity editing** (or some-

[2]Ralph Rosenblum and Robert Karen, *When the Shooting Stops, the Cutting Begins: A Film Editor's Story* (1979; reprint, New York: Da Capo Press, 1986), 2.

[1] [2] [3] [4] [5] [6] [7] [8] [9] [10] [11] [12] [13] [14] [15]

In *Life of an American Fireman*, Edwin S. Porter helped establish the foundation for continuity editing, a method that D. W. Griffith and subsequent filmmakers built from the ground up. Porter simply pointed his camera at different sights, but he then combined those shots into a narrative flow. Here, a sequence of images (two frames per shot, excepting shot 5) represents eight of the shots in Porter's nine-shot version: (1) and (2) are from shot 1, (3) and (4) are from shot 2, (5) and (6) are from shot 3, (7) and (8) are from shot 4, (9) is from shot 5, (10) and (11) are from shot 6, (12) and (13) are from shot 8, and (14) and (15) are from shot 9. Shot 7 is not represented.

times *classical editing*): the creation of filmic unity (beginning, middle, and end) in the establishment and resolution of a problem; in short, the telling of a story as clearly and coherently as possible.

In 1910, film critic H. Kent Webster defined such editing as "that subtle indiscernible thread or mesh, binding and blending scenes [shots] and parts into a harmonious whole."[3] By the 1920s, to tell longer and more complex stories, filmmakers needed editing that would preserve verisimilitude for the audience. Thus continuity editing, now the dominant style of editing throughout the world, seeks to achieve logic, smoothness, sequentiality, and the temporal and spatial orientation of viewers to what they see on the screen. It ensures the flow from shot to shot but also creates a rhythm based on the relationship between cinematic space and cinematic time: the more information a shot contains, the more time the audience needs to see and understand the shot. A simple rule of thumb is that long shots require more viewing time than either medium shots or close-ups. As with so many other universally accepted conventions of film production, however, the conventions of continuity editing remain open to variation. In general, continuity editing ensures that

- what happens on the screen makes as much sense as possible
- action occupies the central zone of the screen
- lighting remains constant from shot to shot (if it is intended to be constant)

- time, space, and causality are continuous from shot to shot
- graphic, rhythmic, spatial, and temporal relations are maintained
- rhythm varies according to the kinds of shots
- screen direction remains continuous

SCREEN DIRECTION. Since the first movies were little more than action filmed by a static camera, they resembled film versions of very short plays, and the early conventions of cinema largely derived from the conventions of theater. Fundamentally, the conventional (or proscenium) theater separates the audience from the actors by means of a *proscenium arch,* which frames the stage opening and is augmented in most cases by curtains that can be drawn to indicate the passage of time, divide a play into acts, or conceal changes of setting. The *frame* created by a proscenium arch functions in one way like the frame of a movie: to include and exclude what we see. Before the movies broke away from the rigidity of the theater—in other words, before films were made in motion picture studios, before the camera began to move, before continuity editing was developed—audiences had little trouble understanding the continuity of *stage direction.* Once the play began (or the curtain rose) and revealed the principal stage setting—a one-room cabin in the woods, say, with the fourth wall removed—the audience understood the layout and became oriented to the space. If a character exited through the door at stage rear and, ten minutes later, reentered through the door at stage right, the audience would naturally assume that character had left the room, gone into the woods, walked around, and returned from outside.

[3]Qtd. in David Bordwell, Janet Staiger, and Kristin Thompson, *The Classical Hollywood Cinema: Film Style and Mode of Production to 1960* (New York: Columbia University Press, 1985), 195.

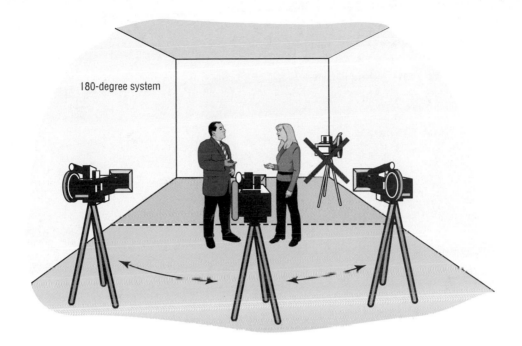

180-degree system

The evolution of films containing many shots (especially involving such action shots as occur in a chase scene) demanded that filmmakers find a way to maintain consistent *screen direction,* to orient the viewer and ensure a sense of the cinematic space in which the action occurs. The fundamental result is the **180-degree system** (also called the *180-degree rule,* the **axis of action,** and the *center line*). As film production expert Bruce Mamer says, this system is "relatively easy to understand on a superficial level, but its role in production is something that takes on-set experience to truly understand."[4] To work effectively, it assumes three things: the action within a scene will always advance along a straight line, either from left to right or right to left of the frame; the camera will shoot consistently on one side of that action; and everyone on the production set will understand and adhere to this system.

The axis of action, an imaginary horizontal line between the main characters being photographed, determines where the camera should be placed to preserve screen direction and thus one aspect of continuity. Once this axis of action is determined, the camera must remain on the same side of the line. The resulting shots orient the viewer within the scene, ensure consistent screen direction across and between cuts, and ensure consistency of space (since something, an object or person, remains consistent in the frame, to identify the relations between sequential spaces). The axis of action shifts, though, as the characters move within the frame and as the camera moves.

[4]Bruce Mamer, *Film Production Technique: Creating the Accomplished Image* (Belmont, Calif.: Wadsworth, 1995), 136.

[1]

[2]

[3]

[4]

In Jonathan Demme's *The Silence of the Lambs* (1991; editor: Craig McKay), Clarice Starling (Jodie Foster), a young student at the FBI academy, visits Dr. Hannibal Lecter (Anthony Hopkins), a brilliant psychiatrist who has been confined to a maximum-security prison for committing murders involving cannibalism. The suspense of this scene is established when we learn about the prison's rigid rules for dealing with Lecter, who is considered extremely dangerous. Starling knows that she must follow these rules if she is to remain safe from anything he might do to her. As the scene of twelve shots begins, she enters the room that separates the guards from the prisoners; a guard named Barney (Frankie Faison) greets her; she passes through two sets of bars and enters the low-ceilinged, cavernlike space that contains several cells, including Lecter's.

The design and meaning of this scene are based on the juxtaposition of opposites: freedom and imprisonment, fear and control, men and women, the sane and the insane. The cinematography, too, which respects the 180-degree line—maintaining screen direction to orient the viewer to this space—also alternates between opposites: (1, 4, 6) shorter shots from the omniscient-camera point of view with longer shots reflecting Starling's point of view, as she too alternates between (2, 5) first looking left at several animal-like prisoners behaving obscenely and then (3, 7) looking straight toward the end, where (8) the well-groomed, charming Lecter stands erect behind a

DISCONTINUITY EDITING

No sooner had Porter's theory of continuity editing and dramatic construction been established as a convention than filmmakers around the world began searching for alternatives to straightforward storytelling. Instead of joining shot A to shot B after considering how the link would advance the narrative spatially and temporally, editors could join them after considering other criteria—for example, their graphic or rhythmic relationships. Such cuts

[5]

[6]

[7]

[0]

Plexiglas barrier in a brightly lit cell. The music underscores the steady pace of her walk.

The continuity editing functions with these other elements by conveying Starling's curiosity, fear, and suspense. Obviously, one way they work together is through the cumulative impact of the elements that constitute the mise-en-scène: design, lighting, cinematography, acting, sound, music, and, of course, editing. The principal function of the editing here, responding to the cinematographer's respect of the center line, is to keep a steady pace between the shots. This helps reinforce that she is in control not just of her body but of her mind, concentrating on the assignment, putting fear behind her. Thus the center line down the corridor is physically, psychologically,

emotionally, and *cinematically* important, for it is truly the *axis of action* between these two characters. To cross over it, to violate its protections, would lead to disaster for Starling.

Within the context of the film, this scene is virtually perfect. Because the continuity editing creates meaning, any other way of editing it—putting the shots in a different order or even in a discontinuous order— would have lessened Starling's control. Such an approach, typical of an exploitive horror movie, would have destroyed the suspense that has been so carefully built up to this point in the film; it would have used this scene simply to scare the wits out of us. To learn more about the 180-degree rule, go to <*www.wwnorton.com/web/movies*>

www

would be abrupt, calling attention to themselves, and thus would *not* preserve the values of continuity editing and *not* convey a plausible, continuous world. In this experimentation, filmmakers were influenced by the major intellectual and artistic currents of the

post–World War I world, a period of great creative and experimental production. The modern novel had illustrated that time was relative; that plots could avoid climaxes and narrative rewards but still have deep meaning; and that individuals, sensing the disintegra-

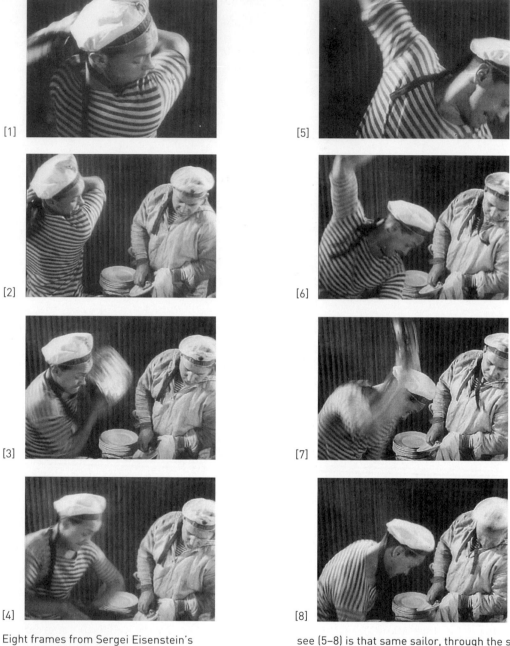

[1]

[2]

[3]

[4]

[5]

[6]

[7]

[8]

Eight frames from Sergei Eisenstein's groundbreaking *Battleship Potemkin* illustrate the interrelationship between continuity editing and discontinuity editing. (1–4) A starving sailor (Mikhail Gomorov), enraged by the words "Give us this day our daily bread" printed on a plate, brings the plate up behind his head and then flings it down. The continuity of these shots and the action within them leads us to believe the plate has broken, but the next thing we see (5–8) is that same sailor, through the same framing, smashing the same plate. Again, the shots and action here are continuous; but their juxtaposition with the previous sequence creates visual, temporal, and logical discontinuity. Only in the following shot, which shows the plate in pieces, is continuity restored. Why might Eisenstein have interrupted our expectations in this way? What artistic, even political, purposes has that interruption served?

tion of civilization and its values, could seek out or construct their own belief systems. Modern psychology and psychoanalysis taught that logic and causality were not the only or even the best ways to explain human behavior. Trends in modern and avant-garde art—expressionism, dadaism, surrealism, cubism—depicted reality as unstable, discontinuous, and fragmented, resulting in images of a world in which all appearances as well as all interpretations seemed equally valid. Thus some filmmakers—Vsevolod Pudovkin, Sergei Eisenstein, Dziga Vertov, Aleksandr Dovzhenko, and Luis Buñuel prominent among them—shifted away from creating logical, continuous relationships among elements within stories and instead sought to create discontinuous (or nonlinear) relationships. They thought primarily in terms of shots rather than scenes, of disjointed moments rather than the fluidity of real time, and of the "poetic" value of individual editing effects. As a result, their work called attention to a relationship other than the one between shots: the relationship between the filmmaker as artist and the images (visual and sound) as expressive material.

Most generally, **discontinuity editing** (also known as *constructve* or *nonlinear editing*) joins shot A and shot B to produce an effect or meaning not even hinted at by either shot alone. Showy rather than seamless, it encourages viewers to notice and consider the cinematic techniques, the mediation, at work before their eyes. While possibly yielding satisfactions for its own sake (a consciousness of being conscious), this heightened awareness may provide viewers with intellectual insight or emotional stimulation beyond what less self-conscious movie-viewing can afford. Although we associate discontinuity-editing techniques mostly with avant-garde and ex-

perimental films (see "Types of Movies" in chapter 1), feature filmmakers also employ them. Indeed, as film editor Walter Murch observes, discontinuity "is the central fact during the production phase of filmmaking, and almost all decisions are directly related to it in one way or another—how to overcome its difficulties and/or how to best take advantage of its strengths."[5]

Every generation attempts to revolutionize cinema by calling attention to the act of filmmaking in its filmmaking. Discontinuity editing figures prominently in many such attempts, and touchstones in the history of discontinuity editing include Eisenstein's *October/Ten Days that Shook the World* (*Oktyabr*, 1928; editor: Eisenstein), Buñuel and Salvador Dalí's *Un chien andalou* (*An Andalusian Dog*, 1929; editor: Buñuel), Orson Welles's *Citizen Kane* (1941; editor: Robert Wise), Jean-Luc Godard's *Breathless* (*À bout de souffle*, 1959; editor: Cécile Decugis; *Breathless* is the suggested case study for this chapter), Alain Resnais's *Hiroshima, mon amour* (1959; editors: Henri Colpi, Jasmine Chasney, and Anne Sarraute) and *Providence* (1977; editors: Jean-Pierre Besnard and Albert Jurgenson), François Truffaut's *Shoot the Piano Player* (*Tirez sur le pianiste*, 1960; editors: Claudine Bouché and Cécile Decugis), and Quentin Tarentino's *Pulp Fiction* (1994; editor: Sally Menke), which tells three interlocking stories with overlapping characters. While it may use discontinuity editing more as a self-conscious stylistic device than as a means of creating meaning *within* the narra-

[5]Walter Murch, *In the Blink of an Eye: A Perspective on Film Editing* (Los Angeles: Silman-James Press, 1995), 7; and Michael Ondaatje, *The Conversations: Walter Murch and the Art of Editing Film* (New York; Knopf, 2002).

In his first feature film, *Hiroshima, mon amour,* Alain Resnais employed innovative discontinuity editing, among other techniques, to render French avant-garde writer Marguerite Duras's screenplay, an impressionistic interracial love story involving memory and history. A member of the group of French critics, theorists, and filmmakers known as the French New Wave, Resnais pioneered such now-commonplace practices as cutting in and out of flashbacks and using very brief flashbacks to suggest parts of the past replaying in characters' minds. Elle (Emmanuelle Riva) and Lui (Eiji Okada) are linked by the pain of war but also separated by their different cultures and experiences, and the filmmaking mirrors their dislocation.

French "New Wave" of the late 1950s and 1960s, a loosely knit movement that combined critical commentary and moviemaking in an attempt to breathe new life into old forms and to celebrate the filmmaker as *auteur* (author). One critic and filmmaker associated with the movement, Alexandre Astruc, called this period of social and artistic unrest the age of the *caméra-stylo* ("camera-pen"), in which filmmakers, using their cameras as personally as they would use pens, could express themselves as freely as writers. Like their forebears in the 1920s, New Wave filmmakers such as Godard, Truffaut, Jean-Pierre Melville, and Claude Chabrol challenged the conventions of narrative cinema (particularly what they saw as a stultified French cinema, as opposed to freer American movies) through discontinuity editing and other "experiments," often juxtaposing standard techniques with newer manipulations (see "Conventions of Editing," below). They showed that onscreen invention could help viewers interpret and draw meaning from cinematic images and sounds.

THE EDITOR'S RESPONSIBILITIES

tive, *Pulp Fiction,* like *Citizen Kane,* invites (and even challenges) viewers to assemble its pieces: you could see it a dozen times before being able to remember the sequence of events. For example, the resolution of the plot—the moment when Butch Coolidge (Bruce Willis) and his girlfriend, Fabienne (Maria de Medeiros), leave town on his motorcycle—comes not at the end but some two-thirds of the way through.

One major influence on *Pulp Fiction* (indeed, on all of Tarantino's work) was the

The creative power of the editor comes close to that of the director. In fact, a number of directors began their careers as editors, among them David Lean, Edward Dmytryk, Robert Wise, Dorothy Arzner, Hal Ashby, Raoul Walsh, Anthony Harvey, Mark Robson, and John Sturges. Many other directors—including Sergei Eisenstein, Alfred Hitchcock, Orson Welles, and Stanley Kubrick—are themselves masters of the principles, if not the actual work, of editing. Still others, such as John Sayles, edit the films they direct. "One gives as

much as possible," says film editor Helen Van Dongen,

> as much as is beneficial to the final form of the film, without overshadowing or obstructing the director's intentions. . . . The editor working with a great director can do no better than discover and disclose the director's design. . . . Though the good editor must be able to subjugate himself to a certain degree to the personality of the director and interpret the director's style and form, he nevertheless leaves an unmistakable personal stamp on the final editing of the film.[6]

(Close collaborations between editors and directors include those between Van Dongen and Robert Flaherty, Barry Malkin or Walter Murch and Francis Ford Coppola, Thelma Schoonmaker and Martin Scorsese, and Susan E. Morse and Woody Allen; others are mentioned elsewhere in this chapter.)

The editor's responsibilities affect the film as a whole and as a collection of parts. Responsibilities affecting the film as a whole involve

- manipulating the footage (the actual handling, cutting, and assembling of film shots)
- constructing the overall form of the movie
- creating continuity out of discontinuity, as necessary
- helping to realize or augment the filmmaking team's collective artistic vision

Within distinct parts of the film, the editor is responsible for creating

Thelma Schoonmaker and Martin Scorsese in the editing room, 1989. Since Schoonmaker began working with Scorsese on his first feature film, *Who's That Knocking at My Door?* (1968), she has edited seventeen of his feature films, including *Gangs of New York* (2002).

- spatial, temporal, and visual relationships between individual shots
- rhythm
- mood
- ellipses
- separations
- patterns
- slow disclosures

Let's examine these specific responsibilities more closely.

SPATIAL, TEMPORAL, AND VISUAL RELATIONSHIPS BETWEEN INDIVIDUAL SHOTS

Editing permits filmmakers to control cinematic space by relating any two points in it, whether similar or completely different, since

[6]Helen Van Dongen, qtd. in Richard Barsam, "Discover and Disclose: Helen Van Dongen and *Louisiana Story*," in *Filming Robert Flaherty's "Louisiana Story": The Helen Van Dongen Diary*, by Helen Durant, ed. Eva Orbanz (New York: Museum of Modern Art, 1998), 86.

[1]

[2]

[3]

[4]

[5]

[6]

In Joel Coen's *Raising Arizona,* a simple example of spatial continuity also pokes fun at the notion of spatial continuity—in fact, becomes an example of spatiotemporal discontinuity. After speeding across the desert, throwing grenades at rabbits to show his power, Leonard Smalls (Randall "Tex" Cobb) rides

(1–2) up and (3) over a hilly road, where, with (4) a cut to the next shot, he (5) enters (6) an entirely different place. Thus we see the motorcycle as racing seamlessly from one location to another, each different in time, terrain, and vegetation.

each shot represents a unit of space; to control cinematic time (in its order and duration), since each shot represents a unit of time; and to control relationships between or among people, things, shapes, light, and shadows.

In Joel Coen's *Raising Arizona* (1987; editor: Michael R. Miller;), the McDonnoughs—H. I. ("Hi") and Edwina ("Ed"), played by Nicolas Cage and Holly Hunter—are a married couple who are not able to have a baby. Hi, a poetic ex-convict, kidnaps a baby to make their life complete, but his crime troubles him, and he has fantastic visions when he sleeps. In one of them, he plays out his fear and guilt by imagining a fierce-looking biker, Leonard Smalls (Randall "Tex" Cobb), who is on to Hi's crime and tries to get the baby in return for money from its parents. The editor creates a *spatial relationship* by relating two locations through which the biker passes on the same day, taking him from a monochrome desert (his natural habitat) to a lush, green estate, where the baby's parents live and where he discovers the ladder down which Hi escaped with the baby.

At the beginning of *The Piano* (1993; editor: Veronika Jenet), Jane Campion creates a *spatiotemporal relationship* between shots. Shot 1 shows Ada McGrath (Holly Hunter) in Glasgow, Scotland, playing her piano, which is partially enclosed in a box marked "New Zealand." After a cut takes us to shot 2, the keel of a boat moving through water, another cut takes us to shots 3 and 4, Ada and her daughter, Flora (Anna Paquin), arriving in New Zealand. These cuts join *space*—Ada and Flora's former home with their new one; *time*—a journey that would have taken months in the mid–nineteenth century is reduced to a moment; and two prominent *elements of the story*—past and present.

In *Stagecoach* (1939; editors: Otho Levering and Dorothy Spencer), John Ford continually repeats a three-part pattern to sustain *visual relationships* during the stagecoach's journey across the desert. The pattern consists of A, a long shot of the coach rolling along the plain; followed by B, a middle shot of Curly and Buck on the driver's seat; followed by C, cross-cuts between middle shots and close-ups of the passengers inside the coach. This shooting-and-editing pattern brings us progressively closer to the characters (from outside to inside the coach) and reminds us of their seating arrangements, which are, in turn, vital to underscoring the tensions that exist between each individual and the group.

RHYTHM

An editor can control the rhythm of a film—the pace at which it moves forward—by varying the length of the shots in relation to one another. Sometimes, the editing rhythm allows us time to think about what we see; at other times, it moves too quickly to permit thought. The opening sequence of Tom Tykwer's *Run Lola Run* (*Lola rennt*, 1998; editor: Mathilde Bonnefoy) illustrates how the editor can have complete control over the rhythm of a film. Lola (Franka Potente) receives a phone call from her boyfriend, Manni (Moritz Bleibtreu), who implores her to help him return $100,000 to the criminal gang for which he works. If he does not do so in twenty minutes, the gang will kill him. Lola hangs up, imagines what her task will involve, and then sets off, running through the rooms of her apartment, down the stairs, and out into the city streets. Tykwer uses a constantly moving camera, live and animated footage, time-lapse cinematography, slow motion and fast motion,

[1]

[2]

[3]

[4]

In Jane Campion's *The Piano*, a quick succession of four shots transports Ada McGrath (Holly Hunter) and her daughter, Flora (Anna Paquin, not shown), across the globe from Scotland to New Zealand, quickly establishing the movie's core sense of physical and emotional isolation, silence, and loss. From here on, we will see mostly discrete incidents, bound more by recurring images than by spatiotemporal continuity. This narrative approach highlights such events as arrivals, departures, and individual moments of character awareness and growth. Later, awakened to sexual passion and love, Ada leaves New Zealand on a boat trip similar to the one that brought her to the island, and the movie returns to the full narrative sweep suggested by its opening. For an in-depth analysis of *The Piano*, see the case study for chapter 5: <*www.wwnorton.com/web/movies*>.

WWW

[1]

[2]

[3]

[4]

[5]

[6]

In Tom Tykwer's *Run Lola Run,* (1) the title character (Franka Potente) receives word of (2) her boyfriend, Manni's (Moritz Bleibtreu), dire situation—a matter of money and (3) time, which is running out. Close-ups show (4) Lola facing facts and (5) imagining the possibilities. Finally, she has no choice but to (6) run for help. From here on, the pace of the editing will match the pace of dramatic developments and Lola's sometimes split-second decision making. To view a clip, consult your CD-ROM.

6.1

[1]

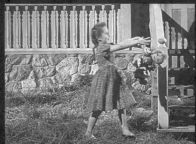

[2]

[3]

[4]

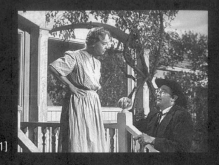

[5]

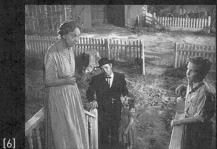

[6]

[7]

[8]

In Charles Laughton's *The Night of the Hunter,* (1) Harry Powell (Robert Mitchum) confronts Rachel (Lillian Gish), who is providing refuge for the children he seeks. The scene begins slowly, to establish in Rachel's eyes who Harry really is: not a preacher who wants to take the kids home, but a con artist who has killed the children's mother and wants the children because their father's money is hidden in a doll. (2) When the children enter the scene, Pearl (Sally Jane Bruce) drops the doll and runs to Harry; (3) a quick cut to a reaction shot, in which he looks at (4) the doll, makes clear his purpose. (5) Close-ups separate Harry and Rachel in their two different worlds (as their respective black and white costumes also do); low and high camera angles separate them physically, with Rachel higher than Harry, signifying good over evil. (6) Once John (Billy Chapin) confirms that Harry is a phony, the pace of the scene quickens. John grabs the doll and scrambles underneath the porch; (7) Harry pulls a knife and goes after him. The suspense and fear shift to surprise as (8) Rachel just as quickly grabs her shotgun, aims it at Harry, and scares him away. To view a clip, consult your CD-ROM.

6.2

different camera positions and angles, hard cuts, dissolves, jump cuts, and ellipses (cuts that create the visual sensation that time has elapsed; see "Conventions of Editing," below). Underscoring the resulting visual rhythm is an equally exciting sound track: a musical score of piano and drums, Lola's voice repeating "I wish I was a . . . ," and other voices chanting "Hey, hey, hey." Together, editing and sound create the steady pace of Lola's run, make us empathize with her dilemma, and establish suspense (Will Lola get the money? Will she save Manni?) that continues until the last moment of the film.

MOOD

Mood in a movie is created not only by lighting but also by editing, as discussed in the example from *The Silence of the Lambs* above and as explored further in the example from *Psycho* below. In Charles Laughton's *The Night of the Hunter* (1955; editor: Robert Golden), during the scene in which the evil Harry Powell (Robert Mitchum) confronts the good Rachel (Lillian Gish), *separation editing* (see below) is used to create the moods of suspense and fear, but adds the element of surprise to change the mood to triumph in the end.

ELLIPSIS

An *ellipsis* is an omission between one thing and another; in a quotation, for example, an ellipsis mark (. . .) signifies the omission of one or more words. In filmmaking, an **ellipsis** generally signifies the omission of time—the time that separates one shot from another—to create dramatic or comedic impact. In Gus Van Sant's *Drugstore Cowboy* (1989; editors: Curtiss Clayton and Mary Bauer), a policeman asks Bob (Matt Dillon), a heroin addict, "Are you going to tell us where you hid the drugs, or are we going to have to tear the place apart bit by bit?" When the next shot shows Bob's house torn apart, the cut implies an ellipsis of time.

SEPARATION

Separation editing cuts between two or more characters involved in simultaneous action in the same place. The characters are divided less by space than by their goals, cultural identities, or moral positions. A terrifying use of separation editing occurs in Stanley Kubrick's *The Shining* (1980; editor: Ray Lovejoy), after Wendy (Shelley Duvall) discovers Jack's (Jack Nicholson) manuscript. During their initial confrontation, both characters occupy the same frame; arguing as they walk across a vast room, they are separated in individual frames; and after mounting a short staircase, they are reunited in the frame as Wendy strikes Jack with a baseball bat. The scale and the moving camera increase the tension created by the separation editing.

In *The Silence of the Lambs* (1991; editor: Craig McKay), Jonathan Demme uses this technique differently during the scene in which Hannibal Lecter (Anthony Hopkins), imprisoned in a cage, leads Clarice Starling (Jodie Foster), talking to him from outside the cage, to reveal a moment in her life when she tried to save lambs from being slaughtered. To clearly define their spaces, the camera shoots all the medium shots and almost all the close-ups through the bars of the cage. In addition, a shot/reverse shot editing pattern (see "Conventions of Editing," below) separates the spaces and the characters. As the scene progresses, however, close-ups edge out medium shots, the camera stops moving, and the two

[1]

[2]

[3]

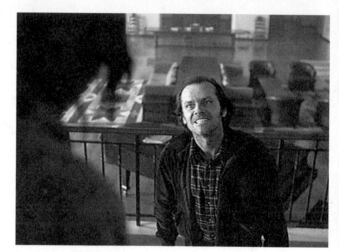

[4]

In Stanley Kubrick's *The Shining,* (1) Jack (Jack Nicholson) menaces Wendy (Shelley Duvall), and separation editing focuses attention on (2) her fear and defensiveness and (3) his gleeful, seemingly indomitable sadism. (4) But when they are "reunited," in a shot that visually parallels the first one, the fact that Wendy stands over Jack's diminished figure signals that power has shifted, and soon after she strikes him with the bat. While Kubrick reportedly spent three weeks shooting this sixteen-minute scene and redoing the entire scene in each take, seamless editing makes the action look spontaneous, as though it occurred in a single take of a single shot.

adversaries grow closer and closer, physically and emotionally. When they are almost close enough to touch, speaking softly rather than edgily, only the bars remind them (and us) of the larger scale of intellectual and ethical values that separate them.

PATTERN

Editing can build and break patterns for dramatic emphasis and impact, as in the opening of Sergio Leone's *Once Upon a Time in the West* (*C'era una volta il West,* 1968; editor: Nino Baragli). Under the opening titles, and within a fanciful graphic border at the top and bottom of the screen, the editor establishes a slow, deliberate pattern of time during which we meet three desperate-looking characters, see the isolated railroad station in which they are waiting, and listen to the sounds of a squeaking windmill, dripping water, and a buzzing fly. Suddenly, this pattern, pace, and mood are shattered by a shot— taken from a position underneath the tracks— of a train speeding toward the station. Now the pattern of editing speeds up, with cuts between close-ups of three men loading their guns. The train stops and departs, and a rapid shootout occurs, after which the editing returns to its previous languorous pattern and the sequence ends with a close-up of the slow, squeaking windmill.

SLOW DISCLOSURE

Slow disclosure is an edited succession of images that lead from A to B to C as they gradually reveal the elements of a scene. Each image sheds light on the one before, thereby changing its significance with new information. "There are two opposing forces at the root of slow disclosure," explains film theorist Stefan Sharff:

> one, the reality of the initial image; the other, the outer limits of the screen frame containing "hidden" images yet to be seen. When the limits of the frame are expanded, usually through camera movement, these forces clash. Even though the initial image, regardless how limited its scope, has an integrity of its own, there looms a possibility that outside that limited scope lies something unexpected or peculiar which might upset that integrity.[7]

The opening of *Once Upon a Time in the West* (discussed above) exemplifies slow disclosure. John Ford uses slow disclosure in *Wagon Master* (1950; editors: Jack Murray and Barbara Ford), when a gang of desperate criminals interrupts a pioneers' square dance. In this scene, through a 90-degree panning shot, we see the bad guys arriving on the scene before the pioneers see them. Thus the slow disclosure functions twice: first for us, and then for the characters, another example of dramatic irony.

CONVENTIONS OF EDITING

To create the effects described above, and to communicate through the "language" of editing, the editor has at his or her disposal a number of conventions.

[7]Stefan Sharff, *The Elements of Cinema: Toward a Theory of Cinesthetic Impact* (New York: Columbia University Press, 1982), 119–20.

[1]

[2]

[3]

[4]

[5]

[6]

In Alfred Hitchcock's *Vertigo*, (1) John "Scottie" Ferguson (Jimmy Stewart) has followed (2) Madeleine Elster (Kim Novak) into the California Palace of the Legion of Honor, an art museum, where she stares, obsessed, at a painting of the long-dead Carlotta Valdes. Match cuts (in fact, eyeline-match cuts) establish continuity between (3) Madeleine's bouquet and (4) Carlotta's; (5) Carlotta's bun and (6) Madeleine's. Through these subjective-point-of-view shots, we experience Ferguson's "detective" work. To learn more about match cuts and other editing techniques, go to <www.wwnorton.com/web/movies>.

www

ESTABLISHING SHOT

An **establishing shot** ordinarily begins a sequence of shots by showing the location of ensuing action. While usually a long shot, it may be a medium shot or close-up that includes some sign or other cue to identify the location. A basic shot on which subsequent editing is often based, it is not so much a convention of editing as a convention of cinematography that facilitates continuity editing. It is also called a *master* or *cover shot* because the editor can repeat it later in the film to remind the audience of the location, thus "covering" the director by avoiding the need to reshoot (or make *additional photography*). Establishing shots open many films in which place is paramount, including such westerns as John Ford's *Stagecoach* (1939), George Stevens's *Shane* (1953), Ford's *The Searchers* (1956), and Sergio Leone's *Fistful of Dollars* (*Per un pugno di dollari*, 1964).

MATCH CUT

A **match cut** helps create a sense of continuity between two shots. Several kinds exist, but the most basic match cut is demonstrated in Alfred Hitchcock's *Vertigo* (1958; editor: George Tomasini), when John "Scottie" Ferguson (Jimmy Stewart) places a necklace around the neck of Judy Barton (Kim Novak). This occurs in a sequence: a medium shot of Barton and Ferguson in front of a mirror as Ferguson fastens the necklace, followed by a pan right to a close-up of him looking at her reflection; cut to a pan forward to a close-up of the necklace on Barton's neck, followed by a match cut to a pan backward from a close-up of a similar necklace in a portrait.

MATCH-ON-ACTION CUT. The typical feature film offers dozens of match-on-action cuts, with most serving to create a basic sense of continuity. Any time a character reaches for something, sits down, walks, or runs, an editor may choose to cut in the middle of one of these physical actions to accentuate the viewer's sense of continuity. Match-on-action cuts might, however, be used not for perfect continuity of time and space but for dramatic and stylistic effects. Imagine a director who wanted to show a long-distance runner's training over an entire year. The director could film the runner in various types of weather and locations and then use match-on-action cuts (cutting, say, every time the runner steps forward with her right foot) to create a montage that was continuous in action and theme (but not space or time). The result might be a visually interesting scene that compresses a great deal of story time in a brief sequence. Perhaps the most audacious and memorable example of a **match-on-action cut**—one in which the action continues seamlessly from one shot to the next—occurs in the prologue of Stanley Kubrick's *2001: A Space Odyssey* (1968; editor: Ray Lovejoy) with a cut that erases millions of years, from a bone weapon of the Stone Age to an orbiting scientific station from the Space Age. The weapon and the station match not only in their tubular shapes but also in their rotations.

GRAPHIC MATCH CUT. The cut in *2001: A Space Odyssey* from oblong white bone to oblong white space station is also a graphic match. In this type of cut, the shape, color, or texture of objects matches across the edit, providing continuity. Graphic matches often exploit basic shapes—squares, circles, triangles—and provide a strong visual sense of design and

[1]

[2]

[3]

In Stanley Kubrick's *2001: A Space Odyssey,* match-on-action cutting enables humanity to rocket from prehistory into outer space. (1) An "ape-man" rejoices in his newfound weaponry, a bone, by (2) tossing it into the air, at which point it becomes (3) technology of a far more sophisticated kind. This astonishing leap of sight, space, and time introduces several of the movie's principal themes: the relativity of time, the interaction of inventiveness and aggressiveness, and the human race's desire to conquer the unknown. To view a sequence of stills from this scene, go to <*www.wwnorton.com/ web/movies*>.

6.3

order. In *Bram Stoker's Dracula* (1992; editors: Anne Goursaud, Glen Scantlebury, and Nicholas C. Smith), Francis Ford Coppola uses a number of graphic matches based on the form of the circle—full moon, eyes, round glass—to visually imply the omnipotent force of vampirism running throughout the world of his story. Most memorably, at the end of the shower sequence in *Psycho* (1960; editor: George Tomasini), Hitchcock matches the eye of Marion Crane (Janet Leigh), tears streaming down, with the round shower drain, blood and water washing down, a metaphorical visualization of Marion's life ebbing away.

EYELINE-MATCH CUT. The **eyeline-match cut** joins shot A, a point-of-view shot of a per-son looking offscreen in one direction, and shot B, the person or object at which he or she is looking. In Irving Rapper's *Now, Voyager* (1942; editor: Warren Low) Jerry Durrance (Paul Henreid) lights two cigarettes, one for him, the other for Charlotte Vale (Bette Davis). As he hands one to her and looks into her eyes, an eyeline-match cut joins a shot of her eyes looking into his.

POINT-OF-VIEW EDITING

As we saw in the discussion of the point-of-view shot in *The Birds* (see "Point-of-View Shot" in chapter 4), **point-of-view editing** is used to cut from shot A (a point-of-view shot, with the character looking toward something

offscreen) directly to shot B (using a match-on-action shot or an eyeline-match shot of what the character is actually looking at). In another Alfred Hitchcock film, *Rear Window* (1954; editor: George Tomasini), the director uses a similarly complex mix of framing, cinematography, and editing to tell his story and create meaning. The narrative of *Rear Window*, a thriller, concerns L. B. "Jeff" Jeffries (Jimmy Stewart), a magazine photographer who is temporarily sidelined by a broken leg; as a result, he sits near the window of his Greenwich Village apartment and watches the activities of his neighbors, one of whom he believes has committed a murder. The movie is all about what constitutes the boundaries of our perceptions and how ordinary seeing can easily become snooping, even voyeurism. The words of the opening titles are framed within a three-panel window frame, in which blinds are raised automatically to reveal the setting outside; this frame-within-a-frame (or inner frame) is used throughout the movie, determining what we see and further defining the idea of perception that is at its core.

In the first shot after the titles conclude, the camera zooms out from a room (we'll soon learn that this is Jeffries's room) through the window to begin three semicircular "tours": the first, which takes a cursory view of the backyard area behind large apartment buildings, quickly returns to its first glimpse of a sleeping man. The second, in which the very mobile camera moves and lingers as it once again surveys the backyard area, introduces us to some of the neighbors with telling details of their lives; again, it returns to the sleeping man and pans down to show us his leg in a cast, on which his name has been written. The third, in which the camera becomes inclined to probe the details of this man's life, establishes that Jeffries is a photographer. After this prowling and snooping, all of which takes place while Jeffries sleeps, this omniscient camera (now outside again) looks through the window into Jeffries's room and shows him sitting up and shaving with an electric razor. As he answers the telephone and talks with his editor, a series of alternating shots follow an ABAB pattern: shot A (omniscient camera views Jeffries from a low angle looking out the window) followed by shot B (camera shows us what Jeffries is looking at: the neighbors going about their morning activities), and so on. Thus Hitchcock uses two basic camera points of view: omniscient camera POV and the character's POV, sometimes heightened by Jeffries's use of his binoculars or his camera's telephoto lens. These POVs complement, even mirror, one another, and are reinforced by the point-of-view editing, which continually keeps us aware of one of the movie's developing meanings: not to trust completely what anyone or any camera sees.

PARALLEL EDITING

Parallel editing (also called *cross-cutting* and *intercutting*) is the cutting together of two or more lines of action that occur simultaneously, a very familiar convention in chase or rescue sequences (as we have seen earlier in Griffith's *Way Down East;* see "Forms and Patterns" in chapter 2). In *Raising Arizona* (1987; editor: Michael R. Miller), Joel Coen uses it to excellent comic effect during a scene in which Hi (Nicolas Cage), aided by his wife, Ed (Holly Hunter), tries to escape from the police. During the chase, Coen cuts among shots of the couple, the police, convenience store employees, neighbors, and a multitude of dogs.

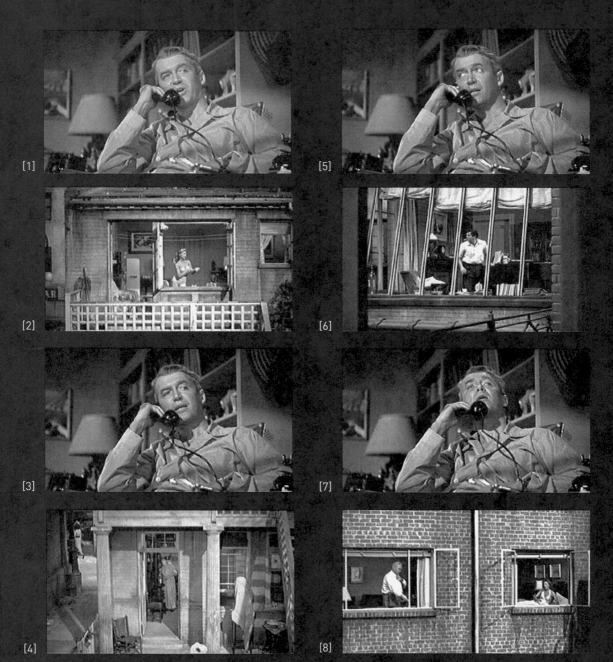

Alternating subjective and omniscient POVs in Alfred Hitchcock's *Rear Window:* (1, 3, 5, 7) From his wheelchair, L. B. "Jeff" Jeffries (Jimmy Stewart) observes his neighbors: (2) a dancer (Georgine Darcy), known as Miss Torso; (4) a sculptor (Jesslyn Fax), known as Miss Hearing Aid because she adjusts hers to silence the noise of Miss Torso's dancing; (6) a songwriter (Ross Bagdasarian); and (8) Lars Thorwald (Raymond Burr) and his wife, Anna (Irene Winston). To view stills of the various POVs in *Rear Window*, go to *<www.wwnorton.com/web/movies>*.

SHOT/REVERSE SHOT

A **shot/reverse shot**, one of the most common and familiar of all editing patterns, cross-cuts between shots of different characters, usually in a conversation or confrontation. When used in continuity editing, the shots are typically framed over each character's shoulder to preserve screen direction. Thus in the first shot, the camera is behind character A, who is looking right, and records what character B says to A; in the second shot, the camera is behind character B, who is looking left, and records that character's response. The opening scene before the credits in Quentin Tarantino's *Pulp Fiction* (1994; editor: Sally Menke), a conversation between Pumpkin (Tim Roth) and Honey Bunny (Amanda Plummer), begins with a low-angle medium shot of both characters in the frame. This establishes the coffee shop setting, including the location of the booth in which the characters are sitting. After discussing robberies in general, Pumpkin and Honey Bunny decide to rob the coffee shop; as they talk, the shots cut between close-ups and medium shots of each of them. Thus the more specific the discussion becomes about what and how to rob, the more specific the shots, and the more rhythmic the cutting. When the two finally jump up, waving pistols and announcing their robbery, they are reunited in the frame.

JUMP CUT

The **jump cut** presents an instantaneous advance in the action—a sudden, perhaps illogical, often disorienting ellipsis between two shots caused by the removal of a portion of the film. Because such a "jump" in time can occur either on purpose or because the filmmakers have failed to follow continuity principles, this cut has often been regarded more as an

[1]

[2]

[3]

[4]

In movies and on television, shot/reverse shot sequences are ubiquitous: the camera cuts back and forth between characters conversing. In *Pulp Fiction*, Quentin Tarantino breathes new life into the convention by speeding up the pace of the editing as (1) Pumpkin (Tim Roth) and (2) Honey Bunny (Amanda Plummer) accelerate their exchange. The shot/reverse shot sequence alternates these perspectives until, their plan finalized, (3) the couple kisses and (4) springs into action.

error than as an expressive technique of shooting and editing. Jean-Luc Godard employs the jump cut effectively in *Breathless* (*À bout de souffle,* 1959; editor: Cécile Decugis) when Michel (Jean-Paul Belmondo) takes off after killing a policeman. In *Mother* (1996; editor: Harvey Rosenstock), Albert Brooks employs a sequence of jump cuts when John Henderson (Brooks) returns to his mother's house and restores his old bedroom to the way it looked when he was in high school. In *Buffalo '66* (1998; editor: Curtiss Clayton), Vincent Gallo uses such a sequence to emphasize the extreme physical discomfort that Billy Brown (Gallo) feels as he tries vainly to find an open men's room in a bus station.

FADE-IN AND FADE-OUT

The **fade-in** and **fade-out** are transitional devices in which a shot made on black-and-white film fades in from a black field (on color film, from a color field) or fades out to a black field (or to a color field). They can be used within a scene, as in James Foley's *After Dark, My Sweet* (1990; editor: Howard Smith)—where shots of a passionate sexual encounter between Kevin (Jason Patric) and Fay (Rachel Ward) are separated by four fades in and out—or between scenes, as in Ingmar Bergman's *Cries and Whispers* (*Viskningar och rop,* 1972; editor: Siv Lundgren). In this dreamlike movie, set in a large manor house, Agnes (Harriet Andersson) is dying, attended by her two sisters, Karin (Ingrid Thulin) and Maria (Liv Ullmann), and a servant, Anna (Kari Sylwan). Color is central to understanding the film, with red not only predominant but also a key to its meanings, suggesting the cycles of life, love, and death with which the story is concerned. Whole rooms are painted red, and the plot, which moves back and forth across the lives of these women, is punctuated with frequent fades to a completely blood-red screen (sometimes, the next scene begins with a fade-in from such a red screen). As a child,

In *Cries and Whispers*, Ingmar Bergman builds the emotional intensity of his story by cutting back and forth between scenes of the past and the present and ending most of those scenes with a fade-out to a blood-red screen. Bergman has said that he thinks of red as the color of the human soul, but it also functions here as a symbolic system that has much to do with the film's focus on women. Just before this brief scene, Agnes (Rosanna Mariano, playing her as a child) has been hiding behind a curtain watching her mother (Liv Ullman playing two roles: Agnes's sister and their mother); when her mother sees Agnes, she summons the girl to her side. Agnes fears that she will be reprimanded, but instead Bergman gives us a moment of great simplicity and tenderness that unfolds in three shots: (1) Agnes touches her mother; (2) her mother is moved by the caress; (3) the screen fades to the blood-red screen. Can we find words to explain the purpose of this fade-out to red?

[1]

[2]

Agnes felt that her mother loved her sisters more, and in a brief scene, she remembers a tender moment in which she touched her mother's face (such touching of faces is another motif throughout the film), after which the screen fades to red. Do not confuse a fade with a *dissolve* (see below).

DISSOLVE

Also called a *lap dissolve,* the **dissolve** is a transitional device in which shot B, superimposed, gradually appears over shot A and begins to replace it midway through the transitional process. Vincente Minnelli's *Meet Me in St. Louis* (1944; editor: Albert Akst) begins with a black-and-white photograph dissolving to a live-action scene in color. The device usually indicates the passing of time, as in John Ford's *My Darling Clementine* (1946; editor: Dorothy Spencer), where a discussion between

[3]

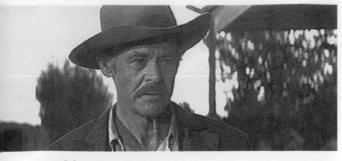

[1]

[2]

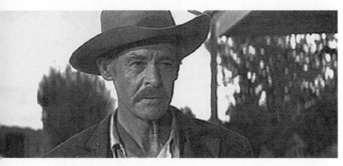

[3]

[4]

In Sam Peckinpah's *The Wild Bunch* (1969; editing: Louis Lombardo), a western famous for its extreme slow-motion and fast-motion editing, (1) a medium close-up of Deke Thornton (Robert Ryan) dissolves to (2) an apparent memory of a whipping, dissolves back to (3) the primary shot, and then quickly dissolves again to (4) a transitional scene of men on horseback. Movies generally employ dissolves like these and straight cuts far more often than they use fades or other transitional devices, such as wipes, iris-ins, and iris-outs.

Wyatt Earp (Henry Fonda) and his brothers ends with a dissolve to a noisy saloon in town. James Whale's *Bride of Frankenstein* (1935; editor: Ted Kent) uses a dissolve that covers a greater ellipsis. In daylight, the Monster (Boris Karloff) leaves a burning house, travels on a forest path, and encounters a group of girls, who scream and run away; after a dissolve to night, we see the Monster staggering through a graveyard.

WIPE

The **wipe** is a transitional device in which shot B wipes across shot A, either vertically or horizontally, to replace it. Although (or because) the device reminds us of early eras in filmmaking, directors continue to use it. For example, in *Star Wars* (1977; editors: Paul Hirsch, Marcia Lucas, and Richard Chew), George Lucas refers to old-time science fiction serials by using a right-to-left horizontal wipe as a transition between the scene in which Luke Skywalker (Mark Hamill) meets Ben (Obi-Wan) Kenobi (Alec Guinness) and a scene on Darth Vader's (David Prowse) battle station.

IRIS-IN AND IRIS-OUT

Iris-in and **iris-out**—named after the *iris diaphragm,* which controls the amount of light passing through a camera lens—are optical wipe effects in which the wipe line is a circle. The iris-in begins with a small circle, which expands to a partial or full image; the iris-out is the reverse. When used to open out or close down to a partial image, it can approximate a close-up that is isolated within an otherwise dark frame. Employed to great advantage by D. W. Griffith and other early filmmakers, this effect is less widely used today because of the fluidity with which editors can cut between close-ups and other shots, but it remains a very expressive design figure. In *The Night of the Hunter* (1955), Charles Laughton uses the iris-in both for its own sake and perhaps as an homage to Griffith and actress Lillian Gish, who was featured in many of Griffith's films and plays a leading role here. During the opening title sequence of Alfred Hitchcock's *Vertigo* (1958; editor: George Tomasini), title designer Saul Bass uses variations on the iris-in and iris-out graphic motif to signal two themes of the movie: perception and voyeurism (both of which are among Hitchcock's most prevalent concerns; see the discussion of *Rear Window* above and "Alfred Hitchcock's *Psycho*," below).

FLASHBACK AND FLASHFORWARD

The *flashback* and *flashforward* are among the most familiar means of manipulating time, particularly story duration, in movies. The **flashback**—a device for presenting or reawakening the memory of the camera, a character, the audience, or all three—is a cut from the narrative present to a past event, which may have already been presented to the viewer in the movie either directly or by inference. If a scene from the past is repeated directly (i.e., just as we saw it before), everything remains the same, including the camera point of view. However, if the flashback returns to the scene through the point of view of a character, the scene changes by becoming subjective. In Martin Scorsese's *Raging Bull* (1980; editor: Thelma Schoonmaker), a black-and-white film, the flashbacks (to memories preserved in home movies) are in color. By contrast, the **flashforward**—a device for presenting the anticipation of the camera, a character, the audience, or all three—is a cut from the narrative present to a future time, one in which, for example, the omniscient camera reveals directly or a character imagines, from his or her point of view, what is going to happen. In Lasse Hallström's *My Life as a Dog* (*Mitt liv son hund,* 1985; editors: Christer Furubrand and Susanne Linnman), Ingemar (Anton Glanzélius) thinks about the dog, Laika, sent into space by the Russians, and the film flashes forward into the starry nighttime sky. Later, the film flashes back to happier times Ingemar spent with his mother at the beach. Dissolves often precede or end flashbacks/flashforwards. Thus when used together by long-established cinematic conventions, the flashbacks/flashforwards inform us that the narrative is going backward or forward in time; the dissolves, which remind us that what we see is the result of a character's memories or thoughts, also suggest, through the haziness that results from the superimposition of shots, that those thoughts and memories may themselves be affected by time.

FREEZE FRAME

The **freeze frame** (also called *stop frame* and *hold frame*) is a still image within a movie, created by repetitive printing in the laboratory of the same frame so that it can be seen without movement for whatever length of time the filmmaker desires. It stops time and functions somewhat like an exclamation point in a sentence, halting our perception of movement to call attention to an image. It momentarily stops violence in Martin Scorsese's *Goodfellas* (1990; editor: Thelma Schoonmaker), in the sequence that begins with young Henry Hill (Christopher Serrone) doing odd jobs for the mob, his offscreen narration telling us that this makes him feel like a grown-up. At home, when Henry lies about his school attendance, his father (Beau Starr) savagely beats him with a belt. During a freeze frame that suspends the beating, Henry continues his narration; when the freeze frame ends, the violence resumes. The effect is ironic: while the film "stops" the violence (as Henry's mother cannot) so that we linger on its wrath, the boy continues his narration in a matter-of-fact voice that suggests he knows domestic and mob violence to be now part of his life. The freeze frame can also be used to conclude a sequence or movie in an unresolved state, as in François Truffaut's *The 400 Blows* (*Les quatre cents coups*, 1959; editor: Marie-Josèphe Yoyotte), where a poignant freeze-frame close-up of young Antoine Doinel (Jean-Pierre Léaud) not only stops his movement on a beach but also points toward the uncertainty of his future.

In the final moments of François Truffaut's *The 400 Blows,* Antoine Doinel (Jean-Pierre Léaud), having escaped from reform school, arrives at a beach. Doinel runs along the shore, the camera following, until he abruptly turns and heads straight toward the camera. The freeze frame that ends the movie clearly doesn't tell us where Doinel goes next, but it conveys just how unsure he feels, here and now, about the possibilities that surround him. As Godard's *Breathless* (see the still on p. 322) popularized the jump cut, so *The 400 Blows* brought a new wave of freeze frames to countless movies.

[1]

[2]

[3]

YANKEE RACERS
FOUNDER

[4]

In Wes Anderson's *Rushmore,* these four shots and seventeen others, in quick succession, illustrate at least *some* of the extracurricular activities that keep Max Fischer (Jason Schwartzman) from his studies. While montages like this one clearly cut across space and time as they present glimpses of different events, others, such as the drug-related ones in Darren Aronofsky's *Requiem for a Dream* (see p. 297), condense single events into spatial and temporal fragments.

with multiple, superimposed full-size images; and ends, as it began, on a single screen.

In *Edward Scissorhands* (1990; editors: Colleen and Richard Halsey), Tim Burton uses multiple-framing, a flashy in-camera variation on the split-screen, in which we see one or more frames within the frame. As Peg (Dianne Wiest), an "Avon lady" having an unsuccessful day, sits in her car deciding which "housewife" to visit next, she adjusts her rearview mirror. In a multiple-framing, the mirror shows two images: in part of the frame, a Gothic castle looming over the town; in the other part, Peg's face reflecting her decision to make the castle her next destination. The film's vibrant color palette enlivens the frame. Similarly, but in black and white, the opening-titles sequence of Nicholas Ray's *In a Lonely Place* (1950; editor: Viola Lawrence) introduces us to Dixon Steele (Humphrey Bogart), the lead character; with the camera placed over his shoulder, his face is reflected in the rearview mirror of the convertible he is driving, and because it is dark, this small framing of his face, gently lit, dominates the frame.

MONTAGE

In France, *montage* is the word for editing, from the verb *monter*, "to assemble or put together." In the former Soviet Union in the

[1]

[2]

Screen space is fluid throughout Michael Wadleigh's *Woodstock* (1970; editors: Jere Huggins, Thelma Schoonmaker, Martin Scorsese, Michael Wadleigh, Stanley Warnow, and Yeu-Bun Yee), a nonfiction film that documents the historic three-day festival of "peace, music, and love." (1) During Santana's performance, a split-screen triptych shows the crowd and two views, a medium shot and a close-up, of drummer Michael Shrieve. (2) A split-screen diptych pits "hippie" audience members, free-spiritedly bathing, against one of the local townspeople, a police officer. Even single images appear in any number of sizes and positions, echoing the loose, multiform event

SPLIT-SCREEN

The **split-screen,** which may be created in the camera or during the editing process, is similar to parallel editing in its ability to tell two stories at the same time. Unlike parallel editing, however, which cuts back and forth between shots for contrast, the split-screen can tell multiple stories within the same frame. In *Napoléon* (1927; editor: Marguerite Beaug[Abel Gance introduced Polyvision, a mu screen technique (see "Duration" in cha 2), as in the epic pillow fight betwee young Napoleon and other boys in school dormitory. The fight begins on a screen; continues on a screen split in equal parts, then on one split into nin parts; reaches its climax on a single

1920s, *montage* referred to the various forms of editing that expressed ideas developed by Eisenstein, Kuleshov, Vertov, Pudovkin, and others (see "Sergei Eisenstein's *Battleship Potemkin*," below, and "Form and Patterns" in chapter 2). In Hollywood, beginning in the 1930s, **montage** designated a sequence of shots, often with superimpositions and optical effects, that shows a condensed series of events. For example, a ticking clock might be superimposed with flipping calendar pages or the rapid movements of pedestrians. In Wes Anderson's *Rushmore* (1998; editor: David Moritz), after the headmaster identifies Max Fischer (Jason Schwartzman) as "one of the worst students we've got," a twenty-one shot montage shows Max as the key person in virtually every club at the school.

CONVENTIONS OF EDITING IN MARK SANDRICH'S *TOP HAT*

To view these conventions in action, let's consider a scene from Mark Sandrich's *Top Hat* (1935; editor: William Hamilton), one of the great comic dance films featuring Fred Astaire and Ginger Rogers. In a prelude to one dance, Jerry Travers (Astaire) and Horace Hardwick (Edward Everett Horton) stay up late discussing the idea of marriage; this opening section of the scene uses shot/reverse shots (high angles for shots of Hardwick; low angles for shots of Travers) to keep their conversation going. Looking down at Hardwick, who is seated, Travers begins to sing "Fancy Free"; when he reaches the end of the first chorus ("free for anything fancy"), he turns toward the tray of liquor and glasses behind him. A match-on-action cut takes us to the next shot, in which Travers mixes himself a drink, all the while continuing the song. To impress Dale Tremont (Rogers), a beautiful woman in

the suite directly below (with whom he has not yet had much luck), Travers begins dancing, knowing that the noise will get her attention. With brief cross-cuts to Tremont, Hardwick, and the manager of the hotel, Travers is photographed with a moving camera in eleven long takes/long shots that record the movements of his full body and preserve the full temporal duration of his dance.

Thus the classical editing produces almost seamless spatial and temporal continuity as it combines the long takes/long shots, cross-cuts, match-on-action cuts, and shot/reverse shots, as well as the diegetic sounds of Travers singing onscreen and an orchestra playing offscreen. Working closely with the director, art director, and cinematographer (who, in turn, have worked very closely with Astaire), the editor has given shape to cinematic space and time. The result is seemingly effortless magic.

EDITING AND POSTPRODUCTION

Editing a movie is usually a long, painstaking process involving many decisions, which, stage by stage, produce different versions of the movie that range from crude forms used in the early stages of editing to the print we see in a movie theater. The editor does not have to wait until shooting is complete to get an idea of how to deal with the challenges to come. Ordinarily, he or she regularly receives footage known as *dailies* or *rushes* from the processing laboratory. (The camera uses negative film stock that produces footage with negative images, meaning that the dark and light areas are reversed. The motion picture–processing laboratory takes these negative images and

prints them onto print stock, which produces footage with positive images, the way we see them onscreen.) These dailies (which usually contain picture and sound in roughly synchronized form) can be studied by the director, editor, and other crew members before the next day's shooting begins. Reviewing the dailies carefully can avert costly reshooting later. Even as the film is being shot, the director may instruct an assistant to "print" a take that looks likely to be in the completed film. For example, if a shot has run to eight takes, the director might ask that takes 3, 6, and 7 be printed. Greatly aiding this process is the video assist camera (see "Costume, Makeup, and Hairstyle" in chapter 3), which enables the filmmakers to instantly view a shot that has been captured simultaneously on film (or digital videotape) and on the videotape in this companion camera, which is aligned to record the shot exactly the way the principal camera does. Such viewing increases the likelihood that shots printed and sent to the lab will be what the director intends. Once the shooting is completed and the chosen takes have been printed, the result is known as the **workprint,** any positive print (either picture or sound or both) intended for use in the initial trial cuttings of the editing process. This work print has not yet been timed or color-corrected. (Today, most often the selected takes are transferred directly to digital video and synched up for digital editing. A workprint is struck only if editing will be done on film, not video. Otherwise, the process described here is basically the same for movies edited digitally on a computer or in the traditional way on a flatbed or other editing equipment.)

An assistant editor then synchronizes the workprint with the appropriate dialogue or whatever sound was recorded at the time the film was shot. All the synched-up shots are then spliced together on film, or sequenced on tape through a *nonlinear digital editing system* such as Avid (see "The Editor's Tools," below). At this point, the editor and the director (usually working together) select which takes (called **selects**) will be kept. To return to the previous examples: they might decide to eliminate take 6 and keep takes 3 and 7 (eventually, only take 3 or take 7 will be used). The result is the **assembly edit,** a preliminary version of the movie, in which sequences and shots are arranged in approximate relationship without further regard to rhythm or other conventions of editing. Then begins the intercutting, adjusting, experimentation with alternatives, timing, and rough sound cutting. Once they have something watchable—an idea of what the movie is going to feel like—they have a **rough cut**, which serves as the "rough" guide as the editing process continues.

Next, the editor, usually working together with the director and other key creative personnel, creates a **fine cut,** which takes its name from fine-tuning the rough cut (through as many versions as necessary). Following this, the editor creates the final edited version of the film, known as the **final cut,** by mixing the sound tracks, inserting the desired optical or special effects, fine-tuning the rhythm of the film, balancing details and the bigger picture, bringing out subtleties and masking flaws, and approving the fidelity and acoustic quality of the mixed sound. Material not used so far is cataloged and saved as **outtakes.** Again, the principal collaborators will review and discuss this version, making whatever modifications (usually minor) they deem necessary. At this crucial stage, they "lock" the picture, meaning that no further changes will be made; this is the **locked print**. Now, an editor can cut the original negative to conform to this print; from that **negative cut**, an **answer**

print is made. This version is "timed" by experts in the lab, usually working with the director of photography and sometimes even the director. Timing means adjusting exposure and color, usually in a series of answer prints, until they are satisfied that everything looks as it should. The result is the **final print**, from which are made the hundreds, even thousands of costly positive **release prints** for theaters around the country and the world. (Once a move is ready for distribution, a **cutting continuity script** is prepared; this specialized document not only reflects the changes made between the shooting script and the actual shooting but also includes the number, kind, and duration of shots; the kind of transitions; the exact dialogue; and the sound and musical effects. This final version provides a record of the form and content of the film as released.)

Because the process is so time consuming, a good editor must love the work. He or she must be painstaking, well-organized, disciplined, strong enough to resist the weariness that comes from a meticulous attention to details, able to work alone for long stretches of time, and willing to take as much time as necessary to fulfill the director's vision. In short, a good editor practices a rigorous craft. But even in a well-planned production, where the director has a clear vision of what to shoot and how it will look, the editor can face problems. Most of these are small, resulting in the inevitable outtakes or reshooting. However, the postproduction problems that really challenge editors, the ones we read about in the press, tend to be extreme examples. For example, pioneer nonfiction filmmaker Robert Flaherty had a history of the uncontrolled shooting that can result from not knowing what you want the camera to photograph or what you want the editor to do with the result. Helen Van Dongen's account of editing Flaherty's

Louisiana Story (1948) provides a cautionary tale for anyone who wants to make or edit movies.[8]

More recently, Walter Murch and his editing team on Francis Ford Coppola's *Apocalypse Now* (1979) worked for two years, eventually shaping 370 hours of footage—a record unprecedented in film history—into a movie that runs two hours, thirty-three minutes. They gave narrative shape to what many people, including at times Coppola, considered the director's massive self-indulgence (see Fax Bahr, Eleanor Coppola, and George Hickenlooper's documentary about the making of the film, *Hearts of Darkness: A Filmmaker's Apocalypse*, 1991). In 2001, Coppola and Murch recut the film, restoring forty-nine minutes of the original footage, adding new music to that footage, and releasing *Apocalypse Now Redux*—a new version and *vision* that, set alongside the original, enables us to look into the heart of filmmakers' choices. (*Apocalypse Now* and *Apocalypse Now Redux* are the suggested case study for chapter 7.)

Everyone who has edited a film has his or her own explanation of what editing is and what an editor does. Alan Heim, the editor of such films as Sidney Lumet's *Network* (1976), Milos Forman's *Hair* (1979), Bob Fosse's *All That Jazz* (1979), and Robert Benton's *Billy Bathgate* (1991), puts it very simply:

> It's not like cinematography where you have to know technical things. We really know very little, we go by intuition. There's a certain dramatic sense that you develop in going to the theater, from reading books. I think life

[8]See Helen Van Dongen, "*Louisiana Story:* Notes during the Production," in Durant, *Filming Robert Flaherty's "Louisiana Story,"* 21–74; see also Van Dongen, "Three Hundred and Fifty Cans of Film," in *The Cinema 1951,* ed. Roger Manvell (London: Penguin, 1951), 57–78.

plays a great part in being a good editor. You're always working with the emotion. You have to open yourself to the material. You can't force film.[9]

THE EDITOR'S TOOLS

Predigital editing equipment was fairly simple. The editing team needed at least one room, with plenty of flat working space on which to cut apart and then tape together the footage being used (this cut-and-tape process is known as *splicing*), viewers, synchronizers, sound-editing equipment, and space for racks and bins to store the outtakes. Today, the editing room will most likely be equipped with computers, monitors, and devices with large-capacity disks for storage. The evolution of editing equipment has occurred in four basic stages: *editing with rudimentary equipment, editing with upright and flatbed machines, linear editing with videotape,* and *nonlinear digital editing with computerized equipment.*

EDITING WITH RUDIMENTARY EQUIPMENT AND WITH UPRIGHT AND FLATBED MACHINES

The first editing was a slow, simple process in which the film editor used scissors to cut apart pieces of exposed, processed film and employed transparent adhesive tape to put them back together. This method of editing remained the industry standard until the mid-

1920s. After the establishment of the studio system, the industry sought to improve key aspects of production and postproduction and to make editing a less tedious and more efficient process. Two major improvements combined to bring real change. First was the invention of the **Moviola,** for years the most familiar and popular upright editing machine. A portable device, operated by foot pedals and leaving the editor's hands free, it is based on the same technical principle as the movie projector and contains a built-in viewing screen. Both sound and picture can be edited, separately or together. Next came the **splicer,** which provides

For William Wyler's *Wuthering Heights* (1939), editor Daniel Mandell runs footage through a Moviola. Although the Moviola, introduced in 1930, has been almost wholly replaced by flatbed and nonlinear digital editing equipment, many editors (including Anne V. Coates—who edited David Lean's *Lawrence of Arabia* [1962], David Lynch's *The Elephant Man* [1980], and Adrian Lyne's *Unfaithful* [2002]) use it for various tasks because it enables them to get to know the film material in a more tactile way.

[9]Alan Heim, qtd. in Gabriella Oldham, *First Cut: Conversations with Film Editors* (Berkeley: University of California Press, 1992), 381.

an edge for cutting film evenly on a frame line and a bed on which to align and tape together cuts that will be invisible to the audience. The **automatic splicer** is a later, even more efficient version of this device.

The **flatbed,** another type of editing machine, is a table on which the reels are pulled horizontally from left to right. Several companies manufacture flatbeds, including Steenbeck, Moviola, and KEMs. Each type of editing machine—upright and flatbed—has its advantages and disadvantages, depending on editors' preferences, and editors are very particular about their equipment. Some prefer the upright for 35mm film stock and the flatbed for 16mm film stock; some prefer the upright for ease of use but the flatbed when they need its larger viewing screen; some prefer one for cutting sound, the other for cutting pictures.

A screen shot from Avid editing software shows a color image and technical specifications for that image. To learn more about editing technology, go to <www.wwnorton.com/web/movies>.

LINEAR EDITING WITH VIDEOTAPE

The development of **linear editing** was a transitional step between the upright and flatbed machines and today's cutting-edge (again, pun intended) editing technology. In principle, storing images in the *linear* system means recording the footage on videotape in a straight line, each shot occupying an amount of space equal to its length in time. Thus editing any shot—deleting, lengthening, or shortening it, or placing it somewhere else in the straight line of the tape—is very time-consuming, because everything that follows has to be re-edited on that "line." Although linear editing was a major breakthrough in editing, the linear storage of images on videotape was a major disadvantage.

NONLINEAR DIGITAL EDITING WITH COMPUTERIZED EQUIPMENT

The disadvantages of linear editing have largely been rendered moot by the invention of **nonlinear digital editing,** which relies on computerized equipment such as the Avid or Lightworks systems. If you have used both a typewriter and a word-processing program on a computer, you will understand one difference between the linear and nonlinear systems of editing. When you write on a typewriter, each word, sentence, and paragraph occupies a fixed amount of space. If you wish to change any of these—for example, move a paragraph from the first page to the third—you have to retype the document to preserve the flow and appearance of your work. If you

write the same document on a word processor, you can cut and paste words, sentences, and paragraphs any way you want. You can prepare as many alternate versions as you wish, then choose the most suitable one. Your options are virtually unlimited, and in that sense, the word processor makes you a better writer because it makes you a more flexible writer.

In principle, storing images (shots, scenes, sequences) in the nonlinear system is just like storing words (or documents) on the hard drive of a computer. The images, stored on the computer's internal disk, can be accessed easily from their random locations as the computer responds to the editor's commands. This process frees the editor from the painstaking care needed to deal with the clumsiness of the linear system and thus enables him or her to imagine the movie—and any scene in it—in any form. The editor can provide the director with different versions of any scene with the same ease that you can produce different versions of your writing. Both the editor and the director benefit from this flexibility.

The advantages of nonlinear editing with digital equipment are thus considerable: it is faster, saves money both by reducing steps in producing the workprint and requiring a smaller crew, provides easier access to the material, offers modern working conditions, and makes it possible to preserve different versions of the movie, to transmit images or the entire movie via satellite or the Internet, and to easily integrate electronic special effects into the movie. Some editors still prefer the tactile pleasures of working with a Moviola or flatbed, both of which remain available. Within the next decade, however, the "film" cameras, processing and editing equipment, and projectors used for professional film-making will in all likelihood be completely replaced by digital equipment, and the film stock itself—the celluloid material that has for more than one hundred years passed through this equipment—will disappear from new productions.

ANALYZING FILM EDITING

When you watch a movie, you *see* the mise-en-scène, design, and acting; you *hear* the dialogue, music, and sound effects; but you *feel* the editing, which has the power to affect you directly or indirectly. Good editing—editing that produces the filmmakers' desired effects—results from the editor's intuition in choosing the right length of each shot, the right rhythm of each scene, the right moment for cutting to create the right spatial, temporal, visual, and rhythmic relationships between shots A and B. In answer to the question "What is a good cut?" Walter Murch says,

> At the top of the list is Emotion . . . the hardest thing to define and deal with. *How do you want the audience to feel?* If they are feeling what you want them to feel all the way through the film, you've done about as much as you can ever do. What they finally remember is not the editing, not the camerawork, not the performances, not even the story—it's how they felt.[10]

As a viewer, you can best understand the effects of an editor's decisions by studying a film as a creative whole. But you can most effectively *analyze* an editor's contributions to distinct parts of a film by examining individual scenes. Indeed, the principles of editing are

[10]Murch, *In the Blink of an Eye*, 18.

generally most evident within the parts that make up the whole. In the following examples, we'll explore the relationships between parts and wholes, between editors' decisions and directors' visions, between seeing and feeling. Above all, we'll look at how editing decisions help create meaning.

D. W. GRIFFITH'S
THE BIRTH OF A NATION

To help free the cinema from the technical and artistic limitations of the static "filmed theater" of his day, D. W. Griffith employed a moving camera; to ensure the continuity of screen direction and keep the spectator properly oriented, he helped perfect the 180-degree system; to simulate depth in shots, he experimented with lighting; and to vary points of view, he explored camera angles. He introduced a balance in shooting and cutting between long, medium, and close-up shots; introduced the *cut-in* from, say, an extreme long shot (action) to a close-up (reaction); and introduced the flashback. As an innovator, Griffith cared not only about what happened *within* shots (intraframe narrative) but also about what happened *between* shots (interframe narrative). In other words, he focused on both story (content) and editing (form).

Griffith's staging and editing of the assassination of Abraham Lincoln in *The Birth of a Nation* (1915; editors: Griffith, Joseph Henabery, James Smith, Rose Smith, Raoul Walsh) consists of thirty-nine shots running just under 3 1/2 minutes. Figure 6.1, an excerpt from the cutting-continuity script, indicates the length of each shot and thus the rhythm of the sequence. Griffith controls the dramatic tension by using short shots (the *average* length is 5.1 seconds). He rarely carries the action over from shot to shot, but instead pre-sents a cumulative series of details from different viewpoints. According to British film editor and director Karel Reisz, who has written extensively on editing, this style of editing has two advantages:

> Firstly, it enables the director to create a sense of depth in his narrative: the various details add up to a fuller, more persuasively life-like picture of a situation than can a single shot, played against a constant background. Secondly, the director is in a far stronger position to guide the spectator's reactions, because he is able to *choose* what particular detail the spectator is to see at any particular moment. . . .
>
> Griffith's fundamental discovery, then, lies in his realisation that a film sequence must be made up of incomplete shots whose order and selection are governed by dramatic necessity.[11]

Through cinematography, Griffith shows us the assassination, one of the most wrenching events in United States history. Through editing, he makes us feel the fateful pace with which the sequence occurs. In both ways, he encourages us to participate in the event vicariously. Any competent depiction of Lincoln's murder, after all, should evoke feelings of some kind, but the manner of the depiction—the dramatic and stylistic form—will shape those feelings. The storytelling, not the story itself, makes meaning. Thus Griffith records the scene, a gala performance to celebrate the Southern General Lee's surrender, from two points of view: that of the omniscient camera and that of Elsie Stoneman (Lillian

[11]Karel Reisz and Gavin Millar, *The Technique of Film Editing,* 2nd ed. (Oxford: Focal Hastings Press, 1968), 20–24. This is one of the essential texts on film editing (written largely by Reisz and updated by Millar); my comments on the Griffith scene draw heavily on Reisz's analysis.

[1]

[2]

[3]

[4]

[5]

[6]

 6.5 The assassination scene in D. W. Griffith's *The Birth of a Nation:* [1] is from shot 21, [2] is from shot 22, [3] is from shot 32, [4] is from shot 33, [5] is from shot 38, and [6] is from shot 39. To view a clip, consult your CD-ROM.

FIG. 6.1

THE ASSASSINATION SEQUENCE FROM
THE BIRTH OF A NATION

INTERTITLE: *"And then, when the terrible days were over and a healing time of peace was at hand"* . . . *came the fated night of 14th April, 1865.*

Two short scenes follow: Benjamin Cameron (Henry B. Walthall) fetches Elsie Stoneman (Lillian Gish) from the Stonemans' house and they leave together. Next seen in a theater, they are attending a special gala performance at which President Lincoln is to be present. The performance has already begun.

INTERTITLE: *Time: 8:30*
The arrival of the President, Mrs. Lincoln, and party.

Shot	Description	Length (sec.)	Type of Shot*
1	Lincoln's party as, one by one, they reach the top of the stairs inside the theater and turn off toward the president's box. Lincoln's bodyguard comes up first, Lincoln last.	7	MS
2	The president's box, viewed from inside the theater. Members of Lincoln's party appear inside.	4	MS
3	President Lincoln, outside his box, giving up his hat to an attendant.	5	MS
4	The president's box (as in shot 2). Lincoln appears in the box.	4	MS
5	Elsie Stoneman and Ben Cameron sitting in the auditorium. They look up toward Lincoln's box, then start clapping and rise from their seats.	7	MS
6	View from the back of the auditorium toward the stage. The president's box is to the right. The audience, backs to the camera, are standing in foreground, clapping and cheering the president.	3	LS
7	The president's box (as in shot 4). Lincoln and Mrs. Lincoln bow to the audience.	3	MS
8	As in shot 6.	3	LS
9	The president's box (as in shot 7). Lincoln enters the box and sits down.	5	MS

INTERTITLE: *Mr. Lincoln's personal bodyguard takes his post outside the Presidential box.*

10	After coming into the passage outside the box and sitting down, the the bodyground starts rubbing his knees impatiently.	10	MS

*CU = close-up; LS = long shot; MLS = medium long shot; MS = medium shot

11	View from the back of the auditorium toward the stage. The play is in progress, but the audience stands and greets the president.	5	LS
12	The president's box (as in shot 9). Lincoln takes his wife's hand and acknowledges the audience's greeting.	9	MS
13	Standing, the audience waves white handkerchiefs at the president.	4	MLS
14	Closer view of the stage. The play continues.	10	MLS

INTERTITLE: *To get a view of the play, the bodyguard leaves his post.*

15	Bodyguard (as in shot 10). He is clearly impatient.	4	MS
16	Close view of the stage (as in shot 14).	2	MLS
17	The bodyguard (as in shot 15). He gets up and puts his chair away behind a side door.	6	MS
18	As in shot 6, the theater viewed from the back of the auditorium. Camera is shooting toward the box of Lincoln's party (next to Lincoln's box) as the bodyguard enters and takes his place. (This shot is framed exactly as shot 6, but a closing iris effect is added to isolate our gaze toward the bodyguard arriving at the box.)	3	LS
19	Within a circular mask, we see a closer view of the action of shot 18. The bodyguard takes his place in the box. The closing iris of the previous shot is repeated in this closer shot, consolidating continuity.	5	MS

INTERTITLE: *Time: 10:13*
Act III, Scene 2

20	A general view of the theater from the back of the auditorium; a diagonal mask leaves only Lincoln's box visible.	5	LS
21	Elsie and Ben. Elsie points to something in Lincoln's direction.	6	MS

INTERTITLE: *John Wilkes Booth*

22	The head and shoulders of John Wilkes Booth seen within a circular mask.	3	MS
23	As in shot 21, Elsie looks in Lincoln's direction.	6	MS
24	As in shot 22, Booth.	2.5	MS
25	View showing both Lincoln's box and the one next to it, with Booth waiting by the door.	5	MLS

26	As in shot 24, Booth.	4	MS
27	As in shot 14, close view of the stage.	4	MLS
28	Close view of Lincoln's box. Lincoln smiles approvingly at the play. He makes a gesture with his shoulders as if he were cold and starts to pull a shawl over his shoulders.	8	MS
29	As in shot 22, Booth moves his head up in the act of rising from his seat.	4	MS
30	Shot 28 continued. Lincoln finishes pulling on his shawl.	6	MS
31	As in shot 20, the theater viewed from the back of the auditorium. The mask spreads to reveal the whole theater.	4	LS
32	As in shot 19, within a circular mask, the bodyguard, enjoying the play, with Booth leaving that box, right behind the bodyguard.	1.5	MS
33	Booth comes through the door at the end of the passage outside Lincoln's box. He stoops to look through the keyhole into Lincoln's box. He pulls out a revolver and braces himself for the deed.	14	MS
34	Booth cocks the revolver.	3	CU
35	Shot 33 continued. Booth comes up to the door, has momentary difficulty in opening it, then steps into Lincoln's box.	8	MS
36	As in shot 28, close view of Lincoln's box. Booth appears behind Lincoln.	5	MS
37	As in shot 14, the stage. The actors are performing.	4	MLS
38	As in shot 36; Booth shoots Lincoln in the back. Lincoln collapses. Booth climbs on to the side of the box and jumps over on to the stage.	5	MS
39	Booth on the stage. He throws up his arms and shouts.	3	LS

INTERTITLE: *"Sic Semper Tyrannis!"* ("thus always to tyrants"—motto of the State of Virginia)

Note: John Wilkes Booth, who assassinated President Lincoln on Good Friday, April 14, 1865, was an actor who won wide acclaim for his Shakespearean roles. He was also an ardent Confederate sympathizer who hated the president. After he shot Lincoln and jumped to the stage, fracturing his leg in the process, he shouted, *"Sic Semper Tyrannis!"*—adding, as Griffith does not, "The South is avenged."

Source: Chart prepared by Emanuel Leonard and Gustavo Mercado, revised from material in Karel Reisz and Gavin Millar, *The Technique of Film Editing*, 2nd ed. (Oxford: Focal Press, 1968), 20–22.

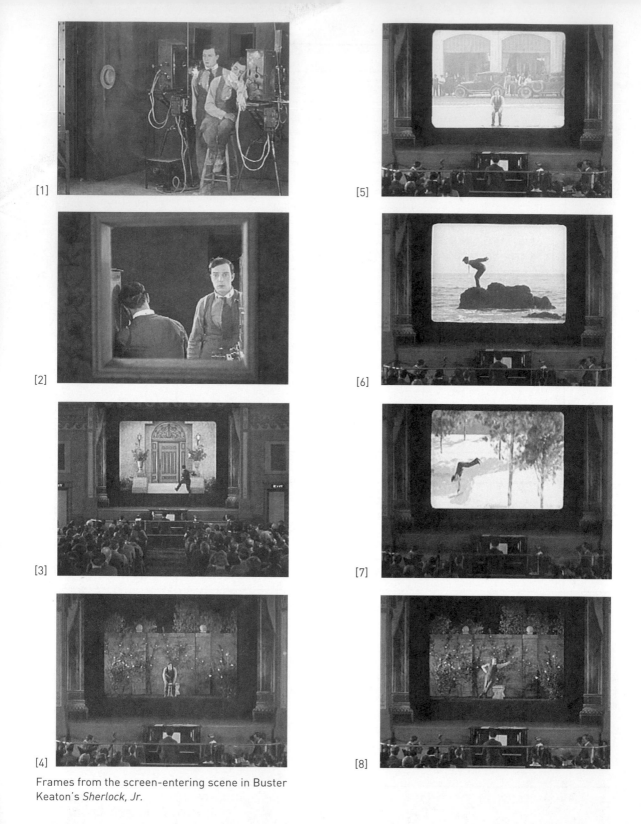

[1]

[2]

[3]

[4]

[5]

[6]

[7]

[8]

Frames from the screen-entering scene in Buster
Keaton's *Sherlock, Jr.*

Gish), our surrogate. Both perspectives, focused on the president, make us eyewitnesses to history. By also masking the screen, Griffith literally blocks our view of everything in the frame but Lincoln (Joseph Henabery). By having Stoneman use her binoculars to get a better view of John Wilkes Booth (Raoul Walsh)—the close-up is created by an iris-in—the director reminds us that Booth, an actor, is about to play his most famous role. Intertitles that mark the passing of time further heighten the suspense surrounding the inevitable climax. Thus the scene illustrates painful ironies of life: that even the most catastrophic events can occur in the most prosaic of circumstances, that celebrations can end in tragedy.

BUSTER KEATON'S
SHERLOCK, JR.

Buster Keaton had already written, directed (or codirected), and played the lead role in twenty films before, at twenty-eight, he made *Sherlock, Jr.* (1924; editor: Keaton), one of several masterpieces that have led critics to call Keaton and Charles Chaplin the two greatest talents in silent-film comedy. Sherlock Jr. expects to become rich and famous as a private detective. For the time being, however, he is stuck in his monotonous job as a projectionist in a movie theater. In one scene, just after he starts a reel in the projector, he falls asleep and dreams of a different life. Here, Keaton uses editing and special effects to take us from everyday reality into the hero's fantasy world, one of the things that movies do best. He creates a movie within the movie that Sherlock is screening and within the movie, *Sherlock, Jr.,* we are watching. Sherlock has watched enough movies to know that all kinds of surprises can happen on the screen, including the transformation of one person into another.

After Sherlock falls asleep, Keaton superimposes one shot over another so that Sherlock appears to wake up and stand beside his sleeping self; this special effect is also called a **double-** or **multiple-exposure.** In a few minutes, Sherlock leaves his projection booth and walks down the theater aisle, onto the stage, and right into the screen. Momentarily rebuffed, he finds himself back on the stage, but then he succeeds in entering the world of the screen (an astonishing effect that Woody Allen later employed, paying homage to Keaton, in *The Purple Rose of Cairo* [1985]). A series of quick edits allows Keaton to perform gymnastic stunts against constantly changing backgrounds: he begins in a garden, moves to various outdoor locations, and finally returns to the garden. To no one's surprise but surely every viewer's delight, he makes his entrance in the story-within-the-story as "the world's greatest Detective—Sherlock, Jr." Thus Sherlock Jr.'s delusions of grandeur are fulfilled through the illusions created by editing.

SERGEI EISENSTEIN'S
BATTLESHIP POTEMKIN

Film changed forever following the two successful 1917 revolutions that established the Union of Soviet Socialist Republics (dissolved in 1991). Russian film is synonymous with revolution, and the films of the Soviet silent period were made primarily to teach, not entertain. Based on the Marxist-Leninist theory of historical dialectics—that all change results from the clash of opposites—reality is seen and filmed as conflict. Thus conflict becomes both form and content. On a more practical

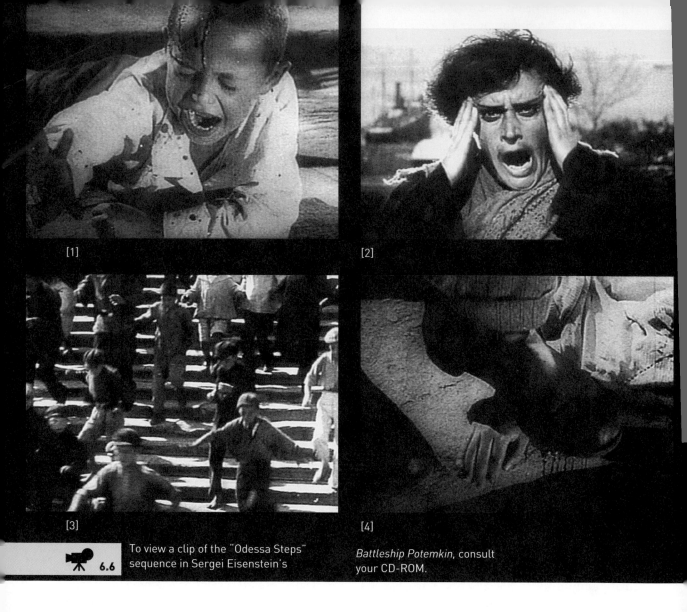

[1]

[2]

[3]

[4]

6.6 To view a clip of the "Odessa Steps" sequence in Sergei Eisenstein's *Battleship Potemkin*, consult your CD-ROM.

level, the severe shortage of film stock following the revolution required filmmakers to make the most of the shots they took and how they edited them. In contrast to the filmmakers known as "realists" (who record and reveal the meaning of what they film), the Soviet filmmakers of this period were "formalists," who interpreted what they shot by giving it a "form" in art that corresponded to their view of life. (For a full discussion of classical and

modern film theory, especially in regard to sound and sound editing, see "Aesthetic Challenges" in chapter 7.)

Theorist and filmmaker Sergei Eisenstein emphasized the relationship between cinematography and editing. First, through cinematography, the filmmaker transforms life into shots, or "cells," as he called them, the cell being the smallest unit of life. Then, through editing, the filmmaker manipulates these shots to correspond with the revolutionary view of life. Eisenstein maintained that you have to destroy realism to attain reality: no two people share common perceptual ground, because reality is all in the mind of the individual perceiver. Thus photographic art does not exist for its own sake or the sake of beauty; it exists for the sake of the ideas it presents, to indoctrinate and propagandize.

We can understand Eisenstein's principle of **dialectical montage** (also called *intellectual montage*), which is complex and often obscure in theory, as a form of editing (often discontinuous) in which shots "collide" or noticeably conflict with one another. It is based on the Marxist concept of *dialectical materialism,* which posits that the history of human society is the history of struggle between classes. In theory, the dominating class in one era will be overthrown by an opposing class in the next, a cycle that should eventually produce a classless society. Eisenstein transformed this idea into the principles that governed his idea of editing: the forces of collision, conflict, and contrast. The dominating idea or image (the thesis) collides with an opposing idea (the antithesis), thereby producing the viewer's thoughts and emotions (the synthesis). His underlying assumption was that we perceive shots in a montage sequence simultaneously and cumulatively, not sequentially and logically. The filmmaker assembles shots A, B, and C sequentially on the strip of film. However, when we see the film, we reassemble them in our minds into a cumulative effect. Because of the rapid speed of most Soviet montage, the result is close to superimposition.

As you learned in "Forms and Patterns" in chapter 2, the most famous single scene ever filmed—or at least the most influential piece of film editing—may be the "Odessa Steps" sequence in Eisenstein's *Battleship Potemkin* (*Bronenosets Potyomkin,* 1925; editor: Eisenstein). Certainly, it is the most famous piece of Soviet montage editing. Its subject is the 1905 rebellion against the czar in the Russian port of Odessa, which led to a massacre of civilians and ultimately foreshadowed the 1917 revolutions. But this is not a documentary reenactment; perception, not realism, is the issue. Eisenstein controls our perceptions and thus evokes our sympathy for the workers and the revolutionary cause. Individual shots have no particular meaning, but Eisenstein brings them into collision with one another and establishes certain themes and effects. The shots conflict in *direction* (people running left to right, right to left), *camera angle* (extreme downward and upward angles), *rhythm* (a group of people running quickly, a group of soldiers marching slowly), *bulk* (a mass of workers and a single face), *emphasis* (four silent workers' faces contrasted with a single worker's clenched fist), *intensity of light* (dark and bright), and *intensity of emotion* (workers struggling against the troops, dead bodies on the steps).

To see one influence of the "Odessa Steps" sequence on a mainstream film, you might consider Brian De Palma's homage to it in *The Untouchables* (1987; editors: Jerry Greenberg and Bill Pankow). De Palma's montage is shorter, slower, less repetitive, and certainly less important than Eisenstein's; as part of a crime film, it exists to entertain, not propagandize.

LENI RIEFENSTAHL'S
OLYMPIA

In *Olympia* (1938; editor: Riefenstahl), a two-part, three-and-a-half-hour record of the 1936 Olympic Games in Berlin and a vehicle for Nazi propaganda, Leni Riefenstahl also demonstrates—through editing—the power of cinema to record the perceivable world as we see it, as well as to create an imaginative world as the director imagined it. In the sequence that records the diving events, Riefenstahl achieves pure cinema. She begins by establishing the cycle of diving: divers approaching the end of the diving board, the dive itself, the plunge into water, and divers leaving the pool. But for her, diving is poetic rather than prosaic; it is similar to flight. She creates this abstract idea by eliminating the footage of the divers entering the water.[12] Through editing, Riefenstahl makes the divers defy gravity and transcend earth in a poetic evocation of flight.

ORSON WELLES'S
CITIZEN KANE

In *Citizen Kane* (1941; editor: Robert Wise), Orson Welles uses a roughly two-minute-long montage to document the breakdown of the marriage of Charles Foster Kane (Orson Welles) and his first wife, Emily (Ruth Warrick), during its first seven years. This scene links short vignettes at the breakfast table through an editing device known as the **swish pan,** a horizontal camera movement so fast

[12]See Richard Barsam, *Nonfiction Film: A Critical History,* rev. and exp. ed. (Bloomington: Indiana University Press, 1992), 132.

that it blurs the photographic image. Progressing from initial happiness to final estrangement, from physical proximity to positions at opposite ends of the table, the sequence begins with Kane serving his wife's breakfast and ends with the two of them glaring at one another, their discord accentuated by Kane's reading his own newspaper, *The Inquirer,* and Emily's reading its chief rival, *The Chronicle*. The passage of time is recorded through changes in costume, hairstyle, and makeup.

ELIA KAZAN'S
ON THE WATERFRONT

On the Waterfront (1954; editor: Gene Milford) tells the story of the mob's corrupt, ruthless hold over labor unions on the New York waterfront, controlling not only the men's jobs but also their hearts and minds. The gangsters give work to those who play by their rules and kill those who don't. When Terry Molloy (Marlon Brando), a dockworker, tells Edie Doyle (Eva Marie Saint) that the mob made him set up her brother's murder, the setting is an actual coal heap on the waterfront, the emotional pitch is high, and the acting is superb. The editing of images (close-ups in a shot/reverse shot pattern) and sounds (intensified, interrupting the conversation) makes the mob's destruction of Terry seem inevitable. Figure 6.2 indicates the shots, sounds, and timing in this scene, whose fifteen shots are cut to the rhythm of natural waterfront sounds. Foghorns provide a kind of punctuation, and a steam-driven pile driver supplies a relentless, concussive sound that almost obscures Terry's and Edie's voices.

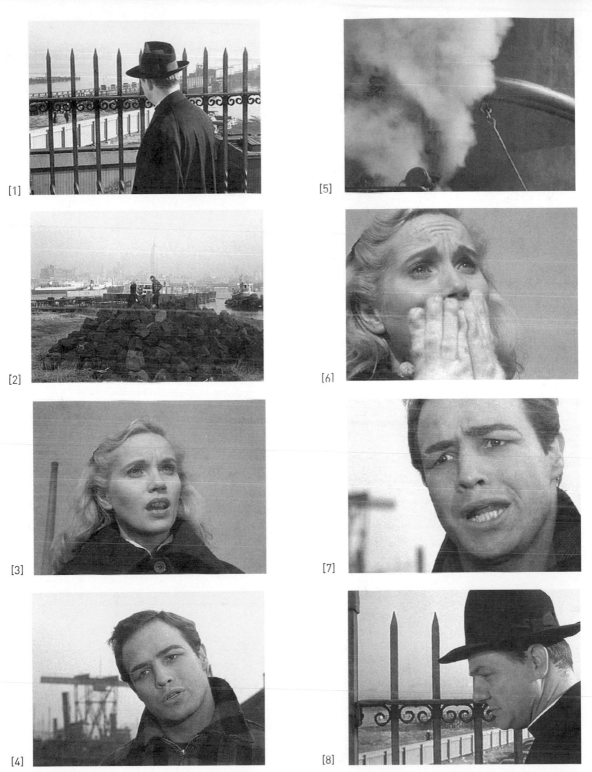

The confrontation scene in Elia Kazan's *On the Waterfront:* [1] is from shot 1, [2] is from shot 3, [3] is from shot 4, [4] is from shot 5, [5] is from shot 6, [6] is from shot 7, [7] is from shot 8, and [8] is from shot 14.

FIG. 6.2 EDITING OF CONFRONTATION SCENE IN *ON THE WATERFRONT*

Shot	Type of Shot and Description of Action*	Sound	Length (sec.)
1	Over the shoulder LS, from behind Father Barry, who is standing on a park terrace above the harbor and looking outward through the bars of an iron fence; he sees Terry and Edie in the distance walking right along the waterfront toward a coal heap.	Horns, steam-driven pile driver, general harbor noises all continue throughout the sequence.	14
2	LS, looking upward at Father Barry from position below the terrace.	As in shot 1	3.5
3	MS, from POV just in front of the coal; Terry begins to talk.	As in shot 1; we do not hear what Terry is saying.	2
4	CU of Edie	Edie: "You?!!"	2
5	CU of Terry	Terry: "Honest to God, Edie, I didn't know that was going to happen." Ship's horn blows loudly.	2.5
6	CU of steam horn blowing	Terry: "They told me . . ." Ship's horn continues.	2
7	CU of Edie	Terry:". . . to get him up on the roof . . ." Ship's horn continues.	2
8	CU of Terry	Terry:". . . I didn't know what they were going to do. I wasn't even there . . ." Ship's horn continues.	2
9	CU of Edie	Terry: (inaudible) Ship's horn continues.	2
10	CU of Terry	Ship's horn stops; pile driver continues. Terry: ". . . Believe me, I swear to God, Edie . . ."	2.5

*CU = close-up; ECU = extreme close-up; LS = long shot; MS = medium shot

11	ECU of Edie	Ship's horn blows again; pile driver gets louder. Terry appears to be silent in this shot.	4
12	CU of Terry	Terry: "Edie, please! I swear to God I didn't know what they were going to do." Ship's horn continues; pile driver continues.	4
13	As in shot 2, MS from POV in front of coal pile; Edie turns and runs left, away from Terry	Nondiegetic musical score begins and continues through rest of scene; ship's horn stops; pile driver continues at a lower volume.	4
14	As in shot 1, over the shoulder LS from behind Father Barry; sees Edie running, turns to face camera, lights cigarette.	Score continues; pile driver continues.	5
15	LS, omniscient-camera POV; Terry on coal pile, puts hands in pockets, looks right.	Score continues; pile driver continues; ship's horn blows again.	7
Total			58.5

Source: Budd Schulberg, *On the Waterfront: The Final Shooting Script* (New York: Samuel French, 1988).

ALFRED HITCHCOCK'S *PSYCHO*

Another of the most famous and influential sequences in movie history is a dynamic use of montage: the shower-murder scene in Alfred Hitchcock's *Psycho* (1960; editor: George Tomasini). Before the murder, we see Marion Crane (Janet Leigh), who is involved in a dead-end adulterous affair, steal $40,000 from her employer and decide to make a new life for herself. Racked with guilt about her crime, she stops at the remote Bates Motel, where she is murdered by Norman Bates (Tony Perkins). The murder, which is about fifty seconds long, incorporates fifty separate shots and sixty-five cuts, carried forward by the momentum of the perceived violence and the music. It achieves greater unity as part of a somewhat longer scene, whose structure moves from an opening circular image (Marion flushing paper down the toilet) to a closing circular image (Marion's eye staring out). Hitchcock appeals to our voyeurism (which in turns plays on Norman Bates's voyeurism); but he also punishes us for that voyeurism, which is repaid by

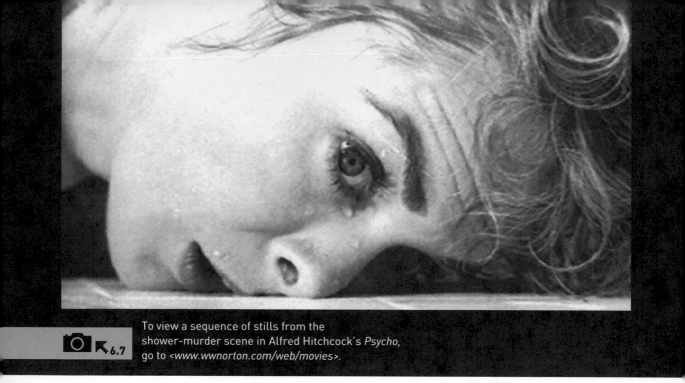

To view a sequence of stills from the
shower-murder scene in Alfred Hitchcock's *Psycho*,
go to *<www.wwnorton.com/web/movies>*.

Marion Crane's hard stare as she lies dead on the bathroom floor. Although we see almost no actual violence, our emotions are so manipulated that we *feel* it.

SIDNEY LUMET'S
THE PAWNBROKER

In the normal pattern of cinematic duration, every shot cuts more or less at the peak of its **content curve**—in other words, when the viewer has absorbed the information from the shot and is ready to move on to the next composition. Sidney Lumet's *The Pawnbroker* (1965; editor: Ralph Rosenblum) manipulates the content curve in the service of story and theme. The story concerns Sol Nazerman (Rod Steiger), a Holocaust survivor and pawnshop owner in New York City. When he hears a dog barking at some boys who are beating up another boy, he remembers a Nazi officer, with a dog, pursuing a Jewish man trying to escape. The inserted shots move so quickly that at first we can't fully comprehend them, a perfect example of cutting before the peak of the content curve. (In another sense, the shots here are subliminal flashbacks of very short duration.) As the movie progresses, these interpolated shots grow longer and longer until finally they

share the durational pattern of the rest of the film. That is, the past scenes take as long as the present ones, illustrating how the pawnbroker's repressed memories slowly force their way into his consciousness and make him experience again the suffering he has tried to repress.

As the above examples show, editors make visual and emotional connections, sometimes between seemingly unrelated items. By manipulating shots to achieve their best narrative and emotional impact, editors can stimulate our feelings about what we see and hear in virtually any situation in a movie.

QUESTIONS FOR REVIEW

1. What is *editing*? Why is it regarded as a *language*? In what sense can you describe the *conventions of editing* as constituting its language? What is the *art* of editing?

2. What is *continuity editing*? What does it contribute to a film? What is the theory behind the *180-degree system*? Why do filmmakers strive to maintain *screen direction*? Given that *discontinuity* is the central fact during the production phase of filmmaking, how does continuity occur?

3. What is *discontinuity editing*? Given the dominance of continuity editing in mainstream filmmaking, what role does it play?

4. In giving final form to a movie, what are the *editor's principal responsibilities affecting the work as a whole*?

5. What is the difference between a *match cut* and *parallel editing*? What is created by the *shot/reverse shot* convention of editing? What is a *jump cut*? What is the difference between a *fade-in/fade-out* and a *dissolve*? Can a *flash-forward* or *flashback* manipulate *space* as well as *time*? In editing, what is a *montage*?

6. Given the magnitude of the editor's overall responsibility during the postproduction stage of filmmaking, why is it considered desirable, if not essential, that the editor also collaborate during the preproduction phase?

7. How has the equipment with which the editor works evolved? What appears to be the future of editing?

8. You *see* the mise-en-scène, design, and acting; you *hear* the dialogue, music, and sound. Why do you *feel* the editing?

9. Cite at least two clear examples of how editing helps create meaning.

QUESTIONS FOR ANALYSIS

1. In the movie (or clip) you are analyzing, what kind of editing does the editor use, *continuity* or *discontinuity*? What are the principal characteristics of the style used by the editor?

2. Is the editing *seamless,* or does it call attention to itself?

3. Which of the following results from the editing of this movie (or clip): *rhythm, mood, ellipsis, separation, pattern,* or *slow disclosure*? Cite one example of each effect you identify.

4. Which *conventions of editing* are used in this movie (or clip)? Cite one example of each.

5. Does the movie indicate, through editing, how the editor wants the audience to *feel*? What is that intended feeling? Do you feel it? Is it an appropriate feeling for the narrative?

6. If you are analyzing an entire movie, do you discern a *particular pattern of editing* that runs through the entire film? If so, explain what that pattern is.

7. Is the editing intentionally disorienting or confusing? If so, explain.

8. Does the editing "work" to develop the story and emotion? Why? Why not?

FOR FURTHER READING

Balmuth, Bernard. *Introduction to Film Editing.* Boston: Focal Press, 1989.

Bayes, Steve. *The Avid Handbook.* Boston: Focal Press, 1998.

Bouzereau, Laurent. *The Cutting Room Floor.* New York: Carol Publishing, 1994.

Browne, Steven E. *Nonlinear Editing Basics: Electronic Film and Video Editing.* Boston: Focal Press, 1998.

Burder, John. *16mm Film Cutting.* New York: Hastings House, 1975.

———. *The Technique of Editing 16mm Films.* 4th ed. London: Focal Press; New York: Focal/Hastings House, 1979.

Case, Dominic. *Film Technology in Post Production.* Jordan Hill, Oxford: Focal Press, 1997.

Hollyn, Norman. *The Film Editing Room Handbook.* 3rd ed. Beverly Hills, Calif.: Lone Eagle, 1999.

Kerner, Marvin M. *The Art of the Sound Effects Editor.* Boston: Focal Press, 1989.

LoBrutto, Vincent. *Selected Takes: Film Editors on Editing.* New York: Praeger, 1991.

Murch, Walter. *In the Blink of an Eye: A Perspective on Film Editing.* Los Angeles: Silman-James Press, 1995.

Ohanian, Thomas A. *Digital Nonlinear Editing: Editing Film and Video on the Desktop.* 2nd ed. Boston: Focal Press, 1998.

Ondaatje, Michael. *The Conversations: Walter Murch and the Art of Editing Film.* New York: Knopf, 2002.

Reisz, Karel, and Gavin Millar. *The Technique of Film Editing.* 2nd ed. Oxford: Focal Press, 1968.

Rubin, Michael. *Nonlinear: A Guide to Electronic Film and Video Editing.* 3rd ed. Gainesville, Fla.: Triad Publishing, 1995.

Schneider, Arthur. *Jump Cut! Memoirs of a Pioneer Television Editor.* Jefferson, N.C.: McFarland, 1997.

Stafford, Roy. *Nonlinear Editing and Visual Literacy.* London: British Film Institute, 1995.

Thompson, Roy. *Grammar of the Edit.* New York: Focal Press, 1993.

Walter, Ernest. *The Technique of the Film Cutting Room.* 2nd ed. New York: Hastings House, 1973.

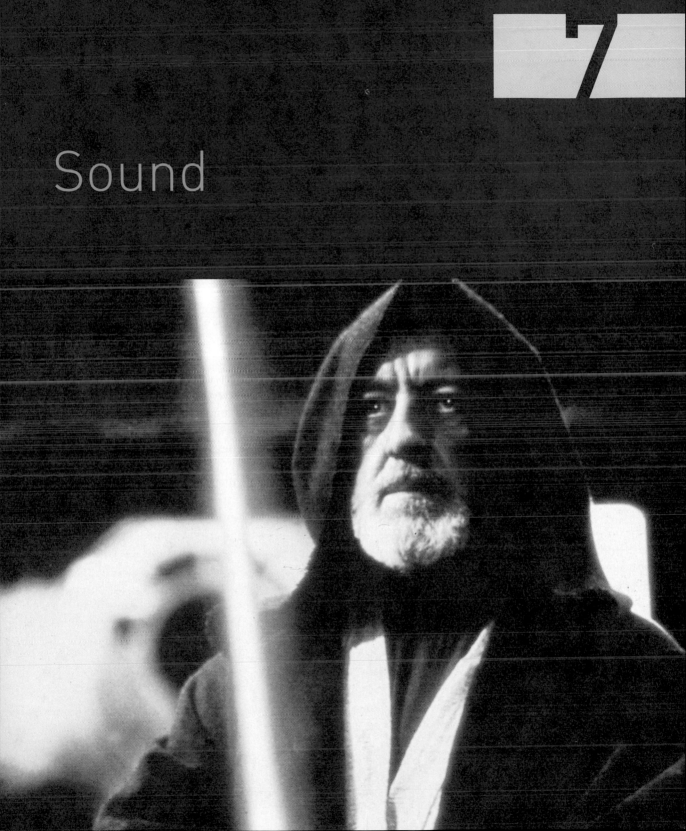

Sound

WHAT IS SOUND?

Great movies draw us into the world of their stories through what we hear as well as what we see. From the helicopter-point-of-view shots that open Stanley Kubrick's *The Shining* (1980; sound: Dino Di Campo, Jack T. Knight, and Wyn Ryder), we see a magnificent landscape, a river, and then a yellow Volkswagen driving upward into the mountains on a winding highway. Without the sound, we might mistake this footage for a TV commercial. Experiencing the shots together with the sound track, we wonder about the location, the driver, and the destination. What we hear gives life to what we see and offers some clues to its meaning. While we might expect to hear a purring car engine, car wheels rolling over asphalt, or the passengers' conversation, instead we hear music: an electronic synthesis by composers Wendy Carlos and Rachel Elkind of the *Dies Irae,* one of the most famous melodies of the Gregorian chant that became the fundamental music of the Roman Catholic Church. The *Dies Irae* (literally, "the day of wrath") is based on Zephaniah 1.14–16, a reflection on the Last Judgment, and is the opening section of the Requiem Mass, or mass for the dead. The symbolic import and emotional impact of this music transforms the footage into a movie pulsating with ominous energy and dramatic potential.

By this point in our study of the movies, we know that sound (like everything else in a movie) is manufactured creatively for the purposes of telling a story. The process has a technical as well as an aesthetic side. This chapter will provide the technical foundation necessary for understanding those aspects of film sound most relevant to an introductory course. In developing the knowledge necessary for making more informed critical judgments about the sound in any movie, we should remember that what we hear results from choices made by directors and their collaborators during production.[1] To illustrate how such choices influence our interpretations, let's examine an example. After the opening credits of Terrence Malick's *Days of Heaven* (1978; sound: James Cox, Robert W. Glass Jr., John T. Reitz, George Ronconi, Barry Thomas, and John Wilkinson), we see Bill (Richard Gere) working in a Chicago steel mill, where the sounds of the manufacturing process are so loud that we cannot hear what Bill or the foreman say when they begin to fight with one another. This ambient sound may be true to the actual noises in such a factory, but by sustaining its loudness at this level, the director lets us know that the sound is more important than the dialogue, more important even than what we see. He thereby creates a scene that illustrates as clearly and concisely as possible that the sounds of Bill's impersonal, alienating, and unhealthy working conditions correspond to his anger, which makes him strike and kill his boss. Indeed, this scene establishes that such frustration and violence will characterize Bill.

The sound in this or any scene operates on both physical and psychological levels. The sound crew has generated and controlled the sound physically, meaning that they have manipulated its properties to produce the effects the director desired. Through the processes of hearing and perception, viewers interpret the sound psychologically, not only in terms of the images they are seeing but also in terms of their own life experiences.

[1]This discussion of sound draws liberally from Tomlinson Holman, *Sound for Film and Television* (Boston: Focal Press, 1997).

In Terrence Malick's *Days of Heaven*, Bill (Richard Gere, *left*), a steel-mill worker, confronts the foreman (Stuart Margolin), whom he impetuously kills soon after. Throughout this scene, the loud, maddening industrial noise matches the intensity of the furnace, whose heat we can practically feel; the characters' surroundings thus enlighten us about and even represent their internal states. In later scenes, sound plays equally expressive roles: a haunting silence accompanies shots of wind-swept fields, the dialogue seems as natural as the acting looks (perhaps, in both cases, thanks to improvisation), and Ennio Morricone's understated score combines his own music with expressionistic pieces by the French Romantic composer Camille Saint-Saëns (performed by the Vienna Philharmonic Orchestra), contemporary American folk guitarist Leo Kottke, and contemporary American Cajun/country singer Doug Kershaw.

PHYSICAL AND PERCEPTUAL CHARACTERISTICS OF SOUND

Sound is a physical phenomenon: airborne vibrational waves that stimulate hearing whenever they reach the inner ear. Although a full (acoustical, philosophical, psychological) explanation of how sounds are made and heard is beyond the scope of this book, understanding the basic perceptual and physical characteristics of sound will help you analyze how sound functions as an element of cinematic form.

Physical characteristics constitute sound; perceptual characteristics are what we perceive. Each of the three physical characteristics corresponds exactly to one of the three

FIG. 7.1 CONNECTIONS BETWEEN THE PERCEPTUAL AND PHYSICAL CHARACTERISTICS OF SOUND

Perceptual Characteristics (*What we perceive in sound*) →	Physical Characteristics ← (*What constitutes the sound*)
Pitch → (or level) Described as either high or low	**← Frequency** (or speed) of the number of sound waves produced per second
Loudness → (or volume or intensity) Described as either loud or soft	**← Amplitude** (or degree of motion within the sound wave)
Quality → (or timbre, texture, or color) Described as simple or complex	**← Harmonic constitution** (or texture resulting from a single sound wave or mix of sound waves)

perceptual characteristics. (Fig. 7.1 shows the connections between these two sets and describes their characteristics briefly.) For example, one perceptual characteristic of sound, its pitch, may range from high to low. A high-pitched scream, such as we hear often in horror movies, is produced when very fast vibrations move through the air and reach our ears. Let's look more closely at these interconnected characteristics.

The **pitch** (or level) of a sound is defined by the **frequency** (or speed) with which it is produced (the number of sound waves produced per second). The speed of sound remains fairly constant when it passes through air, but varies in different media and in the same medium at different temperatures. Most sounds range from both high to low pitches. In Victor Fleming's *The Wizard of Oz* (1939; sound: Douglas Shearer), the voice of the "Wizard" has two pitches, one higher than the other, each helping us to judge the trustworthiness of his statements. Similarly, in the "all work and no play" scene in Kubrick's *The Shining*, the pitch changes from low (apprehensive) to high (panic) to underscore Wendy's state of mind as she discovers Jack's writing.

The **loudness** (or volume or intensity) of a sound depends on its **amplitude,** the degree of motion of air (or other medium) within the sound wave. The greater the amplitude of the sound wave, the harder it strikes the eardrum, and thus the louder the sound. In *The Shining*, during the scene in which Wendy (Shelley Duvall) and Jack (Jack Nicholson) argue and she strikes him with a baseball bat, Kubrick slowly increases the loudness of all the sounds to call attention to the growing tension.

The **quality** (also known as *timbre*) of a sound results from its **harmonic constitution** (also called *texture* or *color*), which distin-

Francis Ford Coppola's *Apocalypse Now* opens with horrific images of war and continues with a scene of a very agitated Captain Benjamin L. Willard (Martin Sheen) in his Saigon hotel room. The first words in his voiceover narration—"Saigon. Shit!"—introduce the movie's counterintuitive logic. Between missions, Willard is distraught not because he has not returned home to the United States but because he is "still only in Saigon." The jungle is where he really wants to be. Intercut with shots of Willard, here seen upside-down, are shots of his ceiling fan, the jungle, helicopters, napalm fires, and so on—all of which are represented in a ferocious and hugely ambitious sound track that combines sonic details, noise, dialogue, voiceover, and music. Together, pictures and sound prepare us for many of the movie's key themes, including the hellishness and surreality of the Vietnam War, the devastating power of military technology to destroy human beings and natural resources, and the complex roles within 1960s American society of countercultural forces such as rock music, drugs, and psychedelia. In addition, Willard's use of the vulgar expletive, coupled with the Doors' song "The End," plays ironically with the title. The movie is just beginning, but this is also the end: the apocalypse is now. To view a clip, consult your CD-ROM. 7.1

guishes it from other sounds of the same pitch and loudness. In the opening sequence of Francis Ford Coppola's *Apocalypse Now* (1979; sound designer: Walter Murch; sound: Mark Berger, Richard Beggs, and Nathan Boxer; *Apocalypse Now* is the suggested case study for this chapter), the sound comes from many sources—including helicopters, the fan in a hotel room, explosions, jungle noises, a smashed mirror, the Doors' recording of "The End," voiceover narration, and dialogue— each of which contributes its own qualities to an overall rich texture. Many of these sounds

are distorted or slowed down to characterize both the dreamlike, otherworldly quality of the setting and Willard's (Martin Sheen) state of mind.

In doing even a cursory analysis involving these physical and perceptual characteristics, you should be able to recognize a sound by its type (vocal or musical, for example), source (where it comes from in the world of the story and the distance between that point of origin and your point of observation), and coverage (whether it radiates equally in all directions or is confined to a clearly identifiable space on

the screen). Perhaps the easiest is to identify the type and source of the sound. A sound changes as its source approaches or moves away, relative to the hearer, in what is known as the **Doppler Effect**. That is, as the source of a constant sound moves away from you, its pitch seems to get lower, and thus you will be less likely to hear the sound as distinctly as you might wish. Though the sound of a rifle fired in the background of a long shot should be "smaller" than the sound of a dynamite explosion in the same place, physical elements may reflect, refract, absorb, or block the sounds on their way to the microphone. In addition, a sound may radiate in a specific, identifiable direction from its source, as does the sound of a match striking to light a cigarette in a close-up; or it may radiate in more than one direction and thus surround us, as do the sounds of a war movie. We must identify the point of the frame from which the sound was recorded by the microphone and the point from which we hear it. Today's digital sound recording and multispeaker theater reproduction make it easier for us to determine exactly the point from which a sound radiates, the direction(s) from which it reaches us, and the physical place at which the microphone records it. However, keep in mind that sound designers today often exaggerate sounds to create a kind of hyperreality.

SOURCES OF FILM SOUND

The movies engage two senses: vision and hearing. Although some viewers and even filmmakers assume that the cinematographic image is paramount, what we hear from the screen can be at least as significant as what we see on it, and sometimes it is *more* significant.

Sound—including talking, laughing, singing, music, and the aural effects of objects and settings—can be as expressive as any of the other narrative and stylistic elements of cinematic form. In the technology it requires, what we hear in a movie is often more complicated to produce than what we see. In fact, because of the constant advances in digital technology, sound may be the most intensively creative part of contemporary moviemaking. Director Steven Spielberg believes that since the 1970s, breakthroughs in sound have been the movie industry's most important technical and creative innovations. He means not the sort of gimmicky sound that takes your attention away from the story being told—"using the technology to show off"—but rather sound used as an integral storytelling element.[2]

The sources of sound may be *diegetic* or *nondiegetic, internal* or *external, onscreen* or *offscreen, synchronous* or *asynchronous,* and *production* or *postproduction* (Fig. 7.2).

DIEGETIC OR NONDIEGETIC

As you know from "Story and Plot" in chapter 2, the word *diegesis* refers to the total world of a film's story, consisting perceptually of figures, motion, color, and sound. **Diegetic sound** originates from a source within a film's world, while **nondiegetic sound** comes from a source outside that world. Most diegetic sound gives us an awareness of *both* the spatial and the temporal dimensions of the shot from which the sound emanates, while most nondiegetic sound has no relevant spatial or temporal dimensions. For example, the sound in the opening sequence of *The Shining* (see "What Is Sound?" above) is com-

[2]Rick Lyman, "A Director's Journey into a Darkness of the Heart," *New York Times,* 24 June 2001, sec. 2, p. 24.

FIG. 7.2 — SOURCES OF MOVIE SOUND

	Diegetic Sound	Nondiegetic
Spatial and Temporal Awareness		
Produces spatial awareness	X	
Produces temporal awareness	X	X
Source of Sound		
Internal	X	
External	X	X
Onscreen	X	
Offscreen	X	X
Synchronous	X	
Asynchronous	X	X
Production	X	
Postproduction	X	X

pletely nondiegetic. Ultimately, however, the distinction between diegetic and nondiegetic sounds depends less on the perceivable sources of sound than on the conventions of how we, as audiences, see and hear.

Diegetic sound can be any or all of the following: internal, external, onscreen, offscreen, synchronous, asynchronous, and recorded during production or postproduction. The most familiar kind of movie sound is diegetic, onscreen, synchronous sound, where the sound occurs simultaneously with the image. For a typical example of this, listen to the street noises and conversation between "Ratso" Rizzo

Diegetic sound in action: in John Schlesinger's *Midnight Cowboy*, right after he steps in front of an oncoming car, "Ratso" Rizzo (Dustin Hoffman, *right*) interrupts his conversation with Joe Buck (Jon Voight) to shout one of the most famous lines in movies, "I'm walkin' here!" Even surrounded by everyday Manhattan pedestrian and traffic noise, Rizzo's nasal voice and heavy New Yawk accent help characterize him as the extremely eccentric and comic foil to Buck, a new and unseasoned arrival in the big city.

Inappropriate and out-of-place things lead to much of the comedy in Alfred Hitchcock's extremely lighthearted thriller *North by Northwest*. Mount Rushmore provides one of the movie's most incongruous and therefore comic settings, as the expensively dressed and perfectly coiffed Eve Kendall (Eva Marie Saint) and Roger Thornhill (Cary Grant) attempt to escape their pursuer and defy death by climbing all over the national monument. Bernard Herrmann, who wrote scores for seven Hitchcock films and is considered the quintessential Hitchcock composer, uses lively Spanish dance music here. (The same music provides the "Overture" under Saul Bass's title sequence.) Perfectly irrational in this setting, the music seems to come from some other world entirely, signaling that the situation's improbability is part of the fun. For an in-depth analysis of *North by Northwest*, see the case study for chapter 3: <www.wwnorton.com/web/movies>.

www

(Dustin Hoffman) and Joe Buck (Jon Voight) in John Schlesinger's *Midnight Cowboy* (1969; sound: Abe Seidman). Nondiegetic sound can be any or all of the following: external, off-screen, asynchronous, and recorded during postproduction. In its most familiar forms, it may be a musical score or a narration spoken by a voice that does not belong to one of the film's characters. When Redmond Barry (Ryan O'Neal) attracts the attention of the countess of Lyndon (Marisa Berenson) in Stanley Kubrick's *Barry Lyndon* (1975; sound: Robin Gregory and Rodney Holland), during a visually magnificent scene accompanied by the equally memorable music from the second movement of Franz Schubert's Trio in E-flat Major (D. 919, opus 100) for violin, cello, and piano, the instrumentalists are nowhere to be seen; furthermore, we do not expect to see them. We accept, as a familiar convention, that this kind of music reflects the historical period being depicted but does not emanate from the world of the story. By its nature, nondiegetic sound is *always* external, offscreen, asynchronous, and created during postproduction. Nondiegetic music is used comically in Alfred Hitchcock's *North by Northwest* (1959; sound: Franklin Milton), when we see Roger Thornhill (Cary Grant) and Eve Kendall (Eva Marie Saint) climbing across the presidential faces sculpted on Mount Rushmore and hear Bernard Herrmann's fandango score, music not only nondiegetic but also completely absurd, given the danger facing these two characters.

These conventions of diegetic and nondiegetic sound may also be modified for other effects. In Bobby and Peter Farrelly's *There's Something about Mary* (1998), the "chorus" troubador, Jonathan (Jonathan Richman), exists outside the story, which makes him and

his songs nondiegetic, even though we can see him. The Farrellys play with this concept by having him get accidentally shot in the climactic scene and thus become part of the story.

INTERNAL OR EXTERNAL

Internal sound, which is always diegetic, occurs whenever we hear the thoughts of a character we see onscreen but we assume that other characters cannot hear them. The character might be expressing random thoughts or a sustained monologue. In the theater, when Shakespeare wants us to hear a character's thoughts, he uses a soliloquy to convey them, but this device lacks verisimilitude. Laurence Olivier's many challenges in adapting *Hamlet* for the screen included making the title character's soliloquies acceptable to a movie audience that might not be familiar with theatrical conventions. Olivier wanted to show Hamlet as both a thinker whose psychology motivated his actions and a man who could not make up his mind. Thus in Olivier's *Hamlet* (1948; sound: John Mitchell, Henry Miller, and L. E. Overton), Olivier (as Hamlet) delivered the greatest of all Shakespearean soliloquies—"To be, or not to be"—in a combination of both spoken lines and interior monologue. This innovation influenced the use of internal diegetic sound in countless other movies, including subsequent cinematic adaptations of Shakespeare's plays. **External sound,** which is always diegetic, comes from a place within the world of the story, which we and the characters in the scene hear but do not see. In John Ford's *My Darling Clementine* (1946; sound: Eugene Grossman and Roger Seman Sr.), Wyatt Earp (Henry Fonda) goes into a bar to capture Indian Charlie (Charles Stevens), who is drunk and shooting up the town. Earp surreptiously enters the building through an up-

"To be, or not to be; that is the question: / Whether 'tis nobler in the mind to suffer / The slings and arrows of outrageous fortune, / Or to take arms against a sea of troubles, / And, by opposing, end them" (*Hamlet* 3.1.58–62). Few lines cut deeper into a character's psyche or look more unflinchingly into the nature of human existence, and yet how ineffective these well-known lines might be if simply recited at a camera. In his *Hamlet*, actor-director Laurence Olivier fuses character and psyche, human nature and behavior, by both speaking his lines and rendering them, in voiceover, as the Danish prince's thoughts, while simultaneously combining, in the background, music and the natural sounds of the sea. Olivier's version of *Hamlet* was the first to apply the full resources of the cinema to Shakespeare's text, and his innovativeness is especially apparent in the sound. For example, as we see Ophelia floating in a stream, the Queen describes the events that led to her death.

stairs window, surprising a group of prostitutes; we hear their screams and his "Sorry, ladies," which provides a distinctive counterpoint to the sounds of the offscreen struggle— the whack and thud we hear later as he conks Charlie on the head. Here, sound not only provides a comic touch but also demonstrates Earp's skill. A variation on this occurs when a character hears a sound, perhaps in memory or imagination, that neither the viewers nor the other characters perceive. In Curtis Bernhardt's *Possessed* (1947; sound: Robert B. Lee), Louise Howell Graham (Joan Crawford), under care in a psychiatric ward for acute schizophrenia, "hears" a piano piece that she associates with the lover who has spurned her. Earlier in the film, we have seen and heard him playing this piece for her, so it exists in the world of the story, but in this instance it emanates only tangentially from that world.

Internal and external sounds may come from either onscreen or offscreen sources.

ONSCREEN OR OFFSCREEN

Onscreen sound, which is always diegetic, emanates from a source that we see as well as hear. It may be internal (as in the previous example of Olivier's *Hamlet* soliloquy) or external (as in the previous example of the struggle in *My Darling Clementine*).

Offscreen sound, which can be either diegetic or nondiegetic, derives from a source that we do not see. When it is diegetic, it consists of sound effects, music, or vocals that emanate from the world of the story (as in the example from *Alien* cited in "Audience Expectations," below). When nondiegetic, it takes the form of a musical score (as in the previous example of music in *Barry Lyndon*) or narra

When diegetic, synchronous sound occurs offscreen, it encourages viewers to use their imaginations. In Mel Brooks's western spoof, *Blazing Saddles* (1974; sound: Gene S. Cantamessa), Sheriff Bart (Cleavon Little), riding across the range, hears what at first seems nondiegetic jazz. This music becomes onscreen, diegetic, synchronous sound as Bart encounters American bandleader Count Basie and his musicians, dressed as if for a nightclub gig, playing quite incongruously in the middle of nowhere.

tion by someone who is not a character in the story (as in the example of Orson Welles's narration in *The Magnificent Ambersons* cited in "Vocal Sounds [Dialogue and Narration]," below).

The total absence of diegetic, onscreen sound, where we expect it most, can be disturbing, as in the concluding, silent shots of a nuclear explosion in Sidney Lumet's *Fail-Safe* (1964; sound: Jack Fitzstephens), or comic, as it is when the otherwise silent nuclear explosion is accompanied by nondiegetic music (Vera Lynn singing "We'll Meet Again") at the conclusion of Stanley Kubrick's *Dr. Strangelove, or: How I Learned to Stop Worrying and Love the Bomb* (1964; sound: John Cox). In Robert Bresson's *A Man Escaped* (*Un condamné à mort s'est échappé,* 1956; sound: Pierre-André Bertrand), a member of the French Resistance named Lieutenant Fontaine (François Leterrier) is being held in a Nazi prison during

World War II. Once he enters the prison, he never sees outside the walls, although he remains very much aware, through offscreen sound, of the world outside. In fact, sounds of daily life—church bells, trains, trolleys—represent freedom to Fontaine.

SYNCHRONOUS OR ASYNCHRONOUS

Synchronous sound comes from and matches a source that is apparent in the image, as when dialogue matches characters' lip movements or we hear the sound of shifting gears as we watch an automobile gather speed. In the previously cited example from *Midnight Cowboy*, Rizzo and Joe's dialogue is external, diegetic, and synchronous. While we are most familiar with synchronous sound, filmmakers also use **asynchronous sound,** which comes from a source that is apparent in the image but is not precisely matched temporally with the actions occurring in it. Following the credits for the production company and movie title at the opening of John Singleton's *Boyz N the Hood* (1991; sound: Tim Song Jones and Renee Tondelli), we hear a montage of sounds—a car screeching to a halt; gunshots; the voices of spectators; a police radio; a child saying, "They shot my brother"; sirens; and more gunfire. As we hear these sounds, the screen remains black, except for two intertitles: "One out of every twenty-one Black American males will be murdered in their lifetimes" and "Most will die at the hands of another Black male."

[1]

The classic example of asynchronous sound occurs in Alfred Hitchcock's *The 39 Steps* (1935; sound: Albert Birch). A landlady (actor not credited) enters a room, discovers a dead body, turns to face the camera, and opens her mouth as if to scream. At least, that's what we expect to hear. Instead, as she opens her

[2]

mouth (1), Hitchcock cuts to (2) a shot of a train speeding out of a tunnel, and we hear its whistle blaring. The sound seems to come from the woman's mouth, but this is in fact an asynchronous sound bridge, linking two simultaneous actions taking place in different places.

PRODUCTION OR POSTPRODUCTION

Filmmakers may record sound during either production or postproduction, but most film sound is constructed during postproduction. **Production sounds** include those synchronous sounds recorded on the set during production (most of which, including dialogue, are changed, cleaned up, or rerecorded during postproduction). **Postproduction sounds** are created during the postproduction (or reproduction) stage.

The process of recording sound for the movies is very similar to the process of hearing. Just as the human ear converts sounds into nerve impulses that the brain identifies, so the microphone converts sound waves into electrical signals that are then recorded in analog or digital form, usually with magnetic tape recorders. Each type of sound occupies an individual **sound track** (one track for vocals, one for sound effects, one for music, etc.) on separate tapes. These tapes are kept separate from the visual footage until the last stages of postproduction, when individual tracks (which can number in the hundreds, as in the case of Coppola's *Apocalypse Now;* see "Editing and Postproduction" in chapter 6) must be matched to the images; edited and mixed together with sounds recorded on other tapes, since directors can combine as many single sounds as they want in single images; and then cut for a precise image/sound fit. Sound editing, like the editing of visual footage, involves both subtraction and addition; unwanted sounds—such as static and other kinds of interference—are removed from the sound track, while appropriate sounds are created for and added to it.

Separating tracks makes it possible not only to combine and layer sounds but also to control the pitch, loudness, and quality of each one. This can result in an "audio mise-en-scène," which allows the filmmaker and the viewer to distinguish between background and significant elements that are arranged in relation to one another. This process resembles the recording of much popular music, where drums, bass, guitars, vocals, and so on, are recorded separately and then mixed and adjusted to achieve the desired acoustic quality and loudness.

Film directors and their collaborators select, edit, and mix whichever sounds are necessary to create a movie's effects. For most narrative films, this means providing cues that help us form expectations about meaning; in some cases, sound actually shapes our analyses and interpretations. As film historian Rick Altman writes, "[W]e learn to hear by hearing, and in doing so we form quite specific notions about how sound should sound."[3] Sound calls attention not only to itself but also to silence, to the various roles that each plays in our world and in the world of a film. The option of using silence is one crucial difference between "silent" and "sound" films; a sound film can emphasize silence, while a silent film cannot even include it. As light and dark create the image, so sound and silence create the sound track. Each property—light, dark, sound, silence—appeals to our senses differently.

[3]Rick Altman, "The Sound of Sound: A Brief History of the Reproduction of Sound in Movie Theaters," 1 January 1995, <www.geocities.com/hollywood/academy/4394/altman.html> (September 2002).

TYPES OF FILM SOUND

The types of sound that filmmakers can include in their sound tracks fall into four general categories: *vocal sounds (dialogue and narration), environmental sounds (ambient sound, sound effects,* and *Foley sounds), music,* and *silence.* As viewers, we are largely familiar with the vocal, environmental, and musical sounds. Vocal sounds tend to dominate most films because they carry much of the narrative weight, environmental sounds usually provide information about a film's setting and action, and music often directs our emotional reactions. However, any of these may dominate or be subordinate to the visual image, depending on the relationship the filmmaker desires between sound and visual image.

VOCAL SOUNDS (DIALOGUE AND NARRATION)

Dialogue, recorded during production or rerecorded during postproduction, is the lip-synchronous speech of characters who are either visible onscreen or speaking offscreen, say from an unseen part of the room or from an adjacent room. It is a function of plot because it develops out of situations, conflict, and character development. Further, it depends on actors' voices, facial expressions, and gestures. Expressing the feelings and motivations of characters, dialogue is one of the principal means of telling a story. In most movies, dialogue represents what we consider ordinary speech, but dialogue can also be highly artificial. During the 1930s, screwball comedies invented a fast, witty, and often risqué style of dialogue that was frankly theatrical in calling attention to itself.

This medium close-up from Preston Sturges's romantic comedy *The Lady Eve* speaks volumes about the imbalance of power between the couple, but it doesn't even hint that con artist Jean Harrington (Barbara Stanwyck) and millionaire Charles Pike (Henry Fonda) are discussing snakes, beer, opera, and teeth. Such details add up to a kind of verbal code for the sexual attraction that remains unspoken throughout the scene — the dialogue says one thing and means another. The exquisite tension builds as Harrington, looking enraptured, and Pike, looking desperate, almost make explicit what we know they're thinking. For countless other examples of such verbal and visual wit, see writer-director Sturges's string of masterworks, from *The Great McGinty* (1940) to *Unfaithfully Yours* (1948).

Among the most exemplary of these films are Ernst Lubitsch's *Trouble in Paradise* (1932; screenwriters: Grover Jones and Samson Raphaelson), Howard Hawks's *Bringing Up Baby* (1938; screenwriters: Dudley Nichols and Hagar Wilde), and Preston Sturges's *The Lady Eve* (1941; screenwriters: Sturges and

Monckton Hoffe), each of which must be seen in its lunatic entirety to be fully appreciated but nonetheless provides countless rich individual exchanges. Let's consider a satirical love scene from *The Lady Eve* (sound: Harry Lindgren and Don Johnson) that mocks conventional Hollywood romances. Jean Harrington (Barbara Stanwyck) meets Charles Pike (Henry Fonda) on an ocean liner; she's a con artist, and he's a millionaire who has renounced management of his father's brewery for the study of snakes. After Harrington visits Pike's stateroom and sees Emma, the snake he is bringing back from the Amazon, she runs screaming to her stateroom, with Pike following. The ensuing scene, a medium close-up of a cheek-to-cheek chat that lasts nearly three and half minutes, reveals each character's basic nature and both characters' sexual synergy. Nobody talks like this in "real life":

HARRINGTON: Are you always going to be interested in snakes?
PIKE: Snakes are . . . my life.
HARRINGTON: [*Drily*] What a life.
PIKE: I suppose it does sound sort of silly. I mean, I suppose I should've married, settled down. I imagine my father always wanted me to. As a matter of fact, he's told me rather plainly. I just never cared for the brewing business.
HARRINGTON: Oh, you say that's why you've never married.
PIKE: No, no, it's just I've . . . never met her. I suppose she's around somewhere in the world.
HARRINGTON: Ah, it would be too bad if you never bumped into each other.
PIKE: Well . . .
HARRINGTON: I . . . I suppose you know what she looks like and everything.
PIKE: I think so.

HARRINGTON: I bet she looks like Marguerite in *Faust.*
PIKE: No, she isn't . . . I mean, she hasn't. . . . She's not as bulky as . . . opera singers . . .
HARRINGTON: Ah, how are her teeth?
PIKE: *Huh?*
HARRINGTON: Well, you should always pick out one with good teeth. It saves expense later.

Movie speech can take forms other than dialogue. For example, French director Alain Resnais specializes in spoken language that reveals a character's stream of consciousness, mixing reality, memory, dream, and imagination. In *Providence* (1977; screenplay: David Mercer; sound: René Magnol and Jacques Maumont), Clive Langham (John Gielgud), an elderly novelist, drinks heavily as he drifts in and out of sleep. Through the intertwining strands of his interior monologue, we learn of his projected novel—about four characters who inhabit a doomed city—and of his relationships with members of his family, on whom his fictional characters are evidently based. Langham's monologue and dialogues link the fantasy as well as the reality of what we see and hear; in this way, sound objectifies what is ordinarily neither seen nor heard in a movie.

Narration, the commentary spoken by either offscreen or onscreen voices, is frequently used in narrative films, where it may emanate from an omniscient voice (and thus not one of the characters) or from a character in the movie. In the opening scene of Stanley Kubrick's *The Killing* (1956; sound: Rex Lipton and Earl Snyder), when Marvin Unger (Jay C. Flippen) enters the betting room of a racetrack, an omniscient narrator describes him for us. The narrator knows details of Unger's personal life and cues us to the suspense of the film's narrative. In Terrence Malick's *Bad-*

In Stanley Kubrick's *The Killing*, Marvin Unger (Jay C. Flippen, pictured) places five-dollar "win" bets on every horse in the fifth race. As the narrator explains, however, Unger has no interest in horse racing. In fact, he holds "a lifelong contempt for gambling." As events unfold, we learn that he is at the track to help Johnny Clay (Sterling Hayden) arrange to steal several million dollars of the racetrack's money.

Billy Wilder's *Double Indemnity* (1944; sound: Stanley Cooley and Walter Oberst) uses onscreen narration in a unique way. Walter Neff (Fred MacMurray, pictured), a corrupt insurance investigator wounded by a gunshot, dictates his confession of murder into an office Dictaphone (a recording device that preceded tape recorders) His story leads to flashbacks that fill us in on events leading to that confession. Similarly, in Wilder's *Sunset Blvd.* (1950; sound: John Cope and Harry Lindgren), a down-on-his-luck screenwriter named Joe Gillis (William Holden) provides offscreen narration. The twist here is that Gillis, whom we first see floating face down in a swimming pool, is already dead.

lands (1973; sound: Maury Harris), Holly (Sissy Spacek) narrates the story, helping us understand her loneliness, her obsession with Kit (Martin Sheen), her participation in a series of brutal murders, and her inability to stop. This technique enhances our appreciation of her character, because rather than simply reinforcing what we are seeing, Holly's understanding and interpretation of events differ so much from ours. She thinks of her life with Kit as a romance novel rather than a pa-

thetic crime spree. In *The Magnificent Ambersons* (1942; sound: Bailey Fesler and James G. Stewart), Orson Welles uses both offscreen and onscreen narrators. Welles himself is the offscreen, omniscient narrator who sets a mood of romantic nostalgia for the American past, while an onscreen "chorus" of townspeople, a device that derives from Greek drama, gossips about what is happening, directly offering their own interpretations. Thus the townspeople are both characters and narrators.

ENVIRONMENTAL SOUNDS (AMBIENT SOUND AND SOUND EFFECTS)

Ambient sound, which emanates from the ambience (or background) of the setting or environment being filmed, is either recorded during production or added during postproduction. While it may incorporate other types of film sound—dialogue, narration, sound effects, Foley sounds, and music—it does not include any unintentionally recorded noise made during production, such as the sounds of cameras, static from sound-recording equipment, car horns, sirens, footsteps, or voices from outside the production. Filmmakers regard these sounds as an inevitable nuisance and generally remove them electronically during postproduction. Ambient sound helps set the mood and atmosphere of scenes, and it may also contribute to the meaning of a scene.

Consider the ambient sound of the wind in John Ford's *The Grapes of Wrath* (1940; sound: Roger Heman Sr. and George Leverett). Tom Joad (Henry Fonda), who has just been released from prison, returns to his family's Oklahoma house to find it empty, dark, and deserted. The low sound of the wind underscores Tom's loneliness and isolation and reminds us that the wind of dust bowl storms reduced the fertile plains to unproductive wastes and drove the Joads and other farmers off their land. In Satyajit Ray's "Apu Trilogy"—*The Song of the Little Road* (*Pather Panchali,* 1955), *The Unvanquished* (*Aparajito,* 1956), and *The World of Apu* (*Apur Sansar,* 1959)—recurrent sounds of trains establish actual places, times, and moods, but they poetically express characters' anticipations and memories as well. These wind and train sounds are true to the physical ambience of both Ford's and Ray's stories, but filmmakers also use symbolic sounds as a kind of shorthand to create illusions of reality. In countless westerns, for example, tinkling pianos introduce us to frontier towns; in urban films, honking automobile horns suggest the busyness (and business) of cities.

Sound effects include all sounds artificially created for the sound track that have a definite function in telling the story. In Ray's *The Song of the Little Road,* two children, Apu (Subir Bannerjee) and Durga (Uma Das Gupta), find their family's eighty-year-old aunt, Indir Thakrun (Chunibala Devi), squatting near a sacred pond and think she is sleeping. As Durga shakes her, the old woman falls over, her head hitting the ground with a hollow sound—a diegetic, synchronous, onscreen sound effect—that evokes death. Such sound artistry plays an increasingly significant role in contemporary filmmaking, although sound crews generally receive less screen credit than other artists with equal responsibilities. Furthermore, it has brought change to many theaters, which have had to install expensive new equipment to process the superb sound made possible by the digital revolution.

A special category of sound effects—**Foley sounds**—were invented in the 1930s by Jack Foley, a sound technician at Universal Studios. Technicians known as Foley artists create these effects in specially equipped studios, where they use a variety of props and other equipment to simulate sounds such as footsteps in the mud, jingling car keys, or cutlery hitting a plate. Foley sounds are mixed into the sound track during the postproduction process. While these sounds generally match the action we see on the screen, they also can exaggerate reality, both loud and soft sounds, and thus may call attention to their own artificiality. However, when they are truly effective

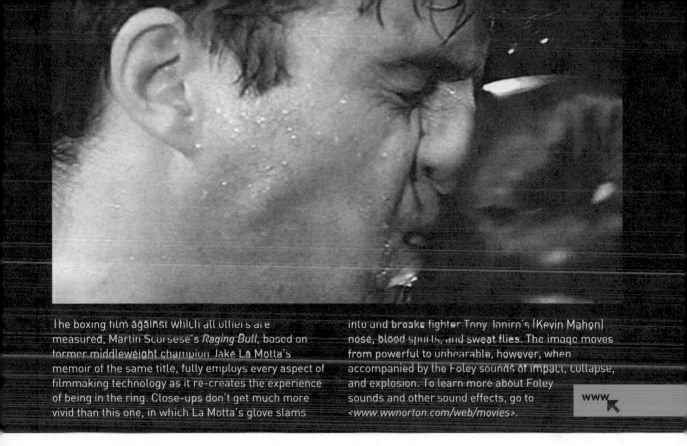

The boxing film against which all others are measured, Martin Scorsese's *Raging Bull*, based on former middleweight champion Jake La Motta's memoir of the same title, fully employs every aspect of filmmaking technology as it re-creates the experience of being in the ring. Close-ups don't get much more vivid than this one, in which La Motta's glove slams into and breaks fighter Tony Janiro's (Kevin Mahon) nose, blood spurts, and sweat flies. The image moves from powerful to unbearable, however, when accompanied by the Foley sounds of impact, collapse, and explosion. To learn more about Foley sounds and other sound effects, go to <www.wwnorton.com/web/movies>.

www

we cannot distinguish Foley sounds from the real sounds. In Martin Scorsese's *Raging Bull* (1980; sound: Frank Warner), brutal tape-recorded sounds from boxing matches are mixed with sounds created in the Foley studio, with as many as fifty different tracks that include a fist hitting a side of beef, a knife cutting into the beef, water (to simulate the sound of blood spurting), animal noises, and the whooshes of jet airplanes and arrows—all working together to provide the dramatic illusion of what in a real boxing match would be the comparatively simpler sound of one boxer's gloves hitting another boxer's flesh.

MUSIC

Although music may be used in a movie in many distinct ways, we are concerned principally with the kind that Royal S. Brown, an expert on the subject, describes as "dramatically motivated . . . music composed more often than not by practitioners specializing in the art to interact specifically with the diverse facets of the filmic medium, particularly the narrative."[4] Such music can be "classical" or

[4]Royal S. Brown, *Overtones and Undertones: Reading Film Music* (Berkeley: University of California Press, 1994), 13.

"popular" in style, written specifically for the film or taken from music previously composed for another purpose, written by composers known for other kinds of music (e.g., Igor Stravinsky, Aaron Copland, Leonard Bernstein, and Philip Glass) or by those who specialize in movie scores (e.g., Bernard Herrmann, Elmer Bernstein, David Raksin, Ennio Morricone, John Williams, Georges Delerue, Toru Takemitsu, and Carter Burwell, among many others), music played by characters in the film or by offscreen musicians, diegetic or nondiegetic. Two of Hollywood's most prolific contemporary composers were formerly rock musicians: for example, Oingo Boingo's Danny Elfman has scored many Tim Burton movies; Devo's Mark Mothersbaugh has scored everything from Joe Roth's *Revenge of the Nerds II: Nerds in Paradise* (1987) to Wes Anderson's *The Royal Tenenbaums* (2001). Like other types of sound, music can be intrinsic, helping to tell the story, whether it pertains to plot, action, character, or mood; indeed, music plays an indispensable role in many movies. Unfortunately, in many other movies the music is neither intrinsic to the story nor particularly meaningful. Many contemporary films, particularly those targeted at younger audiences, which rely on hit songs for their commercial appeal, provide lucrative marketing tie-ins for the filmmakers, the musicians, and the record companies.

Perhaps the most familiar form of movie music is used to set a mood or manipulate our emotions.[5] Few old-Hollywood films were without a "big" score by such masters of the genre as Max Steiner (Victor Fleming's *Gone With the Wind,* 1939), Miklós Rózsa (Alfred

Hitchcock's *Spellbound,* 1945), and Franz Waxman (Billy Wilder's *Sunset Blvd.,* 1950). Such music remains the emotional essence in more recent films, as in Maurice Jarre's neo-romantic score for David Lean's *Dr. Zhivago* (1965), Michael Nyman's Chopin-influenced score for Jane Campion's *The Piano* (1993), and John Williams's "wall-to-wall" scores for the *Star Wars* series.

Movie music can be equally effective when it creates or supports ideas in a film, as in Orson Welles's *Tragedy of Othello* (1952; music: Alberto Barberis, Angelo Francesco Lavagnino; restoration, 1999; supervisor, sound restoration: John Fogelso; supervisor, music restoration: Michael Pendowski). Welles takes a deterministic view of Othello's fate, but he depicts the two central characters, Othello and Desdemona, as being larger than life, even as they are destined for early death. Accompanying their funeral processions is a musical score that leaves no question that these tragic circumstances are the result of fate. In fact, in their cumulative power the sights and sounds express the inexorable rhythm of all great tragedies. The complex musical score covers several periods and styles, but it resembles medieval liturgical music to most ears. Deep, hard, dirgelike piano chords combine with the chanting of monks and others in the processions, spelling out (even drawing us into) the title character's inevitable deterioration and self-destruction.

Irony often results from the juxtaposition of music and image, because the associations we bring when we hear a piece of music greatly affect our interpretation of a scene. In Martin Scorsese's *Mean Streets* (1973; sound: Don Johnson, Walter Goss, Charles Grenzbach, John Wilkinson), a brutal fight ensues after Johnny Boy (Robert De Niro) insults Joey's (George Memmoli) girlfriends. The music playing on the pool hall jukebox calls attention to

[5]See Larry M. Timm, *The Soul of Cinema: An Appreciation of Film Music* (New York: Simon and Schuster, 1998), chap. 1.

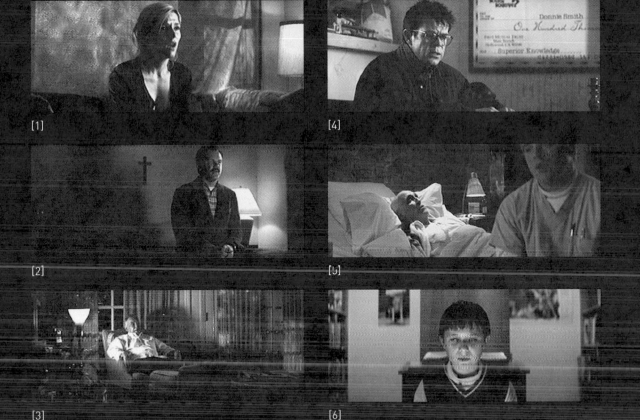

[1]

[4]

[2]

[5]

[3]

[6]

Miraculous things happen, and people and events connect in unexpected ways, throughout Paul Thomas Anderson's *Magnolia* (1999; sound designer: Richard King). Among the inspirations behind Anderson's screenplay was his hearing then-unreleased recordings by American pop-rocker Aimee Mann. In some cases, connections between the songs and the narrative are explicit, as when the lyrics to "Deathly"—"Now that I've met you / Would you object to / Never seeing / Each other again"—become a line of dialogue: "Now that I've met you, would you object to never seeing me again?" At the film's emotional climax and *coup de cinéma*, (1) Claudia Wilson Gator (Melora Walters), (2) Jim Kurring (John C. Reilly),

(3) Jimmy Gator (Philip Baker Hall), (4) Quiz Kid Donnie Smith (William H. Macy), (5) "Big Earl" Partridge (Jason Robards, *left*) and his nurse, Phil Parma (Philip Seymour Hoffman), and (6) Stanley Spector (Jeremy Blackman), all in different places and different situations, sing along with Mann's "Wise Up." It is, perhaps, no *coincidence* (another theme of *Magnolia*) that "Wise Up" was also used in Cameron Crowe's *Jerry Maguire* (1996; sound designer: Soundelux; supervising sound editors: Mike Wilhoit and Wylie Stateman), which, like *Magnolia*, starred Tom Cruise. To learn more about the many uses of film music, go to <www.wwnorton.com/web/movies>.

WWW

neglected women: the Marvelettes singing "Please Mr. Postman," about a teenager longing for a letter from her boyfriend. Music also plays against the action at the conclusion of Peter Jackson's *Heavenly Creatures* (1994), where Richard Rodgers and Oscar Hammerstein II's inspirational classic, "You'll Never Walk Alone" (from the 1945 Broadway musical *Carousel*), provides a cutting irony given the tragic relationship of two disturbed teenagers (Kate Winslet and Melanie Lynskey). Other examples include Kubrick's use of Beethoven's Ninth Symphony, Coppola's use of the Doors' "The End" (both cited above), and Quentin Tarantino's use of Stealers Wheel's "Stuck in the Middle with You" to choreograph the violent cop-torture scene in *Reservoir Dogs* (1992).

Some filmmakers use music to enhance the pace or rhythm of a movie, as in Tom Tykwer's *Run Lola Run* (*Lola rennt,* 1998; music: Reinhold Heil, Johnny Klimek, Franka Potente, and Tykwer), where the music matches the sped-up, almost surreal pace of the action. Music can also slow down fast scenes, as in Akira Kurosawa's *Ran* (1985; composer: Toru Takemitsu), where the siege on the castle of Lord Hidetora Ichimonji (Tatsuya Nakadai) is accompanied first by diegetic sound; then by grand, slow music (recalling Gustav Mahler's First Symphony); and finally, as the battle nears its climax, by more diegetic sound. Music can parallel or underscore the action, as in Leni Riefenstahl's Nazi propaganda film *Triumph of the Will* (*Triumph des Willens,*

[1]

One of the principal concerns of Stanley Kubrick's *A Clockwork Orange* (1971; sound editor: Brian Blamey), the loss of moral choice through psychological conditioning, is developed by a focus on (1) Alex (Malcolm McDowell), a worthless, violent character, here staring at (2) a poster of the German classical/Romantic composer Ludwig van Beethoven. Alex's only good trait is his love for Beethoven's Ninth Symphony—especially the setting in its finale of Friedrich von Schiller's "Ode to Joy," music that represents all that is most noble in the human spirit.

[2]

Here, however, this music is used ironically, to underscore Alex's desire to preserve his freedom to do what he wants (which consists mostly of violent acts) even though society tries to socialize him away from these acts (using a fascistic treatment that attempts to turn him into a "clockwork orange"). In the somewhat muddled world of this controversial film, we're supposed to be glad that Alex is still sufficiently human to embrace Beethoven *and* resist brainwashing.

[1]

[2]

In Spike Lee's *Do the Right Thing*, (1) Radio Raheem (Bill Nunn) and (2) Stevie (Luis Antonio Ramos) face off to determine whose music (and whose boom box) is superior. After a volley of insults and adjustments of volume, Stevie stands down, conceding Radio Raheem's audio supremacy. The diegetic rap and salsa music in this scene helps convey one of the movie's themes, the clash of different cultures in contemporary America. During the movie, among the rap, reggae, soul, and pop records spun (in those pre–compact disc days) are Public Enemy's "Fight the Power," Take 6's "Don't Shoot Me," Steel Pulse's "Can't Stand It," Ruben Blades's "Tu y Yo," and Al Jarreau's "Never Explain Love."

1935; composer: Herbert Windt), where the director actually conducted the studio orchestra herself to keep it in sync with the steps of the marching soldiers.

Many directors use music to provide overall structural unity or coherence to a story, as in Otto Preminger's psychological thriller *Laura* (1944; music: David Raksin), about which Royal S. Brown writes:

> Almost every piece of music, diegetic and nondiegetic, heard in the film either is David Raksin's mysteriously chromatic fox-trot tune or else grows out of it, particularly in the nondiegetic backing. The detective (Dana Andrews) investigating Laura's "murder" turns on a phonograph: it plays "Laura." The journalist throws a party for Laura once she has "returned from the dead": the background music is "Laura." But the way in which the melody travels back and forth between the diegetic and the nondiegetic, making that distinction all but meaningless, likewise reinforces the overall obsessiveness.[6]

Equally obsessive in musical, if not psychological, terms is Malcolm Arnold's score for David Lean's *The Bridge on the River Kwai* (1957), which incorporates as its theme music the traditional British military march "Colonel Bogey" to establish and relentlessly reinforce the courage and persistence that sustain the morale of captured British troops in Japanese concentration camps during World War II.

Musical themes are frequently associated with individual characters, and they may also help present a character's thoughts, as in

[6]Brown, *Overtones and Undertones*, 86.

Lasse Hallström's *My Life as a Dog* (*Mitt liv som hund,* 1985), where Björn Isfält's score reflects the poignant and melancholic state of mind of a boy yearning for his dead mother, or Joseph L. Mankiewicz's *The Ghost and Mrs. Muir* (1947), where Bernard Herrmann's score reflects a widow's loneliness. Herrmann offers another example of using music to indicate thoughts in Orson Welles's *Citizen Kane* (1941); after Susan Alexander Kane attempts suicide and begs Kane to permit her to end her singing career, the distortions in her "theme" suggest her fragile state of mind.

Finally, film music may emanate from sources within the story—a television, a radio or stereo set, a person singing or playing a guitar, an orchestra playing at a dance—as in the music provided by the disk jockey in Spike Lee's *Do the Right Thing* (1989). Although both the characters in a movie and its audience hear such diegetic music, which can be as simple as sound drifting in through an open window, only the audience hears nondiegetic music, which usually consists of an original score composed for the movie, selections chosen from music libraries, or both. Nondiegetic music is recorded at the very end of the editing process so that it can be matched accurately to the images. In recording an original score, the conductor and musicians work on a specially equipped recording stage, which enables them to screen the film and tailor every aspect of the music's tempo and quality to each scene that has music. Further adjustments of the sounds of individual musicians, groups of musicians, or an entire orchestra are frequently made after these recording sessions and before the final release prints are made. Similar efforts are made to fit selections taken from music libraries with the images they accompany.

SILENCE

As viewers, we are familiar with all the types of film sound described above, but we may be unfamiliar with the idea that *silence* can be a sound. Paradoxically, it has that function when the filmmaker deliberately suppresses the vocal, environmental, or musical sounds we expect in a movie. When so used, silence frustrates our normal perceptions. It can make a scene seem profound or even prophetic. Furthermore, with careful interplay between sound and silence, a filmmaker can produce a new rhythm for the film, one that calls attention to the characters' perceptions. Akira Kurosawa's *Dreams* (*Yume*, 1990; no sound credit) consists of eight extremely formal episodes, each based on one of the director's dreams. The third episode, "The Blizzard," tells of four mountain climbers trapped in a fierce storm. The screen is virtually white for most of the episode, and the few colors—yellow parkas; a patch of clear blue sky—are vibrant against this monochromatic background. The episode is shot in dream time: logic doesn't govern its handling of time or ordering of images.

As the episode begins, we hear the climbers' boots crunching the snow, their labored breathing, and the raging wind. They are exhausted, but the leader warns them they will die if they go to sleep. Nonetheless, they all lie down in the snow. Out of the low, howling wind, we hear the sweet, clear, high sounds of a woman singing offscreen. The storm stops, and thus silence falls, filtered sunlight appears, and the leader awakens to hear the woman, now onscreen, say, "The snow is warm. . . . The ice is hot." As she covers the leader with an exquisite shawl, he sleeps and then wakes again, all in silence; but then the loud sound of the storm resumes as

she disappears into air, accompanied by wind and thunder. The other men awaken—they, of course, have not seen or heard any of this. We hear muted trumpets, horns, and Alpine music, and, as the sunlight sparkles on snowy peaks, the men see their camp, only a few hundred feet away. Perhaps the woman's beauty and the silence that accompanies her have given the leader the courage to resist death and thus save the group.

FUNCTIONS OF FILM SOUND

Primarily, sound helps the filmmaker tell a movie's story by reproducing and intensifying the world that has been partially created by the film's visual elements. A good sound track can make the audience aware of the spatial and temporal dimensions of the screen, raise their expectations, create rhythm, and develop characters. Either directly or indirectly, these functions provide the viewer with cues to interpretation and meaning. Sounds that work directly include dialogue, narration, and sound effects (often Foley sounds) that call attention (the characters' or ours) to on- or off-screen events. In John Ford's *My Darling Clementine* (1946; sound: Eugene Grossman and Roger Heman Sr.), Doc Holliday (Victor Mature) noisily tosses his keys on the hotel desk to underscore his desire to leave town if Clementine (Cathy Downs) won't keep her promise to leave before him. In Charles Laughton's *The Night of the Hunter* (1955; sound: Stanford Naughton), the sharp rustling of bills inside a doll makes Harry Powell (Robert Mitchum) suspect the duplicity of the children (Billy Chapin and Sally Jane Bruce).

The sound effects in both films were created by Foley artists.

Sounds that function indirectly help create mood and may thus work to help the audience interpret scenes subconsciously. Sound expert Tomlinson Holman points out that viewers differentiate visual elements in a movie far more easily and analytically than they do sound elements. That is because they tend to hear sound as a whole, not as individual elements. Filmmakers can take advantage of viewers' inability to separate sounds into constituent parts and use sound to manipulate emotions, often via the musical score. In *Bride of Frankenstein* (1935; composer: Franz Waxman), director James Whale uses low-pitched music to accentuate the terror of the scene in which a lynch mob pursues the Monster (Boris Karloff) through the woods. In Steven Spielberg's *Jaws* (1975), composer John Williams uses four low notes as the motif for the shark—the sound of fear being generated in an otherwise placid environment. Whether direct or indirect, sound functions according to conventions, means of conveying information that are easy to perceive and understand.

AUDIENCE AWARENESS

Sound can define sections of the screen, guide our attention to or between them, and influence our interpretation. In a scene featuring games of Ping-Pong and cards in Jacques Tati's *Mr. Hulot's Holiday* (*Les vacances de M. Hulot*, 1953; sound: Roger Cosson), the sounds of the Ping-Pong ball, which are diegetic and on-screen, have several functions. First, they define two sections of a large room: a partially concealed section, in which Ping-Pong is played—we hear it, but do not see it—and a larger, open part of the room filled with people

In this scene from Jacques Tati's *Mr. Hulot's Holiday*, the only Ping-Pong player we see is Mr. Hulot (Tati, *standing*), who moves in and out of the little room, sometimes serving the ball, other times chasing it as it rolls among the feet under the tables in the larger room. The volume of the sound is modulated so that in the first part of the scene, the sound of the ball is louder than that of the conversation and thus guides us to pay attention to it. In the latter part of the scene, when the game stops while Hulot searches for the ball, the people's voices become louder and antagonistic, drawing our attention to them and perhaps suggesting that the back-and-forth bounce of the ball had something to do with maintaining the earlier civility of the guests.

either playing cards at various small tables or sitting and reading or talking with one another, all of which we see and hear.

In addition to directing our attention to both the spatial and temporal dimensions of a scene, as in *Mr. Hulot's Holiday*, sound also creates *emphasis* by how it is selected, arranged, and (if necessary) enhanced. In Robert Altman's *The Player* (1992; sound: Michael Redbourn), sound helps us eavesdrop on the gossip at one table in a restaurant and then, even more deliberately, takes us past

that table to another in the distance where the protagonist is heading and where the gossip will be confirmed. Since the scene takes place on the terrace of an exclusive restaurant in Beverly Hills—the guests all seem to be in the motion picture business—the sound makes us feel as if we were among them, able to see the rich and famous come and go, and, more relevant here, able to hear what they are saying, even if they think they aren't being overheard.

AUDIENCE EXPECTATIONS

In Ridley Scott's *Alien* (1979; sound: Jim Shields), the sound (as well as the visual effects) plays an impressive role in helping to create and sustain the suspenseful narrative. This science fiction/horror movie tells the story of the crew of a commercial spacecraft that takes on board an alien form of "organic life" that ultimately kills all but one of them, Lt. Ellen Ripley (Sigourney Weaver). One device used to sustain this suspense is the juxtaposition of the familiar "meow" sounds made by Ripley's pet cat, Jonesy, with the unfamiliar sounds made by the alien beast. After the alien disappears into the labyrinthine ship, three crew members—Ripley, Parker (Yaphet Kotto), and Brett (Harry Dean Stanton)—attempt to locate it with a motion detector. This device leads them to a locked panel, which, when opened, reveals the cat, who hisses and runs away from them. Since losing the cat is Brett's fault, he is charged with finding it by himself. We hear his footsteps as he proceeds warily through the craft, calling "Here, kitty, kitty. . . . Jonesy, Jonesy," and we are relieved when Brett finds the cat and calls it to him. However, before the cat reaches Brett, it sees the alien behind him, stops, and hisses. Alerted, Brett turns around and is swiftly killed by the beast. This sound motif is

repeated near the end of the film, when Ripley prepares to escape on the craft's emergency shuttle but is distracted by the cat's meow.

RHYTHM

Sound can add rhythm to a scene, whether accompanying or juxtaposed to movement on the screen. In *Citizen Kane* (1941; sound: Bailey Fesler and James G. Stewart), in the comic scene in which Kane moves into the *Inquirer* office, Orson Welles uses the rhythms within overlapping dialogue to create a musical composition, one voice playing off another in its pitch, loudness, and quality (see "Analyzing Film Sound," below). In Atom Egoyan's *The Sweet Hereafter* (1997; sound: Steve Munro), two conversations overlap, joined in time but separated in onscreen space: Wendell and Risa Walker (Maury Chaykin and Alberta Wat-

son) talk with each other while Mitchell Stephens (Ian Holm) speaks with his daughter (Caerthan Banks) on a cell phone.

A montage of sounds is a mix that ideally includes multiple sources of diverse quality, levels, and placement and, usually, moves as rapidly as a montage of images. Such a montage can also be "orchestrated" to create rhythm, as in the famous opening scene of Rouben Mamoulian's *Love Me Tonight* (1932; sound: M. M. Paggi)—one of the first films to use sound creatively—in which the different colors of sounds made by ordinary activities establish the "symphony" that accompanies the start of the day in an ordinary Parisian neighborhood. Jean-Pierre Jeunet and Marc Caro paid homage to Mamoulian's sound montage in *Delicatessen* (1991; sound: Vincent Arnardi and Laurent Zeilig; see "Form and Patterns" in chapter 2), where the tenants in a

Early in *The Sweet Hereafter*, Atom Egoyan establishes the theme of the outsider, city lawyer Mitchell Stephens (Ian Holm, *left*), who enters a rural community, intrudes into its citizens' emotional lives, but keeps his own emotional life secret except when he can exploit it for profit. Split nearly down the middle by the walls' meeting point, this shot conveys the distance between Stevens and the first couple he approaches in the community, the Walkers (Maury Chaykin and Alberta Watson), whose conversation he monitors while engaging in his own, private, cell-phone drama.

Parisian apartment unthinkingly change the rhythm of their daily chores to keep time with the increasing ardor of the sexual encounter between the butcher and his partner. Everybody, consciously or unconsciously, follows the butcher.

CHARACTER

All kinds of sounds—dialogue, sound effects, music—can function as part of characterization. In Mel Brooks's *Young Frankenstein* (1974; sound; Don Hall), when Frau Blucher's (Cloris Leachman) name is mentioned, horses rear on their hind legs and whinny. She is so ugly that even horses can't stand to hear her name; so for the rest of the movie, every time her name is mentioned, we hear the same sounds. In *Jaws* (1975; sound: John R. Carter), Steven Spielberg uses a sound effect to introduce Quint (Robert Shaw), the old shark hunter. When Quint enters a community meeting called in response to the first murder of a swimmer by the shark, he draws his fingernails across a chalkboard to show he's not afraid of a sound that makes most people cringe—nor, by extension, of townspeople or sharks. We might also observe that this sound is as creepy as Quint.

Howard Hawks's *Bringing Up Baby* (1938; sound: John L. Cass; see "Vocal Sounds: Dialogue and Narration," above) tells an unlikely love story about two very different people from very different backgrounds: David Huxley (Cary Grant), an absent-minded paleontologist, and Susan Vance (Katharine Hepburn), an equally daffy society heiress. They meet in confusing circumstances on a golf course, and their rather dazzling romance continues through a hilarious series of accidents. The characters' language, as much as their costumes and overall mannerisms, helps identify them:

HUXLEY: Well, you don't understand—this is *my* car!

VANCE: You mean, *this* is your car?

HUXLEY: Of course.

VANCE: *Your* golf ball? *Your* car? Is there anything in the world that doesn't belong to you?

HUXLEY: Yes, thank heaven—you!

VANCE: Now, don't lose your temper.

HUXLEY: My dear young lady, I'm not losing my temper. I'm merely trying to play some golf.

VANCE: Well, you choose the funniest places. This is a parking lot.

HUXLEY: Will you get out of my car?

VANCE: Will you get off my running board?

HUXLEY: This is *my* running board!

Musical themes often identify characters, occuring and recurring on the sound track as the characters make their entrances and exits on the screen. But music can also underscore characters' insights. In Alfred Hitchcock's *Notorious* (1946; music: Roy Webb), Alicia Huberman (Ingrid Bergman) is enlisted by Devlin (Cary Grant), a U.S. intelligence agent, to spy on a ring of Nazis in Brazil. Alicia and Devlin promptly fall in love. However, as part of her work, Alicia marries Alexander Sebastian (Claude Rains), who soon suspects that she is a spy and, with the help of Madame Sebastian (Leopoldine Konstantin), his mother, begins systematically to poison her coffee. In a stunning sequence, Hitchcock brings this situation to a climax. Madame Sebastian pours the coffee (one pot for Alicia, another for the rest of them) and sets Alicia's cup beside her. In several deep-focus shots during the sequence, the coffee cup, in extreme close-up, forms the apex of a triangle between Alicia and Dr. Anderson (Reinhold Schünzel), who are discussing whether or not she should take a rest cure in the mountains. When Dr. Anderson

In *Mean Streets* (1973; sound: Glen Glenn), Martin Scorsese uses nonfaithful sound when Charlie (Harvey Keitel), after making love to Teresa (Amy Robinson), playfully points his fingers at her as if they were a gun and pulls the "trigger." We hear a gunshot, but there is no danger, for this is just a lover's quarrel.

mistakenly picks up Alicia's cup, Sebastian and his mother grow so agitated that Alicia becomes suddenly aware that they are poisoning her—a realization subtly registered on her face. This insight is accompanied by quiet but ominous music that becomes distorted in quality as we see a close-up of the cup followed by two tracking shots from Alicia's point of view to close-ups of her enemies. She stands, but is dizzy, able to see only distorted images of them. As she staggers into the elaborate front hall and collapses, the music builds in a very controlled crescendo to underscore her fearful state of mind.

FIDELITY

Sound can be either faithful or unfaithful to its source. In James Mangold's *Cop Land* (1997; sound: Allan Byer), in an attempt to threaten the hearing-impaired sheriff, Freddy Heflin (Sylvester Stallone), with a complete loss of hearing, one of several corrupt cops who have waylaid him discharges a pistol close to his one good ear. During the climactic shoot-out, the sound is faithful to Heflin's severely impaired hearing. An excellent early example of an offscreen sound effect that is not faithful to its source occurs in Rouben Mamoulian's *Love Me Tonight* (1932; sound: M. M. Paggi). During the farcical scene in which "Baron" Maurice (Maurice Chevalier) tells Princess Jeanette (Jeanette MacDonald), whom he is wooing, that he is not royalty but just an ordinary tailor, pandemonium breaks out in the royal residence. As family and guests flutter about the palace, singing of this deception, one of the princess's old aunts accidentally knocks a vase off a table. As it hits the floor and shatters, we hear a bomb explode, as if to suggest that the social order is under attack. In William Friedkin's *The Exorcist* (1973; sound: Christopher Newman), the sound is nonfaithful when the devil speaks through the mouth

of Regan MacNeil (Linda Blair). Actor Mercedes McCambridge provides the demon's voice. Other good examples of faithful and nonfaithful sound playing against our expectations include the screaming landlady juxtaposed with the train whistle in Alfred Hitchcock's *The 39 Steps* (1935) and the explosion that does not make a sound in the opening montage of Coppola's *Apocalypse Now* (cited above).

CONTINUITY

Sound can link one shot to the next, indicating that the scene has not changed in either time or space. A **sound bridge** (also called a *sound transition*) carries the sound from a first shot over to the next before the sound of that second shot begins. Vittorio De Sica uses this technique in *Bicycle Thieves* (*Ladri di biciclette,* 1948; sound: Bruno Brunacci). As Antonio Ricci (Lamberto Maggiorani) walks to the labor union headquarters, we hear lively music, which, we learn in the second shot, comes from the union members' rehearsal of a musical play. Another effective sound bridge occurs in Charles Laughton's *The Night of the Hunter* (1955; sound: Stanford Naughton). Harry Powell (Robert Mitchum), a con man posing as an itinerant preacher, has murdered his wife, Willa (Shelley Winters), placed her in an automobile, and driven it into the river. An old man, Birdie (James Gleason), out fishing on the river, looks down and discovers the crime. Through shot A, an underwater shot of great poetic quality, we see Willa in the car, her floating hair mingling with the reeds, and hear Harry singing one of his hymns; that music bridges the cut to shot B, where Harry, continuing to sing, is standing in front of their house looking for his stepchildren (Billy Chapin and Sally Jane Bruce). In the pre-

credits sequence that opens Ralph Nelson's *Requiem for a Heavyweight* (1962; sound: Edward J. Johnstone), whose realistic sound influenced Martin Scorsese's far more ambitious boxing film, *Raging Bull* (1980), a long tracking shot along a neighborhood bar shows a crowd of men watching a boxing match on television; the sound is mixed to make the voice of the ringside announcer louder than the sounds of the crowd. When the sound continues as a bridge to the second shot, which is of the fight itself, the mix is reversed so that the crowd noises dominate.

EMPHASIS

A sound can create emphasis in any scene—that is, can function as a punctuation mark—when it accentuates and strengthens the visual image. In Peter Weir's *The Truman Show* (1998; sound: Lee Smith), Truman Burbank's (Jim Carrey) sailboat hits the inside of the great dome that has enclosed his entire made-for-television life. This distinct bumping sound, amid the silence that follows a huge storm at sea, heralds Truman's break from the world of illusion. In Adrian Lyne's *Lolita* (1997; sound: Michael O'Farrell), the sexual ambiguity of a confrontation between Humbert Humbert (Jeremy Irons) and his nemesis, Clare Quilty (Frank Langella), is punctuated by the sound of an electric bug zapper. In Orson Welles's *Citizen Kane* (1941; sound: Bailey Fesler and James G. Stewart), a particularly appropriate sound bridge also helps define a character. After the conclusion of the "love nest" sequence, Kane (Welles) chases Jim W. "Boss" Gettys (Ray Collins) down the stairs, screaming, "Gettys! I'm going to send you to Sing Sing! Sing Sing, Gettys! Sing Sing, Gettys, Sing Sing!" By this point, Kane has been so thoroughly vanquished by Gettys that

[1]

[2]

[3]

[4]

In Steven Spielberg's *Jaws* (1975; sound: John R. Carter and Robert Heyt), at the hospital, (1) Police Chief Brody (Roy Scheider, *left*) secures the approval of Mayor Vaughn (Murray Hamilton) to hire the shark hunter Quint (Robert Shaw). A sound bridge—a conversation between Brody and Quint at Quint's shop—links (2) shot A, in which Brody is still at the hospital, and (3) shot B, in which the conversation continues at Quint's shop:

SHOT A

Brody: $10,000 . . .

Quint: $200 a day, either I catch him or not.

Brody: You get it.

SHOT B

Quint: Get the men off my back so that I don't have anymore of this zoning crap.

Brody: You got that.

Since the conversation continues through both shots and into the next (4), we don't have to see Brody actually going to Quint's shop; thus the suspenseful story keeps moving quickly as we learn the terms of the contract and how they reveal the shift in power to Quint.

his threat is nothing but hot air, signified by a sound bridge that occurs as Gettys steps out of the house and closes the door on the final "Sing." Because the door has closed, the sounds of Kane's voice are faithfully diminished while the louder sounds of a car horn drown him out completely.

JUXTAPOSITION

By juxtaposing visual and aural images, a director can express a point of view, as we saw (above) in Scorsese's use of "Please Mr. Postman" in *Mean Streets*. Another classic example occurs in the penultimate sequence of Stanley Kubrick's *Dr. Strangelove, or: How I Learned to Stop Worrying and Love the Bomb*, cited above, where Kubrick ironically juxtaposes the deadly sight (but not the sound) of an exploding nuclear bomb with the sentimental strains of Vera Lynn singing "We'll Meet Again," a popular song that strengthened the hopes of parting servicemen and their friends and families during World War II. This

[1]

[2]

[3]

[4]

[5]

[6]

The opening montage in Francis Ford Coppola's *Apocalypse Now* (see p. 355) sets a high visual and sonic standard, but Coppola and his collaborators meet and perhaps exceed that standard during the "Helicopter Attack" scene, in which the lunatic Lieutenant Colonel Kilgore (Robert Duvall, standing in final frame) leads a largely aerial raid on a Vietnamese village. Accompanying horribly magnificent images of destruction and death are the sounds of wind, footsteps, gunfire, explosions, airplanes, helicopters, crowd noise, shouting, dialogue, and Wagner's "Ride of the Valkyries." The grand operatic music gives unity, even a kind of dignity, to the fast-moving, violent, and disparate images. For an in-depth analysis of *Apocalypse Now*, see the case study for this chapter: <www.wwnorton.com/web/movies>.

www

combination recalls Kubrick's earlier juxtaposition of the sounds of "Try a Little Tenderness" with images of the refueling of a bomber carrying nuclear bombs.

MONTAGE

A montage of sounds is a mix that ideally includes multiple sources of diverse quality, levels, and placement and, usually, moves as rapidly as a montage of images. In any event, sounds "collide" (to use the term of theorist and filmmaker Sergei Eisenstein; see "Montage" in chapter 6) to produce an overall sound that is often harsh and discordant. Francis Ford Coppola's *Apocalypse Now* (1979; sound designer: Walter Murch) combines more than 140 sound tracks during the exciting, horrifying helicopter assault on the beach of a Viet Cong stronghold; prominent in the mix is "The Ride of the Valkyries" from Richard Wagner's opera *Die Walküre* (1870). In a later film about Vietnam, Oliver Stone's *Platoon* (1986; sound designer: Gordon Daniel), the personal hatreds that divide a platoon are underscored by a montage that includes the roar of the helicopters, the voices of frightened men, the screams of the dying, and repeated quotations from Samuel Barber's Adagio for Strings (1938).

SOUND VERSUS SILENCE

Until recently, movie history was divided into two periods: the "silent" films produced between 1895 and 1927 and the "sound" films from the years that followed. As a result of further research, we now know that such a simple division is a historical fallacy.[7] Contemporary sound films use silence, after all, in ways silent films could not, and some experimental filmmakers continue to make entirely silent films.

Inventors had been thinking about making sound movies almost from the time they began thinking about making moving pictures. In 1877, eighteen years before the first movies were presented to the public, Thomas A. Edison invented the phonograph, the first machine that could reproduce recorded sound. It played tin-foil disks upon which grooves were cut during the recording process. (Phonograph records, in various sizes and speeds, dominated the recording industry until the late 1980s, when they were almost wholly replaced by compact discs, or CDs.) In 1883, Edison was joined at Menlo Park by the young British amateur photographer William Kennedy Laurie Dickson, who became part of the team that helped Edison improve the phonograph; he was also intrigued by the prospect of capturing moving images. In 1899, Dickson achieved the crucial breakthrough of roughly synchronizing sound with moving pictures. The **Kinetophone,** combining Edison's Kinetoscope and phonograph, enabled viewers to look through the peephole viewer of the Kinetoscope and listen to phonograph recordings through earphones, but this device was far from being a commercial success. Furthermore, Edison and his associates were not alone in their endeavors. The invention of motion pictures took place simultaneously in various countries, but Europeans—including William Friese-Greene, Edweard Muybridge,

[7]Rick Altman, "Introduction: Four and a Half Film Fallacies," in *Sound Theory/Sound Practice,* ed. Rick Altman (New York: Routledge, 1992), 35–45.

Étienne-Jules Marey, and Augustine le Prince—took the initiative in experimenting with adding sound to the movies. Some of them hoped to join forces with Edison, who at least at first was more interested in developing the phonograph.

At the 1900 Paris World Exposition, three different systems for synchronizing phonograph records with projected film strips were exhibited, and similar systems were used to produce hundreds of synchronized short films during the following decade. In 1907, the prominent French composer Camille Saint-Saëns wrote the first original film score; many of the early full-length features, including films by D. W. Griffith, Fritz Lang, and F. W. Murnau, had musical scores. Sheet music for these scores was included when the films were distributed. As for sounds other than music, troupes of actors went from theater to theater to speak the dialogue for "silent" pictures, either in full view of the audience or from behind the screen. In 1907, Lee De Forest, an American inventor known as the "father of the radio," perfected the Audion vacuum tube, which magnified sound and reproduced it through speakers for large movie audiences. By 1910, dozens of sound systems had been devised and installed in hundreds of theaters in both Europe and the United States: movies in those theaters could be accompanied by any combination of sound effects, live music, live singers, speakers or actors, and phonograph recordings.

Thus long before 1927—the turning point from silent to sound production—many efforts were under way to make sound movies, efforts destined eventually to converge. Major challenges remained: in mastering the *technological* process of producing movies, in managing the *commercial* venture of exhibiting them, and in conveying the *aesthetic* qualities that differentiated the movies from the other arts.

TECHNOLOGICAL CHALLENGES

The film industry's first technological challenge was to develop a sound storage device that would hold as much material as a feature film required. That meant recording sounds not on disks but on film. The sound-on-film process permitted image and sound to be recorded simultaneously in the same (photographic) medium, ensuring their precise and automatic synchronization.

As usual in the early history of motion pictures, developments occurred in both the United States and Europe and in several competing systems. The first practical sound-on-film system was invented in 1910 in the United States by Eugène Augustin Lauste, who had worked with Dickson at the Edison Laboratories. A major step forward was taken in Germany in 1919, when inventors Josef Engl, Joseph Massole, and Hans Vogt patented the Tri-Ergon process, which encoded sounds in light waves that could be recorded photographically. In 1923, De Forest patented the Phonofilm system, an optical sound-on-film process similar to the Tri-Ergon process, with which he began producing short films for specially equipped theaters.[8] In 1926, with a multimillion-dollar investment from Wall Street, Warner Bros. bought the exclusive rights to Vitaphone, a third sound-on-film system created by a group of inventors from Western Electric and the Bell Telephone Laboratories; the Fox

[8]In Gene Kelly and Stanley Donen's *Singin' in the Rain* (1952), De Forest is satirized humorously as the pompous man who tells the audience they are watching a "talking picture."

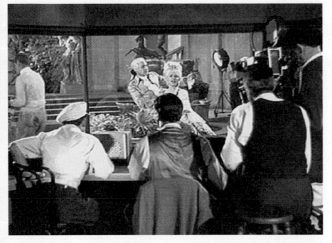

[1]

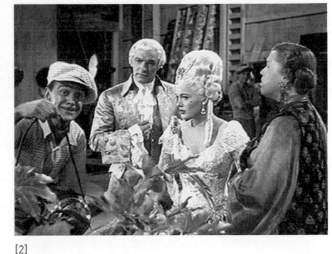

[2]

[3]

[4]

In Stanley Donen and Gene Kelly's *Singin' in the Rain*, a musical that looks back amusedly at Hollywood's conversion from silence to sound, it becomes a huge challenge to (1) record the dialogue between actors Lina Lamont (Jean Hagen, *right*) and Don Lockwood (Kelly). (2) Director Roscoe Dexter (Douglas Fowley) resorts to hiding the microphone behind a huge plant, where it is too far from the actors; (3) planting it inside a corsage attached to Lamont's bosom, where it records the sound of her heartbeat; and (4) moving the corsage practically up to her mouth.

The appeal to the public of Alan Crosland's early "sound" movie *The Jazz Singer* was that they could hear as well as see Al Jolson, one of the country's most popular performers, shown here performing a minstrel-type song in blackface makeup. Jolson's memorable lines "Wait a minute. . . . Wait a minute. You ain't heard nothin' yet!" entered the speech of everyday American life. Blackface has a long and painful history, and Al Jolson's use of it here is merely the most prominent in our cultural memory. To explore these issues further, and to learn about the history of Hollywood's portrayal of and relationship with African Americans and other minorities, go to <www.wwnorton.com/web/movies>.

www

Film Corporation, which had earlier tried to acquire the American rights to the Tri-Ergon process, introduced Movietone; and RCA introduced Photophone (based on Lauste's 1910 invention). The enthusiastic financial support of Wall Street, bolstered by the sharp increase in movie tickets sold in the first year of sound production, continued throughout the lengthy and expensive period of conversion that followed.

Through professional organizations, such as the Society of Motion Picture Engineers (SMPE; now known as the Society of Motion Picture and Television Engineers, or SMPTE), the American Society of Cinematographers (ASC), the American Cinema Editors (ACE), and—most important—the Academy of Motion Picture Arts and Sciences (AMPAS), the leaders of the studios' technical and research departments reached consensus on what they needed for the conversion, the cost of which was reportedly more than $300 million. Incalculable human costs were involved as well. Many creative people—directors, writ-

ers, and actors—did not successfully adapt to making sound films and lost their jobs in the industry. Directors had to learn two major new skills: to prepare actors thoroughly before the cameras rolled, because they could no longer speak during filming for fear their voices would be picked up by the microphones, and to pay attention to how actors actually delivered the dialogue. Before sound, directors and actors concentrated on facial expressions, gestures, and movement; now, they had to bring to the screen the whole range of vocal expression on which successful delivery of the dialogue depended. This, in turn, created challenges for the actors. Many film actors without prior theater experience had difficulty memorizing their lines; others, with foreign accents, had problems speaking English clearly enough to be understood by American audiences. Writers of silent films, who had a talent for creating characters and stories, often did not have the verbal gifts needed to write dialogue for sound films. In addition, early sound-recording equipment

was bulky, clumsy, and far from portable. This is best conveyed in Stanley Donen and Gene Kelly's *Singin' in the Rain* (1952; sound: Douglas Shearer), a retrospective comedy set in Hollywood during the conversion to sound. Using exaggeration for comic effect, this movie shows us that the microphone had to be as close to the actors as possible, thus preventing any normal kind of movement; that the camera was so loud that it had to be placed in a soundproof booth, thus preventing anything but the simplest panning or tilting movements; that the screenwriters had little or no experience in writing believable dialogue; and that many of the actors had not learned how to use their voices.

The first sound film projected for a public audience was Alan Crosland's *Don Juan* (1926; sound: George Groves), which featured the sounds of a recorded orchestra but not of human voices. As the first movie to use synchronized sound as a means of telling a story, Crosland's *The Jazz Singer* (1927; sound: George Groves) used four sequences with synchronized speed, but most of it was shot silent, with music added later. The challenge of completely synchronizing sound and picture was met one year later with Bryan Foy's *Lights of New York* (1928; no sound credit), advertised as the first "100 percent all-talkie," and, according to film historian David Cook, "the first film in history to rely entirely upon the spoken word to sustain its narrative."[9] However, its technical and thus aesthetic limitations are clear: actors had to speak into stationary microphones because neither the microphones nor the camera could easily move to follow them and still capture sound. What audiences saw on the screen remained almost as static as what they had seen on the stage.

Ordinary narrative "talkies" were primarily just dialogue, not true "sound" films. Despite these major drawbacks, talkies were drawing large audiences chiefly because of their novelty. Furthermore, innovative directors and their collaborators were starting to create impressive films that integrated sound: the Walt Disney Studios with *Skeleton Dance* (1929; no sound credit), King Vidor with *Hallelujah* (1929; sound: Douglas Shearer), Ernst Lubitsch with *The Love Parade* (1929; sound: Franklin Hansen), Lewis Milestone with *All Quiet on the Western Front* (1930; sound: C. Roy Hunter), Rouben Mamoulian with *Applause* (1929; sound: Ernest Zatorsky) and *Love Me Tonight* (1932; sound: M. M. Paggi), Dziga Vertov with *Enthusiasm* (*Entuziasm*,

Walt Disney's innovative animated film *Steamboat Willie* (1928; no sound credit), the first Mickey Mouse cartoon, had a complete soundtrack created in postproduction; it mixed dialogue, music, and sound effects. It was based on Charles Reisner's silent film *Steamboat Bill, Jr.* (1928), starring Buster Keaton.

[9]David Cook, *A History of Narrative Film*, 3rd ed. (New York: Norton, 1996), 248.

Members of the sound crew use a boom microphone on the set of John Schlesinger's *Eye for an Eye* (1996).

mechanical device for holding the microphone in the air, out of camera range, and movable in almost any direction; and incandescent lights, which were quieter than the noisier arc lamps.

But the technological development that finally liberated the sound film was **postsynchronization:** the printing of image and sound on separate pieces of film that can be manipulated independently. Since the frame controls the relationship between sound and image, production sound can be brought into synchronization with the picture by printing the sound at least one frame ahead of the image (sound travels more slowly than light). This phenomenon is yet another way in which cinema fools our senses—in this case, fooling our ears to make us think we are hearing synchronized sound. By the mid 1930s, film historian Barry Salt explains, "there was now full freedom to assemble as complicated sound tracks as could be desired, going through several recording stages if that was necessary."[10] It was relatively easy to control noise on heavily insulated *sound stages,* in contrast to the vagaries of recording on location, and Hollywood's practice of shooting against the back projection used in process shots made it possible to have both the illusion of exterior space and clear sound.

Underlying these incremental improvements was Hollywood's slow conversion from optical to magnetic sound recording. In *optical sound recording,* which dominated film production until after World War II, sound was recorded photographically onto film. This optical sound track was "read" by a light in the

1931; sound: Pyotr Shtro), G. W. Pabst with *Comradeship (Kameradschaft,* 1931; sound: Adolf Jansen), Fritz Lang with *M* (1931; sound: Adolf Jansen), and Merian C. Cooper and Ernst B. Schoedsack with *King Kong* (1933; sound: Earl A. Wolcott and Murray Spivack).

Before the 1930s, the quality of sound recording had been limited by **nondirectional microphones,** which tended to pick up more sound from the shooting environment than desired. Strides in noise suppression were made as early as 1931, followed later in the decade by **unidirectional microphones,** which responded, and had greater sensitivity, to sound coming from one direction; **bidirectional microphones,** which responded to sounds coming from the front and back but not the sides; and **omnidirectional microphones,** which responded to sound coming from all directions. Other improvements included the camera blimp, a case mounted around a camera to confine and prevent its noise from reaching the microphone during sound recording; the moving **boom,** a polelike

[10]Barry Salt, "Film Style and Technology in the Thirties: Sound," in *Film Sound: Theory and Practice,* ed. Elisabeth Weis and John Belton (New York: Columbia University Press, 1985), 43.

projector and amplified into a loudspeaker. Thus sound technology was linked to photographic technology. In *magnetic sound recording,* sounds are impressed on a magnetic tape, strip, film, or wire, which is "read" by a magnetic head and then amplified. Its recording equipment is easier to use and more portable. In addition, because it virtually divorces sound technology from image technology, magnetic recording permits the capturing and mixing of as many sound sources as the director wants. (For more information, see "Sound Production," below.)

Throughout the 1930s, the development of sound technology added to what Rick Altman calls the "desire to produce a persuasive illusion of real people speaking real words."[11] Parallel advances in the use and broadcasting of sound on the radio accustomed both filmmakers and audiences to more and better ways of making, reproducing, and hearing sound.

COMMERCIAL CHALLENGES

In 1909, in view of their extraordinary financial prospects, the nine leading production companies formed the Motion Pictures Patent Company (MPPC), a monopoly that controlled virtually all aspects of the fledgling industry, especially innovations such as sound. Fearing any innovation that might destabilize the success of the industry, the MPPC adopted a wait-and-see attitude toward sound. Movie moguls recognized the appeal of sound-on-film, but many still believed that the public's fascination with *moving* pictures made sound unnecessary. They recognized that in addition to unknown and perhaps incalculable costs of

bringing sound into the production process and the theaters, they faced the cost of producing different-language versions of individual movies. However, by 1915, when this monopoly was broken by the U.S. government, only the need to perfect the technology remained an obstacle. The inventors, the public, and the industry were ready.

The history of how the American film industry responded to the commercial challenges of the conversion to sound is too involved to cover here.[12] Because of the risks, the enormous potential for profits, and the competing systems; the involvement of those who invented and manufactured or sold, installed, and serviced these systems; and the involvement of those who produced, distributed, and exhibited motion pictures, the negotiations directed at establishing some sort of standardization were complicated and often ruthless. To set both the domestic and international standards for putting sound on film and into theaters, it became necessary to establish some structure for organizing the different factions and setting an agenda. In the United States, three competing sound systems were under consideration: Western Electric Vitaphone, Fox Movietone, and RCA Photophone. Following the lead of Warner Bros. and its first Vitaphone hits, the Western Electric Corporation formed a new division, Electrical Research Products, Inc. (ERPI), to sell, install, and service both Vitaphone and Movietone. Following the lead of ERPI were General Electric, RCA, and Paramount Famous Lasky (later

[11]Rick Altman, "Evolution of Sound Technology," in Weis and Belton, eds., *Film Sound,* 47.

[12]The full story is told in Donald Crafton, *The Talkies: American Cinema's Transition to Sound, 1926–1931* (New York: Scribner, 1997). See also David Bordwell, "The Mazda Tests of 1928," in David Bordwell, Janet Staiger, and Kristin Thompson, *The Classical Hollywood Cinema: Film Style and Mode of Production to 1960* (New York: Columbia University Press, 1985), 294–97.

Paramount Pictures), which coordinated the film industry's response to the introduction of Vitaphone and, in 1927, reached agreement with the other major producers—Loew's (MGM), First National, Universal, and Producers Distributing Corporation (PDC). The industry judged the sound quality, compatability, and cost of the various systems, and by the end of 1929, most U.S. exhibitors (theater owners) had equipped their theaters with either the Fox Movietone or the RCA Photophone sound-on-film system. By the early 1930s, the Vitaphone sound-on-disc system proved unable to match the flexibility offered by these systems and was phased out.

Since Hollywood had almost completely converted to sound before the 1929 stock market crash, during the Great Depression it concentrated on learning and using the new technology. But the film industry had lost its autonomy by partnering with Wall Street. Conservative bankers joined its boards of directors and changed the kinds of films being made. Before the advent of sound (and the establishment of the Production Code in 1933; see chapter 2), Hollywood movies had reflected diverse social, cultural, and economic outlooks. Afterward, the voice of Hollywood, especially during the Depression and the years leading up to and through World War II, was more in line with what Wall Street and Washington, D.C., were saying. Exceptions existed, as in the populist films of Frank Capra and the gangster films made by Warner Bros., but the cost of talking movies meant that Hollywood spoke less freely than when films were silent.

AESTHETIC CHALLENGES

By 1927, the silent film had been perfected as a mature art form, capable of profound tragedy (D. W. Griffith's *Broken Blossoms*, 1919), hilar-ious comedy (Buster Keaton's *The General,* 1926), sweeping epic (John Ford's *Iron Horse,* 1924), prophetic fantasy (Fritz Lang's *Metropolis,* 1926), frightening horror (Robert Wiene's *The Cabinet of Dr. Caligari* [*Das Kabinett des Doktor Caligari*], 1919), and profound emotional impact (F. W. Murnau's *Sunrise,* 1927). Genres had evolved and stories had became more complex. Established writers of fiction and drama turned their talents to screenplays, theorists began to think seriously about the possibilities of the form, and film criticism became more informed and intelligent. A fairly uniform language of expression—narrative, composition, shots, movement, lighting, editing, and special effects—had been created. Alternative languages were created in the avant-garde or experimental realm, especially in Europe. The borders between the static theater and the dynamic cinema had been clarified and were understood by filmmakers and audiences alike. As much as anything else, the moving camera had demonstrated that there were no limits to the world of the screen. The use of the camera, especially the close-up, gave silent screen acting a freedom and subtlety almost unknown to the stage. In short, the development of movies had culminated *without* incorporating (within themselves) spoken dialogue or recorded sounds of any kind.[13]

Thus as many film historians, including Rick Altman, have emphasized, the first thirty years of film history, theory, and practice were dominated by an emphasis on the image. Film

[13]See Paolo Cherchi Usai, *Burning Passions: An Introduction to the Study of Silent Cinema,* trans. Emma Sansone Rittle (London: British Film Institute, 1994); James Card, *Seductive Cinema: The Art of Silent Film* (New York: Alfred A. Knopf, 1994); and Richard Koszarski, *An Evening's Entertainment: The Age of the Silent Feature Picture, 1915–1928* (New York: Scribner, 1990).

theorists, critics, and directors might disagree over the value of sound in general, but they tended to denigrate speech in particular. They believed the moving image to be the most important element of cinematic form, the one, as noted above, that distinguished cinema from any other art form, especially drama. In their eyes, films with dialogue were little more than filmed drama. And, indeed, before the moving camera liberated the cinema, many films offered little more than filmed pantomime.

Other pioneers believed in sound because it enhanced cinema's potential to reproduce reality. However, they were also concerned with theoretical issues, such as the appropriate balance between dialogue, music, and sound effects; whether images and sound work together or one must take precedence over the other; and whether sound should be diegetic, nondiegetic, or both. They also debated whether sound should work with or against the image and to what extent it should be processed to remove interference. Considering the broad use of sound in today's movies, as well as the perfection of sound recording and reproduction in the movie theater, these may seem like obsolete concerns, but they were, in fact, at the heart of defining the full potential of the movies. Film theory can be divided into two periods, classical and modern, which align roughly with film history's silent and sound periods.

CLASSICAL SOUND THEORY. The first phase of film theory, known today as classical or formalist, flourished between 1920 and 1935. Like most film theorists before and after them, the formalists focused on the nature of cinema: was its purpose to create a uniquely cinematic art or to perfectly capture reality? Should it reproduce the world as the artist sees it or as we see it? The later film theorist J. Dudley Andrew

points out that "film art is a product of the tension between representation and distortion."[14] The most influential formalists writing during the "silent" period were Hugo Munsterberg, Sergei Eisenstein, Lev Kuleshov, and V. I. Pudovkin. After the coming of sound, the formalist tradition was maintained in the positions taken by John Grierson and the other leaders of the British Documentary Film Movement—a group strongly influenced by Eisenstein and the Soviet formalists—and in the writings of such philosophers and filmmakers as Rudolf Arnheim, Béla Balász, and Jean Epstein. The formalists valued cinema as an *art* (i.e., for its ability to transform the substance of daily life into artistic form). Thus they scorned such technological developments as sound, color, three-dimensional photography, and widescreen projection as elements that would enable cinema to reproduce reality in a form that corresponded more closely with our own experiences rather than with the artist's interpretations. Although Eisenstein, the dominant formalist theorist, believed that sound had become more a novelty than a medium of legitimate cinematic expression, he proposed that a sound montage could accompany montage editing. However, he saw the purpose of such sound not as echoing but as providing a counterpoint to the visual image. There was—and still is, of course—a danger in emphasizing one property of cinema over another, and a common ground on which image and sound could coexist would be found in the early 1930s. But the formalists, writing in the 1920s, regarded sound as an element that destroyed the purity of the organic cinematic art form. For them, the silent cinema was the summit of film achievement.

[14]J. Dudley Andrew, *The Major Film Theories: An Introduction* (New York: Oxford University Press, 1976), 31.

In fact, the direction of film history was changed not just by the coming of sound in 1927 but also by the Great Depression. During the early 1930s, some great films confronted the socioeconomic realities of the times, but most movies attracted audiences with a carefree vision of a world untroubled by unemployment, hunger, and homelessness. People wanted to escape those realities—to enter, if only for a few hours, into a world of singing, dancing, stars, and dreams—and Hollywood willingly fashioned the style of its products to satisfy its customers. As a result, sound remained anathema to some formalist, Marxist, and cultural critics, as well as to the devotees of the silent film, who deplored Hollywood's manipulation of both image and sound.

MODERN SOUND THEORY. The realist theories of sound, propounded by such major figures as Siegfried Kracauer and André Bazin, followed the actual innovations in sound films made by such directors as Dziga Vertov, Fritz Lang, G. W. Pabst, Jean Vigo, René Clair, Raoul Walsh, Rouben Mamoulian, Ernst Lubitsch, and King Vidor. Further interest in the theoretical and practical issues and applications of sound has come with the films of such directors as Orson Welles, Robert Bresson, Jean-Marie Straub, Robert Altman, Francis Ford Coppola, and George Lucas, and with the advances in direct sound recording made by the proponents of *cinéma vérité* in France, "free cinema" in England, and "direct cinema" in the United States.[15] Finally, cultural theorists have raised new questions about how ideology influences sound and thus influences meaning.

In contemporary commercial film production, moviemakers strive for verisimilitude and utilize all the available technology, including sound, color, and widescreen projection. "The rhetoric of sound," writes film scholar Mary Ann Doane, "is the result of a technique whose ideological aim is to conceal the tremendous amount of work necessary to convey an effect of spontaneity and naturalness."[16] Although we are often overwhelmed by the sound in movie theaters today, we neither expect nor want to be preoccupied with what is behind it, for we expect the sound of a movie, just like the image, to help transport us into its story.

SOUND PRODUCTION

Sound production consists of four phases: *design, recording, editing,* and *mixing.* (Sound *re*production, or playback, consists of the technology that converts sound signals, mainly through amplifiers and loudspeakers, into what we hear in the movie theater.)

DESIGN

As a result of technical innovation, sound became an integral part of Hollywood's tendency to construct rather than record reality. If the resulting sound was less natural and more artificial than that in earlier films, it also added a more complex sound environment to the movies. Borrowing from nonfiction films of the 1960s (which used highly portable cameras and tape recorders to cap-

[15]See Richard Barsam, "The Nonfiction Film," in *The Sixties,* by Paul Monaco (New York: Scribner, 2001), 198–230.

[16]Mary Ann Doane, "Idealogy and the Practice of Sound Editing and Mixing," in Weis and Belton, eds., *Film Sound,* 61.

ture ambient sound that was left basically unedited) and the recording industry's multitrack recordings of popular music, Hollywood directors of the 1970s—such as George Lucas, with *THX-1138* (1971; sound: Walter Murch); Francis Ford Coppola, with *The Godfather* (1972; sound: Bud Grenzbach, Richard Portman, and Christopher Newman); and Robert Altman, with *Nashville* (1975; sound: Chris McLaughlin and James E. Webb)—mixed multiple channels of sound, each of which could be manipulated individually. These developments laid the groundwork for a new era in innovative sound designs.

Sound design, a state-of-the-art concept given its name by film editor Walter Murch, combines the crafts of editing and mixing and, like them, involves matters both theoretical and practical.[17] While many filmmakers continue to understand and manipulate sound in conventional ways, sound design has produced major advances in how movies are conceived, made, viewed, and interpreted. Previously, producers and directors ordinarily thought about sound only after the picture was shot. They did not design films with sound in mind and, frequently, did not fully recognize that decisions about art direction, composition, lighting, cinematography, and acting would ultimately influence how sound tracks would be created and mixed. They considered sound satisfactory if it could distract from or cover up mistakes in shooting and create the illusion that the audience was hearing what it was seeing. They considered sound *great* if it was loud, either in ear-splitting sound effects or in a heavily orchestrated musical score.

By contrast, sound design rests on the following basic assumptions:

- sound should be integral to all three phases of film production, not an afterthought to be added in postproduction;
- a film's sound is potentially as expressive as its images;
- image and sound can create different worlds;
- image and sound are coexpressible; and thus
- sound is not subordinate to image.

According to Tomlinson Holman "sound design is the art of getting the right sound in the right place at the right time."[18]

Traditionally, the reponsibilities for sound were divided among recording, rerecording, editing, mixing, and sound effects crews; these sometimes overlapped but often did not. In attempting to integrate all aspects of sound in a movie, from planning to postproduction, the *sound designer* supervises all these responsibilities, a development initially resented by many traditional sound specialists who felt their autonomy was being compromised. It has now become unexceptional for sound designers to oversee the creation and control of the sounds (and silences) we hear in movies. They are, in a sense, advocates for sound. During preproduction, sound designers encourage directors and other collaborators to understand that what characters hear is potentially as significant as what they see—especially in point-of-view shots, which focus characters' (and our) attention on specific sights or sounds. Sound designers encourage

[17]Randy Thom, "Designing a Movie for Sound," 13 March 1999, <www.filmsound.org/randythom> (September 2002).

[18]Holman, *Sound for Film and Television*, 172.

screenwriters to consider all kinds of sound; working with directors, they indicate in shooting scripts what voices, sounds, or music may be appropriate at particular points. They also urge their collaborators to plan the settings, lighting, cinematography plan, and acting (particularly the movement of actors within the settings) with an awareness of how their decisions might affect sound. During production, sound designers supervise the implementation of the sound design. During postproduction, after the production sound track has been cut along with the images, they aid the editing team. But while their results may far exceed the audience's expectations of clarity and fidelity, sound designers keep their eyes and ears on the story being told. They want audiences not only to regard sound tracks as seriously as they do visual images but also to interpret sounds as integral to understanding those images.

RECORDING

The recording of production sound is the responsibility of the *production sound mixer* and his or her team, which includes, on the set, a *sound recordist*, a *sound mixer,* a *microphone boom operator,* and *gaffers* (in charge of the power supply, electrical connections, and cables). This team must place and/or move the microphones so that the sound corresponds to the space between actors and camera and the dialogue will be as free from background noise as possible. The standard technique of recording film sound on a medium separate from the picture is **double-system recording,** which allows both for maximum quality control and for the manifold manipulation of sound during postproduction editing, mixing, and synchronization. Once the sound is recorded, it is stored monaurally or stereophonically in one of two formats. The

analog format involves an analogous (or 1:1) relationship between the sound wave and its storage; in other words, the recorded sound wave is a copy of the original wave. The **digital format,** made possible by computer technology, represents the sound wave by combinations of the numbers 0 and 1. Although the earlier analog format remains in use, digital offers greater flexibility in editing and mixing and thus is fast becoming the standard.

Analog sound can be recorded and stored in either of two ways. With **magnetic recording,** for years the most popular method and the one most commonly found in professional production, signals are stored on magnetic recording tape of various sizes and formats (open reels, cassettes, etc.). One of its main drawbacks, unwanted noise such as hiss, was largely solved by the development of such sound-reduction systems as Dolby (discussed below). **Optical recording,** the standard method of analog recording until the 1950s, converted sound waves into light, which was recorded photographically onto 16 or 35mm film stock. Because it is a simpler and far more economical method than magnetic recording, it remains in use. Digital sound, recorded on the set much as analog but converted or digitized by a computerized system, can also be stored on a variety of formats, including videotape and digital audio tape (DAT), compact discs, computer hard drives, and floppy disks or other digital storage devices.

During the 1960s, new technology made it possible to combine a large number of sound tracks. While this technological development created new aesthetic possibilities for recording and mixing sound, it also created problems. The more tracks that were mixed together, the more the unwanted noise would increase on the final sound track. To address this problem, in 1965 the Dolby Laboratories

invented a process of **compressing** (or *companding*) sound that preserves signals but reduces or eliminates noise on the tape. Various Dolby systems improve the quality of production sound by reducing noise, both in professional motion picture production and in audio components for home use. In film production, Dolby technology is ideally used during recording, but it can also be employed during postproduction mixing. Dolby-equipped theaters, those that can accurately reproduce the highest quality sound, are now common.

EDITING

The *editor* is responsible for the technical process of editing and for the sound crew, which consists of a *supervising sound editor, sound editors* (who usually concentrate on their specialties: dialogue, music, or sound effects), *sound mixers, rerecording mixers, sound effects personnel,* and *Foley artists.* The editor also works closely with the musical composer or those responsible for the selection of music from other sources. In the editing room, the editor is in charge, but producers, the director, screenwriters, actors, and the sound designer may also take part in the process. In particular, the producer and director may make major decisions about editing.

The process of editing, of both pictures and sounds, usually lasts longer than the shooting itself. Sound editing takes up a great deal of that time, because almost 75 percent of any feature film sound track—much of the dialogue and all of the sound effects and music—is created during postproduction.

Filmmakers first screen the dailies (or rushes); select the usable individual shots from among the multiple takes; sort out the outtakes; log the usable footage in order to follow it easily through the rest of the process;

Brad Kane records the singing voice of the title character in Ron Clements and John Musker's animated feature *Aladdin* (1992). To learn more about sound production generally, go to <*www.wwnorton.com/web/movies*>.

and decide which dialogue needs recording or rerecording and which sound effects are necessary. **Rerecording** (sometimes called *looping* or *dubbing*) can be done manually (i.e., with the actors watching the footage, synchronizing their lips with it, and rereading the lines) or, more likely today, by computer through **Automatic Dialogue Replacement** (ADR)—a faster, less expensive, and more technically sophisticated process. (Dubbing also refers to the process of replacing dialogue in a foreign language with English, or vice versa, throughout a film.) At this point, the

sound effects are created or edited. For example, to preserve sound continuity, background noise must be added to all shots that were not recorded live.

Next, the sound-editing team synchronizes the sound and visual tracks into an answer print, doing most of the work at these stages on either a Moviola or a horizontal flatbed machine.

MIXING

Mixing is the process of combining different sound tracks together onto one composite sound track synchronous with the picture. A vast number of separate tracks may require combining and compressing during the final mixing. Working with his or her crew at special consoles, the sound mixer adjusts the loudness and various aspects of sound quality; filters out unwanted sounds; and creates, according to the needs of the screenplay, the right balance between dialogue, music, and sound effects. The ideal result is clear and clean. That is, whatever the desired effect, the audience will hear it clearly and cleanly. Even if what the filmmakers want is distorted or cluttered sound, the audience will hear that distortion or clutter perfectly.

ANALYZING FILM SOUND

ORSON WELLES'S *CITIZEN KANE*

During the 1930s, the first decade of sound, many directors used sound as an integral part of their movies. Their innovations were all the more significant because most of them had little or no prior background in sound. Only Rouben Mamoulian, with a distinguished ca-

reer directing Broadway plays and musicals, had a working knowledge and understanding of how sound could help tell a story, as we know from several of his first films, notably *Applause* (1929) and *Love Me Tonight* (1932). However, between 1933 and 1938, Orson Welles, who was to become (in terms of aesthetic achievement, not commercial success) one of the world's greatest film directors, not only acted in and directed Broadway plays and musicals but also established himself as one of the leading innovators in American radio broadcasting. He approached radio the way he approached the theater and, later, movies: *experimenting and making things different.*

At RKO Pictures, his small sound crew included two important collaborators: rerecording supervisor James G. Stewart and production mixer Bailey Fesler. Based on his interview with Stewart, film scholar Robert L. Carringer says that most of the "ideas involving the sound in the film came from Welles . . . [and that] much of what [Stewart] knows aesthetically about sound" he learned from Welles.[19] Welles's complex sound design for *Citizen Kane* was a kind of "deep-focus sound," in that it functions much like deep-focus cinematography. Indeed, we can with confidence call him the first sound designer in American film history, because of the comprehensive way in which he used sound to establish, develop, and call our attention to the meanings of what we see. One of the most impressive uses of sound occurs at the party celebrating Kane's acquisition of the *Chronicle* staff for the *Inquirer*.

This scene takes place during Mr. Bernstein's recollections of Kane's business career,

[19]Robert L. Carringer, *The Making of "Citizen Kane,"* rev. and updated ed. (Berkeley: University of California Press, 1996), 105.

ever, they literally have to shout to be heard because of the pitch, loudness, and quality of the competing sounds: the music, the dancing, the crowd noise. We might go so far as to say that the sound has its own mise-en-scène here (see chapter 3). Although these diegetic, onscreen sounds were recorded directly on the set, some additions were made during the rerecording process. Reversing the ordinary convention of composing the music after the rough cut of a film has been assembled, Bernard Herrmann wrote the music first, and Robert Wise edited the footage to fit its rhythm.

SOURCES AND TYPES OF SOUND. In summary, the sound here is diegetic, external, onscreen, and synchronous; was recorded during both production and postproduction; and is of diverse quality, levels, and placement. The types include overlapping voices, ordinary dialogue, and singing; music from an onscreen band; sound effects; and ambient noise. Welles's handling of sound dominates this scene—he makes us constantly aware of the sources, the types, and the mix and (unsurprisingly) doesn't use much silence. However, two signs mounted on walls read "SILENCE" and thus, as relics of an earlier period, obliquely suggest how quiet these same offices must have been before Kane took over from Mr. Carter, the previous editor. Through this visual pun, Welles employs a touch of silence during the loudest sequence in *Citizen Kane*.

particularly his takeover of the *Inquirer*, its growth, and Kane's rise to power through the acquisition of the famous staff of its rival paper, the *Chronicle*. Although Bernstein and Kane have been together from the beginning, their relationship remains a formal one, and each addresses the other as "Mr." The setting for the party is the *Inquirer*'s offices, which have been decorated for the occasion. The room is both deep and wide, designed to accommodate the deep-focus cinematography. Welles made his complicated sound perspective possible by covering the ceilings with muslin, which concealed the many microphones necessary to record the multiple sounds as the scene was shot.

We hear these multiple sounds simultaneously, distinctly, and at the proper sound levels in relation to the camera's placement, so that the farther we are from the sound, the softer and less distinct the sound becomes. When Bernstein and Leland are talking, for example, they appear in close-up, and their dialogue is naturally the loudest on the sound track; how-

FUNCTIONS OF SOUND. This sound montage

- guides our attention to all parts of the room, making us aware of characters' relative positions (e.g., the contrast between Kane and the others)

- helps define the space and the characters' placement within the mise-en-scène (e.g., sound is loud when the source is closer to the camera)
- conveys the mood and the characters' states of mind (e.g., the sound is frantic and loud and gains momentum until it almost runs out of control, underscoring that these men, Kane and reporters alike, are being blinded and intoxicated by their own success)
- helps represent time (e.g., the sound here is synchronous with the action)
- fulfills our expectations (e.g., of how a party of this kind might sound and that Kane is continuing on his rapid rise to journalistic and political power)
- creates rhythm beyond that provided by the music (within the changing dramatic arc that starts with a celebration involving all the men and ends with one man's colossal display of ego)
- reveals, through the dialogue, aspects of each main character (e.g., establishes a conflict between Kane and Leland over

personal and journalistic ethics, one in which Bernstein predictably takes Kane's side)
- underscores one principal theme of the entire movie (e.g., the song, "There Is a Man," not only puts "good old Charlie Kane" in the spotlight—he sings and dances throughout it—but also serves as the campaign theme song when he runs for governor and becomes a dirge after his defeat; at the same time, while the lyric attempts to answer the question "Who is this man?" it has no more success than the rest of the movie)
- arouses our expectations about what is going to happen as the film evolves (e.g., the marching band signals both that the *Inquirer* won over the *Chronicle* and that the *Inquirer* "declares" war on Spain (a war the United States will win)
- enhances continuity with sound bridges (i.e., the smooth transitions from shot to shot and scene to scene within the sequence)
- provides emphasis (e.g., the sound of the flash lamp when the staff's picture is taken punctuates Kane's bragging about having gotten his candy; after Kane says, "And now, gentlemen, *your complete attention,* if you please," he puts his fingers in his mouth and whistles; the trumpets' blast)
- enhances the overall dramatic effect of the sequence

This overwhelming sound mix almost tells the story by itself.

CHARACTERS. All the functions named above are important to this particular sequence and the overall film. Here we will look more closely only at how the sound helps illu-

minate the character of Kane, Bernstein, and Leland.

Further frustrating our attempts to define Kane, the sound enhances Welles's ambiguous handling of the character, both in his work on the script and in his acting. In several distinct areas, the sound deepens our understanding of this contradictory figure. It helps Kane flaunt his wealth and his power as the *Inquirer*'s publisher: when he brags to the new reporters about feeling like a "kid in front of a candy store" and having gotten his candy, his remarks are punctuated by the sound of the photographer's flash lamp. However, this sound may also be interpreted as Welles's way of mocking Kane's bragging. Kane dominates the table of guests with the announcement that he is going to Europe for his health—"forgive my rudeness in taking leave of you"—but there is in fact nothing physically wrong with him, as we learn when he calls attention to his mania for collection (and wealth) by saying, "They've been making statues for two thousand years and I've only been buying for five." This conversation between Kane and Bernstein is directed and acted as if it were a comedy routine in a vaudeville theater between the "top banana" (Kane) and the "straight man" (Bernstein).

The sound helps Kane build on his power, not only as the boss *and* host of the guests—"And now, gentlemen, *your complete attention,* if you please"—but also as the flamboyant and influential publisher: "Well, gentlemen, are we going to declare war on Spain, or are we not?" As he asks this question, the band enters, playing "Hot Time in the Old Town Tonight" and followed by women dancers carrying toy rifles. When Leland answers, "The *Inquirer* already has," Kane humiliates him by calling him "a long-faced, overdressed anarchist." Even though he says this humorously, it

echoes Kane's treatment of his subordinates throughout the film. Furthermore, his shouting back and forth with Leland and Bernstein calls more attention to himself while trivializing the subject of their conversation: journalistic ethics. Significantly, since we never hear the reporters' view of their new boss or new jobs, they seem like mere employees, depersonalized and not the media stars they seemed to be at the beginning of the sequence.

When asked about the song, Kane tries to deflect attention from himself by saying, with mock humility, that anyone who buys a bag of peanuts in New York City gets a song written about him. Obviously, Kane has commissioned the song for his own purposes, for it praises "good old Charlie Kane" for his public spirit, concern for the poor, and generosity to friends and colleagues. Later, this song becomes his political campaign theme, so the sound in this scene connects us with later scenes in which we hear the music: the first, when a happy Kane addresses his enthusiastic supporters, including Leland, at a rally; the second, when the disillusioned Kane and

drunk Leland encounter one another in the deserted newsroom and Leland challenges Kane about the "people's love." By participating in the singing and dancing, Kane continues to call "complete attention" (his words) to himself. Through both *visual and aural imagery,* Kane remains in the center of the frame for most of the scene, either directly onscreen himself or indirectly reflected in the windows. His voice dominates all the other sounds in this scene because it always seems to be the loudest.

Leland and Bernstein are different from one another in family background, education, level of sophistication, and relationship to Kane, and their conversation about journalistic ethics establishes another major difference. Leland questions Kane's motives in hiring the *Chronicle*'s staff and wonders why they can change their loyalties so easily, but Bernstein does not question anything Kane does. Completely loyal, he replies, "Sure, they're just like anybody else. . . . They got work to do, they do it. Only they happen to be the best in the business." Furthermore, while Leland worries about the future, Bernstein brags about the increase in circulation. When Leland sings along with the crowd, he seems to be doing it out of obligation; Bernstein is just having a good time like everyone else.

THEMES. Sound serves many functions in this scene, including the development of several major themes and concerns:

- *Kane's youthful longings fulfilled.* A major strand of the narrative conveys Kane's lifelong bullying of others, mania for buying things, and egomania as a reaction to being abandoned by his

parents at an early age. Here, he begins the scene by addressing the new reporters and likening his acquisition of the *Chronicle* staff to a kid who has just got all the candy he wants. This is punctuated by the sound of a flashbulb.

■ *Kane's ruthless ambition.* The mix of burlesque dancing, loud music, and serious conversation about ethics only underscores Kane's determination to do whatever is necessary to get what he wants.

■ *Kane's disregard for ethics and principles and his relation with his two closest associates.* Kane's domination of the scene is made personal by his humiliation of Leland (throwing his coat at him, as if he were a lackey) and teasing of Bernstein ("You don't expect me to keep any of those promises, do you?"), a further reference to the "Declaration of Principles" that Kane flamboyantly writes and prints on the first page of the *Inquirer.* The dialogue in this scene (and those scenes that precede and follow it) further clarifies the relations between Kane, Bernstein, and Leland.

The care and attention that Welles and his colleagues enthusiastically gave to the sound design of this scene was virtually unprecedented in 1941 and was seldom equaled until the '70s. In giving this rowdy party the appearance of a real event, not something staged for the cameras, the sound—along with the visual design, mise-en-scène, acting, and direction, of course—plays a major role in depicting a crucial turning point in the narrative.

QUESTIONS FOR REVIEW

1. What is the difference between *diegetic* and *nondiegetic* sources of sound?
2. What are the differences between sounds that are *internal* and *external, onscreen* and *offscreen,* and *synchronous* and *asynchronous?*
3. Most film sound is constructed during postproduction. Which sounds are actually recorded on the set? Why is it appropriate to use the verb *construct* here?
4. Why can a movie have an almost unlimited number of *sound tracks?*
5. Distinguish between *dialogue* and *narration.*
6. How do *ambient sounds* differ from *sound effects*? How are *Foley sounds* different from *sound effects?*
7. Think of a *musical score* that plays against our expectations for how music will support the movie's narrative. What are our expectations in that case, and how does the score thwart them?
8. Can the music in a movie be both *diegetic* and *nondiegetic*? Explain.
9. Explain the paradox that *silence* can be *sound.*
10. How does sound call our attention to both the *spatial* and *temporal dimensions* of a scene?
11. Discuss a movie in which sound (other than music) adds *rhythm.*
12. Cite an example of *sound that is faithful to its source,* another for sound that is *not.*
13. What is a *sound bridge*? What are its functions?
14. In successfully making the transition from silent to sound production, the movie industry overcame *aesthetic, technological, and commercial challenges.* Describe one of each.
15. What is *sound design*? What does it strive to do on behalf of movie sound? What are the responsibilities of the *sound designer*? Why do some traditionalists resent sound design and the role of the sound designer? What, in your opinion, does sound design mean for the future of movies?
16. Distinguish among *recording, rerecording, mixing, and editing.*

QUESTIONS FOR ANALYSIS

1. What are the specific *sources* of sound in the movie (or clip) you are analyzing? Cite one example of each.
2. What *types* of sound are used in this movie? Cite one example of each.
3. In this movie, do you hear evidence of a comprehensive approach to sound—one, specifically, in which the film's sound is as expressive as its images? If so, explain.
4. How would you describe the *dialogue* (and *narration,* if this is used) in this movie? If the movie belongs to a *genre* with which you are familiar, does the dialogue conform to your expectations of how it is traditionally used in that genre?
5. Choose what you believe to be *the most important type of sound* used in this movie and describe both its overall functions and how it helps create meaning.
6. Does the sound here function as part of the *characterization*? If so, explain how it helps develop one character.
7. In the movie you are analyzing, does the sound create *emphasis* by accentuating and strengthening the visual image? Explain.
8. What is the *genre* of this film? Does the *music* conform to, or play against, your expectations of how music is traditionally used in this genre?
9. Do the images and sounds complement one another or does one dominate? Explain.
10. Does this film use *silence* expressively? Explain.

FOR FURTHER READING

Amyes, Tim. *The Technique of Audio Post-Production in Video and Film.* Boston: Focal Press, 1990.

Belton, John. "Technology and Aesthetics of Film Sound." In *Film Sound: Theory and Practice,* ed. Elisabeth Weis and John Belton, 63–72. New York: Columbia University Press, 1985.

Card, James. *Seductive Cinema: The Art of Silent Film.* New York: Knopf, 1994.

Chion, Michel. *Audio-Vision: Sound on Screen.* Ed. and trans. Claudia Gorbman. Foreword by Walter Murch. New York: Columbia University Press, 1994.

Crafton, Donald. *The Talkies: American Cinema's Transition to Sound, 1926–1931.* New York: Scribner, 1997.

Eyman, Scott. *The Speed of Sound: Hollywood and the Talkie Revolution, 1926–1930.* New York: Simon and Schuster, 1997.

Geduld, Harry. *The Birth of the Talkies: From Edison to Jolson.* Bloomington: Indiana University Press, 1975.

Gorbman, Claudia. "Annotated Bibliography on Film Sound (Excluding Music)." In *Film Sound: Theory and Practice,* ed. Elisabeth Weis and John Belton, 426–45. New York: Columbia University Press, 1985.

Holman, Tomlinson. *Sound for Film and Television.* Boston: Focal Press, 1997.

Kozarski, Richard. *An Evening's Entertainment: The Age of the Silent Feature Picture, 1915–1928.* New York: Scribner, 1990.

LoBrutto, Vincent. *Sound-on-Film: Interviews with Creators of Film Sound.* Westport, Conn.: Praeger, 1994.

Lustig, Milton. *Music Editing for Motion Pictures.* New York: Hastings House, 1980.

Pasquariello, Nicholas. *Sounds of Movies: Interviews with the Creators of Feature Sound Tracks.* San Francisco: Port Bridge Books, 1996.

Sonnenschein, David. *Sound Design: The Expressive Power of Music, Voice, and Sound Effects in Cinema.* Seattle: Michael Wiese Productions, 2001.

Timm, Larry M. *The Soul of Cinema: An Appreciation of Film Music.* New York: Simon and Schuster, 1998.

Usai, Paolo Cherchi. *Burning Passions: An Introduction to the Study of Silent Cinema.* Trans. Emma Sansone Rittle. London: British Film Institute, 1994.

8

Writing about Movies

JOINING THE CRITICAL CONVERSATION ABOUT MOVIES

Most of us have been watching movies since childhood, enjoying them primarily as entertainment. And while movies provide us with a great deal of pleasure and occupy much of our time, we are often blind to their inner workings, their circumstances of production, and the means by which they accomplish their illusions and make their meanings. But like other popular entertainments such as music, literature, theater, and dance, movies are taught and studied in college. First-time film students often feel that their college study of film threatens their innocent enjoyment of movies. Later, most students come to feel they have gained a pleasure more involved, interactive, and challenging. This transformation is like moving from a film debate among friends that pivots around "I loved it" and "I hated it" to an ultimately more satisfying *conversation* that understands film complexly and analytically.[1] That special conversation goes on among scholars and cultural critics, filmmakers and literate moviegoers, and this chapter will help prepare you to join the conversation.

Academic conversations about movies have taken many forms through the years, but what nearly every literate student of movies has done, and what you will be asked to do in your own writing, is to peel back the curtain of invisibility, transparency, and verisimilitude to examine how movies influence our emotions and ideas, how movies are themselves influenced by the culture at large, how creativity and finance influence movie production and reception, how movies influence each other, how movies are influenced by and in turn influence other forms of art, and even how the various elements of a film can complement or contradict one another. A major part of undertaking a critical, academic conversation about film is incorporating, as this textbook does, the specialized and sophisticated vocabulary that is an integral part of—indeed, a prerequisite for entering—this more complex and satisfying understanding of movies. Taking you one step further so that you can apply the knowledge you've acquired, this chapter presents

- fundamental techniques you'll need to write about movies
- major types of writing your professor may ask you to do
- major forms of meaning within and ways of "reading" movies
- some practical tips about the writing process

[1]The conversations with friends about movies and discussions in film reviews are much different than those that take place in academic film discussion and writing. Popular talk of movies focuses largely on what individuals enjoy. Speakers and writers are expected to state their preferences, know the latest gossip about the stars, and be ready to offer a rating or endorsement of some kind. As Thomas and Vivian C. Sobchack note in *An Introduction to Film,* 2nd ed. (Boston: Little, Brown, 1987): "The opinions quickly and enthusiastically offered in casual conversation often are pitifully weak on paper. They are unsupported, inconsistent, vulnerable to attack; they reveal that the writer has not thought enough about the subject, has jumped to conclusions that have no visible means of support" (424). In academic film writing, you should be less concerned with your personal enjoyment of a film and more attentive to the cinematic, cultural, or historical significance of the film. While personal reactions to a film frequently provide the genesis of academic analysis, they are only a starting point and never stand alone as a thesis.

FUNDAMENTAL TECHNIQUES

SUMMARIZING PLOT

Nearly all assignments that center on movies themselves (as opposed to, say, the economics of the film industry) require you to summarize the plot of one or more films. A good plot summary includes details such as physical and temporal settings and the names of characters and actors. Most of us have been recounting stories to others since we were children, but summarizing a film's plot is not as easy as it first appears. It is difficult, in general, to write both economically and descriptively. If you find yourself following a this-happened-and-then-this-happened model for pages at a time, you are doing more *retelling* than *summarizing*. Below is a good student plot summary for Allison Anders's *Gas Food Lodging* (1992):

Single mom Nora Evans (Brooke Adams) and her two daughters have man troubles; each of them, in a decidedly different stage of life, discovers her own passion, and reclaims her own past. In a crummy trailer park in New Mexico, Nora's youngest daughter, Shade (Fairuza Balk), desperately wants a "normal" family and proceeds to scout out potential husbands for her mom. Her rebellious and recklessly promiscuous sister, Trudy (Ione Skye), falls in love, but finds herself pregnant and betrayed. The three struggle with loneliness—Shade's absent father, Nora's absent husband, and Trudy's absent lover. After bringing Trudy's new baby into the world, each begins a kind of new life—Shade experiences her first love, Nora finds companionship with a neighbor, and Trudy starts a new life in Houston. (Chantelle Hougland)

Note the deft phrases "crummy trailer park" and "rebellious and recklessly promiscuous sister," which economically and vividly describe setting, character, and dramatic conflicts within the film. Like this one, plot summaries should be largely descriptive and factual. They should reserve personal opinion, yet strive to express the film's tone and treatment of characters and events. Good plot summaries will almost certainly include

- setting (place, time, tone, and treatment: "a contemporary yet gothic New York City in the film noir tradition")
- narrative conflicts (overt conflicts such as feuds, contests, divorces, rivalries, and warfare as well as psychological conflicts such as struggles with self-esteem, weaknesses and addictions, and unrequited love)
- characters (names, traits, and objectives)
- story structure (classic, three-part, with beginning, middle, and end; four-part; five-part)
- conclusion and dramatic resolution (sad, bittersweet, or happy ending; strong or weak closure; setups for sequels)

The student plot summary below suffers from numerous failings:

Thelma and Louise is a great film that begins when Susan Sarandon and Geena Davis go on a trip and Geena Davis is almost raped by this guy and Susan Sarandon has to kill him and so they run away. Later, Geena Davis gets to meet the very cute Brad Pitt at a hotel. When they run out of money they have to rob and become outlaws. One of the best scenes is when they blow up the truck of the trucker who was making obscene gestures at them on the highway. This is kind of a woman's road trip, but with a surprising ending.

This is obviously a hasty first draft. In addition to using ungraceful language to chattily discuss a fairly serious film, the writer

- fails to underline or italicize the film's title (and to provide the director's name and the release date)
- uses the names of actors rather than characters
- interjects personal opinion ("great film," "best scenes") where neutral description is required
- fails to convey the most basic flow and structure (beginning, middle, end) of the plot
- concludes with a vague reference to a "surprise ending," a strategy best used in advertisements or film reviews, not in the plot summary portion of a critical film analysis

Student writers often fail to provide any plot summary at all. In most student film essays it is key to offer a basic overview of the plot at the beginning of the essay and then to elaborate on specific details when those elaborations help develop the essay's argument. A common but very serious mistake is to hand in a paper that claims to analyze a film but actually just retells the story. If your paper consists of nothing but plot, your teacher will be greatly dissatisfied. Avoid this error by resisting the urge to structure a paper on a chronological retelling of the film's plot. Instead, quickly summarize the plot and then structure the body of the essay to develop your thesis and support your argument, returning to plot exposition only when it aids in those primary tasks. One place to review thousands of plot summaries is the Internet Movie Database—<www.imdb.com>—which contains information on almost every professional movie ever made, including links to plot summaries written by nonprofessional contributors to the site (including students like yourself). You will find many examples, some more reliable than others, and often multiple summaries for popular films. Notice how different summaries of the same film may employ diverse styles and tones, thereby creating different emphases. When you compose your own summary, choose the style and emphases that best support your tone and thesis. Remember, however, that while you can model your summary after the ones you see here, you cannot "borrow" other writers' work.

ANALYZING SHOTS, SCENES, AND SEQUENCES

Films are filled with so much information that it is difficult to see even a small part of their formal and narrative arrangement in one viewing. You can learn a good deal by carefully analyzing individual shots, scenes, and sequences. Begin by viewing the segment over and over again, taking notes each time. Multiple viewings enable you to recognize how the parts of a film interrelate, how some elements recall previous events and foreshadow others, how motifs and subplots function, and how actors create characters through voice, gesture, and expression. When analyzing complex scenes, you might focus on one particular formal or narrative element in each viewing: lighting, editing, camera movement, setting, costume, dialogue, music, sound effects, and so forth. Not all films and scenes require such attention, but many do. Many scenes in Orson Welles's *Citizen Kane* (1941) sustain multiple viewings, revealing new details with each pass. For example, during the breakfast table scene that shows the deterioration of Kane's relationship with his first wife, Emily, every

form of cinematic expression changes, each one conveying in its way a movement from the honeymoon time of open lovingness in youth to the failed marriage of closed contempt at maturity.

PLOT SEGMENTATION. The best method for understanding a film's narrative system is to create a *plot segmentation,* a scene-by-scene outline of the entire film. Each scene should be described briefly in a separate line, and the entire segmentation should not exceed more than a page or two. One of the first things a plot segmentation shows you is the function and boundaries of the *scene.* Aristotle held that a scene consists of a unified time, space, and action. When a film significantly shifts in time, space, or action, we recognize that a new scene has begun. The plot segmentation helps reveal a film's overall structure (e.g., three or four acts, perhaps following some thematic pattern) and its smallest details (e.g., a motif of transitions between scenes). In chapter 2, Figure 2.3, you'll find a detailed plot segmentation for John Ford's *Stagecoach* (1939).

TAKING NOTES

Taking notes is an essential part of preparing to write about movies. Whether you are recording your observations during a public or personal screening, copying key points of a classroom lecture or group discussion, or jotting down stray ideas over the course of your day, notetaking can capture observations, attitudes, and insights that you may otherwise not recall when it comes time to actually compose your paper. Memory is less perfect than we often assume, and realizing that "memory," especially in academic settings, exists no less in documents than between our ears encour-

ages good notetaking practices. Notetaking is a highly personal activity; some may meticulously record a good deal of information in a systematic way, while others haphazardly scrawl ideas and shapes and doodles. You should do whatever works for you. Microcassette recorders and pocket PCs allow for voice recording, and might, especially in personal screenings, be a useful tool, enabling you to keep your eyes on the screen while recording an observation. But there is no substitute for learning to take notes in the dark.

TAKING ADVANTAGE OF TAPE, DVD, AND THE INTERNET

Videotapes (VHS and Super VHS, an acronym for Video Home System, are the standard half-inch videotape formats for home-recording, rental, and nonprofessional use in the United States) and digital video discs (DVDs) provide not only convenient playback options for consumers but also useful tools for students of film. Rewind, fast-forward, pause, and scene selection are valuable features for anyone analyzing a film. The pause button allows you to record notes, study the composition of a shot, or view details of setting and background. Because sound and image are so carefully integrated and so compelling together, you might watch a scene with the sound off or, vice versa, turn your back to the screen and only listen to a film. The fast-forward and rewind functions may even reveal something about plotting and structure impossible to notice at regular speed, such as the repetition of cinematic elements, motifs, or themes.

Perhaps the most exciting development in film distribution is the rise of new digital technologies. Both DVDs and the Internet provide amazing amounts of information. Websites for films include cast biographies, filmmakers'

commentaries, and production details. As advertising tools, websites accentuate, embellish, and even shamelessly exaggerate films' themes and conflicts, providing blueprints of sorts to the films' focuses and meanings. Independent films, short films, and art films have benefited from the low- to no-expense marketing and distribution possibilities of the Internet, and Web searches may provide information not available through local libraries. E-mail correspondence may provide access to filmmakers not possible through face-to-face interviews, phone calls, or traditional mail.

Many DVDs now provide special features once available only on laser discs. These often wonderfully convey a film's production background, the hopes and plans of its creators, and its technological underpinnings. DVDs are bringing to students of film an unprecedented wealth of material once reserved for industry insiders or academics lucky enough to visit studios, film libraries, and special collections. *Toy Story* and *Toy Story 2: The Ultimate Toy Box* DVD includes both films as well as a third disc devoted to detailed explanations of Pixar's elaborate computer animation process, which has revolutionized the American animated film. The DVD for Cameron Crowe's *Almost Famous* (2000) includes all of Crowe's *Rolling Stone* articles, the original inspiration for the film; they provide a convenient means of tracing the ways in which Crowe's semiautobiographical film combines, elaborates on, and distorts parts of his own background as a teenage rock-and-roll journalist. A director's edition DVD, *Almost Famous Untitled: The Bootleg Cut* (2001), includes even more extra materials, including thirty-six minutes of previously unseen footage. Such unused or deleted scenes and shots provide interesting lessons in the decision-making process of filmmakers.

Sometimes, a scene is obviously cut because of a poor performance, or an entire subplot is removed because it doesn't seem to work. At other times, very good scenes and performances are left on the cutting room floor; these, perhaps, testify to filmmakers or producers who respect shorter running times at the box office and a greater narrative or thematic unity.

Since many deleted scenes were dropped before they underwent sound editing, effects work, and color correction (that is, they are "rough cuts"), they provide dramatic lessons in the degree to which Hollywood polishes its final product—a reminder that the "realism" and naturalness of the final release is a carefully shaped and crafted construction. The bonus footage of Frank Oz's heist film *The Score* (2001) includes three takes of a scene in which Max (Marlon Brando) tries to persuade his longtime accomplice in crime, Nick (Robert De Niro), to commit to a new heist. Oz uses the common shot-reverse shot, an over-the-shoulder treatment. The three takes we see outside the context of the film focus on Brando and vividly illustrate the improvisational talents of this great actor. Viewing these takes in relation to the final scene in the film makes clear how Oz and his editor, Richard Pearson, have combined the best bits of multiple takes into a seamless whole.

WRITING DESCRIPTIVELY

Whether summarizing plot, analyzing a single scene, or mounting a sophisticated historical argument, you need to offer readers dynamic, example-laden descriptive writing. To be more descriptive, writers of all kinds often try to *show,* not merely *tell,* their readers what happens. Herman Melville, for example, could have simply *told* us that near the end of a

three-day hunt at sea, a large whale rose from beneath the ocean and breached, trying to escape its human hunters. Instead, in his novel *Moby-Dick* (1851), Melville *shows* us the event:

> Suddenly the waters around them slowly swelled in broad circles; then quickly upheaved, as if sideways sliding from a submerged berg of ice, swiftly rising to the surface. A low rumbling sound was heard; a subterraneous hum; and then all held their breaths; as bedraggled with trailing ropes, and harpoons, and lances, a vast form shot length-wise, but obliquely from the sea. Shrouded in a thin drooping veil of mist, it hovered for a moment in the rainbowed air; and then fell swamping back into the deep. Crushed thirty feet upwards, the waters flashed for an instant like heaps of fountains, then brokenly sank in a shower of flakes, leaving the circling surface creamed like new milk round the marble trunk of the whale.[2]

Fiction, of course, offers countless opportunities for descriptive writing. In film essays, it should be developed in passages dealing with shot composition, events of a significant scene, setting and mise-en-scène, the appearance and traits of a character, the performance of actors, evocation of music or sound effects, and the functions of editing or camera movement within a sequence. Danny Peary, a writer of short film reviews, combines a good deal of information into his fine descriptions of a character in Victor Fleming's *Gone With the Wind* (1939), the story of Fleming's *The Wizard of Oz* (1939), and the setting of Ridley Scott's *Blade Runner* (1982):

Vivien Leigh is the beautiful, slim-waisted, high-spirited, emotional, spoiled, indomitable, manipulative southern belle Scarlett O'Hara.

Young children will be excited by its fairytale elements: a journey into a strange land, scary moments (how wonderfully frightening Margaret Hamilton's Wicked Witch is!), and a dazzling assortment of characters: a wizard (Frank Morgan), a good witch (Billie Burke), Munchkins, winged monkeys, a scarecrow without a brain (Ray Bolger), a tin man without a heart (Jack Haley), and a lion without courage (Bert Lahr). In addition, there are horses of different colors, catchy songs, a castle, talking apple trees with arms and lousy dispositions, and many spectacular occurrences provided by M-G-M's special effects department.

Foremost no picture since *Metropolis* has presented such a compelling vision of the future. Conceptual artist Syd Mead and designer Laurence G. Paull created a crowded, hazy city full of huge, deserted, or retro-fitted buildings (they called the style "retro-deco") where acid rain falls constantly, electric advertising covers the sides of buildings, and police spinners fly about. Everything looks old and unhealthy.[3]

Your essays cannot provide images twenty feet tall and offer up enhanced surround sound as theatrical movies do. Yet readers expect you to evoke—through language—something of the film and its experience.

Let's look at three attempts to describe and discuss the opening credit sequence of Alfred Hitchcock's *Vertigo* (1958), the first a very weak student example, the others very good

[2]Herman Melville, *Moby-Dick* (New York: Dodd, Mead, 1979), 520–21.

[3]Danny Peary, *Guide for the Film Fanatic* (New York: Simon and Schuster, 1986), 177, 474, 58.

examples from professional writers and academics. Notice that though the student has something to say, the writing is lifeless and offers the reader little detailed imagery:

> The theme of vertigo can be seen even in the opening credits. The close-up of the woman's face and the music make one think of psychological problems. The circles that begin to appear seem like a vertigo of some kind. The opening makes it clear that the movie *Vertigo* will be about more than just a fear of heights.

This uninspired writing fails to convey confidence in the writer's knowledge and awareness of the film being discussed. The professional examples are not only more descriptive but also draw richer connections with a larger world of ideas:

> One aspect of the theme of *Vertigo* is given us by Saul Bass' credit designs. We see a woman's face; the camera moves in first to lips, then to eyes. The face is blank, masklike, representing the inscrutability of appearances: the impossibility of knowing what goes on behind the mask. But the eyes dart nervously from side to side: beneath the mask are imprisoned unknown emotions, fears, desperation. Then a vertiginous, spiraling movement begins in the depths of the eye, moving outward as if to involve the spectator: before the film proper has begun, we are made aware that the vertigo of the title is to be more than a literal fear of heights.[4]

Robin Wood's analysis of the opening credit sequence works so well because he links his analysis of the theme of vertigo, an abstraction, with direct, concrete description of what is seen on screen as well as the behavior of the camera. To further our understanding of the sequence, Dan Auiler combines both descriptive language and quotations from Saul Bass, the title designer:

> Bass's sequence begins with the left side of the emotionless face of a young woman (not Novak, but an anonymous actress whose features were both specific and universal): "Here's a woman made into what a man wants her to be. She is put together piece by piece and I tried to suggest something of this as the fragmentation of the mind of Judy," Bass explained. Then it pans down to her lips, then up to her eyes, which shift in both directions before the camera finally dollies in for a close-up of the right eye. Out of this eye comes the title VERTIGO, followed by the colorful Whitney/Lissajous spirals. "I wanted to achieve that very particular state of unsettledness associated with vertigo and also a mood of mystery. I sought to do this by juxtaposing images of eyes with moving images of intense beauty. I used Lissajous figures, devised by a French mathematician in the nineteenth century to express mathematical formulae, which I had fallen in love with several years earlier. You could say I was obsessed with them for a while—so I knew a little of what Hitch was driving at. I wanted to express the mood of this film about love and obsession."
>
> As the credits continue, her eyes fade away—the viewer is now within the eye—and Whitney's images spiral in, then quickly out again, and one is back to the eye. The final title card, "Directed by Alfred Hitchcock," is followed by a fade to black.[5]

One last tip: to force your writing to become more descriptive, try to replace adjectives

[4]Robin Wood, *Hitchcock's Films Revisited* (New York: Columbia University Press, 1989), 110.

[5]Dan Auiler, *Vertigo: The Making of a Hitchcock Classic* (New York: St. Martin's Press, 1998), 155.

with nouns and verbs. Adjectives serve as a shortcut for *telling* us things, such as a character's being "interesting" and "quirky." Instead, work a bit harder and *show* us: "Edward Scissorhands (Johnny Depp), true to his name, has long, gleaming scissors for hands; resembles a punk rocker with his pasty complexion, leather outfit, and spiked hair; and can skillfully style both hair and hedges with his intimidating appendages."

MAKING AN ARGUMENT

In the analytical portion of a writing assignment, your teacher expects you to express opinions, make claims, present evidence, and build arguments. That is, you need to make an argument (something debatable, as opposed to a commonly accepted fact) and then support it. People argue all the time in their daily lives without doing more than express their feelings and opinions, but in academic contexts you must support your arguments with ideas, evidence, and references to authorities. Whether you write a single paragraph or a twenty-page essay, your teacher expects you to follow that accepted practice. Note the difference between merely making an assertion, such as

Memento is a contemporary film noir.

and supporting an assertion with ideas and evidence:

In using flashback, black-and-white cinematography, a murderous woman, and a doomed and flawed protagonist, *Memento* adapts key elements of the film noir tradition into a contemporary psychological narrative.

The latter provides the reader with details regarding genre and film form and history; the former offers no insight into the writer's reasons for making the given claim.

DEVELOPING A THESIS. Students sometimes go beyond neglecting to support an argument, and forget to even make one. An argument is something that is debatable. In Figure 8.1, the column on the left holds five unarguable and unimpressive statements, most either facts or descriptions of a subject area; the column on the right offers five debatable theses, which include not only facts and topics but also elaborations on those topics.

As you can see, a topic alone does not make a thesis; additionally, a thesis requires not only an opinion about a topic but also, typically, ideas about the origin, function, cause-and-effect relationships, value, or future development of a topic. For example, a paper that set out to demonstrate that *Star Wars* was an important science fiction film would have little to prove. Almost anyone would agree that the box-office and popular success of *Star Wars* guarantee the label "important science fiction film." While building a paper around an easily winnable point might seem like a safe bet, readers and teachers recognize this as a meaningless exercise and are not impressed. Some topics are more debatable and controversial than others, but even the question of *Star Wars* and its place in the science fiction film canon provides any number of interesting and debatable theses. We might start by improving on the vague phrase "an important science fiction film":

Star Wars became one of the most important science fiction films of the last century by offering an imitable and profitable alternative to Hollywood's dependence on science fiction literary classics (Byron Haskin's *The War of the Worlds,* 1953) or pulp narratives and "B" movies (Christian Nyby's *The Thing from Another World,* 1951). By simultaneously emphasizing special effects, large-scale spectacle,

FIG. 8.1

STATEMENT VERSUS THESIS

Statement	Thesis
Statistics show a rise in suicides during the holiday season.	The rise in holiday-season suicides results, in part, from the greater expectations of personal happiness, family bonding, and financial freedom that the season encourages, ideals that starkly contrast with the interior state of the morbidly depressed.
The 1960s were a time of social upheaval.	The social upheavals of the 1960s were seen either as threats to the social order or as opportunities for social change, depending on one's political orientation; to this day, the left and right continue to view the '60s in this polarized way.
Many comic teams utilize a "straight" man and a more "wacky" partner.	Analysis of the film roles of Jim Carrey reveals a performer who combines the traditional comic team's wacky partner and straight partner into a single person, with some roles maintaining a greater split and others a greater synthesis of these two types of comic performer.
Toy Story was the first feature-length, all-digital animated film.	The subject of the first feature-length, all-digital animated film, *Toy Story*, was mass-produced toys, a choice that helped the filmmakers achieve realism in the new medium, as the plastic and universal appearance of toys was mimicked with relative ease by the computer animation processes then in use.
Alfred Hitchcock's films were suspenseful.	Alfred Hitchcock generates suspense by providing the viewer with more information about and knowledge of possible danger than he provides his unsuspecting characters, who remain blindingly unaware of impending harm because they are preoccupied with other, often trivial matters; the type of frustration for viewers that results accentuates and characterizes what we call "Hitchcockian suspense."

and the fundamentals of the action/adventure genre, *Star Wars* opened up science fiction to a mass, demographically diverse audience, whose members were greatly expanded beyond the genre's traditional fans (dedicated enthusiasts and youth).

To defend this thesis, you might use box-office records, observations from film historians and producers, and a quick survey of the types of science fiction films in the decades before and after *Star Wars*. The point, of course, is that the passage above makes claims that are debatable at their core. Another writer might argue that, say, *Star Wars* was *not* an important science fiction film, since it didn't offer the kind of original story ideas or formal or stylistic innovations found in a film such as Stanley Kubrick's *2001: A Space Odyssey* (1968). A third writer might argue that *Star Wars* was important primarily because of its commercial success, which resulted from innovative and elaborate marketing, orchestrated with a wide variety of merchandise (posters, books, toys) in such a way as to develop what is now commonly known as a "franchise." A fourth writer might extend mythologist Joseph Campbell's famous arguments that *Star Wars* utilized ancient and fundamental myth structures and relate these ties to the movie's success and importance.[6] At this point, we have a lively and revealing debate in four completely distinct arguments regarding the "importance" of *Star Wars*. The exchange of such diverse viewpoints perfectly characterizes academic study; students who join these discussions with curiosity and fresh ideas will develop papers both they and their teachers will enjoy.

INCORPORATING SOURCES

Sometimes, you'll find another writer's opinion so well put, or so supportive of your own point, that you'll want to use it in your own writing. There are three basic ways of enhancing and supporting your own writing with the work of others: summary, paraphrase, and quotation.[7] Summary and paraphrase are useful when you want to employ the ideas of another writer but not their exact expression. Summary condenses a good deal of information into a shorter passage, while a paraphrase might equal or even exceed the original source in length. Use quotation when the dynamic language of the original source can enhance your writing. Paraphrase quotations only when they are especially difficult to understand, making a simplified interpretation possibly helpful to readers.

Each time you employ any of these methods, you must also employ a system of citation and documentation that credits the source author and enables readers to continue the research process. One place to find good summaries of academic film articles is in the brief descriptions and abstracts used in journals and reference sources to describe their content for readers. Here, for example, is a summary used in *Cinema Journal*:

> Some film scholars charge that director John Ford was complicit in the savage racism of *The Searchers'* central character, Ethan Ed-

[6]See Joseph Campbell, with Bill Moyers, *The Power of Myth*, ed. Betty Sue Flowers (New York: Doubleday, 1988), 29–30.

[7]A good source of information on these practices is Brenda Spatt, *Writing from Sources*, 5th ed. (New York: Bedford/St. Martin's Press, 1999).

wards. This essay demonstrates that Ford viewed Ethan as a negative, psychologically damaged, and tragic figure. By comparing the changes made from the source novel to the shooting script to the final film, a constant darkening of Ethan's personality is revealed—most of it directly attributable to director John Ford.[8]

Notice how film scholar David Bordwell uses paraphrase and quotation seamlessly and economically:

> According to Pudovkin, the camera lens should represent the eyes of an implicit observer taking in the action. By framing the shot a certain way, and by concentrating on the most significant details of the action, the director compels the audience "to see as the attentive observer saw." The change of shot will then correspond to "the natural transference of attention of an imaginary observer."[9]

Quotations should exactly replicate their sources. You may add or remove words, phrases, or punctuation marks from within quotations by carefully signaling your changes via ellipses (three periods) or via square brackets. (Some style guides recommend that you place ellipses *within* square brackets.) Use ellipses to tighten up a quotation or to remove unwanted material. Use square brackets to add words, phrases, or punctuation marks in order to clarify or correct sentence meaning, grammar, or tense. If you use square brackets, you may emphasize words with ital-

ics as long as you note this change: "This film [*Raiders of the Lost Ark*] combines a *Saturday matinee 'B' movie style* with big-budget special effects and 'A' film plotting" (emphasis mine).

Just as you shouldn't include too much plot summary in a film essay, so, too, you shouldn't become dependent on quotations. Be sure to break up strings of quotations with summary, paraphrase, and your own thoughts and writing. Similarly, be sure to introduce each quotation, not by merely repeating the exact meaning of the quotation but by providing information about the author, the larger context of the source, or some discussion of how the quotation serves your thesis, like so:

> Although for the most part the present study has sidestepped that issue of crossed boundaries in favor of a limited but critically *useful* vantage—we also need to acknowledge and explore the extent to which the science fiction film does connect with other formulas, to which it follows the dictum offered by Rick Altman, that "Hollywood's stock-in-trade is the romantic combination of genres, not the classical practice of generic purity."[10]

AVOIDING PLAGIARISM. Every year, thousands of students underestimate both their most significant reader—their teacher—and themselves by trying to turn in the work of others as their own. *Plagiarism* (passing off the words and ideas of others as one's own) is one of the more pathetic of crimes, as its greatest victim is ultimately the perpetrator: plagiarizing curtails one's chance to learn and develop as a writer and thinker. Unlike many

[8]Arthur Eckstein, "Darkening Ethan: John Ford's *The Searchers* (1956) from Novel to Screenplay to Screen," *Cinema Journal* 38, no. 1 (fall 1998): 3.

[9]David Bordwell, *Narration in the Fiction Film* (Madison: University of Wisconsin Press, 1985), 9.

[10]J. P. Telotte, *Science Fiction Film* (New York: Cambridge University Press, 2001), 179.

crimes, plagiarism actually leaves behind all the necessary evidence at its scene: that is, the writing itself. Teachers, who have spent years teaching students to write and have read countless student essays, are keenly aware of the great difference between professional and student writing. They also notice when wonderful student-level writing arrives out of the blue, with no apparent development or context. Additionally, the same Internet technologies that make online plagiarism possible also empower teachers, who can utilize sophisticated search programs to scan literally millions of documents for suspect phrases and sentences. The greatest irony is that properly citing and incorporating sources is a much-respected and academically rewarded ideal. You can do the right thing and receive good grades. Or you can do the wrong thing and gamble with your entire academic career.

Of course, you don't have to cite everything you read. The basic rule is to place between quotations and cite any literal phrase, sentence, or passage you transcribe. Our language makes possible billions of different sentences, and even a dull, straightforward sentence created by someone else needs to be placed in quotations and its source cited. Deciding whether you need to give credit for an idea is a bit more difficult. Facts that can be found in multiple sources (e.g., the director of *Creature from the Black Lagoon,* or the release date of Kevin Costner's *Dances with Wolves*) need not be cited. Anything more debatable (such as the idea that hardly any two sentences on the planet are identical) may be traceable to another source (linguist Noam Chomsky frequently receives attribution for his thoughts on the uniqueness of language and sentence structure). Moreover, a unique structure or sequence of ideas should be cited.

ASSIGNMENTS AND STRATEGIES

It's impossible to discuss here all the possible writing assignments you might encounter and paper strategies you might employ in a film course, but we can address the more common ones. Some teachers like to begin the semester by having students write short pieces that require them to practice, in isolation, some of the fundamental techniques set forth above, such as summarizing plot, writing descriptively, making an argument, and incorporating sources. Most teachers, of course, expect students' major essays to demonstrate competence in all such techniques.

Respect length requirements that teachers impose on assignments. Short assignments (250 to 1,000 words—one to four pages) force you to condense a good deal of information into a limited format. Longer assignments (four to fifteen pages) provide ample room for you to develop a fuller argument, to compare multiple films or scenes or styles, and to include extensive details, examples, and research sources.

A common complaint from undergraduate writers is that they don't know what their teachers expect from particular assignments. When asking a teacher for clarification and direction, offer a few ideas you would like to develop. If you don't yet have a thesis, at least mention an aspect of a film or the course you are interested in and share this enthusiasm with your teacher.

Some teachers help by providing examples of "A" papers, but teachers and students may still have quite different ideas about what constitutes excellent work. In part, this disparity has to do with the distinct models of outstand-

ing film analysis that teachers and students have in mind. Students perhaps think of movie reviews and the writing they find in textbooks like this one, meant for introductory students. While teachers are aware of these forms of film writing, they also appreciate the more sophisticated analyses they know from graduate work and professional books and journals. Teachers don't expect undergraduates to deliver publishable essays, but they may think of undergraduate writing assignments as exercises toward developing general competence in critical writing and specific competence in writing about film. To further that development you should seek out excellent writing about film by students, academics, and others, whether you find them on your own (e.g., the journals of student writing on the movies and prize-winning essays published in academic publications) or ask your teacher or librarian to suggest examples of high-quality academic film writing. (The leading academic journals are *Cinema Journal,* produced by the Society for Cinema Studies; *Journal of Film and Video,* produced by the University Film and Video Association; and *Film Quarterly,* an independent journal published by the University of California Press.)

CRITICAL ANALYSIS

Perhaps the most frequent assignment type is the critical analysis of a single film. The critical analysis challenges you to take your subjective observations and feelings about a topic and to develop these into your own argument that incorporates objective facts within a framework that displays awareness of specialized knowledge and vocabulary. Some teachers leave their assignments fairly wide open, while others provide detailed instructions, in

effect telling writers exactly which topic to cover, which elements to discuss, possibly even which scene or shot to analyze. No matter how detailed the assignment instructions, most teachers still look for originality and strong, debatable assertions from their students. Even at the beginning of a course, any writing assignment typically has a larger context: textbook, readings, lectures, online materials, and so forth. Students who carefully relate the ideas and terms being discussed in the course to the film they are writing about demonstrate their learning and development within the course.

When writing about a single film, it is crucial to get the details correct: title, date, director, character and actor names, plot events, and so on. Remember that focusing on a particular film, even a particular shot, does not mean that you cannot mention other films—indeed, other artworks—that might help explain the function and role of the work in question.

COMPARISON AND CONTRAST. "Comparison and contrast" is one of the most common forms of analytical writing. Within film studies, the method can be used in myriad ways, involving one movie or a number of movies; the titles below show how the comparative approach seems inherently suited to forceful, debatable, and revealing theses:

Domestic Ideals and Film Noir Dysfunction in Ridley Scott's *Blade Runner* (1982) and Frank Capra's *It's a Wonderful Life* (1946)

Horror Film Violence Before and After Alfred Hitchcock's *Psycho* (1960)

French and American Style and Sensibility in Luc Besson's *Nikita* (1990) and John Badham's *Point of No Return* (1993)

The first example promises to compare ideology and genre across two seemingly diverse films, both of which include film noir elements though they are usually categorized in other genres. The second example makes a historical contrast, a before-and-after argument. The third example compares national cinemas, as it considers the same story told in two different countries: *Nikita* in France and *Point of No Return,* the remake, in the United States.

In such essays, the writer seeks those similarities and dissimilarities that are significant—that is, when presented together, they can help deepen our knowledge of a topic. When using this approach, you should carefully consider how you organize your paper. If you want to stress the similarities of two things, you should begin by describing the dissimilarities. More frequently, you want to stress the differences, so your paper will end with them, saving the most significant and surprising for the later pages. The format works very well if you either take two things assumed to be very similar and show important differences (say, contrasting Francis Ford Coppola's *The Godfather* [1972] with his *The Godfather: Part II* [1974]) or take two things assumed to be very dissimilar and show important similarities (as in the suggested comparison between *Blade Runner* and *It's a Wonderful Life* above). You can use a long list of elements (say, all the major formal elements: cinematography, editing, acting, and so forth) to order the comparisons, but an effective paper requires an argument as well. A compare-and-contrast paper that offers nothing more than widely known similarities and differences and no broader, enlightening framework will be mediocre at best.

MOVIE REVIEW VERSUS CRITICAL ANALYSIS

Writing about film in college is made difficult by the strong desire of most teachers that students *not* mimic the one type of film writing everyone has had some experience of: the movie review. While many film reviewers are excellent writers and are well aware of the style and methods of academic film writing, the popular and public form of the film review contrasts starkly with the academic film analysis. Simply put, film reviews

- present a brief critique of the film's basic stylistic systems
- mention unusual human interest stories about the film's cast, crew, and production
- offer the writer's personal response to the film

but don't

- assume the reader has seen the film
- recount the film's complete plot
- give away endings and key transitions by discussing "spoilers"

An academic film essay, however, could violate all six of these conventions without drawing criticism. Indeed, most of the conventions of the film review are actually discouraged in academic film analysis.

A few film courses are devoted to teaching film reviewing and criticism, and many courses assign readings in the genre. Andrew Sarris, Pauline Kael, Roger Ebert, and a number of others provide excellent models of the form. James Agee, author of the Pulitzer Prize–winning novel *A Death in the Family*

and film critic for *Time* and *The Nation,* is considered one of film reviewing's greats. Consider the excerpts below from the reviews of Vincente Minnelli's *Meet Me in St. Louis* (1944). Agee wrote the first for the general readership of *Time:*

> The solidest single achievement of the movie, in fact, is to give the Smiths something to be sorry about: the real love story is between a happy family and a way of living. Technicolor has seldom been more affectionately used than in its registrations of the sober mahoganies and tender muslins and benign gaslights of the period. Now and then, too, the film gets well beyond the charm of mere tableau for short flights in the empyrean of genuine domestic poetry. These triumphs are creditable mainly to the intensity and grace of Margaret O'Brien and to the ability of Director Minnelli and Co. to get the best out of her. Her song ("Drunk Last Night") and her cakewalk, done in a nightgown at a grown-up party, are entrancing little acts. Her self-terrified Halloween adventures, richly set against firelight, dark streets and the rusty confabulations of fallen leaves, bring this section of the film very near the first-rate. To the degree that this exciting little episode fails, it is because the Halloween setup, like the film as a whole, is too sumptuously, calculatedly handsome to be quite mistakable for the truth.

For his review in *The Nation,* Agee employed a witty, sophisticated style and tone well suited for that magazine's select, highly educated, politically and culturally engaged audience:

> Her annihilation of the snowmen she [Tootie, played by Margaret O'Brien] can't take to New York would have been terrifying if only she had had adequate support from the snowmen and if only the camera could have had the right to dare to move in close. Being only the well-meant best that adult professionals could design out of cornflakes or pulverized mothballs or heroin or whatever they are making snow out of just now, these statues were embarrassingly handicapped from their birth, and couldn't even reach you deeply by falling apart.[11]

Articles found in film-specific magazines like *Sight and Sound* and *Film Comment* are often similar to these reviews. Notice the informal, witty tone of this paragraph from critic David Thomson:

> But with *Meet Me in St. Louis* just about everyone involved reckoned it was an unlikely project from the start. The only way you could have faith in it was to tell yourself that Arthur Freed was a man of immense taste and refinement. End of joke. Arthur Freed might have been the production chief of Metro musicals, with more talent at his disposal than any executive had ever seen. But he was the proverbial slob and arse-kisser. So trust Arthur! Except that Arthur was always asking Mr. Mayer, "Whaddya you think, boss?" And LB didn't think this one would fly.[12]

Most teachers would not appreciate the informal, playful tone and style common in magazine pieces. Ultimately, your topic, thesis, and audience determine the tone and style you should employ. Occasionally, a freer, witty style can fit an academic paper, but you should check with your teacher early in the writing process if you wish to attempt this personable tone.

[11]James Agee, *Agee on Film* (New York: McDowell, Obolensky, 1958), 356–57, 127.

[12]David Thomson, "A Blind Date in Culver City," *Sight and Sound* 11, no. 12 (December 2001): 12.

Now let's look at some academic analyses of *Meet Me in St. Louis*. Note how film scholar J. P. Telotte, here writing for the *Journal of Popular Film and Television*, maintains a formal tone, goes into greater detail, and spends more time on a single scene than would most film reviews and magazine articles—in other words, he *analyzes* the film:

> What finally consoles her [Tootie] and the rest of the family, though, is another musical inspiration. Mr. Smith suddenly proclaims that they will stay in St. Louis after all, that their happiness as a family—and analogously, as part of a larger society—is more important than his individual advancement; and that announcement seems engendered by a gradual swelling of the "Meet Me in St. Louis" theme, as if it were playing inside his head, inspiring his awakening to the true needs of the family. It recalls the film's opening when that soundtrack music signaled a society at one with itself, happy in the unifying prospect of the fair, while it reminds us as well of Mr. Smith's prior rejection of that theme when he quieted Rose and Esther's duet. Clearly, it was not so much the song as its spirit which, in his self-assertive way, Mr. Smith had earlier denied. Its embrace here signals not simply a change of mind, but a reconsideration of the person's place in society; it thus heralds a rebirth of the family, issuing almost paradoxically from a redefining of the ego.[13]

Telotte's analysis serves his larger thesis: an exploration of Vincente Minnelli's unique reconciliation of the musical genre's competing thematic concerns with self and society. To support such an expansive thesis, the writer needs more room, evidence, and analysis than we commonly find in film reviews and articles in popular magazines.

Thus when Scott Higgins focuses on Minnelli's use of color in *Meet Me in St. Louis*, his formal analysis runs twenty-one pages, space that makes possible great attention to detail:

> Each section of the film begins with a black and white still of the Smith house surrounded by colorful filigree illustrations of seasonal motifs. Minnelli explained that he intended these illustrations, resembling turn-of-the-century greeting cards, to help set the film's nostalgic tone. . . . But beyond this, they present a device for highlighting the power and presence of color. For example, the art-card for "Summer" features a band of pale yellow on a beige background with white daisies and red roses accenting the upper corner of the frame. Some green accents, and gold gilt around the photo of the house, complete the palette. . . . The camera dollies forward until the monochrome image entirely dominates the frame. Then color bursts onto the screen, and the frozen image begins to move. . . . The red and white striped awnings and rust colored roof of the Smith house contrast with the light blue sky. A beer wagon with a green and yellow canopy moves leftward across the frame, only to be passed by a bright red automobile. As the camera cranes toward the house, extras passing along the sidewalk offer more pink, green, and blue accents. The image is organized as a parade of color, demonstrating Technicolor's then unique capacity for simultaneously rendering sharply defined reds, yellows and blues.[14]

[13]J. P. Telotte, "Self and Society: Vincente Minnelli and Musical Formula," *Journal of Popular Film and Television* 9, no. 4 (winter 1982): 186.

[14]Scott Higgins, "Color at the Center: Minnelli's Technicolor Style in *Meet Me in St. Louis*," Style 32, no. 3 (fall 1998): 449–70; quotations, 458.

If a teacher asks you to do formal analysis in an essay, at least part of your essay should offer the kind of detailed description and analysis that you see in the two examples above. Here are two more good examples of formal analysis, both by critic Gerald Kaufman:

> One extraordinary moment, in which acting was combined with action to provide a remarkable cinematic effect, comes when an unnoticed Mr. Smith has seen, through an upstairs window, Tootie's smashing of the snowmen. He walks downstairs, sits in his usual armchair, and gets out a match to light his usual cigar. The lighting of the match illuminates the whole screen, and its flame is simultaneous with, and symbolic of, Smith's change of mind: the family will stay in St. Louis.

> Just as the opening shot of each of the seasonal segments was framed like a greetings card, so, over and over again, Garland herself was framed as in a greetings card. In the Trolley Song she was framed by a circle composed of the decorated hats of the other young women of the trolley-car. At other times she was framed in windows, in mirrors, in a door-frame, by a trellis, by artfully cast shadows. She was shown to superb advantage in luminous close-ups, and she was given freer reign to act, both humorously and dramatically, than ever before. She was the focal point of a lovely succession of patterns which were constantly shifting and re-forming.[15]

In the first passage, Kaufman ties acting, staging, and lighting to a thematic, symbolic, idea expressed in the film. In the second passage, he describes a consistent, filmwide pattern of

[15]Gerald Kaufman, *Meet Me in St. Louis* (London: British Film Institute, 1994), 49, 60.

composition centered on Judy Garland; Kaufman offers this as an example of how Minnelli had "turned *Meet Me in St. Louis* into a love letter to Judy Garland" (60).

RESEARCH PAPER

More is expected of a college research paper than a high school research paper: a greater number of more sophisticated references, more careful writing and argument. Some college teachers like to end a course with the research paper as a major assignment. Writing such a paper requires serious choice, consultation, and use of outside sources, a process that takes considerabile time. The quality of your sources will determine the quality of your paper; one journal article or one book is never enough. Teachers look to not just the number but also the variety of sources consulted, which might include reviews, scripts (and, where appropriate, the stories and novels from which they were adapted), historical and cultural treatments, essays on film theory, and industry trade papers and journals such as *Variety* and *American Cinematographer*. If you were writing a paper on Oliver Stone's *JFK* (1991), for example, you might consult a number of film sources; but you also might draw from the mountain of official and unofficial documents concerning Kennedy and his assassination. In addressing other paper topics, you might act like a journalist, e-mailing or phoning filmmakers or other experts for information and commentary. Don't bother anyone if you don't have a clue what you want to write about; but if you have specific questions and interests, experts may be happy to help (especially via e-mail).

While the amount of online information continues to grow, nearly all teachers require and expect hard-copy sources and trips to the

campus library. Most undergraduate writers of research papers face one of two problems: they are unable to find enough resources or they find so much material that they feel overwhelmed by the ideas and arguments. If you run into either of these difficulties, you may need help honing your research skills or expanding or focusing your research questions and thesis. Speak with your teacher, a librarian, or, if your campus has one, a consultant in a writing center. Always remember two crucial points about the process of writing a research paper. First, the research must be driven by a goal: there must be a hypothesis or a question or series of questions you want answered. Second, the research itself will frequently alter that initial goal. Students often make the mistake of conducting research without any real agenda or, conversely, of clinging to their original agenda despite new information and ideas arising out of the research process. It is best to think of your hypothesis and research work as evolving together. Many writers expect to revise their essay titles and thesis statements as they work.

Nearly any film essay might use historical facts and references, but the typical film paper is primarily designed as a vehicle for understanding film form or theory, or for exploring cultural issues through films. Most pure film histories are written by experts—graduate students working on their Ph.D.'s, professors, and professional historians. However, students should not neglect the opportunity to do original historical research in film if their course and instructor encourage such approaches. Unlike, say, ancient Roman history, film history is everywhere and can frequently be uncovered by those willing to ask some questions. Any North American community, whether small town or big city, has probably been showing films since the days of the nickelodeon. There may have been (or might still be) an old theater in town worth researching. Check for historical landmarks and historical societies, which might know of experts or hold a cache of old press clippings regarding theaters and films in your town. Perhaps visit the town's local library, not just the campus library. Back copies of the local newspaper might reveal a storied past for a local theater, celebrity, or filmmaker. It's possible your campus once hosted film societies or screenings of note. In the sleepy college town of Champaign-Urbana, Illinois, a regal old theater continues to show film classics in the same space that once hosted the Marx Brothers, the Engineering Department holds information and records regarding a local professor who helped develop an early technology for sound film, and any number of award-winning independent filmmakers have gone to school.[16]

EXPLICIT, IMPLICIT, AND IDEOLOGICAL MEANINGS

Sometimes we are happy to be entertained by a movie without delving deeper into its meaning. But more often than not we leave a movie theater thinking about what the movie seems to be saying, or implying, or hinting at. We wonder what, ultimately, the movie means. And we often find that other viewers have different ideas about the movie's meanings. Although any one movie can mean a great num-

[16]Robert C. Allen and Douglas Gomery do an exemplary job of explaining and promoting this type of grass-roots film history in *Film History: Theory and Practice* (New York: Knopf, 1985).

ber of things, and there is plenty of room for argument about those meanings, movies suggest and viewers create three basic kinds of meaning: explicit, implicit, and ideological.

Explicit meaning, which is closest to our everyday understanding of the word *meaning,* is a statement that is a little more sophisticated than plot summary but not overly interpretive. Widely popular movies succeed because they express such meanings, visions of life, with which most of the general public agrees. George Lucas's *Star Wars* (1977) is explicitly about many things: the training of a Jedi knight; the conflict between the Galactic Empire and the Rebel Alliance; the interactions among robots, humanoids, and non-humanoid life forms; the belief that good will eventually triumph over evil. While explicit meaning is on the surface of a film for all to observe, it is unlikely that every viewer or writer will remember and acknowledge every part of that meaning. Because movies are rich in plot and detail, good analyses or "readings" of movies must begin by taking into account the breadth and diversity of what has been explicitly presented. A viewer who recalls how Luke Skywalker's (Mark Hamill) childhood experience shooting womp rats prepares him for the amazing shot that destroys the Death Star at the end of *Star Wars* will be organizing and associating just two of the thousands of pieces of information in the film. Taking good notes, crafting good plot summaries, studying reviews and critical essays, and reviewing tape and DVD copies of films can help you remember and describe such information.

Implicit meaning, which lies below the surface of explicit meaning, is an association or connection or inference that a viewer makes based on the given (explicit) story and form of a film. To recognize Obi-Wan Kenobi (Alec Guinness) as a *father figure* to Luke Skywalker

is to make a simple inference, a type of implicit meaning. To compare Han Solo (Harrison Ford) to a western outlaw hero, or to compare the silly bickering of R2-D2 (Kenny Baker) and C-3PO (Anthony Daniels) to comic buddy teams such as Laurel and Hardy or Abbott and Costello, is to make an implicit association, to *read between the lines.* Another common type of implicit meaning occurs at the thematic level of narrative. Themes are shared, public ideas—metaphors, adages, myths, and familiar conflicts and personality types; thematic structures may or may not be made explicit over the course of the narrative, but perceptive viewers will recognize them. For instance, the Camelot legend runs throughout *Star Wars,* but the film's closest explicit reference to this world of ideas is merely the term Jedi *knight.*

When a movie communicates beliefs—whether belonging to the filmmakers, to one or more characters in the movie, or to the time and place in which the movie was made—it expresses *ideological meaning:* a person's or group's worldview. Such meaning is the product of specific social, political, economic, religious, philosophical, psychological, and sexual forces that shape the filmmakers' perspectives; it may be symptomatic of a group, time, place, and so on. A movie's own worldview, its belief system—its ideology—may be highly personal, may be at odds with others' views, and may lead viewers to interpretations that don't agree with all of the movie's explicit and implicit meanings. For instance, an ideological reading of *Star Wars* might note how the film's galactic politics echo a particular American historical perspective, with the Empire evoking both the British Empire (through actors' English accents) and Nazi Germany (through Darth Vader's helmet and other costume features) and its heroic depiction of the

Rebel Alliance (Han Solo as cowboy hero and Luke Skywalker as all-American boy next door) working within a familiar celebration of American revolutionary democracy as leading a free and diverse galactic (international) coalition—a traditional American historical (*ideological*) view of the nation's role in the Revolutionary and First and Second World Wars.[17]

GENRE STUDY

Filmmakers and marketers depend greatly on the major Hollywood genres to ensure that a particular film has a decent chance of finding an appropriate audience. Genres offer familiar story formulas, conventions, themes, conflicts, and immediately recognizable visual icons, all of which together provide a blueprint for creating and marketing a type of film that has proven successful in the past. Whether or not a paper assignment focuses on genre, nearly any kind of film writing will benefit from an awareness of it. Understanding some basic ways in which genre functions will help you develop interesting critiques of genre films.

Music offers the notion of *variations on a theme,* the idea that multiple composers can take a melody and compose endless variations on it, in which it remains recognizable. Some compositions will be more interesting and expert than others. In poetry, strict adherence to a prescribed form, such as the sonnet or haiku,

allows for endless variation. The most fundamental film-genre analysis thus consists of asking how a film, scene, or image varies or conforms to the genre's standard. For the genre filmmaker, the challenge is to offer enough original variation on the theme or genre to satisfy viewers who want both the familiar and the unfamiliar, who expect both *convention* and *invention.* A focus on genre involves asking where—in what plot developments, scenes, stylistic systems—the film attempts to invent and where it is following convention or, even, as is frequently the case, paying homage to a classic forerunner of its genre.

One simple but very effective way of analyzing genre convention and a particular film's place within a genre is to break down a movie into three discrete temporal aspects: *story formula, scene convention, and iconic shot.*[18] This three-part breakdown helps you isolate the basic conventions of every genre. Story formula refers to the overall plot structure found in a genre. In science fiction, one of the many types is that of *the alien visitor,* the structure of which follows a set pattern: status quo, arrival, discovery by an enlightened local, discovery by fearful members of the local populace, conflict with the local authorities, and resolution by death or departure. We recognize the formula in films as diverse as John Carpenter's *Starman* (1984), Iain Softley's *K-PAX* (2001), and Steven Spielberg's *E.T: The Extra-Terrestrial* (1982). We notice, too, familiar scene types in science fiction films of alien visitors: the point at which the visitor displays otherworldly powers to an appreciative audience, the moment in which fearful

[17]This celebration of American ideology was even more forcefully developed in Roland Emmerich's *Independence Day* (1996), another blockbuster science fiction film, which ultimately drew criticism for its jingoistic plot, in which America saved the world from alien invasion.

[18]This breakdown of genre into formula, scene, and icon is borrowed from the chapter "Genre Films" in Sobchack and Sobchack, *An Introduction to Film,* 227 34.

locals mistake alien overtures of peace for aggression, and so on. Lastly, individual shots within a genre film offer iconic images (an *icon* being an immediately recognizable visual symbol, such as the Stetson cowboy hat or Colt six-shooter of the western). Some icons of the alien visitor story formula include lingering, "homesick" views of the night sky; the shiny metals and kaleidoscopic lights of the alien's mode of travel; and arrays of local police and military squared off against the invader.

Lately, as the major film genres have evolved, the filmmakers working within them have begun to display greater self-consciousness of genre history and conventions. This development is visible in such simple touches as a brief reference or homage to a previous film and in such complex endeavors as Wes Craven's *Scream* (1996), which self-consciously echoes and recasts Alfred Hitchcock's *Psycho* (1960), John Carpenter's *Halloween* (1978), and the horror genre itself. While remakes, parodies, and sequels have long played with self-consciousness, the past decades have brought this approach into the main works of a number of genres. Closely related is another recent development that could be termed *hybridization*—a tendency to combine genres (sometimes genres not often associated) within a single film with a free hand. *Blade Runner* is a classic example, but more recent films such as Andy and Larry Wachowski's *The Matrix* (1999) and Andrew Adamson and Vicky Jenson's *Shrek* (2001) revel in this combinatory approach.

In her study of the family in the action-thriller genre published in the *Journal of Popular Film and Television*, Karen Schneider discusses Roland Emmerich's *Independence Day* (1996) as a hybrid of action and comic elements. Although it substitutes actors' names for characters, the following passage illustrates good genre analysis, descriptive writing, and use of supporting examples drawn from the film:

> *Independence Day* is packed with such a variety of comic elements that its "generic dominant" is left in question. Consider: the satirical treatment of the alien groupies; the hackneyed saving of the dog; Jeff Goldblum's droll demeanor; exaggerated characters such as the Jewish father (Judd Hirsch), the loony scientist (Brent Spiner, an icon of the sci-fi constructs), the drunken crop duster become hero (Quaid), and the sniveling homosexual (Harvey Fierstein); the boys-with-toys gags (putting the alien spacecraft in the wrong gear); the mock fight scene between the macho Will Smith character and an unconscious alien; and the parodically huge cigars. Another feature of the film, its intertextuality or penchant for "raiding, reference, and allusion" (Tasker 57), is also given a comic spin— for example, its wholesale borrowing from *War of the Worlds,* the radio version of which was a hoax; its use of Area 51 folklore; and its allusions to *2001* ("Good morning, Dave"). This "raiding" suggests a humorous self-reflexivity about the fictive quality of the film that the audience can share, and that the other films lack.[19]

When studying any genre film, be sensitive to its ratio of inventiveness to conventionality; its expression of genre convention through formula, scene, and icon; its historical and cultural inflections; and the degree to which it self-consciously asserts its status *as* genre.

[19]Karen Schneider, "With Violence If Necessary: Rearticulating the Family in the Contemporary Action-Thriller," *Journal of Popular Film and Television* 27, no. 1 (spring 1999): 9.

Remakes, sequels, and parodies, like genre films, provide good topics for papers. They offer illustrative comparisons and thus what we might call a built-in thesis, if you can find the most interesting and dramatic difference between them and the original films. As when musicians or singers cover other people's compositions, remakes frequently inspire artists to recast originals in provocative ways. Comparing a sequel (even a poor one) to an original can help expose the formulas, themes, motifs, and stylistic approaches integral to the original film. Remember, poor and even bad films can teach us a good deal, both about film form and about other films' historical and cultural contexts. Even more than remakes, sequels seem obliged to repeat, but in new ways, many of the first films' best bits. And parodies may be better at exposing narrative and stylistic conventions than any other type of film. When one of the *Naked Gun* movies exaggerates the conventions of the detective film, it explicitly draws attention to them—in effect, breaking the illusions of reality, representation, and invisible editing that a "straight" treatment of the conventions does not.

CRITICAL AND THEORETICAL APPROACHES

Traditional criticism attempts to place a value on a work of art, a genre, or an artist; to establish hierarchies of good and bad, high and low; and to distinguish between timeless "classics" and forgettable pulp. Cultivating an appreciation and understanding of art, as practiced for thousands of years, is also the work of criticism. *Formalism* is a traditional type of criticism; when applied to film, it entails seeing cinematic form as the most important source of a movie's meanings, concentrating on the filmmakers' handling of the elements of cinematic form, and attempting to explain how the filmmakers' techniques create (or imply) the movie's layered meanings. As a method, it can be applied by those espousing a wide range of theories, old and new. It does not require making value judgments on artworks.

Critical theories—Freudianism, feminism, Marxism, and others—represent loosely aligned ideas that attempt to explain the way people and societies function. We might contrast formalism, which looks inward at a film, with their *contextualism,* which is outward looking. At their most basic and practical, theories offer specific worldviews that make expansive claims to explain the place of works of art within a larger context. They also represent attitudes toward the activity of interpretation. They are not rules, and the various -isms overlap a great deal in ideas and methodology. Most writing about movies, especially most professional writing about movies, takes a formalist's approach to some aspects of a film and a contextualist's approach to others, balancing them as appropriate. The more you learn about film theory, history, production, and criticism, the better able you will be to choose critical and theoretical perspectives that suit your interpretive goals.

Because you are using this textbook, your teacher likely encourages formal analysis to some degree; but the specific approach you adopt will grow out of the unique context of your particular film course and your own interests. Some film teachers are generalists who see value in, and draw from, a variety of theories; some see themselves as specialists, advocating one theory over, and often against,

others. Contemporary theory is highly politicized. Much of it assumes that sexism, racism, economic injustice, and other wrongs are perpetuated by film through stereotypes, themes, stylistic systems, and narrative patterns that serve the dominant ideology. Thus your teacher may hope to teach you about film for various reasons: to help you develop an appreciation for great filmmaking, to prepare you for a career in media, or to reveal how Hollywood films reinforce certain attitudes and feelings that affect society as a whole. Recognizing your teacher's academic interests and background will obviously help you navigate your course work. One of the virtues of college-level education is that it encourages difference and debate. If you find yourself at odds with your teacher's beliefs, take this as an opportunity to develop your own arguments before a strong critic. You may find that your writing becomes much better as you engage in genuine disagreement.

Whatever your critical perspective, your sources for constructing a film's meaning are on the screen. In practice, you should view a film carefully (and as many times as necessary), concentrating on what you think are the most important cues to meaning; take notes appropriate to the assignment, jotting down as many examples as you can; think about the systematic interaction of its form and content; research it as thoroughly as you think is necessary for your objective (e.g., casual discussion, class assignment, senior thesis); and write about it intelligently and persuasively. If your approach is contextual, you might consider such subjects as the director's style and overall body of accomplishment; works by other filmmakers in the same period or genre; information about the politics, economics, social attitudes, and culture of the period in which the director lived and worked; the ideas

and influences that shaped the director's style; the conventions of filmmaking at the time the film was made; a study of the director's life as it might help you understand the work; and the director's reasons for making the film in particular ways if, and only if, he or she discussed such intentions. In delving further into the context in which the director lived and worked, you could read interpretive essays, reviews, and books; attend a lecture in which a critic explains the work; or take a course devoted to the director. In this way, you could gain further insight into the director's handling of form, content, and meaning.

The following pages will introduce some of the most common critical movements in film studies (auteurism, Freudianism, cognitive psychology, Marxism, feminism, and cultural studies) and a few concepts that we'll call *interpretive frameworks* (mimicry and catharsis, binary oppositions)—ideas so fundamental and resonant that they underlie most theoretical camps and disciplines. Learning about these forms of thought will help you better appreciate many of the debates surrounding film and media as well as offer productive strategies of analysis that can help with any film. Each will be illustrated with short applied readings of specific movies.

INTERPRETIVE FRAMEWORKS

MIMICRY AND CATHARSIS. In the Western tradition, the debate over the effect of art on people and society begins with Greek philosophers and dramatists, who were sharply split. On one side were those—most prominently, Plato—who viewed the arts as dangerous in their potential influence. Plato argued that art was at least two removes from reality: artists copied the ephemeral things around them, which were themselves imperfect copies of the

eternal and unchanging Ideas of those things. He was particularly concerned that poets, by representing bad behavior and bad people, would weaken society. His fear that people will imitate the baser behaviors and emotions they see depicted in art continues to this day. It drives ratings and censorship policies around the world, criticism and campaigns by groups across the political spectrum, and studies and debates on television viewing (in particular, the influence of television violence on children). Since its birth, Hollywood has remained a key target in these debates. Incidents of "copycat" violence, in which individuals commit acts very similar to fictional events they have seen, are highly publicized and widely known, though uncommon.

On the other side among the Greeks were the defenders of art, who found its influence beneficial. In the *Poetics,* Aristotle argued that humans acquire knowledge through imitation. More famously, he used the Greek medical term *katharsis* (purgation, purification) to describe a therapeutic by-product of watching tragedy, which through fear and pity purged viewers of such emotions. This metaphor was taken up by later philosophers, art critics, psychologists, theorists, and social advocates to explain and justify the paradoxical presence of negative content (violence, criminality, and hatred) in art. Today, a cathartic defense of art is commonly offered in nearly all arguments concerning its moral and social status. In film studies, particular genres (horror, thrillers, slapstick comedy, pornography) and especially violent films (Mel Gibson's *Braveheart* [1995], Oliver Stone's *Natural Born Killers* [1994], David Fincher's *Se7en* [1995]) are sometimes seen as case studies demonstrating a cathartic or, instead, detrimental effect on society. While most film essays may not directly explore the issue, many will assume either a general positive or negative influence of the medium on the viewer; you therefore should begin to recognize your own stance in this old dilemma.

BINARY OPPOSITIONS (DUALISM). According to structuralist anthropologist Claude Lévi-Strauss (b. 1908), human cultures share an underlying dualism, which began with distinctions between the raw/the cooked, nature/culture, man/woman, and darkness/light. These binary oppositions are so much a part of the worldview of all cultures that they can be seen in their language, myths, and art. Binary thinking is a universal human condition, yet expressed differently in each culture and individual. Additionally, each binary opposition reveals an underlying tension, a potential conflict that myth or art tries to reconcile. Of course, the form of such resolutions reflects the prevailing culture and its ideological paradigms. Other theorists have applied this approach to the works of popular culture. For example, James Cameron's *Terminator* films exploit an opposition between machine and humanity, frequently challenging our more simplistic binary distinctions so that by the end of the second film, *Terminator 2: Judgment Day* (1991), we have come to recognize the T-800 Terminator (Arnold Schwarzenegger) as akin to "human" while we continue to categorize the T-1000 Terminator (Robert Patrick) as a machine. This opposition becomes even more interesting (and productive for a paper thesis) when we note that both films explore it through the traits of their human characters (notice the emotionless intensity and physical prowess of Sarah Connor, played by Linda Hamilton, in the second film) as well as through their form—the costumes, lighting, sound effects, and so forth.

If we assume that Hollywood narratives are our culture's primary system of myths, we begin to understand something of the incredible success and generational resonance of films such as Victor Fleming's *The Wizard of Oz* (1939) and Frank Capra's *It's a Wonderful Life* (1946), as each film addresses recurring cultural tensions. Both movies treat similar oppositions between rural/small-town and urban lifestyles, and both do so in the context of coming-of-age tales that exploit the more narrow tension arising when youthful idealism and wanderlust are set against traditional respect for family and home ("There's no place like home").[20] *The Wizard of Oz* and *It's a Wonderful Life* treat and ameliorate the fears and frustrations that develop out of evolving conceptions of American ideology. Because storytellers and scriptwriters design stories around dramatic conflict, it is almost impossible to find a film that is not structured around a number of traditional and specific cultural oppositions.

AUTEURISM

The auteur theory postulates the film director as the *auteur* (author) of a film. It has roots in France of the 1920s; its popularity peaked there in the 1950s with the influential film journal *Cahiers du cinéma,* founded and edited by André Bazin. Contributors to this journal and early proponents of the theory (both as critics and directors) included the New Wave filmmakers François Truffaut, Jean-Luc Godard, Eric Rohmer, and Claude Chabrol. Bazin is most closely associated with the auteur theory. Very influential, widely interpreted, and often misunderstood, the auteurist approach is not a theory per se but rather an attitude. As such, it is personal, idiosyncratic, and flexible. Its application frequently takes two forms: a judgment of the whole body of a film director's work (not individual films) based on style and a classification of great directors based on a hierarchy of directorial styles. A director must have made a significant body of films to be considered an auteur. Auteurists believe, to varying degrees, that a film director's style can (and should, according to Alexander Astruc, one of Bazin's followers) be as distinctive as a novelist's. If the director is the visionary, the one person who makes a film what it is, then cinematic style is the "DNA" by which that "author" can be identified.

In the early 1960s, the concept of director-as-author was introduced and popularized in the United States by Andrew Sarris, who was for twenty-nine years the influential film critic for New York's *Village Voice.* His pioneering work, *The American Cinema: Directors and Directions, 1929–1968* (1968)—one of the most provocative books ever published about American movies—employs the auteur theory to create a comprehensive "ranking" of American directors in terms of their personal visions of the world. Sarris's "pantheon" of fourteen directors has probably inspired more arguments among film enthusiasts than any other single list, and his overall theory so enraged Pauline Kael, a longtime critic for the *New Yorker* and one of this country's most influential voices on the movies in the twentieth century, that it ignited a long critical war between them and their followers.

Although its weaknesses—for example, its rigidity, its stress on artistic vision over tech-

[20]A major demographic transformation of twentieth-century America was the tremendous shift of population from rural areas and small towns to urban areas and big cities, accompanied by a decline in extended families and a rise in nuclear and single-parent families.

nical competence, its tendency to view all movies by a single director as equally valuable—limit its application, the auteurist approach to film criticism can be very useful in identifying and appreciating those directors whose body of work displays ideological and stylistic consistency. Because the directors who shaped and influenced film history are often great innovators or stylists, we may refer to them as auteurs.

PSYCHOLOGICAL CRITICISM

FREUDIANISM. Sigmund Freud, the German founder of psychoanalysis, believed that each person had an unconscious that, while utterly beyond conscious reach, could manifest itself through "accidents," slips of the tongue, dreams, and art. The unconscious holds one's darkest fears and desires, including one's desire for and aggression against one's own parents, thoughts so taboo that they resist conscious expression yet so compelling that they are expressed indirectly, as through art. For Freud, *Hamlet* reflected Shakespeare's own oedipal desires and aggressions, projected, without the author's awareness, onto the characters of the play. Freudian theory holds that just as a therapist can uncover the causes of a patient's hysteria, so a critic can uncover the implicit psychological meaning within a work of art. At the societal level, Freudianism holds that a good deal of individual and collective desire and aggression is "vented" through art, narratives, and entertainment. From the Freudian perspective, this venting of the unconscious is generally therapeutic, cathartic, and good for individuals and society. As noted earlier, in almost every debate about the influence of art and film on individuals and society, a defense pointing to the utility of such catharsis will be used to counter the accusation that people will imitate the attitudes and behaviors presented in art and films.

Freudian theory not only is a major influence on film theory but has been explicitly incorporated into the stories of numerous films, from the psychological dramas of Alfred Hitchcock's *Spellbound* (1945) and Jacques Tourneur's *Cat People* (1942; remade by Paul Schrader in 1982) to science fiction films such as Fred M. Wilcox's *Forbidden Planet* (1956) and Ken Russell's *Altered States* (1980). Though traditional Freudian theory has lost influence in film studies as elsewhere, much of the film analysis and interpretation we read and create is still informed by its most fundamental ideas:

- Art may reveal emotional dynamics not deliberately fashioned by the artist (a significant counterpoint to the more traditional formalist and literary assumption that art reflects the artist's conscious choices).
- Expressions of sexual desire in art are intertwined with incompletely suppressed aggression, fear, and guilt.
- A critic can link an artwork and an artist's biographical background within an interpretation that reveals unconscious manifestations of desire, aggression, fear, and guilt.

COGNITIVE PSYCHOLOGY. While Freudianism has had strong adherents over the years, others have reacted against it, preferring psychological explanations that deal with more practical perceptual, emotional, and conscious responses of viewers. Cognitive psychology—drawing on work in perceptual psychology, aesthetic studies, and artificial intelligence, among many other fields—seeks

to explain how we recognize objects, fit disparate elements into orderly patterns, experience joy and sadness through art, simultaneously understand multiple meanings, and so forth. In recent decades, film scholars such as Richard Allen, Joseph Anderson, Gregory Currie, Carl Plantinga, Murray Smith, and especially David Bordwell and Noël Carroll have written articles and books that apply the ideas and findings of traditional cognitive psychology to questions of film reception. In practice, this cognitive approach shifts the critical emphasis from artist, artwork, or context to an emphasis on the viewer—a viewer seen as an active participant in the creation of a film's effects and meaning.

A foundational idea of cognitive psychology is that people use *schemas* to make sense of an always perceptually incomplete world. Schemas are mental concepts that filter our experience. When movie villains enter a dark bedroom and strike out at sleeping figures, we are as surprised as the villains when the covers are pulled back to reveal the old pillows-as-decoy ruse. This trick works again and again because both villains and spectators maintain a schema for the human body shape and "sleeping" that a few pillows and darkness can evoke. In film studies, cognitive approaches join nicely with formalist analysis, enabling us to explore how "cues" in a film activate schemas in viewers to help generate effects and meanings. Cognitive psychology helps explain how the storyteller's plot (what we see and hear) works with the viewer's understanding to create the story (something much larger than what is merely presented to us; for more on the distinction between plot and story, see chapter 2). By focusing on the viewer's minute-by-minute comprehension and experience of a film—of what is literally given to us perceptually—the cognitive approach helps counterbalance the traditional emphasis on the artist as the sole, active contributor to the effects and meanings of a film. Thrillers, horror movies, and mysteries like M. Night Shyamalan's *The Sixth Sense* (1999)—films that leave as much offscreen as they place onscreen—offer countless examples of forcing the viewer to play an active role in making sense of limited information.

IDEOLOGICAL CRITICISM

Many forms of contemporary criticism focus on ideological concerns. While ideological criticism is complex, diverse, and wide-ranging, some underlying general tendencies are worth recognizing. Marxism, socialism, and capitalism are known as ideologies, but the absence of a label does not mean that *ideology* is absent. The term refers to the formal and informal beliefs, feelings, and habits of individuals, groups, and nations. When looking at art from an ideological critical stance, we assume that art reflects the ideologies from which it comes. In practice, this simple assumption—that films reflect ideology—can lead to sophisticated analyses and intense debate, largely because societies and art are so complex, diverse, and frequently contradictory, with theorists divided on the particularities of ideology's relation to art and on the methodology best suited to exploring this relation. Overt examples of ideological expression can be seen in World War II–era propaganda films such as Leni Riefenstahl's *Triumph of the Will (Triumph des Willens,* 1934) and Frank Capra's *Why We Fight* series (1943–45), but contemporary ideological analysis holds that all films are a product of their ideological context, including those in genres such as romance, comedy, and horror. Unlike propaganda films or those treating overtly political

subjects, genre films, even romantic comedies, may indirectly endorse ideological beliefs or obscure more radical solutions to social problems. No matter how drastic the problems exposed in a Hollywood film, the familiar everything-works-out endings betray a tradition of finding resolutions and solutions from within *the system*. Like the Freudian approach and so much contemporary critical analysis, the ideological approach assumes a substructure of meaning that critics decode and reveal in their writing.

MARXISM. Marxism is a body of doctrine developed by Karl Marx and, to a lesser extent, by Friedrich Engels in the mid–nineteenth century. It originally consisted of three interrelated ideas: a philosophical (quasi-religious) view of humanity, a theory of history, and an economic and political program. Marxism has perhaps had its most significant influence in its philosophy. It inspired people to rebel against tyranny and to seek the fulfillment of their hopes within a communal (sometimes communist) society. Its ideology fired up revolutions in many countries in the twentieth century, most notably in Russia and in China. Marxism can be called a quasi-religion in that it requires of its followers fervent commitment and devotion to an ideal. Its view of history is that human and social progress occurs when a thesis and an antithesis yield a synthesis—specifically, it postulates that the conflict between the bourgeoisie and the proletariat will lead to the emergence of a classless society without a government. Ultimately, Marx predicted a revolution in advanced capitalist states, as the proletariat would dissolve all class distinctions and inaugurate a new era of harmony, peace, and prosperity for all humanity: communism.

During the twentieth century, the various socialist movements around the world have adapted Marx and Engels's original ideas to meet their needs. In the West, neither of the two basic forms of Marxism—that of the traditional communist parties and the more diffuse "New Left" form, which has come to be known as "Western Marxism"—has resulted in the revolutionary change advocated by Marx. Even though orthodox Marxism has taken hold in developing nations, it has not proven particularly relevant in modern Western society, in which capitalism appears to have triumphed decisively. However, in the intellectual and academic world, Marxism remains very influential.

Many attempts have been made to incorporate Marxian doctrines into theoretical principles and analytical methods that could be used to relate cinema to the theory and practice of revolution. Following the 1917 Russian Revolution, the party-state paid special attention to the development of visual and sound materials that disseminated their ideas to the mainly illiterate populace. The result in the 1920s and early 1930s was a period of imaginative, ideological filmmaking by such innovators as V. I. Pudovkin, Lev Kuleshov, Sergei Eisenstein, Aleksandr Dovzhenko, Esther Shub, and Dziga Vertov. Starting in the 1930s, led by such European thinkers as Walter Benjamin and György Lukács, writers have produced a large body of Marxist aesthetic theory, which (despite the collapse of the Soviet Union in the early 1990s) remains relevant today because of its concern with power and class.

The history of the American film industry, particularly the studio system, offers abundant opportunities for studying the interaction of the power relations of the production process. Some of the most influential Marxist criticism has focused on the portrayal of politics and the mass media in American films,

past and present. However, the emphasis of Marxism on communal rather than individual life means that Marxist critics today are more likely to write about the class struggle as depicted in films from developing countries in the Middle East, Africa, and Latin America than they are to discuss films from the industrialized United States or European countries, where these subjects are treated less frequently. Yet, American fiction and nonfiction films concerned with social, economic, and political issues are the subject of lively debates in such periodicals as *Jump Cut* and *Cinéaste*. Other critical perspectives, such as those concentrating on gender, race, feminism, and psychoanalysis, also benefit from incorporating the economically aware, class-conscious Marxist approach.

FEMINISM. Feminist film theory brings to the study and criticism of the movies the same overall concerns that mark the feminist movement as a whole: a desire for equality with men, in society as well as in the arts that represent it; the roles that women have traditionally been expected to fulfill in society; the patriarchal structure of society; stereotyped representations of women; and gender discrimination against women. Feminist critics have particularly focused on calling attention to the media's representation of women as passive, dependent on men, or objects of desire. Influential since the 1960s, feminism has incorporated a variety of other critical perspectives, including psychoanalytic, semiotic, gender, and Marxist theories. The journals *Wide Angle, Cinema Journal, Women and Film,* and *Camera Obscura* frequently publish feminist film theory, and they are good places to chart how it has changed. Two of the many contentious issues in feminist film theory are worth briefly addressing here.

First, many feminist critiques focus on whether women and men can challenge or escape patriarchy, a social system in which men dominate. Laura Mulvey's landmark essay "Visual Pleasure and Narrative Cinema" (1975) takes the position that patriarchy is a systemic condition that neither film artists nor viewers can change, for the conventions of classic narrative cinema portray women in films as objects to be looked at, first by male protagonists in films and then by spectators forced to identify with the protagonists. Other writers advocate raising the consciousness of all women, protest negative portrayals of women on the screen, and insist that women be given an equal opportunity to take positions both in the film industry and in independent filmmaking. In one of the first influential feminist film studies, *From Reverence to Rape: The Treatment of Women in the Movies* (1974), Molly Haskell surveys the unrealistic depictions of women throughout the history of the movies. She concludes that they are, essentially, stereotypes of what men want to believe about women and argues that these stereotypes of women as virgins, victims, and sex goddesses should be replaced with depictions that are more diverse, faithful to women's actual lives, and positive. But in "Feminist Politics and Film History" (1975), British theorist Claire Johnston disagrees with Haskell's view on female stereotyping in the movies, asserting that by concentrating solely on the image of women, we ignore the larger contexts through which the image functions—the text (that is, the movie), psychic structures, and historical and institutional frameworks. That is, for Johnston, film is a language and the image of women is a sign within that language. In any case, the balance between these two views—what we might call *deterministic* feminist theory and *liberal-progressive* theory—differs according to the

historical period being considered. During the 1960s and early 1970s, feminist film theory leaned toward the former stance; today, it tends to lean more toward the latter.

Second, some feminist critics seek to determine whether particular characters, stories, filmmakers, or film practices are pro- or anti-feminist, attempts that naturally lead to disagreements. Although no one set of criteria exists for making such judgments, feminist film critics are more likely to find demeaning characterizations of women in films made before than after the 1960s.

CULTURAL STUDIES. An important legacy of Marxist criticism has been its influence on cultural studies, which began in the mid-1920s at the Frankfurt Institute of Social Research in Germany. There scholars attempted to incorporate politics, culture, psychology, and sociology into one discipline. During the next four decades, the work of such intellectuals as Theodor Adorno, Walter Benjamin, Erich Fromm, Max Horkheimer, Siegfried Kracauer, and Herbert Marcuse had a major impact on social and cultural thinking in the United States, to which many of them fled in the 1930s.

Thanks to such influential works as Benjamin's essay "The Work of Art in the Age of Mechanical Reproduction" (1936) and Kracauer's book *From Caligari to Hitler: A Psychological History of the German Film* (1947), cultural studies has opened a new perspective on the movies, one in which the movies are regarded more as a popular art or a cultural artifact than as a traditional art form. As a result, movies are increasingly being studied outside of film studies departments. Cultural studies has even made inroads on such critical perspectives as formalism as it has become the broadest theoretical and critical approach to movie criticism. It is concerned with the movies' function within popular culture, as well as with the influence of popular culture on the movies. Labels such as "high" and "low" have no place here; all products of culture play a role within culture and all are relevant to how members of a society respond to those products. In this light, the hierarchies of the auteurist critics appear to be relics of an outmoded elitist undertaking. Thus "B" movies of the 1940s suddenly become cultural touchstones that enable us to understand wartime America. Cultural studies goes deep beneath the surface of a movie to explore the implicit and hidden meanings. Furthermore, it analyzes the period in which the film was made, especially the dominant social issues—politics, race, ethnicity, class, sexual identity, gender—and their relation to the period in which the analysis is being made.

APPLIED READINGS

Let's now look at a number of films that are well suited to specific critical and theoretical approaches. While all are broadly applicable to almost any film, and while critics often combine various approaches to enrich their analyses, some movies yield more interesting answers to particular kinds of questions.

DIE HARD: MIMICRY AND CATHARSIS

Like most successful action films, John McTiernan's *Die Hard* (1988) presents violence in a form that can both horrify and entertain. Thus the movie provides fuel for the age-old debate about mimicry and catharsis. In the film, John McClane (Bruce Willis), a New York

City cop, has flown to Los Angeles to attend the Christmas party of the Nakitomi Corporation with his estranged wife, Holly (Bonnie Bedelia), a company executive. The party takes place in the firm's beautiful, modern high-rise. Early in the festivities, international criminals arrive and seal off the nearly deserted building to crack a safe containing hundreds of millions of dollars' worth of negotiable bonds. McClane escapes the hostage roundup and battles the villains in an elaborate game of cat and mouse that smartly exploits the various spaces of the tower. As in many action films, much of the hero's violence is justified as self-defense, protection of the weak, and thus legal force. However, in one scene, McClane uses plastic explosives to dispatch some villains and in the process blows up an entire floor, an act presented in the film as excessively zealous if not vengeful. This scene and others in the film visually celebrate the destruction of the lush decor of the Nakatomi high-rise by machine gun, explosives, and fire.

To explore *Die Hard*'s treatment of violence, you could do basic research into the film's reception—reading reviews, criticism, marketing materials, interviews of viewers and fans—to learn how the film's violence was marketed and received and then carefully analyzing the formal and narrative depictions of violence for evidence of tone, attitude, perhaps even contradictions. Do scenes such as the destruction of the Nakatomi high-rise provide catharsis for audiences, venting societal aggression? Do they suggest a more deep-seated human aggressiveness toward objects of great economic and social value? Do the film's release during the height of Japanese international economic ascendancy and the Germanic background of a number of the villains hint at collective U.S. envy and aggres-

sion toward the country's successful World War II enemies? Ultimately, has the movie struck the right balance between its condemnation and its celebration of violence? What role does the individual spectator play in judging the depictions of that violence?

DIE HARD: BINARY OPPOSITIONS

To begin working with binary oppositions, you should compose a simple list shortly after watching a film. These early notes might also include observations that could eventually become important points in or even the thesis of your paper. A typical Hollywood action film like *Die Hard* suggests dozens of binary oppositions, such as

- man versus woman (in fact, a tough, working-class man versus a white-collar woman; notice that the kidnapping takes Holly out of her corporate world and places her into her husband's element: a physical battle for survival)
- black versus white
- New York (East Coast, nervous, tough) versus Los Angeles (West Coast, laid-back, soft; notice that the film was released at a time of West Coast economic ascendancy)
- local cops versus feds (FBI)
- America versus Japan
- America versus Europe
- outlaw hero versus official hero

Notice how entries such as man/woman and East Coast/West Coast add detail to some very basic oppositions. All of those listed are quite common and, at their most general, could apply to hundreds if not thousands of films. The last opposition, outlaw hero versus official hero, is pervasive in American narra-

tives.[21] Hollywood buddy films such as the *Lethal Weapon* and *Rush Hour* series often team up an outlaw and official partner, whose significant differences in behavior and strategy help differentiate and spice up the characterizations and plots. In *Die Hard,* John McClane follows the outlaw hero model: while combating the terrorists, McClane is technically out of his jurisdiction. By film's end, he looks and behaves more like a guerrilla fighter than like a uniformed police officer. In a paper, you could continue this line of analysis by finding elements of the plot, dialogue, costume, and setting suggesting that McClane is being depicted as an outlaw hero. Indeed, you could chart many of the film's characters in relation to their status as outlaw or official hero.

Die Hard is rich with oppositions that speak to tensions and issues in American culture, including the conflict and the possibility of constructive social interaction between African Americans and whites. Essentially alone as he battles a small army of criminals, McClane is befriended primarily by two black men: Argyle (De'voreaux White), the limo driver who brings him to the Nakatomi Tower, and Sergeant Al Powell (Reginald VelJohnson), the first police officer on the scene. Communicating with one another over walkie-talkies, sharing the experiences of their profession, McClane and Powell become so close during their ordeal that they embrace when they finally meet at the end of the movie. In the context of contemporary America and especially Los Angeles, a hotbed of racial tensions and abuses of police power, *Die Hard*'s depiction of black and white unity and collective problem solving (against vaguely European and Germanic villains) offers a therapeutic and hopeful resolution to tremendously difficult and historically fraught social problems. At the same time, the film traffics in stereotypes—for example, Argyle's costume and behavior suggest his less-than-serious attitude toward work and life. In a paper, you could take these general notions and explore *Die Hard*'s treatment of race and of interracial interactions, perhaps in light of Los Angeles history and Hollywood's responses to current events.[22]

WALL STREET: FREUDIANISM

Oliver Stone's *Wall Street* (1987) provides an almost textbook example of a Freudian oedipal narrative. Bud Fox (Charlie Sheen) is a tremendously ambitious young stockbroker who begins working with Gordon Gekko (Michael Douglas), a corporate raider who buys companies and breaks them up, selling their assets and firing employees to make a profit. In the background is Carl Fox (Martin Sheen), Bud's father, a hardworking aircraft mechanic and union member who occupies the moral high ground of business: a concern

[21]The outlaw hero/official hero binary was best developed by Robert B. Ray, in *A Certain Tendency of the Hollywood Cinema, 1930–1980* (Princeton: Princeton University Press, 1985). Ray argues compellingly that American narratives—especially westerns, action films, and cop and crime stories—often develop a contrast between outlaw and official heroes and their respective modes of behavior. Beginning with the historical and legendary contrast between George Washington and Daniel Boone and continuing with cinematic heroes, Ray notes the difference between heroes that play by the rules in order to do good (official heroes) and those that bend and sometimes break the rules in the service of the good (outlaw heroes). Ray traces the need for an outlaw hero to a sort of Achilles' heel of Western democracies, whose broad protections and rights afforded all citizens, including criminals, allow a certain latitude for nefarious types.

[22]During the 1980s a number of public incidents involving the police took place in Los Angeles. The Watts riots of 1965 may provide the major historical context here.

for employees, the creation of good products and services. At first, Bud rejects his father's ethos and embraces Gekko's ruthless, win-at-all-costs philosophy; later, Bud battles with Gekko; finally, Bud embraces Carl's philosophy and pulls a fast one on Gekko, thereby saving the airline his father works for. That Martin Sheen is Charlie Sheen's biological father adds to the film's resonance. Oliver Stone begins the film with a dedication to his own recently deceased father, "Louis Stone, stockbroker," with whom (as he's discussed in interviews) he came into conflict after his voluntary service in Vietnam left him opposed to the war. Though *Wall Street* overtly claims that Stone's father inspires its view of the best of American business practices, we might see the film as one artist's attempt to split the Father into good and bad elements, making it possible to renounce one half and embrace the other. To do a Freudian reading of *Wall Street,* you could investigate Stone's comments on his father and carefully explore the film's treatment of fathers and father figures, perhaps comparing it to that in other Stone films such as *Born on the Fourth of July* (1989) and *Natural Born Killers* (1994)—always remaining mindful of Freud's central idea that oedipal aggression expresses itself indirectly, accidentally, unconsciously.

VERTIGO: COGNITIVE PSYCHOLOGY

In Alfred Hitchcock's *Vertigo* (1958), Gavin Elster (Tom Helmore) asks an old friend, retired detective Scottie Ferguson (Jimmy Stewart), to watch his wife, Madeleine (Kim Novak), whom he fears is losing her grip on reality and coming to believe she is the reincarnation of Carlotta Valdes, who died in 1857. Infatuated with Madeleine, Scottie attempts to put to rest her troubling dreams by taking her to Carlotta's grave; there, Madeleine flees from Scottie, who, battling his fear of heights, chases her to the top of a bell tower; he arrives just in time to see her fall to her death in the courtyard below. Recovering from the nervous breakdown that follows, Scottie revisits places associated with Madeleine and recognizes her in other women. One day, he sees Judy Barton (Kim Novak), who in profile looks exactly like Madeleine, though her dress and hair are different. Scottie approaches her and pleadingly asks to get to know her. When Scottie leaves, the audience learns Judy's story: Gavin Elster set Scottie up to believe that the murder of the real Madeleine Elster was a suicide by having his mistress, Judy, portray a psychologically disturbed Madeleine. Not knowing the truth, Scottie makes Judy over into his memory of Madeleine, and she reluctantly obliges.

Vertigo is interesting cognitively in a number of ways: the point-of-view depiction of vertigo effects, the visually dramatic dream sequences, and the viewer's less spectacular but more significant sharing of Scottie's visions of Madeleine and then his memory of her through Judy. One of *Vertigo*'s strongest visual themes is the use of the profile for Kim Novak's various incarnations as Madeleine. The repeated silhouettes help link Scottie's obsession with Madeleine to the Western aesthetic conventions for representing feminine beauty. That is, Hitchcock transforms Novak/Madeleine into a work of art: statuesque, reserved, posing, in profile—"those beautiful phony trances," Scottie angrily shouts when he discovers the artifice. Of course, these transformations are motivated dramatically, in that Gavin Elster and Judy know how to go about manufacturing a beautiful, mysterious woman because they are familiar with the conventions for representing

feminine beauty, whether in high art, fashion, or Hollywood itself. *Vertigo* exploits our most basic cognitive skills, particularly the ability to remember and recognize a familiar face (profile). While Freudianism emphasizes the unconscious, cognitive science holds that many types of cognition can operate as unthinking habit. Facial recognition, like voice and language recognition, is typically a habituated process that functions as we're busy doing other things. *Vertigo* exploits this ability by habituating viewers (through Scottie's detective work and his obsession) to a Madeleine Ideal, which is then destroyed—only to be reborn in front of our eyes in the guise of Judy. When Scottie sees Judy on the street for the first time, we have been set up to share Scottie's cognitive dissonance (she looks like but doesn't look like Madeleine). A student paper might explore *Vertigo*'s many other hauntingly familiar treatments of feminine ideals, profiles, and hairstyles. More generally, the idea of cognitive dissonance can apply to any number of Hitchcock films, which are famous for complicating "normal" human vision and classical Hollywood perspective.

REAR WINDOW: AUTEURISM

The title of Alfred Hitchcock's *Rear Window* (1954) refers to Jeff Jeffries's (Jimmy Stewart) apartment window, which looks out onto a courtyard and a host of New York apartments. Stuck inside and practically immobile in his hip-to-toe cast, Jeff amuses himself by watching his neighbors. In addition, he is visited daily by his nurse, Stella (Thelma Ritter), and his girlfriend, Lisa Fremont (Grace Kelly). One day, the bedridden wife of his neighbor Lars Thorwald (Raymond Burr) disappears. Jeff suspects foul play. When Thorwald learns that Lisa and Jeff suspect him, he comes to Jeff's

apartment, struggles with him, and pushes him out Jeff's rear window just as the police arrive in time to cushion his fall and save his life.

Rear Window encapsulates much of what has come to be identified with the Hitchcock film. The director's obsession with "cool blondes" is embodied in Grace Kelly, whose Lisa Fremont is as elegant and beautiful as she is strong and funny. His penchant for leading men who could represent the average guy caught in outlandish situations is perfectly satisfied in Jimmy Stewart. Most important, Hitchcock's interest in voyeurism is profoundly evident in both the film's form (Jeff looks; the audience shares Jeff's point of view; the audience sees Jeff's reaction) and its themes (looking is exciting, dangerous, guilt-laden, and a compulsive group activity). In terms of production, *Rear Window* is a good example of Hitchcock's well-documented desire for control and manipulation. The *Rear Window* set built at Paramount Studios was one of the largest and most elaborate ever created, and the film never leaves it (a restricted location similar to Hitchcock's experiments in *Lifeboat* [1944] and *Rope* [1948]). Actors in the apartments across the way wore earpieces that Hitchcock could use to communicate directions, and the lighting for the entire set could be controlled from an electronic console.

An auteur analysis of a film and director is only as good as the writer's knowledge of the director's body of work. Because the main value of this approach is in drawing comparisons and tracing the evolution of the director's work across a number of films, a thorough familiarity is needed. Moreover, an auteur study should avoid the simplistic assumption that any director, even Hitchcock, was solely responsible for his films. Hollywood films, at least, are undertakings too

large for any one person to control in the way that novelists and painters can govern every element of their art. A more nuanced application of auteurism might begin with the notion that Alfred Hitchcock was not only a dominating presence on all his films but also a smart collaborator who hired the best artists and actors in Hollywood and allowed them to contribute to his overall vision. Film scholar Steven DeRosa's *Writing with Hitchcock: The Collaboration of Alfred Hitchcock and John Michael Hayes* (New York: Faber and Faber, 2001) is one of the more recent works to detail how films like *Rear Window* were collaborative affairs that strove for a Hitchcockian style and model that had, by the 1950s, outgrown the direct influence and control of the director himself. The auteur approach need not be undermined by a false dichotomy that sets total directorial control against collaboration—Hitchcock's films are excellent examples of how the director together with his cast, crew, and writers created unified and intelligent works.

METROPOLIS: MARXISM

Fritz Lang's silent masterpiece *Metropolis* (1927) has influenced an extraordinary range of productions, from science fiction dystopias such as Ridley Scott's *Blade Runner* (1982) to music videos such as Madonna's "Express Yourself" (1989). Recognized as the high point of German expressionism, *Metropolis* borrows heavily from Marxist critiques of unrestrained modernism. Set in a futuristic high-rise city with a vast underground population, the film presents a social structure much like that described by Marx: the wealthy leisure and administrative classes of the upper world (the bourgeoisie) run Metropolis, while the laborers (the proletariat) of the lower world must tend the huge array of machinery that powers the upper world. The film's sympathies are obviously with the suffering laborers and against the pampered and ruthless upper classes. Known for its striking compositions, elaborate sets, and expressionistic camera-work and lighting, *Metropolis* presents many images that boldly register the plight of the workers and the domination of the elite: legions of workers marching slowly and mechanically through underground tunnels at the start of their shift; workers stretched across the face of clocklike machine controls, constantly moving the controls as if shackled to them; the elite, arrogant, smartly dressed functionaries and government engineers in the cloud-high command center.

A Marxist reading of *Metropolis* might attend to the basic historical context of the film—1927 Weimar Germany, a time when some viewed communism as a solution to Germany and Europe's economic misery. The social upheavals of the 1920s led instead to the coming to power of the Nazis—deadly enemies of communism—in 1933. Lang obviously sympathized with the Marxist distrust of modern capital and industry, and he turned down the Nazis' offer to run the German film industry under the Third Reich; ironically, though, on the set of *Metropolis* the director's perfectionism and onerous working of his actors and extras seemed profoundly exploitive. Marxism's central tenet—exploitation of workers by those who control capital—remains an undercurrent in all the various science fiction dystopias that *Metropolis* influenced, any of which might be examined in a paper on the film. You might also compare the film, from a Marxist perspective, with classic Soviet films such as Sergei Eisenstein's *Strike* (*Stachka*, 1925) and *Battleship Potemkin* (*Bronenosets Potyomkin*, 1925) or with more recent Ameri-

can films such as Barbara Kopple's documentary *Harlan County, U.S.A* (1976) and John Sayles's feature film *Matewan* (1987), which present worlds in which workers are obviously exploited. Or you might compare *Metropolis* to films that focus on the lives, loves, and pleasures of the American working class but are not overtly about work and economic inequalities, such as Peter Yates's *Breaking Away* (1979), Kevin Smith's *Clerks* (1994), and Alex Cox's *Repo Man* (1984).

THELMA AND LOUISE: FEMINISM

In Ridley Scott's *Thelma and Louise* (1991), Thelma (Geena Davis) is married to a slob of a husband, and her friend Louise (Susan Sarandon) works as a waitress at the local diner, waiting for her musician boyfriend to get serious about their relationship. The two women decide to spend a long weekend together to get away from it all. They stop at a roadhouse for some drinks and dancing, and as they are leaving Thelma is nearly raped in the parking lot. Louise pulls a gun on the man, who defiantly curses at her; Louise pulls the trigger, killing him. Thus begins a flight from the law and a strange road movie, in which Thelma and Louise bond as outlaws against a male-dominated western landscape. Refusing to surrender, the women take to robbing banks and, after a long chase ends with them surrounded by police, drive their T-bird over a majestic southwestern cliff.

At the time of its release, *Thelma and Louise* inspired a good deal of debate simply because it was one of the first big budget Hollywood films to assert a feminist perspective. The details of the film's feminism remain debatable, however. First, at its most simplistic, the film traffics in stereotypes of male chauvinism: a lewd trucker, a sanctimonious highway patrolman, a husband more interested in beer and football than in his intelligent and beautiful wife, a young hunk who steals hearts as well as purses. In the Hollywood tradition, each stereotypical man gets his comeuppance at the hands of the hero(in)es; this pattern seemed appropriate to most mainstream viewers, although the results can be seen as far from progressive or sophisticated. Second, Thelma and Louise take on traditionally male roles as they replace the outlaw-buddy heroes of countless westerns and road movies. Both visually and thematically, the image of Thelma and Louise packing pistols and using them with gusto was a striking inversion of the cultural tradition. Third, in the film's most sophisticated move, Callie Khouri's script presents two women who develop before our eyes into proud, fearless, and genuinely satisfied individuals. Thus the road picture and the western, each characterized by a separate search for identity, overlap with feminist concerns about the formation of new, truer identities for women. Fourth, in the tradition of Hollywood liberal critiques of society, *Thelma and Louise* condemns the criminal justice system and its unwillingness to believe in and protect women victimized by sexual assault. Finally, the movie deflects the traditional Hollywood "male gaze," wherein a male character, the camera, and the viewer share a desire-filled view of a female character; this happens most particularly when Thelma ogles the good-looking J.D. (Brad Pitt). To do a feminist reading of *Thelma and Louise,* you might begin with any of these notions, finding similarities and differences with mainstream, male-centered films of the road picture or buddy genres, such as George Roy Hill's *Butch Cassidy and the Sundance Kid* (1969) or Dennis Hopper's *Easy Rider* (1969). Or you might compare this movie with

a smaller, independent feminist film such as Allison Anders's *Gas Food Lodging* (1992), Julie Dash's *Daughters of the Dust* (1991), or Edward Zwick's *Leaving Normal* (1992), a female-buddy road film reminiscent of *Thelma and Louise*.

REPO MAN: CULTURAL STUDIES

Alex Cox's *Repo Man* (1984) is the strange tale, set in Los Angeles, of Otto (Emilio Estevez), a disaffected urban punk who leaves behind his ex-hippie born-again parents and a string of menial jobs for an apprenticeship with a group of repo men—automobile bounty hunters who repossess (in effect, steal) cars from owners who have failed to keep up their loan payments. Along the way, Otto survives a number of liquor store robberies carried out by old punk acquaintances; is attacked, beaten, and shot at during his various car repossession runs; meets and seduces a young woman working with a secretive UFO cult; is captured by federal agents and tortured; and flies off into the night inside a radioactive Chevy Malibu containing the bodies of four aliens.

Repo Man's low budget, black comedy, and cult status make it the kind of film that traditional criticism frequently dismisses as unworthy of study or analysis. But cultural studies, with its claim that any film—even a low-budget cult film—may speak eloquently about social conditions and attitudes, validates the study of such films and allows for serious appraisals of ostensibly unserious subject matter and genres. Recalling Shakespeare's line that "many a truth is said in jest," we find that *Repo Man* says a great deal about 1980s culture. Besides its admittedly exaggerated portrayal of urban punk attitudes and behaviors (Alex Cox went on to direct the punk biopic

Sid and Nancy [1986]), *Repo Man* parodies our spiritual yearnings, whether expressed through UFO mythology, Scientology, televangelism, or mainstream religion. Also parodied are mass marketing and advertising; characters sing jingles even as every consumer product in the film appears in white-and-blue "generic" packaging, including large cans labeled "food." The film is full of what anthropologists and sociologists call subcultures: the distinctive milieus of punks, repo men, UFOlogists, scientists working on top secret projects, CIA agents. By exploring these subcultures and their interactions, *Repo Man* captures people's attitudes and manners of expression and dress better than most serious, big-budget films do.

Most important, the film traces certain American strains of paranoia, conspiracy theory, working-class cynicism, and millennialism. Ten years before *The X-Files* began its run on television, *Repo Man* was exploring this terrain of urban legend and mythology. Though the movie's plot is ridiculous, the attitudes, language, dress, and paraphernalia of popular culture offered up suggest actual subcultures and thinking. To do a cultural studies reading of *Repo Man,* you might examine the film's treatment of the punk movement, urban legends, and conspiracy theories, or you might compare this film with others that depict subcultures of disaffected youth, such as Richard Linklater's *Slacker* (1991), Francis Ford Coppola's *Rumble Fish* (1983), or Kevin Smith's *Clerks* (1994). Cult films, by definition, have small but devoted audiences that admire and value certain aspects of them. The films may then perpetuate attitudes and stances among the subcultures that embrace them. You might explore the narrow demographics of cult films, contrasting these audiences with our monolithic conception of a mainstream audience.

THE WRITING PROCESS

Teachers of writing refer to the *writing process,* emphasizing the process because, for many writers, the act of writing itself generates attitudes, ideas, and styles. Inexperienced writers sometimes stare into space hoping for inspiration to come to them. You'll have more luck finding your muse if you dive into the process and just start writing.

PREWRITING: DISCOVERING WHAT YOU WANT TO SAY

The technique called *freewriting* involves writing without restrictions or concerns for correctness. To freewrite, just pick a general topic, subtopic, or question related to your planned essay, set a time limit (between five and thirty minutes), and start writing. Some believe writing by hand (as opposed to using a keyboard) allows for more freedom of thought and exploration. This writing is "free" in that you know it may never be presented to a reader, it shouldn't be burdened by concerns with spelling or grammar, and it isn't bound by assumptions and plans about the assignment. The key to freewriting is for you to do it first and then return later to the piece with a more critical eye: Did I create or discover any useful phrases or sentences? What questions or parts (of the film, of the topic, and so on) kept drawing my attention? Did my attitude toward something grow stronger? What was I using for supporting evidence and examples? Freewriting thus enables you to create and discover through writing. Even a freewriting session that provides nothing useful for your paper may reveal a boring approach to a topic, or one that leads only to a dead end. Would you rather have that dead end discarded in one of your freewriting exercises, or publicly displayed in the final draft of your paper?

Concept mapping is another writing and organizing strategy that may help you develop ideas. Instead of relying only on words, here you use hand-drawn diagrams, flow charts, and other graphic methods of association. Fill a page with key terms, ideas, and phrases, laid out in some kind of logical spatial array. Which ideas are subordinate? Which dominate? What are equally important? What should be grouped? Do the ideas seem to relate better in a sequence, a grid, a simple juxtaposition? Begin with topic words and phrases, but then include words that provide evidence or counterarguments. Use concept mapping first to explore the breadth of your topic and how it may ultimately connect to everything, and then to become aware of the limits and focus you will need when writing your essay.

GENERATING TEXT

Sometimes, when you set out to write a paper, you confidently adopt a stance or thesis. As you invest more time and effort and compose page after page, it becomes ever more difficult to alter or discard your initial thesis. Remember, though, that eight pages of boring prose or a paper without a debatable thesis will not succeed. You should explore any hint of a more exciting angle on the topic. You might find it quicker to begin again than to try to salvage an approach that leads nowhere. Treat your thesis as provisional, and take into account what you learn as you research, study, and compose your essay; you might start out arguing *for* a particular position and eventually come to argue *against* it. Be sure to let your ideas evolve—don't be afraid to change your mind and your paper.

All writers, neophytes and professionals alike, have experienced *writer's block*. Like any inner struggle, writer's block can be difficult to overcome and can have any number of causes: lack of confidence, lack of ideas, confusion regarding an assignment, or panic over an assignment's importance. Freewriting is one excellent way to crack through writer's block. Another approach is to begin with a simple, narrowly focused task. If you know you are going to write about a particular scene, shot, or character, start writing solely with the purpose of description. Or you might begin with a quotation, either from the film or from a critic, and write an introduction and a follow-up for the quotation, explaining its importance and relevance. Sometimes, the detailed notes you take while analyzing a tape or DVD can help you work your way toward more sophisticated writing worth including in an essay. Finally, you might compose a rough outline, and begin expanding the bullet points into sentences and paragraphs in whatever order seems easiest to you. The introductory paragraph can be the most intimidating part of a writing assignment, and it is often best saved for the last task. Follow any of these strategies and you'll eventually obliterate writer's block and reach your goal—a complete first draft.

REVISING

Reflection and the passage of time are a writer's greatest allies. Have you ever returned to an old paper you wrote only to be confused by your own writing? When the writing is still fresh, you easily supply connections left unmade on the page by referring to the thoughts and ideas within your head. Your readers, however, are not mind readers. By putting aside your first draft for a while, you allow yourself to shift naturally from *writer* to *reader*. In a pinch, you can force this critical stance by reading your paper out loud, thereby accomplishing two ends. First, the act of reading helps show where the prose needs revision—you'll stumble over your own words if they're not properly composed. Second, the act of listening to yourself empowers your own "critical ear," enabling you to hear what works and what doesn't in your own writing. Reading your paper in front of a mirror may be particularly helpful. As you grow more experienced and learn to force yourself to view your draft as a reader would, you'll be able to lessen the amount of time between initial composition and critical revision. But almost nothing can replace the benefits of allowing at least one full day to pass before you return to the draft. If you begin your essays the night before they are due, you are taking a gamble you will probably lose.

Moreover, leaving time between your first and last drafts enables you to share your early drafts with friendly readers, who can discuss possible revisions and help you recognize that your words can have very different meanings than you intended. Though we often view our writing as a personal extension of ourselves, its purpose is to communicate. In the end, a reader (parent, sibling, friend, roommate) who is willing to give honest feedback can be invaluable in showing where improvement is needed. If a reader hesitates to offer criticism, ask pointed questions about what you thought you conveyed, focusing on specifics of your argument. Force readers to pick their favorite paragraphs and their least favorite. Readers can, of course, be wrong or misguided, but if two readers agree, you probably should trust their judgment.

James Arnett, a student at the University of Illinois, wrote the following paper for an introductory film course. In it, he employs several strategies to present his thesis and to develop his supporting arguments, and he backs up his claims using different types of sources. Marginal comments elaborate on the paper's strengths.

SAMPLE STUDENT PAPER

This short, playful title invites readers to decode it, just as the film noir narratives discussed in the essay invite viewers to decode them. Once decoded, the title, though only two words, prepares readers for the essay's linkage of "modern" film noirs with the classics. Because Billy Wilder's *Double Indemnity* (1944) is so well known, the writer knows he can count on his teacher's getting the reference, even though his essay never makes the connection explicit. A more obscure reference, however, might be lost on everyone but the writer.

This direct opening sentence uses a rhetorical strategy common to academic papers: it states a problem, in this case the difficulty of defining the film noir genre.

The writer uses ellipses to trim the quotation to what is directly relevant to this essay. The essay begins with an authoritative quotation that reiterates the problem—defining film noir—that the opening sentences assert.

The writer makes clear his methods and turns from Cook's somewhat problematic treatment of film noir toward Hardy's "working definition," which allows the author to search for three traits—gender reversal, Freudian psychoanalysis, and fractured fabulas—in the contemporary noirs.

Arnet 1

James Arnett

Professor Baird

English 4-1

May 2, 2003

Modern Indemnity

Film noir is a tricky subject. No single, universal definition exists for this term; as David A. Cook notes in his A History of Narrative Film, "it has become fashionable to speak of film noir as a type . . . of realism . . . but . . . it seems better to characterize it as a cycle rather than to delimit its boundaries too rigidly" (451). To analyze some aspects of film noir in this paper, however, I must establish at least a working definition for the term. Phil Hardy's article in The Oxford History of World Cinema pinpoints some notable features of film noir. One facet involves a gender reversal from the crime films of the 1930s. Women are imbued with more power --typically sexual in nature--while men are presented as less energetic than in other films

(306). Hardy's second major characteristic of
the film noir focuses on the influence of Freudian
psychoanalysis on the crime film and the
subsequent development of characters who are
governed as much by their subconscious minds as
by their conscious ones (308). Hardy's final
point concerns the fabula, or the chronology of
the narrative's presentation. Pointing to its
ability to prevent progress for the central
character, he emphasizes the importance of the
flashback in the film noir (309). For the
purposes of this discussion, I will use Hardy's
tenets as the central features of the film noir.

> Another clear articulation of the essay's forthcoming method.

 The term "film noir" was coined in 1946,
midway through the film cycle's first era of
popularity (Cook 449). The cycle has reappeared
in American films at various points; the mid-
1980s saw a resurgence in popularity, and the
era of independent film in America in the 1990s
kept film noir alive (950-51). Recently,
numerous films--including Bryan Singer's The
Usual Suspects (1995), Christopher Nolan's
Memento (2000), and David Lynch's Mulholland Dr.
(2001)--have tampered with and twisted the basic
elements of film noir listed above with the
intention of engaging and surprising the
audience; the results for The Usual Suspects and
Memento were sustained theatrical runs that
seemed to build on good word of mouth, while
Mulholland Dr. has enjoyed steady and strong

Good use of a nontraditional film.

While anecdotal evidence carries less weight than do surveys and other studies, its use here to stimulate thinking about contemporary spectator response is useful and appropriate.

A quotation used to begin an essay or a section is called an *epigraph*. This essay uses four epigraphs (drawn from dialogue from the various films) to structure the sections of the paper.

When referring to sources, the writer varies his language to avoid reusing the same form (*Hardy says, Hardy says, Jackson says, Sugimoto says,* and so forth). Among the many words that can work in this context are *says, observes, finds, believes, holds, argues, concedes, thinks, reiterates, concludes, begins, stresses, asserts,* and *claims.* Note, too, that each word offers a distinctive meaning that can help convey the tone and context of the original source.

Of course, phrases provide even more tone and expression to characterize the original source author's ideas as well as your stance toward them: *As Cheng has made clear again and again . . . , In the opening pages of Jones's brilliant opus . . . , Struggling with the complexities of the topic, Smith begins . . . , Ali, ever hopeful of setting us straight, . . .*

References to German expressionism reveal the writer's appreciation for the larger historical context of the films he is studying.

video and DVD rentals and sales. All three films currently appear in the top 100 of the Internet Movie Database's list of the top 250 films, which is established by votes from visitors to the site. In addition, from conversations with friends and acquaintances I have determined that many viewers chose to see these movies repeatedly, thus increasing the profit for all three films. I intend to examine these films and discover what changes have been made to the essential film noir that (or, perhaps, in order to) stimulate such multiple viewings.[1]

"If he comes up for anything, it'll be to get rid of me."

Hardy observes that the emergence of film noir in the 1940s was triggered by a variety of influences. The two primary movements that prompted the new style were the burgeoning importance of Freudian psychoanalysis in Hollywood society and the immigration of German expressionist filmmakers to Hollywood (308). The effect of Freudian analysis on the film noir is fairly obvious; Freud's concepts of the ego, the superego, and the id, the conscious and the subconscious, fit well within the framework of human beings' destruction and self-destruction through compulsion toward their baser instincts. The expressionists, meanwhile, were well versed in the art of visually portraying characters'

frayed mental states and displaced identities. The struggle among humanity's split natures became a central issue of the film noir.

A case study in split natures, <u>The Usual Suspects</u> ends with a twist that requires a psychological rereading of Verbal Kint's story. Dave Kujan notices that several key elements of the story have come from the objects in his office. The name of Keyser Soze's henchman came from the brand of china that Kint was drinking coffee from, the reference to the barbershop quartet in Skokie was derived from a poster on Kujan's wall, and so on. Thus the ending of the film implicates Kint's story as both a fabrication and, in its artistry, a reflection of his subconscious.

> Some students might only *tell* their readers that the "key elements of the story come from the office," but this writer *shows* us, by offering two concrete details from the film: the china and the barbershop quartet.

What does Kint's story tell us about the subconscious mind of Verbal Kint/Keyser Soze? A possible answer lies in the characterization of Kint's fellow criminals. Dean Keaton, the group's unspoken leader, is obviously a double for Soze's intellectual self. He delights in outwitting the police; this is evidenced by the banter that is exchanged when the police arrive at Keaton's restaurant to bring him in for questioning. This quality is also seen in Kint's conscious self through his deception of Kujan during questioning. Michael McManus represents the rage and violence that Soze developed in response to his wife's murder.

> A good rhetorical strategy, when used in moderation: begin a paragraph with a question.

Fred Fenster and his accent embody Soze's Hungarian background and his status as an outsider. Todd Hockney brings to life Soze's neuroses and fears of death and capture. Observed from this view, The Usual Suspects appears an elaborate puzzle, engaging the viewer in the traditional whodunit questions but also in what is ultimately revealed to be an elaborate psychological allegory. Part of the film's popularity may reside in the problem-solving element for the viewer, who is encouraged to seek connections between Kint's story and the "real" scenes in Kujan's office.

The Usual Suspects employs an unusual narrative form in that the principal narrative strand occurs through flashback. As Kint is interrogated by Kujan in the film's "present," the interrogation scenes are intercut with the visual display of his story, which appears in flashback. This technique effectively grounds the bulk of the movie in Kint's perspective and thus facilitates one of the film's major devices. Kint has been captured by the police; the rest of the criminals' having suffered their respective fates seems to spell doom for him. His point of view on the behind-the-scenes machinations of the raid is the only one the viewer sees; however, his squirming before Kujan indicates that Kint fears Soze and is most likely telling the truth with little

The writer develops his ideas further by introducing a new metaphor (in this case, a further explication of the repeat-viewing phenomenon): the tampering and twisting of the classic form becomes a type of "puzzle" that encourages "problem solving" in viewers.

embellishment. While the viewer will likely interpret Kint as a tragic character due to the inescapable nature of his story, the film's conclusion upsets this assumption. When the viewer realizes that Kint is the mysterious Keyser Soze, Kint's story loses validity. When Kujan notices that Kint's story contains elements from his office, the story falls apart. Thus the ending of <u>The Usual Suspects</u> aborts and annihilates the prime narrative in the film. Since Kint's story doesn't hold, the viewer is left wondering just what happened. To make sense of the pieces, the viewer most likely will watch the film again.

> "I always thought the joy of reading a book is not knowing what happens next."

<u>Memento</u> provides an interesting look at the conscious mind and subconscious of its protagonist, Leonard Shelby. Shelby's inability to form short-term memories disturbs, fragments, all of his mental workings. Shelby's conscious mind is readily available to the viewer; the voiceover narration offers direct access to his thoughts throughout the film. In the film's final moments, Shelby's voiceover reveals that he has deliberately been telling himself a false story and thus living a lie, in fact a series of lies-- in Freudian terms, he has repressed the truth. His subconscious, the viewer may infer, knows the truth and is at war with his conscious mind.

> The writer colorfully and provocatively dramatizes the film's concluding revelation, but he avoids excessively ornate language, or *purple prose*.

> By employing a technical film term (*voiceover narration*), the writer demonstrates that in the process of film analysis he can apply the specialized vocabulary and ideas learned in class.

Just as Shelby's mind must be struggling
to reconcile what it knows (on a subconscious
level) with what it has been told to believe
(consciously), so Shelby struggles, from moment
to moment, to make sense of reality. When he
finds a man beaten up and bound in his closet, he
does not know how to react because he cannot
remember why the man is there. In fact, he does
not know that he should remember. In situations
like this, he must either rely on the "facts" he
has assembled in the form of notes, Polaroid
photos, and tattoos or he must ask others for
information. This dependence allows the other
characters (Teddy, Natalie, Burt the motel
clerk) to manipulate Shelby for various
purposes.

Narratively, Memento puts its own special
twist on the idea of living in the moment. The
order of the events as portrayed in the film--the
fabula--does not correspond with the actual
chronological sequence of events. In addition,
making matters more complicated, the narrative
has two parts, one shot in color, the other in
black and white. The first scene in the color
sequence shows Shelby killing Teddy. From
there, the fabula of the color sequence
progresses backward, step by step, with each
scene depicting the events that have led to the
preceding scene. The fabula becomes an
expression of Shelby's condition; the viewer,

who also (but for a different reason) has no memory of the events prior to Teddy's death, is locked into a spiral, traveling backward into the story. The black-and-white sequence of the film's narrative is intercut with the color sequence; these scenes progress chronologically, but they exist outside any other time frame. Until near the end, when the two strands meet, the viewer does not know whether the black-and-white sequence occurs at some point during the color sequence, or before or after the color sequence. Like Shelby, the fabula has no real concept of the passage of time. In one sense, it skips backwards; in another, it is lost.

This technique not only draws the viewer into the story, but also creates a great deal of suspense. Shelby's notes, photos, and tattoos seem to maintain his grasp on reality throughout the film, but the nature of that reality remains mysterious. The double-stranded narrative both reveals the circumstances under which Shelby created his mementos and continually modifies the viewer's understanding of the mementos and their creator. One of the film's most compelling mysteries concerns the admonition on Shelby's photo of Teddy--"do not believe his lies." By the time that mystery is finally explained, the viewer has absorbed so much information, so much of it in conflict, that a second viewing is in order.

Descriptive detail from the film makes the writer's point concrete.

"I have a recurring dream. I come to this
Winkie's."

Mulholland Dr. portrays the conscious mind
and the subconscious of its protagonist quite
literally. After the opening shots of a
jitterbug contest, a brief shot shows a person
climbing into bed and falling into a pillow
before the sign proclaiming Mulholland Dr.
shimmers into view. As we later learn from a
shot of her emerging from that same bed, the
sleeping person is Diane Selwyn, and a large
portion of the film consists of Diane's dream--
her subconscious life, we might say. She finally
wakes, however, and the remainder of the film
deals with her conscious life.

The long sequence of Diane's dream
intricately displays her subconscious desires.
She is transformed through this dream into
Betty, a beautiful young woman who has the world
at her fingertips. She is living rent-free in
her aunt's Hollywood apartment; she is a
brilliant actress capable of wowing everyone at
an audition and willing to cut short a meeting
with Adam Kesher, one of Hollywood's hottest
directors; she finds love with Rita, a woman she
meets, literally, in her aunt's shower. Camilla
Rhodes's transformation into Rita is the most
revealing aspect of Diane's dream. In reality,
Camilla abandons Diane for Adam and behaves
spitefully and condescendingly toward the lover

she has outgrown; in the dream, Diane fashions Camilla into exactly what she desires. Rita is helpless without her identity; she has no home, no friends, and nowhere to go. She depends completely on Betty. Additionally, Rita's amnesia places her in a "virginal" state equal to Betty's; although she initiates sexual contact with Betty, Rita does not know whether she has had a lesbian relationship before.

Likewise, in her dream Diane nearly ruins Adam. He is intimidated by the sinister Cowboy into giving up creative control of his film; he discovers his wife cheating on him. In each of these situations, Diane's subconscious emasculates the director. This aspect of the dream is indicative of Diane's unconscious asserting itself; Adam is rendered as ineffectual as Rita. On first viewing, <u>Mulholland Dr.</u> seems to present a disjointed and fragmented narrative similar to that of <u>Lynch's Lost Highway</u> (1997), in which characters in one part of the film simply seem to take on different names, appearances, and personalities (and to be played by different actors) in the later part. However, with a deeper look at what takes place in <u>Mulholland Dr.</u>, the viewer will recognize that the narrative chronology is straightforward. The sequence of the film following the Cowboy's message is actually Diane's life. The minor flashbacks here

In this fairly sophisticated psychological reading of the film's characterization, the writer avoids doing too much "armchair analysis." He doesn't want to give the impression that he has mistaken fictional psychologies for literal ones, that he has begun work as a licensed psychologist and is "treating" characters as real people.

Without showing off, the writer displays his knowledge of the director's work and thus lends his whole essay a degree of credibility.

represent delusions and guilty memories that accompany Diane's growing insanity following Camilla's murder.

If the narrative confuses the viewer, this occurs because only that single, early shot indicates that most of the film is a dream. A viewer who misses the significance of the person climbing into bed will assume that the narrative is a normal one and will be puzzled by the correlation between the two parts of the film. For instance, female characters' names become jumbled in the two parts. Likewise, the blue metallic house key is transformed into a mysterious blue box and key in the dream. Lynch's plan is rather devious. By appearing to create a disjointed fabula, the filmmaker ensures confusion, curiosity, and repeated viewings.

"Maybe it's time you started investigating yourself."

The Usual Suspects, Memento, and Mulholland Dr. examine the psychologies of their main characters. Each film engages the viewer through a narrative mode or style that approximates the experience or psyche of its protagonist. The central theme of The Usual Suspects revolves around the identity of the mysterious Keyser Soze; ultimately, he is a myth, a composite of stories and legends that may or may not be true. Such is also the nature

Here the author carefully summarizes and brings together the three films and the particular ways each expresses character psychology through narrative mode and style.

of Kint's ultimately unreliable narrative. The
audience is unable to discern the fiction from
the reality in much the same way that Soze/Kint
is both a mythic figure and a real person whose
actual identity has become blurred.

Likewise, the experience of being Leonard
Shelby is replicated by *Memento's* narrative
strands. Shelby constantly tries to delve
backward to understand the significance of events
that are happening to him. The film's use of
backward chronology forces the viewer to think
in a similar fashion; this thought process is
rendered visually in the film's opening scene, in
which Teddy is unshot. The intercut black-and-
white sequence fleshes out the experience of
being Shelby. Not knowing when these events
occur or two whom Shelby is speaking, the viewer
experiences some of the isolation, fear, and
suspense that Shelby lives and deals with.

In <u>Mulholland Dr.</u>, Diane Selwyn has a
dream that causes her to kill herself. To make
this premise believable, Lynch renders the dream
in as tantalizing a manner as possible, using
several methods. His use of deep, saturated
color during the dream sequence gives the scenes
a lush feel, which clashes with the muted
dinginess of Diane's apartment and the bleak
light in her kitchen. Additionally, the
eroticism of the film's first part creates a sense
of peace, happiness, and sanctuary, all of which
the dreamer will lose in her waking life. In

Good descriptive language captures some of the film's mise-en-scénes.

comparison with the dream state, the latter portions of the film seem unbearable, and the juxtaposition of these two expressions of Diane's mental state allows the viewer to understand her suicide at the conclusion of the film.

These three films have found a resonance among audiences in part because of their narrative expressionism. The films have been designed to make audiences empathize with and relate to the plights of the characters. Through their presentations of events, the filmmakers have subtly coerced viewers into thinking along certain lines--namely, those of the protagonists. By combining the film noir tradition of fractured fabulas, flashbacks, Freudian psychology, and expressionism with ever more elaborate puzzles, contemporary filmmakers are developing film noirs that encourage repeated viewings through diverse and redundant distribution methods: movie theaters, television, video, and DVD. With videogaming now a multibillion-dollar industry, adopting narrative strategies that approximate puzzle solving is probably anything but a subconscious strategy on the part of Hollywood filmmakers.

The best endings for papers offer readers something more than summaries of the previous pages. Note how this writer extends the success and profitability of the puzzlelike noir films into the current cultural context, where video games and films influence and mimic one another. Note, too, the clever echo of the word "subconscious"—here by way of a more common meaning.

[1] The three films in question--particularly Mulholland Dr.-- address the issue of gender in new ways. This essay, however, is primarily concerned with the psychological and narrative ramifications of said films. For this reason, I will not discuss gender in this essay, where it could not receive the full and rigorous examination it deserves.

Works Cited

Cook, David A. <u>A History of Narrative Film</u>. New
 York: Norton, 1996.

Hardy, Phil. "Crime Movies." <u>The Oxford History
 of World Cinema</u>. Ed. Geoffrey Nowell-Smith.
 Oxford: Oxford UP, 1996, 304-12.

Appendix
Overview of Hollywood
Production Systems

The story of Hollywood film production—the pre–World War II rise and subsequent "fall" of the studio system, followed by the rise and dominance of the independent system—forms a colorful chapter in the history of American industry. Movie studios still coexist with independent production companies, but in such a variety of organizational and industrial configurations that the term *studio system* no longer means what it once did. Today, six major studios release both their own movies and some independently produced movies; other independently produced movies are released by autonomous organizations. At the beginning of 2002, the "big six" studios were, in alphabetical order, Disney (owned by the Walt Disney Corporation), Paramount Pictures (owned by Viacom), Sony Pictures (owned by Sony), Twentieth Century Fox (owned by the News Corporation), Universal Pictures (owned by Vivendi Universal), and Warner Bros. (owned by Time Warner).

Given the many changes of ownership that have occurred over the years, it is a remarkable testament to the overall value of motion pictures to the U.S. economy that with the ex-ception of Sony, all of these studios have been in business since the late 1920s or before.[1] Dominating the market worldwide, they define the nature of movie production in the United States. Other studios include Dream Works SKG (owned by Steven Spielberg, Jeffrey Katzenberg, and David Geffen), MGM/UA (owned by the Tracinda Corporation), Columbia/Tri Star (owned by Sony), New Line Cinema (owned by Warner Bros.), Lions Gate Studios, and Miramax, Touchstone Pictures, and Hollywood Pictures (all owned by Disney). When one of these smaller studios has a larger corporate owner, the parent firm is usually its distributor. In addition, countless independent producers must distribute their movies through the "big six" studios if they want the largest possible audience and the maximum profits on their investments.[2]

[1] Columbia Pictures, a minor studio founded in 1924, is now owned by Sony Pictures, which has emerged as a major studio. See Benjamin M. Compaine and Douglas Gomery, *Who Owns the Media?: Competition and Concentration in the Mass Media Industry,* 3rd ed. (Mahwah, N.J.: Lawrence Erlbaum Associates, 2000), esp. chap. 6.

[2] Compaine and Gomery, *Who Owns the Media?,* 373.

To get a better sense of how this arrangement works today, let's consider how the five Oscar nominees for Best Picture of 2001 were produced and released. Ron Howard's *A Beautiful Mind,* produced by Howard and Brian Grazer and Imagine Entertainment, was released in the United States through DreamWorks SKG and Universal Pictures; Robert Altman's *Gosford Park,* produced by Altman, Bob Balaban, David Levy, and six production companies, was released by USA Films; Baz Luhrmann's *Moulin Rouge!,* produced by Luhrmann, Fred Baron, Martin Brown, and Bazmark Films, was released by Twentieth Century Fox; Todd Field's *In the Bedroom,* produced by Field, Graham Leader, Ross Katz, and three production companies, was released by Miramax; and Peter Jackson's *Lord of the Rings: The Fellowship of the Ring,* produced by Jackson, Barrie M. Osborne, Tim Sanders, and three production companies, was released by New Line Cinema. At work here is a new idea of the Hollywood studio. Each director was also a producer. For three of the five movies (*Gosford Park, In the Bedroom,* and *Lord of the Rings*), more than one production company was involved. And only one of them (*Moulin Rouge!*) was distributed solely by a "big six" studio.

As the following figures show, the American film industry is very healthy.[3] In 2001, Hollywood released 482 films (close to the previous five years' average of 485). Those 482 movies were shown on a total of 36,754 screens across the country and yielded a gross revenue of $8.4 billion, a 9.8 percent increase over 2000. To see these movies, audiences paid an average ticket price of $5.66. At that low average price,

theater admissions hit a record high of 1.49 billion, almost 78 million more than in 2000. (On average, U.S. residents have attended at least five movies per year between 1996 and 2001.) To create these 482 movies, the industry employed 259,000 people in production and related services alone, with another 140,400 people employed in the theaters. The MPPA rated these 482 films as follows: R (67 percent), PG-13 (22 percent), PG (7 percent), G (4 percent), and NC-17/X (0 percent).

THE STUDIO SYSTEM

ORGANIZATION BEFORE 1931

The studio system roots go back to the first decade of the twentieth century and the pioneering attempts of men such as Thomas A. Edison, Carl Laemmle, and D. W. Griffith to make, distribute, and exhibit movies. In 1905 Laemmle began to distribute and exhibit films, but by 1909 his efforts were threatened by the Motion Picture Patents Company (MPPC—not to be confused with the Motion Picture Production Code), a protective trade association (or "trust") controlled by Edison, which sought not only to completely control the motion picture industry but also to eliminate competition by charging licensing fees on production and projection equipment. However, widespread resistance to the MPPC encouraged competition and laid the groundwork for both the studio and independent systems of production. The U.S. government broke the MPPC monopoly in 1915.

Between 1907 and 1913, a large number of movie production companies in New York and New Jersey migrated to various spots in

[3]The statistics were supplied by the Motion Picture Association of America.

warmer climates, including Florida, Texas, and New Mexico, but eventually the main companies settled in Southern California, in and around Hollywood. They did so to take advantage of the year-round good weather, the beautiful and varied scenery, the abundant light for outdoor shooting, and the geographical distance from the greedy MPPC; soon, they had a critical mass of both capital and talent on which to build an industry. By 1915, more than 60 percent of the American film industry, employing approximately fifteen thousand workers, was located in Hollywood.

Before 1931, typical Hollywood studios were dominated by central producers such as Louis B. Mayer at Metro-Goldwyn-Mayer, Adolph Zukor at Paramount, and Harry and Jack Warner at Warner Bros. These men—known as "moguls," a reference to the powerful Arabic Mongol (or Mogul) Muslim conquerors of India—controlled the overall and day-to-day operations of their studios. Executives in New York, generally called the "New York office," controlled the studios financially; various personnel at the studios handled the myriad details of producing films. Central producers, such as Irving Thalberg at MGM, supervised a team of associate supervisors (not yet called producers), each of whom had an area of specialization (sophisticated comedies, westerns, etc.). The associate supervisors handled the day-to-day operations of film production, but the central producer retained total control.

By the late 1920s, the film industry had come to see that the central producer system encouraged quantity over quality and that less-than-stellar movies did not draw audiences into theaters. As a result, the industry sought a new system, one that would value both profits and aesthetic originality.

ORGANIZATION AFTER 1931

In 1931, the film industry adopted the *producer-unit system,* an organizational structure that typically included a general manager, executive manager, production manager, studio manager, and individual production supervisors.[4] Each studio had its own configuration, determined by the New York office. The producer-unit system as it functioned at MGM in the 1930s can serve to illustrate the structure. (Fig. A.1 indicates the basic form and responsibilities of the producer-unit system; note that the titles of these team members are generic, since the actual titles varied with each studio.) The general manager, Irving Thalberg, who had been supervising MGM's production since 1924, continued this work in the new unit. At the time, MGM's annual output was some fifty films. Reporting directly to him was a staff of ten individual-unit production supervisors, each of whom was responsible for roughly six to eight films per year; the actual number varied widely because of the scope and shooting schedules of different productions. Each producer, who usually received screen credit with that title, was able to handle various types of movies. Such flexibility also enabled the general manager to assign these producers according to need, not specialization. This producer-unit management system (and its variations) helped create an industry that favored

[4]The material in this section was drawn from David Bordwell, Janet Staiger, and Kristin Thompson, *The Classical Hollywood Cinema: Film Style and Mode of Production to 1960* (New York: Columbia University Press, 1985), parts 2 and 5; Thomas Schatz, *The Genius of the System: Hollywood Filmmaking in the Studio Era* (1988; reprint, New York: Henry Holt, 1996), parts 2 and 3; and Joel Finler, *The Hollywood Story* (New York: Crown, 1988), part 2.

General Manager
Irving Thalberg
Thalberg supervised the overall production of some fifty films each year; his responsibilities included selecting the property, developing the script (either by himself or in collaboration with writers), selecting the actors and key production people, editing the film, and supervising marketing. Thus, without ever leaving his office to visit the set, he could be intimately involved in every phase of every production at the studio. He generally received screen credit as "Producer."

Executive Manager
Responsible for the studio's financial and legal affairs, as well as daily operations.

Production Manager
Responsible for all pre- and postproduction work; key liaison between the general manager, studio manager, and the individual production supervisors.

Studio Manager
Responsible for the support departments (research, writing, design, casting, cinematography, marketing research, etc.) representing almost three hundred different professions and trades.

Individual Unit
Production Supervisors
Ten men (e.g., Hunt Stromberg and Bernard Hyman), each responsible for the planning and production of the six to eight individual films per year to which they were assigned by the general manager and production manager; often called associate or assistant producers, and sometimes given screen credit as such. Each producer was sufficiently flexible to be able to handle various types of movies.

standardization, within which workers were always striving for the ideal relationship between "cost" and "quality." The system produced movies that had a predictable technical quality, often at the cost of stylistic sameness, or what we call the studio "look"; and it resulted in an overall output that, inevitably, as hundreds of films were produced each year, valued profitability above all else. Yet although it could be stifling, standardization allowed for creative innovation, usually under carefully controlled circumstances. To help ensure such creativity, unit producers received varied assignments.

Let's look at a typical year for two of Thalberg's individual-unit production supervisors, Hunt Stromberg and Bernard Hyman. (During this period, MGM had no female producers.)[5] In 1936, a busy year for MGM, the studio released six movies for which Stromberg received screen credit as producer, including W. S. Van Dyke's *After the Thin Man* (comic murder mystery), William A. Wellman's *Small Town Girl* (romantic comedy), Robert Z. Leonard's *The Great Ziegfeld* (musical biopic), Clarence Brown's *Wife vs. Secretary* (romantic comedy), and W. S. Van Dyke's *Rose-Marie* (musical). Thus Stromberg produced two musicals, two romantic comedies, and the second of four "Thin Man" movies. Bernard Hyman, a Thalberg favorite among the MGM unit producers, produced four films for 1937 release: W. S. Van Dyke's *San Francisco* (a musical melodrama about the 1906 earthquake, starring Clark Gable and Jeanette MacDonald and released in 1936), George Cukor's *Camille* (a romantic melodrama, starring Greta Garbo and Robert Taylor), Clarence Brown's *Conquest* (a romantic historical epic about Napoleon and Countess Marie Walewska, his Polish mistress, starring Greta Garbo and Charles Boyer), and Jack Conway's *Saratoga* (a romantic comedy, starring Clark Gable and Jean Harlow). The first three were lavish productions, while *Saratoga* was a bread-and-butter movie featuring two of MGM's most popular stars. While Hyman regularly produced fewer films each year than Stromberg, both were members of Thalberg's inner group. Reliable if not particularly imaginative (exactly what Thalberg liked in his subordinates), these producers made movies that met MGM's "quality" profile, kept its major stars in the public eye, and satisfied the studio's stockholders. That's what the studio system was all about. Finally, they were forerunners of what today we call a *line* (or *executive*) *producer*, the person responsible for supervising a film production.

The Hollywood studio system established the collaborative mode of production that dominated American filmmaking during its golden age and that, concurrently, influenced the mode of film production worldwide. It also established an industrial model of production through which American filmmaking became one of the most prolific and lucrative enterprises in the world. Furthermore, while its rigidity ultimately led to its demise after some forty years, the system contained within itself the seeds—in the form of the independent producers that would replace it—to sustain American film production until the present day.

ORGANIZATION DURING THE GOLDEN AGE

By the mid-1930s, Hollywood was divided into four kinds of film production companies: majors, minors, "B" studios, and independent producers (Fig. A.2).[6] The five major studios MGM, Paramount, Warner Bros., Twentieth Century Fox, and RKO—were all vertically in-

[5]In late 1932, because of ill health and Mayer's growing dislike of his power, Thalberg took a break, returning in 1933 not as general manager but as a unit producer. The production staff, answerable directly to Mayer, also included David O. Selznick (Mayer's son-in-law) and Walter Wanger, both of whom had left their jobs as central producer at, respectively, RKO and Columbia. And both soon left MGM: Wanger in 1934 to become an independent producer, Selznick in 1935 to found Selznick International Pictures, where he produced a series of major films, successful artistically and commercially, including Victor Fleming's *Gone With the Wind* (1939).

[6]See David A. Cook, *A History of Narrative Film*, 3rd ed. (New York: Norton, 1996), 284–307.

FIG. A.2 — STRUCTURE OF THE STUDIO SYSTEM UNTIL 1950

Major Studios (5), listed in order of relative economic importance	Minor Studios (3)	Most Significant "B" (Poverty Row) Studios (5)	Most Significant Independent Producers (3)
• Paramount • Metro-Goldwyn-Mayer • Warner Bros. • 20th Century Fox • RKO	• Universal Studios • Columbia Pictures • United Artists	• Republic Pictures • Monogram Productions • Grand National Films • Producers Releasing Corporation • Eagle-Lion Films	• Samuel Goldwyn Productions • David O. Selznick Productions • Walt Disney Studios

tegrated companies, meaning they followed a "top-down" hierarchy of control, with the ultimate managerial authority vested in their corporate officers and boards of directors. These were, in turn, responsible to those who financed them: wealthy individuals (e.g., Cornelius Vanderbilt Whitney or Joseph P. Kennedy), financial institutions (e.g., the Chase Manhattan Bank in New York or the Bank of America in California), corporations related to or dependent on the film industry (e.g., RCA), and stockholders (including studio executives and ordinary people who purchased shares on the stock market). Controlling film production through their studios and, equally important, film distribution and exhibition through their ownership of film exchanges and theater chains, they produced "A" pictures, meaning those featured at the top of the double bill (ordinarily, for the price of a single admission, moviegoers enjoyed almost four hours of entertainment: two feature films, plus a cartoon, short subject, and newsreel). The three minor studios—Universal, Columbia, and United Artists—were less similar.

Universal and Columbia owned their own production facilities but no theaters and thus depended on the majors to show their films. By contrast, United Artists—founded in 1919 by Mary Pickford, Charles Chaplin, Douglas Fairbanks, and D. W. Griffith—was considered a "studio" even though it was essentially a distribution company established by these artists to give them greater control over how their movies were distributed and marketed. During the 1930s, however, UA was distributing the work of many other outstanding producers, directors, and actors. While UA declined during the 1940s, it was revived in the 1950s and today is part of MGM. The five "B" studios (sometimes called the "poverty row" studios because of their relatively small budgets) were Republic Pictures, Monogram Productions, Grand National Films, Producers Releasing Corporation, and Eagle-Lion Films. Their films filled in the bottom half of double bills described above. The most important independent producers in the '30s, when independent production was still a relatively unfamiliar idea, were Hollywood titans: Walt

Disney, Samuel Goldwyn, and David O. Selznick. Each producer owned his own studio but released pictures through either his own distribution company, one of the majors, or United Artists. Disney produced his classic animated films, such as *Pinocchio* (1940), at the Walt Disney Studios and released them through his own distribution company, Buena Vista Productions. Goldwyn produced such major pictures as William Wyler's *The Best Years of Our Lives* (1946), which he released through RKO. In 1936, Selznick left MGM to establish Selznick International Pictures. In 1940, three of his films—Victor Fleming's *Gone With the Wind* (1939), Alfred Hitchcock's *Rebecca* (1940), and Gregory Ratoff's *Intermezzo* (1939)—together earned some $10 million in net profits, more than all the films of any of the majors, each of which produced roughly fifty-two films that year. Although he released his films through the major studios, including MGM, Selznick's prestige pictures and remarkable profits established the independent producer as a dominant force in Hollywood for the next sixty years and beyond.

The producer's primary job is to guide the entire process of making the movie from its initial planning to its release. Thus the producer is responsible for the organizational and financial aspects of the production, from arranging the financing to deciding how the money is spent. Dominated by producers, the studio system depended on contract directors, who were under studio contract to direct a specific number of films in each contract period. While some—Alfred Hitchcock, John Ford, and Vincente Minnelli, for example—could be involved from the beginning and participated actively throughout every production, most were expected to receive a script one day and begin filming shortly thereafter. They were seasoned professionals capable of working quickly and were conversant enough with various genres to be able to handle almost any assignment.

The career of Edmund Goulding, who directed thirty-eight movies, exemplifies very clearly the work of a contract director. After starting in silent films in 1925 and directing several films at Paramount Pictures, he made an auspicious start as a director at MGM with *Grand Hotel* (1932), an all-star blockbuster. It was followed by *Blondie of the Follies* (1932), a comedy featuring Marion Davies; the melodrama *Riptide* (1934), starring Norma Shearer; and *The Flame Within* (1935), a melodrama. From MGM he moved to Warner Bros., where as a contract director he made *That Certain Woman* (1937), *Dark Victory* (1939), and *The Old Maid* (1939), all starring Bette Davis; *The Dawn Patrol* (1938), a World War I action film; *'Til We Meet Again* (1940), a wartime romance; and *The Constant Nymph* (1943), a romantic drama. After World War II, Goulding moved to Twentieth Century Fox, where the declining quality of the movies he was assigned truly reflects the challenges facing a contract director. Starting with *The Razor's Edge* (1946), a quasi-philosophical movie nominated for an Oscar as Best Picture of 1946, and *Nightmare Alley* (1947), a melodramatic film noir, he went on to direct *We're Not Married* (1952), an episodic comedy featuring Marilyn Monroe; *Teenage Rebel* (1956), a drama; and, for his last film, *Mardi Gras* (1958), a teenage musical starring Pat Boone. Goulding made the most of the challenges inherent in such variety. He was also popular with actors and noted for his screenwriting, which accounts for some of the gaps between pictures (most contract directors were expected to make three or four movies per year). He did not have a distinctive style and was never nominated for an Oscar.

The actual, physical studios (called "dream factories" by anthropologist Hortense Powdermaker[7]) were complex operations. If you were fortunate enough to get through a studio's protected gates, you would find yourself in a vast, industrial complex. For example, MGM, the largest studio, covered 117 acres, over which ten miles of paved streets linked 137 buildings. There were twenty-nine sound stages—huge air-conditioned and soundproofed production facilities, the largest of which had a floor area of nearly one acre. The studio was a self-contained community with its own police and fire services, hospital, film library, school for child actors, railway siding, industrial section capable of manufacturing anything that might be needed for making a movie, and vast back lot containing sets representing every possible period and architecture. In the average year, MGM produced fifty full-length feature pictures and one hundred shorts. Depending on the level of production, the workforce consisted of four thousand to five thousand people.

LABOR, LABOR UNIONS, AND THE DIVISION OF LABOR. Before the industry was centralized in Hollywood, movie production was marked by conflicts between management and labor. Strikes led to the formation of guilds and unions, which led to the division of labor; that, as much as anything, led a hodgepodge of relatively small studios to prosper and grow into one of the world's largest industries. In 1926, the major studios and unions stabilized their relations through the landmark Studio Basic Agreement, which provided the foundation for future collective bargaining in the industry.

[7]See Hortense Powdermaker, *Hollywood, the Dream Factory: An Anthropologist Looks at the Movie-Makers* (Boston: Little, Brown, 1950).

Workers in the industry formed labor unions for the standard reasons—they sought worker representation, equity in pay and working conditions, safety standards, and job security. In addition, because of the uniquely collaborative nature of their jobs, they needed a system that guaranteed public recognition of their efforts. Contracts between the labor unions and the studios covered the workers' inclusion in screen credits. Executive managers often had similar contracts.

In any manufacturing enterprise, "division of labor" refers to breaking down each step in that process so that each worker or group of workers can be assigned to and responsible for a specialized task. Although this system was designed to increase efficiency in producing steel, cars, and the like, it was applied very successfully in the film industry. Indeed, Hollywood has often been compared to Detroit. Both of these major industrial centers were engaged in the mass production of commodities. Detroit's output was more standardized, though the automobiles that roll off the assembly line are differentiated by manufacturer and model. Each studio specialized in certain kinds of films in its own distinctive style (e.g., MGM excelled in musicals and Warner Bros. in films of social realism); but unlike the Detroit product, each film was a unique creative accomplishment, even if it fit predictably within a particular genre such as film noir. For the most part, each studio had its own creative personnel under contract, though studios frequently borrowed talent from each other on a picture-by-picture basis. Once a studio's executive management—board of directors, chairman, president, and production moguls—determined what kinds of films would most appeal to its known share of the audience, the studio's general manager (here, titles varied among studios) developed projects and se-

lected scripts and creative personnel consistent with that choice.

In Hollywood, preproduction, production, and postproduction are carried out by two major forces: management and labor. Management selects the property, develops the script, chooses the actors, and assigns the key production people, but the actual work of making the film is the responsibility of labor (the artists, craftspeople, and technicians belonging to labor unions). Members of management receive the highest salaries; the salaries of labor depend on the kind and level of skills necessary for each job. Such a division of labor across the broad, collaborative nature of creating a film shapes the unavoidable interaction between the work rules set by union contracts and the standards set by professional organizations.

PROFESSIONAL ORGANIZATIONS AND STANDARDIZATION. Beyond the labor unions, other organizations are devoted to the workers in the motion picture industry. These include the American Society of Cinematographers (ASC, founded in 1916), the Society of Motion Picture and Television Engineers (SMPTE, 1918), and the Association of Cinema Editors (ACE, 1950), which set and maintain standards in their respective professions. They engage in the activities of a traditional professional organization: conducting research related to equipment and production procedures, standardizing that equipment and those procedures, meeting, publishing, consulting with manufacturers in the development of new technologies, promulgating of professional codes of conduct, and recognizing outstanding achievement with awards. Although they do not represent their membership in collective bargaining as do labor unions, they voice opinions on matters relevant to the workplace.

In 1927, the industry established the Academy of Motion Picture Arts and Sciences (AMPAS), which seeks, among its stated objectives, to improve the artistic quality of films, provide a common forum for the various branches and crafts of the industry, and encourage cooperation in technical research. Since ancient times, an academy has been defined as a society of learned persons organized to advance science, art, literature, music, or some other cultural or intellectual area of endeavor. While profits, not artistic merit, are the basic measure of success in the movie industry, using the word *academy* to describe the activities of this new organization suited early moviemakers' strong need for social acceptance and respectability. A masterful stroke of public relations, the Academy is privately funded from within the industry and is perhaps best known to the public for its annual presentation of the Academy Awards, or Oscars. Membership in the Academy is by invitation only. Now numbering around five thousand, members fall into thirteen categories: actors, administrators, art directors, cinematographers, directors, executives, film editors, composers, producers, public relations people, short-subject filmmakers, sound technicians, and writers. Members in each category make the Oscar nominations and vote to determine the winners, whose careers are inevitably furthered by their receiving the most prestigious awards in the industry.

DECLINE OF THE STUDIO SYSTEM

Fostered by aggressive competition and free trade, the studio system grew to maturity in the 1930s, reached a pinnacle of artistic achievement and industrial productivity in the 1940s, and then went into decline at the

beginning of the 1950s. We can see this trajectory clearly by looking at the actual number of films produced and released by American studios during the period in which the studio system began its decline (1936 to 1951; Fig. A.3). The average number of films annually produced and released in the United States between 1936 and 1940 was 495; between 1941 and 1945, the war years, that number fell to 426; in the immediate postwar period, 1946–50, it fell again, to 370. In 1951, the total number of U.S. films was 391, the highest it would be until 1990, when 440 films were released. In looking at these data, we must remember that the total film releases in any one year usually reflect two kinds of productions: those begun in that year and those earlier. In any case, one thing is clear: total Hollywood production between 1936 and 1951 fell by 25 percent.

By the mid-1930s, in fact, the system had reached a turning point, as a result of three intertwined factors. First, the studios were victims of their own success. The two most creative production heads—Darryl F. Zanuck, who dominated production at Twentieth Century Fox from 1933 until 1956, and Irving Thalberg, who supervised production at MGM from 1923 until his death, in 1936—had built such highly efficient operations that their studios could function exceptionally well, both stylistically and financially, without the sort of micromanaging that characterized David O. Selznick's style at Selznick International Pictures. In a very real sense, these central producers and others had made themselves almost superfluous. Second, several actions taken by the federal government signaled that the studios' old ways of doing business would have to change. President Franklin D. Roosevelt's plan for the economic revitalization of key industries—the 1933 National Industrial Recovery Act (NIRA)—had a major impact on Hollywood. On one hand, it sustained certain practices that enabled the studios to control the marketing and distribution of films to their own advantage; on the other, it fostered the growth of the labor unions, perenially unpopular with the studio heads, by mandating more thoroughgoing division of labor and job specialization than Hollywood had yet experienced. However, in 1938, the federal government began trying to break the vertical structure of the major studios—to separate their interlocking ownership of production, distribution, and exhibition—an effort that finally succeeded in 1948. Third, the studios began

FIG. A.3	FEATURE FILMS PRODUCED AND RELEASED IN THE UNITED STATES (1936–51)

Year	Total
1936	522
1937	538
1938	455
1939	483
1940	477
1941	492
1942	488
1943	397
1944	401
1945	350
1946	378
1947	369
1948	366
1949	356
1950	383
1951	391

Source: Joel Finler, *The Hollywood Story* (New York: Crown, 1988) 280.
Note: These figures do not include foreign films released in the U.S.

to reorganize their management into the producer-unit system. Each studio had its own variation on this general model, each with its own strengths and weaknesses. While the resulting competition among the units increased the overall quality of Hollywood movies, the rise of the unit producer served as a transition between the dying studio system and the emergence of the independent producer.

Three additional factors further undercut the studio system. The first was a shift in the relations between top management and creative personnel that loosened the studios' hold on the system. From the mid-1930s on, actors, directors, and producers sought better individual contracts with the studios—contracts that would give them and their agents higher salaries and more control over scripts, casting, production schedules, and working conditions. For example, in the early 1950s, actor Jimmy Stewart had an agreement whereby he would waive his usual salary for appearing in a film (then $200,000 per picture) in exchange for 50 percent of the net profits. Equally significant, these profits would extend through the economic life of the film, whether it was shown on a theater screen, broadcast on television, or distributed via other formats. Second was World War II, which severely restricted the studios' regular, for-profit operations (they were also making movies that supported government initiatives, such as films instructing people how to cope with food rationing or encouraging them to buy war bonds). As we noted above, production of feature films fell precipitously during the war. Because many studio employees (management and labor alike) were in the armed services and film stock was being rationed to ensure the supply needed by armed services photographers, there were fewer people and materials to make films. Thus even though audiences went to the movies in record numbers, fewer films were available for them to see. Third was the rise of television, to which Hollywood reacted slowly. When the federal government made the studios divest themselves of their theater holdings, it also blocked their plans to replicate this dual ownership of production and distribution facilities by purchasing television stations. At first, the majors were not interested in television production, leaving it to the minors and to such pioneering independents as Desilu Productions (Desi Arnaz and Lucille Ball, producers). By 1955, though, the majors were reorganizing and retooling what remained of their studios to begin producing films for television. Some efforts were more successful than others, but even more profitable was the sale both of their real estate—on which the studios were built—for development and of the valuable films in their vaults for television broadcasting. Universal Studios had the best of both worlds, continuing to use part of its vast property at the head of the San Fernando Valley for film and television production and devoting the rest to Universal City, a lucrative theme park devoted to showing how movies are made.

THE INDEPENDENT SYSTEM

Through the 1930s and 1940s, the independent system of production (sometimes called the *package-unit system*) coexisted with the studio system; since the studio system's collapse, the independents have dominated production. The package-unit system, controlled by a producer unaffiliated with a studio (and thus a so-called independent), is a personal-

ized concept of film production that differs significantly from the industrial model of the studio system. Based outside the studios but heavily dependent on them for human and technical resources, the package-unit system governs the creation, distribution, and exhibition of a movie (known as the "package"). The independent producer does what a movie producer has always done: chooses the right stories, directors, and actors to produce quality films.

Depending on the size of the production and the nature of his or her interests and experiences, the producer may also have creative responsibilities as well, ranging from developing the property, revising the screenplay, assembling the key members of the production team, supervising the actual production (including the editing), and marketing and distributing the finished product. Consider the career of Sam Spiegel, one of the most successful independent producers; his movies included John Huston's *The African Queen* (1951), Elia Kazan's *On the Waterfront* (1954), David Lean's *The Bridge on the River Kwai* (1957) and *Lawrence of Arabia* (1962), Joseph L. Mankiewicz's *Suddenly, Last Summer* (1959), and Elia Kazan's *The Last Tycoon* (1976), inspired by the life of his fellow producer Irving Thalberg. Spiegel would have agreed with the successful Hollywood producer who said, "Since I control the money, I control the process."[8] While that attitude may seem arrogant, it makes excellent business sense to a producer responsible for films like Spiegel's—characterized by high costs, high artistic caliber, and high profits.

[8]Robert Simonds, qtd. in Bernard Weinraub, "What Makes Boys Laugh: A Philosophy Major Finds the Golden Touch," *New York Times,* 23 July 1998, sec. E, p. 5.

The producer's team may include an *executive producer*, a *line producer, associate or assistant producers,* and a *production manager.* These variations on the overall title of producer reflect the changes that have occurred since the studio system collapsed and, in different ways, reinvented itself. By the nature of film production, titles must be flexible enough to indicate greater or fewer responsibilities than those listed here. Unlike the members of craft unions—cinematographers or editors, for example—whose obligations are clearly defined by collective bargaining agreements, producers tend to create responsibilities for themselves that match their individual strengths and experiences.

At the same time, the comparative freedom of independent filmmaking brings new benefits. Creative innovation is both encouraged and rewarded; actors, writers, and directors determine for themselves not only the amounts of but also the ways in which they receive their compensation; and though the overall number of movies produced each year has decreased, the individuality and quality of independently produced films have increased. While the producer helps transform an idea into a finished motion picture, the director visualizes the script and guides all members of the production team, as well as the actors, in bringing that vision to the screen. The director sets and maintains the defining visual quality of the film, including the settings, costumes, action, and lighting—those elements that produce the total visual impact of the movie's image, its look and feel. When a film earns a profit or wins an Oscar as Best Picture, the producer will take a large share of the credit and accept the award (true under the studio system also). But the director usually bears the artistic responsibility for the success or failure of a movie. When a film loses money, the di-

rector often is saddled with the major share of the blame. Because creativity at this high level resists rigid categorization, we cannot always neatly separate the responsibilities of the producer and the director. Sometimes, one person bears both titles; at other times, the director or the screenwriter may have initiated the project and later joined forces with the producer to bring it to the screen. But whatever the arrangement, both the producer and the director are involved completely in all three stages of production.

A quick snapshot of a few differences between the studio and independent systems will give you an idea of how moviemaking has changed. At first, each studio's facilities and personnel were permanent and capable of producing any kind of picture; and the studio owned its own theaters, guaranteeing a market for its product. Now, by contrast, an independent producer makes one film at a time, relying on rented facilities and equipment and a creative staff assembled for that one film; and—even figuring for rising costs and inflation—the costs are staggering. Note that there are various kinds of "cost" in moviemaking. In both the "old" and "new" American film industry, the total cost of a film is what it takes to complete the postproduction work and produce the *release negative,* and usually one or two positive prints as well for advance screening purposes (on types of prints, see "Editing and Postproduction" in chapter 6). But this "total cost" does not include the cost of marketing or additional prints for distribution, so it is useful only for the special purposes of industry accounting practices. You will generally see this figure referred to as the *negative cost* of a movie, where "negative" refers to the costs of producing the release negative.

In the studio system, Orson Welles made *Citizen Kane* (1941) at RKO in four and a half months and completed postproduction in another three months; the cost of the release negative was $840,000 (approximately $10.1 million in 2002 dollars). In 2002, the production stage of a feature film took at least one year, with the release negative costing an *average* of $55 million. However, the average marketing costs per movie are now $30 million, a figure that brings the total cost of the release negative to approximately $85 million. (Unlike expenses calculated today, the costs of the release negative of *Citizen Kane* included marketing and distribution, elements that were then simpler and less costly.) James Cameron's *Titanic* (1997) cost $200 million, making it the most expensive movie produced to that time, and Steven Spielberg's *Saving Private Ryan* (1998) cost $65 million, a relatively low figure for such an epic film. The use of the most advanced special effects raised the costs of the Cameron film, while costs remained low on the Spielberg film because both its director and major star, Tom Hanks, received only minimal fees up front rather than their usual large salaries. According to a clause in their contracts, each man was guaranteed 17.5 percent of the studio's first-dollar gross profit, meaning that thirty-five cents of every dollar earned on the film went to Spielberg and Hanks. A similar arrangement applied to Spielberg's *Minority Report* (2002), which reportedly cost more than $100 million to make. With this movie, Spielberg and his star Tom Cruise also stand to make up to 17.5 percent of every dollar earned; thus, it is estimated that each man could earn $70 million once the revenues from all ticket receipts, DVD and video sales, promotional products, and sales of movie rights are computed. As in any other industry, costs and revenues are controlled by supply and demand. As costs increase for making the kind of blockbuster

films that return sizable revenues, producers make fewer films, forcing people who work in the industry to become financially creative in negotiating the contracts that preserve their jobs.

FINANCING IN THE INDUSTRY

The pattern for financing the production of motion pictures, much like the establishment of labor practices, developed in the industry's early years. Within the two decades after the invention of the movies, there were two major shifts: first from individual owners of small production companies (e.g., Edison and Griffith) to medium-sized firms, and then to the large corporations that not only sold stock but also relied heavily on the infusion of major amounts of capital from the investment community. While investors have always considered producing films to be a risky business, the motion picture industry recognized that efficient management, timely production practices, and profitable results created the best formula for attracting the capital necessary to sustain it. As Hollywood grew, its production practices became more and more standardized.

From the beginning, however, the vertical organizational structure of the studios was challenged by independent producers. Thus while the studios dominated the distribution and exhibition of films (at least until 1948, when the federal government broke that monopoly), the independents still had access to many movie theaters and could compete successfully for the outside financing they required. The early success of independent producers—such as David O. Selznick in gaining the financing for such major undertakings as *Gone With the Wind* (1939)—demonstrates not only their individual strengths but also the vi-

ability and possible profitability of their alternative approach to the studio system.

No rule governs the arranging of financing—money may come from the studio, the producer, the investment community, or (most probably) a combination of these—just as no one timetable exists for securing it. By studying the production credits of films, you can see just how many organizations may back a project. For example, Figure A.4 lists, as they appear, the opening credits of Bill Condon's *Gods and Monsters* (1998). Universal Studios released the film, which involved the financial as well as creative input of six entities: Lions Gate Films, Showtime, Flashpoint, BBC Films, Regent Entertainment, and Gregg Fienberg. Separate title screens identify two line producers, three coexecutive producers, two executive producers, and two more executive producers; finally, a "Produced By" screen credit lists three more names. Each person receiving credit as a producer was affiliated with one of the six entities listed at the beginning of the film and may also have had some creative responsibility.

Some producers will have enough start-up financing to ensure that the preproduction phase can proceed with key people on the payroll; others will not be able to secure the necessary funds until they present investors with a detailed account of anticipated audiences and projected profits. Whether a movie is produced independently (in which case it is usually established as an independent corporation) or by one of the studios (in which case it is a distinct project among many), financial and logistical control is essential to making progress and ultimately completing the actual work of production as well as to holding down costs. Initial budgets are subject to constant modification, so budgeting, accounting, and auditing are as important as

UNIVERSAL
[Title superimposed over company logo]

LIONS GATE FILMS
SHOWTIME and FLASHPOINT
in association with
BBC FILMS
Present

A
REGENT ENTERTAINMENT
PRODUCTION

in association with
GREGG FIENBERG

A
BILL CONDON
FILM

Next, separate titles list the principal members of the cast, film title, and major members of the production crew.

LINE PRODUCERS
JOHN SCHOUWEILER
&
LISA LEVY

CO-EXECUTIVE PRODUCERS
VALERIE MASSALAS
SAM IRVIN
SPENCER PROFFER

EXECUTIVE PRODUCERS
CLIVE BARKER
AND
STEPHEN P. JARCHOW

EXECUTIVE PRODUCERS
DAVID FORREST
BEAU ROGERS

PRODUCED BY
PAUL COLICHMAN
GREGG FIENBERG
MARC R. HARRIS

SUMMARY BUDGET FOR *CASABLANCA*

	Subtotals	Totals	Grand Totals
DIRECT COSTS			**$638,220.00**
Story		$67,281.00	
Story	$20,000.00		
Continuity and treatment (writers, secretaries, and script changes)	$47,281.00		
Direction		$83,237.00	
Director: Michael Curtiz	$73,400.00		
Assistant Director: Lee Katz	$9,837.00		
Producer: Hal Wallis		$52,000.00	
Cinematography		$11,273.00	
Camera operators and assistants	$10,873.00		
Camera rental and expenses	$400.00		
Cast		$217,603.00	
Cast salaries: talent under contract to studio, including Humphrey Bogart, Sydney Greenstreet, Paul Henreid, and others	$69,867.00		
Cast salaries: outside talent, including Ingrid Bergman, Claude Rains, Dooley Wilson, Peter Lorre, and others	$91,717.00		
Talent (extras, bits, etc.)	$56,019.00		
Musicians (musical score, arrangers, etc.)		$28,000.00	
Sound expenses		$2,200.00	
Sound operating salaries		$8,000.00	
Art department		$8,846.00	
Wardrobe expenses		$22,320.00	
Makeup, hairdressers, etc.		$9,100.00	
Electricians		$20,755.00	
Editor's salaries		$4,630.00	
Special effects		$7,475.00	
Negative film stock		$8,000.00	

	Subtotals	Totals	Grand Totals
Developing and printing		$10,500.00	
Property labor		$10,150.00	
Construction of sets		$18,000.00	
Stand-by labor		$15,350.00	
Striking (dismantling sets and storing props)		$7,000.00	
Property rental and expenses		$6,300.00	
Electrical rental and expenses		$750.00	
Location expenses		$1,252.00	
Catering		$1,200.00	
Auto rental expenses and travel		$5,000.00	
Insurance		$2,800.00	
Miscellaneous expenses		$3,350.00	
Trailer (preview)		$2,000.00	
Stills		$850.00	
Publicity		$3,000.00	
INDIRECT COSTS			**$239,778.00**
General studio overhead (35%)		$223,822.00	
Depreciation (2½%)		$15,956.00	
GRAND TOTAL COST (*Release Negative*)			**$878,000.00**
Source: Adapted from Joel Finler, *The Hollywood Story*, 39.			

they would be in any high-expense industrial undertaking.

In the old studio system, the general manager, in consultation with the director and key members of the production team, determined the budget for a film, which consisted of two basic categories: *direct costs* and *indirect costs.* Direct costs included everything from art direction and cinematography to insurance. Indirect costs, usually 20 percent of the direct costs, covered the studio's overall contribution to "overhead" (such items as making release prints from the negative, marketing, advertising, and distribution). Figure A.5 shows the summary budget for Michael Curtiz's *Casablanca* (1942), including a line-item accounting for each major expense. Direct costs were 73 percent of the total budget.

Today, in the independent system, budgeting is done somewhat differently. The producer

or a member of the producer's team prepares the budget with the assistant director. The total cost of producing the completed movie generally breaks down into a 30 percent to 70 percent ratio between *above-the-line costs* (the costs of the preproduction stage, producer, director, cast, screenwriter, and literary property from which the script was developed) and *below-the-line costs* (the costs of the production and postproduction stages and the crew).[9] Categorizing costs according to where they are incurred in the three stages of production is a change from the studio system method. Costs also vary depending on whether union or nonunion labor is being used. In some cases, producers have little flexibility in this regard, but usually their hiring of personnel is open to negotiation within industry standards. Finally, we must always remember that no matter what approach is taken to making movies, movie industry accounting practices traditionally have been as creative as, if not more creative than, the movies themselves.

MARKETING AND DISTRIBUTION

After screening a movie's answer print for executives of the production company, as well as for family, friends, and advisors, the producer may show it to audiences at previews. Members of preview audiences are invited because they represent the demographics of the audience for which the film is intended (e.g., teenagers). After the screening, viewers are asked to complete detailed questionnaires to gauge their reactions. At the same time, the producer may also have chosen a smaller "focus group" from this audience (boys or girls) and will meet with them personally after the screening to get their reactions firsthand. After analyzing both the questionnaires and the responses of the focus group, the person in charge of the final cut—either the producer or the director—may make changes in the film. While this procedure is presumably more "scientific" than that employed in previous years by the studios, it reflects the same belief in designing a film by the numbers. Since *most* major movies are intended as entertainment for the largest, broadest audience possible, the strategy makes business sense. Films intended to appeal to smaller, more homogeneous audiences must attract them through publicity generated by media coverage, festival screenings and awards, and audience word of mouth.

The mode of production determines how the activities in this final phase of postproduction are accomplished. Under the studio system, in the days of vertical integration, each studio or its parent company controlled production, distribution, and exhibition. Independent producers, however, have never followed any single path in distributing films. A small producer without a distribution network has various options, which include renting the film to a studio (such as Paramount) or to a producing organization (such as United Artists or Miramax) that will distribute it. These larger firms can also arrange for the film to be advertised and exhibited. As noted earlier, the average cost of marketing a film today is $31 million.

Deciding how and where to advertise, distribute, and show a film is, like the filmmaking process itself, the work of professionals. During the final weeks of postproduction, the people responsible for promotion and market-

[9]An excellent source of information on current budgeting practices is Deke Simon and Michael Wiese, *Film and Video Budgets,* 3rd ed. (Studio City, Calif.: Michael Wiese Productions, 2001).

FIG. A.6 — VOLUNTARY MOVIE RATING SYSTEM

Rating Category	Explanation
G: General Audiences	All ages admitted.
PG: Parental Guidance Suggested	Some material may not be suitable for children.
PG-13: Parents Strongly Cautioned	Some material may be inappropriate for children under 13.
R: Restricted	Under 17 requires accompanying parent or adult guardian.
NC-17: No Children under 17 Admitted	No one 17 and under admitted.

Source: © Motion Picture Association of America, 1990.

ing make a number of weighty decisions. They determine the release date (essential for planning and carrying out the advertising and other publicity necessary to build an audience) and the number of screens on which the film will make its debut (necessary so that a corresponding number of release prints can be made and shipped to movie theaters). At the same time, they finalize domestic and foreign distribution rights and ancillary rights, contract with firms who make videotapes and DVDs, schedule screenings on airlines and cruise ships, and, for certain kinds of films, arrange marketing tie-ins with fast-food chains, toy manufacturers, and so on. Some or all of this activity is responsive to the voluntary movie-rating system administered by the Motion Picture Association of America, the trade association of the industry (Fig. A.6). Since the rating determines the potential size of a film's audience, it is very important. The release of Stanley Kubrick's last film, *Eyes Wide Shut* (1999), provides an excellent example of how a studio might try to influence the rating decision. Featuring top box-office stars

Tom Cruise and Nicole Kidman, *Eyes Wide Shut* is a complex movie about sexual realities and fantasies—not for everyone, and certainly not for younger viewers. Because Kubrick died just after preparing a cut of the film, we do not know whether the released version represents his complete vision for it. We know that Warner Bros. digitally obscured an orgy scene to avoid an NC-17 rating (no children under seventeen admitted), and some have suggested that the studio also tried to remove other material that might have proved offensive and thus harmful to the box office. *Eyes Wide Shut* was eventually rated R (for strong sexual content, nudity, language, and some drug-related material); after opening strong, it proved a financial disappointment.

Once initial marketing and distribution decisions have been made, all that remains is to show the film to the public, analyze the reviews in the media and the box-office receipts of the first weekend, and make whatever changes are necessary in the distribution, advertising, and exhibition strategies to ensure that the movie will reach its targeted audience.

FOR FURTHER READING AND VIEWING

You can learn more about moviemaking, especially about the long hours and hard work that go into production, from the following movies, which are about making movies or are set within the film industry: F. Richard Jones's *Extra Girl* (1923); King Vidor's *Show People* (1928); George Cukor's *What Price Hollywood?* (1932); William Wellman's version of *A Star Is Born* (1937); Nicholas Ray's *In a Lonely Place* (1950); Billy Wilder's *Sunset Blvd.* (1950); Vincente Minnelli's *The Bad and the Beautiful* (1952) and *Two Weeks in Another Town* (1962); Gene Kelly and Stanley Donen's *Singin' in the Rain* (1952); Stuart Heisler's *The Star* (1952); George Cukor's version of *A Star Is Born* (1954);[10] Robert Aldrich's *The Big Knife* (1955), *The Legend of Lylah Clare* (1968), and *What Ever Happened to Baby Jane?* (1962), the last of these remade by David Greene (1991); George Sidney's *Jeanne Eagels* (1957); John Cromwell's *The Goddess* (1958); Federico Fellini's *8½* (1963); Jean-Luc Godard's *Contempt* (*Le mépris,* 1963); Robert Mulligan's *Inside Daisy Clover* (1965); François Truffaut's *Day for Night* (*La nuit américaine,* 1973); John Schlesinger's *The Day of the Locust* (1975); Elia Kazan's *The Last Tycoon* (1976); Frank Perry's *Mommie Dearest* (1981); Graeme Clifford's *Frances* (1982); Robert Altman's *The Player* (1992); Tim Burton's *Ed Wood* (1994); Tom DiCillo's *Living in Oblivion* (1995); Bill Condon's *Gods and Monsters* (1998); David Mamet's *State and Main* (2000); and Steven Soderbergh's *Full Frontal* (2002).

Abramovitz, Rachel. *Is That a Gun in Your Pocket?: Women's Experience of Power in Hollywood.* New York: Random House, 2000.

Acker, Ally. *Reel Women: Pioneers of the Cinema, 1896 to the Present.* New York: Continuum, 1991.

Balio, Tino, ed. *The American Film Industry.* Madison: University of Wisconsin Press, 1985.

———. *United Artists: The Company Built by the Stars.* Madison: University of Wisconsin Press, 1976.

Basinger, Jeanine. *The "It's a Wonderful Life" Book.* New York: Knopf, 1986.

Beauchamp, Cari. *Without Lying Down: Frances Marion and the Powerful Women of Early Hollywood.* New York: Scribner, 1997.

Behlmer, Rudy, and Tony Thomas. *Hollywood's Hollywood: The Movies about the Movies.* Secaucus, N.J.: Citadel Press, 1975.

Bernstein, Matthew. *Walter Wanger: Hollywood Independent.* Berkeley: University of California Press, 1994.

Bouzereau, Laurent, and Jody Duncan. *Star Wars: The Making of Episode I, "The Phantom Menace."* London: Ebury Press, 1999.

Brodbeck, Emil E. *Handbook of Basic Motion Picture Techniques.* Philadelphia: Chilton Books, 1966.

Clark, Barbara, and Susan Spohr. *Guide to Production for TV and Film: Managing the Process.* Boston: Focal Press, 1998.

Custen, George F. *Twentieth Century's Fox: Darryl F. Zanuck and the Culture of Hollywood.* New York: Basic Books, 1997.

Davis, Ronald. *The Glamour Factory: Inside Hollywood's Big Studio System.* Dallas: Southern Methodist University Press, 1993.

Goldner, Orville, and George E. Turner. *The Making of "King Kong": The Story behind a Film Classic.* 1975. Reprint, New York: Ballantine Books, 1976.

Gomery, Douglas. *The Hollywood Studio System.* New York: St. Martin's Press, 1986.

Harmetz, Aljean. *The Making of "The Wizard of Oz": Movie Studio and Studio Power in the Prime of MGM—and the Miracle of Production #1060.* 1977. Reprint, New York: Limelight Editions, 1984.

———. *On the Road to Tara: The Making of "Gone With the Wind."* New York: Abrams, 1996.

———. *Round Up the Usual Suspects: The Making of "Casablanca," Bogart, Bergman, and World War II.* New York: Hyperion, 1992.

[10]A third version (Frand Pierson, 1976) sets the story in the world of rock music.

Kawin, Bruce F. *How Movies Work.* 1987. Reprint, Berkeley: University of California Press, 1992.

Kinden, Gorham, ed. *The American Movie Industry: The Business of Motion Pictures.* Carbondale: Southern Illinois University Press, 1982.

Lumet, Sidney. *Making Movies.* 1995. Reprint, New York: Vintage Books, 1996.

McClelland, Doug. *Down the Yellow Brick Road: The Making of "The Wizard of Oz."* New York: Pyramid Books, 1976.

Mordden, Ethan. *The Hollywood Studios: House Style in the Golden Age of the Movies.* New York: Knopf, 1988.

Rilla, Wolf Peter. *A–Z of Movie Making.* New York: Viking Press, 1970.

Ross, Clark. *Stars and Strikes: Unionization of Hollywood.* New York: Columbia University Press, 1941.

Salt, Barry. *Film Style and Technology: History and Analysis.* London: Starword, 1983.

Spottiswode, Raymond, et al. *The Focal Encyclopedia of Film and Television Techniques.* London: Focal Press, 1969.

von Sternberg, Josef. *Fun in a Chinese Laundry.* New York: Macmillan, 1965.

Glossary

Words set **boldface** within definitions are also defined in the glossary.

Aerial view: also known as *bird's-eye view;* an **omniscient-point-of-view shot** that is taken from an aircraft or extremely high crane and implies the observer's omniscience.

Alienation effect: also known as *distancing effect;* a psychological distance between audience and stage that, according to German playwright Bertolt Brecht, every aspect of a theatrical production should strive for by limiting the audience's identification with **characters** and events.

Ambient sound: sound that emanates from the ambience (or background) of the setting or environment being filmed, either recorded during **production** or added during **postproduction.** While it may incorporate other types of film sound—**dialogue, narration, sound effects, Foley sounds,** and music—it does not include any unintentionally recorded noise made during production.

Amplitude: the degree of motion of air (or other medium) within a sound wave. The greater the amplitude of the sound wave, the harder it strikes the eardrum, and thus the louder the sound.

Analog format: one of the two ways of storing recorded sound, either monaurally or stereophonically (the other is the **digital format**). This format involves an analogous (or 1:1) relationship between the sound wave and its storage; in other words, the recorded sound wave is a copy of the original wave.

Animated films: also known as *cartoons;* drawings or other graphic images placed in a **series photography**–like sequence to portray movement. Before computer-graphics technology, the basic type of animated film was created through drawing.

Answer print: the first combined print, incorporating picture, sound, and special effects, from which the editor determines whether further changes are needed before creating the **final print.**

Antagonist: the **major character** whose values or behavior are in conflict with those of the **protagonist.**

Antirealism: a treatment that is against or the opposite of **realism.** However, realism and antirealism (like realism and **fantasy**) are not strictly opposed polarities.

Aperture: the camera opening that defines the area of each frame of film exposed.

Apparent motion: the movie projector's tricking

us into perceiving separate images as one continuous image rather than a series of jerky movements; the result of such factors as the **phi phenomenon** and **critical flicker fusion.**

Aspect ratio: the relationship between the frame's two dimensions: the width of the image to its height.

Assembly edit: a preliminary edited version of a movie, in which selected sequences and shots are arranged in approximate relationship without further regard to rhythm or other conventions of editing.

Asynchronous sound: sound that comes from a source apparent in the image but is not precisely matched temporally with the actions occurring in it.

Automatic Dialogue Replacement: designated ADR; **rerecording** done via computer, a faster, less expensive, and more technically sophisticated process than via actors.

Automatic splicer: a later, even more efficient version of the **splicer.**

Backlight: lighting, usually positioned behind and in line with the subject and the camera, used to create highlights on the subject as a means of separating it from the background and increasing its appearance of three-dimensionality.

Balance: see **unity and balance.**

Best boy: first assistant electrician to the **gaffer** on a movie **production** set.

Bidirectional microphones: sound-recording equipment that responds to sounds coming from the front and back but not the sides.

Bit players: actors who hold small speaking parts.

Black Maria: the first movie studio—a crude, hot, cramped shack in which Thomas A. Edison and his staff began making movies.

Blimp: a soundproofed enclosure somewhat larger than a camera, in which the camera may be mounted to prevent its sounds from reaching the microphone.

Blocking: actual physical relationships among **figures** and **settings.**

Boom: a polelike mechanical device for holding the microphone in the air, out of camera range, and moveable in almost any direction.

Call sheets: detailed daily records that indicate what is being shot each day and inform cast and crew members of their assignments.

Cameos: small but significant roles often taken by famous actors.

Camera obscura (dark chamber): a box (or a room in which a viewer stands); light entering through a tiny hole (later a lens) on one side of the box (or room) projects an image from the outside onto the opposite side or wall.

Cel: a transparent sheet of celluloid or similar plastic on which drawings or lettering may be made for use in animation or titles; not to be confused with a **gel.**

Celluloid roll film: also known as *motion picture film* or *raw film stock;* consists of long strips of perforated cellulose acetate on which a rapid succession of still photographs known as **frames** can be recorded. One side of the strip is layered with an emulsion consisting of light-sensitive crystals and dyes; the other side is covered with a backing that reduces reflections. Each side of the strip is perforated with sprocket holes that facilitate the movement of the stock through the sprocket wheels of the camera, the processor, and the projector.

Chiaroscuro: the use of deep gradations and subtle variations of lights and darks within an image.

Characters: an essential element of film **narrative;** the beings who play functional roles within the **plot,** either acting or being acted on. Characters can be **flat** or **round; major, minor,** or **marginal; protagonists** or **antagonists.**

Character roles: actors' parts that represent distinctive **character** types (sometimes stereotypes): society leaders, judges, doctors, diplomats, and so on.

Cinematic conventions: accepted systems, methods, or customs by which movies communicate; they are flexible, not "rules."

Cinematic time: the imaginary time in which a movie's images appear or its narrative occurs; time that has been manipulated through editing; one aspect of **duration** (the other is **real time**).

Cinématographe: a remarkably compact, portable, hand-cranked device, invented by the Lumières, that was a camera, processing plant, and projector all in one.

Clapper/loader: the person on the camera crew responsible for slating **shots** with the **clapperboard** and loading film containers into the camera.

Clapperboard: sometimes called *clapboard* or *clapstick board;* a device consisting of two short wooden boards, hinged together, on which essential identifying information—some of which changes with each take—is written in chalk. The person handling the device claps the boards together in front of the camera and says the number of the take. The resulting reference marks, on both the photographic film and the sound-recording tape, facilitate the rematching of sounds and images during editing.

Closed frame: a frame of a motion picture image that, theoretically, neither **characters** nor objects enter or leave.

Close-up: sometimes designated CU; a **shot** that often shows a part of the body filling the frame—traditionally a face, but possibly a hand, eye, or mouth.

Coherence: logical or aesthetic consistency within a movie; the organization of all the basic elements of cinematic **form** into a harmonious or credible whole.

Colorization: the use of digital technology, in a process much like hand-tinting, to "paint" colors on movies meant to be seen in black and white.

Composition: the process of visualizing and putting visualization plans into practice; more precisely, the organization, distribution, balance, and general relationship of stationary objects and **figures,** as well as of light, shade, line, and color within the frame.

Compressing: also known as *companding;* the process of combining **sound tracks** that preserves signals but reduces or eliminates noise ("hissing") on the tape.

Computer-generated effects: one category of special effects (the others are **in-camera effects** and laboratory effects). This kind is created by digital technology and transferred to film.

Conforming: see **negative cutting.**

Contact printer: a machine that shoots light through the positive and prints it onto the raw **film stock** to make an exact positive copy.

Content: the subject of an artwork, a subject expressed through **form.**

Content curve: in terms of cinematic **duration,** an arc that measures information in a **shot;** at the curve's peak, the viewer has absorbed the information from a shot and is ready to move on to the next **composition.**

Continuity editing: sometimes called *classical editing,* and now the dominant style of editing throughout the world (the other style is **discontinuity editing**). It seeks to achieve logic, smoothness, sequentiality, and the temporal and spatial orientation of viewers to what they see on the screen; ensures the flow from **shot** to shot; creates a rhythm based on the relationship between cinematic space and **cinematic time;** creates filmic unity (beginning, middle, and end); establishes and resolves a problem; in short, tells a story as clearly and coherently as possible.

Costumes: the clothing worn by an actor in a movie (sometimes called *wardrobe,* a term that also designates the department in a studio in which clothing is made and stored).

Crane shot: movement of a camera mounted on an elevating arm that, in turn, is mounted on a vehicle capable of moving on its own power. A crane may also be mounted on a vehicle that can be pushed along tracks.

Critical flicker fusion: a phenomenon that occurs when a single light flickers on and off with such speed that the individual pulses of light fuse together to give the illusion of continuous light.

Cut: a direct change from one shot to another; i.e., the precise point at which shot A ends and shot B begins; one result of **cutting.**

Cutting: also known as *splicing;* the actual joining together of two **shots.** The editor must first cut (or splice) each shot from its respective roll of film before gluing or taping all the shots together.

Cutting continuity script: a specialized document that not only reflects the changes made between the **shooting script** and the actual **shooting** but also includes the number, kind, and duration of **shots,** the kind of transitions, the exact dialogue, and the musical and **sound effects.**

Dailies: also known as *rushes;* usually synchronized picture/sound **workprints** of a day's **shooting** that can be studied by the director, editor, and other crew members before the next day's shooting begins.

Deep-focus cinematography: using the **short-focal-length lens,** this captures **deep-space composition** and its illusion of depth.

Deep-space composition: a total visual composition that occupies all three **planes** of the frame, thus creating an illusion of depth, and usually shot with **deep-focus cinematography.**

Depth of field: the distance in front of a camera and its lens in which objects are in apparent sharp focus.

Dialectical montage: also known as *intellectual montage,* a form of editing (often **discontinuous**) pioneered by Soviet film theorist and filmmaker Sergei Eisenstein, in which **shots** "collide" or noticeably conflict with one another. It is based on the Marxist concept of dialectical materialism, which posits the history of human society as the history of struggle between the classes.

Dialogue: the lip-synchronous speech of **characters** who are either visible onscreen or speaking offscreen, say from another part of the room that is not visible or from an adjacent room.

Diegesis: the total world of a **story**—the events, **characters,** objects, **settings**, and sounds that form the world in which the story occurs. Its elements are called **diegetic elements** (as opposed to **nondiegetic elements**).

Diegetic elements: the elements—events, characters, objects, settings, sounds—that form the world in which the story occurs; see **diegesis** and **nondiegetic elements.**

Diegetic sound: sound that originates from a source within a film's world (as opposed to **nondiegetic sound**).

Digital format: one of the two ways of storing recorded sound, either monaurally or stereophonically (the other is the **analog format**). This format, made possible by computer technology, represents the sound wave by combinations of the numbers 0 and 1.

Direct point of view: one of two main categories of **subjective point of view** (the other is **indirect**). It occurs when a **character** is in the frame and we see directly what he or she sees; this preserves time and space and creates a greater sense of **verisimilitude.**

Discontinuity editing: also known as *constructive* or *nonlinear editing;* less widely used than **continuity editing**; often but not exclusively in **experimental films.** This style joins **shot** A and shot B to produce an effect or meaning not even hinted at by either shot alone.

Dissolve: also known as a *lap dissolve;* a transitional device in which **shot** B, superimposed, gradually appears over shot A and begins to replace it at midpoint in the transitional process. It usually indicates the passing of time.

Distancing effect: see **alienation effect.**

Documentary films: nonfiction movies originally created to address social injustice. When they are produced by governments and carry governments' messages, they overlap with **propaganda films.**

Doppler effect: the principle that the further away a sound is, the "lower" its pitch will seem and thus the less likely it is to be heard distinctly.

Double-exposure: a special effect in which one **shot** is superimposed over another; may be expanded to a *multiple-exposure.*

Double-system recording: the standard technique of recording film sound on a medium separate from the picture; it allows both for maximum quality control of the medium and for the many aspects of manipulating sound during **postproduction** editing, mixing, and synchronization.

Dramatic irony: an effect felt when the audience learns something before the **characters** on the screen do.

Duration: the time a movie takes to unfold on-screen. For any movie, we can identify three specific kinds: **story duration, plot duration,** and **screen duration.** Also see **real time** and **cinematic time.**

Dutch angle: also known as *Dutch tilt* or *oblique angle;* one of the five basic camera angles (the others are **eye level, low level, high angle,** and **aerial view**). In a Dutch-angle **shot,** the camera is tilted from its normal horizontal and vertical position so that it is no longer straight, giving the viewer the impression that the world in the frame is out of balance.

Ellipsis: in filmmaking, generally an omission of time—the time that separates one **shot** from another—to create dramatic or comedic impact.

Establishing shot: a **shot** that ordinarily begins a sequence of shots by showing the location of ensuing action. While usually a **long shot,** it may also be a **medium shot** or **close-up** that includes some sign or other cue to identify the location. It is also called a *master* or *cover shot* because the editor can repeat it later in the film to remind the audience of the location, thus "covering" the director by avoiding the need to **reshoot.**

Experimental films: also known as *avant-garde films,* a term implying that they are in the vanguard, out in front of traditional films. Such films are usually about unfamiliar, unorthodox, or obscure subject matter and are ordinarily made by independent (even underground) film-makers, not studios, often with innovative techniques that call attention to, question, and even challenge their own artifice.

Exposition: the images, action, and dialogue necessary to give the audience the background of the **characters** and the nature of the situation they are in, laying the foundation for the story-telling.

External sound: a form of **diegetic sound** that comes from a place within the world of the **story,** which we and the characters in the scene hear but do not see.

Extras: actors who, usually, appear in nonspeaking or crowd roles and receive no screen credit.

Extreme close-up: sometimes designated ECU; a very close **shot** of some detail, such as a person's eye, a ring on a finger, or a watch face.

Extreme long shot: sometimes designated ELS; a **shot** that places the human figure far away from the camera, thus revealing much of the landscape.

Eye level: one of the five basic camera angles (the others are **high angle, low angle, Dutch angle,** and **aerial view**). An eye-level **shot** is made from the observer's eye level and usually implies neutrality with respect to the camera's attitude toward the subject being photographed.

Eyeline-match cut: this type of **match cut** joins **shot** A, a point-of-view shot of a person looking offscreen in one direction, and shot B, the person or object at which he or she is looking.

Factual films: nonfiction films that usually present people, places, or processes in straight-forward ways meant to entertain and instruct without unduly influencing audiences.

Fade in and **fade out:** transitional devices in which a **shot** made on black-and-white film fades in from a black field (on color film, from a color field) or fades out to a black field (or to a color field). Do not confuse a fade with a **dissolve.**

Fantasy: an interest in or concern for the abstract, speculative, or fantastic. Compare **realism.**

Fast motion: photography that accelerates action by photographing it at a filming rate less than the normal 24 fps, then projecting it at normal speed, so it takes place cinematically at a more rapid rate.

Feed spool: the storage area for unexposed film in the movie camera.

Fiction films: see **narrative films.**

Figures: any significant things that move on the screen—people, animals, objects.

Fill light: lighting, positioned at the opposite side of the camera from the **key light,** that can fill in the shadows created by the brighter key light. Fill light may also come from a **reflector board.**

Film stock: celluloid used to record movies—one type for black-and-white, the other for color.

Each type is manufactured in several standard **formats.**

Filters: pieces of plastic or glass placed in front of a **lens** to manipulate the quality of light—the level or intensity of its illumination.

Final cut: the final edited version of the film, created by mixing the sound tracks, inserting the desired optical or special effects, fine-tuning the rhythm of the film, balancing details and the bigger picture, bringing out subtleties and masking flaws, and approving the fidelity and acoustic quality of the mixed sound; do not confuse with **fine cut** or **final print.**

Final print: an edited version of the film that contains everything that is to appear in the **release prints;** do not confuse with **fine cut** or **final cut.**

Fine cut: the result of the editor's fine-tuning the **rough cut** (through as many versions as necessary), usually in consultation with the director and producer.

Flashback: a device for presenting or reawakening the memory of the camera, a **character,** the audience, or all three; a cut from the narrative present to a past event, which may or may not have already appeared in the movie either directly or through inference.

Flashforward: a device for presenting the anticipation of the camera, a **character,** the audience, or all three; a cut from the narrative present to a future time, one in which, for example, the omniscient camera reveals directly or a **character** imagines, from his or her **point of view,** what is going to happen.

Flatbed: one type of predigital editing machine; a table on which the footage on the reels is pulled horizontally from left to right.

Flat characters: one of two types of **characters** (the other is **round**); these are one-dimensional, and we easily remember them because their motivations and actions are predictable. They may be **major, minor,** or **marginal.**

Floodlights: lamps that produce soft (diffuse) light.

Focal length: the distance from the optical center of a **lens** to the focal point (the film plane—

foreground, middle ground, or background—that the cameraperson wants to keep in focus) when the lens is focused at infinity.

Focusable spots: lamps that produce hard (specular) light.

Focus puller: an assistant camera operator responsible for following and maintaining the focus during **shots.**

Foley sounds: a special category of **sound effects,** invented in the 1930s by Jack Foley, a sound technician at Universal Studios. Technicians known as Foley artists create these sounds in specially equipped studios, where they use a variety of props and other equipment to simulate sounds such as footsteps in the mud, jingling car keys, or cutlery hitting a plate.

Form: words in poetry, speech and action in drama, pictures and sound and so on in the movies; a means of expressing **content.**

Format: the dimensions of a **film stock** and its perforations, and the size and shape of the image frame as seen on the screen. The format extends from Super 8mm through 70mm (and beyond into such specialized formats as IMAX), but is generally limited to three standard gauges: Super 8mm, 16mm, and 35mm.

Freeze frame: also known as *stop frame* and *hold frame;* a still image within a movie, created by repetitive printing in the laboratory of the same frame so that it can be seen without movement for whatever length of time the filmmaker desires.

Frequency: (1) the number of times a thing occurs, such as the number of times with which a **story** element recurs in a **plot;** (2) the speed with which a sound is produced (the number of sound waves it produces per second; the speed of sound remains fairly constant when it passes through air, but varies in different media and in the same medium at different temperatures).

Front projection: stills or footage are projected from the same direction as the camera onto the process screen; used in **process shots.**

Fusil photographique: a form of the chronophotographic gun (see **revolver photographique**)—

a single, portable camera capable of taking twelve continuous images.

Gaffer: the chief electrician on a movie **production** set.

Gauge: also known as **format;** the width of the film stock and its perforations, measured in millimeters, extending typically from Super 8mm through 70mm.

Gel: a sheet of colored filter material placed in front of lighting instruments on a movie production set to alter the tone, color, or quality of their illumination. Not to be confused with a **cel.**

Genre: the categorization of fiction films by **form, content,** or both. Genres include musical, comedy, biography, western, and so on.

Grip: all-around handyperson on a movie **production set,** most often working with the camera crews and electrical crews.

Group point-of-view shot: a shot which shows us what a group of characters would see, but at the group's level, not from the much higher **omniscient point of view;** see also **single character's point-of-view shot.**

Harmonic constitution: also known as *texture* or *color;* the characteristic that distinguishes one sound from other sounds of the same **pitch** and **loudness.**

High angle: one of the five basic camera angles (the others are **eye level, low angle, Dutch angle,** and **aerial view**). A high-angle **shot** (or *downward-angle shot*) is made with the camera above the action and typically implies the observer's sense of superiority to the subject being photographed.

High-key lighting: lighting that produces an image with very little contrast between the darks and the lights. Its even, flat illumination expresses opinions about the subject being photographed. Its opposite is **low-key lighting.**

Hubs: major events in a **plot;** branching points in the plot structure that force **characters** to choose between or among alternate paths.

Improvisation: (1) actors' extemporization—that is, delivering lines based only loosely on the written script or without the preparation that comes with studying a script before rehearsing it; (2) "playing through" a moment, making up lines to keep **scenes** going when actors forget their written lines, stumble on lines, or have some other mishap.

In-camera effects: one category of special effects (the others are **laboratory effects** and **computer-generated effects**). This kind is created in the **production** camera (the regular camera used for **shooting** the rest of the film) on the original **negative** and includes such effects as **montage** and **split screen.**

Indirect point of view: one of two main categories of **subjective point of view** (the other is **direct**). It affords us the opportunity to see and hear what a **character** does, but as the result of at least two consecutive **shots.**

Instructional films: nonfiction movies that seek to educate viewers about common interests rather than persuading them with particular ideas.

Interior monologue: one variation on the mental, **subjective point of view** of an individual **character** (see **point of view**), which allows us to see a character and hear that character's thoughts (in his or her own voice, even though the character's lips don't move).

Internal sound: a form of **diegetic sound** that occurs whenever we hear the thoughts of a **character** we see onscreen and assume that other characters cannot hear them.

Intertitles: brief texts that appear onscreen within the body of a film.

Iris: a circular cutout made with a **mask** that creates a frame within the frame.

Iris-in and **iris-out:** optical **wipe** effects in which the wipe line is a circle; named after the *iris diaphragm,* which controls the amount of light passing through a camera lens. The iris-in begins with a small circle, which expands to a partial or full image; the iris-out is the reverse.

Jump cut: the removal of a portion of a film, resulting in an instantaneous advance in the action—a sudden, perhaps illogical, often disorienting **ellipsis** between two **shots.**

Key light: also known as the *main* or *source light;* the brightest light falling on a subject.

Kinetograph: the first motion picture camera.

Kinetophone: an early motion picture device that allowed viewers to look through the peephole viewer of the **Kinetoscope** and listen to phonograph recordings through earphones.

Kinetoscope: a peephole viewer, an early motion picture device.

Laboratory effects: one category of special effects (the others are **in-camera effects** and **computer-generated effects**). This kind, created on a fresh piece of **film stock,** includes more complicated procedures, such as contact printing and bi-pack.

Length: the number of feet (or meters) of **film stock** or the number of reels being used in a particular film.

Lens: the piece of transparent material that focuses the image on the film being exposed.

Linear editing: a transitional step between the old upright machines (see **Moviola**) and **flatbeds** and today's **nonlinear digital editing.** The linear system records footage on videotape in a straight line, each **shot** occupying an amount of space equal to its length in time; thus editing any shot means reediting everything after it on that "line."

Lined script: a copy of the script on which, during **production,** the script supervisor records all details of continuity from **shot** to shot, ascertaining that **costumes,** positioning and orientation of objects, placement and movement of actors are consistent in each successive shot and, indeed, in all parts of the film.

Locked print: the crucial stage in editing after which no further changes are made; the editor cuts the original negative to conform to this print.

Long-focal-length lens: also known as the *telephoto* **lens,** and one of the four major types of lenses (the others are the **short-focal-length lens,** the **middle-focal-length lens,** and the **zoom lens**). It flattens the space and depth of the image and thus distorts perspective relations.

Long shot: sometimes designated LS; a **shot** that shows the full human body, usually filling the frame, and some of its surroundings.

Long take: sometimes called a *sequence shot;* a **shot** that can run anywhere from one minute to ten minutes. The average shot runs ten seconds.

Loudness: the volume or intensity of a sound, which depends on its **amplitude.**

Low angle: also known as *upward angle;* one of the five basic camera angles (the others are **eye level, high angle, Dutch angle,** and **aerial view**). A low-angle **shot** is made with the camera below the action and typically places the observer in a position of inferiority.

Low-key lighting: lighting that creates strong contrasts; sharp, dark shadows; and an overall gloomy atmosphere. Its contrasts between light and dark often imply ethical judgments. Its opposite is **high-key lighting.**

Magic lantern: an early movie projector.

Magnetic recording: one of two ways of recording and storing sound in the **analog format** (the other is **optical recording**), and for years the most popular medium and the one most commonly found in professional **production;** in this method, signals are stored on magnetic recording tape of various sizes and formats (open reels, cassettes, etc.).

Major characters: the main **characters** in a movie; they make the most things happen or have the most things happen to them.

Major roles: also known as *main, featured,* or *lead roles;* principal agents in helping move the plot forward. Whether **movie stars** or newcomers, actors playing major roles appear in many scenes and—ordinarily, but not always—receive screen credit "above the title."

Marginal characters: **minor characters** that lack both definition and screen time.

Mask: an opaque sheet of metal, paper, or plastic (with, for example, a circular cutout, known as an **iris**) that is placed in front of the camera and admits light through that circle to a specific area of the frame—to create a frame within the frame.

Match cut: a joining together that preserves continuity between two **shots.** Several kinds exist, including the **match-on-action cut** and the **eyeline-match cut.**

Match-on-action cut: a type of **match cut** in which the action continues seamlessly from one **shot** to the next or from one camera angle to the next.

Mediation: an agent, structure, or other formal element, whether human or technological, that transfers something, such as information in the case of movies, from one place to another.

Medium long shot: sometimes designated MLS; also known as the *American shot* and the *plan américain;* a **shot** that is taken from the knees up and includes most of a person's body.

Medium shot: often designated MS; a **shot** showing the human body, usually from the waist up.

Method acting: also known as *the method;* a naturalistic acting style, loosely adapted from the ideas of Russian director Konstantin Stanislavsky by American directors Elia Kazan and Lee Strasberg, that encourages actors to speak, move, and gesture not in a traditional stage manner but in the same way they would in their own lives. Thus it is an ideal technique for representing convincing human behavior on the stage and on the screen.

Middle-focal-length lens: or the *"normal"* lens, and one of the four major types of lenses (the others are the **short-focal-length lens,** the **long-focal-length lens,** and the **zoom lens**). It does not distort perspectival relations.

Minor characters: the supporting **characters** in a movie, they have fewer traits than **major characters,** and thus we know less about them. They may be so lacking in definition and screen time that we can consider them **marginal characters.**

Minor roles: also known as *supporting roles;* second in the hierarchy after **major roles.** They also help move the plot forward (and thus may be as important as major roles), but the actors playing them generally do not appear in as many scenes as the featured players.

Montage: (1) in France, the word for editing, from the verb *monter,* "to assemble or put together"; (2) in the former Soviet Union in the 1920s, the various forms of editing that expressed ideas developed by theorists and filmmakers such as Sergei Eisenstein; (3) in Hollywood, beginning in the 1930s, a sequence of **shots,** often with superimpositions and optical effects, showing a condensed series of events.

Motion picture film: see **celluloid roll film.**

Movie star: a phenomenon, generally associated with Hollywood, comprising the actor and the **characters** he or she has played, an image created by the studio to coincide with the kind of roles associated with the actor, and a reflection of the social and cultural history of the period in which that image was created.

Moving frame: the result of the dynamic functions of the frame around a motion picture image, which can frame moving action but can also move and thus change its viewpoint.

Moviola: for years the most familiar and popular upright editing machine; a portable device, operated by foot pedals and leaving the editor's hands free, it is based on the same technical principle as the movie projector and contains a built-in viewing screen.

Multiple-exposure: see **double-exposure.**

Narration: the commentary spoken by either offscreen or onscreen voices, frequently used in narrative films, where it may emanate from an omniscient voice (and thus not one of the **characters**) or from a character in the movie.

Narrative: the overall connection of events within the world of a movie; see **story** and **plot.**

Narrative films: also known as *fiction films;* movies that tell **stories**—with **characters,** places, and events—conceived in the minds of the films' creators. These stories may be wholly imaginary or based on true occurrences, realistic or unrealistic or both.

Negative: a negative photographic image on transparent material, which makes possible the reproduction of the image.

Negative cut: the penultimate stage of editing, in which the editor cuts the original negative to conform to the **locked print,** resulting in the **final print.**

Nondiegetic elements: the things we see and hear on the screen that come from outside the world of the story (including background music, titles and credits, or voiceover comment from an omniscient narrator). See **diegesis.**

Nondiegetic sound: sound that originates from a source outside a film's world (as opposed to **diegetic sound**).

Nondirectional microphones: sound-recording equipment that tends to pick up more sound from the **shooting** environment than desired; improved on by **unidirectional, bidirectional,** and **omnidirectional microphones.**

Nonfiction films: factual, instructional, documentary, and **propaganda** films, traditionally produced by governments, foundations, charity organizations, and independents. "Nonfiction" and "documentary" are often used synonymously, but while all documentaries are nonfiction films, not all nonfiction films are documentaries.

Nonlinear digital editing: editing with computerized equipment, storing images (**shots,** scenes, sequences) on the computer's internal disk, from which they can be accessed easily as the computer responds to the editor's commands. Compare **linear editing.**

Offscreen sound: a form of sound, either **diegetic** or **nondiegetic,** that derives from a source we do not see. When diegetic, it consists of **sound effects,** music, or vocals that emanate from the world of the **story.** When nondiegetic, it takes the form of a musical score or **narration** by someone who is not a **character** in the story.

Offscreen space: space outside the frame; one of two kinds of cinematic space (the other is **onscreen space**).

Omnidirectional microphones: sound-recording equipment that responds to sound coming from all directions.

Omniscient point of view: the most basic and most common **point of view.** *Omniscient* means that the camera has complete or unlimited perception of what the cinematographer *chooses* for it to see and hear; this POV shows what that camera sees, typically from a high angle.

180-degree system: also known as the *180-degree rule,* the *axis of action,* and the *center line;* the fundamental means by which filmmakers maintain consistent *screen direction,* orienting the viewer and ensuring a sense of the cinematic space in which the action occurs. The system assumes three things: the action within a scene will always advance along a straight line, either from left to right or right to left of the frame; the camera will remain consistently on one side of that action; and everyone on the production set will understand and adhere to this system.

Onscreen sound: a form of **diegetic sound** that emanates from a source we see as well as hear. It may be **internal** or **external.**

Onscreen space: space inside the frame; one of two kinds of cinematic space (the other is **offscreen space**).

Open frame: a frame around a motion picture image that, theoretically, people and things can enter and leave.

Optical recording: one of two ways of recording and storing sound in the **analog format** (the other is **magnetic recording**), and until the 1950s the standard method; the conversion of sound waves into light, which is recorded photographically onto 16 or 35mm **film stock.**

Option contract: during the classic Hollywood period, an actor's standard seven-year contract, reviewed every six months: if the actor had made progress in being assigned roles and demonstrating box-office appeal, the studio picked up the option to employ that actor for the next six months and gave the actor a raise; if not, the studio dropped the option and the actor was out of a job.

Order: the arrangement of **plot** events into a logical sequence or hierarchy. Across an entire **narrative** or in a brief section of it, any film can use

one or more methods to arrange its plot: chronological order, cause-and-effect order, logical order, and so on.

Outtakes: material not used in either the **rough cut** or the **final cut,** cataloged and saved.

Pan shot: the horizontal movement of a camera mounted on the gyroscopic head of a stationary tripod; like the **tilt shot,** a simple movement with dynamic possibilities for creating meaning.

Parallel editing: also called *cross-cutting* and *intercutting;* the intercutting of two or more lines of action that occur simultaneously, a very familiar convention in chase or rescue sequences.

Persistence of vision: the process by which the human brain retains an image for a fraction of a second longer than the eye records it.

Phi phenomenon: the illusion of movement created by events that succeed each other rapidly, as when two adjacent lights flash on and off alternately and we seem to see a single light shifting back and forth.

Photography: literally, "writing with light"; technically, the static representation or reproduction of light.

Pitch: the level of a sound, defined by its **frequency.**

Planes: the three theoretical horizontal planes—foreground, middle ground, and background—or areas within the frame; see **rule of thirds.**

Plot: a structure for presenting everything we see and hear in a film, with an emphasis on causality, consisting of two factors: (1) the arrangement of the diegetic events in a certain order or structure and (2) added nondiegetic material. See **diegesis** and **nondiegetic elements.**

Plot duration: the elapsed time of those events within a story that a film chooses to tell; one of three parts of a film's overall **duration** (the other two are **story duration** and **screen duration**).

Point of view: abbreviated as POV; the position from which a film presents the actions of the **story;** not only the relation of the narrator(s) to the story but also the camera's act of seeing and hearing. The two fundamental types of cinematic point of view are **omniscient** and **subjective** (or **restricted**), which can be either **direct** or **indirect.**

Point-of-view editing: the joining together of a point-of-view **shot** with a **match cut** (specifically, a **match-on-action cut**) to show, in the first shot, a **character** looking and, in the second, what he or she is looking at.

Postproduction: the third stage of the production process, consisting of editing, preparing the final print, and bringing the film to the public (marketing and distribution).

Postproduction sounds: those **synchronous** and **asynchronous sounds** created during the **postproduction** stage.

Postsynchronization: the printing of image and sound on separate pieces of film that can be manipulated independently.

Preproduction: the initial, planning-and-preparation stage of the production process.

Process shot: live shooting against a background that is **front-** or **rear-projected** on a translucent screen.

Processing: the second stage of creating motion pictures, in which a laboratory technician washes exposed film (which contains a **negative** image) with processing chemicals.

Production: the second stage of the production process, the actual **shooting.**

Production sounds: those **synchronous sounds** recorded during **production** (most of which, including dialogue, are changed, cleaned up, or rerecorded during **postproduction**).

Production values: the amount of human and physical resources devoted to the image, including the style of its lighting; helps determine the overall style of a film.

Progression: the process by which we move from the beginning, through the middle, to the end of a temporal work of art (poetry, fiction, music, theater, film).

Projecting: the third stage of creating motion pictures, in which edited film is run through a projector, which shoots through the film a beam of

light intense enough to reverse the initial process and to project a large image on the movie theater screen.

Propaganda: nonfiction films that systematically disseminate deceptive or distorted information; compare **documentary films.**

Protagonist: the **major character** who serves as the "hero" and who "wins" the conflict.

Pull-down claw: within the movie camera, the mechanism that controls the intermittent cycle of **shooting** individual frames and advances the film frame by frame.

Quality: also known as *timbre;* the characteristic of a sound that results from its **harmonic constitution.**

Raw film stock: see **celluloid roll film.**

Realism: an interest in or concern for the actual or real; a tendency to view or represent things as they really are. Compare **antirealism** and **fantasy.**

Real time: time that is continuous, as in life; one aspect of **duration** (the other is **cinematic** time). Many directors use real time within films to create uninterrupted "reality" on the screen—denoted by a direct correspondence of **screen duration** to **story duration**—but they rarely use it for entire films. See also **stretch relationship** and **summary relationship.**

Rear projection: the projection of stills or footage onto a translucent screen, to provide a background for live shooting; used in **process shots.**

Reflector board: a piece of lighting equipment, but not really a lighting instrument, because it does not rely on bulbs to produce illumination. Essentially, it is a double-sided board that pivots in a U-shaped holder. One side is a hard, smooth surface that reflects hard light; the other is a soft, textured surface that provides softer **fill light.**

Release print: the version of the **final print** used by the filmmakers to create hundreds, even thousands of costly prints for distribution.

Rerecording: sometimes called *looping* or *dubbing;* the replacing of **dialogue,** which can be done manually (i.e., with the actors watching the footage, synchronizing their lips with it, and rereading the lines) or, more likely today, through **Automatic Dialogue Replacement** (ADR). (*Dubbing* also refers to the process of replacing dialogue in a foreign language with English, or the reverse, throughout a film.)

Reshoot: to make *additional photography* as supplemental material for **production** photography.

Restricted point of view: also known as **subjective point of view.**

Revolver photographique: also known as *chronophotographic gun;* a cylinder-shaped camera that creates exposures automatically, at short intervals, on different segments of a revolving plate.

Rough cut: a further refinement of the **assembly edit**—close enough to the **final cut** to give a sense of the finished movie.

Rough draft screenplay: also known as *scenario;* the next step after a **treatment,** it results from discussions, development, and transformation of an outline in sessions known as **story conferences.**

Round characters: one of two types of **characters** (the other is **flat**); these are three-dimensional, unpredictable, complex, and capable of surprising us in a convincing way. They may be **major** or **minor characters.**

Rule of thirds: a compositional principle that enables filmmakers to maximize the potential of the image, put its elements into balance, and create the illusion of depth. A grid pattern, when superimposed on the image, divides it into horizontal thirds representing the foreground, middle ground, and background **planes** and vertical thirds that break up those planes into further elements.

Rushes: see **dailies.**

Satellites: minor **plot** events in the **diegesis,** or world, of the narrative but detachable from it (though they may be removed at some cost to the overall texture of the narrative).

Scale: the size and placement of a particular object or a part of a scene in relation to the rest, a relationship determined by the type of **shot** used and the placement of the camera.

Scenario: see **rough draft screenplay.**

Scene: a complete unit of plot action incorporating one or more shots; the setting of that action.

Scope: the overall range of a **story.**

Screen duration: a film's running time; one of three parts of a film's overall **duration** (the other two are **story duration** and **plot duration**).

Screen test: a filming undertaken by an actor to try out for a particular role.

Self-reflexivity: the quality of a **form** that reflects, mirrors, and even critiques its own **content.**

Separation editing: a series of cuts between two or more **characters** involved in simultaneous action in the same place. The characters are divided less by space than by their goals, cultural identities, or moral positions.

Sequence: a series of edited **shots** characterized by inherent unity of theme and purpose.

Series photography: the use of a series of still photographs to record the phases of an action, though the actions within the images do not move.

Set: not reality but a fragment of reality created as the **setting** for a particular **shot** in a movie; must be constructed both to look authentic and to photograph well.

Setting: the time and space in which a **story** takes place.

Setup: one camera position and everything associated with it. While the **shot** is the basic building block of the film, the setup is the basic component of the film's **production.**

Shooting: the recording of images on previously unexposed film as it moves through the camera.

Shooting angle: the level and height of the camera in relation to the subject being photographed. The five basic camera angles are **eye level, high angle, low angle, Dutch angle,** and **aerial view.**

Shooting script: a guide and reference point for all members of the **production** unit, in which the details of each **shot** are listed and can thus be followed during filming.

Short-focal-length lens: also known as the *short-focus* or *wide-angle* **lens,** and one of the four major types of lenses (the others are the **middle-focal-length lens,** the **long-focal-length lens,** and the **zoom lens**). It creates the illusion of depth within the frame, albeit with some distortion at the edges of the frame.

Shot: one *uninterrupted* run of the camera. It can be as short or as long as the director wants, but it cannot exceed the length of the **film stock** in the camera.

Shot/reverse shot: one of the most prevalent and familiar of all editing patterns, which **parallel edits** (*cross-cuts*) between shots of different **characters,** usually in a conversation or confrontation. When used in continuity editing, the shots are typically framed over each character's shoulder to preserve screen direction.

Shutter: a device that shields the film from light at the **aperture** during the film movement portion of the intermittent cycle of **shooting.**

Single character's point-of-view shot: a shot made with the camera close to the line of sight of a character (or animal or surveillance camera), showing what that person would be seeing of the action; see also **omniscient point-of-view shot** and **group point-of-view shot.**

Slow disclosure: an edited succession of images that lead from A to B to C as they gradually reveal the elements of a **scene.** Each image sheds light on the one before, thereby changing its significance with new information.

Slow motion: photography that decelerates action by photographing it at a rate greater than the normal 24 fps, so that it takes place in **cinematic time** at a rate less rapid than the rate of real action that took place before the camera.

Sound bridge: also known as a *sound transition;* sound carried from a first **shot** over to the next before the sound of that second shot begins.

Sound design: a state-of-the-art concept given its name by film editor Walter Murch, combining the crafts of editing and mixing and, like them, involving both theoretical and practical issues. In essence, it represents advocacy for movie sound (to counter some people's tendency to favor the movie image).

Sound effects: all sounds artificially created for the **sound track** that have a definite function in telling the **story.**

Soundstage: a windowless, soundproofed, professional shooting environment, which is usually several stories high and can cover an acre or more of floor space.

Sound track: a separate recording tape, occupied by each type of sound recorded for a movie (one track for vocals, one for **sound effects,** one for music, etc.).

Speed: the rate at which film must move through the camera to correctly capture an image; very fast film requires little light to capture and fix the image, while very slow film requires a lot of light.

Splicer: an editing device with an edge for cutting film evenly on a frame line and a bed on which to align and tape together cuts that will be invisible to the audience.

Splicing: see **cutting.**

Split-screen: a method, which may be created in the camera or during the editing process, of telling two stories at the same time. Unlike **parallel editing,** however, which cuts back and forth between **shots** for contrast, the split-screen can tell multiple stories within the same frame.

Sprocketed rollers: devices that control the speed of unexposed film as it moves through the camera.

Stand-ins: actors who look reasonably like **movie stars** (or at least actors playing **major roles**) in height, weight, coloring, and so on, and who substitute for them during the tedious process of preparing **setups** or taking light readings.

Stanislavsky system: A system of acting developed by Russian theater director Konstantin Stanislavsky in the late nineteenth century, which encourages students to strive for realism, both social and psychological, and to bring their past experiences and emotions to their roles. It influenced the development of **method acting** in the United States.

Steadicam: a camera actually *worn* by the cameraman, so it is not "handheld"; it removes jumpiness, and it is now much used for smooth, fast, and intimate camera movement.

Stock: see **film stock.**

Story: in a movie, (1) all the events we see or hear on the screen; and (2) all the events that are implicit or that we infer to have happened but that are not explicitly presented. See **diegesis.**

Storyboard: a scene-by-scene (sometimes a shot-by-shot) breakdown that combines sketches or photographs of how each **shot** is to look along with written descriptions of the other elements that are to go with each shot, including **dialogue,** sound, and music.

Story conferences: sessions during which the **treatment** is discussed, developed, and transformed from an outline into what is known as a **rough draft screenplay** or *scenario.*

Story duration: the amount of time that the implied story takes to occur; one of three parts of a film's overall **duration** (the other two are **plot duration** and **screen duration**).

Stream of consciousness: a literary style that gained prominence in the 1920s in the hands of such writers as Marcel Proust, Virginia Woolf, James Joyce, and Dorothy Richardson and that attempted to capture the unedited flow of experience through the mind.

Stretch relationship: one in which **screen duration** is longer than **story duration.** See also **real time** and **summary relationship.**

Stunt persons: performers who double for other actors in scenes requiring special skills or involving hazardous actions, such as crashing cars, jumping from high places, swimming, and riding (or falling off) horses.

Subjective point of view: also known as *restricted point of view.* **Point of view** that shows us a shot or scene as viewed by a **character—major, minor,** or **marginal.**

Summary relationship: one in which **screen duration** is shorter than **story duration.** See also **real time** and **stretch relationship.**

Surprise: a taking unawares, potentially shocking.

Suspense: the anxiety brought on by a partial uncertainty—the end is certain, but the means is uncertain.

Swish pan: a horizontal camera movement so fast that it blurs the photographic image.

Synchronous sound: the type of film sound we are most familiar with, which comes from and matches a source apparent in the image, as when dialogue matches **characters'** lip movements or we hear the sound of shifting gears as we watch an automobile gather speed (as opposed to **asynchronous sound**).

Synopsis: see **treatment.**

Take: an indication of the number of times a particular **shot** is taken (e.g., shot 14, take 7).

Take-up spool: a device that winds the film inside the movie camera after it has been exposed.

Tilt shot: the vertical movement of a camera mounted on the gyroscopic head of a stationary tripod. Like the **pan shot,** it is a simple movement with dynamic possibilities for creating meaning.

Tracking shot: smooth camera movement, with the action (alongside, above, beneath, behind, or ahead of it), when the camera is mounted on a set of tracks, a dolly, a crane, or an aerial device, such as an airplane, helicopter, or balloon.

Treatment: also known as *synopsis;* an outline of the action that briefly describes the essential ideas and structure for a film.

Two-shot: a **shot** in which two **characters** appear; ordinarily a **medium shot** or **medium long shot.**

Typecasting: the casting of actors because of their looks or "type" rather than for their acting talent or experience.

Unidirectional microphones: sound-recording equipment that responds, and has great sensitivity, to sound coming from one direction.

Unity and balance: related to **coherence** and **progression** and two of the oldest and most universally recognized criteria in analyzing a work of art. Unity, sometimes called *organic unity,* means that the basic elements of cinematic **form** are organized within and give structure to the larger system of the film. When the elements work in complementary ways, the movie as a whole seems unified and balanced.

Verisimilitude: a convincing appearance of truth; movies are verisimilar when they convince you that the things on the screen—people, places, what have you, no matter how fantastic or antirealistic—are "really there."

Video assist camera: a tiny device, mounted in the viewing system of the film camera, that enables a script supervisor to view a scene (and thus compare its details with those of surrounding scenes, to ensure visual continuity) before the film is sent to the laboratory for processing.

Viewfinder: on a camera, the little window you look through when taking a picture; its frame indicates the boundaries of the camera's **point of view.**

Walk-ons: roles even smaller than **cameos,** reserved for highly recognizable actors or personalities.

Wipe: a transitional device in which **shot** B wipes across shot A, either vertically or horizontally, to replace it. Although (or because) the device reminds us of early eras in filmmaking, directors continue to use it.

Workprint: any positive print (either print or sound or both, but not yet timed or color-corrected) intended for use in the initial trial cuttings of the editing process.

Zoom lens: one of the four major types of **lenses** (the others are the **short-focal-length lens,** the **middle-focal-length lens,** and the **long-focal-length lens**). It is moved toward and away from the subject being photographed, has a continuously variable **focal length,** and helps reframe a **shot** within the **take.**

Zoopraxiscope: an early device for exhibiting moving pictures—a revolving disk with photographs arranged around the center.

Permissions
Acknowledgments

CHAPTER 1

Still from Victor Fleming's *The Wizard of Oz*. Courtesy of Photofest.

Stills from William K. L. Dickson's *Fred Ott's Sneeze*. Courtesy of the Museum of Modern Art / Film Stills Archive, New York.

A staging of Shakespeare's *Henry V*. Courtesy of the Alabama Shakespeare Festival, Montgomery, Alabama.

Edweard Muybridge's camera setup. Courtesy of the University of Pennsylvania Archives and Records Center, Philadelphia.

Edweard Muybridge's horses. Photo © Corbis.

Zoopraxiscope and disk. Courtesy of the Kingston Museum, Local History Room, Kingston upon Thames, Surrey, England.

Standard motion picture film gauges. Filmstrips courtesy of Photofest.

Thomas Edison's Black Maria. Courtesy of the Museum of Modern Art / Film Stills Archive, New York.

Interior view of Thomas Edison's Black Maria. Courtesy of the Museum of Modern Art / Film Stills Archive, New York.

Auguste and Louis Lumière. Courtesy of the Museum of Modern Art / Film Stills Archive, New York.

The Lumière brothers' Cinématographe. Courtesy of the Museum of Modern Art / Film Stills Archive, New York.

Stills from the Lumière brothers' *L'Arrivée d'un train en gare*. Courtesy of the Museum of Modern Art / Film Stills Archive, New York.

Still from the Lumière brothers' *Workers Leaving the Lumiére factory*. Courtesy of the Museum of Modern Art / Film Stills Archive, New York.

Still from Georges Méliès's *A Trip to the Moon*. Courtesy of the Museum of Modern Art / Film Stills Archive, New York.

Edouard Manet's *The Railroad*. Photo © Francis G. Mayer / Corbis.

Thomas Gainsborough's *Lady Innes*. Courtesy of The Frick Collection, New York.

Marcel Duchamp's *Nude Descending a Staircase, No. 2*. Courtesy of the Philadelphia Museum of Art; The Louise and Walter Arensberg Collection.

Still from Robert Flaherty's *Nanook of the North*. Courtesy of the Museum of Modern Art / Film Stills Archive, New York.

Camera crew shooting Leni Riefenstahl's *Triumph of the Will*. Courtesy of the Museum of Modern Art / Film Stills Archive, New York.

Still from Leni Riefenstahl's *Triumph of the Will*. Courtesy of the Museum of Modern Art / Film Stills Archive, New York.

Stills from Fernand Léger's *Ballet Mécanique*. Courtesy of the Museum of Modern Art / Film Stills Archive, New York.

Still from Luis Buñuel and Salvador Dalí's *Un chien andalou*. Courtesy of the Museum of Modern Art / Film Stills Archive, New York.

CHAPTER 2

Still from Douglas McGrath's *Emma*. Courtesy of Photofest.

Filmed theft of a Picasso painting from a London gallery. Photo © Ben Gott / Corbis.

Praxiteles's *Hermes with infant Dionysos on his arm*. The

Archeological Museum, Olympia, Greece. Photo © Erich Lessing / Art Resource, NY.

Alberto Giacometti's *Walking Man*. Photo © The Burstein Collection / Corbis.

Keith Haring's *Self Portrait 1989*. In the outdoor exhibition *L'Homme qui Marche* at the Gardens of Le Palais Royal, Paris, March 23–June 18, 2000. Photo © Bernard Annebicque / Corbis.

Still from D. W. Griffith's *The Lonely Villa*. Courtesy of the Museum of Modern Art / Film Stills Archive, New York.

Storyboard from Alfred Hitchcock's *The Birds*. Courtesy of Photofest.

Posters for Robert Z. Leonard's *The Divorcee* and Howard Hawk's *Scarface*. Courtesy of Photofest.

Still from David Lean's *Great Expectations*. Courtesy of the Museum of Modern Art / Film Stills Archive, New York.

CHAPTER 3

Still from Baz Luhrmann's *Moulin Rouge!* Courtesy of Photofest.

Still from Buster Keaton's *The General*. Courtesy of the Museum of Modern Art / Film Stills Archive, New York.

Still from Busby Berkeley's *Gold Diggers of 1933*. Courtesy of the Museum of Modern Art / Film Stills Archive, New York.

Still from Giovanni Pastrone's *Cabiria*. Courtesy of the Museum of Modern Art / Film Stills Archive, New York.

Still from W. S. Van Dyke's *Marie Antoinette*. Courtesy of the Museum of Modern Art / Film Stills Archive, New York.

Still from Robert Wiene's *The Cabinet of Dr. Caligari*. Courtesy of the Museum of Modern Art / Film Stills Archive, New York.

Still from Vittorio De Sica's *Bicycle Thieves*. Courtesy of the Museum of Modern Art / Film Stills Archive, New York.

Still from Yasujiro Ozu's *Late Spring*. Courtesy of the Museum of Modern Art / Film Stills Archive, New York.

CHAPTER 4

Still from Bernardo Bertolucci's *The Last Emperor*. Courtesy of Photofest.

Gregg Toland and Orson Welles on the set of *Citizen Kane*. Courtesy of Time Life, Inc.

Still from Billy Wilder's *Sunset Boulevard*. Courtesy of the Museum of Modern Art / Film Stills Archive, New York.

Still from Charlie Chaplin's *Modern Times*. Courtesy of the Museum of Modern Art / Film Stills Archive, New York.

Still from Charlie Chaplin's *The Great Dictator*. Courtesy of the Museum of Modern Art / Film Stills Archive, New York.

Tracking shot for Victor Fleming's *Gone With the Wind*. Courtesy of Photofest.

Steadicam used on the set of James Cameron's *Titanic*. Courtesy of Photofest. Steadicam is a registered trademark of the Tiffen Company, LLC.

Still from Fritz Lang's *Metropolis*. Courtesy of the Museum of Modern Art / Film Stills Archive, New York.

CHAPTER 5

Still from Spike Lee's *Malcolm X*. Courtesy of Photofest.

Still from Henri Desfontaines and Louis Mercanton's *Queen Elizabeth*. Courtesy of the Museum of Modern Art / Film Stills Archive, New York.

Photo of D. W. Griffith. Courtesy of the Museum of Modern Art / Film Stills Archive, New York.

Photo of cinematographer Lee Garmes and producer William Goetz on the set of Alexander Korda's *Lilies of the Field*. Courtesy of the Museum of Modern Art / Film Stills Archive, New York.

Still from Rouben Mamoulian's *Applause*. Courtesy of the Museum of Modern Art / Film Stills Archive, New York.

Jean Arthur's screen test for Victor Fleming's *Gone With the Wind*. Courtesy of Photofest.

Ryan Phillipe and Robert Altman on the set of *Gosford Park*. Courtesy of Photofest.

CHAPTER 6

Still from Quentin Tarantino's *Pulp Fiction*. Courtesy of Photofest.

Stills from Edwin S. Porter's *Life of an American Fireman*. Courtesy of the Museum of Modern Art / Film Stills Archive, New York.

Still from Alain Resnais's *Hiroshima, mon amour*. Courtesy of the Museum of Modern Art / Film Stills Archive, New York.

Thelma Schoonmaker and Martin Scorsese in the editing room, 1989. Photo © David Leonard, Photographer.

Still from Jean-Luc Godard's *Breathless*. Courtesy of the Museum of Modern Art / Film Stills Archive, New York.

Editor Daniel Mandell using a Moviola for William Wyler's *Wuthering Heights*. Courtesy of the Museum of Modern Art / Film Stills Archive, New York.

Avid editing software. Screen shot courtesy of Avid Technology, Inc.

CHAPTER 7

Still from George Lucas's *Star Wars*. Courtesy of Photofest.

Still from Laurence Olivier's *Hamlet*. Courtesy of the Museum of Modern Art / Film Stills Archive, New York.

Stills from Alfred Hitchcock's *The 39 Steps*. Courtesy of the Museum of Modern Art / Film Stills Archive, New York.

Still from Alan Crosland's *The Jazz Singer*. Courtesy of the Museum of Modern Art / Film Stills Archive, New York.

Still from Walt Disney's *Steamboat Willie*. Courtesy of the Museum of Modern Art / Film Stills Archive, New York.

Sound crew on the set of John Schlesinger's *Eye for an Eye*. Courtesy of Photofest.

Brad Kane recording the voice of the title character in Ron Clements and John Musker's *Aladdin*. Courtesy of Photofest.

CHAPTER 8

Still from Curtis Hanson's *Wonder Boys*. Courtesy of Photofest.

Every effort has been made to contact the copyright holders of each still image. Rights holders of any still not credited should contact W. W. Norton & Company, 500 Fifth Avenue, New York, NY 10110, for a correction to be made in the next reprinting of our work.

Index

Page numbers in *italics* refer to illustrations and captions; those in **boldface** refer to main discussions of topics.